CHANGING PERSPECTIVES
in Literature and the Visual Arts
1650–1820

CHANGING PERSPECTIVES

in Literature and the Visual Arts
1650–1820

MURRAY ROSTON

PRINCETON UNIVERSITY PRESS

COPYRIGHT © 1990 BY PRINCETON UNIVERSITY PRESS
PUBLISHED BY PRINCETON UNIVERSITY PRESS,
41 WILLIAM STREET, PRINCETON, NEW JERSEY 08540
IN THE UNITED KINGDOM: PRINCETON UNIVERSITY PRESS, OXFORD

THIS BOOK HAS BEEN COMPOSED IN LINOTRON BEMBO

CLOTHBOUND EDITIONS OF PRINCETON UNIVERSITY PRESS
BOOKS ARE PRINTED ON ACID-FREE PAPER, AND BINDING
MATERIALS ARE CHOSEN FOR STRENGTH AND DURABILITY

PRINTED IN THE UNITED STATES OF AMERICA BY
PRINCETON UNIVERSITY PRESS,
PRINCETON, NEW JERSEY

LIBRARY OF CONGRESS
CATALOGING-IN-PUBLICATION DATA

ROSTON, MURRAY
CHANGING PERSPECTIVES IN LITERATURE AND THE VISUAL ARTS,
1650—1820 / MURRAY ROSTON.
P. CM.
SEQUEL TO: RENAISSANCE PERSPECTIVES.
BIBLIOGRAPHY: P.
INCLUDES INDEX.
ISBN 0–691–06795–3 (ALK. PAPER)
1. ENGLISH LITERATURE—EARLY MODERN, 1500–1700—HISTORY
AND CRITICISM. 2. ENGLISH LITERATURE—18TH CENTURY—
HISTORY AND CRITICISM. 3. ART AND LITERATURE—EUROPE.
4. RENAISSANCE. 5. PERSPECTIVE. I. TITLE.
PR428.A76R67 1990 820.9'357—DC20 89–10545

CONTENTS

ACKNOWLEDGMENTS vii

LIST OF ILLUSTRATIONS ix

INTRODUCTION 3

LATE BAROQUE

CHAPTER 1 Milton's Herculean Samson 13

CHAPTER 2 Dryden's Heroic Dramas 41

ROCOCO

CHAPTER 3 Pope's Equipoise 89

CHAPTER 4 The Emergence of the Novel 151

PRE-ROMANTICISM

CHAPTER 5 The Beautiful and the Sublime 193

CHAPTER 6 Blake's Inward Prophecy 255

CHAPTER 7 The "Inconvenience" of Jane Austen 311

ROMANTICISM

CHAPTER 8 Lowering Skies 339

CHAPTER 9 The Contemplative Mode 373

v

CONTENTS

NOTES 399

INDEX 441

ACKNOWLEDGMENTS

I HAVE, IN PREPARING THIS BOOK, ENJOYED THE HOSPITALITY OF three academic institutions in the United States, to all of which I am deeply grateful. A fellowship at the National Humanities Center in North Carolina provided me with a year in idyllic surroundings free from administrative and other duties, while in subsequent years visiting positions in the English departments at UCLA and once again at the University of Virginia allowed me to combine the pleasure of teaching there with access to larger library facilities than are available to me in Israel.

Three small sections of this book have been published in an earlier form, and I wish to record my appreciation to the editors of the *Milton Quarterly*, of *HSLA*, and of *Reading Hogarth: the 1988 annual lectures of the Grunwald Center for the Graphic Arts at UCLA*, for permission to make further use of the material here.

I have been fortunate in obtaining many helpful comments from friends and colleagues who, during my varied peregrinations, have kindly read parts of this book in draft form, namely, Ralph Cohen, Reginald Foakes, Jean Hagstrum, Lawrence Hoey, Wolf Z. Hirst, and Anne K. Mellor, as well as from students in both Israel and the United States who have shared with me in the task of exploration. I am grateful to the many galleries, museums, and private owners who have granted me permission to reproduce illustrations of works in their possession. Mr. Charles Ault has carefully supervised the copyediting of the text, Mr. Peter Anderson and Ms. Margaret Davis have been responsible for the art design of this volume, while Mr. Robert E. Brown, the literature editor of Princeton University Press, has been unfailing in his courtesy and support.

My final thanks are, as always, reserved for my wife Faith, who, in addition to her constant encouragement, has continued to participate so joyfully and so constructively in our annual tours through the art centres of Europe.

Bar Ilan University
Ramat Gan, Israel

LIST OF ILLUSTRATIONS

1. ALBERTI, S. Maria Novella, Florence
Alinari 15

2. CORTONA, SS. Martina e Luca, Rome
Alinari 16

3. BORROMINI, S. Agnese in Piazza Navona, partly designed
by Girolamo and Carlo Rainaldi, Rome 17

4. CELLINI, *Perseus with the Head of Medusa*
Loggia dei Lanzi, Florence. Alinari–Scala 26

5. GIOVANNI BOLOGNA, *Hercules and the Centaur Nessus*
Loggia dei Lanzi, Florence. Alinari 27

6. BERNINI, *The Rape of Persephone*
Galleria Borghese, Rome. Alinari–Scala 28

7. RUBENS, *Battle of the Amazons*
Alte Pinakothek, Munich. Scala 31

8. RUBENS, *Hercules Slaying Envy*
Banqueting House, Whitehall. British Crown Copyright: Reproduced with
the permission of the Controller of Her Britannic Majesty's Stationery Office 32

9. RUBENS, *Samson and the Lion*
National Museum, Stockholm. Marburg 33

10. Chair from the Commonwealth period 46

11. Chair from the Restoration period, English carved walnut, c. 1685
Victoria & Albert Museum, London 47

12. POUSSIN, *The Rape of the Sabine Women*
Metropolitan Museum of Art, New York. Harris Brisbane Dick Fund, 1946 (46.160) 51

13. POUSSIN, *A Bacchanalian Revel before a Term of Pan*
Reproduced by courtesy of the Trustees, The National Gallery, London 52

14. TITIAN, *Bacchus and Ariadne*
National Gallery, London. Marburg 53

15. BERNINI, *The Ecstasy of Saint Teresa*
S. Maria della Vittoria, Rome. Alinari 61

16. EL GRECO, *St. Francis with Brother Rufus* (detail)
Hospital de Mujeres, Cadiz 62

17. DUQUESNOY, *St. Andrew*
St. Peter's, Rome. Alinari 64

18. FERRATA, *St. Agnes on the Pyre*
S. Agnese in Piazza Navona, Rome. Alinari 65

19. TINTORETTO, *Transporting the Body of St. Mark*
Accademia, Venice. Alinari 67

20. BERNINI, *S. Bibiana*
S. Bibiana, Rome. Alinari–Scala 69

21. GUIDO RENI, *The Virgin in Contemplation*
Private collection, Rome 70

22. MURILLO, *The Immaculate Conception*
Prado, Madrid 71

23. EL GRECO, *The Assumption of the Virgin*
Courtesy of the Art Institute of Chicago 73

24. RIGAUD, *Louis XIV*
Musée du Louvre, Paris. Alinari 77

25. LELY, *James II, when Duke of York*
Scottish National Portrait Gallery, Edinburgh 78

26. VANBRUGH, The Great Hall, Castle Howard, York
From the Castle Howard Collection 79

27. JOHN RILEY, *Bridget Holmes*
Royal Collection, Windsor Castle 81

28. MOLINARI, *The Fight of the Centaurs and Lapiths*
Palazzo Rezzonico, Venice. Giacomelli 85

29. ANDREA POZZO, *The Triumph of St. Ignatius*
S. Ignazio, Rome 95

30. THORNHILL, *Allegory of the Protestant Succession*
Royal Hospital, Greenwich 96

31. SEBASTIANO RICCI, oil sketch for the ceiling of
Bulstrode House Chapel
Shipley Art Gallery, Gateshead. Tyne and Wear Museums Service 98

32. G. B. TIEPOLO, *The Institution of the Rosary*
Gesùati, Venice. Alinari–EPA 99

33. G. B. TIEPOLO, *The Marriage of Frederick Barbarossa*
Residenz, Würzburg — 100

34. Royal Hospital, Greenwich — 102

35. Longleat House, Wiltshire — 103

36. RAINALDI (and Bernini), Piazza del Popolo, Rome
Alinari — 104

37. Wall panel, Hôtel de Rohan, Paris — 105

38. WATTEAU, *The Embarkation for Cythera*
Staatliche Museen, Berlin. Marburg — 109

39. WATTEAU, *Les Fêtes vénitiennes*
National Gallery of Scotland, Edinburgh — 113

40. FRAGONARD, *The Swing*
Wallace Collection, London. Marburg — 114

41. PALLADIO, Villa Rotunda, Vicenza
Alinari — 122

42. BURLINGTON and KENT, Chiswick House, Middlesex — 123

43. Salisbury Cathedral — 130

44. GIBBS, St. Martin-in-the-Fields, London — 131

45. HAWKSMOOR, St. George's, Bloomsbury — 133

46. GRINLING GIBBONS, wood panel carving
Kirtlington Park, Oxfordshire — 135

47. ARTHUR DEVIS, *The James Family*
The Tate Gallery, London — 137

48. ZOFFANY, *The Garricks at Twickenham*
By courtesy of Lord Lambton — 138

49. BOFFRAND, salon interior Hôtel de Soubise, Paris.
Giraudon — 142

50. BOULLE, commode
Palace of Versailles. Giraudon — 144

51. WATTEAU, sheet of sketches
Teylers Museum, Haarlem — 149

52. LORRAIN, *Landscape with Hagar and the Angel*
Reproduced by courtesy of the Trustees, The National Gallery, London — 157

53. CANALETTO, *Regatta on the Grand Canal*
Reproduced by courtesy of the Trustees, The National Gallery, London 158

54. CANALETTO, *Whitehall and the Privy Garden*
Goodwood House 161

55. GUARDI, *The Embarkation of the Doge on the Bucintoro*
Musée du Louvre, Paris 162

56. MÜLLER, *Gulliver Viewing Military Manoeuvres* 163

57. RUBENS, *The Rape of the Daughters of Leucippus*
Alte Pinakothek, Munich. SEF 166

58. GILLRAY, *Hero's Recruiting at Kelsey's* 173

59. HOGARTH, *The Harlot's Progress*, Plate 1 177

60. HOGARTH, *Marriage à la Mode*, Plate 1 178

61. HOGARTH, *Gin Lane*
Bibliothèque Nationale, Paris. Giraudon 179

62. LORRAIN, *The Marriage of Isaac and Rebecca*
Reproduced by courtesy of the Trustees, The National Gallery, London 205

63. LORRAIN, *The Sacrifice to Apollo at Delphi*
By courtesy of the Galleria Doria Pamphili, Rome 206

64. The gardens at Stourhead, Wiltshire
By courtesy of the National Trust Photographic Library. John Bethell 208

65. POUSSIN, *Winter*, or *The Deluge*
Musée du Louvre, Paris. Giraudon 218

66. SALVATOR ROSA, *Landscape with the Crucifixion of Polycrates*
By courtesy of the Art Institute of Chicago 224

67. SALVATOR ROSA, *Grotto with Cascade*
Pitti Gallery, Florence. Scala 225

68. WILLIAM WRIGHTE, design for a hermit's cell,
from *Grotesque Architecture* (1767) 240

69. SALVATOR ROSA, *Democritus in Meditation*
By courtesy of the Museum of Fine Arts, Boston 242

70. ROUBILIAC, *Nightingale Tomb*
Westminster Abbey, London 243

71. PIGALLE, *Monument to Comte d'Harcourt*
Notre Dame, Paris. Giraudon 244

72. JOSEPH WRIGHT, *The Iron Forge*
Broadlands Collection, Romsey, Hants 247

73. GUIDO RENI, *Adoration of the Shepherds*
National Gallery, London. Marburg 248

74. JOSEPH WRIGHT, *An Experiment on a Bird in the Air-Pump*
Reproduced by courtesy of the Trustees, The National Gallery, London 249

75. DE LOUTHERBOURG, *Coalbrookdale by Night*
Reproduced by permission of the Trustees of the Science Museum, London 251

76. JOHN MARTIN, *The Bard*
From the collection at the Laing Art Gallery, Newcastle-upon-Tyne.
Reproduced by permission of Tyne and Wear Museums Service 252

77. JOHN MARTIN, *The Deluge*
Engraving, British Museum 253

78. BLAKE, *The Vision of the Last Judgment*
Petworth House. By courtesy of the National Trust Photographic Library 258

79. BLAKE, *Ezekiel's Vision*
By courtesy of the Museum of Fine Arts, Boston 259

80. BLAKE, *God Writing upon the Tables of the Covenant*
National Gallery of Scotland, Edinburgh 266

81. BENJAMIN WEST, *Leonidas and Cleombrotus*
The Tate Gallery, London 271

82. BERTHÉLEMY, *Manlius Torquatus Condemning His Son to Death*
Musée des Beaux-Arts, Tours 272

83. DAVID, *Lictors Returning to Brutus the Bodies of His Sons*
Musée du Louvre, Paris. Giraudon 274

84. GREUZE, *The Punished Son*
Musée du Louvre, Paris 275

85. REYNOLDS, *The Age of Innocence*
The Tate Gallery, London 277

86. BLAKE, *The Finding of Moses*
Victoria & Albert Museum, London 278

87. BLAKE, titlepage to *The First Book of Urizen*
The Pierpont Morgan Library, New York. PML63139 copy B plate 1 279

88. GOYA, *Saturn Devouring His Children*
Prado, Madrid. Giraudon 281

89. BLAKE, *Satan Watching the Endearments of Adam and Eve*
National Gallery of Victoria, Melbourne. Felton Bequest — 291

90. BLAKE, *Los*, plate 97 from "Jerusalem"
Fitzwilliam Museum, Cambridge — 295

91. BLAKE, *Satan Going Forth from the Presence of the Lord*,
and *Job's Charity*
The Pierpont Morgan Library, New York. Book of Job #5 — 296

92. RUBENS, *The Fall of the Damned*
Alte Pinakothek, Munich. Giraudon — 301

93. BLAKE, *The Fall of Satan*
The Pierpont Morgan Library, New York. Book of Job #16 — 302

94. BLAKE, *The Reunion of Albion*, plate 99 from "Jerusalem"
Fitzwilliam Museum, Cambridge — 303

95. BLAKE, *Jacob's Dream*
British Museum, London — 305

96. TINTORETTO, *The Last Supper*
S. Giorgio Maggiore, Venice. Alinari — 306

97. BLAKE, *Soldiers Casting Lots for Christ's Garments*
Fitzwilliam Museum, Cambridge — 307

98. WILLIAM KENT, entrance hall, Holkham Hall, Norfolk
Copyright Coke Estates Ltd. — 319

99. WILLIAM KENT, marble parlour, Houghton Hall, Norfolk
By courtesy of English Life Publications Ltd., Derby — 320

100. ROBERT ADAM, music room, 20 Portman Square, London
Conway Library, Courtauld Institute of Art — 321

101. ROBERT ADAM, "Etruscan Room," Osterley Park, Middlesex
By courtesy of the National Trust Photographic Library — 322

102. FLAXMAN, Wedgwood vase depicting *The Apotheosis of Homer*
British Museum, London [Cat. 32b] — 324

103. FLAXMAN, plaque prepared from Wedgewood vase design
By courtesy of the Trustees of the Wedgwood Museum, Barlaston, Staffordshire — 325

104. FLAXMAN, *Penelope's Dream*
British Museum, London — 325

105. THOMAS JEFFERSON, The Rotunda, University of Virginia
Photo courtesy of Bill Sublette, University of Virginia *Alumni News* Magazine — 326

106. Model of the lower floor of the Rotunda — 327

107. REYNOLDS, *Three Graces Adorning a Statue of Hymen*
The Tate Gallery, London ... 334

108. REYNOLDS, *Lady Elizabeth Foster*
Devonshire Collection, Chatsworth. Reproduced by permission of the
Trustees of the Chatsworth Settlement. Photograph: Courtauld Institute of Art ... 335

109. GAINSBOROUGH, *Cornard Wood*
Reproduced by courtesy of the Trustees, The National Gallery, London ... 345

110. GAINSBOROUGH, *The Cottage Door*
Huntington Art Gallery, San Marino ... 346

111. CONSTABLE, *Dedham Vale*
National Gallery of Scotland, Edinburgh ... 349

112. WILLIAM CHAMBERS, The Pagoda, Kew Gardens ... 358

113. WILLIAM PORDEN, design for the Royal Pavilion, Brighton ... 360

114. NASH, The Royal Pavilion, Brighton, as completed ... 360

115. THOMAS HOPE, chair and settee in the Egyptian style, Buscot Park
Reproduced by courtesy of Lord Faringdon ... 361

116. GAINSBOROUGH, *Rustic Courtship*
The Montreal Museum of Fine Arts' Collection ... 364

117. GAINSBOROUGH, *The Market Cart*
Reproduced by courtesy of the Trustees, The National Gallery, London ... 366

118. CONSTABLE, *The Haywain*
National Gallery, London. Marburg ... 369

119. FRIEDRICH, *Traveller Gazing over the Mists*
Kunsthalle, Hamburg ... 380

120. FRIEDRICH, *Man and Woman Contemplating the Moon*
Staatliche Museen, Nationgalerie, West Berlin. Anders ... 381

121. CARAVAGGIO, *The Conversion of St. Paul*
S. Maria del Popolo, Rome. Alinari ... 387

122. RUNGE, *Morning*, from the *Times of Day*
Kunsthalle, Hamburg ... 392

123. RUNGE, *The Child in the Meadow*
Kunsthalle, Hamburg. Marburg ... 393

(Illustrations 1, 2, 4–7, 9, 13, 15, 17–19, 20, 24, 32, 36, 38, 40, 41, 49, 50, 57, 61, 65, 67, 71, 73, 83, 88, 92, 96, 118, 121 and 123 were provided by Art Resource, New York.)

CHANGING PERSPECTIVES
in Literature and the Visual Arts
1650–1820

INTRODUCTION

THIS PRESENT BOOK IS A SEQUEL TO *RENAISSANCE PERSPECTIVES*, the second in a series which is planned eventually to reach to the modern period. As the very concept of interart studies, especially in their synchronic form, has frequently been viewed with critical disfavour, the opening volume began with an *apologia*, suggesting the justification for such research and defining the specific analytical principles to be adopted throughout the series. It has seemed logical to reprint that statement of intent, suitably up-dated, as the introduction to each subsequent unit too, for those who may read only the volume relevant to their interests.

The appearance in recent years of a number of impressive interdisciplinary studies, including works by V. A. Kolve, Roland M. Frye, and Ronald Paulson,[1] has bestowed legitimacy upon that originally suspect area of research, the relating of literature to the visual arts. These latter studies have achieved respect in no small part because of their authors' rigorous insistence upon the established criteria of orthodox scholarship. Their methodology needs no defence, for it rests upon the accepted norms of chronological sequence, examining the iconographic traditions which had accumulated in the generations preceding the writers they examine and which were therefore available for such poets as Chaucer or Milton to draw upon as part of the cultural heritage of Europe during the years when they were forming their own body of images.

It is, however, the unfortunate sibling of such orthodox interart study whose legitimacy has remained under suspicion—that waif of literary scholarship, the "synchronic" approach, whose credentials are still frowned upon by much of the academic community. The theory there is admittedly less securely based, for it rests on the assumption that in each era literature and the visual arts, as aesthetic expressions of the cultural patterns dominant at that time, are likely to share certain thematic and stylistic qualities.

3

The objection of those unsympathetic to such enquiry has arisen not so much from the claim that every work of art is essentially the product of an individual and not of an age; for even the individual, however idiosyncratic or innovative he may be, is still organically part of his time, responding to contemporary stimuli even in his most rebellious moods. The reservation is rather that the disparities, both in conception and technique, between verbal and visual forms of expression, as well as the different limitations which each medium must strive to overcome, are too wide to allow for the drawing of any ultimately valid comparisons.

On this point the structuralists have, tangentially, come to the aid of synchronist research. The separation of *langue* from *parole* in the semiotic studies of Ferdinand de Saussure has revealed the extent to which language communication, both written and spoken, relies even in its most primitive forms upon a matrix of social norms. That matrix, it is argued, endows the reader or listener with a competence for deciphering patterns of meaning which the words in isolation would otherwise possess in only a restricted sense. The cultural setting of texts becomes by this linguistic approach not merely an interesting background to the works but intrinsic to their comprehension, making literary criticism isolated from that context no longer fully persuasive. Furthermore, the seminal studies of Lévi-Strauss and his followers, exposing in literature a concealed level of systematized mythic relationships bearing universal significance, have furthered the recognition that any segregation of literature from other forms of artistic expression (which by their nature share such mythic elements) is both arbitrary and artificial.[2] The result has been a new impetus for interart studies which, with the added momentum of Julia Kristeva's concept of intertextuality developed by Harold Bloom, takes us outside the bare text to consider those philosophical, literary, or social traditions which impose preconditions on our reading, as they do on our responses to other arts. Mary Ann Caws can now posit the existence of an "architexture" in each era, an intertextual overstructure created with the reader's collaboration, which transcends the barriers between the media. Structural interpretation has, for example, made possible, as in her own work, *The Eye in the Text*, the application to literature, too, of psychologically analyzed principles of "perception" or creative illusionism which had previously been the exclusive preserve of such art historians as Gombrich and Arnheim; and by that cross-application, has demonstrated as outmoded the claim that each art form must be judged solely by its own rules.[3]

Recent critical developments have, then, confirmed, at least theoretically, the legitimacy of the waif, offering linguistic, mythological, and sociological justifica-

tion for interdisciplinary studies even in the absence of demonstrable historical sequence. What remains questionable, however, is the youngster's right to acceptance into academic society on the grounds of his performance hitherto. For on the basis of the work which has appeared, there exists considerable scepticism whether the study of such an amorphous entity as periodized interart relationships can be responsibly pursued. It is, for example, a firm principle of such enquiry that no direct contact need be established between the writer and the contemporary painter or architect, nor even any knowledge of each other's work evidenced for stylistic affinities to be perceived; for it is assumed that each may independently be fulfilling the task of the creative artist as defined by Shakespeare—to show "the very age and body of the time its form and pressure," with that shared age or time producing stylistically comparable results. Such a principle, however, offering a justifiable release of the critic from one scholarly requirement, has proved a temptation for the synchronist to relax other requirements, too, encouraging him to rely only too often on an allusive juxtaposing of contemporaneous works of art and literature in place of the detailed critical scrutiny necessitous in other branches of literary history and analysis.

In an article which should be required reading for all aspiring students in the field, Alastair Fowler has justifiably castigated the methodology adopted by the leading exponents of the synchronic approach who have, he suggests, fallen into the very trap which René Wellek foresaw as early as the 1940s, "the tendency to impressionistic comparisons and easily elastic formulas" which can be stretched to fit almost any preconceived theory.[4] Mario Praz and Wylie Sypher have indeed stimulated much thought and have often proved truly valuable in opening up new lines of investigation; but Fowler was surely voicing an exasperation felt by many readers when he complained that they leave the hypotheses of their analysis substantially untested and, as such, must be regarded as academically unacceptable. They rely for the most part on a vague gesturing towards supposed parallels or, what is worse, on subjective assertions unsupported by evidence. He quotes in this regard a characteristic passage from Sypher's best-known work:

> We can believe that mannerism is an art of bad conscience when we see the helpless gesture of El Greco's Laocoön, who seems destined to his serpent beneath a torn sky that is like a wound in the mind. The restlessness in Michelangelo's figures, the wilful David-frown, the writhing Night, and the unfinished marbles he left in their stony anguish provoke us to ask psycho-

5

analytic questions—the questions we are tempted to ask about El Greco's enraptured saints, Saint Teresa, the puzzled Hamlet, and the strange people in Ford's evasive play *'Tis Pity She's a Whore*.[5]

Why the helpless gesture of Laocoön should be interpreted as a sign of "bad conscience" (whatever that may mean here) is left unexplained, as is the putative connection between the stony anguish of Michelangelo's unfinished sculpture and Hamlet's puzzlement. Since such indeterminate comparisons form the basis for his broader interpretation of the mannerist temperament in art and literature, there can be little wonder that the edifice he erects upon that foundation may to many appear unstable and that the synchronic method itself has, at least in that form, as yet failed to win the confidence of scholars.

There is, however, an area of synchronic research which can, I believe, prove rewarding and entirely legitimate. It aims not at period definitions *per se*, nor at analogue-hunting, but at something both more specific and more constructive, employing what may be termed a process of inferential contextualization. Instead of establishing initially some broad premiss defining the spirit of the age and demonstrating how various works of art and literature may be seen to conform to it, a reverse direction is followed. The research begins from a literary text and, even more specifically, often from a particular problem related to it, which has (perhaps for lack of further evidence obtainable from that era) remained in dispute. On such occasions, a knowledge of contemporary stylistic changes in the plastic or visual arts and, even more so, of the historical reasons which motivated painters, sculptors, or architects of that time to desert one technique in favour of another, may offer a fresh approach to the literary work by assuming that a writer living in that era and experiencing the same historical pressures may well have shared those impulses too. Thus Robertson's claim that Chaucer was essentially medieval in outlook and his consequent rejection of attempts to read into *The Canterbury Tales* a growing responsiveness to contemporary life (a claim almost impossible to refute from the text alone, because of the ambiguities inherent in Chaucer's irony) may lose much of its force when it is placed within the setting of contemporary painting. For at exactly the same time throughout Europe, as I have argued elsewhere, there may be perceived a sudden and unprecedented interest in the theme of the Magi: paintings by Bartolo di Fredi, by the Limbourg brothers, and numerous others, concentrating less on the homage of the kings before the crib than on their *journey* toward it, a journey conceived in fixed spatial and temporal terms, with processions of men in

6

sundry garb appropriate to their class, accompanied by dogs and cheetahs—engaged, like Chaucer's travellers, upon a holy pilgrimage yet clearly delighting, as does the artist himself, in the worldly pleasures the journey offers.[6]

One requirement is, however, indispensable to such research if it is to achieve credibility. Any theory arising from these interart comparisons must be empirically tested by a rigorous and detailed analysis both of the art works and of the literary text, in place of the impressionistic responses and vague gesturing which have given synchronic enquiry its doubtful reputation. Due caution is needed to ensure that a theory is not being read into the literary work but genuinely arises out of it once the principle has been perceived, with the imagery, diction, and thematic treatment confirming the interpretation. Ideally, the reading offered of that work should emerge at the final stage as totally independent of the art parallels, resting instead upon substantiation adduced from the text; but the use of the art context will have been retrospectively justified since it served as the source of the original insight, suggesting an approach without which the subsequent analytical investigation could not have been conducted. If at certain times the argument may still fail to convince—and the reader's freedom to judge is, mercifully, a precondition for all criticism—at least the evidence on which it was based will have been made fully available, and upon that evidence the theory (again, as in all criticism) must finally stand or fall. Indeed, for those denying in principle either the existence of a *Zeitgeist* or the validity of interart parallels, the textual analysis may be judged independently on its own merits; but for those who do acknowledge, however hesitantly, some degree of interrelationship between the arts, there will be the added satisfaction, where the theory does seem convincing, that it is corroborated by the broader aesthetic context within which the literary work was produced.

One further aspect of this study requires justification. It is the assumption, implicit in such synchronic research, of a cultural patterning in each era, a theory which, under the generic name "periodization," has in past decades been generally spurned as outmoded, as the retrospective imposition of a monolithic design upon the complex and contradictory sensitivities of individual writers within each generation. The rejection of that older method in the mid-century was to prove a healthy corrective to the *Zeitgeist* tradition, encouraging by its condemnation of blanket formulations a finer critical awareness of the paradoxical, often polarized elements functioning within the same span of years and often within the same literary work—a condemnation culminating in the deconstructionist readings of the 1970s disqualifying not only unifying themes within periods but even cohesive designs within a

single text. But those responsive to the most recent trends in critical theory, in the areas both of historical and of literary research, will have perceived the emergence of a countermovement, a swing back to the necessity once again of "situating" works and events within the cultural motifs of their time. Among historians, Michel Foucault's stern warning, which had predominated for many years, that the "discontinuities" or disruptions of individual events are more significant than the larger designs supposed to be operative, has been to a large extent reversed by Hayden White's reassertion of the need for historical patterning. White has argued cogently (with echoes from contemporary linguistics) for the existence of a "deep structure" or *metahistory* unifying the apparently disparate events of the past and requiring their relocation within the larger setting of their period.[7] And in literary criticism, too, the rise of the New Historicism, exemplified by the stimulating series of publications now appearing at Berkeley under the general editorship of Stephen Greenblatt, while it employs fresh terminology in order to differentiate it from the older forms of periodization, has nonetheless marked a return to many of those discarded assumptions, demanding the re-situating of literature within the contemporary cultural poetic. It has argued for the existence in each generation of, as Greenblatt expresses it, "a shared code, a set of interlocking tropes and similitudes that function not only as the objects but as the conditions of representation."[8]

Periodization in its more sophisticated form does not presuppose the impositon of a fixed patttern upon an age to produce a dull uniformity among its writers, artists, and thinkers. It perceives rather, as the quality shared by each generation, the existence of a central complex of inherited assumptions and urgent contemporary concerns to which each creative artist responds in his own individual way. He may adopt those assumptions and priorities, may challenge them, may even deny them, but only at his peril may he ignore them. And even when he resists them most forcefully, they will, as matters of immediate pressure, continue to affect, often with no conscious awareness on his part, aspects of his own art, including the contextual terms for viewing the world about him.

The employment in this present study of such terms as "baroque" or "Augustan" rests, therefore, not on an old-fashioned conception ignorant of the opprobrium cast upon those categorizations some forty years ago or unaware of the automatic disapproval they may arouse in readers less familiar with the most recent critical trends, but on the revalidation in our own generation of historicity as a significant factor in artistic creation. As we do return to that earlier critical mode, it is, of course, with a caution heightened by the intervening condemnatory phase,

with an increased sensitivity to the contradictions and paradoxes within each period, as well as to the fascinating and constant interplay between the individual personality of the creative artist and the moral, philosophical, and aesthetic codes prevailing in his society.

Each essay here is a self-contained unit devoted to a single author, work, or literary topic; but by offering them in chronological order, I have hoped that a further aspect will emerge as a unifying theme, the subtle changes in "perspective" within the period examined—perspective not in its narrower sense of mimetic fidelity, as in the attempt to transfer a three-dimensional scene onto a two-dimensional canvas or page, but in its original meaning of "seeing through" one scene into another scene beyond. It may be helpful to elaborate.

There has in the past few years been a renewal of interest in the concept of spatial form, whether in the illusionist sense of volumetric verisimilitude or as a metaphor applied to the morphology of language and to narrative sequence in literature. The journal *Critical Inquiry* has been particularly active in that area, with Earl Miner suggesting there the connection of spatial metaphor to physiological factors in the brain, others examining the assumption of measurable linear or circular movement for chronological progression, as in the use of *long* and *short* to describe intervals of time (with Wayne Booth musing whether the introduction of the digital clock will affect that usage), and the editor of that journal, W.J.T. Mitchell, offering a helpful overview of the debate.[9] My own interest, however, goes further than concern with the spatial measurement of actuality, whether in its literal or metaphorical forms, and even than the illusionism implicit in attempts to capture the concrete world realistically. For I would argue that the artist's and writer's view of the tactile world in which he lives is itself profoundly affected at all times by his conception of the imagined world beyond, whether that has been the Christian eternity of afterlife, the semi-pagan Neoplatonic heaven of idealized forms, the redemptive dreamworld of the Loyolan meditator distorted by the intensity of his religious fervour, or the physically conceived and rationalized infinity of the baroque cosmos. In each instance, as in those of subsequent eras, the entity beyond constituted a projection of dissatisfactions and assertions, aspirations and fears implicit in man's mortal condition as conceived in that generation. It has both reflected and retroactively modulated areas of human experience outside the religious sphere as well as within, including the preference man accorded to rational proof as opposed to transcendental paradox, to social conformity as opposed to a cultivation of the inner life, to self-indulgence in contrast to asceticism, and, above all, the degree of authenticity which

he afforded to the tangible reality about him. Volumetric fidelity in painting and verisimilitude in drama or narrative are not skills to be evaluated on their own terms, with the highest marks awarded for the depiction most faithful to nature, but (as the deliberate stylization of Egyptian portraiture and of modern expressionist drama suggest) are functions of the way the creative artist used his earthly setting as a frame through which man's hope of future, eternal existence could be asserted, implied, and at times bitterly denied. Such "perspective," in this specific meaning of the term, forms the coordinating theme of the following chapters.

LATE BAROQUE

I

MILTON'S HERCULEAN SAMSON

THE BAROQUE CHURCH, THE PRE-EMINENT EXPRESSION OF THAT artistic mode, testified to a revolution in man's conception of the universe and of his place within it. The religious buildings of the Renaissance had evinced a quieter aim, conveying there the dignity and centrality of man, either in smaller churches fitted to serve his devotional needs, such as Brunelleschi's charming Pazzi Chapel, or, within the larger structures, by a proportioned coordination of design manifesting the rational achievements of the human architect who had planned or constructed them. In Brunelleschi's more spacious church, Santo Spirito, the slender columns, placed equidistantly both from the wall and from each other in order to create harmony of form, raise the eye to graceful semicircular arches above, extending along both sides of the aisle within the well-lit interior. The purpose of the baroque church was markedly different, to evoke not a sense of tranquillity but of rapturous exaltation, in effect to awe the worshipper into adoration. The appearance of the interior contrasts dramatically with the earlier style, as all windows at ground level are blocked off, transferred to the upper course above the cornice. The resultant lighting suggests an antithesis between the darker, weightier area below, oppressive with masonry and representing, as it were, the rich physicality of this earth, while relief is offered above by the vision of heavenly scenes bathed in light from the dome interior and from the concealed or recessed windows along the upper nave.

Behind such change lay an essentially new apprehension of the divine and of the process of creation. Throughout the Renaissance, the formation of the universe had come to be regarded, in terms of Christian Neoplatonism, as a single inaugurative act in the past, a moment in universal history which had placed the planetary spheres in their constant and perfect orbits. There they were henceforth to emit a music, if no longer audible to human ears after the Fall, at least serving as a perpetual model

for the undisturbed concord desired by both society and the individual. Divine creation in the baroque era, however, was apprehended as more immediately relevant, an act of dazzling power, of incalculable dynamism and energy continuing throughout eternity but requiring to be renewed and revitalized at every moment. At a time when Galileo had revealed through the newly refined telescope that the moon was not a smooth, unblemished celestial sphere but a physical mass with a rugged and pitted surface like the earth's, when Tycho Brahe had disproved the eternity of the stars by showing them subject to accident, and when Giordano Bruno had posited an innumerable series of solar systems in an intimidatingly vast, perhaps infinite universe, the religious artist of the baroque period had come to conceive of the cosmos anew as a complex system of immense, interacting physical forces, awesomely held in control by the power of a Supreme Being.

The new style of church manifested that vision architecturally, both in its impressive facade and in the enhanced grandeur of its interior, designed to overwhelm the spectator by its massiveness and ornate splendour. Externally, it preserved the symmetry and order of Renaissance tradition; but that symmetry had grown heavier in appearance and, as Wölfflin was the first to note, a restlessness and sense of constriction had entered to disturb the perfect proportions.[1] Where the facade of Alberti's S. Maria Novella (*fig. 1*) had been smooth in surface, serenely integrated, and geometrically rationalized, the facade which Pietro da Cortona designed between 1635 and 1650 for the church of SS. Martina e Luca in Rome (*fig. 2*) was intended to convey not only a new plastic and tactile quality but, even more, a feeling of suppressed movement, of stresses with difficulty sustained or overcome. Weighty cornices project over the upper and lower sections, creating a top-heavy, overhanging effect, a sense that they would come crashing down were they not sturdily supported from below by the numerous columns and pilasters. Where the two storeys of Alberti's design are elegantly unified by twin "scrolls," here the impression is created of one cumbersome building deposited upon another, of resisted gravitational pressures, of a mass sustained only by the solidity of the stone. The ornamental details further this effect, the medallions appearing spatially constrained, with no margin to ease them optically away from the encroaching columns, thereby again suggesting constriction and resistance. Similarly, the pediments over window and door penetrate into the areas occupied by the adjoining pillars, overlapping as though both were struggling for room; and the articulation of mingled curves and straight lines in the overall design of the facade increases the impression of plasticity, of an interplay of forces achieving stasis by a series of implied thrusts and counterthrusts.

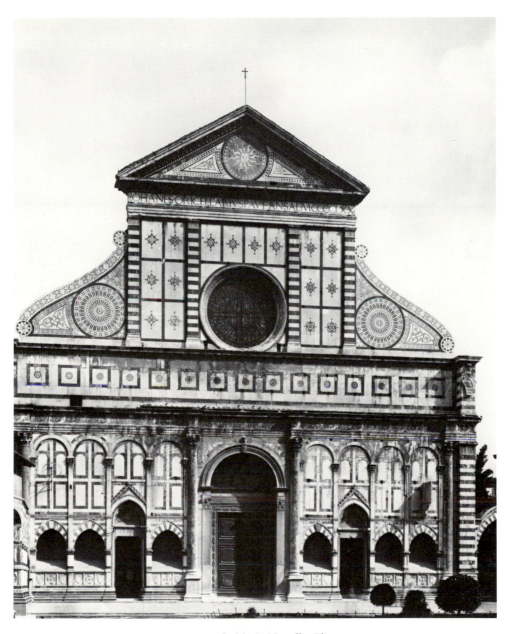

1. ALBERTI, S. Maria Novella, Florence

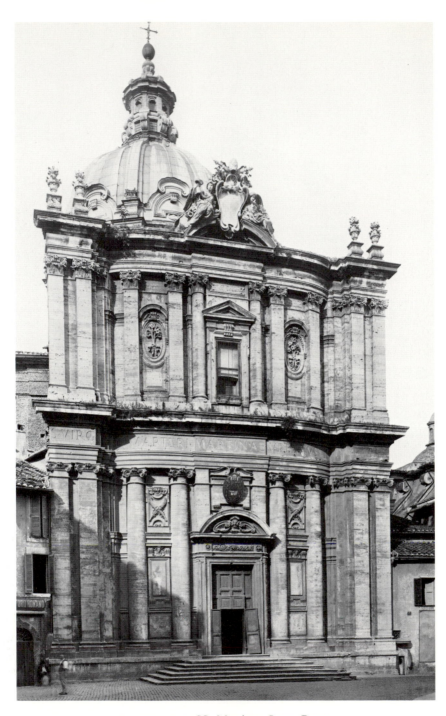

2. CORTONA, SS. Martina e Luca, Rome

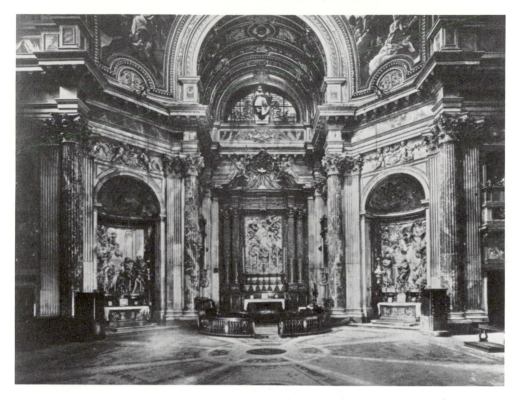

3. BORROMINI, S. Agnese in Piazza Navona

Inside the churches, the impetus to echo the new conception of the cosmos and of man's terrestrial abode is no less marked. In Borromini's S. Agnese in Piazza Navona (*fig. 3*), completed in 1666, the surface of the lower church is thickly encrusted with ornamentation, every inch filled with fluted columns, lavishly executed entablatures, architraves, friezes, frescoes, and bas-reliefs, with the deep-set arch over the altar adorned with variegated courses of stonework and stucco in exuberant testimony to earthly bounty. Here, too, the altar is compressed into an area seemingly too small to contain it, the columns beside it crowding upon its frame as though even in so large an edifice the proliferation of wealth spills, as from a cornucopia (a favoured motif of the baroque) beyond its confines, to produce an atectonic effect. In many of these churches, splendid ceiling frescoes in illusory *quadratura* perspective, such as those by Gaulli in Il Gesù and by Andrea Pozzo in the

17

church of S. Ignazio (cf. *fig. 29*), offer a vision of innumerable angels floating upward into a heaven blinding in its splendour.

The nature of the baroque, its relationship to the new cosmology (which by its non-sectarian quality made the mode available to the Protestant despite its origin in a Counter-Reformation setting), and its more specific relevance to Milton's *Paradise Lost* I have examined in some detail elsewhere,[2] and the above discussion is intended therefore as only the briefest of summaries. In this present chapter, I should like to apply some of the principles of that theory to Milton's *Samson Agonistes*, and to explore how a knowledge of the baroque artist's motivation, deduced from the sculpture, paintings, and architecture of the time, may assist in illuminating certain enigmatic aspects of that drama.

To enquire why Milton chose Samson as the hero of his drama may seem gratuitous, so intertwined in the literary imagination have author and hero become. Indeed, the apparent superfluity of the question is a tribute to the compelling authority of Milton's writing, his ability, as in *Paradise Lost*, so to impose upon us his own fictional reconstruction of biblical narrative that he dislodges from our memory the lineaments of the original text. We return to Genesis surprised to find no hint in the scriptural Adam of the noble Grand Parent for contemplation and valour formed, capable of intelligently discussing with archangels the purposes of creation. So here, the discrepancy is wide. The sensitive, penitent character of Samson as Milton presents him, tortured by guilt, bears little relation to the somewhat brutish, vainglorious figure emerging from the Book of Judges, lusting after harlots and forever boasting of his muscular exploits—"With the jawbone of an ass, heaps upon heaps, with the jaw of an ass have I slain a thousand men" (Judges 15:16). Ironically, in his Old Testament form he would appear more appropriate as a model for Milton's braggart Harapha, the object of ridicule in the drama, than for the remorseful, soul-searching hero of the play. As Northrop Frye has remarked, were it not that we have the play before us, the "wild berserker" engaged in the savage and primitive exploits recorded in the scriptural account might have been thought the most unlikely of biblical characters for Milton to choose, entailing on the poet's part a casuistic suppression of Samson's less amiable features in order for him to be transmuted and tamed to suit the dramatist's needs.[3]

To elevate this scriptural figure to the dignity of a tragic protagonist demanded in effect a reconstruction of his character. Milton was obliged to enlarge Samson's intellect, to purify him from lewdness by omitting the reason for his visit to Gaza, to present Dalila as his lawful wife instead of his mistress, and, above all, to endow him with a profound moral consciousness.[4] In that latter regard, the biblical Samson, from his recorded comments in the various episodes related there, would seem to have been motivated in his responses to the Philistines by jealousy for his personal reputation rather more than championship of a national cause, with the *me* and *my* repeatedly accorded prominence in the justification of his acts—"As they did unto me, so have I done unto them." In Milton's play, he is oppressed primarily by his sense of having failed in a divine mission and, without the slightest warrant within the scriptural account, yearns for spiritual renewal, for the purging of his guilt by an act of penitence, and thereby for eventual regeneration in the eyes of God. The discrepancy between the two accounts is highlighted in their contrasting conclusions. As the Old Testament Samson reaches for the pillars, he prays only for personal vengeance, an opportunity to retaliate for the blinding he has suffered, to achieve satisfaction by settling his score with his enemies: "Strengthen me, I pray thee, only this time, O God, that I may at once be avenged on the Philistines for my two eyes." Milton's Samson, as he sets out for the Temple of Dagon, has a higher aim, a determination to prove spiritually worthy of his new-found purity and his rededication to the religious and national tasks for which he had originally been selected:

> of me expect to hear
> Nothing dishonourable, impure, unworthy
> Our God, our Law, my Nation, or myself.
> (1423–25)

If, therefore, the character of Samson required so radical a metamorphosis in order to be made suitable to the theme of this play, why did Milton need that story at all? For his basic theme he required it minimally, for it has long been recognized that in its deeper dramatic concerns the play draws more substantially upon the book of Job than upon the book of Judges, as its structural design confirms.[5] Where the Bible presents the entire span of the champion's life, from the announcement of his birth through the period of his full vigour and on to his death, Milton's play focusses solely upon the final phase of his suffering, when disaster has already

struck, the period when, like Job, he must face the full implications of his tragic condition. Both have been unpredictably flung from high public regard, cruelly afflicted in body and mind, and each reaches out painfully to question the justice of God's act in casting him away, their search for meaning and spiritual renewal providing the main thrust for the two works. The echoes of Job in Milton's play cannot be missed, as he is visited by a series of supposed comforters—Manoa, the Chorus, and Dalila paralleling Eliphaz, Bildad, and Zophar—whose misunderstanding of his grief only sharpens his own anguished quest for meaning.[6] The two situations are not identical. While Job is convinced beyond doubt that he has never sinned in a manner commensurate with the punishment he has received at God's hand, Samson is fully conscious of the magnitude of his crime. Yet the inner turmoil of the two as they grope towards the truth remains essentially similar. Each is intellectually convinced of the justice of God's acts towards him; but welling up from within is a passionate, instinctive denial of that justice, the belief that his suffering is in excess of his deserts. It is the wrestling between these two contradictory impulses that creates in both characters the tragic intensity of their agony.

The quiet opening lines of *Samson Agonistes*, with their echo of *Oedipus at Colonus*, have suggested to some critics a contrary effect, a prevailing mood of calm resignation on his part:

> A little onward lend thy guiding hand
> To these dark steps, a little further on;
> For yonder bank hath choice of Sun or shade . . .

They misled Tillyard, for example, into declaring that Samson at the very beginning of the play has already established himself in his Protestant-Stoic citadel, that he has "achieved his personal integrity. He has purged his pretensions by an utter humility, and is content with his sad lot, however servile."[7] The text, however, informs us otherwise. That quiet opening mood is shattered a moment later as we learn of his true condition, and of the torments racking him within. The pleasant bank to which he asks to be led may provide external balm, but it cannot touch the inner lacerations of conscience. It will offer

> Ease to the body some, none to the mind
> From restless thoughts that like a deadly swarm
> Of Hornets arm'd, no sooner found alone,
> But rush upon me thronging.

Consciously he admits responsibility for his lot, but only too humanly his self-condemnation is deflected into a fusillade of barbed questions directed at God. Job had cried bitterly: "Why died I not from the womb? Why did I not give up the ghost when I came out of the belly? . . . Wherefore is light given to him that is in misery, and life to the bitter in soul?" Samson asks no less sorely and uncomprehendingly: "O wherefore was my birth from Heaven foretold? . . . Why am I thus bereav'd thy prime decree?" The deadly swarm of restless thoughts which afflict him are in large part this bitter questioning of the divine justice and order in which he had, until the calamity, so firmly believed:

> Why was my breeding order'd and prescrib'd
> As of a person separate to God,
> Design'd for great exploits; if I must die
> Betray'd, Captiv'd, and both my Eyes put out,
> Made of my enemies the scorn and gaze?

His more sober judgment, an abiding faith in God's ultimate righteousness, rises repeatedly to stem the flood of questions, to turn them against himself as he realizes their blasphemous implications:

> Yet stay, let me not rashly call in doubt
> Divine Prediction

or

> But peace, I must not quarrel with the will
> Of highest dispensation, which herein
> Haply had ends above my reach to know.

Yet the protests continue surging up, crashing against his rational beliefs to create the seething eddies of his religious crisis. All, he declares, has occurred through his own fault; of whom has he to complain but himself who weakly betrayed his trust to a woman? But at the very moment that he condemns his own impotence of mind in body strong, he cannot resist protesting against a God who failed to bestow upon him a double share of wisdom to match and shore up his double share of strength. That, he implies, was God's fault, not his. And why was sight to such a tender ball as the eye confined, why his strength hung so lightly in his hair? For these, he cannot be held responsible.[8] The agony of Samson is this struggle to come to terms with his

abject state despite the turmoil of bitter complaints churning within him, complaints which, "finding no redress, ferment and rage, / Nor less than wounds immedicable / Rankle and fester, and gangrene, / To black mortification" (619–22). Only when that storm has been stilled, when the anger has been vented, can patience be achieved—that calm of mind all passion spent which he will find only towards the conclusion of the play.

It would seem, therefore, that the story of Job, with his tormented protest against a punishment outweighing his sins and a spiritual striving after reconciliation with God, would have been ideally suited to Milton's purpose, carrying with it overtones of Oedipus and Lear, also engaged in their spiritual odysseys. Yet instead he turned to the story of the rough swaggerer Samson, which required extensive remoulding of character and manipulation of sources before it could be made suitable to his needs. The question remains, then, what elements there were in the Samson story which succeeded in drawing Milton away from the more natural choice of Job.

The most obvious answer is also the least satisfactory, leading as it does into that most sensitive area of Milton criticism, the autobiographical interpretation of the play. If, as is widely but by no means universally believed, the drama was written not long before its publication in 1671, at a time when Milton was blind, when the Puritan régime had collapsed, and when he himself had fallen from a position of eminence to comparative poverty and obscurity, then his choice of Samson would seem to require little explanation.[9] Vanquished by his enemies, imprisoned, eyeless in Gaza, that biblical figure offered at the end of his life a close parallel to Milton's own condition. Even those who resist the autobiographical reading find it difficult to deny a personal note in those moving passages on blindness, or to imagine that Milton could have been unaware of their application to himself:

> Light the prime work of God to me is extinct,
> And all her various objects of delight
> Annull'd, which might in part my grief have eas'd,
> Inferior to the vilest now become
> Of man or worm; the vilest here excel me,
> They creep, yet see; I dark in light expos'd
> To daily fraud, contempt, abuse and wrong . . .
> (70–76)

There is, however, a powerful argument against such autobiographical reading. Predictably, in their attempt to discredit the regicides, the enemies of the Puritans such as Pierre du Moulin had pointed derisively to Milton's blindness as patent evidence of divine disapproval and punishment. Stung by that charge, in his *Second Defence* of 1654, Milton had staunchly denied that his loss of sight constituted in any way a heavenly retribution for sin. He insisted that, by determining to continue to work on as Cromwell's Latin Secretary even though he knew his vision was failing, he had knowingly sacrificed his sight in the service of God, and he rejected outright any attempt to interpret his physical disability as celestial punishment on the grounds that blindness "has been known to happen to the most distinguished and virtuous persons in history." For his own condition, he declared categorically that "though I have accurately examined my conduct, and scrutinized my soul, I call thee, O God, the searcher of hearts, to witness, that I am not conscious either in the more early or in the later periods of my life, of having committed any enormity which might deservedly have marked me out as a fit object for such a calamitous visitation."[10]

It would be strange indeed if one so sensitive to that charge and so passionately rejecting it should, a few years later, invite the public to identify him with a biblical figure whose blindness had so clearly formed the direct punishment for a betrayal of trust. In regard to the autobiographical parallels, therefore, the same evaluation holds true as for the story at large, that Job's innocent suffering would have been perfectly suited to Milton's needs, and the blindness of the Samson theme a serious deterrent. Nevertheless, Milton did choose the Samson story, and the question remains whether that brief tale from the book of Judges may have held some significant attraction for him which, despite the crudity of the original hero and the undesirable complications raised by parallels to his own life, proved irresistible to him in making his final choice.

It is here that the artistic context of the play, the stylistic form dominant at the time of its composition, becomes so relevant, for it may explain the peculiar attraction which the Samson theme did hold for the playwright. Baroque artists, as we have seen, felt impelled by the new challenge posed by the cosmologists to reply in kind, their response permeating all aspects of their art. Abstract notions, whether theological or political, were to be translated into physical terms, into energized visions of enormous corporeal might. As part of his focus upon the centrality of "power" for social and literary studies, a focus echoed throughout the writings of

the New Historicists, Stephen Greenblatt has revealed how the Elizabethan theatre preserved, in its stage presentations of royal prerogative, a certain distancing of the audience, a sense, while engaged by the presence of majesty, that they were at the same time witnessing a spectacle;[11] and the point may be extended by noting the emphasis within that generation upon ritualistic, heraldic devices to represent such authority, as in Spenser's allegory of the courtly ideal or in the Gheeraerts portrait of Queen Elizabeth, her hand resting upon a globe to represent her imperial power. Now, however, both within political and theological realms, such emotional distancing was discarded in favour of a new objective, imaginatively to dwarf or crush the viewer by an awesome demonstration of such power in action. Theological assertions of the omnipotence of God as an intangible tenet of faith or doctrinal claims for the absolute power of the monarch were no longer sufficient. Milton's Satan, rejecting mere predications of the divine prerogative of the Creator, is prompted instead to

> put to proof his high Supremacy,
> Whether upheld by strength, or Chance, or Fate
> (*PL* 1:131–32)

and only when overwhelmed in physical combat will eventually acknowledge the perpetual kingship of God. Within earthly kingdoms the sole means of restraining man's aggressive acquisitiveness, as Hobbes now argued, was through imposing upon him "the terror of some Power" whose ability to exact retribution should be unequivocally demonstrated. The second part of *Leviathan* opens with the warning that the miserable condition of war would inevitably result from "the naturall Passions of men, when there is no visible Power to keep them in awe, and tye them by fear of punishment for the performance of their covenants."[12] Where the baroque church in its solidity, splendour, and opulence offered visual affirmation of the supremacy of God, so the Palace of Versailles, with its majestic avenues radiating from a massive royal residence, confirmed architecturally the inviolable power of Le Roi Soleil.

In sculpture and painting, the depiction of heroic scenes revealed a similar impulse, marking a break with previous tradition. In the Renaissance, artists and sculptors had preferred, as part of their contemporary faith in Neoplatonic ideals, to impress the spectator with the calm confidence and superiority of their heroes. Accordingly, they portrayed them either before the fight was joined or after victory had been secured. Donatello's *St. George* of 1416, although symbolizing Christian-

ity's conquest of the dragon Satan, is displayed as standing in quiet meditation, a victor only in potential, with his shield at rest before him, his tranquillity representing the undisturbed harmony of his faith. Similarly, Verrocchio, for his equestrian statue of the military leader *Colleoni* in 1486, chooses the moment of the condottiere's setting out for battle with stern visage, taut rein, and leg stiffened in defiance; but he is not shown in the battle itself. Michelangelo's *David* of 1502 is similarly shown prior to the arrival of Goliath, gazing thoughtfully before him, his sling over his shoulder, symbolizing in his stance the perfect merger of the *vita contemplativa* and (in potential only) of the *vita activa*. And Benevenuto Cellini's *Perseus* of 1545 (*fig. 4*), moves beyond the fight to the security of attained victory, as the hero calmly holds aloft the already-severed head of the Medusa.

Giovanni Bologna's treatment of *Hercules and the Centaur Nessus* of 1599 (*fig. 5*) marks a totally different approach.[13] The scene is captured not merely in action but at the very climax of the struggle, the moment before ultimate victory, as the centaur's head, straining mightily against the hero's muscular arm, is forced back for the final blow. According to the original myth, it may be noted, there was no such personal struggle, Nessus being felled from afar by Hercules' arrow. The fact that the sculptor chose to alter the incident suggests that he was seeking an opportunity to display a situation closer to the needs of the new mode—the pitting of two forces against each other in order to exhibit the awesome strength required to overcome a formidable and almost invincible opponent. Bernini, consciously following Bologna's lead, produced in 1621 his *Rape of Persephone* (*fig. 6*) with the powerfully built figure of the god at the high point of his adventure, raising the struggling maiden aloft and about to carry her triumphantly past a grimly threatening Cerberus, guardian of the border of Hades. In his *David* of 1623–24, unlike Michelangelo (and, indeed, as no sculptor had before him), he presents the youth engaged in the conflict itself, combatting an unseen Goliath assumed to be menacingly present before him, the young warrior biting his lower lip in the exertion of determined effort, and pivoting his body to deliver the projectile with maximum force.

Rubens, the baroque painter *par excellence*, displays a similar interest in demonstrated might, presenting in his *Battle of the Amazons* of c. 1618 (*fig. 7*) two charging armies clashing at the centre of a bridge, whose narrowness intensifies the impact of the numberless forces, with bodies spilling over the parapet into the waters below and the turmoil of fighting figures swirling along the banks. On the ceiling of the Banqueting Hall in Whitehall, where Milton would certainly have seen it (as he no doubt saw much of the new baroque architecture and sculpture during his lengthy

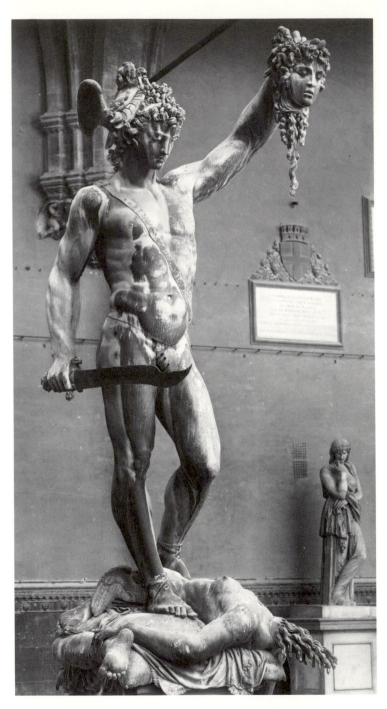

4. CELLINI, *Perseus with the Head of Medusa*

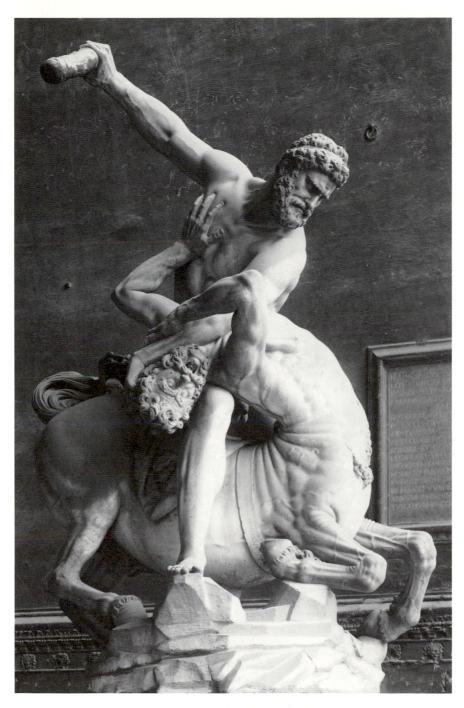

5. GIOVANNI BOLOGNA, *Hercules and the Centaur Nessus*

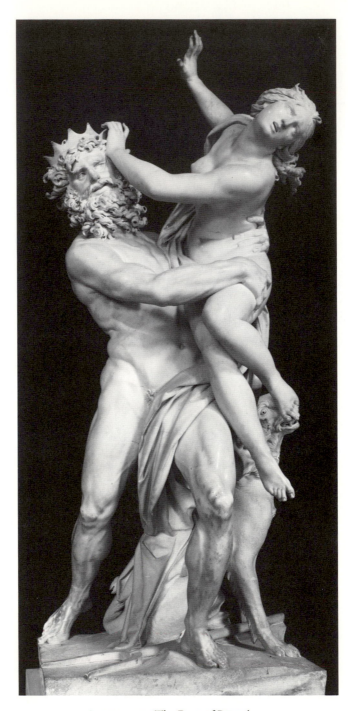

6. BERNINI, *The Rape of Persephone*

visit to Italy in 1638), was Rubens's panel of *Hercules Slaying Envy* of approximately 1634 (*fig. 8*) which marks the epitome of the baroque portrayal of heroism. There, a titanic figure of strength, his thigh muscles bulging from exertion, thrusts away the head of a dangerously venomous Envy with his foot as he is about to bring his thick club crashing down upon her. And finally, closer to our present theme, there is his depiction of *Samson and the Lion* from 1625 (*fig. 9*), which exemplifies all these elements so central to the baroque mode, catching the scene at the moment of maximal muscular effort, the strong hands of the hero tearing apart the lion's jaws as the beast thrashes and struggles against its unconquerable adversary.[14]

The new principles motivating the visual arts in this period may be seen as no less operative in its literature. Milton, in designing his drama of Jobian anguish, was, by virtue of this baroque conception, reaching out, we may assume, for some tangible, physical means whereby that inner strife of the soul could be projected into visible form. The anguish of Job's great struggle had, of course, been entirely verbal, some thirty-eight chapters recording his passionate poetic colloquy with himself, with his interlocutors, and finally with his God; and those chapters, placed between the brief enveloping scenes of devastation and restoration, were devoid of action. Milton's brilliant innovation, I would suggest, was to provide for his artistic needs by the technique of projecting Job's spiritual agony into the muscular body of Samson—rather as Rubens depicted man's intangible struggle against envy in terms of a brawny Hercules battling with all his strength against a poisonously serpentine foe. This was not allegory in the Renaissance sense, the heraldic personification of abstract ideas as in Botticelli's *Calumny of Apelles*, but a rooting of spiritual experience in the flesh, in the haptic world of powerfully conflicting forces, so that what amazes the reader in the final analysis is less the purity or nobility of the hero than the enormity of the temptation to be overcome, the gigantic effort required for the struggle, with the narrowness of the ultimate victory testifying not to the weakness of the victor but to the mythic grandeur of the contest.

By combining the figures of Samson and Job, Milton created the ideal conditions for a baroque exposition of his theme. Samson as he appears in the Bible may have lacked that sensitivity of soul Milton needed for his central figure, but he possessed in remarkable degree both the physique and the dramatic setting for this larger baroque image. The spiritual progression of his hero from despair to self-renewal could, by this merger of the two figures, now be presented simultaneously as parallel developmental processes in mind and body, at the levels both of metaphor and fact, with the Herculean struggle culminating in that great final scene in

which Samson gathers all his revived strength to bend and crack the massy pillars and bring the edifice crashing down upon God's enemies.[15] In that single act, the visible manifestation of spiritual and physical renewal, the themes of Job and Samson blend climactically in perfect union as the final exertion of muscle and sinew wins him his inner peace with God:

> straining all his nerves he bow'd;
> As with the force of winds and waters pent
> When Mountains tremble, those two massy Pillars
> With horrible convulsion to and fro
> He tugg'd, he shook, till down they came, and drew
> The whole roof after them with burst of thunder
> Upon the heads of all who sat beneath . . .
>
> (1646–52)

That was a scene not available in the book of Job. From the viewpoint of a baroque writer, it was alone sufficient reason for Milton's choice of the Samson story. Certainly those passages in which the hero laments his blindness were too tenderly close to Milton's own predicament for them to be free from personal reverberations and, once the decision had been taken to adopt the Samson theme, many of the autobiographical elements could be legitimately exploited; but there can be little doubt that, in reaching his decision to use the story of Samson, Milton must have needed to overcome a grave fear of their misapplication to himself, being finally impelled despite that deterrent by the great baroque potentialities of the overall theme.

That strange term *Agonistes* which Milton appended to the title reinforces this suggested duality of the play's theme; for as Krouse has shown, the word carried a double meaning even in ancient usage, denoting both the corporeal might of a champion wrestler and the inner suffering or *agony* of a tragic hero or martyr.[16] By combining in the play, as in that epithet, the processes of muscular and spiritual regeneration, Milton was able to endow his hero's struggle against guilt and despair with the grandeur of a titanic trial of strength. Image and fact could intertwine, alternately fortifying and sensitizing each other.

These two layers of meaning, permeating all aspects of the work, are strikingly exemplified in the function accorded within the play to Samson's hair. For readers less learned than Milton, the placing of the champion's strength within his hair might seem in the biblical story to be no more than a piece of fairy-tale mumbo

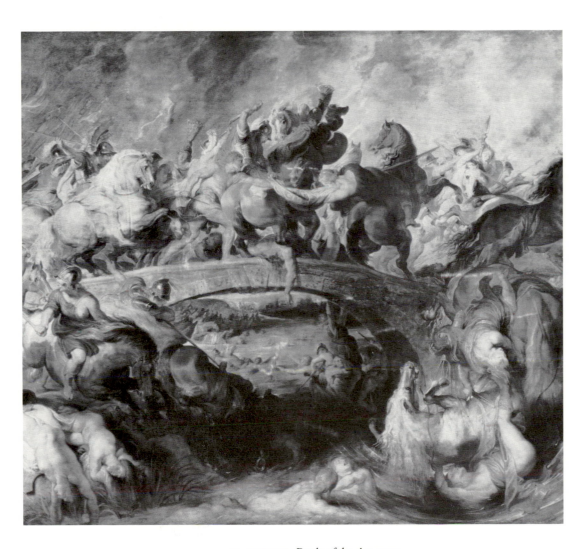

7. RUBENS, *Battle of the Amazons*

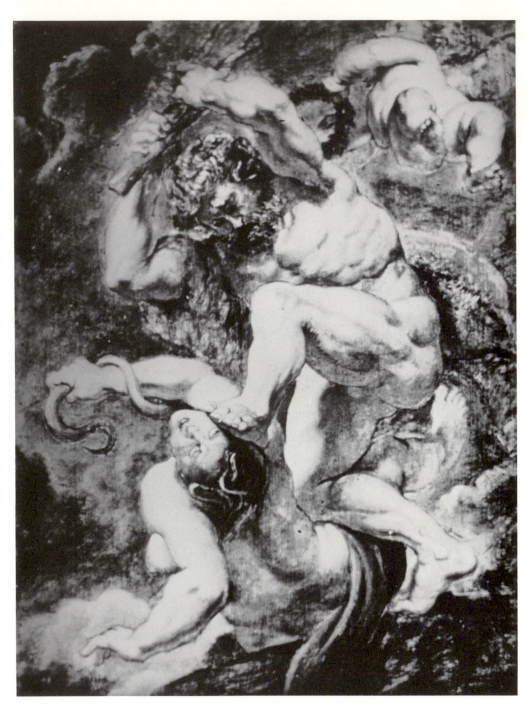

8. RUBENS, *Hercules Slaying Envy*

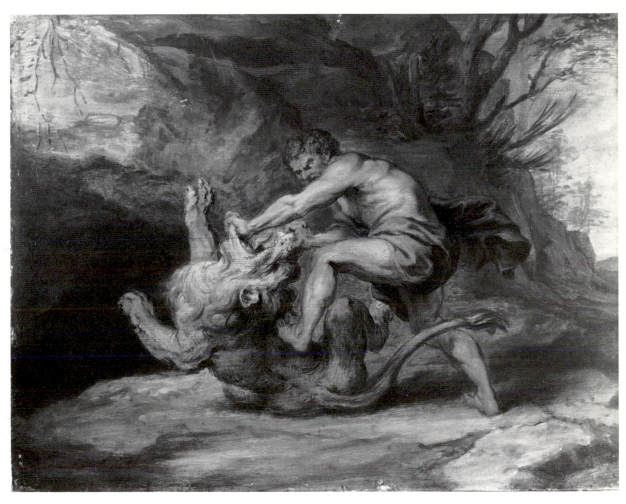

9. RUBENS, *Samson and the Lion*

jumbo—like Cinderella's carriage which, for no intelligible reason, must turn back into a pumpkin at midnight. Milton, however, grasped the profounder connotations there, the assumption in the book of Judges of the reader's familiarity with the Nazarite vow as earlier specified in the Pentateuch, whereby such an oath not only included abstinence from strong drink, from contact with unclean objects, and from allowing a razor to touch his hair, but also made the hair itself consecrate, to be burnt upon the altar on completion of the designated period:[17]

> And the Nazarite shall shave his consecrated head at the door of the tabernacle of the congregation, and shall take the hair of his consecrated head and place it on the fire beneath the sacrifice. (Numbers 6:18)

Strangely enough, in a Bible normally so intent on moral teachings, the account in Judges makes little of that aspect; but Milton perceived in it an ideal opportunity for anchoring the spiritual theme of his play in the corporeal. For him the uncut hair becomes the outward, physical symbol of Samson's inner dedication to a divine task. Accordingly, the moment that he succumbs to Dalila's seductive wiles—and the Puritans condemned lust, we recall, even in marriage[18]—he has betrayed his divine calling, and his locks, the "hallow'd pledge" of his vocation, are at once shorn off. As Samson himself recalls the scene, it is the lasciviousness of the setting as much as the political deception which disqualifies him, depriving him instantaneously of the mark of his election. Fallen into the snare of fair fallacious looks, and softened with pleasure and voluptuous life, he was tempted

> At length to lay my head and hallow'd pledge
> Of all my strength in the lascivious lap
> Of a deceitful Concubine who shore me
> Like a tame Wether . . .
>
> (535–38)

From that point on, the slow awakening of Samson's moral responsibility will be matched by its physical counterpart, the gradual regrowth of his hair representing, in addition to the return of his muscular vigour, the progress of his spiritual renewal.

That reading has important implications for one of the earliest and most troublesome criticisms levelled against the play, Samuel Johnson's charge that, while possessing a noble beginning and end, it lacked a middle, the scenes of Dalila's and Harapha's visits adding little to the forward movement of the plot.[19] In the context

of this suggested duality, they may be seen not only as integral to its dramatic development but also as prerequisites for the final act, the two scenes constituting a testing out of the hero's recovery on both levels of presentation, first in heart and then in body. His meeting with Dalila is in that sense the trial of his spiritual regeneration. The sole effective proof of true remorse is, of course, a penitent's determination to resist any recurrence of the original temptation, and Dalila provides precisely that—in effect a second attempt at seduction, testing out the degree of his moral commitment. She has come, he recognizes at once, "to try / Her husband," but he is now armed, not so unwary this time, he assures us, as

To bring my feet again into the snare
Where once I have been caught.

The narrowness of his victory over her allurements, indicated psychologically by his furious refusal to let her touch him, his threat to tear her limb from limb if she approaches further, is a mark of the magnitude of the temptation and hence of the enormous spiritual dedication demanded from him. It is in that context that the genuine persuasiveness of her arguments should be seen, not, as some critics have argued, as weakening the moral message of the play but, as always in the baroque, setting up the powerful opposition to be overcome.

The subsequent scene, his meeting with the giant Harapha, might have been expected to provide the awesome physical conflict between two mighty forces so beloved by that mode, but Milton preferred to delay that for the climax of the drama, leaving this meeting to function solely as the counterpart to Dalila's visit, confirmation that the hero's corporeal strength, too, has been regained, as he frightens away, without the need for any contact, the comically braggart challenger. The very comedy arises from the audience's recognition by this point of Samson's clear superiority to the challenger after the regaining of his own physical might and courage.[20]

As the Job and Samson elements blend in a combined renewal of strength, with the spirit now able to control and direct the regained muscular force, the play moves firmly towards its climax. Where Job, on learning from the whirlwind the answers to his questions, had subsided into humility and acquiescence, Milton's hero must yet perform some spectacular act as a public assertion and affirmation of God's victory. At first he refuses the call of the Philistines, lest as a Nazarite he "abuse this Consecrated gift / Of strength, again returning with my hair." When assured that it is God's will, he entertains the crowds in the Temple with feats of "incredible,

stupendous force," but only as a prelude. The *agonist* in the baroque tradition requires an *antagonist* against whom, like Bologna's Hercules wrestling with the Centaur, he can display his enormous power; but, as the Messenger informs us, there was "None daring to appear Antagonist." With no challenger worthy of that name, Samson must devise his own Herculean task, some trial apparently beyond all human strength. The biblical Samson had desired only to slay his enemies, but the baroque Samson desires even more than that, to *amaze* his viewers with an awesome display of the force which God has restored to him, to overwhelm them visually as well as physically:

> Hitherto, Lords, what your commands impos'd
> I have perform'd, as reason was, obeying . . .
> Now of my own accord such other trial
> I mean to show you of my strength, yet greater;
> As with amaze shall strike all who behold.
> (1640–45)

Spiritually he has already prepared himself, standing beside the pillars with head awhile inclined "as one who pray'd." Now begins the physical demonstration, the wrestling against immense opposition until with one final thrust the bulging muscles crack the pillars, and as the vast pent-up energy of body and soul is discharged, the edifice crashes upon his enemies and himself.

There is a corollary to the placing of this drama within a baroque setting; for if the artistic contextualization is correct, it would offer some valuable corroborative evidence for that vexed problem, the dating of the play. Certain writers and artists have preferred throughout their careers to restrict themselves to a single artistic mode. Alexander Pope and Caspar David Friedrich, for example, each produced a corpus of work which could serve as the consummate expression of a specific style, while others, among them Michelangelo, Ibsen, and Picasso, have spanned and at times inaugurated in their careers a succession of changing styles. Milton comes within the latter category, reflecting sequentially within his creative work and, on occasion, initiating within English literature the developing forms of seventeenth-century European art. His early period belongs acknowledgedly within the courtly humanist tradition of the Renaissance. *Comus*, employing Spenserian forms of alle-

gory and personification, culminates in an exhortation to the soul to ascend the Platonic ladder and rise beyond the "chime" or music of the harmonious spheres; and together with that masque, his pastoral elegy *Lycidas* openly acknowledges its classical antecedents, as the shepherd-poet "touch't the tender stops of various Quills / With eager thought warbling his *Doric* lay."[21] Then came the interruption caused initially by his visit in 1638–39 to Italy (where Bernini and Pietro da Cortona were in the process of transforming Rome into a baroque city), followed by the long gap in poetic activity as he devoted himself wholly to the Puritan cause. At last, in 1667, his publication of *Paradise Lost* revealed a fundamental change in style, constituting an epic in the High Baroque mode, with a vast cosmic setting, an awesome battle between the immense armed forces of Heaven, as well as its scenes of plenitude upon earth, where nature in the fecund Garden of Eden "multiplies/Her fertile growth and by disburd'ning grows/More fruitful" (5:318–20).

To complete the progression, there appeared in 1671 his "brief epic," *Paradise Regained*, in the more austere and restrained style now entering English poetry. In the Restoration period, marked by a rational distrust of the prophetic fervour, of the infinite power, and of the emotional disturbance which had characterized the High Baroque, at a time when Dryden's *All For Love* and Nahum Tate's version of *King Lear* preferred clear demarcations of good and evil, distinguishing between admired reason and reprehensible passion, Milton's sequel similarly avoids any sense of complex, spiritual struggle. Christ here needs to withstand no powerful opposition, no searing agony of temptation, but coolly penetrates Satan's disguises and loftily dismisses his guileful offers:

> To whom our Saviour calmly thus replied.
> Thou neither dost persuade me to seek wealth
> For Empire's sake, nor Empire to affect
> For glory's sake by all thy argument.
>
> (3:43–46)

As Kenneth Muir has noted, the language here is close to that of Dryden's *Religio Laici*, being "fitter for discourse and nearer prose"; and while Barbara Lewalski has been primarily concerned with establishing the indebtedness of this work to the epic tradition rather than to contemporary changes in taste, she readily acknowledges that Satan has here deserted the splendid oratory he used with such effect in *Paradise Lost* in favour of a new decorum, closer to Christ's own "reasonable and precise speech."[22]

The problem arises with *Samson Agonistes*, the last of Milton's works to appear, issued bound together with *Paradise Regained* but placed after that work with a note on the frontispiece: "To which is added *Samson Agonistes*." Although published in a manner which suggests it is his final work, the date of its composition has, of course, long been subject to inconclusive scholarly debate, with A. H. Gilbert arguing for the 1640s, W. R. Parker placing it between 1647 and 1653, A.S.P. Woodhouse between 1660 and 1661, while Masson's earlier view had proposed 1666 to 1670. None of the evidence adduced, however, is more than circumstantial, as a recent participant in that debate, Mary Ann Radzinowicz, has confirmed.[23] It is, perhaps, here that the placing of the play within the sequential phases of European art may prove relevant.

Between the opulent High Baroque represented by Rubens and Bernini and the eighteenth-century Rococo of Pope and Lancret, there intervenes the period generally known as Late Baroque. It is a term applied with some elasticity to the transitional phase, to the gradual desertion of the swirling dynamism of the baroque in favour of more temperate forms before the Rococo became firmly established. Within that transitional area, *Samson Agonistes* belongs on the very borders of the High Baroque, not located within the most opulent phase of that mode but in the modified version as it passed the peak of its intensity. The play adopts a more formal, Attic style, and its setting is transposed from the cosmic to the terrestrial sphere. Yet despite those modifications, its focus is still upon an immense human struggle against seemingly irresistible impulses, and its passionate concern is with spiritual dedication and divine vocation, as well as with the determination of its hero to perform publicly before his death "some great act" which should astound all who view it, elements which place that work very close indeed to the High Baroque style.

In the process of Milton's artistic development, reflecting in due order the sequential progression of European aesthetic modes from its harmonious Renaissance manifestations, through the stirring splendour of the High Baroque, and on to the more restrained temper of the later phase bordering on Rococo, he evolved his stylistic forms, we should note, not in imitation of passing fashions but organically, as part of his own aesthetic response to those major changes in philosophical and religious sensibility which were themselves creating the continental modes. It would have been in conflict with that progression, visible in all the arts of his time, for Milton to have reversed the order and, after establishing his affinities to the rationalistic trends of the late seventeenth century in *Paradise Regained*, suddenly to

revert in his final work to the then-outmoded baroque style with all its vigour, passion, and striving to overwhelm. The most natural sequence in terms of such stylistic development would call, therefore, for the placing of its composition between *Paradise Lost* and *Paradise Regained*, with the reversal of order in the final volume having been dictated not by chronology of composition but by thematic continuity, by Milton's understandable desire to link in the reader's mind the loss of Eden with its reacquisition.

Such evidence is, of course, no less circumstantial than any other theory adduced for the dating of the play. It has the signal advantage, however, of being based not on speculative connections with Milton's personal life—biographical hypotheses which are at all times notoriously difficult to establish with any certainty—but on the broader, acknowledged sequences in seventeenth-century European art. These were aesthetic developments which, as we know from those of his writings possessing firmly assigned dates of composition, Milton closely paralleled in his own artistic progression. An extrapolation of that graphic curve would suggest that in these two final works, too, he conformed to the more natural sequence, consecutively embodying in them the two later phases of the baroque, with the more passionately conceived and vigorous drama *Samson Agonistes* taking chronological precedence over the stylistically restrained and reasoned presentation of what he termed his "brief epic."

2

DRYDEN'S
HEROIC DRAMAS

THE HEROIC PLAYS OF THE RESTORATION HAVE, JUSTIFIABLY PER-
haps, failed to capture the imagination of the twentieth-century critic and theatre-
goer, and in contrast to the comedy of that time, notably the lively works of Wych-
erley, Etherege, and Congreve, have been accorded no enthusiastic revival. Yet if
those serious plays are less suited to present tastes, their success upon the contempo-
rary stage should not be forgotten. Villiers's *Rehearsal* (1671), it is true, poured such
withering scorn upon the heroic drama that the early plays which had served as the
targets for its satire never recovered; but the genre as such did survive with remark-
able vigour. Otway's *Venice Preserv'd*, enormously popular in its day, continued to
be acted throughout the eighteenth century, achieving a total of 337 performances
between 1703 and 1800 and being presented in an English theatre every year of that
century except one.[1] Yet in most respects it was not intrinsically different from the
plays which had preceded it, the formulas it adopted conforming closely to those
promulgated for the earlier plays which had formed the object of derision. It, too,
portrayed the rise and fall of large human passions, it elaborated as its theme a
conflict between the rival claims of love and honour within the soul of a great man,
it aimed at an epic elevation of style such as Dryden had demanded, and it employed
verse no less rhetorical than that of *The Conquest of Granada*:

> BELVIDERA: Do, strike thy sword into this bosom. Lay me
> Dead on the earth, and then thou wilt be safe.
> Murder my father! though his cruel nature
> Has persecuted me to my undoing,
> Driven me to basest wants, can I behold him
> With smiles of vengeance, butchered in his age?
> (*Venice Preserv'd* 3.2.151–56)

41

Its rationale remains the Cartesian psychological principle, the belief that evil results from a failure of the human will to control the emotional impulses threatening to dominate all action.[2] Yet despite its basic conformity to the traditions already established for the heroic play, its own success was immediate and sustained, while those previously written remained associated with the scathing burlesque of Villiers and his associates. Indeed, to appreciate the contrast in dramatic quality between the serious plays of the earlier and later Restoration stage there is no necessity to move outside the range of Dryden's own dramas. His *Tyrannic Love* and *Conquest of Granada* produced prior to *The Rehearsal* are today remembered only by the historian, while in contrast his *All for Love*, dating from 1677, occupies an honoured place in dramatic anthologies.

The success of the later plays may be seen as casting some doubt upon the widely held assumption that the prime fault of the heroic drama was its rodomontade, the vainglorious boasting of its protagonists that they held the victory or defeat of armies in their own hands and could determine the fate of kingdoms by a word. That element had certainly achieved prominence as a butt for the parodists, with Almanzor of *The Conquest of Granada* pilloried by a strutting player:

> DRAWCANSIR: Where'er I come, I slay both friend and foe . . .
> If they had wings and to the gods could fly,
> I would pursue, and beat 'em through the sky:
> And make proud Jove, with all his thunder, see
> This single arm more dreadful is than he.
> (*The Rehearsal* 5.1.341–47)

On the other hand, that very theme of a hero's immense ambition and confidence had, we may recall, served Marlowe admirably in his triumphant *Tamburlaine the Great*, whose protagonist had with no less panache challenged the gods above and Fate itself to dare resist his mortal power, yet without there arousing the ridicule of audience or critic:

> TAMBURLAINE: I hold the Fates bound fast in iron chains,
> And with my hand turn Fortune's wheel about:
> And sooner shall the sun fall from his sphere
> Than Tamburlaine be slain or overcome.[3]

One may suspect, therefore, that the primary cause for the poverty of the early heroic drama lay in some quality other than the braggadocio and rhetoric, particu-

larly if we bear in mind that *The Rehearsal* had not originally been aimed against Dryden personally but in general against Davenant and the other initiators of the new drama. Begun in 1663 and delayed by the closure of the theatres because of an outbreak of the plague, its satire had only later been turned on Dryden, who had by then become the leading exponent of the genre.

The primary characteristic of the pilloried heroic drama, distinguishing it both from the form holding the stage prior to the Puritan régime as well as from the more successful plays subsequent to *The Rehearsal*, was, of course, its adoption of rhymed couplets in place of blank verse—a distinguishing quality which mercifully disappeared once it had been so successfully parodied. It is upon that element I should like to concentrate, posing a question which has, I feel, too often been sidestepped on the grounds that such usage merely represented a personal preference on Dryden's part. We need to enquire more closely what prompted Dryden to insist so long and so fervently on the appropriateness of the heroic couplet for drama and to experience such obvious reluctance in surrendering it, even when it had been proved ineffective upon the stage and had become the object of such fierce attack. Shadwell had written scornfully of heroes who absurdly conduct their fighting and wooing in verse and "still resolve to live and die in Rhime"; Dryden's brother-in-law and past collaborator, Sir Robert Howard, was highly critical of its adoption into drama;[4] and the victory of the opposition in burlesquing that aspect of the plays may be confirmed statistically. Although some forty-two dramas were composed in heroic couplets between 1660 and 1680, the fashion withered away after those repeated attacks, only five such plays being recorded for the following twenty years.[5] Yet despite the ridicule, when Dryden did at last decide to desert dramatic rhyme—a literary form which he had once enthusiastically described as "the last perfection of Art"[6]—he still did so with reservation, maintaining in the preface to *All for Love* (perhaps a trifle disingenuously) that his change was only local, dictated solely by the need in that specific play to remain close to his model, Shakespeare, "which that I might perform more freely, I have disencumbered myself from rhyme. Not that I condemn my former way, but that this is more proper to my present purpose."

Earlier criticism during this century had assumed that Dryden's adoption of rhyme had no broad cultural significance or motivation, identifying it as a matter of the poet's individual proclivity. T. S. Eliot, in voicing what was to become the predominant view for those years—that Dryden had employed rhyme "because it was the form of verse which came most natural to him"—highlighted what he saw as Dryden's unaffectedness in the use of couplets by using him as a foil for an attack

upon Milton. The Puritan poet, at that time in critical disfavour as the supposed inaugurator of the artificializing diction of eighteenth-century poetry, should, he argued, be contrasted with Dryden, "whose *style* (vocabulary, syntax, and order of thought) is in a high degree natural."[7] Allardyce Nicoll later maintained for the Restoration theatre at large that the heroic couplet was entirely adventitious in its appearance there, a chance phenomenon in no way central to the drama it produced, including Dryden's early plays; and for evidence he pointed to the continuation of essentially the same heroic patterns in drama long after the rhymed couplet had disappeared from the stage.[8]

Arthur Kirsch, however, later took issue with that tradition, arguing persuasively that rhyme must be seen as intrinsic to Dryden's conception of the heroic play, a principle for which the dramatist was prepared to fight valiantly, repeatedly advocating it in his critical writings as being a "perfecting" of dramatic verse, defending it on the authority of the best French, Italian, and Spanish tragedies of his day, and only surrendering it when public opinion proved impossible to resist. But the motivation Kirsch offers for Dryden's determined support of rhymed drama is a strange one. Relying on the dramatist's occasional murmurs of discontent with the theatre (common enough among playwrights exposed to the vicissitudes of audience response and the notorious mordancy of theatre critics), Kirsch claims that Dryden was never at ease as a dramatist, his natural aptitude being for poetry, and that in consequence, since his preoccupations were fundamentally verbal rather than dramatic, he imported into the drama what naturally belonged on the printed page, namely, to his verse satires.[9] Again a supposed "natural" propensity, although here employed for a different purpose, is identified as the source of its introduction into drama. But while it might conceivably provide an explanation for the weaknesses of Dryden's early efforts as a dramatist, such a theory of an innately poetic and non-dramatic bent would hardly be consistent with the writer's considerable success later in the theatre at the time of his *All for Love*.

In turning to continental painting for possible insights into this problem, there is no necessity, as in the earlier volume in this series, to rely upon the principle of cultural osmosis in order to explain how European ideas were filtering through to England or traversing the barriers between the media; for the relationship between painting and poetry had by now become fully acknowledged in England as an integral part of aesthetic theory and practice, and contact with continental movements was at this time being assisted by the burgeoning collections of art works at

last becoming available in England. The comparative insularity of English art had ended with the succession of Charles I, an ardent purchaser of paintings and a discriminating connoisseur, whose superb collection, for the most part disbanded and sold by the Puritans, began to be partially reassembled and replaced at this time by a son who had inherited his father's pleasure in *objets d'art* together with his cultivated taste. The despoiling of the royal collection by the Puritans, while it could never be fully reversed, since so many of its most valuable items had either disappeared or been irretrievably sold abroad, received some compensation in the seventy-two paintings which Charles II purchased in the Netherlands to bring back with him on his triumphal accession to the throne, as well as in the magnificent donation, by a Dutch government anxious to be on good terms with the new king, of twenty-seven old masters, including a remarkably fine Titian and a Lorenzo Lotto.[10] The king himself was a generous patron of the arts, persuading Antonio Verrio to come to England to assist in the redecoration of Windsor Castle, initiating numerous other projects, and, by his own example, bestowing a new status upon the activity of the connoisseur.

The fashion of art collecting now re-established by royalty began to spread, being adopted first by the wealthier courtiers and before long by subjects of more moderate means. During the interregnum, Royalists on the continent had begun to develop discriminating tastes, and their visits to stately homes and art collections laid the groundwork for the Grand Tour of Europe which was soon to become part of every cultivated person's education. John Evelyn, whose own interests in painting had been encouraged by Charles I's friendly rival in art collection, the Earl of Arundel, recorded in meticulous detail within his diary the specific art works he examined in the numerous palaces he visited in France, noting, for example, for only one such visit the paintings by Da Vinci, Michelangelo, Raphael, Veronese, Correggio, Primaticcio, Poussin, and many others viewed by him in the Count de Liancourt's palace in the rue de Seine, together with various medals and curious agates.[11] In brief, the tastes of the upper and middle levels of society on Charles II's return were becoming far more sophisticated aesthetically, not only in their interest in painting but also in the furnishing of their homes. The severely designed chairs permitted under the Puritan Commonwealth, with their low backs, sturdy construction, rows of brass-headed nails, and the exclusion of all decoration other than the simplest turning (*fig. 10*), were being replaced by elaborate versions more suited to the refined sensibilities of the Restoration aristocrat. They were provided with

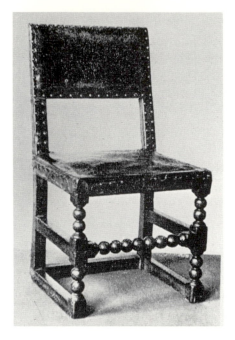

10. Chair from the Commonwealth period

elegantly curved armrests for more leisurely reclining, their high, stately backs embellished with countless curlicues resembling the ornate periwigs now in vogue (*fig. 11*), and with their owner's coat of arms often proudly incorporated into the design. Japaned cabinets imported from the Far East were becoming prerequisites for fashionable interior furnishing, as was the delicate china gracing cabinet and table in so many homes—the latter importation fated to achieve amusing notoriety in a famous scene upon the contemporary stage.[12]

In the literary world, Horace's maxim, *ut pictura poesis*, quoted only occasionally in the Renaissance,[13] now dominated discussions of poetry to the point of becoming platitudinous, with Raphael, Guido Reni, Correggio, and Titian continually cited as authority by writers who had themselves toured the art centres of Europe, had visited private art collections in England, or were at the very least acquainted with such paintings through the prints and engravings that were now becoming more readily available to the public. Dryden's own familiarity with continental art needs no documentation, since, apart from the many references to painting in his own writings, it was he who helped introduce to England the French art critic destined

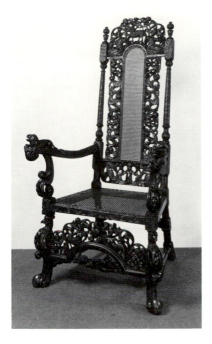

11. Chair from the Restoration period

in the following decades to exert the most powerful influence on English taste, Alphonse Dufresnoy, whose Latin poem *De arte graphica* he translated, prefacing it with his own widely read essay, *The Parallel of Poetry and Painting*.[14]

On the other hand, even though the broadened awareness of poet-painter connections in this period now offers the historian the possibility of investigating conscious interart borrowings, my interest remains less in any direct interaction between painting and literature than in exploring once again the shared contemporary problems encountered by their respective practitioners and the comparable methods they devised to cope with them. In this regard, Nicolas Poussin may prove particularly relevant to a study of Dryden, not least because of their close similarity both in philosophical outlook and in artistic purpose.

Louis Bredvold's study of Dryden's intellectual milieu pointed out long ago the centrality of Pyrrhonism in his thought, perhaps not in terms of any formal system, since he did not think of himself primarily as a philosopher, but in terms of his more general response to the religious and political complexities of the era in which he lived.[15] Throughout seventeenth-century Europe the doctrines of Pyrrho of Elis, as

transmitted to the western world through the writings of the second-century Sextus Empiricus, had been gaining widening respect, not least through the impressive advocacy they had received in Montaigne's *Apology for Raymond Sebond*. For an age distinguished by its rationalist tendencies, exemplified by the foundation of the Royal Society, of which Dryden was himself a member, there was a special appeal in a philosophy of impartiality, in the view that every human proposition must be recognized as effectively countered by its opposite, and that accordingly the wise man should strive to attain to a calm objectivity of spirit even when, perhaps for reasons of prudence, he has determined to subscribe officially to some accepted moral or religious code. For those, too, who remained religiously committed, Pierre Charron's *De la sagesse* had, at the very beginning of the century, provided an attractive blending of Stoicism with Christianity which eased the acceptance of Pyrrhonism among those loyal to the church. In England, such Cambridge Platonists as Benjamin Whichcote, Ralph Cudworth, and their Oxford colleague Joseph Glanvill, despite their declared allegiance to Neoplatonic thought, leaned heavily on the Pyrrhonian tradition, as in Glanvill's publication of 1661 firmly asserting *The Vanity of Dogmatizing*, but adding the important qualification that a sceptic in philosophy need not be one in religion.

Dryden's predilection for Pyrrhonism was one that he openly acknowledged. In the preface to his *Religio Laici* he described himself, as he did elsewhere in his writings,[16] as being "naturally inclined to scepticism in philosophy"; and it has been rightly pointed out that, in accordance with the phlegmatism recommended by that philosophical mode, he possessed a facility for presenting with equal persuasiveness the two opposing sides of an argument. While in the *Essay on Dramatick Poesie* Neander serves as the spokesman for Dryden's own literary creed, the contrary arguments of Eugenius, Crites, and Lisideius are offered with no less eloquence and with no less vigour; his *Hind and the Panther* allows for lively presentation of both Catholic and Anglican tenets; and his *Religio Laici*, although not constructed in the form of a debate, offers a similarly balanced discussion of conflicting concepts. More recent criticism has modified certain of these assumptions, Phillip Harth pointing out that Dryden's scepticism, even when self-admitted, does not necessarily class him with the Pyrrhonists, since it may well have signified a more general resistance to dogmatism, partaking of the intellectual diffidence characterizing the leading members of the Royal Society; but that distinction, valid as it may be, does not alter the point being made here, namely, his insistence on a balanced and rational reserve in judgment.[17]

If the vein of scepticsm in Dryden's writings, however central to his work, needed to be disclosed by later critics, Nicolas Poussin, in contrast, was at all times publicly acknowledged as the *pictor philosophus* of the Pyrrhonist school—an eponym bestowed upon him during his lifetime and with which he continued to be associated both during the period of his veneration by the French Royal Academy under LeBrun and throughout subsequent generations. By nature slow in his early artistic development, he had failed to find himself during the period in Rome when he was attempting to model himself on the more opulent baroque artists popular in his day. Only when he broke away to experiment with new techniques did his individual contribution to painting begin to emerge. Dedicated in his private life to the ideals of Stoic restraint and moderation such as were already permeating the European intellectual scene, he determined that his major artistic works should convey his conviction that only through rational judgment could man achieve virtue and thereby attain to tranquillity of mind. As he wrote to his patron and friend, the influential art connoisseur Paul de Fréart, Sieur de Chantelou, a man's actions must lead to virtue on one condition, that they be "guided by reason."[18]

In his later period, when that conviction was paramount in his mind, the subjects he chose for his paintings were to leave no doubt of the message he wished to convey. His patently didactic intent led him to select scenes which should illustrate the ideal of the *honnête homme*. His *Continence of Scipio* (1642) offered as *exemplum virtutis* the noble self-discipline of the Roman general in renouncing his rights to a beautiful captive Numidian princess in deference to her vows to an affianced lover. Another admired painting portrayed *The Burial of Phocion* (1648), the Athenian unjustly executed by his fellow citizens for his insistence on proclaiming the truth and later reinstated with public funeral as his moral dignity was retrospectively acknowledged. But it is in the earlier, less overtly moralizing period that his artistic subtlety in transmitting these principles is best to be observed.

Elsewhere, I have already discussed an innovative artistic technique which Poussin employed in that earlier phase,[19] but I should like briefly to return to it here in order to offer an additional literary application. It has long been noted as a characteristic of his style that in many of his canvases the figures seem to be "frozen" or posed. Anthony Blunt, in his definitive study of Poussin, attributed that effect of immobility to the artist's depiction of the instant of rest when a dancer or reveller, as in *The Worship of the Golden Calf* of 1635, has swung his or her leg to its fullest extent and is about to begin the reverse movement.[20] However, the artistic motive for selecting that specific instant in time for depiction is left entirely unexplained, as

is the reason why the painter should have been interested at all in suggesting a "freezing" of movement when most artists, particularly in the baroque era, were anxious to convey the very opposite effect—the dynamic element in a scene which should override the essentially static quality of painting. But a close study of the group of canvases he produced at this stage of his career may reveal the impulse behind that interest.

Significantly, in contrast to the static scenes of his later phase representing the self-control of a Scipio or Phocion, he was in this period particularly attracted by themes of fervour and passion. *The Rape of the Sabine Women* (*fig. 12*) dramatically portrays the women in terrified, struggling resistance, as they are snatched forcibly away from their homes by their male captors; and there is the licentious dancing of the Israelites before the Golden Calf, as well as his *Bacchanalian Revel before a Term of Pan* (*fig. 13*), all three paintings dating from 1635–37. It is instructive to compare his depiction of such revelry with Titian's bacchanalian paintings which had set the pattern for such canvases in this period and by which we know Poussin's to have been initially inspired. Titian's *Bacchus and Ariadne*, for example, dating from about 1523 (*fig. 14*), displays a wonderfully sweeping movement as Bacchus leaps from the chariot, his robe swirling behind him, that movement being deflected by Ariadne's own gesture which carries the eye onward towards the distant landscape, where may be seen the heavenly constellation soon to bear her name. With Bacchus's leap captured on canvas as he is still in mid-air, a dog barking excitedly in the foreground of the painting, a satyr to one side vigorously brandishing a calf's leg, and another twining a serpent around his naked body as he strides forward, there is no way in which the vivid action of the scene can be conceived as static.

For all the similarity in theme and the conscious indebtedness linking the paintings, Poussin's purpose has introduced considerable change. His aim is (however paradoxical it may sound) to portray action in immobility, and he achieves his purpose with consummate skill. At first glance his scene may seem no less wild than Titian's as naked or half-naked figures prance before the statue of a garlanded Pan, while to the right a bearded satyr, assaulting a laughing female, is being playfully attacked by a second bacchante. Yet in a strange way the spectator here remains emotionally undisturbed, not drawn into the scene as he is by Bacchus's great leap; and the reason emerges as one examines closely the disposition of the figures. For although supposedly whirling in a circle, each of the dancing revellers—just as in his *Worship of the Golden Calf*—is in fact poised in perfectly balanced stance, a posture anatomically impossible were the celebrants really in motion, when the body natu-

12. POUSSIN, *The Rape of the Sabine Women*

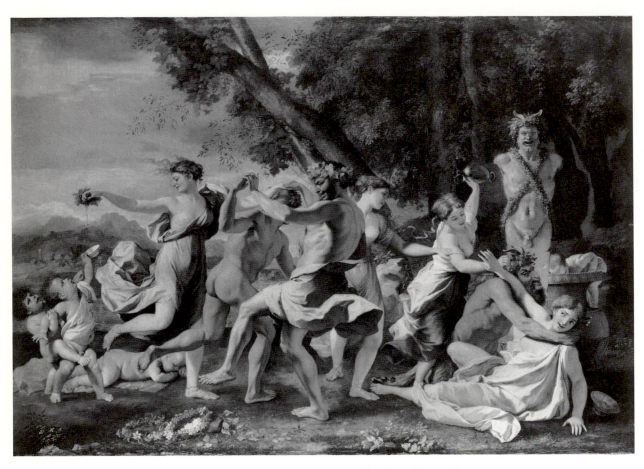

13. POUSSIN, *Bacchanalian Revel before a Term of Pan*

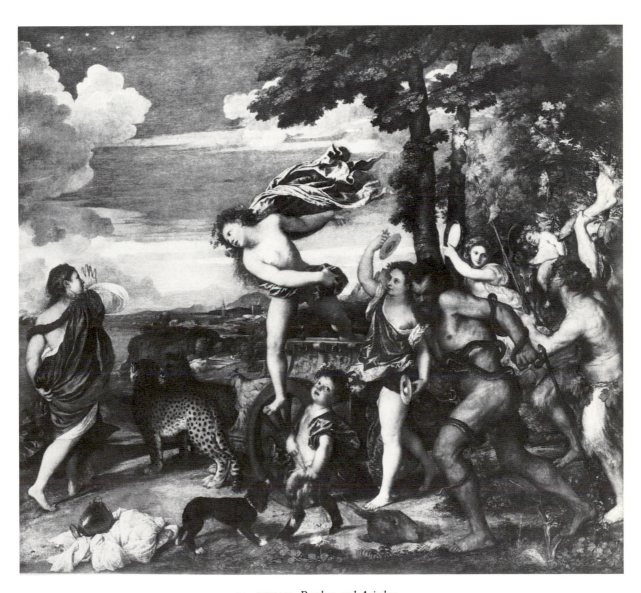

14. TITIAN, *Bacchus and Ariadne*

rally throws its weight forward either to increase momentum or to respond to it. Indeed, if the dancers here were to release hands, they would imperturbably preserve their equilibrium, each remaining upright upon one leg. It is that technique of illusory motion, an impression of action belied by the carefully retained balance, which creates the effect that his scenes are frozen or posed.

Poussin's motivation for employing that technique may be seen as integral to the philosophical principles which he had by now openly espoused, the ideal that intellectual restraint was to be at all times imposed upon impulse or passion, an ideal at this time becoming widely adopted throughout Europe. Some interesting contemporary evidence would seem to corroborate that view; for Dufresnoy, in the very poem which Dryden was later to translate, suggested an essentially similar device for conveying artistically the new precept of intellectual control. Maintaining that the fury of the Fancy, which cannot contain itself within the bounds of Reason, must be moderated by the Mind, he recommended, as a means of implementing that concept in painting, a design with "each Figure carefully poised on its own Centre."[21]

Poussin, like Titian, was clearly an admirer of human passion, seeing in it the necessary impetus for love, for patriotism, and for any form of noble self-dedication. Indeed, a close study of his drawings as well as of his life in general has led one art historian, Walter Friedlaender, to conclude that Poussin was by temperament impulsive, strong-willed, even vehement.[22] But such passion, as Descartes was soon to argue explicitly for the Pyrrhonists of the time, needed to be curbed by the rational self and redirected towards its rightful end. Accordingly, in validation of such initial impulses of strong feeling or passion as the welcome prerequisite for eventual balance, the bacchanalian revelry here is in itself presented as attractive in a light, airy, and vigorous scene, not grimly condemned for its excess. Yet the posing of the figures, for all their supposed emotional abandonment, is designed to act as a barrier to viewer involvement, forcing upon us the role of calm, detached spectators, and thereby conveying with the indirectness of true art (in effect by making us rehearse the lesson rather than by relaying it to us explicitly) the need for the intellectual disciplining of our emotions, a reining in of the impulse to revelry which the painting thematically inspires. It is a technique to which modern critical theory, with its focus upon the reader as active participant rather than as mere recipient, should have sensitized us—as in the interpretation of *Paradise Lost* in terms of a work compelling each reader to undergo personally the shock of being deceived by Satan, and hence of being "surprised by sin."[23]

In my earlier discussion of this element in Poussin's work, I had used it to suggest that Sir Thomas Browne's *Religio Medici*, so long regarded as the leading exemplar of English mannerist or "Attic" prose writing, was in fact closer in allegiance to the rationalism of the approaching age; but in that instance its application was to a writer transitional both in outlook and in style. Poussin had served there as no more than an indication of elements which were soon to enter the English literary scene and which had as yet appeared in only embryonic form in Browne's writings. Here, however, Poussin's relationship with Dryden is both more integral and more specific. Both were avowed admirers of the Stoical or sceptical patterns of thought predominating at that time, and both earnestly expressed their philosophical tenets through their artistic work.

This technique for suggesting intellectual restraint, so central to Poussin's paintings, may have a particular relevance for an understanding of Dryden's experiments in drama at this time. There is, indeed, a striking similarity between the two men in their warm advocacy of passion. Although, understandably, Dryden is normally associated with the rationalist tendencies of the seventeenth century, human emotions were in a sense his primary concern, as he recognized both in his critical and his dramatic writings. It was, for example, insufficient in his eyes for tragedy merely to excite the two emotional responses that Aristotle had required. As he claimed in his *Heads of an Answer to Rymer*:

> If then the Encouragement of Virtue, and Discouragement of Vice, be the proper End of Poetry in Tragedy: Pity and Terror, tho' good Means, are not the only: For all the Passions in their turns are to be set in a Ferment; as Joy, Anger, Love, Fear . . .[24]

As Earl Wasserman has pointed out, there is, concealed beneath the cool exterior, a markedly sensual element in the very theory of tragedy at this time as well as in its practice, with Dryden seeing the exciting of emotion not only as a means for achieving the didactic aim of poetry (*aut prodesse volunt*) but as in itself fulfilling poetry's second, more pleasurable purpose (*aut delectare*). The passions, including those of pity and terror, were therefore to be savoured in their own right—a hedonistic indulgence which, it has been argued, may well have prepared the way for the flood of sentimental drama in the following generation.[25]

To condemn these heroic dramas for the "swashbuckling" braggadocio of their strutting heroes is, as has been mentioned, unjustified in itself in the light of such plays as Marlowe's *Tamburlaine*, which, by its awesomeness and daring, its splen-

dour and imaginative range, in fact won the enthusiasm of audiences both at the time of the original performances and in the twentieth-century revival at the National Theatre. It, too, presents a hero supremely confident of his invincibility, driven by an egoistical passion which brooks no opposition, his love reflecting in its irresistible force the impetus of his martial ambition. Dryden's plays, therefore, are not to be disqualified merely on the basis of their theme. Moreover, we are dealing here not with some minor writer unworthy of comparison to Marlowe, but with an author acknowledged as a major poet in his own right, whose rich contribution to the development of English verse is unquestionable. Indeed, there is in these plays a dramatic potential justifying the comparison, a delight in the magnificence of powerful emotion, of the human imagination soaring beyond mortal limitations, which is often reminiscent of Tamburlaine at his best. When, in *The Conquest of Granada*, Abdalla announces that he will grant Almanzor his life, the latter rejects the offer with a scornfulness and pride cosmic in their range:

> ALMANZOR: If from thy hands alone my death can be,
> I am immortal as the gods above.
> If I would kill thee now, thy fate's so low
> That I must needs stoop down before I strike.

Had Dryden indeed written so—for the above quotation is a version which (to use the terminology of his time) I have had the temerity to "improve out of the original"—the vision and grandeur of the hero's confidence might well have carried the play to success, as they did in Marlowe's dramas. But, in the same way as Poussin needed, as part of his philosophical creed, to "freeze" his characters to convey to his spectator the rational control to which emotion must be subjected, so Dryden, in what may be seen as the literary counterpart of that technique, insisted upon the introduction of rhymed couplets to restrain and modify the exuberance of a passion whose force he himself acknowledged and which he believed needed to be tempered for the reader too. The heroic couplet, by the reiterated end-stopped lines which the rhyme and designed pauses produce, halts or constrains the emotion, preventing any overflow of feeling, and thereby reducing the potentially cosmic vision to a mere rhetorical gesture. The passage in its original form, as can be seen by comparing it with the altered version, shackles the rising movement at the conclusion of each line, thereby hampering the surge of feeling with which the audience might empathize. The resultant effect is of a fervour objectively and critically observed, an emotion recorded rather than internally experienced:

ALMANZOR: If from thy hands alone my death can be,
 I am immortal; and a God, to thee.
 If I would kill thee now, thy fate's so low,
 That I must stoop 'ere I can give the blow.[26]

The dramatic character himself seems, by that device, no less dispassionate in ana-lyzing his own emotions, even when ostensibly proclaiming his inability to control them:

MAXIMIN: I can no more make passion come or go,
 Than you can bid your *Nilus* ebb or flow.
 'Tis lawless, and will love, and where it list:
 And that's no sin which no man can resist.[27]

The innate artificiality of the closed couplet was acknowledged by Dryden him-self, who declared that, in composing such verse, a good poet "never establishes the first line, till he has sought out such a rhime as may fit the sense, already prepar'd to heighten the second."[28] Although he was speaking there of the process of compos-ing poetry, that halt in emotional flow, the reaching out for a rhyme to close the couplet, produces in the reader or audience essentially the same response, a sense of mechanical structure incompatible with natural speech. A potentially noble senti-ment, however appropriate to the speaker's condition, becomes reduced thereby to mere apophthegm and, by constraining the thought within the ordered hem-istyches, contradicts by its closed literary form the breadth of vision implied by the content:

ABDALLA: Vast is his Courage; boundless is his mind,
 Rough as a storm, and humorous as wind.[29]

The Poussin analogy would, then, by its cultural contemporaneity seem to sug-gest that Dryden's insistence on employing the parallel technique of rhyme in his dramas was neither fortuitous nor simply a personal preference—whether in general terms or, as Kirsch maintained, deriving from his discomfort as a poet writing by default within the theatre. It should be seen rather as a device intrinsic to his transla-tion into artistic terms of the rationalist principles to which he and Poussin sub-scribed and their shared desire to impose some limitation to the emotions liable to be aroused by their scenes.

The close relationship between the French and the English views is indicated by the similarity both in conception and formulation with which the principle was

promulgated. Dufresnoy in the passage quoted earlier in this chapter (a passage written well before Dryden's definition but not published until later and therefore in no way influencing him) had urged that the Mind be employed to restrain the fury of the Fancy. Dryden, in the dedicatory epistle to *The Rival Ladies* (1664), identified as the benefit he valued most in rhyme its fulfilment of that same function, that "it bounds and circumscribes the fancy. For imagination in a poet is so wild and lawless that like an high-ranging spaniel, it must have clogs tied to it, lest it outrun the judgement." And later in his career, when the time had come for him to discard the couplet form in drama, he claimed that he had grown weary of his long-loved mistress Rhyme for the same reason as had originally attracted him to it, because "Passion's too fierce to be in Fetters bound."[30]

How far his pertinacity in advocating the couplet hampered his success in the theatre during the period he remained faithful to it can be gauged from the progress of his dramatic career once he undertook to discard it, notably in the nobility and grandeur of his *All For Love*. There his concern with the control of passion by reason remained dominant, but its new location in that tragedy allowed for more effective dramatic use. Removed at last from its dampening usage within the couplet form, it here was transferred to the dramatic structure of the play, with the figure of Ventidius functioning in place of the couplet as the choric reprover of emotional excess. George Saintsbury, the doyen of English prosodists, noted that this tragedy did not mark a sudden, unheralded break with the heroic couplet, a change dictated, as Dryden had claimed, by his adoption of a Shakespearean model. Instead, there may be discerned previous to it a gradual weakening of the end-stopped line in his dramas, due, we may presume, to his eventual recognition that it was failing to serve his purpose. In *Aureng-Zebe*, the play he wrote prior to *All For Love*, Saintsbury already perceived a marked inclination towards enjambement, commenting not only for Dryden but for all the dramatists of that time that "as soon as this tendency gets the upper hand, a recurrence to blank verse is, in English dramatic writing, tolerably certain."[31]

At this point, a question of aesthetic relativity arises—why did essentially the same technique of "freezing" passion, which proved so valuable for Poussin, emerge as so detrimental for Dryden? The answer, we may suspect, lies in a fundamental difference between the disparate media, a difference inherent in their artistic forms. Whatever devices a painter may employ to create an effect of movement on his canvas in order to suggest that the scene depicted is in dynamic process of change, in the final analysis, as the spectator knows full well, that art form is restricted to presenting only a single and fixed moment in time. For that reason,

Poussin's "freezing" of action in his paintings does not immediately impinge upon one's consciousness as an artificial device, since it is no more than an extension or intensification of an element integral to all painting. In contrast, drama, although it may employ comparable forms of artificial convention in relation to illusory time-lapse or changing stage locations, strives, in all but the expressionist theatre, to persuade its audience that the characters represented upon the stage are real human beings in the process of emotional development, of movement, and of naturally flowing action. At a certain level of consciousness we may be aware that the characters on stage are only actors performing roles, but at that role level, within the scene conjured up before us, any freezing of natural speech or movement is inimical to its artistic aim. In Shakespeare's poetic dramas, the distinction of the dramatic verse lies in its ability, despite the richness of its imagery, to recreate the ripple of spontaneous speech. It elevates us to a world of intensified imaginative experience, but ensures that any awareness of the character's speaking in verse recedes to a subdued level of consciousness.

As Dryden's contemporary critics repeatedly stressed, if in somewhat vaguer terms, the regular reiteration of a rhyme sequence halting the spontaneous flow of thought and thrusting the metrical regularity to the foreground of the audience's consciousness was destined to destroy the very illusion of reality he was attempting to create. His reply that such predecessors as Shakespeare had also employed verse on the stage glossed over the enormous distinction between blank verse and rhyme, the obstinate obtrusiveness of an innovative heroic couplet which Shakespeare had never employed—except, significantly, to mark the end of a scene, suddenly reminding the audience by the very artificiality of the rhyme form that it is, after all, seated in the playhouse and not in Athens or Agincourt. For the purposes of satire, the couplet Dryden popularized was ideal, for there the contrived structure provided that very aesthetic distancing required by the genre—the ambience of an intellectually discriminating poet contemptuous of the foolishness of mankind, refusing to become involved, and assuming in his reader a similar desire to be the detached, adjudicating spectator; but it could not function effectively in the drama, particularly in a form of drama specifically devoted to the study of human passions.

Jean Hagstrum has interestingly perceived in Dryden's plays a reworking of certain allegorical themes dominating the painting and statuary of his time. Annibale Carracci's *Hercules at the Crossroads*, depicting the mythic hero compelled to choose

between the rival attractions of Virtus and Voluptas and understandably hesitating in his choice, had inspired many subsequent versions. It served, he argues, as a prototype for Dryden's Antony vacillating between Roman virtue and Egyptian voluptuousness.[32] But that thematic affinity with contemporary painting and sculpture needs to be extended much further, to embrace an innovation in portraiture too, characterizing the art of his day. From the third decade of the seventeenth century, marking the first signs of what has generally been termed the Late-Baroque phase of European art, a significant change is to be discerned in the portrayal of holy figures. Emil Mâle, in a classic work, has drawn attention to the more fervent spirit which entered ecclesiastical art at that time, the cult of ecstasy or rapturous martyrdom arising partly in response to the Council of Trent's demand for a stricter devotionalism in art and partly to the emotional intensity of worship encouraged during the Counter-Reformation, with the mystic visions of Ignatius Loyola, Philip Neri, Teresa of Avila, and John of the Cross serving as paradigms for their followers. It is important, however, to distinguish a dichotomy within that tradition, the profound contrast between the mannerist version of such ecstasy and martyrdom, which had continued from its origins in the 1570s well into the seventeenth century, and the Late-Baroque forms that began to develop alongside during its concluding phase but were different in both nature and purpose.[33] The spiritual exercises advocated for devotees of the Loyolan tradition of meditation and for its subsequent Protestant versions had been primarily individualistic in intent. They were designed to assist the isolated Christian worshipper to attain to personal communion with the divine, to achieve ideally a climactic experience wherein the soul, in the literal meaning of the term *ecstasy*, would momentarily move outside the body and undergo imaginatively the same agony of martyrdom or the same bliss of salvation as the saint whose scene he was conjuring up in his mind's eye.[34] With the meditation intended as a form of retreat from worldly affairs into the inner self, the mannerist art arising out of that tradition had represented the saint in similar seclusion, as totally absorbed in the intimately personal moment of divine ecstasy, unaware of his or her surroundings, which shimmer away into nothingness beside the intensity of the climactic emotion. Bernini's sculpted *St. Teresa* swooning before the vision of angelic visitation (*fig. 15*) is, within her separately framed scene, utterly oblivious of the onlookers represented as seated outside.[35] El Greco's *St. Francis* (*fig. 16*), emotionally divorced from the distracting realities of the mundane, sensitively gazes above in rapt adoration. Such spiritual isolation and withdrawal from this world was integral to a religious philosophy which had revalidated the medieval

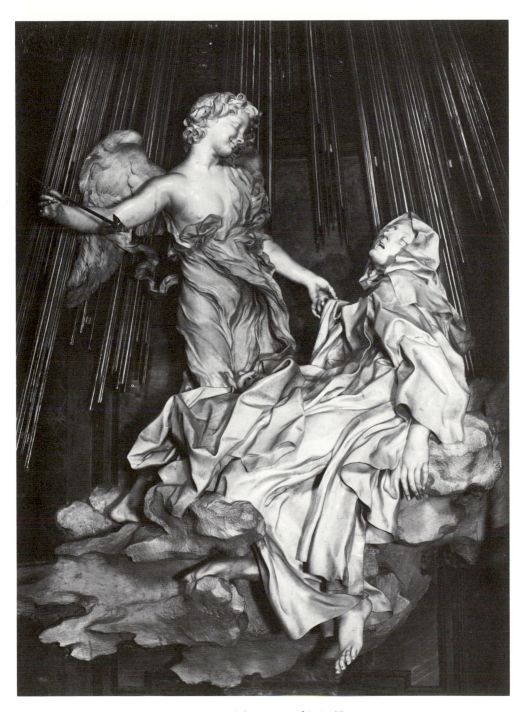

15. BERNINI, *The Ecstasy of Saint Teresa*

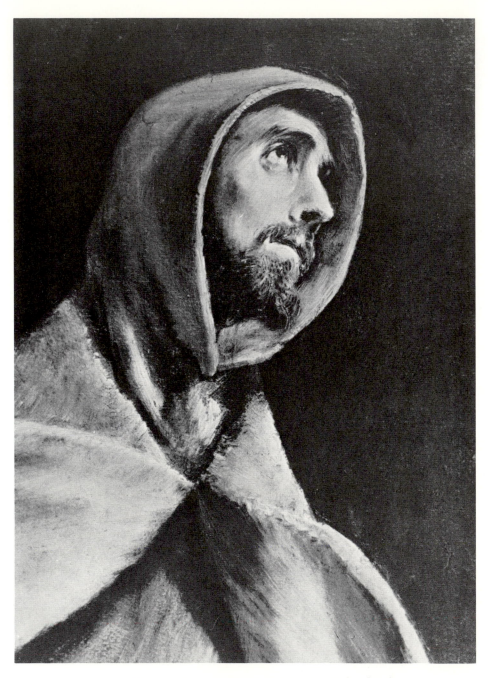

16. EL GRECO, *St. Francis with Brother Rufus* (detail)

contemptus mundi. And in its literary form, the divine colloquies of the leading English exponent of the mode are marked by a confessional privacy so intense as to bestow upon the reader a sense almost of eavesdropping:

> But who am I, that dare dispute with thee?
> O God, Oh! of thine onely worthy blood,
> And my teares, make a heavenly Lethean flood,
> And drowne in it my sinnes black memorie . . .[36]

In the Late-Baroque versions, however, that sequestered yearning for revelation on the part of the individual meditator or martyr is replaced by an unwonted self-consciousness, a theatricalism suggesting that the saints were now more concerned with the dramatic effect of their scenes upon the spectator than with the intimacy of the personal experience. Francesco Duquesnoy's figure of *St. Andrew*, on which the sculptor worked from 1629 to 1640 (*fig. 17*), while gazing heavenward in expectation of his martyrdom, at the same time dramatically stretches out one arm in a sweeping gesture, as though calling upon all who view him to share with and respond to his suffering. And Ercole Ferrata's *St. Agnes upon the Pyre* from 1660 (*fig. 18*) is typical of the new hagiographic art of its time in echoing that characteristic gesture of invitation to the audience.

Such change in sacred portraiture was symptomatic of a new ecclesiastical intent. As the wider educational purpose of the later baroque became aimed at the masses rather than at the rarefied asceticism of the already-dedicated Christian, the focus in art began to turn away from the martyr in the loneliness of his agony to the martyr as a public exemplar of devotionalism. The result is a more popular form of art in which, without demanding from the worshipper the discipline of spiritual exercise, self-preparation, and devotional concentration, the new scenes offer a more easily attained vicarious experience, a ready-made meditation in which a scene of achieved ecstasy asks only for the spectator's admiration or sympathy.

Artistically the change was far-reaching, producing in effect a reversal of the previous conception of ecstasy, the vantage-point shifting, for the depicted martyr as well as for the audience, from the etherial to the terrestrial. It is now not the soul leaving the discarded body in spiritual elevation but the earthly self which is given primacy, standing, as it were, outside the soul at the moment of divine afflatus, and looking on approvingly. Like the mind of an actor which, even at the climax of his tragic scene, coolly assesses the effect he is producing on his spectators, so the martyr here, at the very moment of his agony, reveals himself by his welcoming gesture

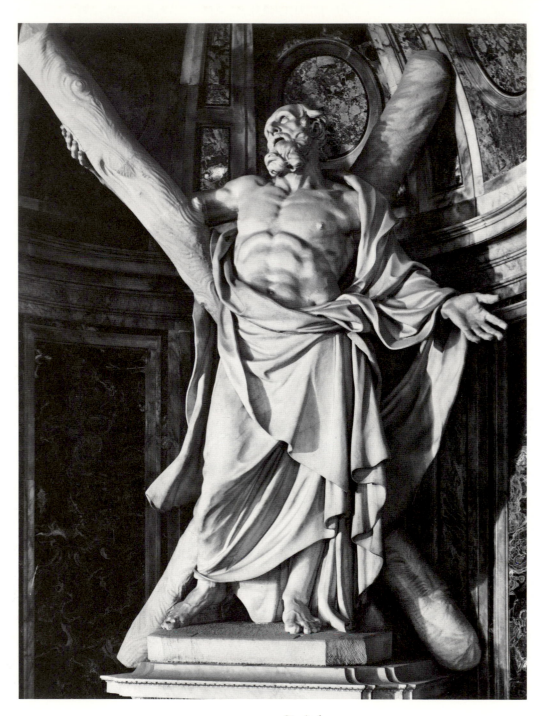

17. DUQUESNOY, *St. Andrew*

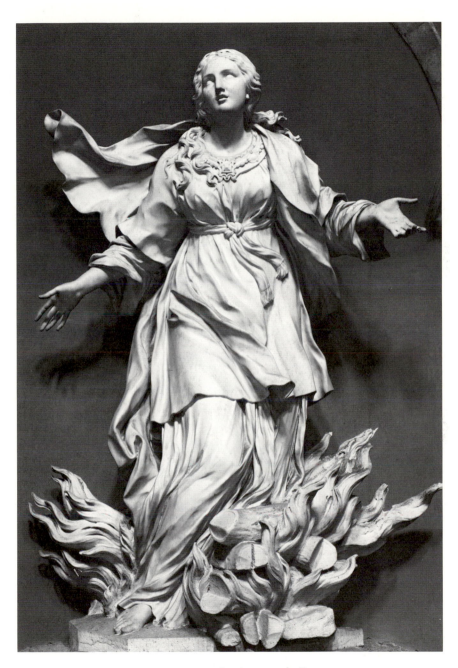

18. FERRATA, *St. Agnes on the Pyre*

to be conscious of his own experience from without as well as from within, as though acting a destined role and thereby himself becoming in part an audience of the event. The relationship of the creative artist and of the spectator is altered too. In mannerist painting, the figure of the *Sprecher*, mediating between the viewer and the envisaged scene and serving in part at least as a projection of the artist himself, had been presented, like the lonely meditator, as an anguished participant in the miraculous re-enactment, himself writhing in ecstasy as he draws aside the curtain to reveal the sacred moment (*fig. 19*). And the mannerist poet had submerged himself no less passionately in the identity of the visionary, undergoing with him the process of self-identification with the martyr.[37] In this newer form, however, both artist and poet consciously withdraw from the scene to join the spectator or reader in admiring from afar, venerating the purity and splendour of the holy event but no longer projecting themselves into a personal re-enactment from within as the meditative tradition had required—often with a marked loss of aesthetic intensity:

> Live, o forever live and reign
> The *Lamb* whom his own love hath slain!
> And let thy lost sheep live to inherit
> That *Kingdom* which this *Cross* did merit.[38]

In secular scenes of passion in this period there is a similar reversal of the traditional roles assigned to body and soul, to the importance of observation over experienced emotion. Dryden's heroic characters at the high point of his dramas, instead of speaking from within the turbulence of their own fervour—as Othello had in the transports of jealousy or Lear in the raging storm of his own madness—stand, as we have seen, outside themselves, their rational faculty commenting critically, calmly, even analytically upon the emotions supposedly occurring powerfully within them, as though invoking the audience to share their interesting observations concerning their supposed passions:

> I'm numm'd, and fix'd and scarce my eyeballs move;
> I fear it is the Lethargy of love!
> 'Tis he; I feel him now in every part:
> Like a new Lord he vaunts about my Heart.[39]

This transference of focus from suffering to observation merged with the distancing provided by the rhymed couplets to confirm the subordination of the emotional self

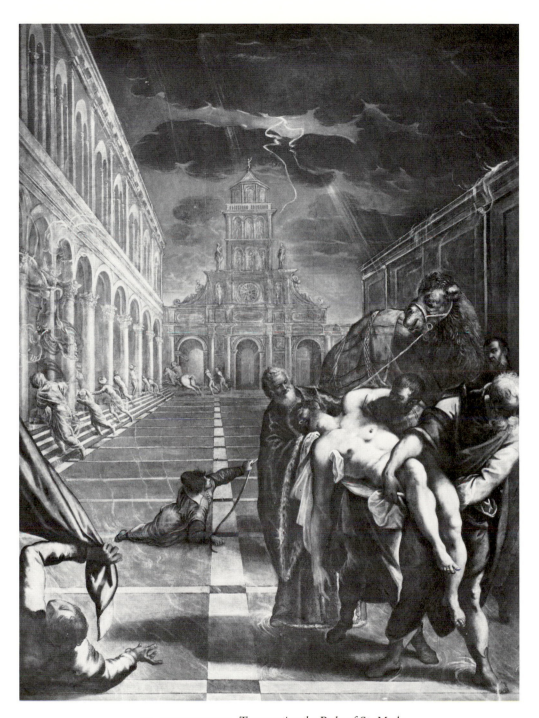

19. TINTORETTO, *Transporting the Body of St. Mark*

to the reasoning faculty even in the speeches of those characters who, by the weakness of their surrender to irresistible passion, are intended to represent the opposite.

The effect upon the portrayal of heroines in this period was perhaps even more radical. It has long been remarked that in religious art the representation of female saints undergoes a transformation in the seventeenth century, although the nature of that transformation has been variously defined, depending on the proclivities of the critic. For many contemporaries, such innovative sculpture as Bernini's *St. Bibiana* of 1624 (*fig. 20*), or Duquesnoy's *Susanna* dating from a few years later, was seen as having introduced a new innocence and purity into female portraiture, described lyrically by Bellori as "un aria dolce di grazia purissima."[40] For others, particularly in later years, it marked a cloying sentimentalism, as in Guido Reni's *Virgin in Contemplation* (*fig. 21*), a sentimentalism which was to reach its climax in the immensely popular *Immaculate Conceptions* of the Spanish painter Murillo (*fig. 22*; this specific version painted in 1678), where the Virgin floats above a cluster of attendant cherubs.

The primary source of the change may be traced to the contrast suggested above, the shift from the selflessness implicit in mannerist portraiture to the saint's new consciousness in this Late-Baroque form of her own perfection as a public model of virtue. It had no precedent in the earlier depiction of holy figures. A medieval Madonna and Child by Cimabue or Duccio had conveyed above all the mother's grieving concern for her son, her haunting sadness at the suffering destined for the child held to her breast. In the Renaissance, as part of the Platonic belief in the divinely beautiful-and-good at the apex of the heavenly hierarchy, a Madonna painting by Da Vinci or Raphael had transformed its emphasis from suffering to love, the Virgin representing an ideal maternal benevolence directed towards the children playing before her, at whom she gazes with generous fondness. But in these newer representations, whether of the Madonna or of a female martyr, the saint's concern is centred upon herself. She crosses her hands over her bosom in a gesture of personal devoutness, of conscious piety as she is singled out for glory or ascends to occupy the place deservedly awaiting her in heaven. In Spain, where the cult of the Immaculate Virgin was to reach its apogee, Francesco Pacheco, the art-censor to the Inquisition, summarized in his *Art of Painting* of 1649 the essential features of the new formula as he had defined it, that she be represented as a young girl clothed in a white robe and blue cloak, her hands across her breast or meeting in prayer, with a crown of twelve stars above her head, and a moon, the symbol of chastity, beneath her feet.

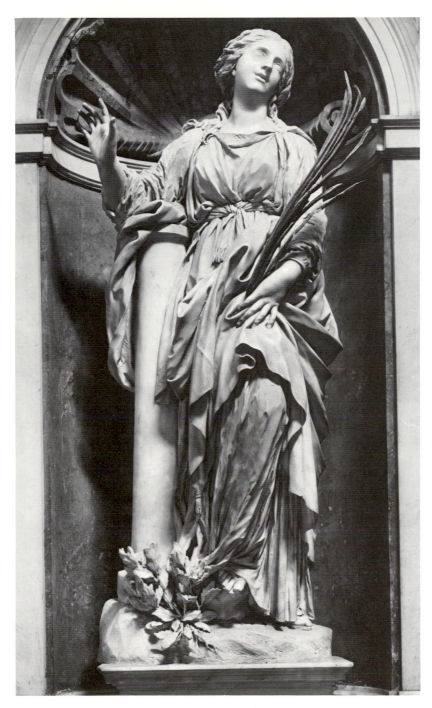

20. BERNINI, *S. Bibiana*

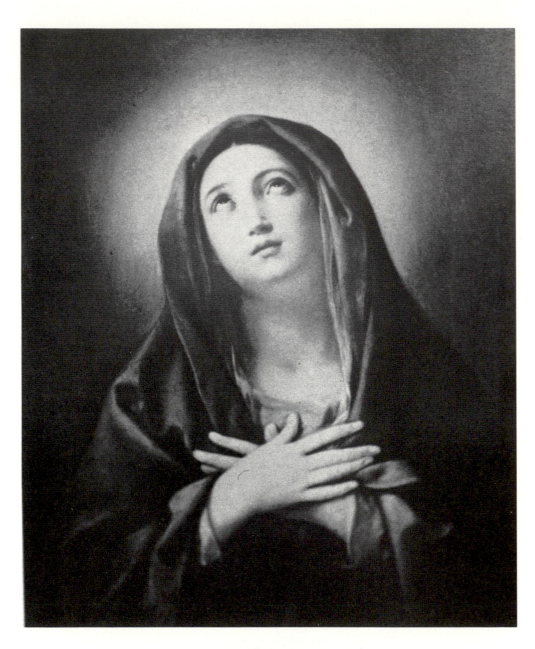

21. GUIDO RENI, *The Virgin in Contemplation*

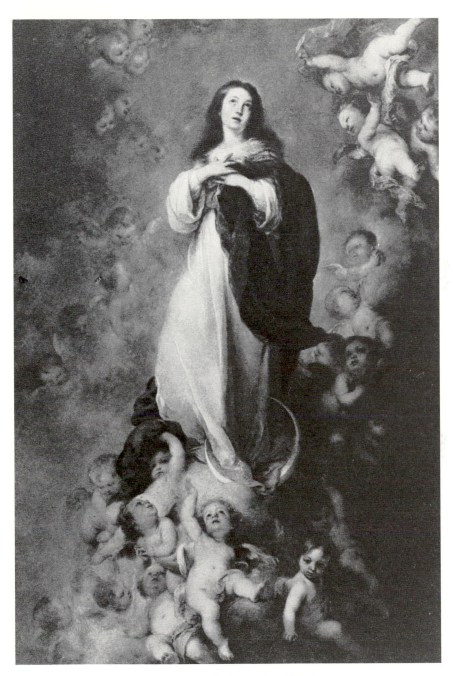

22. MURILLO, *The Immaculate Conception*

In an altered religious climate, such figures of Madonnas and Magdalenes were now to serve, therefore, as symbols of spotless purity or fully achieved penitence rather than, as in an El Greco painting or a holy sonnet by Donne, as yearning, suffering mortals (including Jesus himself in his human form) with whom the Christian worshippers could identify in their own dissatisfied longing for salvation and their own weary sense of the manifold sins requiring atonement before they could entertain even the most meagre hope of divine mercy. It is enlightening to compare with Murillo's painting, El Greco's version of a similar scene painted in the earlier tradition, his *Assumption of the Virgin* from 1577 (*fig. 23*). There, too, she stands upon a crescent moon and rises heavenward surrounded by angels. But her expression is not of demure piety. It is of sadness for the lot of mankind; and that gravity of mien, as she raises her arms not to invite audience participation but upward in a plea for heavenly mercy for mankind, is reflected in those about her, as in the solemnity of the angel to the far right.

In poetry, the distinction between the selflessness of mannerist martyrs and the complacency of the Late-Baroque figures is no less operative. As George Herbert, belonging within the earlier group, conjures up his vision of the Magdalene, he sees her not at the moment of beatification but earlier, in her striving for penitence, humbly washing Christ's feet while still in the "filth" of her own sins—a scriptural projection, as the continuation shows, of the poet's own grievous sense of mortal sin and his frustrated yearning for purity:

> She being stain'd in her self, why did she strive
> To make him clean, who could not be defil'd?
> Why kept she not her tears for her own faults,
> And not his feet? Though we could dive
> In tears like seas, our sinnes are pil'd
> Deeper than they, in words, and works, and thoughts . . .[41]

As so often in religious verse of the metaphysical poets, the comfort he finds is in the discovery of a paradox transcending earthly logic, in the recognition that, by that very act of supererogation, in cleansing Jesus who needed no cleansing, Magdalene was purifying herself—"in washing one, she washed both." The envisioned scene and the lesson derived from it are in full accord with the older Loyolan tradition, that the purpose of such meditation was not merely to conjure up the scene imaginatively but to return to oneself with an urgent questioning of one's own failings and the possibility of their correction: "What have I done for Christ? What am I now doing for Christ? What ought I do for Christ?"[42]

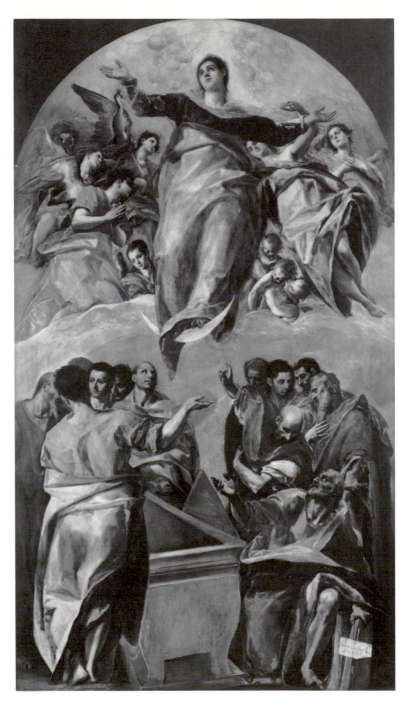

23. EL GRECO, *The Assumption of the Virgin*

The subsequent view of the female saint luxuriating in her own deserved bliss, more concerned with the rewards awaiting her as martyr than the humility requisite for true *imitatio Dei* was, of course, to be most vividly exemplified in English poetry by Richard Crashaw in his hymn to St. Teresa. Whether one feels with Yvor Winters and others the predominance of a "fairy-tale" piety in this hymn or accepts the argument of Louis Martz and, more recently, R. V. Young that it contains a vein of mild wit, what emerges indubitably from the poem is its depiction of martyrdom as unqualified bliss. Both in childhood and at the moment of immolation Teresa is seen not in doubt, disturbance, or despair but as beyond such earthly concerns, as impervious to human temptations, the paragon of an already achieved perfection. Martyrdom is not fearful pain tearing at body and soul at the moment of genuinely altruistic sacrifice, but a negligible, transitory prelude to the rich recompense it guarantees for the volunteer. Accordingly, Crashaw perceives Teresa, even as a child, "thirsting" to die, and so eager to take her due place among the holy angels that if she cannot find her death at home, she'll cheerfully "travel to a martyrdom." After she has at last received her dearest wish, a death whose agony is here at once sublimated from pain to pleasure, into "those delicious wounds that weepe," Crashaw again envisions her not from within but as participating in a celestial scene which he and others may watch respectfully from afar. She is a figure rising heavenward surrounded, like a Murillo Madonna, by attendant angels, who, in contrast to the agonized Sprecher of the earlier phase, represent by extension in both poem and painting an audience intended to perform only an admiring, laudatory function:

> Thy self shalt feele thine owne full joyes.
> And hold them fast for ever. There,
> So soone as thou shalt first appeare,
> The moone of maiden starres; thy white
> Mistresse, attended by such bright
> Soules as thy shining-selfe, shall come,
> And in her first rankes make thee roome.
> Where 'mongst her snowy family,
> Immortall wellcomes wait on thee.[43]

Behind the implicit theatricality of that artistic representation of the martyr in terms of public exemplar, with the poet functioning as adulatory spectator, may be perceived a modulation of sensibility closely related to the elements we have been examining in contemporary Restoration drama. Rymer's theory of poetic justice, as

well as Nahum Tate's rewriting of *King Lear* in a manner which should distribute the rewards and punishments at its conclusion with a more simplistic equitability, had drawn upon broader aesthetic revaluations on the European scene. Intrinsic to High Renaissance art and literature had been the conviction of the close integration of ideal and real, a conviction persisting even through the subsequent phase of mannerism, where beauty in its most etherial and spiritualized form remained imaginatively linked to the actuality of this world by means of a bracelet of bright hair about a bone or the limbecks and medicinals of contemporary alchemy. Such art transcended the physical, but acknowledged the intellectual struggle needed to reach beyond to the celestial and intangible. However, as alchemy, stripped of its magical or occult associations, was replaced by the objective, empirical enquiries of seventeenth-century science, so the world gradually became denuded of its participation in the Platonically conceived harmonies of the universe. Light was transferred from the sphere of the heavenly to a terrestrial setting, even before its scientific analysis into the component colours of the spectrum. No longer the dazzling mystery symbolic of divine creativity as it had been for the High Baroque, it became in the seventeenth-century Dutch art of De Hooch and Vermeer the calm light of reason, evenly diffused over all. What had been an integrated worldview now became polarized. On the one hand there emerges a realism divorced from any hint of cosmic associations, with unpretentious everyday scenes of a housemaid about to sweep the yard, of skittle players at an inn, or of smokers relaxing in the parlour.[44] On the other hand, what had once been naturally elevated as participating in the celestial proportions governing all the universe, now needed to be artificially aggrandized in order to divorce it from the mundane.

The idealized Madonnas formed part of that tendency. No longer, as in a Raphael painting, can they be sanctified simply by their heavenly peacefulness and benevolence. They require now the symbolic homage of adoring cherubs, together with an ecstatic spirituality of countenance suggesting that they have discarded the flesh, while the introduction of a crescent moon below their feet ensures their sublimation above the earthly. In the secular sphere that change in perspective produces a similar need to inflate monarchal glory or nobility above the terrestrial, as in the monumental splendours of Versailles aimed at creating an absolutist concept of kingship. Royal portraiture strains to achieve a magnificence not discernible in earlier traditions. Canvases of Queen Elizabeth such as the "Ditchley" portrait of 1592 or the version by Marcus Gheeraerts had been essentially heraldic in form, associating her by the symbols of pearls and other devices with the Neoplatonic ideals of

Chastity and Wisdom as part of her hierarchical due. But the notion of the divine right of kingship had faded, not least since the execution of Charles I, to be replaced by a general recognition that royalty ruled by political power rather than heavenly right.

In such a changed setting, the purpose of royal portraiture is no longer to establish heavenly associations but to elevate by association with earthly wealth and power beyond the reach of other mortals. Hyacinthe Rigaud's portrait of Louis XIV (*fig. 24*) depicts him very much in the flesh, proudly displaying his shapely legs, his graceful pose, and his handsome periwig; but the swirling robe richly embroidered with the royal crest and generously lined with ermine, the crimson drapery flowing above and around him, and the gilded column behind all attest to a grandeur beyond the dreams of common men. It marked the culmination of a continental movement to enhance monarchal splendour which had been introduced to England in its earlier and more modest form by Van Dyck but was now to be more fully developed by Lely, as in his portrait of James II (at that time, still Duke of York) seated in gorgeous apparel, with golden silks lavishly draped on either side, and the inevitable classical column placed behind to form an ennobling background (*fig. 25*).[45]

Within English architecture, this desire to aggrandize finds expression in Vanbrugh's immense Castle Howard, designed in 1699. The entrance hall (*fig. 26*) is monumental in scale, its height approximating to that of a baroque church, with massive arches elaborately ornamented by Corinthian pilasters, by marble panels, and by decorative courses. But where the baroque church had aimed at dwarfing man, overwhelming him with a sense of the ineffable splendour of his Creator, and the baroque palace had similarly suggested, as in the allegory on the ceiling of the Barberini Palace in Rome, the cosmic magnificence of the noble family, here the purpose of the grandeur aims more at suggesting the earthly achievements of its human owner. Within this entrance hall, for example, Vanbrugh, as may be seen on the illustration, ingeniously inserted within the lofty arch a marble fireplace which, rising only to one third of the arch's height, serves as a visual stepping-stone, reminding the viewer that the huge edifice is a human habitation despite its giant proportions. The wider acceptance of this new criterion is best indicated by the criticism levelled at Vanbrugh's Blenheim Palace, built a few years later, the charge that, in striving after artistic magnificence the architect had at times forgotten the human needs of its owner, such everyday matters as the distance from the kitchens to the dining hall, to which meals inevitably arrived tepid. And, in order to provide more spacious state rooms, he so cramped the living accommodations of the

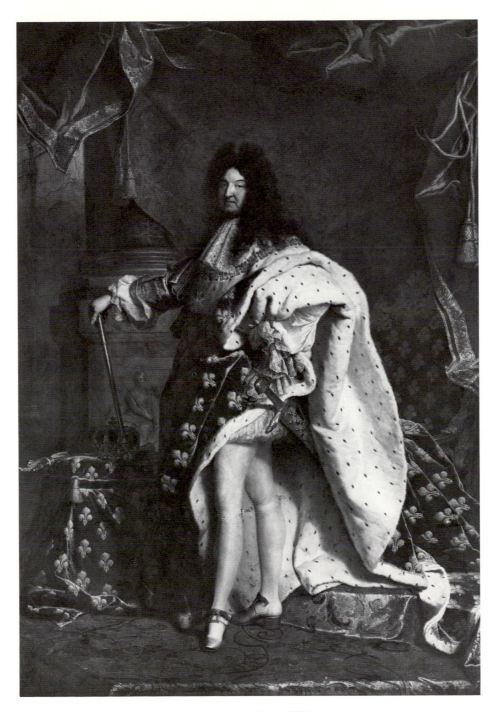

24. RIGAUD, *Louis XIV*

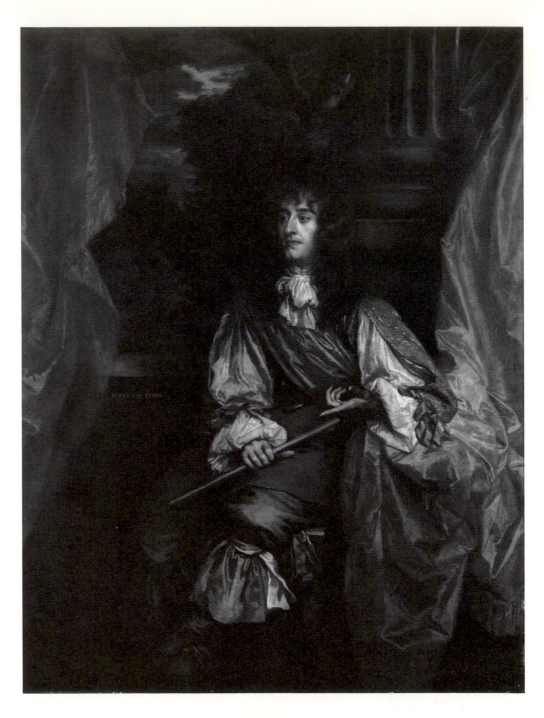

25. LELY, *James II when Duke of York*

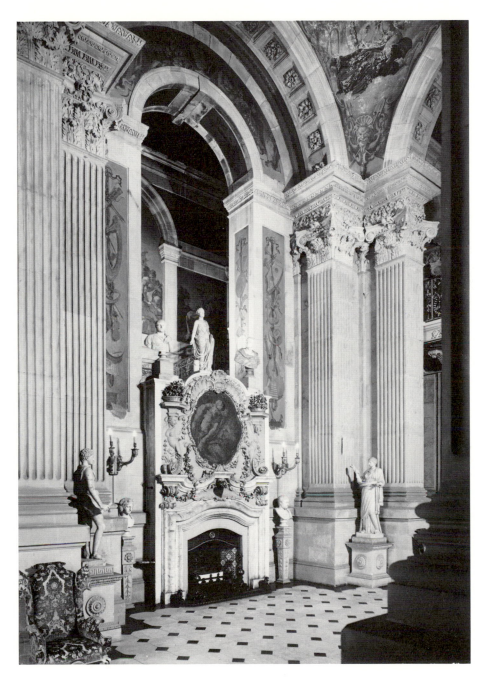

26. VANBRUGH, The Great Hall, Castle Howard, York

resident family as to prompt the wry, if unpoetic jingle from a contemporary satirist:

'tis very fine,
But where d'ye sleep, or where d'ye dine?
I find by all you have been telling,
That 'tis a house, but not a dwelling.[46]

The widening gap between the ideal and the real in mid-to-late seventeenth-century art would seem to shed some light on the marked bifurcation of Restoration drama, whose audiences seemed so strangely unperturbed by the contrast between the impossibly heightened honour, nobility, and glory of the heroic plays set in exotic climes, and the uncompromising realism of its comedies, depicting the sexual licence, bawdiness, and cuckoldry prevailing in the social patterns of the contemporary upper classes.[47] That gulf within the Restoration stage, which Mildred Hartsock and others have attempted to bridge by perceiving Hobbesian qualities in the heroes of the serious drama, in fact needs no bridging; for it accurately reflects the aesthetic polarity of ideal and real on the European scene at large, in both its religious and secular manifestations.[48] Paralleling the rational verisimilitude of seventeenth-century Dutch painting, English Restoration comedy, despite its links with the earlier drama through Thomas Killigrew and William Davenant who had been active playwrights before the closure of the theatre under the Puritans, preferred now to move into prose. The poetic "green world" of idealized fantasy, the imagined realms of the midsummer wood and the forest of Arden have disappeared from the comic stage, to be replaced by the city. The Truewit, the new ideal of urban society, coolly penetrates all disguises, illusions, and moral pretence in favour of empirically based assessments—of utilitarian appraisals previously restricted to the villainous Iagos and Edmunds of the Jacobean stage but now approved as qualities appropriate for the hero. Restoration comedy introduced, moreover, an uncompromising literalism, often shocking to the "cits," as in the stage direction in *The Man of Mode* that Dorimant and Bellinda are to be followed from their pleasures in the bedroom by a servant "tying up linen."[49] English art of this time, dominated economically by the commissioned family portrait intended to honour the sitter, has little room for either realism or comedy; but signs of this incipient interest can occasionally be discerned, as in John Riley's 1686 painting of James II's housekeeper *Bridget Holmes* (*fig. 27*), set traditionally against the usual classical column and hanging curtain, but, perhaps because she was not a member of the aristocracy, permitted here to be seen in a less serious pose, raising her mop against a mischievous page.

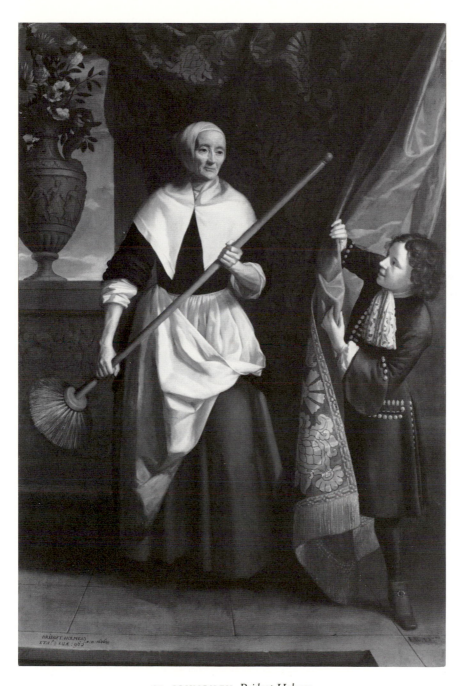

27. JOHN RILEY, *Bridget Holmes*

In general, however, the distinction prevailed between the serious and elevated on the one hand and the real and everyday on the other. The polarization of tragedy and comedy at this time is perhaps most clearly exemplified in that peculiar form of tragicomedy attempted at this time, in which, as in Dryden's *Marriage à la Mode*, the serious main plot and humorous subplot remain entirely compartmentalized, even further divorced by a separation into verse and prose, and never blend in mutually enriching form as they had on the Elizabethan and Jacobean stage.[50] Even in that compartmentalized form, the very juxtaposition seemed untenable, and the hybrid genre which had flourished so long withered away. The conviction that the two could not be effectively merged would seem to have arisen from the impression in an age preferring clear demarcations and definitions that Horace's dictum was itself to be divided neatly in two. The dramatist's desire to instruct could thus be allocated to the heroic plays, while the purpose of entertainment was diverted to the comedies. Shadwell, in the preface to his *Squire of Alsatia*, might invoke the well-worn defence against Puritanical attack that comedy's purpose was to expose the follies and vices of mankind; but in an era openly using that genre to authenticate profligacy and make the town rake its hero, such claims could scarcely be taken seriously. In a rarer moment of commendable frankness, Dryden admitted that the didactic rewarding of virtue and the punishing of vice had never been a main purpose of comedy despite Horace's claim for the instructional end of all writing: "At least I am sure it can be but its secondary end: for the business of the poet is to make you laugh."

As a result of such absolving of comedy from graver moral purposes, the full weight of the didactic intent in drama fell upon the serious play whose hero was accordingly designed, as Tate's reworkings of Shakespeare testify, either as a model of perfection or at the least as a close approximation. Dryden declared that "it is absolutely necessary to make a man virtuous, if we desire he should be pitied" and, while he admitted in that same passage that "alloys of frailty" are to be allowed for in the leading characters, as there never was in nature any perfect example of virtue, what applied to the man was not extended to the object of his love.[51] For the noble women in these heroic dramas the principle of immaculate perfection began to prevail, and it is here that the connection with the female saints of contemporary painting may be discerned. For, like the monarchs in painting and in the edifices erected for them, such heroines, too, now needed to be raised artificially above the mundane in order to mark their separation from the earthly, the terrestrial having by this time lost its natural Renaissance connection with the divine.

In an essay on the morality of the heroes and heroines of eighteenth-century sentimental drama, Paul Parnell analyzed some years ago in an illuminating article the reasons for the sense of mawkishness they arouse, particularly in modern audiences, in direct contrast to the avowed intent of their authors. The weakness in those plays, he points out, is the essential un-Christianliness of the supposedly model hero and heroine who, in total unawareness of the humility, the self-searching doubts, and the sense of personal unworthiness which true Christianity demands, are invariably convinced beyond a shadow of doubt of their own spiritual superiority over all around them.[52] To put it differently, the playwright is so anxious to provide his audiences with a perfect model of Christian behaviour that the very perfection of his leading characters—only too often pointed out by themselves—undercuts the morality he wishes to teach.

What holds true for the sentimental drama of the eighteenth century (as well as the sentimental novel, where Pamela's consciousness of her own unassailable virtue again disturbed the sensitive reader) may be traced back to the Restoration melodrama out of which it developed, and which was itself contemporary with the Late-Baroque apotheoses and ecstasies of saints. It is in that drama that we meet for the first time these heroines turning to heaven for aid at moments of crisis in unhesitating conviction of their own spotless piety and unable to comprehend how they, whom the gods ought so obviously to cherish most, should be exposed to danger and cruelty in this world. In his *Tyrannick Love*, Dryden, no doubt inspired by Huysmans's painting of the Queen in the character of St. Catherine and wishing tactfully to compliment her, introduced that martyr into his play, where she functions in precisely that way. In rejecting Maximin's plea for her love, Catherine, echoing the contemporary depictions of female saints in painting and sculpture, not merely invokes Heaven to testify to the rightness of her cause but does so with certain knowledge of the noble role in which it has cast her and which she is about to fulfil:

> ST. CATHERINE: No, Heav'n has shown its pow'r, and now thinks fit
> Thee to thy former fury to remit.
> Had Providence my longer life decreed,
> Thou from thy passion hadst not yet been freed.
> But Heav'n, which suffer'd that, my Faith to prove,
> Now to its self does vindicate my Love.

As she explicitly declares, she sees herself as a public model "plac'd, as on a Theater, / Where all my Acts to all Mankind appear, / To imitate my constancy or fear."

83

Unlike the holy figures conceived by the mannerist meditator in their spiritual tor-
ment and sense of personal unworthiness, Dryden's St. Catherine will here, of
course, display no hint of fear, only the perfect constancy she is destined to repre-
sent. And as usual in these plays, that sense of personal virtue is extended to the
secular heroines too, who again see themselves unhesitatingly as paragons of purity,
to whose virtue Heaven will assuredly testify.

> BERENICE: In death I'le owne a Love to him so pure:
> As will the test of Heav'n it self endure:
> A Love so chast, as Conscience could not chide;
> But cherisht it, and kept it by its side.
> A Love which never knew a hot desire,
> But flam'd as harmless as a lambent fire:
> A Love which pure from Soul to Soul might pass,
> As light transmitted through a Crystal glass.[53]

Such had not been the earlier tradition in drama, before that self-centred morality
had entered Christian art. One recalls Shakespeare's Cordelia, who suffered so
grievously at her father's hand, gently assuring him with utter sincerity that she has
"No cause, no cause" for reproach, concerned as a true Christian only with his pain,
never with the praise due her own virtue. That was in a play not primarily religious
in theme, but sensitive to the principles of humility, suffering, and altruistic love
implicit in Christianity.

The dramatic posing in these scenes from the heroic drama was not unconnected
with Poussin's theory of the *affeti* which he introduced to the secular painting of the
time, the vocabulary of gestures he derived from the writings of Cicero and Quin-
tilian. It now became standard procedure in art that moments of high passion should
be expressed through one of the recognized poses, each indicating a specific emo-
tion. The female held aloft at the centre of Antonio Molinari's *Fight of the Centaurs
and Lapiths* (*fig. 28*), curving one arm over her head in the accepted representation
of helpless and innocent suffering, by the very use of that standardized depiction of
emotion, becomes a theatrical figure, as though signalling her plight to all onlookers
in expectation of their sympathetic response. It echoes, in fact, the protestations of
impeccable virtue and piety reiterated in the heroic drama of the time.

I have always preferred in interart studies of this kind to select the very best that was
produced in each period and to explore in what way the finest creative works of each

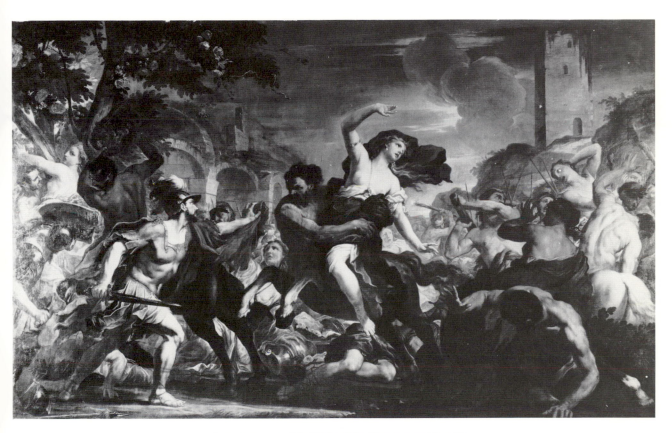

28. MOLINARI, *The Fight of the Centaurs and Lapiths*

medium can prove mutually illuminating. The concentration here upon the weaknesses in Dryden's plays has had a similar purpose, although that purpose may be apparent in the conclusions to be drawn rather than in the examination of the plays. For the greatness of Dryden both as poet and as dramatist remains firmly established even after the admission that his early heroic plays deserved much of the opprobrium cast upon them at the time. My aim has been to suggest that the faults in them were not fortuitous, but arose from his sensitivity to the winds blowing across from the continent, both in the new idealization of the female figures and in his recognition of the need to respond, as painters and writers were responding abroad, to the artistic implications of the scepticism and rationalism that had entered the philosophical modes of his day. His mistake was not in his acknowledging the need for a literary technique of restraint, such as the heroic couplet supplied. That innovation was indeed to succeed brilliantly in his satirical verse. The mistake, as he ruefully recognized late in his dramatic career, was his introduction of it into the theatre where it could not function in the way that Poussin's parallel technique had succeeded so impressively in painting. When he discarded the rhymed couplet, transferring his message of restraint from its embedding in the verse form to the broader structuring of his play, to an Antony torn between the attractions of passionate love and the sober advice of the choric Ventidius, the result was one of the most distinguished dramas of that generation. There, the fervour of the royal lovers is not hamstrung by the metre at the time of utterance but conveyed with the splendour of genuine feeling in free-flowing blank verse. And the success of the drama lay in a technique remarkably close to that employed by Poussin in his *Rape of the Sabine Women* (*fig. 12*), where the turmoil of the action in the foreground is delicately balanced by the calm figure of Romulus above, disinterestedly supervising the action and providing that controlling sense of order which the painting finally conveys. So in Dryden's *All for Love*, the transference of the theme of restraint from the end-stopped verse form to its embodiment in the character of Ventidius—a non-participant overseeing but not determining the direction of the plot, authenticating the principle of reasoned behaviour while yet allowing the passions of the protagonists to work themselves out—eventually created, like Poussin's Romulus, a dramatic counterpointing more powerful than Dryden's heroic couplet had ever been able to offer. And his thematic choice there of two leading characters destroyed by their admitted weaknesses freed him from the virtuous figures assured of their own moral perfection, which had, as in *Tyrannick Love*, reflected in the secular drama the consciously pious martyrs and saints appearing in contemporary religious art.

ROCOCO

3

POPE'S

EQUIPOISE

(i)

Since the appearance of Arthur O. Lovejoy's seminal study over fifty years ago, the centrality of the Great Chain of Being in the history of European thought has been self-evident—the vision it suggested of a hierarchically structured universe in which all species from the lowliest of insects to the highest forms of creation exist as necessary links leading up to the Demiurge or Supreme Creator, within the harmony of a cosmic system established on the principle of *concordia discors*.[1] The initial absorption of that Neoplatonic *schema* into medieval theology had, he pointed out, been problematic, leading at times to such open conflict as Peter Lombard's attack on Abelard in the *Liber Sententiarum*, charging him with unorthodoxy for having adopted the deterministic and antinomian implications of the theory. Yet the system in its broadest form had eventually been integrated into medieval patterns of thinking and for later generations formed part of accepted doctrine. During the fifteenth and sixteenth centuries, he maintained, the emerging belief in a plurality of inhabited worlds existing within an infinite universe may have owed even more to that established concept than it did to Copernican theory or to the confirmations of it provided by Galileo's telescope. The idea of plenitude, with its emphasis upon the illimitable engendering capacity of the Creator and its faith in the completeness of a cosmic chain wherein all possibilities of such generative action had already been fulfilled, should be seen, he felt, as having introduced an unprecedented expansiveness into early Renaissance apprehension of the heavens even before the investigations of the cosmologists were made known. It may have encouraged Nicholas of Cusa in 1440 to reject, however tentatively, the finite universe of

89

traditional belief and have served in later years as a basis for the more forthright claims for a limitless cosmos urged by Giordano Bruno and others. With the incorporation of the Great Chain into Renaissance cosmology firmly established in its opening chapters, Lovejoy's study was then able to proceed to its main theme, the continuing predominance of that conception of the universe in European thought until the very end of the eighteenth century.

Yet a curious remark in the body of his work should at the very least alert us to the existence of an anomaly in this theory of uninterrupted continuity. On noting how the idea achieved its widest diffusion and acceptance in eighteenth century thought, the Great Chain of Being becoming for that period a "sacred phrase" second only to the word "Nature," he muses in passing on the strangeness of its enhanced popularity at that time, the incongruity that something deriving from Neoplatonism and hence more naturally suited to Renaissance thought "had so belated a fruition," particularly as there was so much within the intellectual assumptions of the later age that was inimical to the basic premises of the idea.[2] A philosophical idea fundamentally unsuited to contemporary thought and merely inherited from an earlier period would scarcely be expected to achieve its widest acceptance at that later period, rather than at the time of its inception. Yet his momentary hesitation is left unexplored, even though his comment on the late burgeoning of the ideational pattern clearly deserves further investigation, with its implication that the scale of being was in some way fundamentally *more* suited to the sensibilities of Pope's era, at least in the form it took then, than it had been to the Renaissance in which it had achieved its earlier prominence.

Recently Martin Battestin has taken Lovejoy's argument a stage further. In opposition to the views of Rudolf Wittkower, John Hollander, Gretchen Finney, and others that Renaissance beliefs had in general ceased to be meaningful to the eighteenth century, he has pointed out with a wealth of pertinent quotation how prevalent the idea of the universal chain continued to be within that later period. Newton, he maintains, magnificently confirmed that humanist tradition, giving it a new lease of life until such time as the subjectivism implicit in Lockean thought eventually caused its disintegration. On the basis of the evidence adduced—evidence which points undeniably to the continued prominence of the belief—Battestin then poses as the central motif of his book a question arising out of the proven persistence of that credo, namely, how far Neoclassical faith in the paradigms of cosmic order, beginning with the *fiat* of Genesis and closing at the end of days with the Apocalypse, may be seen as accounting for the formal organization discernible in the writ-

ings of Pope, Gay, Fielding, and Goldsmith; and conversely how far a querying of such cosmic organization may have led to the conscious violation of stylistic formality in such writers as Lawrence Sterne.[3]

The argument for the persistence of belief in the scale of being in the eighteenth century is in itself, I think, unassailable. The principle of *concordia discors* integral to that conception of an ordered universe, whereby contrary elements in the cosmic system achieved harmony by their very opposition, prevailed as a philosophical and religious tenet and was reiterated in the literature of the time. In a poem composed in 1709, John Reynolds contemplated the divine plan of creation, marvelling how

> Close Union and Antipathie,
> Projectile Force, and Gravitie,
> In such well pois'd Proportions Fall,
> As strike this Artfull, Mathematic Dance of All.[4]

Newton himself, as Battestin points out, had presented his revelation of the spectrum not as a mechanistic refutation of mystical order but as a confirmation of it, as comprising a series of colour ratios conforming with mathematical precision to those of the traditional Pythagorean musical chords, the component hues harmoniously relating to each other "as the Cube Roots of the Squares of the eight lengths of a Chord which sound the Notes in an Eighth."[5]

However, this claim for the durability and persistence of the concept into the eighteenth century has ignored, or at the very least seriously underplayed, certain far-reaching changes which had occurred within it. For in the process of its transmission from the Renaissance to that subsequent period, the doctrine of the Great Chain underwent, it may be argued, an internal metamorphosis so profound that, while outwardly it preserved the impression of historical continuity, in effect it constituted a new version. In its older High Renaissance form the principle of universal hierarchy had, of course, powerful socio-political ramifications, providing a moral imperative, fortified by the interests of the reigning monarch, to preserve degree, priority, and place. But if that sense of a divinely enjoined political order was deeply engraved on the contemporary imagination, philosophically the primary impetus of Neoplatonic belief had always been to encourage a *transgression* of established bounds, urging man to break out of his allotted rank, to ascend in spirit from the mundane to the divine and, having participated in the creative force of the celestial, to return to earth imbued with its infinite splendour and power. That very word "infinite" in its application to the human spirit marks most vividly the distinc-

tion between the Renaissance version of the theory and its eighteenth-century manifestations. Ficino could exhort a young disciple to aim far above the stars in the assurance that "you too will be greater than the heavens!"[6] In contrast, whether as the moulder of new ways of thinking or as himself the philosophical exponent of the altered outlook of his time, Leibniz employed the principle of plenitude with reverse effect, to posit a closed and perfected universal system wherein all creatures were to operate solely within the limits assigned to each rank. There was indeed room in this system for human striving towards self-improvement, but such improvement was circumscribed, existing within the area specified for mortal potential. Within that modified version of the scale of being, any desire to soar with Plato to the empyreal sphere had become mere absurdity, ridiculed, as it was in Pope's *Essay on Man*, as an irresponsible ignoring of mortal confines.

> Go, soar with Plato to th' empyreal sphere,
> To the first good, first perfect, and first fair;
> Or tread the mazy round his follow'rs trod,
> And quitting sense call imitating God.[7]

Nor were the proponents of Leibnizian philosophy alone in subscribing to the theory of strictly enforced boundaries; for the sense of human immobility within the system was shared by its detractors. Samuel Johnson, conscious of the vastness separating man from the divine—the antithesis of Renaissance belief in the possibility of transcending mortal limits—saw in that intimidating gulf a disproof of the Leibnizian theory of plenitude at large, as well as of the derivative version propounded by Soames Jenyns; for if even the highest being in the created world must, by reason of its very finiteness, be at an infinite distance from the divine, "in this distance between finite and infinite, there will be room for ever for an infinite series of indefinable existence." Voltaire, too, demonstrating a similar belief in the inherent restrictions of man's condition, scoffed at the Leibnizians for thinking of the Chain of Being as paralleling the hierarchy within the Catholic church, pointing out that whereas in the church every priest possessed the potential of eventually ascending to the papal throne, in the universal system as posited by the eighteenth-century philosophers no man could ever become God. That infinite hiatus, he maintained, automatically vitiated the basic comforts in what was fondly believed to be a philosophy of optimism.[8] On either side of the dispute, therefore, there was firm accord in discrediting the doctrine of ascent to the divine. For Pope that very striving for etherial inspiration which Ficino had advocated has become the cardinal sin of the

Fall, the absurdity of man's recurrent attempt to rise above the station allocated to him:

> In Pride, in reas'ning Pride, our error lies;
> All quit their sphere, and rush into the skies.
> Pride still is aiming at the blest abodes,
> Men would be Angels, Angels would be Gods.
> Aspiring to be Gods, if Angels fell,
> Aspiring to be Angels, Men rebel;
> And who but wishes to invert the laws
> Of ORDER, sins against th' Eternal Cause.[9]

The universal hierarchy, in the course of its transmission to the eighteenth century, had been imaginatively transformed from a ladder leading invitingly heavenward into a forbidding series of fixed compartments within which each creature was forever enclosed.

The blurring of this major distinction between the earlier conception of the Great Chain and its subsequent version has been interestingly paralleled in art history, in the frequent and misleading application of the term Late Baroque to the early eighteenth century, as if the art of that period represented an essentially unbroken continuity, its productions somewhat reduced in size from the grandeur of cathedral interiors to the more modest splendours of salons but yet belonging to the same artistic mode. For here, too, there may be perceived behind those surface continuities aesthetic changes reflecting a philosophical revolution similar both in character and in extent. There was indeed a period of transition towards the end of the seventeenth century when the baroque impulse was losing its momentum and the new aesthetic tendencies were only beginning to assert themselves. To that period, as I suggested in an earlier chapter, the term Late Baroque can legitimately be applied; but not in any meaningful sense to the full eighteenth-century mode which, like most innovative styles, while inheriting certain aspects of earlier tradition, radically transformed them to suit its new needs.

That very difference in the conception of the Great Chain, the shift from a sense of an accessible and wondrously attractive celestial infinity to a sequestration of man within his terrestrial habitation, finds its expression in contemporary ceiling frescoes, in the modification of inherited tradition which they reveal. Within the High Baroque church, such frescoes executed above the nave had served as the culmination, both literally and figuratively, of the overwhelming yet ultimately uplifting

effect at which the planning of the interior had aimed. The calmer Renaissance faith in man's ability to ascend spiritually to the heavens had, like so much of Renaissance art (including such details as its classical columns and porticoes), been absorbed into the religious impulse of the baroque and in that process charged with a new dynamism. Gaulli's *Sanctification of the Holy Name* above the nave of Il Gesù and Andrea Pozzo's vision of the acceptance of Loyola's soul into heaven in the church of S. Ignazio (*fig. 29*) had, as we have seen, been designed to provide the worshipper with just such an ecstatic experience. Invited there to stand on the black marble circle set in the centre of the nave from which the *quadratura* illusion could be seen with maximum effect, he was, on gazing upwards, encouraged to experience himself a dizzying sense of spiritual elevation similar to that of the saint. The opaque roof physically blocking the spectator's view of the heavens seems there to disintegrate, the frescoes revealing through it, as it were, a view of the cosmos whose brilliance and infinitude emotionally sweep the viewer upwards into the dazzling light of eternity.

In the paintings of James Thornhill, who as the first native English painter to be knighted represents England's belated independence from subservience to continental art, the tradition of such ceiling frescoes continues, as it was to persist through much of the early eighteenth century; but two central elements have disappeared from the genre. The sense of cosmic magnitude is now severely reduced; and with that change, the attempt to carry the spectator emotionally aloft is discarded. Where Andrea Pozzo's fresco had evoked empathic experience by means of intermediary figures seeming to rise from within the nave in which the viewer himself stands, soaring past the cornice into the optically extended architecture above, and then beyond that into the bright heavens, imaginatively drawing the viewer with him, Thornhill's *Allegory of the Protestant Succession*, begun in 1708 (*fig. 30*), prefers to leave the spectator emotionally distanced, admiring the splendour of the vision from *terra firma* but in no way absorbed into it, as though the realm of the heavens were no longer available to mere mortals. The scene is consciously dissociated from the terrestrial by being isolated within a strongly defined oval frame, with now only the mildest spillover of figures, more as a gesture recalling the High Baroque tradition than to create any immediate sense of personal involvement.

The overall impression is thus of stasis rather than of dynamism. Where the depiction of Loyola's triumph had, through the disturbingly contrasting angles of ascending saint and floating cross, created a visual vortex, forcing the viewer mentally to shift his vantage point and thereby to be become part of that swirling up-

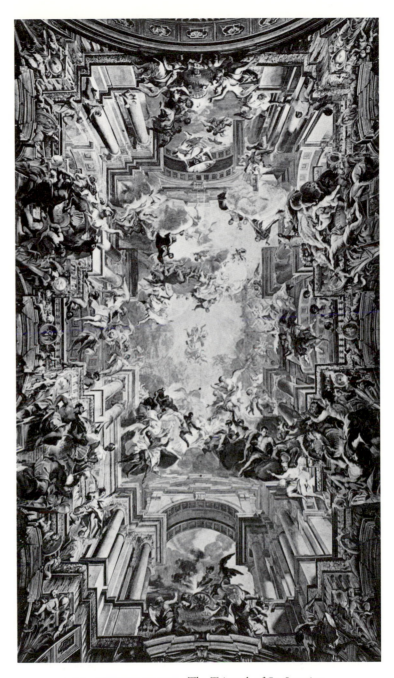

29. ANDREA POZZO, *The Triumph of St. Ignatius*

30. THORNHILL, *Allegory of the Protestant Succession*

ward movement, Thornhill's is markedly terrestrial in design, the central figures of the scene uniformly presented in a gravitationally oriented position. It permits intelligible viewing, therefore, only from one vantage point with the personages seen upright, so that the viewer's stability on earth is left secure. How far his painting is from the true baroque ceilings of the seventeenth century may be perceived by visualizing the main scene located upon a side wall. As a mural, the painting would lose little if any of its effectiveness—it in fact closely resembles Thornhill's murals in the same hall—since it relies to so limited a degree on the cosmic associations of its positioning above the viewer's head, a placing which had been so vividly exploited by the baroque. The limitless height suggested in the Pozzo fresco is again deliberately countered here by the insertion of a canopy over the main group of figures, cutting them off visually from the heavens beyond, the heavens themselves being presented in shallower perspective by means of hillocks of clouds suggesting the closeness of the scene to earth.[10] Pope's injunction, "presume not God to scan," finds its artistic expression in this lowering of implied height in such heavenly scenes as continued to be represented. And the Leibnizian compartmentalizing of creatures into their separate ranks is to be traced at the same time in the altered depiction of the traditional choric figures marvelling at the vision. No longer are they portrayed as rising upwards from within the nave or hall, obliterating the strict divisions between earthly and etherial, but (as was now to become the fashion for such paintings) they are presented here, as they are in Sebastiano Ricci's sketch of 1713 for the chapel at Bulstrode House (*fig. 31*), in more palpable form, seated or standing around the inner circle of the frame, themselves only spectators of the scene as though to emphasize their affinity to the world of the viewers below and their separation from the heavenly beings next in rank above them.[11]

In this painting by Thornhill, dating from the earliest years of the century, the elements of transition are still apparent; but a glance at Giovanni Battista Tiepolo's *Institution of the Rosary* from 1738 in the church of Gesùati in Venice (*fig. 32*) confirms the direction such ceiling paintings were to take throughout Europe. The cosmic element has been reduced to a few angels serving as background figures, while the main scene has now been brought close to earth. The monumental staircase leads us visually aloft, but only to a raised platform beyond which we are not encouraged imaginatively to ascend. And the downward gaze of the flying angels deflects attention from those heights to the events being enacted below them, within an essentially terrestrial setting.

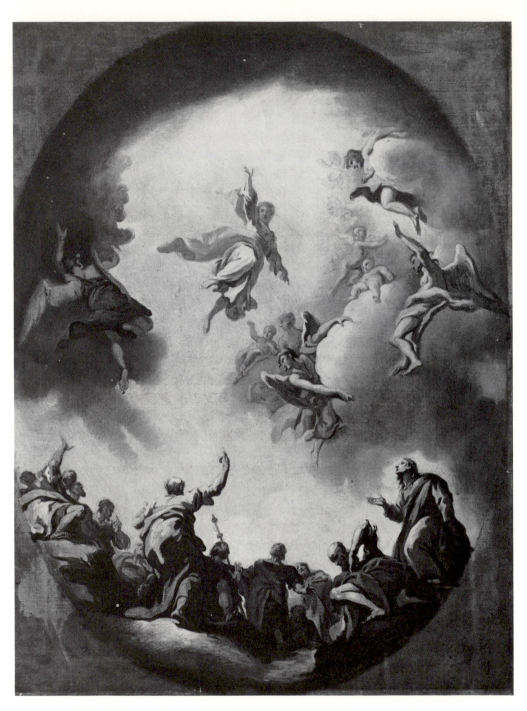

31. SEBASTIANO RICCI, oil sketch

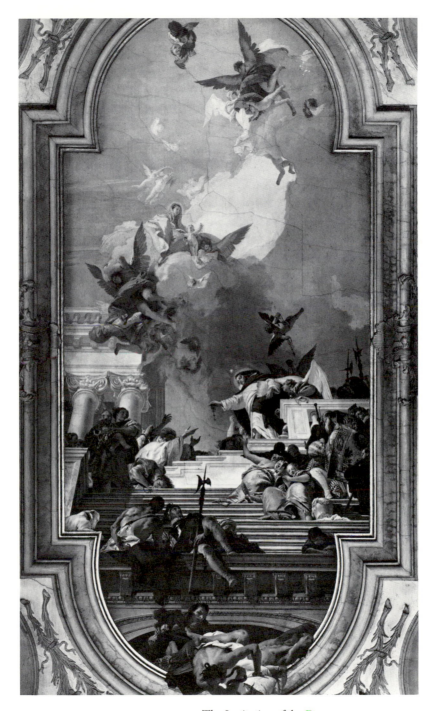

32. G. B. TIEPOLO, *The Institution of the Rosary*

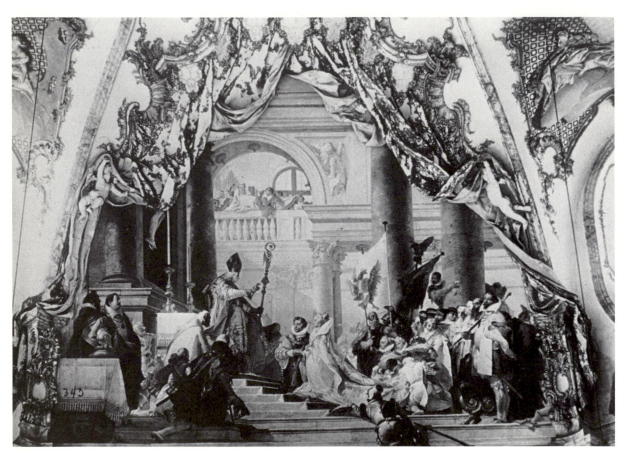

33. G. B. TIEPOLO, *The Marriage of Frederick Barbarossa*

That reversed direction of gaze, downward towards man rather than in ecstatic yearning aloft, suggests the change in focus of interest. It is confirmed in Tiepolo's *The Marriage of Frederick Barbarossa* (*fig. 33*), situated high above the cornice in the Residenz at Würzburg, which, while retaining the theatricality of that earlier mode with sumptuous draperies of gilded stucco opening like the curtains of a theatre onto a splendid scene, nevertheless alters the angle of perception. The event to be admired is not an apotheosis seen dizzyingly from below as in Rubens's baroque tribute to James I on the ceiling of the Banqueting Hall in Whitehall, but the royal wedding of two human beings upon earth. That altered direction of interest had been foreshadowed in Dryden's scene in the *Annus Mirabilis* where the heavenly host is no longer, as in such apotheoses, the audience of an awesome celestial event but instead looks down admiringly at the dramatic splendour of mortal affairs, the victory of the English fleet over the Dutch:

> To see this Fleet upon the Ocean move
> Angels drew wide the Curtains of the skies.[12]

With Deism having scaled down man's aspirations, contemporary taste began to disapprove even of the traditional desire of the epic poet to soar above, such claims for inspiration now being regarded as reprehensible, a foolish longing for "giddy heights."[13] The existence of the boundless cosmos continued, as it did for Thornhill and Tiepolo, to be fully acknowledged by Pope; but the terms in which the universe was to be verbally conceived or optically represented were henceforth to be those immediately comprehensible to man, drawn only from his earthly surroundings:

> Say first, of God above, or Man below,
> What can we reason, but from what we know? . . .
> Thro' worlds unnumber'd tho' the God be known,
> 'Tis ours to trace him only in our own.[14]

The shallower vertical perspective in ceiling frescoes and the thematic lowering of gaze in literature which were to express that change produced an accompanying aesthetic modification which was to prove of considerable significance in both art forms—a compensatory lengthening or emphasizing of horizontals. In architecture one of the most impressive structures to rise in England at the turn of the century was, of course, the Royal Hospital complex at Greenwich, for which Thornhill was soon to provide the interior decoration. Externally it adopted a technique basically

34. Royal Hospital, Greenwich

new on the English architectural scene (*fig. 34*). The massive domes which had formed the hallmark of the High Baroque and of which Wren had recently provided so splendid an example in St. Paul's Cathedral, have here been diminished in size, lowered in height, and, by means of their duality, made to function as contributory elements in an overall design rather than as the dominant, centralizing factor familiar from the previous style. More important was the decision reached early in the planning, in 1694, not to enlarge the block built there by John Webb for Charles II but to erect instead a counterpart to it, using Inigo Jones's earlier Queen's House as a distant visual pivot and modifying Webb's block to accord with the new. By designing the hospital itself in two separate units, mirroring each other in form as buildings stretching away on either side in reversed order, Wren and his associates produced a facade with the significantly innovative effect of what may be called "horizontal equipoise," a term which perhaps requires elaboration.

Symmetry as such was not, of course, new on the architectural scene. The careful preservation of proportion in buildings, including a repetition of design on either side of a central vertical, had been widely adopted into European architecture at the time of the High Renaissance in accordance with Alberti's advocacy of overall harmony as a prerequisite for every artistic work. In England, Longleat and Hatfield House, as well as the Palladian style introduced by Inigo Jones in such buildings as the Banqueting House at Whitehall, had adopted that norm of a basically symmetrical design. But the symmetry entering architecture during this latter period is fundamentally different. It is intended to suggest not a static relationship of formalized ratios as at Longleat (*fig. 35*), with its orderly rows of windows varied by the slight projection of four bays, but instead a dramatic split between two free-standing,

35. Longleat House, Wiltshire

equiponderant units which reflect and counterpoint each other. The use of the latter term recalls how, with the fugues of Bach, the nature of musical counterpoint at this time underwent a similar transformation, from its polyphonic structure in the Renaissance producing harmonic accord between upper and lower registers, to its new application as the inversion, echoing, or reciprocation of a main theme by a secondary—a change which has long been described by musicologists as the transition from a "vertical" form of counterpoint to a "horizontal."[15] How central such design was to the cultural proclivities of the age may be evidenced from the contemporary work of Carlo Rainaldi in Rome who, in the same years as Greenwich Hospital was being built, constructed as the dominant architectural element of the Piazza del Popolo twin churches spaced slightly apart, identical in appearance (*fig. 36*) but reversed in design, to create that same effect of reduplication and counterbalance.

The study of iconology, as Erwin Panofsky has shown, demands an examination not only of representational images but also of the "forms" or spatial structures in which they reside, an insight which has sensitized subsequent historians to the significance of the geometrical configurations dominant in each period. In an earlier work he had himself provided an illustration of such configuration by pointing to the complex articulation, the series of subdivisions underlying the structure both of the medieval cathedral and such contemporary compendia of knowledge as the works of Aquinas. There was the perfect sphere favoured by Neoplatonism, or, as W.J.T. Mitchell has noted, the vortex which fascinated both Shelley and Turner.[16] Within the eighteenth century, the prevailing geometrical symbol representing the intellectual shift away from Renaissance norms is to be found, I would suggest, in

36. RAINALDI (and Bernini), Piazza del Popolo, Rome

37. Wall panel, Hôtel de Rohan, Paris

this modification of traditional symmetry—a desertion of the generalized harmonizing of parts as at Longleat in favour of an equipoise between two distinct, often independent units. It constituted the perfect conceptual pattern for a rationalist age by representing in visual form the objective weighing of alternatives, the ideal achieved when, as Pope expressed it, "Reason's *comparing balance* rules the whole."[17]

Nor was the adoption of a new ideogrammic pattern of horizontality in music and the arts a merely aesthetic preference. In the social sphere, the "horizontal" reading was eventually to produce far-reaching results as Locke deserted the traditional application of vertical hierarchy to the social scene (where in earlier generations only Death was the leveller and equalizer), to maintain instead the democratic view that Natural Law "teaches all mankind, who will but consult it, that being all equal and independent, no one ought to harm another in his life, health, liberty, or possessions."[18]

Inside the Rococo salons of France, the reciprocation discernible at Greenwich or in the Piazza del Popolo was to become a dominant principle of its decorative motifs. The grotesques by Raphael in the Vatican Loggia in the form of vertical panels with vegetal shapes sprouting out of central stems had been widely imitated in the intervening period; but in the Rococo they lose their slim verticality, opening out into more complex arabesques whose irregularity is controlled by a delicate equilibrium, as in a wall panel in the Hôtel de Rohan (*fig. 37*). Elegantly varied to avoid mere repetition, bird figures appear contrapuntally on either side of a wreath-like arabesque design, the latter serving as both divider and unifier of the two sections.

Recurring throughout the *Essay on Criticism* as a quality requisite for both the true critic and the true poet is *judgment*, the ability to discriminate and assess. Locke had identified as one of the primary distinctions between man and beast the human ability to compare, such judgment consisting "in separating carefully, one from another, ideas wherein can be found the least difference, thereby to avoid being misled by similitude, and by affinity to take one thing for another," and it is that discriminatory faculty which Pope adopted as his controlling notion. With the task of the eighteenth-century critic not, as today, to explicate or interpret texts but rather to evaluate them, the poet, who must serve as the judge or critic of his own writings as well as that of others, is required to exercise that same talent of sober arbitration, of adjudicating in accordance with the most reliable standards available to him.[19]

As an indication of this new sensitivity to judgmental equipoise, one may note the frequency with which the word "symmetry" is introduced in this period as a replacement or at the very least as a qualification for the more generalized Renaissance terms "proportion" and "harmony" in discourses on art, on nature, or on the Great Chain of Being itself. Newton had drawn attention to the symmetry evident in the bodies of animals, seeing in it proof of a rational Creator; Alexander Malcolm, in *A Treatise of Musick, Speculative, Practical, and Historical*, writes in 1721 of the Creation as, like music, expressing "archetypal Ideas of Order and Symmetry, according to which God formed all things"; Batty Langley maintained in 1736 that the beauty and pleasure afforded by ancient architecture were "only the Effects of a *well-chosen Symmetry* connected together according to the *harmonick Laws of Proportion*"; and Edward Manwaring's *Stichology* of 1737 similarly declared that "Harmony is a Species of the Cause, which produces Symmetry."[20] Yet because it constituted no clear break from earlier modes, no marked rebellion against previous traditions, this essentially new concern with pivotal balance, with contrapuntal regularity rather than overall proportion, has, like the Great Chain itself, been regarded as merely a continuation of Albertian principles rather than as exemplifying an essentially different set of aesthetic and philosophical assumptions.

The reduced proportions implicit in this horizontal, terrestrial perspective may serve as a useful point at which to dissociate myself from the attitude of condescension towards both Pope and Rococo art which has so often marred attempts to interrelate them. Wylie Sypher's widely read study, for example, which makes

many pertinent, often penetrating observations on the art forms, is openly patronizing in approach, regarding both the poetry and the plastic art of the period as essentially trivial. "Admittedly, he did not have a first-class mind," he remarks of Pope, assuring his readers that neither he nor they need like the verse in order to understand its aims.[21] These comments, published in 1960, display a surprising imperviousness to the growing critical esteem in which Pope had been held since Maynard Mack began the task of revalidation in the late 1940s, revealing the artistic complexity and allusive brilliance of his poetry.[22] And no art historian requires evidence of the way in which the art of Rococo has suffered from similar condescension as being merely a minor style, fragile, playful, but ultimately trifling in importance.[23]

It is scarcely surprising, as Fiske Kimball has rightly noted, that the earlier twentieth century, with its dedication to austere functionalism in architecture and interior design, should have experienced little sympathy for an art form delighting in surface ornamentation, in the floral patterning, gilt, and ormolus of the eighteenth-century salon.[24] Nor, we may add, was its conception of verse as an elegant social activity likely to endear that age to a later generation identifying poetry with the innovative challenging of convention both in technique and content. In this specific instance, however, the disparaging tone entering criticism was augmented by a linguistic factor, difficult to resist and conducive to such deprecation.

Historians proceeding chronologically from an account of the baroque to an examination of the Rococo, whether in art or in literature, necessarily (and justifiably) point to the "reduction" in size of canvas or the "narrowing" in thematic scope as they move from the grandeur of Rubens to the delicacy of Watteau, from the epic range of Milton to the reasoned, the tasteful, and the socially oriented themes of Pope's verse. Yet such terms of diminution, however valid in themselves, are liable to carry with them qualitative connotations pejorative in import, implying a diminution in aesthetic achievement too, as if a sonnet were automatically inferior to an epic, a miniature artistically subordinate to a mural. Pope was fully conscious of the associative danger, remarking of his *Dunciad* that "a poem on a slight subject requires the greatest care to make it considerable enough to be read."[25] The emergent poem, we may note, despite its apparent ephemerality as part of a local literary feud, did achieve lasting acclaim, acknowledged today as nugatory neither in its poetic power nor in its mordant attack upon a contemporary decline in civilized standards. The narrowing of focus was, as in all compelling art, an assertive gesture affirming the contemporary creed, a deliberate act of policy which, however it may appear to later generations, was hailed by Pope's contemporaries with deep satisfaction as marking a gratifying and long-awaited stride forward in human progress.

The desertion of divine, cosmic themes of grandeur in favour of a reasoned concern with the tangible and social formed part of what Thomas Sprat, the secretary of the Royal Society, had acclaimed as the relinquishing of the blindness of former ages, of the religious ecstasies and messianic superstitions which had torn England apart, in favour of a sober, empirically oriented pursuit of knowledge:

> But now since the *Kings* return, the blindness of the former *Ages*, and the miseries of this last are vanish'd away: now men are generally weary of the *Relicks* of *Antiquity*, and satiated with *Religious Disputes*: now not only the *eyes* of men, but their *hands* are open, and prepar'd to *labour*: Now there is a universal *desire*, and *appetite* after *Knowledge*; and not after that of ancient Sects, which only yielded hard indigestible *arguments* or sharp *contentions* . . .[26]

The deflecting of man's attention from the cosmic to the terrestrial, from the infinite to the human, was (no less than Rubens's reverse process had been for the baroque) an authentic artistic expression of the new standards cherished by the age, the conviction that divine inspiration was an unreliable path to humanly valid truths. As Peter Browne claimed in his *Procedure, Extent, and Limits of Human Understanding* of 1728, speculation about the divine, while it may be necessary for determining matters of theological doctrine, provides no real extension of human knowledge; it "gives us no *New* Faculties of Perception, but is adapted to those we *Already have*; . . . it is altogether performed by the *Intervention* and Use of those Ideas which are *Already* in the Mind; first conveyed to the Imagination from the Impression of external Objects upon the Organs of *Sensation*."[27] And yet the overt claim to lucidity of exposition and the pursuit of universally held truths comprehensible to all men did not result in the simple clarities which might have been expected and which Sypher and others saw as characterizing its art and literature. The products of that age possess instead, beneath their surface serenity, the tensions, the complexities, and the intricacies that we associate with all great art, ambiguities which post-structural critical theory may prove particularly helpful in revealing. It is upon that aspect that I should like to concentrate.

Watteau's *Embarkation for Cythera*, as it has come to be known, exists in three versions, all executed between 1710 and 1717. The finest of them, now in Berlin (*fig. 38*), has long been regarded as his masterpiece in more than the literal sense that it gained him formal acceptance into the Académie. This painting, for which the term *fêtes galantes* was coined, depicts, like so many of his vignettes, the

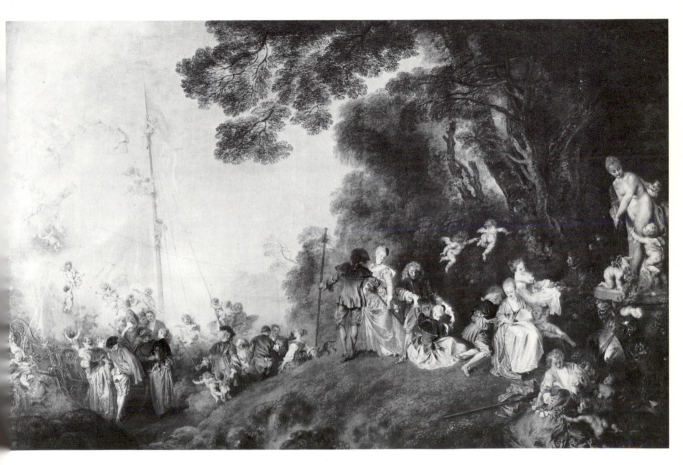

38. WATTEAU, *The Embarkation for Cythera*

graceful love-play of a refined age. The participants, decorously clothed in the elaborate silks fashionable at the time, but presided over by the statue of a naked Venus (hinting at the end-purpose of such courteous rites of love), lean forward to whisper or to catch words of endearment, gather flowers, offer guiding hands, or stroll amicably together. The structural symmetry of the canvas, with the figure holding a staff serving as the axis, might not in itself be remarkable. Since the Renaissance, such careful deployment of figures to create a sense of visual parity and hence of harmonious tranquillity, had become the norm. But what distinguishes this painting is the remarkable effect it produces of countermanded movement, the directional diffusion of a pilgrimage which is going nowhere. The young man at the centre, his arm loosely about the waist of his companion, appears to be guiding her forward; but that hint of purposeful motion at the focal point of the canvas is offset by the backward turn of her head to gaze at the couples still behind her, who display so little disposition to depart. The pair closest to her is indeed in the process of rising, but three other couples, still facing away towards the dark wood, remain too engrossed in each other to have noticed the embarkation slowly proceeding on the further side. Even those at the head of the procession, gathering beside the ship, seem hesitant to climb aboard, continuing to enjoy each other's company.

The reciprocal counterbalance in this painting, resulting in the sense it conveys of arrested movement, is intimately connected with the controversy that has arisen concerning its theme. The titles accorded to the various versions of this painting all indicate that they portray in some way a pilgrimage to Cythera, the island birthplace of Venus; but so ambivalent is the treatment of that scene, so balanced in its emotional and visual equipoise, that it has been impossible to establish whether it represents a bemused setting out to the island of Love or, as Michael Levey has argued, a reluctant return in sweet sadness from such a pilgrimage. A contemporary engraving by Desplace of a Watteau figure which closely resembles the young man holding the staff here was captioned in that version as a pilgrim returning *from* Cythera, evidencing that the duality of the reading is no modern invention.[28]

For all its apparent simplicity of design, it should be read as offering the viewer what deconstructionists have encouraged us to discern in recent years as the unresolvable tension between indeterminate opposites. Derrida's extension of Saussure's *langue-parole* distinction into what he terms *différance* (as opposed to *différence*), the perception of a non-synthetic contradiction between the perspective of the event and of the structure, has frequently been interpreted, as the name adopted by the critical movement suggests, as destroying the unified meaning of a work. But there

is also the possibility, emanating from that distinction, of acknowledging as intrinsic to an artistic work the existence of an unreconciled and perhaps irreconcilable bifurcation into two meanings, which the reader or viewer, endowed with the responsibility of choice, must resolve either by arbitrarily selecting one of the alternatives or by acknowledging the ambiguity as itself constituting the message.

Bakhtin's stimulating suggestion of a dialogic quality in literature, an authorial duality allowing for the merger of ambivalent views, is particularly relevant here in its transference to the visual forms of art.[29] In this painting, such signifiers as the title or the central male figure's gesture towards the boat, neutralized by the irresolution of the other participants, creates an indeterminate movement, leaving unspecified, open for each viewer's interpretation, whether the scene being witnessed represents the island itself and therefore the experience of ideal love from which they are about to be removed, or alternatively the less satisfying everyday world of amorous etiquette and ritual which they are about to leave for an experience of a nobler form, beyond the scope of the canvas and left to our imagination. The very irresolution, the semiotics of a scene offering the viewer contradictory readings, would thus betray the artist's own discontent, perhaps explaining the sense of melancholy so characteristic of his works. Such ambiguity of response has implications for the forms dominating contemporary poetry too, an aspect to which we shall soon return.

The scene, in conformity with the new directional tendencies, abandons the vertical focus, the upward view traditional to the baroque, suggesting no vision of the heavens, even though the mythological associations of its theme would in other eras have prompted some hint of a celestial dimension. Instead, trees overhang the lovers' leisurely stroll, framing it to confine attention to the social world below. Venus appears here only as a statue, the memory of a classical past lending dignity to the present but no longer, as in the Renaissance or baroque, representing allegorically the dynamics of human relationships with the divine. With the mystery of such heavenly myths discarded, the introduction of Cupid-like *putti* to the human sphere is now acknowledgedly a game. They have ceased to serve, in the way they had in seventeenth-century apotheoses, as angelic intimations of spiritual immortality, admiringly escorting the saint aloft. Instead, they have become a pleasantry of art, like the sylphs that Pope added as an afterthought to his *Rape of the Lock*. The game element in both painting and poem resides partly in the supposed unawareness on the part of the human participants that such airy sylphs exist among them, a whimsical suggestion of the myopic limitations of grosser man unable to perceive

the finer and subtler elements of his condition. By means of this shared response, Pope's description of Belinda's airy escorts parallels the gossamer-like *putti* flitting about the sails to the left of this painting, unseen by the lovers:

> The lucid Squadrons round the Sails repair:
> Soft o'er the Shrouds Aerial Whispers breathe,
> That seem'd but *Zephyrs* to the Train beneath.
> Some to the Sun their Insect-Wings unfold,
> Waft on the Breeze, or sink in Clouds of Gold.
> Transparent forms, too fine for Mortal sight,
> Their fluid Bodies half dissolv'd in Light.

The *putti* on the right of the painting, however, are given a more specific role, now representing not angelic ministration but extrapolations of human desire. As impishly indulgent concomitants of amorousness on earth, reflecting in their breezy flight the exaltation of spirit produced by love, they also serve at times as visible manifestations of suppressed human longing. One of them to the right, lying nakedly beside a lady decorously holding a fan in her lap who is responding with modest hesitation to her admirer's advances, pushes her towards him, thereby embodying (as we may assume by her very participation in the pilgrimage to Cythera) her deeper impulse for love. Like Belinda's guardian-sylph, this Cupid, too, has disclosed "in spite of all her Art, / An Earthly Lover lurking at her Heart."

Myth is no longer the larger Platonic ideal personified in classical allegory, a heavenly "type" of which the individual offers shadowy instances upon earth, but has become instead a light-hearted visualization of human response, an artistic device engrafted onto the social scene, to be treated as such by reader or spectator. In open acknowledgment of the new function of myth in a rationalist age, its employment as an invoked artifice free from divine associations, Watteau playfully mists over, here as elsewhere, the distinction between mythic archetype and localized event, as two out of the three *putti* clambering over the statue of Venus are discovered on closer inspection to be not of stone but flesh.[30]

The device of projecting into statuary suppressed human desires, rather than the abstract allegorical significances familiar from earlier periods, is introduced into a number of his paintings, where, as in his *Les Fêtes vénitiennes* (*fig. 39*), the languorous statue is more sexually provocative both in pose and in the sensuous texturing of her body than the clothed women present in the scene. Kenneth Clark has tentatively suggested that these "unfrigid" statues may reveal a too tremulous desire in

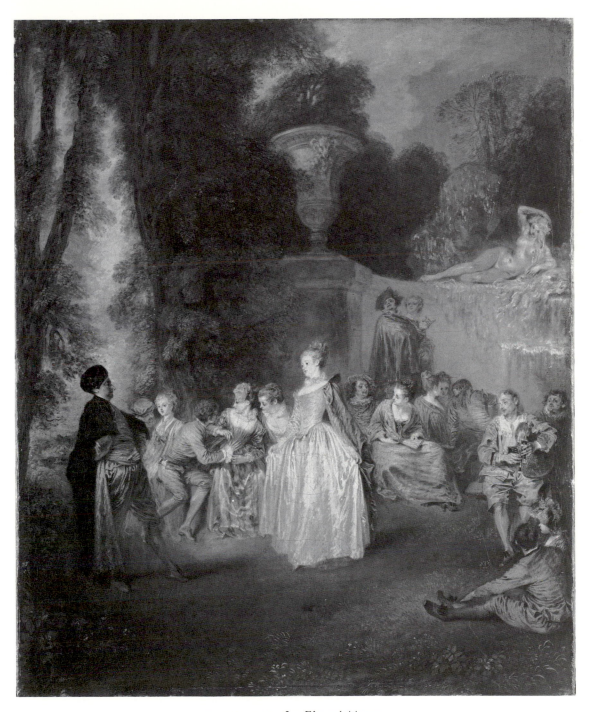

39. WATTEAU, *Les Fêtes vénitiennes*

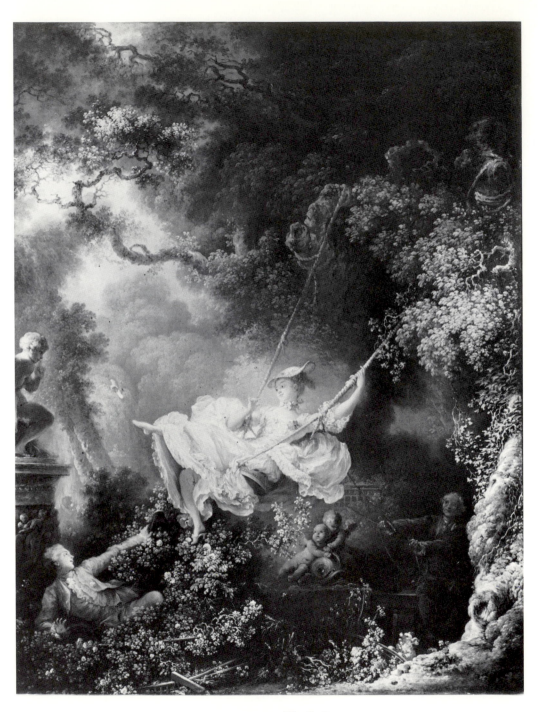

40. FRAGONARD, *The Swing*

Watteau, an ability only to contain his excitement when the nude body was supposedly of stone;[31] but apart from the oddity of such a theory, the mingling of real and marble Cupids on the Venus statue would seem to confirm that there is in Watteau's works a deliberate blurring of the line between reality and the imagination, partly to add sexual piquancy to the gentility of the scene, a glimpse, as in Pope's poem, of the emotions concealed beneath the ritualized social graces (compare the erotic *double entendre* in Belinda's cry of protest) and partly also to suggest, with a touch of sad whimsicality, the ephemeral quality of such love, whose passions cannot be preserved in the durability of stone. In a letter Pope wrote to his friend Cromwell in 1711, he bemoaned this very element of impermanence in the artistic imagination:

> The gay Colouring which Fancy gave to our Design at the first transient glance we had of it, goes off in the Execution; like those various Figures in the gilded Clouds, which while we gaze long upon, to separate the Parts of each imaginary Image, the whole faints before the Eye & decays into Confusion.[32]

It is a sentiment echoing the pervasive melancholy of Watteau's own paintings.

The indeterminate symmetry of this painting reflects what was now becoming fashionable as the primary decorative motif in the Rococo salon, the arabesques (cf. *fig. 37*) in which, as one historian has put it, "two curves of contrary direction are brought into contact, with the result that the motion of the eye is arrested and gently reversed."[33] It is not, however, only the motion of the eye which is arrested in such art forms. Emotion, too, is restrained and controlled by the implied reversion of direction, preserving even in potentially erotic scenes a cooler detachment on the part of the viewer. Fragonard's *The Swing (fig. 40)*, whose full title, *Les Hasards heureux de l'Escarpolette*, was more indicative of its content, won wide regard for the roguish impertinence of its theme. It had, in fact, been specifically ordered by a *bon-vivant* financier of the day and became immediately popular for its risqué quality when its engraving by Nicolas Delaunay made it available to the public. A bishop to the right innocently pulls on the swing's ropes to assist the fair lady by whom he has been conscripted for the task, while, unknown to him, her lover lies strategically concealed in the bushes beyond, a position designed for him to catch forbidden glimpses as she sails aloft. Her collusion is indicated both by the slipper she has enticingly kicked off in his direction and by the statue of Discretion to the left, a finger held warningly to the lip. But the very choice of a swing here, about to begin

its reciprocal journey away from the voyeur as well as from the viewer of the painting, provides the emotional constraint cultivated in the arts of that time, making the scene, in fact, an entertaining comment on social norms rather than a personally titillating experience. Throughout European painting, apart from occasional scenes of children at play, the swing, it has been noted, had never appeared as a significant theme for art until Watteau's charming arabesque, *L'Escarpolette*, of 1709, introduced it as a favoured topic for *fêtes galantes*. It simulated so perfectly the coquettishness implicit in the contemporary love-game, a teasing oscillation of response and withdrawal, of arousal and restraint, in a period preferring balanced alternation to passionate commitment even in the sphere of love. And, as the Cythera canvas demonstrated, it symbolized, too, a poignant irresolution in man's reading of his own situation upon earth.[34]

The relation of this symmetrical or oscillatory indeterminacy to the poetry of the time involves both thematic and prosodic elements. Thematically, critical evaluations of Pope's verse have in recent years, even prior to the advent of deconstructionism, distinguished a certain tension in his view of the universe, the ordered cosmos constituting for him both a pattern and a puzzle. The very aura of authority with which he speaks in the *Essay on Man* is, as Dustin Griffin has reminded us, in itself a tacit contradicting of his main message, his ridiculing of man's intellectual pretentiousness in claiming to understand the cosmic frame on the basis of a limited knowledge of this earth.[35] That assertion is countered throughout the verse-essay by the implication that the poet himself has nonetheless succeeded somehow in looking through the cosmic gradations, has perceived the order beyond, and may therefore serve, despite that general prohibition for mankind, as a trustworthy mentor for the reader. Yet the assumption of privilege is never conveyed, even indirectly, as resulting from a Miltonic ascent on the part of the poet, an inspired vision of the heavens; only as the outcome of rational assessment and discrimination.

In connection with that anomaly, Thomas Edwards aptly comments that the learned notes to the Twickenham edition analyzing the poem's structural design lend a coherence to the text which a reading of the original fails to confirm, since the argument itself is composed of repeated false starts, changes of direction, and shifts of emphasis revealing, behind his apparent confidence, Pope's recognition of the uncertain, provisional nature of his views. What creates the magisterial tone is the stylistic presentation, the sense it evokes of judicial objectivity.[36] Douglas White has similarly noted, in line with an earlier comment by Reuben Brower, how it is not the philosophy itself that justifies the poem but its literary form, the attempt to

grapple with the problems poetically, the energy and control whereby Pope manipulates and modulates those ideas to present them with an effect of originality and verve. And more recently, Leopold Damrosch has revealed how more generally in his verse Pope was engaged in a constant struggle to speak *for* a culture from which he felt nevertheless personally alienated.[37]

The stylistic form Pope selected as the primary vehicle for his verse, that specific version of the heroic couplet which he moulded to suit his poetic needs, merits close examination in this regard. In one of the most influential essays on Pope to have appeared during this century, Earl Wasserman offered an illuminating comment on the nature of the heroic couplet as it was employed in the seventeenth century (that is, in the form Pope had inherited it) and then applied his insight to Pope's usage too, assuming, as so often for this period, that no noteworthy change occurred in the course of its adoption. Central to his discussion is the theory that both in Denham's *Cooper's Hill* and in Pope's *Windsor Forest* (which he sees as modelled upon it), the topographical setting symbolized the poet's advocacy of *concordia discors* as a universal governing principle. For Denham, the ideal political system was the harmony arising from the contrary pressures of king and parliament. As a paradigm of that ideal he looked to Nature's own blending of contraries, here represented by the river Thames, whose unified temper he longs to imitate as poet too:

> O could I flow like thee, and make thy stream
> My great example, as it is my theme!
> Though deep, yet clear, though gentle, yet not dull,
> Strong without rage, without o'er-flowing full.[38]

The heroic couplet, Wasserman here adds, was designed to reflect in its parallels the harmonious oppositions that Denham was espousing, the hemistiches neatly containing within them the contrasts of "deep/yet clear," "gentle/not dull," "strong/ without rage." The same, he maintained, held true for *Windsor Forest* and hence for the antithetical rhythm of the lines which Pope employed.

I would like to propose, however, that in the period between Denham's day and Pope's, the nature of the heroic couplet had, as a natural outcome of the philosophical developments discussed earlier in this chapter, itself undergone a notable change. For Denham, the Renaissance view of the *concordia discors* prevailed. His purpose, as he confirmed in these very lines, was to recapture within his verse the harmony that Nature's complex order exemplifies. In that regard, he shared with such contemporaries as George Herbert the mid-seventeenth-century conception of the natural

world as a book to be read, as an unfailing source of anagrammatic paradigms to be deciphered for the truths they contain.[39] The function of the poet is thus dual, not only to act as a decoder of those truths—in Denham's lines, perceiving the message silently conveyed by the Thames—but also to exemplify within his verse the order he discerns within Nature, thereby participating as a creative artist in that same process of harmonizing antitheses.

In Pope's verse, the source of the desired order has been displaced. Whatever lip service may still be paid to the hierarchical Chain of Being and the system of reconciled opposites within it, that heavenly vision has in effect been removed beyond the human sphere of concern as an essentially unknowable entity. Man must fall back upon his own resources. It is not the cosmos, therefore, but the poet who must impose upon his potentially chaotic material the same control as he must rationally impose upon life. When Pope does endorse the doctrine of harmonious contrarieties, it is significant that he sees it not, as had the Renaissance, in terms of a celestial concord, nor in terms of two cosmic forces whose conflict creates divine *stasis*, but instead in entirely human terms, as an equipoise to be achieved by *man's* efforts, by human prudence in social and ethical conduct upon earth. Virtue, he maintained, is not the opposite of vice; it is a median attained when two extremes of vice, such as avarice and prodigality, "serve like two opposite biasses to keep up the Ballance of things."[40]

In *Windsor Forest*, the widely quoted passage in which he does appear to perceive a cosmic *concordia discors* in the nature around him emerges on closer inspection as a token gesture rather than a firmly held belief, at once undercut by the image supposedly authenticating it:

> as the World, harmoniously confus'd:
> Where Order in Variety we see,
> And where, tho' all things differ, all agree.
> Here waving Groves a checquer'd Scene display,
> And part admit and part exclude the Day;
> As some coy Nymph her Lover's warm Address
> Nor quite indulges, nor can quite repress.
> (12–20)

The concluding simile, as any alert reader must sense, is far from being an illustrative or confirmatory image. It is itself the witty and paradoxical climax towards which the earlier lines have been leading. Nor do its delicate antitheses, even though

they are embedded in a passage dealing with the harmonious varieties of the natural world, in any real sense derive from that cosmic pattern. On the contrary, they constitute an implied parody of it, the humour arising from the contrast suggested between the supposed concord of the natural world and the exasperating perversities of human conduct. The problematic hesitations of a "nymph," how far to permit her swain's advances without compromising her honour, or, if we respond to the more cynical untertow, her calculations how to fan his ardour by temporarily frustrating it, have little to do with trees waving back and forth in a breeze. And that hiatus in logical progression points to an aspect of Pope's verse which intensifies the larger ambiguity in his conception of the universe. For the order which the reader is led to admire here, as elsewhere in his writings, is not some universally ordained system discernible within the scene invoked, but rather the poetic or verbal order *into* which the human author has inventively translated it. As in the ornamenting of a Rococo salon, true wit works its filagree effects upon the surface without re-moulding the basic geometric forms, the rectilinear panels on which the arabesques are located; it "gilds all objects but it alters none." The heroic couplet thus no longer reflects in its antithetical unity, as it had for Denham, a cosmic pattern, but has been transformed into an instrument for artificially imprinting upon the natural and the social worlds contrasts of the poet's own making, or, through their verbal presentation, highlighting for the delectation of the reader polarities not previously perceived—as in the coquette's alternating indulgence and repression of her lover's ardour, prosodically suggested here by the sly, oscillatory echoing of "nor quite" in the parallel hemistiches.

One antithesis which has been recognized as central to Pope's thought, particularly in these earlier poems, is the contrast between the ephemerality of earthly existence and the eternity of art. In first alerting readers to this dichotomy some years ago, Thomas Edwards remarked how those two realms are not presented in conflict in his verse but are by the discipline of his authorial voice held in serene parallel. Eden perishes, but its memory lingers on in the imagination; Belinda's tresses will one day be laid in dust, but the lock which the Muse has consecrated will, through that poetic apotheosis, survive amidst the stars.[41] But again what has been left for the reader to perceive is less a firm directive than, as in the Watteau canvas, the existence of an unresolved tension between the claim and the reality. In the passage from *Windsor Forest* which Edwards quotes, there is no authorial assertion to convey, as in Shakespeare, the throb of genuine belief, the faith that art will impart eternity to the temporal—"So long lives this, and this gives life to thee"—

but a surface wit which may temporarily distract from the melancholy transience of life but cannot in any lasting sense console. And it is primarily through the structural form that he creates that ambiguous effect:

> The Groves of *Eden*, vanish'd now so long,
> Live in Description, and look green in Song:
> *These*, were my Breast inspir'd with equal Flame,
> Like them in Beauty, should be like in Fame.
>
> (7–10)

The durability of poetry over the passing vegetative world is conveyed as a verbal construct, not as a vibrant truth or conviction. It functions as a chiastic design, with the outer echoing of *Groves* in *green* neatly paralleled by the inner contrast of *vanish'd . . . Live*. And the climax, too, is a strictly literary triumph, as the modest disclaimer of comparable inspiration conveyed in the word *equal* opens out into the elegantly poised hemistiches of *Like . . . like*—a demonstration of his own poetic charm which wittily contradicts the humble denial.

In general, Dryden's rhymed couplets had been more relaxed in form, relying less upon tightness of poetic structure and flowing more freely from line to line:

> In pious Times, e'r Priest-Craft did begin,
> Before *Polygamy* was made a Sin;
> When man, on many, multiply'd his kind,
> E'r one to one was, cursedly, confin'd . . .[42]

Despite the pauses at each line ending and the regularity which the echoing rhyme creates, the sentence proceeds smoothly, and the wit, diffused throughout the passage, achieves its impact cumulatively rather than through a series of compressed or self-contained units. After the satirical antithesis of *pious* and *Priest* in the opening line, there is no further barb until the word *cursedly* some three lines on. Symptomatic of that looser structure is his frequent introduction of a triple rhyme to avoid monotony (with a printed marginal bracket drawing the reader's attention to the variation), the deviation from regularity having no relation to the subject matter of those combined lines.

Pope recognized that there was room for improvement in that verse structure, noting generously that Dryden would probably "have brought it to its perfection, had not he been unhappily obliged to write so often in haste."[43] His own prosodic innovation, in addition to discarding such triplet irregularity, was to change the

very pattern of the verse, intensifying the rhythmic pulse by duplicating it. Creating a balance within the individual line, he produced thereby an echo of the equipoise achieved by the outer rhymed couplet, ensuring a more complex series of internal and external juxtapositions which, by their very intricacy, demanded from the reader the constant exercising of his discriminatory faculties. The oscillatory rhythmic form is employed to enforce similarities and contrasts and to invite thereby the reader's judicious perception of subtler distinctions. Keats's unkind cut that eighteenth-century poets "sway'd about upon a rocking horse / And thought it Pegasus,"[44] had this reduplicated, pivotal verse form in mind—although as every admirer of Pope recognizes and he himself testified, he took infinite care to achieve variety in the placing of his caesuras in order to avoid the monotonous *clik-clak* effect which imitative poetasters too often produced. As in the cultivation of fashionable gardens, he recognized that grove must not simply nod at grove, nor each alley have a brother.

In his own art, the more compact couplet offered an opportunity for zeugmatic and chiasmatic interrelationships which the previous form had not supplied. If the purpose of art is in general to conceal art, in this instance the reverse was true, at least with regard to the poetic pattern; for the Popean version of the heroic couplet was calculated at all times to draw attention to the conscious artistry of the verse presentation, to win applause for the verbal effects achieved. The description of Belinda as she issues forth on the bosom of the Thames relies for its wit overtly upon that chiastic exploitation of the verse form:

On her white Breast a sparkling *Cross* she wore,
Which *Jews* might kiss, and Infidels adore.[45]

The two lines are broken up into respective halves, apparently independent units merely joined by a relative pronoun, with the reversal of verb and object in the first line creating a slight variation to avoid the excessive regularity which Keats was later to deplore. But the effect depends not simply upon a parallel between the balanced halves but, more humorously, upon a subdued cross-reference or internal interaction between the four units of which the couplet is composed. If ostensibly the passage states that her cross sparkled so beautifully that even Jews and infidels would wish to kiss it, the echoing stress on "Breast" and "Cross" in the first line intimates, of course, that the true attraction of the cross is its location rather than its beauty, with the pun in "adore" highlighting the erotic implications of the line.

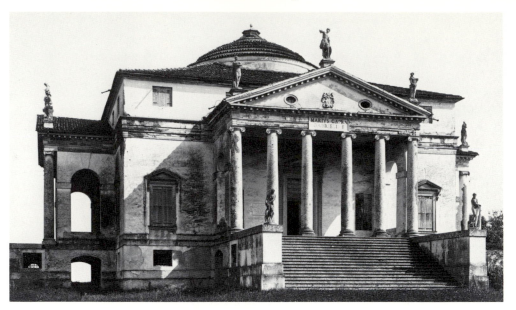

41. PALLADIO, Villa Rotunda, Vicenza

The centrality of this symmetrical subdivision in expressing the cultural patterns of contemporary thought may be suggested by an architectural innovation in the country house built by Pope's friend and patron, Lord Burlington. As the re-introducer of Palladianism into England after a lapse of interest during the later seventeenth century (Burlington was responsible for inviting Giacomo Leoni across to England to supervise the translation of Palladio's treatise on architecture, which appeared under the nobleman's patronage in 1715), it was natural that in planning his Chiswick House he should take as his model the Italian architect's most famous country house, the Villa Rotunda near Vicenza (*fig. 41*).

The new building, completed in 1725, was designed, like the original, for the entertainment of day visitors rather than as a home, thus permitting an indulgence of aesthetic sensibility, if necessary at the expense of domestic need. It adopted, again like Palladio's, the design of a central dome placed over a square building; but there were two basic differences. The first was a desertion of the Renaissance harmony in the round which had guided Palladio, the Neoplatonic belief that the unchanging perfection of the sphere and circle should serve as the ideal for art. Where the earlier building had been recognized in its day as a virtual paradigm of circular

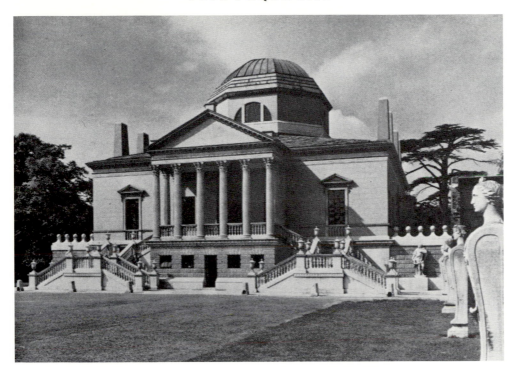

42. BURLINGTON and KENT, Chiswick House, Middlesex

Renaissance proportion, that is, with four identical porticoes projecting from each side of the square building, Burlington moved in the direction of a linear or horizontal symmetry, with porticoes only at the front and rear facades. Secondly, and perhaps more importantly, where the porticoes of the Villa Rotunda had each been approached by a single majestic stairway, the stairs at Chiswick House (*fig. 42*), breaking away from previous tradition, provide what may be seen as a remarkable architectural counterpart to Pope's version of the heroic couplet. The stairways, emerging in parallel like the two rhymed lines of the couplet, split internally into contrapuntal subdivisions, creating a fourfold pattern echoing the hemistiches of Pope's verse. The appearance of that innovative design just at this time was not fortuitous, both verbal and architectural versions expressing the controlled play with balance and equipoise intrinsic to rationalist patterns of thought and now dominating eighteenth-century Augustan verse.[46] And as though to confirm the principles enunciated by Pope, the stairways in the garden facade at the rear of Chiswick

123

House offer an elegant variation on that inner bifurcation, again emerging in symmetrical parallel but splitting half-way into complementary, but directionally antithetical subsections.

<div align="center">(ii)</div>

The long-established assumption that the rationalism of the early eighteenth century was modelled upon the Augustan period of Rome has, of course, come under attack in recent years. Howard D. Weinbrot, developing earlier cautions by J. W. Johnson and Ian Watt, has left us in no doubt that many of the political and ethical standards prevailing under that Roman emperor were in fact generally rejected by Pope's contemporaries and should in no sense be regarded, as historians had long assumed, as representing the ideals aspired to by that generation. Significantly, however, Weinbrot excluded from his valuable rectification the area of poetry itself, which, as his own studies have shown, was overtly and acknowledgedly imitative of the Augustan writers—of Juvenal and Horace for satire and of Vergil for other forms of poetry. In the following pages I shall, therefore, with Weinbrot's warning in mind, be using the term "Augustan" in its legitimate sense, that is, in reference to the poetic implications.

Less persuasively, Donald Greene has made the stern demand that the term "Neoclassical," too, be expunged from all textbooks in reference to this period, arguing that the writers of the time placed no especial emphasis upon logic, and alleging that Dryden, Pope, and Johnson "were entirely unaware that they were 'neoclassicists.' " His claim may have some value in tempering excessively broad generalizations, but it needs itself to be severely modified. Quite apart from the demonstrably close connection between the prosody of eighteenth-century verse and the Vergilian forms (to be examined later in this chapter), Greene ignores Pope's specific injunction to all aspiring poets in his *Essay on Criticism* to follow classical example and to adopt Homer and Vergil as their models since they alone had discovered the true rules of verse writing:

> Be *Homer*'s Works your *Study*, and *Delight*,
> Read them by Day, and meditate by Night,

<div align="center">124</div>

Thence form your Judgment, thence your Maxims bring,
And trace the Muses *upward* to their *Spring*.

However fashionable it may be in current criticism, as part of the cyclical question-
ing of inherited ideas appearing in each generation, to deny to this period its Neo-
classical quality and its attempt to achieve the urbanity and rationalism associated
with the poets of the Augustan age, the older attributions still seem to me eminently
supported by close readings of the texts, as well as substantially corroborated by the
avowals of the eighteenth-century writers themselves.[47]

The desire in that period to submit all belief to the test of reasoned judgmental
scrutiny extended to the conception of myth. Jean Hagstrum, in a pioneering study
which includes what is still one of the most sensitive analyses of the pictorial ele-
ments in eighteenth-century verse, avoids synchronic comparisons, focussing in-
stead upon the indebtedness Pope's writing displayed to earlier art, that of the Italian
Renaissance which he and his friend Jervas so greatly admired:

Each heav'nly piece unweary'd we compare,
Match *Raphael*'s grace, with thy lov'd *Guido*'s air,
Caracci's strength, *Correggio*'s softer line,
Paulo's free stroke, and *Titian*'s warmth divine.[47]

In addition to the specific painters Pope admired, Hagstrum draws attention to
Cesare Ripa's *Iconologia* of 1593, whose illustrations of allegorical figures, accompa-
nied by explanations of their symbolic meanings, had greatly influenced poets, as
well as artists and sculptors, at the time of its original appearance. Ben Jonson had
possessed a copy of the book, certainly by 1604, and the connection between the
annotated allegorical figures included there and the court masques he produced in
partnership with Inigo Jones has been fully explored, notably by Stephen Orgel.[48]
Ripa's work continued to serve as a major sourcebook throughout the seventeenth
century, providing writers with a stock of accepted personifications of abstract ideas
upon which to draw; but the translation of the book into English in 1709 provided
an added incentive on the British scene, imbuing the statuary figures of this period,
especially those erected as sepulchral memorials, with an unwonted allegorical di-
mension. It encouraged representations in human form of virtues attributed to the
deceased or the sentiments of the mourning family, such as the noble statues of
Charity, Learning, or Inconsolable Grief now being placed above the tombs. Out-

side the chapel or cemetery, the close interrelationship between poetry and garden-ing ensured that the characteristic proclivity for personification in verse should be carried across to the newly designed walks too, where such sculptural figures were introduced to evoke a moralizing mood into the visitor's contemplation of the hor-ticultural scene. Joseph Warton remarked on the pleasure which is imparted to the viewer "when in wandering through a wilderness or grove, we suddenly behold in the turning of the walk, a statue of some VIRTUE or MUSE," comparing that practice of the landscape gardeners to the pensive digressions interpolated in contemporary poetry.[49] It was, of course, evocative, too, of the encountering of *Pride* or *Envy* in a poem such as *Windsor Forest*, the noun capitalized to elevate it above the specific to the mythic and universal.

Yet the concept of myth as an authoritative tradition was being undermined at the very time it seemed ostensibly to be so courted in art and literature. Ronald Paulson, in a stimulating study of the "verbal" elements in eighteenth-century art, has explored in a close reading of Stourhead the function of such statuary in convey-ing literary associations or symbolic messages. But there is a distinction to be made between the eighteenth-century version of such didactic nature walks and the earlier versions with which he identifies them. His statement that those garden statues provided the visitor with what was "virtually a page from an emblem book" and that all that was mythic in the eighteenth-century garden was removed when Capa-bility Brown dispensed with them must be viewed with caution.[50] The emblem books, like the *Iconologia*, had been profoundly serious in intent, assuming a tran-scendental validity in the personifications they presented. For Ripa, as for the Ren-aissance at large, the universalizing of myth through the influential writings of Pico della Mirandola had presupposed a genuine belief that classical mythology formed a shadowy reflection of Christian truths, the equations being worked out in meticu-lous detail.[51] Even allegories less specifically Christian or classical in source fre-quently drew their strength from that widely prevalent tradition of myth as arche-typal truth. Macbeth's vision of Pity like a naked newborn babe striding the blast or heaven's cherubim horsed upon the sightless couriers of the air had relied upon the apocalyptic vision in the Book of Revelation. And in the emblem context, George Herbert's personification of Love, who bids the guest, troubled by his unworthi-ness, to partake of the feast, is not simply a residue of the morality tradition, a vague abstraction of virtue such as Good Deeds or Fellowship. The figure is vibrant with sacred connotations, functioning as a proxy for Christ himself, the allegory becom-

ing for the reader no mere literary device but a compelling evocation of the Eucharist, the invitation to eat of *my meat*:

> Love took my hand, and smiling did reply,
> Who made the eyes but I?

> Truth, Lord; but I have marr'd them; let my shame
> Go where it doth deserve.
> And know you not, sayes Love, who bore the blame?
> My deare, then I will serve.
> You must sit down, sayes Love, and taste my meat:
> So I did sit and eat.[52]

Lévi-Strauss, in the tradition of the Jungian archetype, argued in *The Savage Mind* for the validity of myth as a positive phenomenon, creating by mental projection an area in which temporal exigencies are annihilated and apprehended truths are free to operate, released from the trammels of mundane existence. More recently, Roland Barthes has taken a contrary view, insisting in his *Mythologies*, with the example of the poster of a black soldier saluting the French *tricolor* to encourage the belief that the colonies are uniformly patriotic towards the mother country, that all myths are ultimately lies, a form of propaganda.[53] In certain ways, both interpretations would seem to be correct, but applicable to different forms of myth, or to differing usage of it. Renaissance practice, including that of the emblemists, comes clearly within the Lévi-Strauss definition, employing personification to represent ideas genuinely held to be true, as in Botticelli's *Birth of Venus* representing, in accordance with Neoplatonic belief, celestial Love being clothed in the "rags" of mortality as she floats ashore to earth. But for the allegorical forms entering art and literature towards the close of the seventeenth century, the Barthes definition would surely be more appropriate. There is an obvious sense of contrivance, almost of playacting, as in Thornhill's *Allegory of the Protestant Succession* the King, seated beside Concord, tramples upon Tyranny while he presents Peace and Liberty to Europe.

As intensity of faith in the supranatural, whether Christian or Neoplatonic, began to wane, replaced by a Deistic rationalism, there may be perceived a concomitant depreciation in the authenticity accorded both to myth and to allegory itself. The euhemerist reading of ancient religions as the superstitiously retrospective apotheosis of human heroes had, in the late seventeenth century, been so force-

fully applied by learned scholars to the classical gods as to leave little room for the anagogical exegesis traditional to the Renaissance. Pierre Bayle and Bernard Fontenelle, rejecting with scorn the elevating interpretations implicit in the Neo-platonic tradition, had coldly argued that the scenes of incest, adultery, and cruel bloodshed associated with Olympus had in fact been regarded in ancient Greece and Rome as literal accounts of historical events, not as symbols of universal verities; and this stripping away of divine aura from the Greco-Roman deities left them, for the new generation of rationalists, denuded of their authenticating symbolism.[54]

Accordingly, a vein of flippancy, even of condescension, enters. It is at this time that Marvell offers his sly misreading of the Apollo-Daphne myth, his tongue-in-cheek assumption, in praise of the garden, that the god's sole intent in pursuing her had been to turn her into a laurel bush even more enticing than the nymph he admired; and the picture the poet conjures up, implied rather than overtly acknowledged, of Fair Quiet and her sister Innocence seducing him as the luscious clusters of the vine crush their wine upon his mouth, delicately turns the very concept of personification upon its head by its image of man's physical seduction by abstract ideas. Even biblical myth becomes available for the same light-hearted treatment, as God's statement that "it is not good for man to be alone" is blandly misinterpreted as a justification of misogyny:

> Such was that happy Garden-state,
> While Man there walk'd without a Mate:
> After a Place so pure, and sweet,
> What other Help could yet be meet!
> But 'twas beyond a Mortal's share
> To wander solitary there:
> Two Paradises 'twere in one,
> To live in Paradise alone.[55]

Such casual treatment of sacred sources, in this instance even by a Puritan, was no isolated phenomenon. Dryden's *Absalom and Achitophel* formed part of a serious attempt among Charles II's followers to restore to England the sense of the divinity of their monarch, if no longer in the absolute sense in which the theory had been held in the Elizabethan era, then at least as part of the philosophy of second causes, the belief that divine will may manifest itself indirectly, as a result of seemingly political or economic factors. His identification of Charles with the biblical King

David, compelled to suppress the insurrection of a wayward offspring, was therefore peculiarly apt, as well as satirically damaging to his opponents. Yet the poem, for all its serious political intent, conjures up a scriptural scene not only devoid of holiness but in its wit at times verging upon blasphemy, with King David's begetting of Absalom providing an incongruously indelicate image of divine participation in human affairs:

> Whether, inspired by some diviner lust,
> His father got him with a greater gust . . .

It invokes the sanctity of a theological aegis and at the same time sardonically undercuts it. In Pope's writings, the act of creation itself, which had for Milton's *Paradise Lost* and for the baroque at large provided the most intimidating symbol of cosmic splendour and infinite power, becomes more than once a subject for parody.[56] And his epitaph to Newton,

> Nature and Nature's Laws lay hid in Night.
> God said, *Let Newton be!* and All was *Light*.[57]

wryly places God in an anomalously background position, with a mortal scientist usurping the creative function of divine illumination of the universe in a manner unlikely to have been tolerated by an earlier age.

Within the context of this general disenchantment with the sanctity of myth, the statues of gods and goddesses, of virtues and heroic figures in the grottoes and gardens of this time as well as in the *fêtes galantes* scenes by Watteau, should be understood not as emblems or *figurae* in any Platonic sense, but rather as scholarly evocations of such past beliefs for the sophisticated guest, learned allusions intended more for pleasurable identification than as cogent images. They function as decorative concomitants to human activity, no longer as exemplars of universal verities. Milton's investing of post-lapsarian earth with the monstrous crew of Death, Intemperance, Famine, and Rheum, as well as the more congenial Grace and his consort Libertie, belongs to the older tradition representing the genuinely conceived and dynamic interaction between the terrestrial and the divine, while the personifications in Gray's *Elegy in a Country Churchyard* are drawn from the new dispensation. The purpose of the latter is not to elevate human affairs to a cosmic context but rather to establish their human validity below. As embodiments of human traits, free from celestial overtones, their lineaments and gestures are derived from more familiar models, conventional statuary erected upon church tombs:

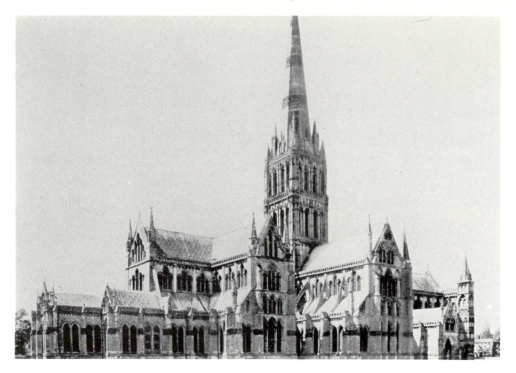

43. Salisbury Cathedral

Let not Ambition mock their useful toil,
Their homely joys, and destiny obscure;
Nor Grandeur hear with a disdainful smile
 The short and simple annals of the poor.[58]

The new churches commissioned for London and Westminster betray architecturally this reduced sense of mystery within a latitudinarian Christianity. In the Gothic structures of the past, such as Salisbury Cathedral (*fig. 43*), every external feature of the building, from the slimly tapered windows to the delicately pointed pinnacles, had been designed to raise the eye towards the central symbol, the majestic spire pointing upwards to the heavens in which man's thoughts should reside. The re-introduction of the spire once the Renaissance and baroque domes had fulfilled their purpose was not a return to that earlier usage, but only a mild echo or evocation of it. In James Gibbs's St. Martin-in-the-Fields of 1721–26 (*fig. 44*), a structure widely imitated in subsequent decades, the spire is no longer the climactic element of the edifice embodying the message of *contemptus mundi*. Its effect is of an

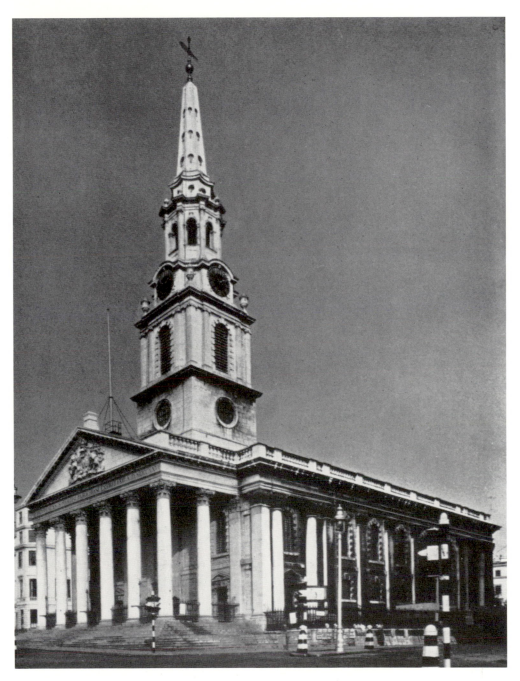

44. GIBBS, St. Martin-in-the-Fields, London

afterthought, a token acknowledgement of religious purpose added to a building which is already an independent and self-contained unit, indistinguishable from its secular counterparts, and inside which, as elsewhere, reason should prevail. In the Christian faith as presented within the eighteenth-century church, there was, it was now asserted, "nothing in the subject and should be nothing in the orator to warrant . . . vehemence of emotion."[59] The body of the church is accordingly secularized, designed in the solidly based form of a Greek temple, with a broad and imposing portico, tall columns, and a stone balustrade separating off the building from anything above it. It could be a Senate house intended for academic affairs, like the building Gibbs himself was concurrently erecting for that purpose at Cambridge, were it not for the added spire, signifying its intended function as a place of Christian worship. In other contemporary churches, such as St. George's in Bloomsbury by Nicholas Hawksmoor (*fig. 45*) constructed in 1723, the ornamental function of the spire is evidenced by the irrelevant incorporation within it of a classical mausoleum and an Egyptian stepped pyramid, the hybrid structure crowned with an effigy not of the eponymic saint but, significantly, of the reigning monarch, George I.[60] Like the statues derived from classical myth, the spire had become a decorative accessory to urban living rather than the expression of a commitment to heavenly ideals.

That toning down of myth has horticultural relevance too. Much has been written on the relationship between the gardening art of this period and the influence exerted upon it by Milton's poetic descriptions of Eden. His conception of it was used as a model, a cultural support for circumventing the established patterned topiaries and parterres of the Renaissance and seventeenth-century Italian and French traditions in order to reach back to what was considered, both in its primordial setting and in its indebtedness to Homer and Vergil, a truer and uncorrupted form of nature. In the essay on gardens which Pope published in 1713, he wrote of the "amiable Simplicity of unadorned Nature" in the tastes of the ancients, translating at length from Homer's description of the gardens of Alcinous in Book 7 of the *Odyssey*,[61] and, in the opening lines of *Windsor Forest* quoted earlier in this chapter, he had admired, with obvious allusion to Milton, the groves of Eden "green in Song" by which he longed to be inspired.

Yet for all the overt praise, the distinction we have been examining applies here no less, and any acknowledgment of that indebtedness needs to be hedged with an awareness of the profound differences involved. For Milton, subscribing to the seventeenth-century "anagrammatic" reading of nature as a divinely ordained para-

45. HAWKSMOOR, St. George's, Bloomsbury

digm for human behaviour, the garden was far more than a delight to the eye. It was above all a living hieroglyph, a symbolic source of moral instruction, exemplifying, as Barbara Lewalski has shown,[62] the most profound lesson of all for mankind. Representing in externalized form the inner world of man and woman, Eden demonstrates in its own plants the wanton tendency of nature to reach out beyond permitted bounds, that perpetual desire for the forbidden which only constant vigilance can, by the pruning, restraining, and repeated redressing of such tendencies, effectively check:

the work under our labour grows,
Luxurious by restraint; what we by day
Lop overgrown, or prune, or prop, or bind,
One night or two with wanton growth derides
Tending to wilde.

(*PL* 9:207–12)

So, too, in the passage which served as the primary model for the eighteenth-
century gardeners, the reader's first view of Eden in the poem, that symbolism of
wanton growth prevails. The description of

umbrageous Grots and Caves
Of cool recess, o'er which the mantling Vine
Lays forth her purple Grape, and gently creeps
Luxuriant;

(*PL* 4:257–60)

presages the description of Eve herself a few lines later, whose "wanton ringlets
wav'd/As the Vine curls her tendrils, which impli'd/Subjection but requir'd with
gentle sway" the guidance of a wise but firm husband. In Milton's setting, there-
fore, the garden had functioned as a force superior to man, directing his moral
choices in accordance with a divinely ordained plan and offering him in emblematic
form, whether he heeded the advice or not, the guidance which his weakness
required.

The Rococo represents not simply a scaling down of Milton's proportions but
a reversal of the roles assigned to Nature and to man, with Nature no longer in the
superior position, the representative of divine will and repository of moral instruc-
tion, but becoming instead subservient to human requirements. The poet, discard-
ing the ethical imperatives previously perceived in nature, pictured it now as a
source of amusement and leisure, a charming storehouse not of moral teachings but
of the comforts and necessities of human life generously provided by the Creator.
The view of Nature's subordination to man, its supply of his daily needs, permeates
the art and literature of the period, captured in one of the very earliest of Pope's
poems, describing the happiness of one whose wish and care a few paternal acres
bound:

Whose herds with milk, whose fields with bread,
Whose flocks supply him with attire,
Whose trees in summer yield him shade,
 In winter fire.[63]

46. GRINLING GIBBONS, wood panel carving

Within the country home, nature is now imported as a charming background decoration, as in the skilful wood carvings of Grinling Gibbons. The limewood carving set against an oak panel which he devised for Kirtlington Park (*fig. 46*) makes no attempt to evoke nature in its rich, vegetal setting but depicts instead the provinder it proffers to man, the game trophies of his hunting and fishing supplying his culinary needs. Its artistic arrangement is in perfect accord with contemporary taste, a variegated horizontal symmetry within a delicate floral design. And not least, recalling the technique of Pope's couplets with their deliberate artificializing of language and syntactical rhythm to draw overt attention to the wit of the poet, the replicas of birds, fish, and foliage are here left unpainted, despite the studied accuracy of their reproduction, as conscious artefacts inviting admiration for the crafts-

135

manship of the woodcarver rather than for the wonders of nature itself. The floral forms, woven into wreaths about the panels and worked into the surrounds, performed within the salon a similar function, with Nature offering its bounty to ornament the human abode.

This new conception of a subservient nature, emerging from the 1720s, was to release English art from the indoor portraiture which had dominated its painting for so long by introducing the so-called "conversation piece," as in Arthur Devis's canvas of the James family (*fig. 47*). Partly to provide an open-air freshness, but partly also to display the splendid grounds of their newly landscaped home, the members of the family are placed in an outdoor setting; but, by retaining the formal stance of traditional portraiture, the artist creates the impression that the sitters are really posing within the drawing room, the backdrop having been added for decorative effect. Zoffany's painting of *The Garricks Taking Tea at Hampton Garden* (*fig. 48*), does acknowledge the outdoor setting more fully by presenting the scene as a form of picnic, but the subordination of nature to social activity predominates here too. The table, chairs, and other appurtenances necessary for human comfort, the formal clothing of the sitters, and their stiff positioning about the table make the scene a social occasion transposed into a country setting rather than a genuine picnic upon the grass. And the principle is extended to their surroundings. The smooth lawns and calm water are there to provide a pleasing context for human discourse, even the facilities for fishing offering entertainment only mildly occupying the attention of the angler, who is clearly more interested in the discussion proceeding behind him. The cattle are, as usual, carefully placed on the further bank of a river, which serves to keep them conveniently distant while yet allowing them to improve the prospect.

That last point recalls the artificial device introduced to produce the same effect in areas where a river could not provide it, the need to ensure that the less palatable aspects of nature would not encroach on the ordered world of civilized man in his enjoyment of its pleasant prospects and walks. The *ha-ha* offered in certain ways a horticultural parallel to poetic diction and wit. Constructed to prevent cattle from approaching and dirtying the lawns about the house without resorting to "unnatural" fences, it consisted of a shallow ditch, whose banks, on a level with the general angle of the slope, would be indistinguishable from the distance. The visitor, coming unexpectedly upon it, was expected to utter an exclamation of mild surprise—as its name the *ha-ha* suggests—recognising after a momentary pause that he is not facing some dangerous chasm but only a device charmingly arranged to contribute

47. ARTHUR DEVIS, *The James Family*

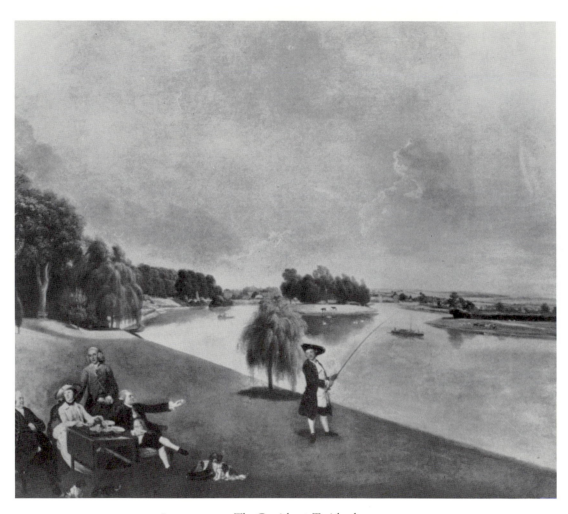

48. ZOFFANY, *The Garricks at Twickenham*

to his comforts. It accorded with Pope's dictum on the art of gardening, applying as always to the art of poetry no less than verse: "He gains all points, who pleasingly confounds, / Surprizes, varies, and conceals the Bounds," where the potential violence of *confounds* is modified by *pleasingly*, an adverb reassuringly mitigating its force.[64]

Wit necessarily involves an element of surprise, providing sudden perceptions of aspects previously unseen. But where the metaphysical poet had used a shock tactic to jolt the reader out of his conventional assumptions and thereby to assert some vibrant, transcendent truth—"Batter my heart, three-person'd God"—Pope's genius works in a reverse direction, to resolve the potentially startling and confirm the security of the mundane, of human standards, and of social order. In the course of the description of Belinda's dressing table, bearing its exotic burden of Indian pearls and Arabian perfumes, a strange image is devised to create a momentary shock:

The Tortoise here and Elephant unite,

conjuring up the grotesque picture of a monstrous coupling in nature. But where the metaphysical poet would have proceeded to validate the prodigious image in spiritual terms (as in George Herbert's "Only another head / I have, another heart and breast," leading us away from the anatomical to the metaphorical meanings of those terms in relation to Chirst), here the enigma is at once satisfactorily resolved, the conclusion of the couplet comfortably restoring the undisturbed logic of human affairs:

Transform'd to *Combs*, the speckled and the white.

Any potential shock is, like the *ha-ha*, carefully reduced in scale, and deflected as a pleasing witticism.[65]

The same principle motivates his use of zeugma: "Or stain her Honor, or her new Brocade, / Forget her Pray'rs, or miss a Masquerade."[66] His own yoking together of the most heterogeneous ideas aims not at the *discordia concors* which Dr. Johnson was so to deplore in the verse of Cowley and his contemporaries, but, on the contrary, by the mild humour implicit in the yoking, it dissociates poet and reader from such lack of discrimination, achieving thereby a reconfirmation of settled priorities in a society whose individual members too often misapprehend them. As Ralph Cohen has remarked, there is, throughout his work, a sense that true harmony can be achieved in human affairs, even though it is to be found only too rarely.[67] And it is in human affairs that Pope seeks it, not in the heavens beyond.

Even the remodelling of Nature to serve man's interests—aesthetic, fashionable, or intellectual—was to be kept within the bounds of the moderate, and in his play *Lethe* of 1740, Garrick was to satirize the excesses of that genre too, protesting that even Paradise would not have satisfied the contemporary landscape gardener. There, the spirit of Lord Chalkstone, being ferried by Charon towards the fields of Elysium, gazes at them through his telescope, proclaiming, with a side glance at Hogarth's ogee Line of Beauty, that they are:

> . . . laid out most detestably—No taste! No fancy in the whole world! Your river there, what d'ye call it? . . . Aye Styx—why 'tis as strait as *Fleet-ditch*. You should have given it a serpentine sweep and sloped the banks of it.— The place, indeed, has very fine *capabilities*; but you should clear the wood to the left, and clump the trees to the right: in short, the whole wants variety, extent, contrast, and inequality—*(Going towards the orchestra, stops suddenly and looks into the pit)*. Upon my word, here's a very fine *hah-hah!* and a most curious collection of ever-greens and flowering shrubs.[68]

(iii)

Within that most characteristic manifestation of Rococo style, the salon, the same principles as had moulded the subservience of Nature in both the poetry and landscape gardening of the day were at work subordinating artefacts to the needs of man—and, increasingly, of woman too. Perhaps furniture may appear by its functional purpose as being at all times at the service of mankind, for whom it is, after all, specifically constructed. Yet the history of interior decoration reveals how sparse and generally uncomfortable such furnishings were, how little exploited for human enjoyment, until the reign of Louis XIV. In Renaissance palaces, where the elegance of interiors gained new prominence, not least as a means of establishing the prestige of the owners, the primary outlay had been not upon the furniture but upon the decoration of the walls, hung with rich tapestries depicting mythological scenes, often with heraldic associations. But the furniture itself, even when elaborately ornamented, was remarkably standardized, consisting almost exclusively of beds, chests, stools, benches rather than chairs, and a long table for use in the great hall. In the latter part of the seventeenth century, the growing desire for privacy, which

Lawrence Stone has identified as emanating from broad sociological and religious realignments, by encouraging the family's withdrawal from communal meals in the great hall to smaller dining rooms, produced a new configuration in the overall design of such homes.[69] In place of the linear succession of chambers through which (bedrooms included) it was necessary for family and servants to pass in order to reach those located beyond, the introduction of an external corridor running alongside the existing rooms allowed for a structural compartmentalization isolating individual apartments from the traffic of the house, with the owners of older buildings often creating such corridors artificially by the erection of thin internal partition-walls. Rooms could now be devoted more conveniently to specific purposes, designated as library, study, bedroom, dressing room, or boudoir.

Only towards the end of the seventeenth century, therefore, as part of this functional separation of living quarters, does the change occur which has continued into our own day, the proliferation of furniture designed to suit precisely the variegated activities of owner and guests. The commissioning of a table now required a predetermination of its specific social function, as a card table, a coffee table, a half table to stand against a wall, a corner table to support an ornamental vase, a writing table, or a dressing table. Chairs began being shaped for comfort, soon to be widened to fit the voluminous hoopskirts or *paniers* of the day. At the court of Louis XIV such chairs functioned, too, as a means of discriminating social rank, those with armrests and back being strictly reserved for the use of royalty. It was a hierarchical distinction eagerly imported from the royal palace into the homes of the aristocracy, soon to be imitated by the bourgeoisie throughout Europe. The distinction was to persist in England well into the Edwardian era, where every dining suite contained (as in the familiar tale of *The Three Bears*) an impressively larger chair with armrests for the father of the household, a smaller chair with armrests for his lady, and simpler, straight-backed chairs without armrests for family and guests.

This change of emphasis in interior decoration has its bearing on contemporary shifts in poetic form. An Elizabethan house such as Hardwick Hall had been constructed primarily to impress the visitor by its grandeur, to proclaim in the size of the long gallery and hall, as in the initials "ES" proudly displayed above the facade, the dignity and wealth of its owner Elizabeth, Countess of Shrewsbury. In the eighteenth-century salon, the purpose has become more personal, to indicate in every article and ornamental device the aesthetic sensibilities of the owner in selecting the fabrics, mirrors, and furnishings, in choosing the craftsman or designer best

suited to producing the effects desired, and thereby in displaying through its testimony that *taste* which Shaftesbury had introduced for this period as the distinguishing criterion for the man of fashion and culture.[70] By extension, such sensibility served as a compliment to the visitor too, without whose own artistic discrimination such taste would not be acknowledged. A new relationship was thus created between owner and viewer, a mutual respect for their shared appreciation of aesthetic values elevating them above the rest of humanity.

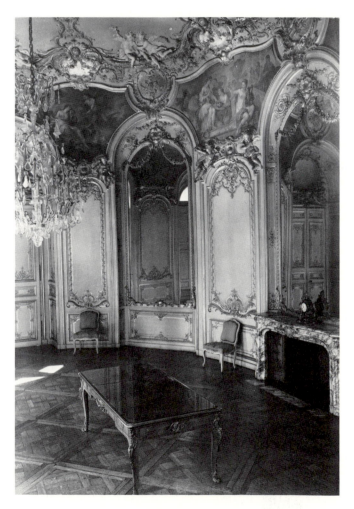

49. BOFFRAND, salon interior, Hôtel de Soubise

The salon (*fig. 49*) displays in all its aspects that self-appreciative quality, extended to the visitor by his host. It is designed as the setting for exchanges of witty repartee, of learned conversation, or of entertaining social commentary. Where the mirrors at the Palace of Versailles had been introduced into only one wall of the long gallery to reflect the magnificence of the royal processions passing through, the mirrors in the salon are now affixed on all walls to reflect back the human scene from various angles.[71] They encourage the participants to view themselves functioning within the social context and thereby to become, like the Augustan satirist himself, "spectators" of such refined activities, assessing the scene with an urbane detachment, even when they themselves formed an integral part of it:

> In various talk th' instructive hours they past,
> Who gave the *Ball*, or paid the *Visit* last.[72]

The marquetry of brass and tortoiseshell with the addition of ormolu mounts which André-Charles Boulle introduced to the design of furniture and which became a hallmark of Rococo style throughout Europe exemplifies the new philosophical concerns. His commode from 1708–9 (*fig. 50*), is, in accordance with the new fashion, one of a pair, intended to create that balance and symmetry so characteristic of the era. The source of its opulent ornamentation, the wealth of swirling curves and deliberately variegated materials is, of course, the baroque. It is no longer designed, however, for the greater glory of God nor even for the splendour of the monarch in any cosmic sense, but in tribute to the social refinements of the new era. Where the baroque had impressed by marmoreal solidity and monumentality, the emphasis here has been transferred to delicacy of surface, the intricate inlay and subtle arabesque design which once again decorously clothes Nature, serving as the "dress" for the naked grained wood concealed beneath. That surface ornamentation, furthermore, takes on a predominant effect of gilt, with the gold-coloured ormolus contributing to the surface sparkle of the scene, so that the impression it creates is of brilliant artefact. Indeed, throughout Pope's poetry the adjectives of gilt and glitter abound,[73] since for him that gilding is to be equated to the function of poetry as surface form or dress:

> But true *Expression*, like th'unchanging *Sun*,
> Clears and *improves* whate'er it shines upon,
> It *gilds* all Objects, but it alters none.
> Expression is the *Dress* of *Thought* and still
> Appears more *decent* as more *suitable*.[74]

143

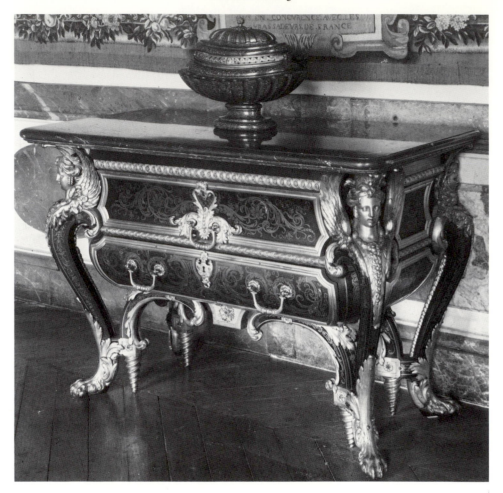

50. BOULLE, commode

Even the wit of Augustan poetry is paralleled in this commode, namely, in the mild puzzle provoked by the legs of the piece, obviously too delicate in their curved shaping as elongated winged figures to support the tabletop, but in fact assisted, as we are meant to perceive a moment later, by the gilded spirals half hidden behind them, which really bear the weight.

Poetry has in all eras been to some extent a display of literary skill, but the prominence overtly accorded to that aspect has varied. An Elizabethan sonnet or a seventeenth-century love lyric was still primarily an exposition of the speaker's emotional condition and a religious poem essentially a yearning for divine union. If

144

the reader admires the poetic brilliance whereby those purposes are achieved, it is as the vehicle assisting the poet to attain the acknowledged aim. In Augustan verse, as in the design of the contemporary salon, artistic sensibility has become the criterion to which even the subject matter is subordinated. There is throughout, not least in the pauses at the end of each rhymed couplet, an invitation for the reader to applaud the ingenuity and adroitness demanded for its delicate construction and carefully balanced antitheses. And conversely, in the finesse demanded for perceiving that skill, there is an unspoken recognition of the reader's own aesthetic discernment, thereby creating a bond between poet and reader as between two intelligent and discriminating members of a refined society, possessing the requisite qualification of aesthetic, social, and moral discretion.

The artistic tact assumed for the salon is relevant to an aspect of Pope's poetry which has understandably attracted wide critical attention, generally negative, from the Romantic era onwards—his cultivation of a poetic diction. In the earlier part of this century, Raymond D. Havens contributed to the temporary eclipse of Milton's reputation by attributing to his supposedly baleful influence much of the artificial diction which dominated eighteenth-century poetry, the latter being assumed unquestionably to be a regrettable literary failing.[75] That attribution was modified by Geoffrey Tillotson some few years later when he pointed out that such circumlocutory forms as "purpled main" for "sea" arose less from any direct imitation of Milton's own verse techniques than from the fact that both Milton and his Augustan successors had chosen to take Vergil as their poetic model. Tillotson went further, tracing the source of eighteenth-century periphrases back to Sylvester's translation of Du Bartas's *Divine Weeks* and Sandys's translation of the *Metamorphoses*, both of which, he maintained, had introduced into English literature the tendency to employ Latinate phrases sounding strangely on the English ear. But there are two weaknesses in the theory. The parallels he draws between Sylvester's usage and Pope's are unconvincing, going no further than similarities which any two poets consciously imitating their Roman predecessors would display. More importantly, the lengthy gap in time between the appearance of those translations in 1595 and 1627, respectively, and Pope's composition of *Windsor Forest* from 1704 onwards militates against his case. One would need to know what immediately relevant changes had prompted Pope and his contemporaries just at that time, approximately a century after the appearance of those translations, to prefer such phrases as "leaden death" for gunshot and "watery plain" for sea, and in what way they saw them as particularly suited to the verse form they were creating at that time. For these Latinate phrases achieved a prominence in their poetry which every reader

must recognize and which Wordsworth, in his preface to the *Lyrical Ballads* on poetic diction, identified as the distinguishing weakness of Augustan verse. He quotes there as his example Gray's periphrastic description of the dawn in which the sun does not rise, neither do the birds sing, but instead:

> *reddening Phoebus* lifts his golden fire:
> And birds in vain *their amorous descant join.*[76]

More relevant, it would seem, to the adoption of that stylistic form was a significant change that had taken place in the school curriculum during the period of Pope's boyhood, a training in a new literary technique which was to prove remarkably well suited to the needs of an Augustan poet desirous of conveying in his verse the discriminatory intellectualism admired in his day. In the Renaissance, the main emphasis in Latin studies had fallen upon the translation back and forth from Latin to English of classical plays, especially the comedies of Plautus and Terence. The choice arose largely through the perceptiveness of such educators as Roger Ascham, who had realized that youngsters needed to be provided with entertaining material in order to enliven their studies. The performance of such plays in class, and often by royal request at court, required that they learn the text by heart—a process which helped impress the vocabulary and style of the Latin originals upon the boys' memories. However, at the close of the seventeenth century, curricular practice, partly, we may suspect, through the notorious bawdiness of the contemporary stage and its consequent unsuitability for educational purposes, had moved away from drama to poetry, which became the new focus of study, with the system of translation back and forth from English to Latin versions still occupying a major place.

Whoever has himself been trained in the composition of Latin hexameters will appreciate the difficulties to be overcome. Since any naturally short vowel becomes lengthened when it is followed by two consonants, the schoolboy versifier is required to perform a continuing and often exasperating juggling of word locations and juxtapositions in order to meet the strict quantitative requirements of the line, and it was as a welcome aid for such verse composition that the *Gradus ad Parnassum* was introduced at this time. The earliest recorded printing in London of the innumerable versions which were to become a staple ingredient of school teaching from then onward was the edition that appeared in 1691, its authorship attributed to Paul Aler.[77] If we recall that Pope, born in 1688, received his youthful training in Latin verse translation during the 1690s, the date of the introduction of the *Gradus* to England becomes significant. The purpose of that indispensable reference work, subtitled *sive, Novus synonymorum, epithetorum, et phrasium poeticarum thesaurus*, was

to offer under each lexical heading a selection of metrically varied Latin words available for the specific slot vacant within the line; but also, to the relief of the schoolboy, it would suggest ways of filling a substantial portion of the line with periphrastic phrases culled from the best Latin poets. Elegant circumlocutions, such as *perpetua nox* under the listing of "death," would not only satisfy the sternest schoolmaster by the approved accuracy of the scansion but would have the added virtue of echoing a Roman poet, thereby adding to the scholarly allusiveness and stylistic acceptability of the final poem. At a time when, as the educationalist Hoole informs us, proficiency in scanning Latin verse was regarded as a prerequisite for poetizing in English and the system of translating back and forth between the two languages remained mandatory,[78] the transference of the cherished Latin technique of periphrasis to English verse writing from Pope's time onward, as in "watery plains" (*campi liquentes*) for "sea," would seem to require little explanation. Tillotson argued with some ingenuity that Pope's expanded synonym for "fish"

> With looks unmoved be hopes *the scaly breed*

may derive from such new scientific theories as William Derham's *Physico-Theology* of 1713, which devoted a chapter to the wonder of creation in endowing each creature with the clothing most suited to its needs. "Scaly breed" and "feathered choir" are thus perceived as species distinguishable by their garb.[79] But the fact that Pope in his earliest student years, long before the appearance of that treatise, would have found under the heading *piscis* in the *Gradus* the helpful phrase *squamigera gens* ("scaly breed") and under *avis* the suggested substitute *pennata cohors*, would seem to be more pertinent to such usage.

On the other hand, no poetic training in Latin, however vigorously applied, could have been successfully transplanted into English verse were it not in itself suited to the cultural needs of the day. It was the perfect marriage between that newly learned *Gradus* technique and the fashions exemplified in the salon which ensured its centrality in Augustan poetry. In an age assuming in reader and poet a mutual respect, a shared appreciation of artistic skill, such instances of wit as the couplet on the elephant and the tortoise or the mild surprise provided by the *ha-ha* could now be offered in miniature within the circumlocutory phrases borrowed from the *Gradus*. It provides a striking instance of the poet–reader strategy which post-modern critical theorists have highlighted, focussing microscopically upon the reactions evoked by the wording of the text. The substitution of "glittering forfex" for "scissors" before the climactic snipping of Belinda's lock not only avoids the use of a mundane word which might damage the elevated tone of the mock-epic. The

periphrasis offers also a momentary intellectual puzzle, a potential stumbling point, which is at once satisfactorily resolved in the reader's mind as the obliquity of reference is grasped. The process results in that very mutual appreciation of sensibility at which the poem aims—the reader mentally congratulating himself for his success in having deciphered the enigma, while at the same time applauding the poet for the wit involved in its presentation. As Pope himself defined the technique, periphrastic diction in poetry must be "so misteriously couch'd, as to give the Reader the Pleasure of guessing what it is that the Author can possibly mean; and a Surprize when he finds it."[80]

The affinity between this *Gradus* element in poetry and the artistic display of wit, skill, and learned allusion in the landscaped gardens, with their pleasing turns, mildly surprising cascades, and carefully placed statuary is, in its assumption of shared appreciative sensibility, sufficiently apparent. But there is a further interdisciplinary relationship. The basic purpose of the *Gradus* was, as has been seen, to encourage the use of ready-prepared modular forms so skilfully introduced that they should contribute to the artistic unity of the whole. The final work was, of course, an original creation, often brilliantly so in Pope's writings; but the process of composition favoured the amalgamation of such prefabricated units. Watteau's own process of creativity displays a remarkable similarity in that respect. Throughout history artists have sketched out figures before transferring them to canvas, many such draft designs having survived; but such sketches were normally executed when the artist was already planning out the specific painting or fresco for which the figures were intended, in order to help him visualize how they would contribute to the larger work. Watteau worked differently, preparing for himself a superb reservoir of sketched figures, men and women in varied poses and viewed from contrasting angles (*fig. 51*), from which he would select whenever he required one for a particular scene. So rich was that series of sketches that in 1726–28, soon after his early death, a collection, by no means exhaustive, was issued in Paris in a well-known two-volume edition by J. de Joullienne under the title *Figures de différents caractères, de paysages et d'études*. Watteau's habit of incorporating such images from his notebooks and albums into his paintings is known from remarks recorded by his contemporaries; and historians have been able to identify numerous instances in which a prepared figure from these sketchbooks has been transferred unchanged to a painting and, on occasion, appears in almost identical form in two different canvases. His practice does, therefore, suggest a preference for modular construction of prepared units, similar to that employed in the Augustan heroic couplet drawing

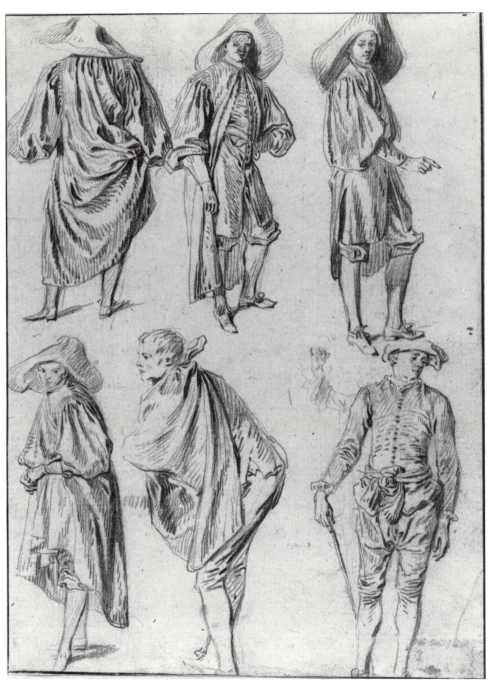

51. WATTEAU, sheet of sketches

upon the storehouse of the *Gradus*, the similarity deriving, as so often, not from mere chance but from a shared aesthetic conception. The current belief in the universality of art, assigning less significance to the inspiration of the moment and more to the lasting validity of generalized forms, had authenticated for both artist and poet their reliance upon a figural pose or verbal phrase of proven validity, the art consisting of the grace or wit whereby the modules were assembled.

That constructional form, which left so much to the poet's creativity yet at the same time preserved a sense of comfortable familiarity in his verse, ensured that even in the most emotional of themes a certain artistic distance and sophistication should be preserved. *Eloisa to Abelard* is a genuinely moving, first-person conjuring up of a dramatic moment in time. Yet if, in comparison with Pope's other writings, it does seem closer to true passion, we should not ignore the effect it still creates of being a contrived artefact, the careful balance of ideas reflecting the poetic control so intrinsic to such verse:

> Thy oaths I quit, thy memory resign,
> Forget, renounce me, hate whate'er was mine.

And contributing to that dominant sense of control is the employment of circumlocutory forms which, as part of Pope's intention, blunt the immediacy of the emotion so that, even at moments of highest tragedy, it is not *she* who is inflamed but more abstractly:

> In seas of flames *my plunging soul* is drown'd.[81]

The periphrasis counters the immediacy of the account, producing the impression of third-person narration despite the ostensible subjectivity of presentation. Such, of course, is not the weakness of Pope's poetry but its strength, its ability, in a generation preferring Nature adorned, placing its trust in the sophistication of reasoning man, to produce a poetry rich in allusiveness and satirical power but, as in the visual arts of his day, more congenial to connoisseurship, the appreciation of delicate artistry and intellectual brilliance, than to the yearning for personal salvation or the awed sense of cosmic vastness which had animated the European baroque.

4

THE EMERGENCE
OF THE NOVEL

IT IS A CURIOUS ANOMALY THAT THE EARLY EIGHTEENTH CENTURY—
a generation so overtly committed to artistic imitation, reverentially asserting
throughout its critical treatises, prefaces, prologues, and declarations of intent that
Homer, Vergil, Juvenal, and Horace were to be its models and arbiters in all matters
of literary performance—should have been responsible for creating the first essen-
tially new genre to appear in literature since the classical era, destined eventually to
rival all competing forms both in popularity and in copiousness of production.
Among the causes that might be regarded as responsible for the singularity of such
literary initiative in a predominantly conservative and classically oriented period are
certainly those which Ian Watt first noted in the 1950s in his stimulating study on
the rise of the novel and which have continued to be explored by subsequent schol-
ars, most recently by Michael McKeon. Economic individualism emanating from
the work ethic of inherited Puritan tradition had produced an increasingly bour-
geois readership which was responsive to a species of literature emphasizing the
rewards awaiting the industriousness, enterprise, and pious husbandry of men such
as Robinson Crusoe. The attraction was augmented when, as Paul Hunter has ob-
served, this new narrative form functioned at a subdued level as a surrogate sermon
recounting, in a manner patterned upon the spiritual biographies of Richard Baxter,
Vincent Jukes, and John Bunyan, the protagonist's progress through guilt, punish-
ment, penitence, and potential salvation under a divine providence. Sociological
changes had contributed too, the growing fondness for privacy producing in the
wealthier and middle classes more time for reading and correspondence, the emer-
gence of a more literate servant class encouraging the production of reading matter
relevant to its own interests, while such seemingly minor factors as the affixing of

locks to bedroom doors could add a new dimension to plot technique, a device enabling Pamela to elude her master's pursuit.[1]

Yet one suspects that so radical an innovation in literature, manifesting itself simultaneously in France (which had never experienced the impact of the Puritan work ethic) and spreading rapidly throughout the continent, should not be attributed exclusively to localized changes in the social, religious, and economic fabric of Protestant England, important though such elements may have been in fostering the specific form which it took in that country. The accolade for the inauguration of the genre has, indeed, been bestowed by some historians on France rather than England, Diana Spearman with some justice claiming for *La Princesse de Cleves* precedence over Richardson's contribution as the prototype of the psychological novel. And even if that claim be questioned, certainly the work of l'Abbé Prévost in the 1720s would confirm that the rise of the novel was not an entirely English phenomenon.[2] In the light of that corrective, one should, perhaps, search behind the localized sociological and Protestant-related elements which have hitherto occupied historians for causes of a more European dimension, for a realignment of interest at a broader continental level expressing itself, among other manifestations, in the emergence of this new literary genre.

It may be helpful to begin the search with one of the most dramatic instances of such altered perspective occurring in a prominent inaugurator of the novel form, *Gulliver's Travels*. The fictional journeys to Lilliput and Brobdingnag were many years ago, in an essay familiar to all students of Swift, identified as examples *par excellence* of literature's indebtedness to contemporary scientific discovery. The account of tiny creatures examined, as it were, under a magnifying lens, or the story of human giants whose physical characteristics were perceived in nauseating enlargement, Marjorie Nicolson maintained, "could not have been written before the period of the microscope." The work itself, she suggested, belongs to a group of "microscopical satires" which appeared at that time, ridiculing the fashionable interest aroused among laymen by contemporary research.[3] Antony van Leeuwenhoek's discovery of "little animals," discernible in rainwater as well as in the secretions of the human body, had prompted Robert Hooke, the curator of research experiments at the Royal Society in England, to construct an improved version of the instrument and to conduct further investigations. His resulting publication, *Micrographia*, of 1665 so caught the public imagination that by 1691, as he noted in a report to the Society, the microscope had become a popular plaything for amateurs. The vogue inevitably invited derision as well as respect, giving rise to numerous satires, of which *Gulliver's Travels* is seen as the most distinguished.

The validity of that reading for occasional minor scenes in the work cannot be questioned. The Maid of Honour's skin, seen in loathsome close-up at the court of the Brobdingnagians, undoubtedly relies upon the fascinating world of *minutiae* which had suddenly been made visible to the human eye. To the tiny Gulliver, the youthful skin of this giantess appears as it would if seen through a powerful magnifying lens—repulsively coarse and particoloured, "with a Mole here and there as broad as a Trencher, and Hairs hanging from it thicker than Pack-threads."[4] Such occasional incidents do not, however, justify Nicolson's judgment that the work as a whole complements, for a later generation fascinated by the microscope, Milton's earlier interest in the telescope, the two providing classic illustrations of the extent to which scientific discoveries may affect the literary themes of contemporary writers by offering them new modes of viewing the world.

There is, for example, a technical discrepancy which suggests that the assumption needs to be approached with greater caution than it has been accorded. To supply Swift's main requirement in the work, the optical expansion and contraction necessary for the accounts of Lilliput and Brobdingnag, there had been no need whatever to await the invention of the microscope. Over a hundred years before Swift began composing this work, when, around 1610, Galileo first refined the cruder prototype of the telescope into an effective scientific tool, its invention had aroused enormous excitement throughout Europe for the unprecedented views it offered of the moon, which (rather like the Maid of Honour's skin) was now seen in close-up to possess not the smooth, unblemished surface posited by Neoplatonic philosophy but, as was noted in an earlier chapter, a roughly textured corrugated range of mountain peaks, valleys, and ravines. In that regard, therefore, the Brobdingnagian section offered no substantial advance on Milton's usage. And for the Lilliputian section too, the technique he required already lay ready to hand; for the invention of the telescope had offered man, we should recall, not only the possibility of optical enlargement but a choice between two startlingly polarized perspectives, large or small, by means of a simple inversion of the tube. The alternate application of the viewer's eye to the opposite ends of that instrument supplied all that Swift needed for his imaginary travels to the land of the giants and of the dwarfs. The point was not lost upon Swift's contemporary Des Fontaines, who translated the work into French in 1727, for he at once identified this dual use of the telescope as the source of the satire, commenting perceptively in the preface:

Dans ces deux *Voyages*, il semble en quelque sorte considérer les hommes avec un Télescope. D'abord il tourne le verre objectif du côté de l'oeil et les

153

voit par conséquent très-petits: C'est *Le Voyage de Lilliput*. Il retourne ensuite son Télescope, et alors il voit les hommes très-grands: C'est *Le Voyage de Brobdingnag*.[5]

The legitimate question to be posed, therefore, relates less to the immediate impact of contemporary scientific inventions upon literature than to the reasons which prompted Swift to employ at that particular time an ocular technique which had long been available to the writer. And since he was not the first of English authors to adopt the invention of the telescope for literary purposes, we should enquire above all into the innovations he introduced into its usage.

Elsewhere I have argued that the process of optical enlargement and diminution in Milton's *Paradise Lost*, enabling him to present in that work a more cosmic vision than was otherwise possible, was considerably more than an incidental literary exploitation by him of the comparatively recent discovery of the telescope. Its invention was intimately connected with Milton's most urgent theological purpose in composing the epic. One principal aim of his work was, as he declared in the invocation, to "assert Eternal Providence," to reaffirm the controlling presence of a divine Creator in a universe which was being increasingly seen by scientific investigators—not least by means of the newly developed telescope—as a mechanistic, self-regulatory system. If his interpretation of the Fall of Man was to prove in any way convincing to a seventeenth-century reader exposed to the New Philosophy, that interpretation, as he realized, could only be effectively presented after the larger, cosmic reaffirmation had been achieved. Accordingly, Satan's journey through the immensity of those heavens becomes Milton's paean to a divinely created and divinely supervised universe seen anew, now revealed by the astronomer's "glaz'd Optic Tube" as consisting of huge orbiting masses, with the Milky Way no longer to be imagined as a celestial stream but recognized as composed of millions of massive planets, most of them far larger than the Earth. The technique of optical magnification and diminution which the telescope offered was adopted there in order to convey that very sense of vastness, as Satan descries in the far distance a star no larger than a dot, and, soaring towards it, watches it, like the astronomer applying his eye to the optic tube, enlarge enormously into an entire world in its own right, as he winds

> his oblique way
> Amongst innumerable Stars, that shone
> Stars distant, but nigh hand seem'd other Worlds . . .
> (PL 3:564–66)

The telescopic views of his epic are thus not a casual importation into the poem of an opportunely available technique but the poet's determination to confront the disturbing theological implications of its discovery, the challenge to faith implicit in the new conception of the cosmos to which it had given rise. By assimilating that conception into an expanded religious framework, he aimed to allay the doubts which its invention had initiated.[6]

That same critical principle, that the literary employment of a scientific discovery may reflect a cultural shift in human thought rather than the mere capitalizing on a convenient tool, can be seen as operative in Swift's later use of the telescope—in fact representing in its contrasting purpose a cultural reaction to the assumptions of Milton's day. For it is not only Swift's preference for applying the opposite end of the telescope to his eye, his use of it for purposes of diminution, that distinguishes him from his Puritan predecessor but also the direction in which he points the instrument. In his hands the telescope is turned away from the heavens towards earth, focussing there upon a new scene, a panorama not of the cosmos but of the human social fabric.

In a recent study of Swift, Carole Fabricant has cogently argued that, although Pope and many of his other literary friends perceived so intimate a relationship between literature and Nature methodized, between the landscape gardening in which they indulged and the rules of poetry and prose which they enunciated, Swift himself does not belong within that aesthetic movement, being unresponsive by temperament to the splendours of the natural scene. If he occasionally expressed token appreciation of the rural retreat offered by so cultivated a location as Moor Park, he was himself alien to its pleasures, his own inner tensions divorcing him from the serenity it implied. Noting how rarely he has even been mentioned in connection with the painting and landscape gardening of his day, Fabricant therefore finds herself impelled to take both for her theme and for the title of her book an extended, somewhat strained use of the term "landscape" to denote the harsh physical and political surroundings to which Swift responded so directly and so vigorously, her work providing a study of the Irish world in which he found himself.[7] Yet her isolation of Swift from such aesthetic concerns in the kindred media is not, I believe, justifiable, as there is a way in which he may be seen to belong very centrally to immediately contemporary trends in landscape painting.

In the latter half of the seventeenth century, the growing interest in the natural scene as constituting a theme for painting sufficient in itself rather than as a mere background, evidenced in the increasing importance it received in the works of Claude Lorrain and his followers, did begin to offer a broadened sweep of vision

with something of the panorama effect soon to be found in the novel; but by their concentration upon what was later termed the "picturesque," the composition of the natural scene into a harmonious whole, the artists had displayed little interest in the activity of the human beings occupying the foreground. Claude Lorrain's *Hagar and the Angel* of 1672 (*fig. 52*), the pride of Sir George Beaumont's collection and a canvas extraordinarily influential on the English scene, exemplifies the artist's nonchalant employment of a biblical theme to justify a personal indulgence in the pleasure of portraying landscape at a time when the landscape genre had not yet achieved respectability as an art form. That the biblical theme serves only as a subterfuge may be perceived in the patent inconsistency between the setting and the event supposedly occurring within that context. This characteristically Claudean view—dominated by a graceful tree surrounded by rich vegetation, with a small hill town and bridge reminiscent of antique Roman structures, and a wide, calm lake with two boatmen rowing across it—is manifestly inappropriate for the parched, desolate wilderness in which the angel appeared to Hagar after her son Ishmael had almost perished of thirst. The artist has either forgotten or deliberately ignored the real environs of the scriptural event in order to present the kind of scenery in which he delighted.[8] In *The Marriage of Isaac and Rebecca* (*fig. 62*), the human figures authenticating the title are so insignificant amidst the beauty of the scenery that it requires an effort to identify the activities of the celebrants; and that primary artistic focus upon the natural setting holds equally true for the works of Salvator Rosa.

The genre of painting which comes into prominence in the early years of the eighteenth century, however, at the very time when Swift was composing *Gulliver's Travels*, has a markedly different intent, related though it may be to those earlier traditions. In the 1720s, Canaletto developed in Italy a type of *veduta* painting which at once captured the imagination of English travellers and art collectors, henceforth to be the main source of his patronage. Des Brosses in 1739 remarked that the English had completely spoilt that painter by offering him three times as much as he asked for his canvases;[9] and such patronage led Canaletto, when the War of the Austrian Succession interfered with continental travel and threatened to break his contact with his English buyers, eventually to move to England and reside there for almost ten years, influencing the English painters Samuel Scott and William Marlow to pursue similar artistic themes.

Canaletto's *Regatta on the Grand Canal* (*fig. 53*) retains the earlier landscape interest in its depiction of a broad vista, but the changes are significant. Its desertion of the natural countryside in favour of the city was not in itself entirely new—Ver-

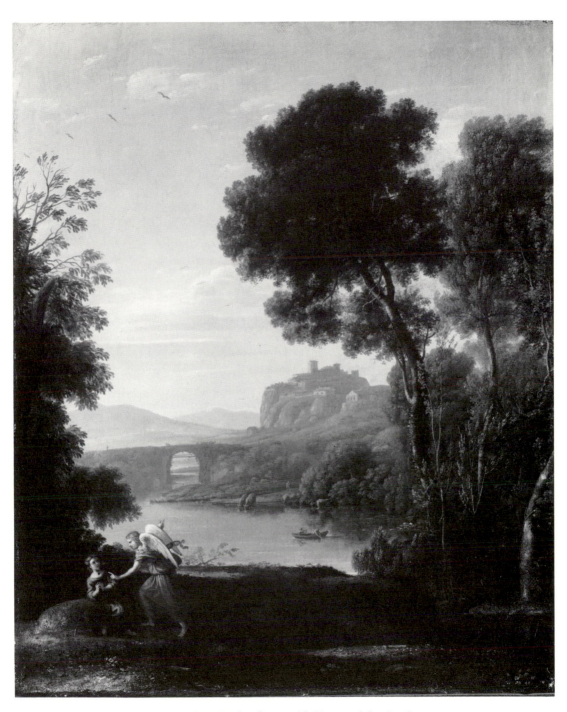

52. LORRAIN, *Landscape with Hagar and the Angel*

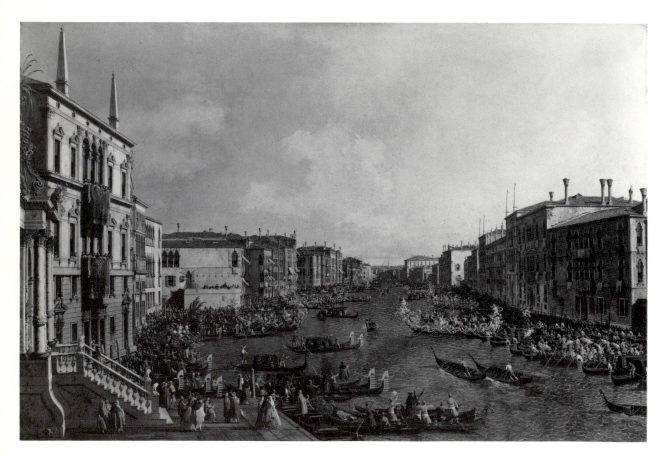

53. CANALETTO, *Regatta on the Grand Canal*

meer's views of Delft had established a precedent—but in contrast to Vermeer's interest in the play of light upon water and skyline, Canaletto's objective has become the city as a human habitation, the location for social activity *en masse*. Neither the individual nor any specific story or incident engages his attention, but the urban populace viewed as a community, operating according to its local rituals and social practices. To achieve that effect, the scene is presented from a distant, raised vantage point, as if scanned through a telescope by an uninvolved spectator. The result is an overview of a crowded city singularly reminiscent of Gulliver's first visit to the Lilliputians' metropolis. Wearing his short waistcoat for fear of brushing against the roofs, he observes interestedly from above the throng of people turning out to witness his visit, how the "Garret Windows and Tops of Houses were so crowded with Spectators, that I thought in all my Travels I had not seen a more populous Place." The similarity lies not merely in the new viewpoint for examining mankind from above, but in the suggestion in both instances of artist or narrator as an objective investigator examining with curiosity the conduct of the human species in its variegated communal rites. It was this aspect of Canaletto's work which especially appealed, we may surmise, to the taste of the English tourist, since the Grand Tour itself, by now obligatory for any self-respecting young gentleman, was intended not only as a pilgrimage to the sites and relics of classical antiquity but also as a means of broadening the mind by travel, indulging an intellectual curiosity concerning the laws and customs prevailing in other civilizations in search both of shared qualities and of contrasts in order to assess more effectively the values predominating at home. Johnson's *Vanity of Human Wishes* was to be animated by that same impulse, opening with a panoramic view of human societies, specifically the crowded scenes of urban living, and noting with a sense of universal truth the conformity yet diversity of mankind's behavioural patterns:

> Let observation with extensive view,
> Survey mankind, from China to Peru;
> Remark each anxious toil, each eager strife,
> And watch the busy scene of crouded life. [10]

If the scenes which Canaletto painted in Venice were intended primarily as souvenirs for the tourist, presentations of the city as it would appear to a foreigner, those he completed during his residence in England came more naturally to him as the equivalents of Gulliver's journeys to foreign lands, that is, an opportunity as a visitor to portray the unfamiliar customs of his host country. In the paintings he produced for his patron the Duke of Richmond, the one, for example, depicting

Whitehall and the Privy Garden viewed from the upper storey of the Duke's home (*fig. 54*), he records in meticulous detail the local fashions and social graces similar to, yet slightly different from, those pertaining in Venice. To the right may be discerned the diminutive figure of the Duke, wearing the riband of the British Order of the Garter, being welcomed with a graceful bow by a liveried servant as he enters through the gateway, and to the left people strolling alone or in groups through a spacious and open garden such as was not to be found in the elaborately structured piazzas or narrow alleyways beside the canals of Venice.

Canaletto's choice of theme was by no means an isolated phenomenon, such views of urban activity or concourse becoming fashionable at this time. Pannini's *Interior of St. Peter's*, Rome (1735), now in the Norton Simon collection, is typical of that new angle of vision, presenting from the lofty upper reaches of the basilica what seem to be mannikins engaged not in worship but in the social act of admiring the artistic merits of the edifice. And the numerous canvases by Canaletto's pupil and later rival, Francesco Guardi, again manifest the new interest. The latter's *Embarkation of the Doge on the Bucintoro* (*fig. 55*) depicts a crowded, open-air, metropolitan scene on a ceremonial occasion, forming, in fact, part of a series initiated by Canaletto and adopted by his disciple, entitled *Twelve Ducal Ceremonies and Festivals*. The event is presented, as usual, from afar, with a cool detachment contrasting markedly with the energized involvement characteristic of baroque painting and, no less markedly, devoid of that ever-present sense of divine participation in natural and human events so long established in the grand painting of the seventeenth-century tradition. In its scrupulously detailed survey of the scene and in that absence of divine immanence it resembles Gulliver's dispassionate account of his travels, perhaps most closely that scene in which, after carefully choosing his vantage point, he gazes through his binoculars, in their eighteenth-century version, to ascertain with precision the size and quality of the Blefuscu navy: "I walked to the North-East Coast over against *Blefuscu*; where, lying down behind a Hillock, I took out my small Pocket Perspective Glass and viewed the Enemy's Fleet at Anchor, consisting of about fifty Men of War, and a great Number of Transports." The illustrations commissioned for John Hawkesworth's 1754 edition of the *Travels* suggest how closely the novel approximated to the Canaletto perspective. The first of these (*fig. 56*) by Johann Sebastian Müller, a German artist resident in England, depicts the hero interestedly observing from above the minuscule Lilliputian soldiers holding their military manoeuvres, both the scene laid out before him and the angle from which it is viewed providing him with just such a spectacle of human activity as would have appeared on a *veduta* canvas.[11]

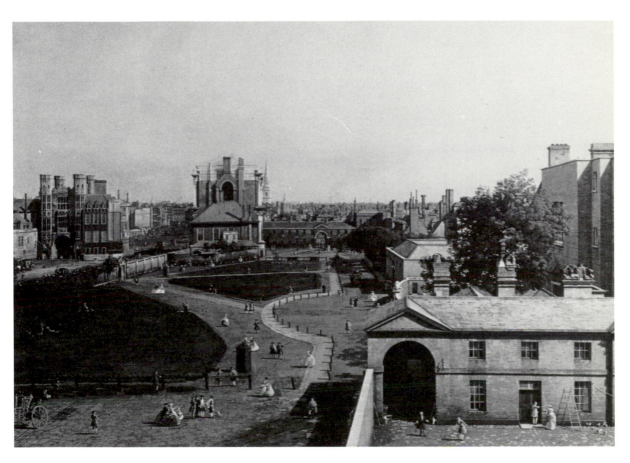

54. CANALETTO, *Whitehall and the Privy Garden*

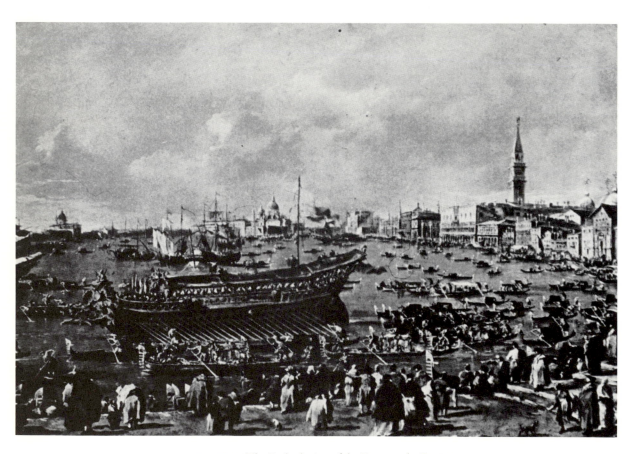

55. GUARDI, *The Embarkation of the Doge on the Bucintoro*

56. MÜLLER, *Gulliver Viewing Military Manoeuvres*

As W. B. Carnochan has observed, there is in Gulliver's use both of spectacles and perspective glass a reinforcement of his role as scientific observer, metaphorically correcting his human myopia in order to see human affairs more objectively and with the distancing necessary for empirical observation.[12] The very technique of satire, we may recall, involves the establishment of a firm communion with the reader or viewer who, at least in his immediate response, is encouraged to assume a superiority to the object of ridicule. As Swift himself mordantly commented: "Satire, being levelled at all, is never resented for an offence by any, since every individual Person makes bold to understand it of others, and very wisely removes his particular Part of the Burthen upon the shoulders of the World, which are broad enough and able to bear it."[13] That vantage point from above, now adopted in both painting and prose, is thus representative of the superior position which the viewer-reader is invited to share. In Swift's work, it is only in the final tale of the Houyhnhnms that the situation is irrevocably reversed, as the reader is compelled inescapably to recognize in himself the stench and bestiality of the Yahoo and thereby to desert his elevated status as observer and to join the nauseating object of the satire below.

The purpose of the entire venture in recounting Gulliver's visits to far-away lands in order to compare and contrast the habits, traditions, and moral sensibilities of their inhabitants with the reader's own sets of values and practices is fulfilled in a manner quite different from the tradition of travel literature popularized in the previous century. In Swift's own library there resided numerous travel books, including the five volumes of *Purchas his Pilgrimes*, Hakluyt's *Voyages*, the *Voyage de Siam*, *Histoire d'Aethiopie*, and *Voyage de Maroc*, together with Bernier's *Grand Mogul*; and his knowledge of such accounts extended well beyond those on the shelves of his study. In a letter which he wrote to Vanessa in July, 1722, while engaged on the composition of *Gulliver*, he informed her that he was reading "I know not how many diverting Books of History and Travells."[14] Yet helpful as they may have been in stimulating his own imaginary journeys, the purpose of those earlier works had been essentially to report back on the eccentric and strange discernible overseas, to entertain the reader with the queer customs observable in foreign, generally uncivilized lands, and thereby to confirm the reader's sense of sophistication in belonging to a more cultured and enlightened community. If Swift looked to the travel books for the verisimilitude of detail concerning shipwrecks, navigation, and topography, his literary purpose was, as Robert Elliott has shown, closer to such fictional forebears as More's *Utopia*, intended to expose by such com-

parison the cruelties, injustices, and absurdities of the system at home, in which both writer and reader lived.[15] It marked also a turning point in eighteenth-century cultural relativism, foreshadowing Goldsmith's *Letters from the Chinese*, his criticism of contemporary English society in the guise of a learned foreign visitor.

Such changes in attitude are often reflected artistically in apparently minor modifications, far-reaching though they may be. This instance involves a development already hinted at in our examination of the satirist's (and, by extension, his reader's) assumption of superiority. In baroque painting there was a marked tendency, as in Rubens's *Hercules and Envy* (*fig. 8*) or his *Rape of the Daughters of Leucippus* (*fig. 57*), to move the artist's vantage point below the level of the subject, thereby lending an aura of elevated magnificence to the scene presented. In the same way as in baroque ceiling frescoes, such as those by Gaulli and Pozzo, the divine, the mythic, and the heroic, gazed at from the inferior position of humankind, emerged as awesome and intimidating, so in the canvases produced by baroque artists the gap between the human and the heroic was deliberately enlarged. A painting by Canaletto or Guardi, however, like Gulliver's account of his visit to the Lilliputians, reverses that trend. The theme may be potentially no less magnificent—the embarkation of a Doge or the hostile advance of a mighty fleet—but now it is the human spectator who is elevated, attaining, as it were, the vantage point of God gazing down at the activities of puny man. At times Gulliver even adopts the prerogatives of the divine, exerting his superior power to transform the petty affairs of man below, when, for example, he captures the entire Blefuscudian fleet, according a crushing and unearned victory to his hosts.

This raising of spectator level is apparent in many eighteenth-century paintings, including some we have already examined. Watteau's *Cythera* (*fig. 38*) and Zoffany's portrait of the Garricks (*fig. 48*) both assume a personal distancing on the part of the artist, as well as an elevated vantage point such as had been the norm neither in mannerist nor baroque art. On the other hand, the raising of man to the position of a superior spectator did not bestow upon him any of the splendour previously attributed to the celestial figures soaring above in baroque painting; for here the coolly objective presentation ensures that the focus of attention, both in the canvases and in their literary counterpart, is exclusively on the activities of humanity below. A Canaletto canvas, if it provides an overview, offers no glimpse of the elevated spectator himself, only a viewpoint *from* above; and if Gulliver seems at times to be playing God, no sensitive reader needs to be told that it is the moral dwarfishness of man which is at all times the object of the satire. The sycophancy and corruption he

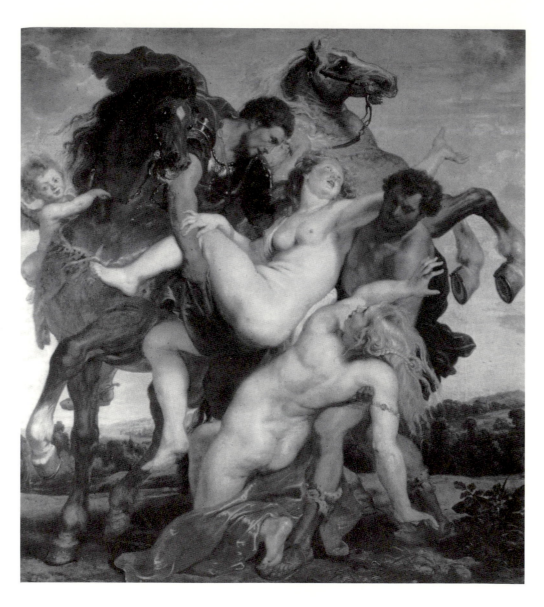

57. RUBENS, *The Rape of the Daughters of Leucippus*

perceives when gazing down at the minuscule emperor's court is no more than a grievous reflection of the hypocrisy pertaining in the court of the author's own monarch; and when he does discern some nobler quality in their system of government or law, the discovery invariably redounds to the detriment of the reader's own kingdom: "these People thought it a prodigious Defect of Policy among us, when I told them that our Laws were enforced only by Penalties, without any Mention of Reward. It is upon this account that the Image of Justice, in their Courts of Judicature is formed . . . with a Bag of Gold open in her right Hand, and a Sword sheathed in her left, to shew she is more disposed to reward than to punish."[16]

Nor is Gulliver's diminution in size in the land of the Brobdingnagians in any sense a contradiction of this principle of elevated vantage point, since the two-way satire of course functions there in inverted form, with Gulliver himself now in the position of the Lilliputian discovering how absurd his human affairs must appear through the eyes of a giant and, when boastfully recounting the military ingenuity developed by the human species, how disgusting such devilish inventiveness must seem to any rational creature regarding it in its true perspective. In such passages, he is, despite his physical subjection, in effect seeing himself in all his human absurdity from above—as he recalls how the Prince enquired in a fit of laughter whether Gulliver called himself a Whig or a Tory, and adds in his own voice "how contemptible a Thing was human Grandeur, which could be mimicked by such diminutive Insects as I."[17]

In examining the literary quality of Swift's work, both Edward Rosenheim and Denis Donoghue have been troubled by the fact that Gulliver is not, strictly speaking, a character at all, but rather someone to whom things happen. As a *persona* he compels from us at different points responses which are not only varied but even incompatible;[18] but if that valid perception has been offered as a stricture on Gulliver's lack of fictional identity, it may also be interpreted as a role consciously selected by the author for his protagonist. For Gulliver is intended to serve as the medium through whom the changing vantage point is obtained, sometimes functioning as the spectator, sometimes as the insect scrutinized, but consistently offering the reader at all times either directly or vicariously that telescopic overview of mankind favoured during the earlier years of the eighteenth century by both artist and writer.

The panoramic effect introduced in a literal sense into *Gulliver's Travels* by means of a reduction or enlargement in the physical size of man has its metaphorical counterpart in the eighteenth-century novel as it was to develop in the following

decades. The most innovative aspect of the novel genre, distinguishing it from drama and epic as well as from such precursors in prose fiction as the picaresque tale, was to be found in the more intimate and often unmediated relationship it was able to establish between narrator and reader. The stage enactment of drama, with characters speaking their own lines, had confined authorial commentary upon the affairs of the protagonists to the marginal locale of prologue and epilogue; and the epic, by the elected loftiness of its theme, its concern with gods and demigods rather than humans, could neither presume to supply a running critique on the motives, actions, and personal feelings of its heroes nor, from the Olympian heights at which the poetic tone was set, permit the poet to relax with the reader and communicate with him in natural dialogue. That major attraction of the novel, its animadversions on the sensibilities and prejudices of the participants, on the significance of the events in which they are involved, and on the philosophical, ethical, or religious implications of the story, projects the narrator into the position of overseer, casting his eye critically over the entire scene unfolding before him. It is a principle holding true, if in a more limited form, even for the epistolary form of the novel where no authorial voice was to be heard. There the very device of a letter writer, seated alone in a room, wishing to communicate to some distant relative or friend the details of his or her immediate predicament, provided a literary pretext for informative description, a filtering of events through the writer's personal impressions and conjectures in a manner far closer to the role of a narrator than of a *dramatis persona* speaking upon the stage.

When the narrator is omniscient, however, the full panoramic effect is achieved. Fielding's lengthy prefaces to his chapters, criticized though they may have been for their temporary disruption of the fictional flow, in this respect constituted extrapolations rather than interpolations, extensions of his acknowledgedly prejudiced remarks on the behaviour, motives, virtues, or moral blemishes of his characters generously offered to the reader in the course of the narrative itself. The account of Captain Blifil's choice of a future wife leaves no room for a romantic reading of the event. In what Bakhtin has termed the "dialogizing" process characteristic of the new novel genre, especially in its comic form, Fielding speaks here in two contrasting voices, the first in ironic parody of society's ceremonial, hypocritical sententiousness and the second with the crushing bluntness of inexorable truth. The Captain, he explains, "very wisely preferred the more solid Enjoyments he expected with this Lady, to the fleeting Charms of Person: he was one of those wise Men, who regard Beauty in the other Sex as a very worthless and superficial Qualifica-

tion; or, to speak more truly, who rather chuse to possess every Convenience of Life with an ugly Woman, than a handsome one without any of those Conveniences."[19]

It was no doubt because of his function as narrator within the new genre that Fielding saw himself as now belonging to the fraternity of epic writers rather than dramatists, even though his own previous experience in the theatre might more naturally have led him to establish the lineage of the novel from that source. Conscious that he was "in reality, the Founder of a new Province of Writing," and repeatedly presenting the new mode as being an outgrowth of the epic, he invoked the leading classical proponents of that genre, sometimes seriously, sometimes with an ironic awareness of the contrasts, to serve as standards both for himself and for his reader in his experimental excursions into untried areas of narrative form. In defining the new genre at the outset of his career, he drew attention to two qualities relevant to those elements discussed here, noting both the broadening of vista and the downward angle of vision contrasting with the traditional epic and romance. The novel he proposed to write would, he confirmed, be "more extended and comprehensive; containing a much larger Circle of Incidents, and introducing a greater Variety of Characters" than the graver form of romance. Furthermore, it would not treat elevated characters, as did the epic and the graver form of romance, but would deflect its attention to "Persons of inferiour Rank and consequently of inferiour Manners."

That duality in Fielding's reliance upon the epic tradition, his awareness of the altered angle of vision from above instead of from below, coupled with his insistence upon the shared quality of authorially presented narrative, is discernible throughout his writings. Molly Seagrim's battle in the graveyard, "sung by the Muse in the *Homerican* Stile, and which none but the classical Reader can taste," provides on the one hand an exercise in that favoured mode of his time, the mock-epic, in which the reader is invited to perceive the ludicrous effect of applying the elevating language of the graver epic to characters inferior in every sense of the term. Yet on the other hand, in a serious discourse elsewhere on the qualifications necessary for the novelist, amongst which must be included sound learning and a knowledge of *belles lettres*, it is to the epic writer, acknowledged as a fellow member of the guild of storytellers, that he turns for evidence, claiming that Homer and Milton, "though they added the Ornament of Numbers to their Works, were both Historians of our Order."[20]

The novel's broadening of social concern, paralleling the overview of a Canaletto or Guardi, was to some extent implicit in this authorial commentary upon

human action. The fascination in the Renaissance with the complexity of man's nature had necessarily included some interest in the relations of the individual to those about him; but the primary focus at that time had been upon the inner experience of the individual, a penetrating of illusory external appearances to acknowledge, as in the study of Hamlet or the portrait of the Mona Lisa, the mystery within. It was an interest continued through the period of metaphysical poetry too, where the operative link was with the divine or supranatural rather than with the fellowship of man. In contrast, it is of course the social implications of the eighteenth-century novel which provide its motive force even in those works which may appear removed from such enquiry. Defoe's Robinson, shipwrecked upon an island far from civilization, may seem to offer little opportunity for examining the functioning of man as part of a community; but the central theme which emerges is that very concern with social responsibility and the moral support to be derived from human fellowship examined from its negative aspect, an exploration of the resources a Christian could effectively draw upon when segregated in an imprisoning Island of Despair from the blessed concourse of men.[21] Similarly, even Richardson's psychologically oriented *Pamela* had placed at the very forefront of its didactic concern the sexual, ethical, and religious mores regarded by its author as desirable for a Christian society. Within its enclosed atmosphere, he presented his reader with a spectrum of class attitudes to chastity, self-indulgence, and Christian piety ranging in variety from the aristocrat to the serving wench in a manner intended to mirror the behavioural patterns of society outside. And the motley journeyings of Fielding's characters through the English countryside at large, meeting *en route* with Quaker and soldier, felon and magistrate, parson and prostitute, all perceived through the discriminating eye of an author sensitive to the individual's responsibilities to the human community, exemplified in its fullest form the aspect of social panorama intrinsic to the mainstream eighteenth-century novel, and so clearly represented in the visual arts by the innovative perspective of *veduta* canvases.

One of the few areas immune to academia's traditional suspicion of interdisciplinary synchronic studies has been the relationship between Hogarth and Fielding; for in this instance the documented contact between author and artist as well as their own recognition of the similarities in their moral and aesthetic aims obviated any need for defensiveness on the part of a critic attempting to establish parallels. As early as

1948, when so very little scholarship in the area of interart studies, other than Chauncey Brewster Tinker's tentative thesis *Poet and Painter*, had as yet appeared in the English-speaking world, Robert E. Moore published his thematic and stylistic comparison of Hogarth and Fielding confident that their own assertions of mutual admiration and shared interests, including their attack upon contemporary social abuses, would protect him against any charge of that blurring of boundaries in art media which Lessing had so sternly warned against.[22] Fielding's generous tribute to Hogarth in *The Champion*, lauding the artist as among the best satirists that "any Age hath produced," and his repeated apostrophes to him in the course of his own writings as having excelled in visual presentation anything that he, a mere writer could create—"O, *Hogarth*, had I thy Pencil! then would I draw the Picture of the poor Serving-Man"—as well as his direction of the reader from time to time to a specific work by the painter in order to flesh out his own descriptions, was reciprocated by the frontispiece Hogarth provided for Fielding's play *Tom Thumb*, by the note "See the Preface to *Joseph Andrews*" at the foot of his drawing, *Characters and Caricatura*, in 1743, and by the posthumous portrait of the author which he provided for the collected edition of the latter's works.[23] Both were conscious innovators breaking with the traditions of their media. Fielding's innovations we have already noted. Hogarth was rebelling stylistically against the elevated formality of painting imported from the continent by such foreign artists as Van Dyck, Lely, and Kneller, and was determined to inaugurate a full-blooded English mode, sharply contemporary in its topicality, lively rather than posed, tending even to the boisterous in its satiric yet morally didactic presentation of the London scene.

Moreover, Hogarth had brought painting a significant stage nearer to literature in having introduced to the more static medium of painting the principle of a morally didactic progression, a narrative sequence which, as Paulson has pointed out, was intended by the construction of each picture (if the engravers refrained from reversing the drawings) to be read from left to right in a manner reminiscent of the written form. All these elements, as has been widely recognized in the past forty years, either moulded or reflected Fielding's own contributions to the novel during that same period.[24]

There is, moreover, the mutually acknowledged bond between them in their eschewing of caricature, identified by them as a form of burlesque, with Fielding turning to Hogarth's drawings as exemplifying the avoidance of such excess even within the satirical mode and Hogarth reciprocating the compliment in the foot of his drawing on caricature cited above. In general terms, Hazlitt recorded perceptively in his day how Smollett reversed that principle in the novel by deliberately

cultivating the despised burlesque form, commenting that "Smollett excels most as the lively caricaturist: Fielding as the exact painter"; and, although this is not a point which I propose to elaborate here, it may be worth noting in passing how closely that development paralleled visual satire in its movement from the more restrained forms in Hogarth to the rumbustious and often unbridled cartoons by Rowlandson and Gillray. Smollett's delightful description of Lismahago, the most colourful character in *Humphry Clinker*, does not desert entirely Fielding's insistence upon exhibiting in the novel men rather than monsters. Lismahago comes vividly to life, his physical features remaining technically within the bounds of the possible; but Smollett's comparison of his thighs to grasshopper's legs, and his employment of the term "half a yard" rather than eighteen inches for the length of his face create a ludicrously hyperbolic effect remarkably close to that produced in the cartoons by Rowlandson and Gillray, such as the latter's *Hero's Recruiting at Kelsey's, or Guard-Day at St. James* (*fig. 58*):

> He would have measured above six feet in height, had he stood upright; but he stooped very much; was very narrow in the shoulders, and very thick in the calves of his legs, which were cased in black spatter-dashes—As for his thighs, they were long and slender, like those of a grasshopper; his face was at least half a yard in length, brown and shrivelled, with projecting cheek-bones, little grey eyes on the greenish hue, a large hook-nose, a pointed chin, a mouth from ear to ear, very ill-furnished with teeth, and a high narrow forehead, well furrowed with wrinkles.[25]

A comparison of Gillray's caricatures with any of Hogarth's characters reveals the principle involved. Any Hogarthian figure, however eccentric he or she may appear, could, like Fielding's Squire Western, conceivably walk out of the picture into the real world, whereas Gillray's or Rowlandson's, like Smollett's (if the imagery be included as intrinsic to the description), belong ultimately to the realm of fantasy. The latter artists titillate the imagination, commenting indeed on events in the real world, but employing as their means an extrapolation of the mundane into the absurd.

The aspect of the artistic initiative shared by Hogarth and Fielding which I would like to examine here is related to a central concern of modern critical theory, what has come to be called reader-response criticism—the focus upon the cognitive faculty of reader and viewer as forming an intrinsic part of literary or artistic discourse, no longer to be regarded as passive recipients but as active contributors to

58. GILLRAY, *Hero's Recruiting at Kelsey's*

the communicative process. Where the New Critics had placed the main, often the exclusive creative function upon the author as a conscious manipulator of reader reaction through connotations and allusions implanted designedly within the text, Wayne Booth argued that fiction involved a more intricate procedure, the establishment of a delicate relationship between author and reader, at times through the mediation of a supposed narrator. In a work such as *Tom Jones* he posited the projection of two separate images, implied author and implied reader, whose eventual coalescence in ideological principles and moral values was to be seen as marking the

consummation of its literary purpose.[26] The implied reader, in that theory, is a fictive role which the true reader is gently persuaded to adopt in the course of the narrative.

In such an interpretation, the text, as the medium whereby the author constructs that reader-role and seduces the reader into enacting it, still retained the primary controlling function. It did so in a manner which was to prove unacceptable to a subsequent generation of critics sensitive to language as semiotics, as a system of intertextual communication in which the reader serves as the destination for multi-dimensional code messages available for him to decipher in accordance both with his own independent judgments and with the cultural norms of the time in which he was living. Northrop Frye's categorical statement that the author provides the words and the reader the meaning assumed a distribution of responsibility wherein the recipient performs a major creative role.[27] The more radical assessments by de-constructionists such as Derrida, perceiving in the act of reading the superimposition of a contrary view upon the logic of the text to produce the violence of unresolved dual meaning, have led to a further diminishing of the authority of the text as such, which, although Derrida does not himself apply the theory to specific literary works, would appear to make the act of writing itself quite pointless.

The defensive critical reaction that deconstructionism provoked has resulted in more moderate voices making themselves heard and being likely to prevail. In E. D. Hirsch's helpful distinction between the totality of a text's intended *meaning*, for which the author is wholly responsible, and the *significance* which that text may have for a reader living in a later generation and a different culture, there has been seen a possibility, by separation, of restoring the validity both of the literary text and of the gloss legitimately placed upon it by the reader.[28] That critical progression has not only been paralleled for the visual arts but has there often pioneered the change, Ernst Gombrich's fascinating study, *Art and Illusion*, proving seminal for literary critics too, together with studies by Rudolf Arnheim and others, the two streams merging in such contemporary scholarly journals as *Representations*, exploring the interconnection of the two critical approaches. It is against the background of that new sensitivity to communicative discourse that we may approach the innovations introduced by Hogarth and Fielding to the process of "reading" involved in both painting and literature.

Perhaps the most valuable outcome of the critical oscillation between the primacy of author and of reader during this century has been the attention directed in recent years to instances of planned, creative cooperation between the two. Whatever conflicts may exist between the demands of the text and the imposition upon

it of the reader's will, there has emerged a perception, most clearly defined by Wolfgang Iser but already implicit in Wayne Booth's earlier analysis, that there may be discerned within the narrative text, deliberately inserted by the author, certain "gaps" or omissions which the reader is required to fill.[29] That technique may manifest itself more overtly, as in the blank page which Sterne obligingly inserted in *Tristram Shandy* on which the reader is invited to sketch his own impression of the heroine's beauty, since no two conceptions are identical. More frequently, the requirement may be inserted obliquely, with room left in the text for the reader to make some necessary judgment before proceeding further. The fact that Iser, in a wide-ranging work examining changing fictional forms over many centuries, first develops this theory of intentional omissions in the course of his treatment of Fielding may have especial significance. Its origin at that time, I propose to suggest, was not fortuitous but, as always, reflected certain cultural changes indigenous to his time, a theory supported by its simultaneous and independent appearance in the works of Hogarth, with that process functioning in both media as a central element of the artistic genre they were inaugurating.

It may be useful to begin with an intriguing preface to an otherwise insignificant pamphlet published in 1748, the preface providing a valuable insight into the way in which Hogarth's engravings were received by the public of his day. The anonymous author of that pamphlet, entitled *The Effects of Industry and Idleness Illustrated . . . Being an Explanation of the Moral of Twelve Celebrated Prints, lately Published, and Designed by the ingenious Mr. Hogarth*, had been duly impressed by the popularity of Hogarth's prints. Determined to avail himself of the opportunity it offered for some didactic preaching, he decided to publish a small work expounding, for those who might (incredibly!) miss the point, the moral lessons to be derived from the newly issued series of engravings entitled *Industry and Idleness*.

In the preface itself, markedly more informative than the pedestrian teachings which follow, he recalls the experience he had which led him to his decision, a visit to a number of print shops on the day when the engravings were first displayed there for sale. Jostled by the crowd of people of all ranks eager to see them, the grave author of the pamphlet had decided while awaiting his turn to take note of the opinions expressed by the onlookers, and by that means "to find out the Influence which a Representation of this kind might have upon the Manners of the Youth of this great Metropolis, for whose Use they seem chiefly calculated." Surprised by the reaction, he extended the experiment, visiting other London print shops to confirm his impression. At each the public's response was the same, echoing in different forms the comments which had prompted him to begin the tour. Instead of an awed

acceptance of the moral lessons conveyed by the series, an awakening, as he had expected, to the dire penalties awaiting idleness and the rewards laid up for the industrious, the mood was one of lively curiosity:

> . . . the first I heard break Silence was one of the Beadles belonging to the Court-End of the Town, who upon viewing the Print of the idle 'Prentice at play in the Church-yard, breaks out with this Exclamation, addressed to a Companion he had along with him, *G-d Z-ds, Dick, I'll be d-n'd if that is not* Bob ——, *Beadle of St.* —— *Parish: its as like him as one Herring is like another: see his* Nose, *his Chin, and the damn'd sour Look so natural to poor* Bob. *G-d suckers, who could have thought* Hogarth *could have hit him off so exactly?*[30]

Appalled that the populace should waste its time upon such trivia, the pamphleteer proceeds at once to the solemn task of spelling out the ethical lessons of the pictorial sequence.

The consistency of the commentaries the pamphleteer overhears at each station on his tour has a message for us that must not be overlooked—that what attracted the public even more than the ethical teachings developed in the plot line was the invitation Hogarth offered the viewer for personal, creative response, the challenge of deciphering the details of the picture, including facial identification of those minor characters whom Hogarth included with such mordant topicality as a means both of conveying and of reinforcing his message. The impact of his series, *The Harlot's Progress*, had, we know, owed much of its powerful effect to the immediate recognition by viewers in its initial picture (*fig. 59*) of figures only too familiar to all Londoners. Welcoming the innocent country girl to the city is the notorious "Mother" Needham, the procurer responsible for enticing countless country girls into prostitution on their arrival in London by offering them positions as servants in supposedly respectable homes; and behind her, watching the entrapment, stands the evil roué, Colonel Charteris, in whose household many such girls had innocently found themselves installed as domestic help, there to be seduced or forcibly raped by him, and callously discarded at a later date when found pregnant.[31] This aspect of Hogarth's work is both well known and well documented. It is the extension of it, however, which may prove enlightening for certain aspects of Fielding's art.

In that same plate, there may be perceived behind the potential harlot a clergyman seated upon a horse, studying a letter, and seemingly unconnected with the events in the foreground; but the discerning "reader" of the picture familiar with Hogarth's technique will take the trouble to examine the writing upon the letter

59. HOGARTH, *The Harlot's Progress*, Plate 1

being scrutinized, discovering that it is addressed to "the Right Reverend Father in God . . . London," that is, to Bishop Gibson, the senior churchman responsible for advising Sir Robert Walpole on matters of ecclesiastical preferment. There is, as Iser would say, a gap here which the viewer is invited to fill out by reliance upon his own knowledge, intelligence, and deductive skill, recognizing from that hint Hogarth's scathing attack on the clergy, so preoccupied with their own professional and material advancement as to turn their backs upon those of their parish urgently in need of spiritual guidance.

This invitation to ferret out and resolve the visual cryptograms became characteristic of Hogarth's prints, familiar to the initiated and, as the description of the crowds at the print shops confirms, eagerly taken up by them. In Plate 1 of *Marriage à la Mode* (*fig. 60*), in what might have been a traditional genre painting in the Dutch style, the viewer is offered a host of clues from which he himself must deduce the

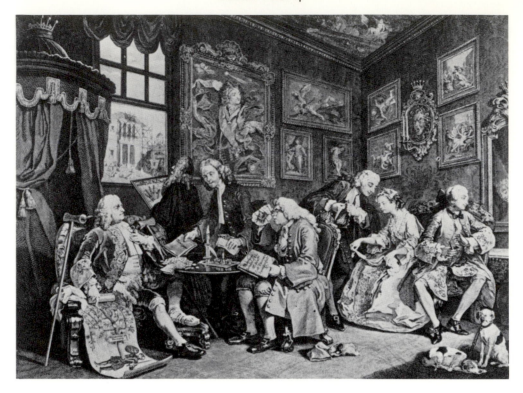

60. HOGARTH, *Marriage à la Mode*, Plate 1

message; to discern in this marriage of convenience the unloving relationship between the dandyish son of an impoverished Lord Squanderfield, gazing narcissistically at his own reflection in the mirror, and the wealthy merchant's daughter already more interested in the amorous advances of the lawyer than in the proposed bridegroom on whom she has turned her back. There are the chained dogs in the foreground ironically prophesying the couple's marital fate, Lord Squanderfield's bandaged foot suggesting the life of self-indulgence which has brought on the gout, a self-indulgence which the son will no doubt inherit, and the artist's commentary on the contemporary vogue of constructing ostentatious Palladian-type buildings which has drained the family coffers. The clues are scattered everywhere, as in the following plate in the series, the period after marriage where the lace bonnet carelessly left protruding from the husband's pocket reveals the reason for his exhaustion, the infidelity and debauchery of the preceding night, while the curtained picture in the farther room disclosing only a naked foot indicated for contemporary

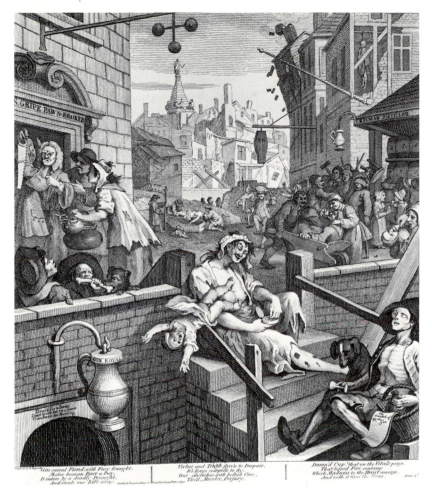

61. HOGARTH, *Gin Lane*

viewers the young couple's fashionable indulgence in pornographic art. In Plate 5 of *The Rake's Progress*, depicting his mercenary marriage to an ugly harridan, the cob-web covering the charity poor-box at the side of the engraving offers a sceptical commentary on the congregation at large, a commentary which, once again, the viewer must seek out and deduce for himself. The same holds true for all his satiric work. The main message of a print such as *Gin Lane* (*fig. 61*), the drunken mother oblivious as her child falls to its death in the foreground and the skeletal form of an inebriate sprawling before her, is so shockingly presented as to require little elaboration on the part of the viewer; but the background constitutes a veritable treasure

trove of clues demanding decipherment and welcoming detailed search. Among the buildings collapsing in ruins or ineffectively propped up by cheap wooden planks, the only commercial ventures thriving in the neighbourhood and displaying shop signs in good repair are the two gin-shops, the pawnbroker's (to which a workman is bringing the very tools by which he earns his livelihood in order to obtain a few coins for gin), and the coffin maker's. A suicide can be dimly discerned hanging from a rafter, a famished tippler gnaws a bone snatched from a dog, and ironically presiding over all is the steeple of Nicholas Hawksmoor's St. George of Bloomsbury, symbolizing a church remote from and untouched by the delapidation, spiritual decay, and human suffering occurring within its own parish.

Another pamphlet produced by a Grub-street hack in April 1733 underscores this aspect of his work. Its author, attempting to exploit the popularity of Hogarth's harlot sequence by means of a heroi-comical poem entitled *Morality in Vice*, prefaced the work with a letter, spuriously attributed to Ambrose Philips, in which he praised the poem as providing: "A true Key and lively Explanation of the Painter's Hieroglyphicks."[32] The latter is a particularly telling term, since it suggests, however uninspired the pamphlet itself may have been, a popular perception of the lineage to which Hogarth's artistic technique belonged.

The deciphering of symbols or hieroglyphs in literary and artistic works was in itself, of course, not new, but Hogarth's deviation from the established norms proves of more interest than his conformity to them. The mainstream iconological tradition, emanating from the medieval world, modified by the Renaissance, and continuing well into his own era, had reserved only a limited task for the observer, namely the explication of the symbols in accordance with a fixed and universally accepted code. The presence of a peacock in a Nativity painting by convention indicated Eternal Life, a lily represented the chastity of the Virgin, and a dove was the universally accepted symbol for the Holy Spirit. In the Renaissance, that code became more complex as, in accordance with Pico's positing of a universal religion, classical mythology was merged with the Christian, the gods of Greece and Rome being seen anew as adumbrations of Christian concepts for pagans not yet privileged to know the true faith. Furthermore, as burgeoning philosophical interests broadened the range to allow for more abstract allegorization, symbolism acquired ramified accretions. But for those in need of assistance in coping with this expanding pattern of allusions there lay ready to hand Cesare Ripa's *Iconologia*. First published in Rome in 1593, reissued with illustrations shortly thereafter, and appearing

in an English translation together with illustrations in 1709, it supplied a ready key for unlocking the meanings encoded in the symbols of Renaissance art, proving particularly valuable for those embarking on the Grand Tour. In that system of exegesis, where a knowledge of a standard interpretive cipher or the consulting of a handy reference book could resolve the cryptogram, the imaginative creativity demanded from the viewer was minimal.

The emblematic tradition, whose development in the sixteenth and seventeenth centuries has been widely studied, notably by Rosemary Freeman and Mario Praz,[33] may be seen as having turned away from such established cryptograms, derived in the main from literary sources including the text of the Holy Scriptures, in favour, as in the works of Francis Quarles, of a free-ranging process of invented hieroglyphs designed in both visual and verbal form to strengthen the moral message imparted. In that tradition, however, it was the poet-teacher alone who performed for an essentially passive reader the task of deciphering the enigmas, conveying in an often simplistic form the lessons encapsulated in the title of the poem or in the illustrative emblem printed above.[34]

In Hogarth's prints two notable changes in technique are to be perceived, relating both to the character of the symbols themselves and to the role demanded of their "reader" in the process of decoding. With regard to the former, the emblem requiring decipherment has, as part of the more general eighteenth-century focus upon urban activity, been removed from the divine or natural setting to the everyday human scene viewed in all its mundane realism—in the ward of a London jail, at a stagecoach terminal, or in the hospital for the insane at Bedlam. The symbol, moreover, is no longer a standard representation derived from a recognized and authoritative code, wherein the artist acts only as the transmitter of the image, but is now of the artist's invention and hence demands some degree of viewer interpretation. There is the black servant-boy pointing amusedly at a horned figure, wryly placed in the foreground of Plate 4 of the *Marriage à la Mode* to suggest the imminent cuckolding of the husband, or the device so often employed by him of ironic contrasts between ennobling mythological paintings hanging upon the wall and the sordid scene being enacted in the foreground. Some instances, such as the chained dogs, may be more obvious, intended for the populace; but some are less so, offering a challenge and a more satisfying reward to the perceptive, such as the banner above the somnolent members of *The Sleeping Congregation* in church, whose message, half-blocked by an intervening pillar, is appropriately godless in its truncated announcement, "ET MON DROIT."[35]

No less innovative than the nature of the symbols is the role Hogarth imposes upon the viewer, symbols such as these making a demand upon the "reader" beyond that of previous traditions. The latter must not only search out for himself those significant details, often, like the church banner, teasingly hidden away in unlikely places, but must also activate his own intelligence, without the aid of reference book, without an inherited system of decoding, and without authorial guidance, to discover the enigmatic allusion intended by the artist. No overt connection is established between the mythological paintings on the walls and the events depicted below—between the Rape of Io representing the soul ecstatically caught up by the divine spirit, visible above the soirée scene in Plate 4 of *Marriage à la Mode*, and the squalid seduction of a bored newly wed by the parvenu lawyer Silvertongue with which it is to be contrasted. But, by that very absence of authorial direction in indicating the significance of their presence in the engraving, the artist invites the viewer to exercise his own faculties of perception or (to return to Wolfgang Iser on the fictional narrative of that period) ensures that such intentional "omissions are repaired by the reader's own imagination."[36] It was an innovation peculiarly suited to a rationalist age priding itself on the logically deductive powers of the human mind, the individual now being encouraged to activate those intellectual qualities in the process of responding to the work.

The connection of this technique with Fielding's novels is more than tangential, revealing there an aspect of his narrative art which is, I believe, of major importance for assessing his contribution to the direction of the new genre. The sense of intimacy which Fielding established between implied author and implied reader, with his genial request that the digressive prologues to each section be regarded as inns or resting places where a glass of ale could be drunk in amity, was, of course, to become a hallmark of the subsequent novel, and the effectiveness of that device for creating fictive credibility has been fully recognized in criticism. Less obvious is the manner in which that established communion and the opportunity it offered Fielding for gentle raillery of the reader were exploited by him to coax us into performing a more creative interpretive role in the process of plot development, a task very similar indeed to that imposed by Hogarth upon the viewer of his prints. The epithet which Fielding repeatedly invokes in addressing his reader is *sagacious*, sometimes employed banteringly to scold the reader for failing to be alert, but more often as an incentive to a more discriminating response to the text, a spur to the reader's exercising of his investigative and inferential faculties. The area to which the sagacity is to be directed is not, as Iser has argued, a general perception of Fielding's

purpose but much more specifically the uncovering of clues hidden within the unfolding plot which might help solve mysteries or riddles only to be fully revealed at the conclusion of the work. In a significant passage, urging the reader of *Tom Jones* to utilize that perceptiveness effectively, Fielding makes a distinction between, on the one hand, the author's duty to supply the necessary particulars or clues within the text and, on the other, the reader's responsibility for eschewing lazy passivity, employing instead a constant vigilance in responding to those details, the interpretation of which will require, he assures us, not divination or guesswork but deductive observation based on the evidence so carefully provided:

> Bestir thyself therefore on this Occasion; for tho' we will always lend thee proper Assistance in difficult Places, as we do not, like some others, expect thee to use the Arts of Divination to discover our Meaning; yet we shall not indulge thy Laziness where nothing but thy own Attention is required, for thou art highly mistaken if thou dost imagine that we intended, when we began this great Work, to leave thy Sagacity nothing to do, or that without sometimes exercising this Talent, thou wilt be able to travel through our Pages with any Pleasure or Profit to thyself.[37]

This technique of concealing within the text ambiguously worded information whose significance—if only to be recognized retrospectively by the less acute reader—was available there for the more discriminating to seize upon, functions throughout the work in a manner to be found neither in the epic tradition nor in the drama previous to the appearance of the novel. The quality of Fielding's plot construction was at once acknowledged not only as outstandingly effective but as unprecedented in the economy of its patterned progression. Fielding's first biographer claimed in 1762 that there was no fable whatever that "affords in its solution, such artful states of suspense, such beautiful turns of surprise, such unexpected incidents, and such sudden discoveries, sometimes apparently embarrassing, but always promising the catastrophe, and eventually promoting the completion of the whole"; and James Beattie asserted a few years later that not since the days of Homer had the world seen "a more artful epick fable."[38] One main constituent of its tightness of structure, distinguishing it from previous works, is, I would suggest, this quality of the teasing challenge constantly posed to the reader to utilize his own powers of observation and deduction in a work calculated to withstand and indeed to reward such close scrutiny. All literature, including drama, had of course employed images, connotations, and ambivalences to reinforce its effects, often encap-

sulating within some early allusion a fateful hint of events to come. The scene of the witches in *Macbeth* supplies at the outset a general foreboding of evil, as well as the sense of inevitability requisite for tragedy. That traditional process offered, however, no composite informational design from which the audience was invited to piece out the future course of the plot or to elucidate some narrative riddle it posed. The audience at the time of witnessing the witches' scene, for example, as yet lacks the knowledge which could make such inferential analysis feasible. In comedy, to which Fielding's novel is more closely related, the audience was often made fully cognizant of the cause of the dramatic confusion—as in the existence of a surviving twin sibling in *Twelfth Night*, the dénouement furnishing them the satisfaction of witnessing the belated discovery of that fact by the other characters in the play. Alternatively, as in the comedy of the Restoration and early eighteenth century to which the new novel was even more closely allied, the dénouement came as a surprising reversal to the audience too—the notorious "strawberry mark" or family heirloom recognized in the final scene, which unexpectedly reveals Indiana in Steele's *Conscious Lovers* to be the long-lost daughter separated from her father in a shipwreck. That latter cliché was, of course, precisely the stage format incorporated with tongue in cheek into Fielding's earlier venture into the novel genre, with Joseph Andrews disclosing at its end the inevitable strawberry mark and Fanny being identified as the babe stolen by gypsies. It was only in his subsequent work, in *Tom Jones* published in 1749, that Fielding began to develop the new technique, a sowing of clues earlier in the plot to supply the audience with the possibility of foretelling its direction by searching out allusive details—a process closely reflecting Hogarth's inclusion of the horned figurine in *fig. 61* already adumbrating for the alert viewer the future cuckolding of the young husband.

This innovative aspect of the eighteenth-century novel, once it has been identified, may be claimed as the prototype for one of the most characteristic elements in the later bifurcated development of the novel genre. In the less profound form, it was to lead to the vastly popular detective novel of the nineteenth and twentieth centuries, to be inaugurated in America by Edgar Allen Poe's short story, "The Murders in the Rue Morgue," and in England by Wilkie Collins's *The Moonstone*. Among literary historians, the detective story has come to be regarded almost universally as an offshoot of the Gothic novel, not least because of Poe's simultaneous popularizing of both forms in such stories as "The Fall of the House of Usher" and "The Purloined Letter." There are indeed certain affinities in the sense of mystery they both evoke. But surely the most distinctive and engaging element

in the detective novel has always been not the Gothic gloom of the opening scenes of murder but the stimulating process of deductive investigation in which the reader is invited to participate, competing with the inspector in a race to unravel the mystery on the basis of factual details which, as part of the convention of that genre, must be provided by the author, concealed within the text, but available for the more discriminating. That major attraction of detective fiction has, of course, no precedent in the eighteenth-century Gothic novel, whose fantasy worlds were too far removed from reality to allow the principles of logical inference to function. Poe's "Murders in the Rue Morgue" opens indeed with a lengthy celebration of the theme to be adopted for such detective stories, the functioning of the human analytical faculty or *acumen*, which is able to "disentangle" enigmas. If, in fact, the American form of the detective story was soon to take a different direction, appropriating the frontiersman tradition and focussing upon a hero battling the corrupt forces of society, in the English variety typified by Agatha Christie's stories, the game element, as an intellectual solving of a mystery, remained paramount, with the police, as foils to the detective, not corrupt but slow-witted and comically inept.[39]

The concealment of clues within the text was to prove valuable not only for the rise of the detective story but for the development of the mainstream novel too. One has only to examine the works of Dickens, a self-declared admirer of Fielding and a personal friend of Wilkie Collins, to perceive how integral the principle of embedding cryptograms within the text was to become to the more literary variant of the genre, employed there as a means of creating increased suspense within the plot. There is the mysterious Lady Dedlock in *Bleak House*, whom only the more ingenious reader responding to strategically deployed allusions would, prior to the formal moment of authorial revelation, succeed in identifying as the mother of Esther. The hints are all there, waiting to be discovered. On her first meeting with Lady Dedlock, convinced she has never seen her before, Esther wonders "why her face should be, in a confused way, like a broken glass to me, in which I saw scraps of old remembrances; and why I should be so fluttered and troubled (for I was still), by having casually met her eyes."[40] And Mr. Guppy, the lawyer's clerk whom we had first met welcoming Esther to London, is, on confronting Lady Dedlock's portrait, puzzled at a disturbing, unidentifiable likeness it brings to mind. Read in isolation, such hints may appear too obvious to be missed; but within a novel shrouded in mistiness, in secrets hidden away within crumbling manuscripts and fetid churchyards, they are liable to be grasped only by the more perceptive reader. The closeness of Dickens's art to that offshoot genre of the detective novel is evi-

denced, of course, not only by the introduction into this work of the embryonic detective figure Inspector Bucket but by the author's own experiment in the genre in his final and tantalizingly unfinished tale *The Mystery of Edwin Drood*.

In the novel at large, such provocative insertion of clues within the text of a gradually unravelling story became an essential ingredient in creating suspense and structural tightness of plot development long before the detective novel as such was to arise. And for that innovation, it is time to turn back to the original appearance of the technique in *Tom Jones*. Since Tom's parentage is eventually to function as the plot's dénouement in the final chapters (the equivalent of the famed strawberry mark), its treatment in the earlier chapters deserves some closer scrutiny. The cryptograms embedded there for the vigilant do provide the "proper Assistance" which the author has promised, allowing the reader, if only retrospectively, to admit that he had certainly been supplied with appropriate hints had he only been sufficiently wary. Bridget Allworthy could, in fact, have been left out of the opening scenes completely had Fielding preferred, sketched in only as a shadowy background figure to be returned to in the final scene when she is revealed as Tom's mother; but, on the contrary, he thrusts her into the foreground, slyly hinting there at the resolution of the story in a manner which, as in an Agatha Christie tale, makes one wonder in retrospect how the hint could possibly have been missed. Her presentation as an unbendingly stern prude leads us to imagine that she will be the first to insist that the foundling revealed in Squire Allworthy's bed be removed immediately from the house. She had, we are told, "herself maintained such a Severity of Character, that it was expected, especially by *Wilkins*, that she would have vented much Bitterness on this Occasion." But there surely can be no retrospective complaint of unfairness on Fielding's part when he archly informs us that the orders she in fact gave for its welfare (ostensibly to please her brother, the Squire) were indeed so liberal "that, had it been a Child of her own, she could not have exceeded them." Like the dead goose in the first plate of Hogarth's *Harlot's Progress*, offering the discriminating viewer a clue to the eventual demise of its foolish owner, so here the authorial hint tests out our perceptiveness, challenging us to grasp its import. Teasingly, the hint is reinforced immediately afterwards as Bridget, whose hatred for her mercenary husband has alienated their joint offspring Blifil from her affections, transfers her maternal feelings to Tom, so that, we are informed, "at last she so evidently demonstrated her Affection to him to be much stronger than what she bore her own Son, that it was impossible to mistake her any longer." Again one must stress that the context of these passages provides a camouflage allowing them to be passed over undetected, but there can be no question of the purpose of their insertion in the text.

This principle may be discerned as a motive force throughout the novel. As part of the new dialogue between narrator and reader instituted by Fielding, the reader is continually chided for possible inattention to such details or praised for his supposed diligence, often with the panache one associates with an accomplished conjuror displaying his sleight of hand. When Tom imagines with horror that he has committed incest with his long-lost mother, the query naturally arises in the reader's mind why Partridge, so well acquainted with Jenny in earlier days, had failed to recognize her in Mrs. Waters. At that point the author steps in, blandly advising us to check back into the previous chapter and into the details or "little Circumstances" there which had been carefully designed to protect the plot against this eventuality, a principle, he warns us, which is to be widely employed in the narrative and which the reader would do well to prepare for:

> If the Reader will please to refresh his Memory, by turning to the Scene at *Upton* in the Ninth Book, he will be apt to admire the many strange Accidents which unfortunately prevented any Interview between *Partridge* and Mrs. *Waters*, when she spent the whole Day there with Mr. *Jones*. Instances of this Kind we may frequently observe in Life, where the greatest Events are produced by a nice Train of little Circumstances; and more than one Example of this may be discovered by the accurate Eye, in this our History.

Such admonitions of the supposedly inattentive reader are occasionally counterbalanced by wry encouragement for his assumed alertness. When a strange lady, who has joined Sophia on her night-time journey, is joyfully recognized by her in the light of the dawn, Fielding applauds the reader for catching, as he presumes, an earlier hint and forestalling the revelation: "This unexpected Encounter surprized the Ladies much more than I believe it will the sagacious Reader, who must have imagined that the strange Lady could be no other than Mrs. *Fitzpatrick*, the Cousin of Miss *Western*, whom we before-mentioned to have sallied from the Inn a few Minutes after her." The game element in this process of clue hunting, with the reader continually urged to be on his guard, is given a new and delightful twist immediately after this incident in what may be seen as a parody or inverse image of the responsible investigative reading we have been examining. The key word *sagacious* is placed there as a signal that parody is on the way, the epithet being bestowed not by the author but by the simple local rustics. The Landlord of the next inn, we are told, "had the Character, among all his Neighbours, of being a very sagacious Fellow. He was thought to see farther and deeper into Things than any Man in the Parish, the Parson himself not excepted." Playing, as it were, a dim-witted Watson

to the (supposedly) intelligent reader's Sherlock Holmes, the Landlord disastrously misreads the "circumstances" attending Sophia, solemnly reaching by his process of deduction the absurd conclusion that she is Jenny Cameron, the mistress of the Young Pretender.[41] The reader has thus been obliquely warned against undue haste in drawing conclusions from the hints implanted in the text.

This process of clue scattering prevails throughout the novel, with instances too numerous to be listed; but perhaps a brief sampling may be offered. The dramatic disclosure of Square crouching behind the makeshift curtain in Molly's bedroom comes as a surprise to every reader on a first reading, but it serves Fielding as a perfect opportunity for training the reader in vigilance, for offering a reproving reminder to him that he might have foreknown the event had he noted a certain lacuna in the text. As he reminds us after the bedroom revelation:

> Sack had caused all that Disturbance. Here he first observed her and was so pleased with her Beauty, that he prevailed with the young Gentlemen to change their intended Ride that Evening, that he might pass by the Habitation of *Molly*, and, by that Means, might obtain a second Chance of seeing her. This Reason, however, as he did not at that time mention to any, so neither did we think proper to communicate it then to the Reader.

For the less astute player, he at times provides more obvious signals in the text, like directional arrows left in a paper chase for pursuers who tend to lose the trail. Although Mrs. Waters passed as Northerton's wife, we are offered the warning long before we know of her true identity that "there were some Doubts concerning the Reality of their Marriage, which we shall not at present take upon us to resolve." At other times silence may be more telling than such heavy hints. The arrival early in the novel of the lawyer Dowling whom Blifil, through Allworthy's indisposition, is sent to receive, is granted no authorial comment, nor any indication of its place in the story. An incident deliberately left hanging in the air, it teases the imagination of the alert reader, until the nature of the vital document which the lawyer brought at that time, and which Blifil selfishly concealed, is at last revealed in the final pages of the book.[42]

It is surely not fortuitous that both Fielding and Hogarth should have developed simultaneously this invitation and, indeed, demand for reader/viewer participation as interpreters of the clues embedded in text or engraving. The conception of hieroglyph had been secularized. Detached from the fixed religious or mythological patterns of earlier traditions, it had now been accommodated by both artist and writer

to the empirical orientation of the eighteenth century, offering a challenge to the intellectual discrimination, the perceptiveness of detail, and the deductive reasoning of the individual viewer. Only the careful viewer of Plate 3 in *The Harlot's Progress* will note that she is using as a butter dish Bishop Gibson's pastoral letter condemning the Deists. Hogarth says nothing, expressing neither anger nor condemnation. It is for the viewer both to perceive and to infer from that detail once again the dreadful failure of a church leadership too involved in theological quarrels to give thought to the straying members of the flock so deeply in need of guidance.

That innovation in reader participation offered a fresh direction for both media. In the graphic arts it was to lead to a new genre, the political caricatures of Rowlandson, Gillray, and their progeny continuing into our own day. There the import of each cartoon, including the need to identify the political characters parodied, was, as in the reception accorded to Hogarth's engravings with which we began, left for each delighted viewer to grasp independently, the very process of reader participation providing the pleasure of discovery. And in the novel it inaugurated a tightening of structure by the challenge it provided to the reader's perception, whether in the more literary forms of that genre represented by the mystery element in *Bleak House* or in the popular genre which grew from that mode, the detective story, of which Fielding, in the fellowship of Hogarth, should be seen as the true progenitor.

PRE-ROMANTICISM

5

THE BEAUTIFUL
AND THE SUBLIME

(i)

England's artistic subservience to Europe, with its reliance for over two centuries on the importation of foreign artists to keep it, if not abreast of current fashion, at least not too deplorably behind, drew to a close in the early eighteenth century. Hogarth's patriotic insistence on an indigenous art no longer indebted to French or Italian models, the emergence of Reynolds and Gainsborough as portraitists comparable with the finest in Europe, and the foundation of a Royal Academy of Art to encourage and advance British talent marked its new-found independence. From the vantage point of the continent, however, England's aesthetic initiative was neither acclaimed nor particularly noticed in the realm of painting. For all their admirable advancement English artists remained largely conservative, competing for recognition within the framework of established European traditions. Recognition was accorded instead, as the universally accepted term indicates, to its creation of the *jardin anglais*, boldly deserting the trim parterres and clipped topiaries of Le Nôtre's fashionable Versailles to experiment with innovative concepts of landscapes offering broad "prospects," undulating lawns, and groves of trees deployed to produce the effect of natural scenery.

That contribution has been the subject of wide-ranging scholarly research, beginning with a fine pioneering study by Elizabeth Manwaring in the 1920s, continued through the intervening years by such investigators as Christopher Hussey, Walter Hipple, and Edward Malins, and culminating in a veritable flood of critical studies in the present period, including that final accolade of academic acceptance,

193

the foundation of a scholarly journal devoted to its history.[1] The resulting publications have provided valuable accounts of the development of the movement from the cautious innovations of Charles Bridgeman, through the more sweeping changes introduced by William Kent and Capability Brown, and on to the eventual reversal of the fashion at the end of the century through the opposition of Uvedale Price and Richard Payne Knight. Central to such investigation has been a generous recognition of the literary aspects of that mode, including the prominence of leading writers among its early proponents, such as Pope and Shenstone. As devoted theoreticians as well as practitioners of the new art form, they and their colleagues perceived the close affinities of eighteenth-century gardening principles to the rules of Nature methodized now being enunciated for contemporary literature, affinities which make Pope's *Epistle to Lord Burlington* read almost as a gloss on his *Essay on Criticism*.

In all this enquiry into the contribution England made to horticultural design and, in a larger sense, to the transformation of its country estates into a series of varied walks, strategically located cascades, Doric temples, and grottoes for meditation, one question deserving of serious thought has been largely ignored—why, without any precedent, this sudden enthusiasm for re-creating the natural landscape, for digging artificial lakes and removing entire villages at such enormous cost, should have arisen as an essentially English phenomenon, admired and occasionally imitated overseas but acknowledged as indigenous to England itself, both in its formulation and in its elaborate implementation.[2] Such exclusivity in art form would suggest a motivational source in some way specific to the English scene.

This present chapter makes no claim to provide any neat solution, to conjure up any single cause which would explain the phenomenon in its manifold ramifications. The landscape movement, like all such artistic modes, was too complex and multitiered to allow of simplistic explanation. But it may be possible to suggest, for a period which had at last recognized painting and poetry as "kindred arts," a shared subliminal impulse which contributed significantly to the inauguration of the gardening movement in England, modulated its development through the century, and determined to no small extent the future course of romanticism itself.

We could begin with one of the commonplaces repeated with such frequency in this period by the virtuosi of the new taste as to constitute a hallmark of the movement—their admiration of scenery which conformed or might (by change of vantage point or removal of natural blemishes) be made to conform to

Whate'er Lorrain light-touch'd with softening hue,
Or savage Rosa dashed, or learnèd Poussin drew.[3]

Elizabeth Manwaring's impressive and informative study of the movement at large, *Italian Landscape in Eighteenth Century England*, in fact focussed upon this very aspect, confirming in its subtitle that it was a study "chiefly of the influence of Claude Lorrain and Salvator Rosa on English taste." That theme, justifiably pursued by subsequent critics and historians, might appear to militate against the conception of England's new independence from continental art and the exclusivity of its innovative response to the natural scene. Yet as so often in such instances of artistic indebtedness (witness Shakespeare's use of borrowed plots), identification of the source may prove less significant than the process of the adaptation of that source to contemporary needs and the reasons prompting the selection of the particular prototype. We shall need to enquire why, of the host of continental painters available as models to the eighteenth-century connoisseur, just those should have been universally chosen, and in what way they were made to answer to the specific aesthetic leanings of their admirers. If landscape paintings were needed, Ruisdael, Cuyp, and Hobbema offered such canvases in abundance; but as Hazlitt was to claim in retrospect, echoing in his own fervent admiration for Claude Lorrain the preference established by his eighteenth-century predecessors, "No one ever felt a longing, a sickness of the heart, to see a Dutch landscape twice; but those of Claude, after an absence of years, have this effect. The name of Claude has alone something in it that softens and harmonizes the mind. It touches a magic chord."[4] That magic chord may well have been the aesthetic predisposition of the viewer to be touched, the impulse that led him towards the works of Claude and Rosa as symbolizing for him elements which, even if scarcely intended by the artists themselves, spoke eloquently to the eighteenth-century viewer.

How deeply that chord echoed in the imagination has itself been subject to some doubt. The term "folly" applied later in the century to the grottoes, obelisks, ruined abbeys, and mock-hermitages erected on the grounds of the new estates, as well as the ridicule often poured upon them by contemporaries unsympathetic to their owners' aims, have led them to be regarded for the most part as little more than aesthetic aberrations. Barbara Jones, the author of the leading study of these structures, although admitting in her opening pages that they were intended seriously by their builders and were only regarded as follies by their detractors, proceeds to treat them in both the earlier and later versions of her book as no more than trivial fads,

"nonsensical" anomalies, amusing to the antiquarian or hobbyist interested in tracking them down but of no real significance.[5] Yet Pope, who was nobody's fool, invested, as we know, inordinate time and energy in the task of designing and overseeing the construction of his own elaborate grotto at Twickenham which, in its day, aroused considerable public interest. And Horace Walpole was already an established and admired connoisseur of contemporary artistic taste when he transformed his Strawberry Hill into a crenellated Gothic castle which attracted so wide an appeal that he was compelled to issue advance free tickets for visitors in order to avoid congestion. If critics have rightly perceived the intimate relationship existing between the principles adopted for landscape gardening and those prevailing for contemporary poetry, there seems no reason that we should dismiss as insignificant these buildings which were regarded in their day as so intrinsic to the overall design.

How seriously such elements were in fact treated by their designers may be suggested by one such garden begun in 1734 and completed during the following decade. Jonathan Tyers, a deeply committed Christian who claimed that salvation would come only to those combining true belief in heaven with a moral, useful, and upright life, purchased with the money he had acquired as proprietor of the popular Vauxhall Gardens a small estate at Denbies, near Dorking, intended as a Sunday retreat from his business affairs. Within the garden he designed a twofold *memento mori*. In the midst of one grove named *Il Penseroso* he erected a Temple of Death, where a clock chimed not each hour but every minute as a solemn reminder to visitors of the transience of human life. The adjacent grove was denominated *The Valley of the Shadow of Death*, one gateway to it being composed of two vertical coffins crowned by skulls (reputedly those of a hanged highwayman and of a notorious courtesan), while a second gateway depicted, in contrasting alcoves, the blissful death of a virtuous Christian and, opposite it, of a libertine tortured by the fear of imminent damnation.[6] Such grotesquerie is, of course, unpalatable to modern taste, like the worst excesses of the Catholic baroque, with hideous skeletons peering forth from sepulchral grates to remind the living of the fate awaiting them. But debased forms of art may provide valuable insights into the nobler variants. Tyers's groves recall in their theatricality the very attractions he had designed so successfully at Vauxhall, including the decorated pavilions, the exotic Turkish Tent, and the Druid's Walk; and that very echoing of technique in the two gardens suggests an underlying affinity, the Sunday retreat forming a religious obverse to his secular

concerns, a prompting on his part in an era of increased dichotomy between professional and spiritual affairs, to dedicate the proceeds of his commercial success to compensatory religious devotions excluded from his daily activities.

The relationship, contrasting yet analogous, between Tyers's two gardens does strengthen the impression that the follies fulfilled some deeper need in the dispositions of their builders, a more serious impulse than has been acknowledged. It is, at all events, unquestionable that they did form an important constituent of eighteenth-century taste, and for that alone they merit some thought. Is it fortuitous, for example, that so many elements in these landscape follies together with the literary associations they summoned up—ruined abbeys, forms of *memento mori*, hermitages, and grottoes—were predominantly Catholic in their nostalgic evocation? To suggest their source, we shall need to move back in time.

Despite the recent tendency of historians to de-emphasize or even to deny outright the dominance of rationalism in the thought of the late seventeenth and early eighteenth centuries,[7] in the area of theological writing, sources clearly confirm the long-established assessment of the transformation that occurred. The intensity of belief, the personal fervour animating the writings of earlier divines such as Lancelot Andrews or John Donne, their conviction of the almost desperate condition of the individual Christian in urgent need of divine mercy, was replaced towards the end of the seventeenth century in the sermons of John Tillotson and Isaac Barrow by a calmly reasoned advocacy of Christianity as the promoter of ordered and virtuous social conduct among rational believers. The preacher in earlier decades had wrestled passionately with his own soul and thereby with those of his congregants before the dreadful vision of eternal perdition:

> Forgive me my crying sins and my whispering sins, sins of uncharitable hate, and sinnes of unchaste love, sinnes against *Thee* and *Thee*, against thy Power, O Almighty Father, against thy Wisdome, O glorious Sonne, against thy Goodnesse, O blessed Spirit of God; . . . and sinnes against *Me* and *Me*, against mine own soul, and against my body, which I have loved better than my soul.[8]

Barrow, on the other hand, combining his scientific eminence as professor of mathematics at Trinity College, Cambridge, where Newton was his distinguished pupil, with his reputation as a learned divine and persuasive exponent of Christian doctrine, devoted the measured tones of his sermons primarily to the demonstrable

expediency of Christian belief. Throughout his writings, the message which made him to such eighteenth-century admirers as Fielding the most reliable of spiritual guides[9] was his insistence that the embracing of the Christian faith—"profitable for doctrine, for reproof, for correction"—demanded no miraculous signs from heaven nor emotional transports on the part of the penitent. It was, as he repeatedly assured his listeners,

> . . . a most rational act, arguing the person to be sagacious, considerate, and judicious; one who doth carefully inquire into things, doth seriously weigh the case, doth judge soundly about it.[10]

Archbishop Tillotson, too, although no mathematician by profession, took as a primary theme of his preaching the assurance that Christian belief, so far from being negated by the contemporary trust in empirical reasoning, was in entire conformity to those rational principles which, rightly interpreted, should provide for the sober thinker full confirmation of its tenets:

> The being of GOD is not mathematically demonstrable, nor can it be expected it should, because only mathematical matters admit of this kind of evidence. Nor can it be proved immediately by sense, because GOD being supposed to be a pure spirit, cannot be the object of any corporal sense.

Having achieved reasoned philosophical conviction of God's being, the true Christian is repeatedly enjoined to allow his judgment rather than his passion to rule him and to know that thereby he will have fulfilled the divine will:

> . . . let us always be calm and considerate, and have the patience to examine things thoroughly and impartially: let us be humble and willing to learn, and never too proud and stiff to be better informed: let us do what we can to free our selves from prejudice and passion, from self-conceit and self-interest, which are often too strong a bias upon the judgments of the best men, as we may see every day in very sad and melancholy instances: and having taken all due care to inform our consciences aright, let us follow the judgment of our minds in what we do; and then we have done what we can to please GOD.[11]

Were it not for the critical questioning of this rational disposition voiced in our own day, it would be unnecessary to demonstrate an aspect of eighteenth-century thought so long familiar to scholars. It is, however, the corollary to that point which has particular relevance to our present theme. For an extrovert such as Field-

ing, delighting in the hurly-burly of social life and, like the protagonists of his own novels, assuming that the sowing of wild oats in one's youth was a necessary prelude to moral maturation and therefore by no means to be regarded subsequently as a source of melancholy recrimination or guilt, such reasoned Christian ethic was both satisfying and welcome. Having outgrown the more urgent temptations of youth, he was able, like his own Squire Allworthy, to channel his energies into good works, to strive for the improvement of the judicial system, for the suppression of crime, and for the removal or mitigation of other social abuses. But not all Christians were of so practical a disposition, and the rational restraints upon spontaneous or emotional forms of devotion imposed by society and advocated within the Anglican church weighed heavily upon those more spiritually inclined. It is scarcely surprising that a recurrent disorder among such devotionally oriented Christians, a disorder more apparent in the eighteenth century than at any time before or since, was the disease of melancholia, a mental oppressiveness with strong religious overtones, bordering upon and at times plunging over into actual insanity. Michel Foucault, in his study of madness in the age of reason, has commented how, in the dialectic of insanity, "where reason hides without abolishing itself, religion constitutes the concrete form of what cannot go mad," offering a refuge for the mentally unstable; but when religion is repressed, as in the eighteenth century, instances of severe melancholia increase significantly.[12]

In England such mental instability was, we may note, particularly evident among those reaching their adulthood around the mid-century who had, during its early decades, been nurtured within the environment of emotional restraint. Among writers, who provide records not readily available from other sources, it was markedly prevalent. In the poet-clergyman Thomas Parnell, whose sanity was never in question but whose tendency to gloomy thoughts was to inaugurate the graveyard school of poetry, one may witness the process of frustrated adoration at the moment of its occurrence. His poem *The Ecstasy* expresses a yearning for the kind of personal communion with God which had so characterized devotional writings in the seventeenth century, the prayer for a longed-for "beam of brightness to my longing heart" which should drive away all error and doubt. In that poem a vision of heaven is granted to him; but where for his predecessors such vision had convinced the poet-seer of some transcendent truth beside which the mundane logicalities of human existence faded into insignificance, here it is the heavenly vision itself which disintegrates, cancelled out by the prosaic qualities of the eighteenth-century world:

But where's my rapture, where my wondrous heat,
What interruption makes my bliss retreat?
The world's got in, the thoughts of t'other's crost,
And the gay picture's in my fancy lost.[13]

It is not a distinguished poem, but it effectively documents the emotional sterility within the religious world of the eighteenth-century intellectual. With access to the heavenly vision blocked for him, it is not perhaps surprising that Parnell's thoughts turned to more melancholy themes, as in the haunting churchyard scenes of his influential *Night-Piece on Death*.

Such frustration of religious yearning was to extort a higher price a little later in the century. There was Christopher Smart whose suppressed devotional impulses erupted, from within an asylum for the mentally disturbed where he was temporarily freed from social and intellectual restraints, into that impassioned paean to the divine, the *Jubilate Agno*; there was the gentle William Cowper, terrified by a conviction of his own damnation, fleeing from worldly responsibilities and finding temporary relief only in the composition of his moving *Olney Hymns*; and there was Samuel Johnson himself, outwardly a pillar of sanity and common-sense, but, as those close to him soon discovered, subject throughout his life to a constitutional melancholia expressing itself, among other compulsive neuroses, in his dread of solitude—a solitude which, as we shall soon explore, was so closely allied to the religious experience of the age. Johnson had disqualified all religious poetry on the strictly logical ground that it can never preserve its lustre "because it is applied to something more excellent than itself";[14] but his prose work, *Prayers and Devotions*, reveals the innate religious feelings to which he would no doubt have given expression had he lived in another age. One entry reads: "Since the communion of last Easter, I have led a life so dissipated and useless, and my terrors and perplexities have so much increased, that I am under great depression and discouragement; yet I purpose to present myself before God tomorrow, with humble hope . . ." And perhaps most significant of all in this connection were the evangelists Isaac Watts and brothers Wesley who, unable to tolerate the stifling of individual emotion within the official church, broke away to found their own movement outside its confines, encouraging that very emotional dependence upon God and those moving appeals for divine mercy which formal Christianity had come to regard as no longer suited to a rational society:

Other refuge have I none:
Hangs my helpless soul on Thee:

Leave, ah! leave me not alone,
 Still support and comfort me.[15]

One reason for this breakaway may be traceable to an aspect of the English church unparalleled in France or Italy. Within Catholicism, whose other-worldly emphasis made it in any case less vulnerable to the rationalist and empiricist tendencies of the enlightenment, the confessional continued to provide an outlet for the religiously disturbed, offering an opportunity for a soul oppressed by intense piety, or by other anxieties, to find possible comfort and relief. With regular attendance at the confessional constituting a ritual obligation, the likelihood of the Catholic finding spiritual direction in time of need was considerable. Initially, the Protestant disqualification of that rite had not abolished it completely from its midst. In seventeenth-century Puritan circles, as Lawrence Stone has shown, particularly in those families more susceptible to religious self-discipline, the paterfamilias began to take over the functions of the priest, his ministering to the needs of the household often including regular conferences and private prayers with its members. Sir Nathaniel Barnardiston was recorded as having fulfilled towards his children "the office of an heavenly father to their souls . . . and many times he would take them into his closet and there pray over them and for them"; and Nicholas Ferrar was reputed to have performed a similar function towards those outside his immediate family who came to him for guidance and encouragement, revealing an ability "to see far into their dispositions and find how to work upon their passions; and then he would gently ply them with . . . effectual persuasives to better things."[16] However, with the new advocacy of intellectual independence at the onset of the enlightenment, the confessional was fated to disappear even in its surrogate forms, leaving the potentially more passionate Christian with no outlet for his suppressed devotionalism and no relief for his sense of sinfulness and guilt. It was not surprising that at the end of the century J. G. Spurzheim's *Observations on . . . Insanity* listed religion as a major source of it on the contemporary scene.[17]

The changes in attitude to nature in the eighteenth century, including its landscape gardening and painting, after being extensively researched in terms of their aesthetic significance, have more recently been examined in sociological, political, and economic terms too. In a stimulating article, Carole Fabricant has argued that the distant "prospects" opened up before the viewer represented a shift in class consciousness, a sense of freedom never previously enjoyed by the members of the new middle class. Addison claimed in *Spectator* 412 that "a spacious Horison is an Image of Liberty, where the Eye has Room to range abroad, to expatiate at large in

the Immensity of its Views," and Fabricant suggests that the viewer's sense of "commanding" a prospect from a hilltop was particularly invigorating to one of non-landowning stock who felt that his political and economic advancement in a new society were offering him an unprecedented control and direction over the country's progress.[18] John Barrell has seen that sense of command over the rolling lawns and meadows in more practical terms, as reflecting the innovative agricultural techniques being introduced at that time, not so much the seed drill and threshing machine *per se*, but the impetus for a more imaginative and productive farming of land, the amalgamation of small tenant lots into large areas of tillage, a tendency eventually resulting in the notorious enclosure laws which were to transform the very appearance of the countryside.[19]

I have no doubt that these were important contributory factors, but they relate only to a limited area of landscape interest, not touching, for example, upon the second aspect of the dual artistic concerns which were to dominate the aesthetic responses of the century, the cults of the Beautiful and the Sublime. The very Addison passage quoted by Fabricant in fact continues beyond the idea of Liberty suggested by the prospect of fields, to discuss in the next sentence "the Speculations of Eternity or Infinitude" to which such scenes stimulate the fancy—elements which could scarcely form part of changed political configurations. The cause of what came to be called the sublime, of man's delight in gazing upon "that rude kind of Magnificence which appears in many of these stupendous Works of Nature," he identifies a little later in unequivocally theological terms: "The Supreme Author of our Being has so formed the Soul of Man, that nothing but himself can be its last, adequate, and proper Happiness. Because, therefore, a great Part of our Happiness must arise from the Contemplation of his Being, that he might give our Souls a just relish of such a Contemplation, he has made them naturally delight in the Apprehension of what is Great or Unlimited."[20]

The origin of this twofold movement, of the Beautiful as well as the Sublime, is to be traced in large part, I propose to argue, to the displacement of certain suppressed religious impulses, such impulses being channelled, through lack of any outlet in traditional Christian frameworks, into secular and aesthetic forms which, throughout their variegated ramifications during the century, retained discernible manifestations of their devotional origins. Once again, that is not to deny the existence of other factors, but to suggest an underlying motif which unifies these apparently disparate elements in the aesthetic consciousness of the eighteenth century.

To begin with the cult of the Beautiful, one maxim of landscape theory which has been widely acknowledged by historians, especially in recent years, was the intention that the newly designed gardens were to serve as re-creations of Eden upon earth, restorations of Paradise achieved by man's removal of those blemishes introduced into nature at the Fall. As early as the 1680s, Charles Cotton had seen Chatsworth, set in its formal gardens amidst the wildness of the surrounding countryside, as:

> Environ'd round with *Natures* Shames and Ills,
> Black Heaths, wild Rocks, bleak Craggs, and naked Hills,
> And the whole *Prospect* so informe, and rude.
> Who is it, but must presently conclude
> That this is *Paradise*, which seated stands
> In midst of *Desarts*, and of barren Sands?

Addison regarded the contemporary interest in landscaping as one of the most innocent delights in human life on the grounds that a garden "was the Habitation of our first Parents before the Fall," John Hill's poem on the new gardening techniques published in 1757 was pointedly entitled *Eden*, and, among countless other instances, Elizabeth Montagu declared in 1744 that the garden at Stowe was "beyond description, it gives the best idea of Paradise that can be; even Milton's images and descriptions fall short of it."[21] For the landscape gardeners themselves that task had from the first occupied a prominent place in their activities, Stephen Switzer urging his patrons in 1718 to counter the "unhappy Lapse of our First Parents" and the permanent curse it had entailed. They were, he assured them, to provide "a Reparation of that Loss, by a studious and laborious Application towards the Redress of those Malignities contain'd within the scope of that dismal Imprecation, *Thorns and Thistles shall it bring forth*, and so manure, cultivate, dress, and improve."[22]

That eighteenth-century equation of cultivated nature with the restored Eden had not always been made, the repeated identification in this period of landscaped estates with the first garden presupposing an altered apprehension of Eden itself. Traditionally, at least from the time of the Gospels, the new Paradise had been conceived in celestial terms, on the premiss that the lost Eden of the Fall had been translated heavenward into an eternal abode for the virtuous after death, as in the assurance of Jesus to the repentant criminal about to die on the cross: "Truly, I say to you, today you will be with me in Paradise."[23] In Milton's epic, the original Garden of Eden, once it had been violated by Satan's deceit, was in its physical form

laid waste for ever, its temperate scene parched by the torrid heat, with the faithful being offered a "paradise within" in this world and an immortal Paradise thereafter; while for Marvell the seventeenth-century garden, with its formal parterres and floral sundial, offered at most a hint of joys to come, a preparatory experience whereby the soul, soothed and charmed by the delights of the earthly garden, could temporarily cast aside the body's vest in training for its "longer flight" beyond the grave.[24]

The refocussing of perspective in subsequent decades, the deflecting of human gaze from the celestial visions of Andrea Pozzo to a concern with human activity upon earth, involved a transformation in the conception of Eden too, a desire, perhaps not consciously recognized, to reconstitute it in terrestrial rather than cosmic form. The literary model for the newly designed "prospects" was, as has long been recognized, the passage describing Eden in Milton's *Paradise Lost*, the "happy rural seat of various view"; and the instinctive choice of Adam's abode as the prototype for the groves, winding streams, lake, and level lawns strengthens the impression that those eighteenth-century landscapes were intended to function as compensatory substitutes for a lost Eden. There were such overt reminders of this intent as the inscription displayed by Edward Young in his garden at Welwyn—*Ambulantes in horto audiverunt vocem Dei.* Moreover, the connection repeatedly drawn between Milton's description of Paradise and Claude Lorrain's landscape paintings, even when the latter depicted scenes in no way connected with the Adamic setting, suggests the extent to which those paintings became themselves interpreted as symbolic representations of Paradise. Horace Walpole's *Essay on Gardening* summarized the general view that Milton's Eden and Claude's canvases were together the true prophets of such contemporary landscaping as at Hagley and Stourhead.[25]

The attraction of Claude's landscapes for those in search of a new Eden—particularly of a secularized Eden which should be aesthetically pleasing in its location on earth rather than religiously satisfying in heaven—was, of course, their patent Arcadian setting, the evocation of pastoral idyll whether the theme was scriptural or classical in source. *The Marriage of Isaac and Rebecca* from the National Gallery, London (*fig. 62*), and *The Sacrifice to Apollo at Delphi* in the Galleria Doria Pamphili at Rome (*fig. 63*) are, like all his canvases, almost interchangeable in title, both conveying a universalized sense of peace, harmony, and repose within an airy setting supplied with arboreal shade, often graced by a nobly proportioned temple. The popular Claude glass, or tinted mirror, was soon to be carried on country walks by all self-respecting initiates in order, at selected points, to "compose" the views of nature within its frame in a manner conforming to the Lorrain tradition, and that

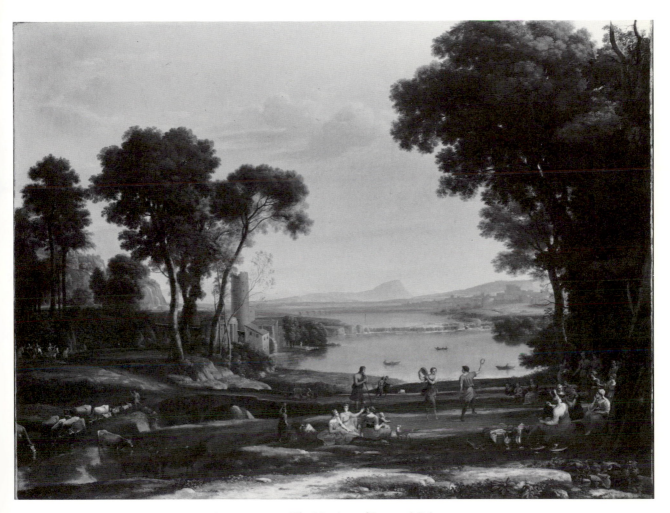

62. LORRAIN, *The Marriage of Isaac and Rebecca*

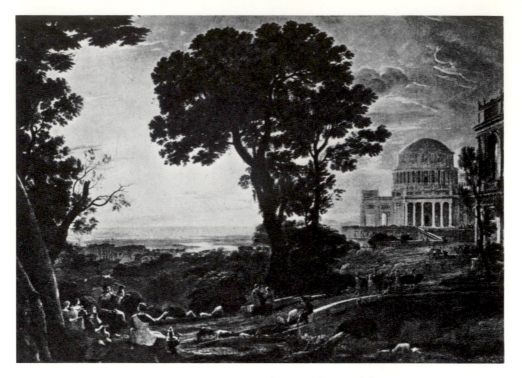

63. LORRAIN, *The Sacrifice to Apollo at Delphi*

very practice testifies to his special attraction for the eighteenth century—the effect his paintings produced of the human imposition of order upon an otherwise haphazard nature, a tectonically organized scene perfectly proportioned and free from chance disfigurements.

The patterning of a Claude painting was, however, more subtle than a mere balancing of the component elements, achieving a symbolic as well as a naturalistic effect. Jay Appleton's stimulating analysis of landscape painting has presented the theory of an aesthetic psychology based upon primitive survival instincts. The viewer's pleasure arises, he argues, from instinctual responses traceable to man's early experiences as hunter and hunted, with open plains offering welcome escape routes and strategically placed trees or bushes providing concealment for stalking prey. Within that reading of the *prospect-refuge* elements in such scenery, Appleton notes that horizons, although seemingly boundaries on a painting, in fact offer a sense of escape into the area known by the spectator to exist beyond. The argument

needs, however, to be taken a stage further, beyond the tactile; for, as in a Claude canvas, that area beyond may be associated not with a physical escape route but, symbolically, with the heavenly or supraterrestrial refuge. In most of Claude's canvases, including those reproduced here, the spectator's eye is gradually drawn from the Arcadian figures in the foreground towards a lighter area in the middle distance, whence a river or lake gently leads on to more luminous prospects beyond. The transition from a restful pastoral scene set within the tangible surroundings of nature to a remote and hazier radiance in the distance implies associatively a happiness in this world with assurance of a contentment yet to come, a secular version indeed of the Christian promise extended to the faithful. As Daniel Bellamy was to describe such paintings, they opened

> some ideal plain
> On which in all their bloom arise,
> Perennial springs of Paradise.[26]

Particularly valuable for a later generation seeking models for a lay Paradise, a generation turning away from the cosmic vision, was the terrestrial form of that implied promise; for the direction in Claude's paintings suggestive of future happiness is never, as it had been in the High Baroque, presented as a dynamic upward surge toward the heavens but, in the most literal sense, as a gently horizontal movement, following the low contours of the land towards the meeting place of earth and sky. Its appeal for the eighteenth century is amply illustrated by Richard Wilson's *Apollo and the Seasons*, now in the Museum of Fine Arts in Boston. One of many imitations of Claude he was commissioned to produce, it preserves with remarkable fidelity that symbolic progression from a pastoral foreground with small human figures towards a distant luminosity beyond.

The very merging of scenes drawn from both biblical and classical sources in a period which no longer, as in the Renaissance, assumed any profound typological equations between the two cultures bore notable implications for the eighteenth-century adaptations of its scenery to English country estates. For Claude's inclusion of Doric or Ionic temples in his scriptural scenes (the rotunda, for example, in *The Marriage of Isaac and Rebecca*) lends to the temples depicted in his canvases a universalizing effect, the impression of worship as being a noble activity shared by all civilized human societies rather than valid only in its Christian form. It was an impression which was to lead to one of the most prominent aspects of secularization in the eighteenth-century attempts at reconstructing Eden on earth—the temples of

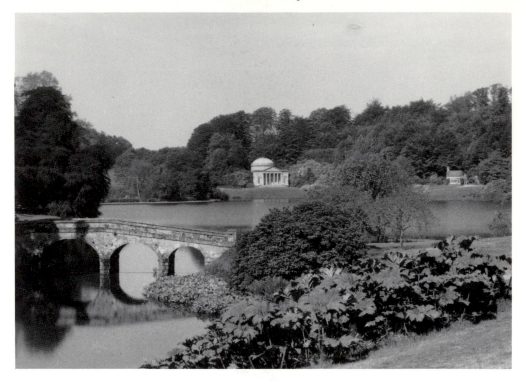

64. The gardens at Stourhead, Wiltshire

classical design, as in the gardens at Stourhead (*fig. 64*) or Stowe, ecumenically dedicated by the enlightened owner to such non-sectarian themes as Ancient Virtue, Liberty, the British Worthies, Music, or the Four Winds.

<center>(ii)</center>

The conscious identification of these landscaped prospects with an Eden restored on earth may prove significant for an understanding of its counterpart, the cult of the horrific and awesome, of the eighteenth-century Sublime. If there has been a tendency, still prevalent, to think of that latter interest as essentially "pre-romantic," only faintly adumbrating in the earlier part of the eighteenth century its full realization in the Gothic novel or in the paintings of misty crags overhanging huge chasms

before which a projected figure of the artist gazes in wonder, neither the strength of that interest in the earlier period nor its manifestations in art and literature at that time substantiate the later dating. Its influence was indeed to prove more pervasive and more durable than that of the gardening interest, and it was destined to become a primary ingredient of romanticism in its fully developed form; but as Burke, following Addison's lead, so clearly suggested for his own age in his *Philosophical Enquiry into the Origin of our Ideas of the Sublime and Beautiful*, it was a concomitant to the pursuit of Beauty in the re-designed pleasure gardens and deserves to be studied as the complement to that pursuit, as part, indeed, of a *twofold* aesthetic concept.

The two most impressive studies of the sublime in this century have assumed it to be an independent phenomenon, divorced from the cult of the beautiful. Samuel H. Monk's authoritative work traced it back to the revived interest in a treatise ascribed to the first-century Longinus, identifying that as the primary source of the movement. Boileau's translation of the work in 1674 and the publication of the English version by Welsted in 1712 were, he argued, turning points in the recognition that art, in addition to amusing and instructing, might also elevate, ravish, and transport by its awareness of the vast and the magnificent.[27] By the end of the century, as is noted in the opening pages of his book, the sublime had become so dominant in aesthetic circles as to prompt Martin Shee's complaint in 1809 that "those who talk rationally on other subjects, no sooner touch on this, than they go off in a literary delirium; fancy themselves, like Longinus, 'the great sublime they draw,' and rave like methodists, of inward lights, and enthusiastic motions, which, if you cannot comprehend, you are set down as un-illumined by the grace of criticism, and excluded from the elect of Taste."[28] Monk's scholarly account of the movement treats it throughout, then, as essentially secular in orientation; but it may be worth noting at this stage the patently religious imagery employed in the very instances which he himself highlights as marking the genesis and culmination of the tradition, but on which he offers no comment. The description of the sublime by so urbane and restrained a critic as Boileau in terms of "elevating, ravishing, and transporting" the reader—(qui fait qu'un ouvrage enlève, ravit, transporte)—betrays an instinctive recourse to the traditional vocabulary of religious ecstasy, the emotional transport represented in painting by allegorical scenes of ravishment, of the Christian soul swept heavenward by the divine spirit in such canvases as Guido Reni's *Rape of Europa*, and exemplified poetically in the anguished conclusion to Donne's holy sonnet "Nor ever chaste, except Thou ravish mee.'[29] And as Martin Shee irrita-

bly perceived, the language which over a century later continued to be used by his contemporaries in reference to the sublime was again the language of religious enthusiasm and of divine, inward illumination.

Some twenty years later, an entirely different origin for the sublime was presented, no less persuasively, in Marjorie Nicolson's fine study, *Mountain Gloom and Mountain Glory*. Thomas Burnet's widely-read *Sacred Theory of the Earth*, first published in 1681 and as influential in its day as Thomas Huxley's advocacy of Darwinism was for a later era, had, she points out, revolutionized man's conception of history by its argument, borrowed from recent scientific findings, that the Flood had constituted a second Creation, wiping away, in punishment for man's second Fall, the smoothness, beauty, and serenity of the still Paradisial scenes of earth to replace them with the raging oceans, desert wastes, and bleak mountains in the unpopulated areas of man's earthly habitation. Paradoxically, she continues, Burnet's rational acceptance of limit, restraint, and order as the natural constituents of true beauty was strangely offset by an emotional attraction to the grandeur and awesomeness of those supposedly bleak prospects. Although a leading theologian, likely to have been appointed Archbishop of Canterbury were it not for the controversy aroused by his espousal of this geological theory and writing his work primarily to prove that scientific reasoning was not incompatible with Christian faith, he revealed an unclerical sympathy for those mountains and chasms supposedly originating, according to his own theory, as divine punishments for human sin and corruption. In the midst of arguing for their source in the catastrophic Deluge, he unexpectedly admits that such scenes "strike an Awe into us and incline us to a kind of superstitious Timidity and Veneration," describing himself (and again one notes the language) as having been "rapt" and "ravished" by the Alpine mountains. That sympathetic response for the wild and magnificent was, Nicolson claims, transmitted to his readers, who from this time demonstrated, frequently with specific reference to Burnet's work, a growing admiration for such prospects, not least for those craggy mountains previously condemned as "hook-shoulder'd" deformities.[30]

Her study opened a new chapter in the investigation of what she termed "the aesthetics of the infinite," providing impressive evidence of the extent of Burnet's influence, the frequency with which he was quoted throughout the earlier part of the eighteenth century, and the effect of his own admiration for the bleak places of the earth upon his successors, well into the Romantic era. What is missing in the study is an enquiry into the reason behind Burnet's unexpected or "paradoxical" admiration of the products of human sin, an admiration which, as she admits, was

quite at variance with the argument he was presenting; and missing, too, is the reason for its having elicited an immediate echo in his readers' sensibilities. Here, too, there should be some significance in the otherwise odd fact that the source of the eighteenth-century concept of the secular aesthetic sublime is to be traced to a specifically religious work, a theological study aimed at reconciling traditional Christian belief with the new scientific rationalism. She does indeed remark that the adjectives and epithets which came to Burnet's mind in praising such scenes "were words that had always been legitimate when applied to God," but that element is seen by her as no more than a curiosity.[31]

The recognition of the religious basis to the eighteenth-century sublime began only with Ernest Tuveson's brilliant article, "Space, Deity, and the 'Natural Sublime,' " appearing shortly after the delivery of her lectures. The medieval and, indeed, biblical identification of God with the infinite, Tuveson pointed out, had inevitably undergone considerable transformation in response to changes in the philosophical apprehension of the physical world. Nicholas of Cusa's fifteenth-century identification of the finite world located within a boundless universe as being the material complement or manifestation of a divine force which is "everywhere and nowhere" remained an influential but somewhat abstract theory until Giordano Bruno momentously welded it to the newly apprehended relativism of the post-Copernican cosmos. The infinite universe, now recognized as devoid of any fixed centre, to be viewed with equal validity from any point within it, was therefore in a very real sense the physical manifestation of a deity who was everywhere. As part of the deepened sense of sacral immanence, Tuveson sees the later search for God in the vast and limitless tracts of earth as a transference of that cosmic apprehension to a terrestrial setting, to the mountains, deserts, and oceans which represented a form of divine immensity available to ordinary human beings, soon to be making their pilgrimages to Grasmere and the Alps rather than to the spiritual centres of Canterbury and Loretto. Particularly valuable was his reassessment of Burnet. No longer regarding him as an aesthetician who happened to be a theologian, he recognizes him as the inaugurator of a view of nature intimately related to his Christian beliefs, initiating what a more recent critic, David Morris, has called "the religious sublime" of the eighteenth century.[32] But for all his genuine perceptiveness, Tuveson still leaves unexplained the patent contradiction in Burnet's thesis, his arguing for the divinely ordained ugliness of mountain and ocean while yet experiencing a rapture and admiration at their sight totally inconsistent with his intellectually held principles.

Before embarking upon any close examination of Burnet's treatise, it may be helpful to suggest in broader terms the theory to be proposed in this chapter, an attempt to go beyond the very generalized recognition of the religious associations of the sublime and to identify the more specific theological impulses which dictated the associating of new aesthetic responses to nature with displaced forms of Christian belief. If the weight of rationalism, stifling spontaneous articulation of devotional experience, diverted potential pietism into secular channels, it will be essential to explore the nature of the emotions being suppressed, emotions often more complex than might be imagined. For they included not only a desire for continued spontaneity of religious response but, in a manner more closely related to the predicament specific to this period, of guilt feelings emanating from the very rationalism which had become the dominant philosophical mode.

The theme of Eden, translated into the landscape gardens and employing both Milton's poetic description of Paradise and Claude's Arcadian paintings as its models, represented, it is clear, the contentment of the eighteenth-century landowner achieving control over his prospects, manipulating the capabilities of his ground to yield what was pleasing to the human eye, with a sense of security that he was monarch of all he surveyed. But no sensitive Christian nurtured within the ideological framework of that faith could be unaware, at some stratum of consciousness, of the profoundly un-Christian assumptions underlying that process both at the symbolic and the literal level. For the desire to restore Eden upon earth and the landowner's indulgence in a sense of lordly control over the redesigned prospect constituted the very reverse of Christian humility. It was an appropriation of God's role as creator, partaking of the sin of pride which had hurled Satan to hell, had corrupted Adam within the very garden serving as the model for these estates, and could eternally exclude the virtuous Christian from the paradise for which he yearned. Confidence of one's rightful acceptance into heaven was, as a long succession of Christian theologians had confirmed from the Gospels onward, the surest means of disqualifying oneself from salvation. It marked a lack of the humility enjoined in the Gospels: "Let a man humble himself till he is like this child, and he will be the first in the kingdom of heaven" (Matt. 18:4). The newly designed gardens were intended, as Johnson phrased it so perceptively, to arouse in the owner or visitor "a flattering notion of self-sufficiency, a placid indulgence of voluntary delusions, a secure expansion of the fancy." The only effective antidote to such dangerous complacency, as he himself discovered on his tour of the Hebrides, was to experience the wildness of nature untamed, where man is "made unwillingly ac-

quainted with his own weakness, and meditation shows him only how little he can sustain, and how little he can perform."[33]

In a generation prior to that of the landscape artists, George Herbert had wrestled with this same problem, also employing a garden image. Pathetically recalling, in his poem *The Flower*, the terrifying "winter" of divine displeasure, the agony of despair through which he had just so painfully passed and would no doubt pass again once his present remission ended, he soberly acknowledged within himself the self-indulgence which had caused his own spiritual downfall:

> But while I grow in a straight line,
> Still upwards bent, as if heav'n were mine own,
> Thy anger comes, and I decline:
> What frost to that? what pole is not the zone,
> Where all things burn,
> When thou dost turn . . . ?

It is at the very moment when he feels he has attained his Eden, assured of his acceptance there—"as if heav'n were mine"—that his dread sin occurs, arousing what he now sees as the justified wrath of God. The sole refuge for the poet, as for all Christians, lies in the reversal of such pride, in utter self-abasement, in a humble recognition of the wonders of God, the immense powers here symbolized by the polar frosts and burning equatorial zone and, finally, in an acknowledgment of God's mercy in deigning even to consider that ephemeral creature man. Only then, chastened and stripped of his complacency, of "swelling" pride, can he hope for entry into the true and eternal garden of Paradise:

> These are thy wonders, Lord of love,
> To make us see we are but flowers that glide;
> Which when we once can finde and prove,
> Thou hast a garden for us where to bide;
> Who would be more,
> Swelling through store,
> Forfeit their Paradise by their pride.[34]

That recurring paradox of religious faith, projected into secular forms, would seem to lie at the heart of the interconnnected eighteenth-century cults of the Beautiful and the Sublime, comprising on the one hand the sense of pleasurable "command" over an Edenic prospect and on the other (partly implicit in that Edenic content-

ment, and serving as its grim counterpart) a horror of annihilation in a Nature acting as the instrument of divine wrath.

The peculiar relevance of this spiritual concern to the intellectual climate of the late seventeenth and early eighteenth centuries, and to their symbolic responses to landscape, may be perceived most vividly in Milton's adaptation of the biblical account of the Fall to suit more immediately contemporary conditions. In an era when enlightenment was making intellectual self-reliance the dominant form of spiritual pride, it was less the Knowledge of Good and Evil which constituted the temptation for mankind than, as Milton preferred to abbreviate the term, the Tree of Knowledge as such. The lure which Satan proffers to Eve within the epic is that his partaking of its fruit had endowed him with enhanced *rational* faculties, producing

> Strange alteration in me, to degree
> Of Reason in my inward Powers.[35]

For the poet, therefore, whose description of Eden was to provide a model for the landscape artists, the corrupting force within that garden was the very confidence in rational, humanly devised standards which was to animate those later designers. And the effect was not dissimilar. Where, in the epic, surrender to the blandishments of Reason led to lowering skies, thunder, and the earth's trembling in its entrails as Nature prepared to wreak its torrid vengeance on the Grand Parents of mankind, in eighteenth-century landscaped parks the pleasures of lordly self-sufficiency was to produce a parallel sense of imminent destruction—self-abasement before the sublime terrors inspired by the untamed Nature outside those parks, viewed as personifying the wrath of the Creator. These two eighteenth-century modes are in large part, then, as both the early critical texts and their artistic expression were to confirm, to be seen as transmutations, into secular, aesthetic form, of the twin polar forces of religious experience through which a sensitive Christian was liable to pass, the contrasting and successive moods of assured faith and of agonized humility or guilt.

The emotion of total self-negation before the divine whereby the devotionally oriented Christian could alone achieve some sense of spiritual restoration was, of course, singularly unsuited to the new intellectual disposition of the age. The rationalist was by nature neither humble nor self-deprecatory. He might recognize the due limits of his knowledge, presuming not God to scan; but that very definition of boundaries presupposed his intellectual command over the areas which did lie

within his jurisdiction, a trust in his autonomous employment of logical processes and empirically provable rules. As Locke assured his readers, although the human mind may not be qualified to uncover the secrets of heaven, in pursuit of other knowledge the "Candle that is set up in us shines bright enough for all our purposes."[36] In so intellectual an environment, it was not surprising that the passionate self-abasement of the devotee humbled before the Deity should have found little religious expression, being accordingly displaced, translated into a supposedly aesthetic experience which the rationalist, now functioning not as pious devotee but as a connoisseur of taste, could experience with an air of objectivity and impersonality, while yet finding there a disguised outlet for his religious fervour. From the psychological viewpoint, the process might be termed not so much a religious sublime as a religious *sublimation* in the full meaning of that term—the elevating of a primitive or instinctual impulse causing social embarrassment to an artistic level situated higher on the contemporary cultural scale and thereby made more acceptable in its transformed state both to the experiencer and to the community within which he resides.[37] It was a process which found expression in the artistic configurations of the time and in the texts which formulated its aesthetic principles.

Seen within this context, the twin elements of the beautiful and sublime, as they manifested themselves in that generation, may be recognized as a counterpart to that peculiarly alternating perspective dominating *Gulliver's Travels*, constituting in effect a spiritual version of Swift's social concern. The transition from Gulliver's overview of the Lilliputians to his own diminution before the Brobdignagians, with the inversions implicit in each setting, finds its parallel, in a manner more fundamental than may at first appear, in the phenomenon we have been examining—the eighteenth-century landscape designer gazing across his rolling lawns and distant prospects with the lordly authority of a superior being, only to discover as he moved out into untamed nature the crushing insignificance of his true stature, dwarfed before the towering cliffs, the tumultuous oceans, and the vast desert tracts over which he could exercise so little control. In both forms, the social and the spiritual, that alternating vantage point reflected Pope's rueful recognition of man's location on a narrow isthmus, the middle state between the divine and the contemptible: "Great lord of all things, yet a prey to all."

The Judeo-Christian tradition of the western world had always seen man in that middle category, but a change had occurred, noted in an earlier chapter, which was particularly relevant to the philosophical assumptions of this time. The Renaissance sense of man's enormous potential, his ability to rise heavenward to participate in

the divine, had evaporated, leaving him caught inextricably in the middle state. The poet or artist needed to accommodate himself to that condition in a manner fundamentally different from his predecessors. Unable to reach out in ecstasy for a ravishing of his soul into the bosom of the eternal, he necessarily resorted instead to a more sober assessment of his situation upon earth, as a lord of all tangible *things*, yet ultimately impotent before the immense power of Nature, priding himself on his intellect yet grievously aware of its limitations, the alternating vantage point reflecting his predicament.

It is this emotional ambivalence which should be seen as creating the paradox in Burnet's writings. The tone of his *Sacred Theory* is restrained, scholarly, and scientific as befits an intellectual treatise of this kind, a somewhat dry, rational analysis of earlier theories, with learned substantiation of his own argument displaying the confidence of academic discourse. In those larger sections, he fulfils the superior role of the objective enquirer in command of his information and logical faculties. At those moments, however, when emotion breaks through that outward control, when his dread acknowledgment of human vulnerability takes command, the tone changes dramatically to produce those passages of reverential fervour so influential for his readers.[38] The Paradisial world which he describes as having existed before the Flood conforms closely to the Claude-like idyll of Eden—"Nature, fresh and fruitful, and not a Wrinkle, Scar or Fracture in all its Body; no Rocks or Mountains, no hollow Caves, nor gaping Channels, but even and uniform all over . . . 'Twas suited to a golden Age, and to the first innocency of Nature." But when he turns to the cataclysmic Deluge which he believed to have transformed the surface of the earth, what fascinates him at that moment is less the geological metamorphosis of the earth's surface, which he is ostensibly propounding, than the dreadful fragility of the small craft representing mankind's sole hope of salvation amidst the enormity of the chaos threatening to engulf it. At that point the language becomes emotionally charged, the current of feeling sweeping aside the sober tone of objective discourse prevailing in the main body of the work:

> . . . when the Deluge was in its Fury and Extremity, when the Earth was broken and swallowed up in the Abyss, whose raging Waters rose higher than the Mountains, and fill'd the Air with broken Waves, with an universal Mist, and with thick Darkness, so as Nature seem'd to be in a second Chaos; and upon this Chaos rid the distress'd Ark, that bore the small Remains of Mankind. No Sea was ever so tumultuous as this, nor is there any thing in present Nature to be compar'd with the Disorder of these Waters; all the Poetry and all the Hyperboles that are used in the Description of Storms and

raging Seas, were literally true in this . . . That Abyss which had devoured and swallow'd up whole Forests of Woods, Cities and Provinces, nay the whole Earth . . . could not destroy this single Ship . . . A Ship whose cargo was no less than the whole World; that carry'd the Fortune and Hopes of all Posterity, and if this had perish'd, the Earth for any thing we know had been nothing but a Desart, a great Ruin, a dead heap of Rubbish, from the Deluge to the Conflagration. But Death and Hell, the Grave and Destruction have their Bounds.[39]

Whatever impetus this passage may have given to later theories of art, it draws its strength not from aesthetic considerations, but from religious. It expresses the reverential awe of a believing Christian, convinced, like Herbert, of the justice of divine wrath, amazed at its power as demonstrated in the elements of nature, and fearful for a humanity dwarfed by its grandeur and reliant solely upon heavenly mercy.

Thematic convergence is a phenomenon particularly relevant for interdisciplinary studies—the emergence of some recurrent topic to which writers, painters, and musicians of a given period seem especially attracted, often quite independently, because it answers in some way to the specific concerns of their time. If Burnet's view of the Deluge proved, as historians have acknowledged, so influential in moulding subsequent artistic taste, the existence of Poussin's important painting on that same theme a few years prior to the treatise, a painting depicting it in a manner remarkably close to Burnet's own view, may lead us to suspect that Burnet was not so much the inaugurator of the movement, as Marjorie Nicolson has argued, as a further manifestation within a larger complex. Poussin, we may recall, had been recognized in his day as the representative *par excellence* of Stoic restraint and rational self-control. He was thus particularly susceptible (as Burnet was to be in his attempt to reconcile empiricist principles with religious doctrine) to the suppression of religious emotion implicit in the new dispensation, and hence to the psychological side-products of that suppression. His subject, *The Deluge* (*fig. 65*), was, as in Burnet's account, treated as a terrifying scene of divine vengeance transmitted through nature, in which man, recognizing his impotence, is thrown in utter dependence on heavenly aid. Michelangelo's earlier version of that event on the ceiling of the Sistine Chapel had, in contrast, manifested a primarily humanistic interest, giving prominence to the varied postures of the fleeing figures, evocative of the pious Aeneas bearing his father on his back from the ruins of Troy, with the flood itself scarcely visible. But in Poussin's canvas it is the terror of nature itself which is dominant. The gloomy nocturnal setting discloses bleak rocks, offering no permanent haven, protruding grimly on either side of the flood, with humans clinging in

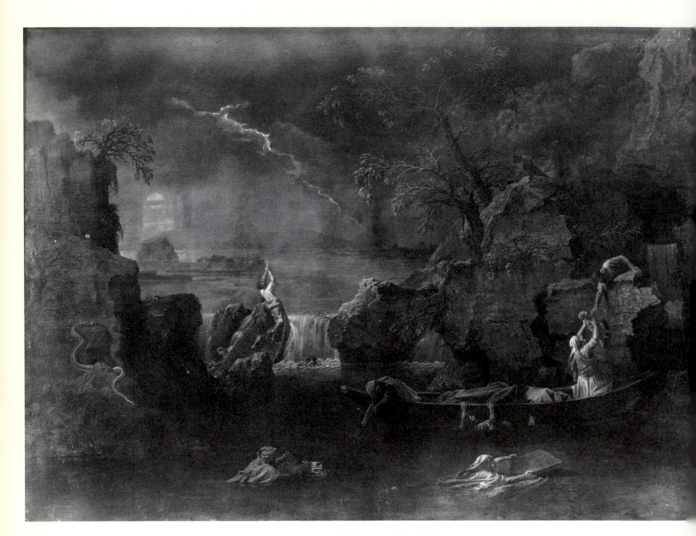

65. POUSSIN, *Winter,* or *The Deluge*

the rising waters to floating debris, to drowning animals, and to a sinking boat, while a second boat, swept uncontrollably over a waterfall, contains the focal figure of the canvas, raising his hands heavenward in desperate prayer as he is about to be engulfed. To the left, a huge snake serves as a reminder of the corruption for which the flood forms the retribution and, only faintly visible in the open sea beyond, is the Ark of man's hope, floating below a partly obscured moon, the obscurity itself forming part of the new conception of the sublime.

The influence of this painting upon English artists was considerable. Horace Walpole in 1774 selected it as one of the paintings most worth seeing in Paris, Fuseli maintained that it alone placed Poussin "in the first rank of art," Constable admired its "awful sublimity," Hazlitt painted a copy of it when at the Louvre in 1802, and Shelley singled it out on his visit to Paris in 1814 as being "terribly impressive . . . the only remarkable picture" which he managed to view. As Morton Paley has recorded (although with the traditional attribution to the Longinian source), it produced a succession of distinguished imitators on the English scene, among them de Loutherbourg, Turner, and Martin.[40] In literature, too, this image of man drowning within an immense ocean as a symbol of his spiritual insufficiency before God was to recur throughout the eighteenth century, as in the touchingly personal conclusion to William Cowper's poem, *The Castaway*, written during the period of his life when he was terrifyingly convinced of his own spiritual damnation:

No voice divine the storm allay'd,
No light propitious shone;
When, snatch'd from all effectual aid,
 We perish'd, each alone;
But I beneath a rougher sea,
And whelm'd in deeper gulphs than thee.[41]

The attraction of both Poussin and Burnet to the theme of the Deluge was symptomatic of a wider thematic convergence; for Poussin's canvas was, in fact, the final in a series of four paintings devoted to the seasons of the year and using Old Testament scenes in order to illustrate both the annual cycle of nature and its symbolic associations. During the period included within this volume there is a marked interest not only in the theme of the flood but in the topic of which this painting formed part, the four seasons of the year. Apart from the Poussin sequence, there was Vivaldi's orchestral suite of that name, as well as the frequent incorporation of that theme into eighteenth-century Rococo ornamentation, with decorative panels

illustrating the changes of the year appearing, characteristically, in the four corners of a Boffrand salon; then there was the enormously popular poetic contribution by James Thomson, which in its turn inspired Haydn's oratorio *The Seasons*, together with numerous other examples. What, we may ask, gave that theme its special significance for the period?[42]

The function of the gods, Freud has pointed out, was, both in its primitive and in its later more sophisticated forms, primarily to exorcise the terrors inspired by nature; and anthropological research has tended to confirm that view, notably in its focus upon such religious ceremonies as the symbolic deposition and restoration of the god in the fertility rites of propitiation at the close of winter and the onset of the spring.[43] In a broader sense within the western world, Christian faith in a Supreme Creator, believed to be intimately concerned with the daily governance of the universe, had provided a valued sense of security, making those propitiatiory rites less urgent. It was when that faith began to be weakened that a change may be perceived in the current attitudes to the natural world. In the Herbert poem quoted above, the seasonal movement from winter to spring had functioned, it will be recalled, solely as a metaphor, a helpful illustration for his central theme, the vicissitudes of the spirit as it withdraws into frozen despair or blossoms into rebirth. From the mid-seventeenth century onwards, attention becomes directed to the seasons themselves not as an image but for the comforting sense of order which their annual cycle provided and, with that orderly progression, the welcome impression of divine control. As Thomson declared in the opening lines of the Hymn he appended to *The Seasons*:

> These, as they change, Almighty Father! these
> Are but the varied God. The rolling year
> Is full of thee.

Retained from the earlier view (exemplified in this chapter, for convenience, by Herbert's poem) is the equation of winter with those humbling manifestations of divine wrath demanding subservience, which were to constitute in both poetry and painting a primary source of the sublime:

> In Winter awful thou! with clouds and storms
> Around thee thrown, tempest o'er tempest rolled,
> Majestic darkness! On the whirlwind's wing
> Riding sublime, thou bidst the world adore,
> And humblest nature with thy northern blast.[44]

Poussin, in his series on *The Four Seasons* (1660–64) which he completed during the last years of his life and of which *The Deluge* formed the final work, had conveyed a deepened apprehension of the regular, ordered processes of nature by duplicating the process, by making his representations of the annual cycle conform also to the four periods of each day. His depiction of spring is set at sunrise, of summer in the noonday period, of autumn at eventide, and of winter within a gloomy night-time setting. Moreover, the posited connection between this convergent interest in the pattern of nature and a desire for belief in a controlled cosmos finds confirmation in his selecting, as the theme for illustrating each season, an episode from the Old Testament which should suggest, too, the overarching and ordered progression of human history. As Sauerländer has rightly shown, the themes of *The Earthly Paradise*, *Ruth and Boaz*, *The Grapes of the Promised Land*, and *The Deluge* chosen to characterize each annual period are, in addition, intended to represent typologically the four main stages of the Christian narrative—Eden at the springtime of history, Ruth and Boaz symbolizing the Nativity (since their union was to produce the messianic line of David), the carrying of the grapes in autumn allegorizing the Eucharistic fulfilment of prophecy, and the winter Deluge adumbrating the Last Judgment.[45] Moreover, we may add, by the merger of the literal and symbolic levels of meaning in the final painting, the cyclical effect is rounded out, representing in the Flood a cataclysmic beginning to the history of mankind at large which at the typological level marks also its closure.

Poussin, who had, together with Claude Lorrain and Salvator Rosa, served as a main pictorial model for eighteenth-century views of nature, differed from his associates only in this regard, that whereas Claude always represented for them the Edenic world and Rosa the savage and sublime, Poussin was seen as contributing to both forms, with his pastoral idylls on the one hand and his more sombre canvases on the other respectively suiting, as in this series, the contrasting concepts. In a letter frequently quoted in contemporary periodicals (it was, for example, reprinted in Pearch's 1768 supplement to *Dodsley's Miscellany*), a letter which helped to make the Lake District a favoured area for the romantically inclined, the "ingenious Dr. Brown" wrote to Lord Lyttelton in the 1750s of the varied attractions of the scenery there, each element reflecting the interests of one of these artists:

> The full perfection of Keswick consists of three circumstances, beauty, horror, and immensity united. To give you a complete idea of these three perfections, as they are joined in Keswick, would require the united powers of Claude, Salvator and Poussin. The first should throw his delicate sunshine

over the cultivated vales, the scattered cots, the groves, the lake and wooded islands. The second should dash out the horrors of the rugged cliffs, the steeps, the hanging woods and foaming waterfalls; while the grand pencil of Poussin should crown the whole with the majesty of the impending mountains.[46]

Here Poussin, as a painter of mountains, is associated more closely with Rosa, while in the reflections on an engraving published in the *British Magazine* of June, 1761, he is placed in the opposite category, the commentary praising the sublime horror "of the celebrated Salvator Rosa, in contra-distinction to the more mildly pleasing scenes which rose from the labours of a Poussin and Claude Lorrain."

Although Salvator Rosa's paintings were less patently religious in theme, presenting dark scenes of nature and of human vulnerability to bandits concealed within its rocks, the effect upon his admirers was not without its theological connotations of sin and redemption. "Salvator Rosa—never was man so blest in a name!" Hartley Coleridge pointedly proclaimed, proceeding to describe in terms of humans writhing within the power of the serpent a landscape of his which had deeply impressed him with its imaginative force: "Such shaggy rocks,—such dark and ruinous caves,—such spectre-eyed, serpent-headed trees, wreathed and contorted into hideous mimicry of human shape, as if by the struggles of human spirits incarcerated in their trunks . . ."[47]

The insight was peculiarly acute. Rosa had studied under the Spanish painter José de Ribera who, although at that time resident in Naples and an admirer of Caravaggio, had retained the religious, pietistic traditions of his native land, portraying the mental and physical sufferings of Christian penitents and martyrs. That interest Rosa translated into the sombre atmosphere of his own landscapes and their dream effect of threatening and retributive forces, of which the *banditti* in his landscapes often formed a part. If Claude Lorrain's canvases had conjured up allusions to Paradise, Rosa's, repeatedly contrasted with them by eighteenth-century viewers, suggested to them not merely an alternate view of nature but its antithesis, an evocation of what Milton, in a passage familiar to them, had described as the wild country blocking entry to Eden,

> . . . where delicious Paradise,
> Now nearer, Crowns with her enclosure green,
> As with a rural mound the champaign head
> Of a steep wilderness, whose hairy sides

With thicket overgrown, grottesque and wild,
Access deni'd;

(*PL* 4:132–37)

In contrast to the delights of Eden, that wilderness represents the primitive sav-agery in nature, associated with grottoes and uncultivated regions.

The legends surrounding Rosa's life and the symbolic elements perceived in his paintings were, as has been increasingly recognized in recent years, often of his admirers' invention[48]—a fact which strengthens the view that he was less the in-spirer of a particular conception of nature than a convenient peg on which to hang contemporary predilections. The paintings by Rosa that held a special fascination for the English were those conveying iconographically that same sense of the steep-ness of the craggy wilderness as appeared in the Milton passage, scenes such as his *Landscape with the Crucifixion of Polycrates* (*fig. 66*), where massive boulders, darkly towering over the small humans, threaten symbolically to crush them with their weight. At times, as in such pastoral scenes as his *Rocky Landscape with Figures*, the symbolism achieves a deepened effect from the apparent tranquillity of the scene, of shepherds resting unconcernedly beneath the projecting rocks, seemingly unaware of their own mortal transience beside the ancient durability of the rocks. By that technique, the viewer is invested with an enhanced consciousness of ominous ele-ments intimated rather than explicitly represented.

Grottoes and caverns were for Rosa a further means for implying man's vulner-ability and ephemerality in nature, the sombreness and antiquity of their enveloping structure creating a sense of claustrophobic mystery, often intensified by his En-glish imitators. Rosa's *Grotto with Cascade* (*fig. 67*), which was in the Pitti at the time of Joseph Wright's journey to Italy and was in all likelihood seen by him there, certainly creates that impression, but in the latter's *A Grotto in the Kingdom of Naples with Banditti*, where the mention of *banditti* in the title marks his acknowledgment of Rosa's inspiration, the menacing chiaroscuro effect is significantly deepened, confirming which elements in Rosa's natural scenes had proved particularly attrac-tive to the eighteenth-century artist. The impressive paintings of uncultivated scenes in nature, of waterfalls rushing between crags, produced by Rosa's Dutch contemporary Jacob van Ruisdael, which might have satisfied a general interest in untamed nature, had in fact aroused only limited interest in England, the Dutch artists being for the most part dismissed as merely slavish in their imitation of na-ture, as "drudging Mimicks of Nature's most uncomely coarseness"; for their can-

66. SALVATOR ROSA, *Landscape with the Crucifixion of Polycrates*

67. SALVATOR ROSA, *Grotto with Cascade*

vases lacked the symbolic force associated with Rosa's work, the threatening mystery perceived in the sublime forces of nature.[49]

To return to the aesthetic theorists of the sublime, Burnet was certainly not alone in his specifically religious conception of it. In 1688, only a few years after the appearance of his treatise, the influential critic John Dennis journeyed across the Alps, experiencing a sense of their magnificence which was to alter fundamentally his own theory of literature and, through him, that of his successors. In a passage familiar to all students of the eighteenth-century sublime, for which it was to serve as a prototype, he expressed his fascination with the prospects it opened before him without specifying at that stage any religious implications: "the unusual heighth in which we found our selves, the impending Rock that hung over us, the dreadful Depth of the Precipice, and the Torrent that roar'd at the bottom, gave us such a view as was altogether new and amazing."[50] That experience led him, however, to argue in his *Grounds of Criticism in Poetry* that the true wellspring of great writing lay in religious contemplation, in meditating on the vastness, power, and terror of the deity which alone could produce the sublimity of thought requisite for noble poetry. His advocacy of the sublime led, understandably, to his being satirized by Gay and Pope as "Sir Tremendous Longinus," the theme by now being associated with the treatise of that name, and Samuel Monk in his own study followed through that association by stressing the influence that treatise exerted upon him. But in fact, as David Morris has rightly noted, Longinus enters the theory promulgated by Dennis only at a late stage in its development, as support for principles already formulated on the basis of his religious convictions, when he expresses his wonder how so great a man as Longinus "should miss of finding so easy a thing as this," that religion was the main ingredient for the sublime.[51] The nature of Dennis's religious convictions bears a specific relevance to the theme of this present chapter.

In the letter recording his crossing of the Alps, written from Turin while the emotional impact of the journey was still upon him, the seed of that theory, the distinction between the Beautiful and the Sublime, was already taking form, and the articulation of the distinction offers an insight into its ideological source: "I am delighted, 'tis true at the prospect of Hills and Valleys, of flowry Meads, and murmuring Streams, yet it is a delight that is consistent with Reason . . . But transporting Pleasures follow'd the sight of the *Alpes*, and what unusual transports think you were those, that were mingled with horrours, and sometimes almost with despair?" The contrast, one notes, is between reason and despair, between a satisfaction gained from Arcadian scenes and the horrifying "transports" to be derived from

viewing the Alps. Moreover, he provides in that latter account of the ravishing effect the Alps had upon him the first clear statement of the paradox which was to accompany views of the sublime throughout the following years, the strange mingling of pleasure and terror they aroused, what Addison was later to term the "agreeable Horrour" inspired by such scenes and to which we shall need to return.

Within the more detailed propounding of his artistic theory for poetry, the contrasts drawn here between reason and passion are more specifically delineated. Beginning with the noble forms of literature produced by reason, by the "Power of ruling our own Minds which may be refer'd to as Temperance," here illustrated by a Latin quotation from that most urbane and restrained of all classical poets, Horace, he turns to what he sees as the more powerful emotions of fear and terror. The latter experience, the sublime, he defines in unambiguous terms as an apprehension of approaching evil, finding its most potent manifestation in the idea of "an angry God," and a little later elaborates on that terror in a passage which, in its emotional force and rhetorical splendour, might have been taken from a sermon preached to sinners on the inefficacy of reason and the dangers of pride, rather than from a sober treatise on literary aesthetics:

> . . . nothing is so terrible as the Wrath of infinite Power, because nothing is so unavoidable as the Vengeance design'd by it. There is no flying nor lying hid from the great universal Monarch. He may deliver us from all other Terrors, but nothing can save or defend us from him. And therefore Reason, which serves to dissipate our Terrors in some other Dangers, serves but to augment them when we are threatened by infinite Power; and that Fortitude, which may be heroick at other times, is downright Madness then.[52]

If we have said that this passage has the fervency and rhetorical force of a sermon, that sermon, it should be added, would have belonged to an earlier era. Neither the sentiments expressed nor the impassioned tone would have found a place in the sedate and reasoned sermons of an Isaac Barrow or John Tillotson, an anomaly suggesting once again the displacement of religious ardour into the secular realm of aesthetic theory.

Shaftesbury, the last of the three main theorists recognized by historians as initiating the eighteenth-century sublime, characterises above all the current insistence upon rationalist restraint in religion, his *Letter Concerning Enthusiasm* providing for his age a *locus classicus* for the rejection of false messiahs and the ridiculing of prophesying fanatics, with its suggestion that the sole effective antidote for society lay in

an application of reasoned judgment to all such claims. To distinguish genuine inspiration (and the Christian rationalist needed always to leave room for true prophecy, without which the Bible itself would be invalidated) "we must antecedently judge our own spirit, whether it be of reason and sound sense; whether it be fit to judge at all, by being sedate, cool, and impartial, free of every biassing passion, every giddy vapour, or melancholy fume." Yet the emotional self-discipline he demanded in areas of Christian worship was to find its release, as so often in this period, in the less dangerous sphere of aesthetics, validating there that very indulgence in emotional self-abandonment and sense of personal inspiration which he had so sternly condemned in the messianic preachers. In *The Moralists* he was to endorse not only a surrender to the terrors of human insignificance—"See! with what trembling step poor mankind tread the narrow brink of deep precipices, from whence with giddy horror they look down, mistrusting even the ground which bears them, whilst they hear the hollow sound of torrents underneath, and see the ruin of impending rock"—but was to see within such impulses from nature originating outside the church, in the deep shades of towering, silent woods where "horror seizes" the traveller, more reliable evidence for the presence of the divine than he had ever been prepared to recognize in the raptures and transports of Christian pietists:

> The faint and gloomy light looks horrid as the shade itself . . . Here space astonishes; silence itself seems pregnant, whilst an unknown force works on the mind, and dubious objects move the wakeful sense. Mysterious voices are either heard or fancied, and various forms of deity seem to present themselves and appear more manifest in these sacred sylvan scenes, such as of old gave rise to temples, and favoured the religion of the ancient world. Even we ourselves, who in plain characters may read divinity from so many bright parts of earth, choose rather these obscurer places to spell out that mysterious being, which to our weak eyes appears at best under a veil of cloud . . .

Rationally he protects himself by such sober phrases as "voices are either heard or fancied" and conceals his own tingling sense of horror behind a scholarly reference to the more credulous pagan religions of old. But the concluding sentence leaves no doubt of the author's true feelings, the mysterious sense of the divine, to which he is prepared to surrender in aesthetic terms, leading him to respond more positively to the sublime in nature, so that "the rude rocks, the mossy caverns, the irregular unwrought grottos and broken falls of waters, with all the horrid graces of the

wilderness itself . . . will be the more engaging, and appear with a magnificence beyond the formal mockery of princely gardens."[53]

The duality comprised in such reiterated oxymorons as "horrid graces," "pleasurable terror," and "agreeable horror," later fictionalized into the relished terror of the Gothic novel, has long been accepted without any special surprise as a standard feature of eighteenth-century aesthetic; but the paradox it involves is one unusual in general human response. Human emotions have always been complex, but that particular combination of pleasurable terror, the source of modern Dracula and Frankenstein films, had not been prevalent before the eighteenth century. If we return to the religious form of that experience before its secular translation, the paradox may become more comprehensible. For at the moment when the Christian, acknowledging the transgression implicit in his unthinking complacency, shrinks before the wrath of God, that very terror offers, by means of the humility it has induced in the worshipper, the hope of divine forgiveness. The horror ironically becomes thereby transformed into a comforting source of trust. Such suggested connection between the secular and religious forms may seem tenuous, but less so when the source of Addison's phrase is re-examined. The passage from *Spectator* 489 in which Addison first employed it—to be adopted thereafter as the accepted term for eighteenth-century experience of the sublime—has been frequently quoted by modern historians as a major source for the fascination with the immensity of the ocean: "I cannot see the Heavings of this prodigious Bulk of Waters, even in a Calm, without a very pleasing Astonishment, but when it is worked up in a Tempest, so that the Horizon on every Side is nothing but foaming Billows and floating Mountains, it is impossible to describe the agreeable Horrour that arises from such a Prospect." Rarely noted in such accounts is the religious context of that seminal passage and of its continuation: "Such an Object naturally raises in my Thoughts the Idea of an Almighty Being." The entire passage serves, in fact, as a lead-in for Addison's main point, a eulogy of Psalm 107 ("They that go down to the sea in ships") as being a perfect instance of the poetic sublime; and the verses he quotes from it are those describing that very experience of man terrified and dwarfed by the sea's vast might, yet through humble prayer granted divine salvation:

They that go down to the Sea in Ships, that do Business in great Waters: These see the Works of the Lord, and his Wonders in the Deep. For he commandeth and raiseth the stormy Wind, which lifteth up the Waters

thereof. They mount up to the Heaven, they go down again to the Depths, their Soul is melted because of trouble. They reel to and fro, and stagger like a drunken Man, and are at their Wit's End. Then they cry unto the Lord in their trouble, and he bringeth them out of their Distresses. He maketh the Storm a Calm, so that the Waves thereof are still. Then they are glad because they be quiet, so he bringeth them unto their desired Haven.

To conclude the essay, he provides a "divine ode" for the reader which, he explains, was "made by a Gentleman upon the Conclusion of his Travels" and was, no doubt, by the author himself. It is, in fact, a poetic account of the emotional vicissitudes from which the secular sublime was derived—the terror of being engulfed in the vastness of nature, a plea for divine mercy from amidst the storm, and the sense of trust and spiritual union with the Creator which the process eventually inspires:

> Confusion dwelt in ev'ry Face,
> And Fear in ev'ry Heart;
> When Waves on Waves, and Gulphs in Gulphs,
> O'ercame the Pilot's Art.
>
> Yet then from all my Griefs, O Lord,
> Thy Mercy set me free,
> Whilst in the Confidence of Pray'r
> My Soul took hold on Thee:
>
> For tho' in dreadful Whirles we hung
> High on the broken Wave,
> I knew Thou wert not slow to hear,
> Nor Impotent to save . . .

How fundamental this experiential matrix was to the developing concept of the sublime in England may be seen by glancing ahead for a moment for evidence of its persistence as a model. Over a century later, in a milieu different in so many ways from either Burnet's or Addison's, that same emotional pattern may be discerned in Shelley's *Ode to the West Wind*, animated by its recognition of the immense forces of nature as both punitive and purgational, as Destroyer and Preserver exorcising guilt only in return for submission, for abject

> prayer in my sore need.
> Oh! lift me as a wave, a leaf, a cloud!
> I fall upon the thorns of life! I bleed!

By that time, humility in the presence of personified tempestuous scenes might be thought to have become remote from the biblical or Christian setting, the poet's prayers now addressed not to God but to a Spirit vaguely identified with Nature itself. But the scriptural source of that inspiration was not foreign to the poet himself, as in the image of bleeding from the thorns of life and in the speaker's climactic plea to become, within the seasonal movements of nature, the bearer of an apocalyptic message:

> Be through my lips to unawakened Earth
> The trumpet of a prophecy!

Two years after Addison's illuminating discourse on the religious aspects of agreeable horror he was to offer further confirmation of the intimate connection between his sense of the sublime in nature and the twofold experience of Christian pride and humbling which forms the theme of this investigation. In *Spectator* 565 he recalls how, gazing at the moon on the previous evening, he had been struck by a thought which, he believed, very often perplexes and disturbs men of serious and contemplative nature, as it had King David himself; and he quotes there the verses from the Psalmist asking what is man that God should be mindful of him, his wonder at the grandeur of heaven and earth and the insignificance of man who is yet the object of divine care. Then in a passage again recognized as central to the development of the eighteenth-century sublime, Addison proceeds to record the two stages which together form the agreeable horror of which he had spoken earlier. First comes the shock of humiliation, the recognition that the supposedly self-reliant rationalist he believed himself to be is as nothing: "I could not but look upon my self with secret Horror as a Being, that was not worth the smallest Regard of one who had so great a Work under his Care and Superintendency. I was afraid of being overlooked amidst the Immensity of Nature, and lost among that infinite Variety of Creatures, which in all Probability swarm through all these immeasurable Regions of Matter." From that sense of *horror* at his own insignificance dwarfed in nature there then arises a comforting or *agreeable* assurance, a trust in the omnipotence and omniscience of the Divine Being who, as Job had recognized, considers his creatures even when they cannot see him. The one prerequisite, he adds, is *humility* on the part of the worshipper. As it is impossible God should "overlook any of his Creatures, so we may be confident that he regards with an Eye of Mercy, those who endeavour to recommend themselves to his Notice, and in an unfeigned Humility of Heart think themselves unworthy that he should be mindful of them."

Therein, it would seem, lay the paradoxical attraction of the sublime which was to permeate the conception of it throughout the century. At times it would shift away from its religious source, often substituting for the calls to God apostrophes to a more generalized Nature; yet its enthusiasts repeatedly echoed the more specifically Christian sentiments of those who had inaugurated the movement, of Burnet, Dennis, Shaftesbury, and Addison, retaining Claude Lorrain and Salvator Rosa as the artistic prototypes for that complex intertwining of the Beautiful and the Sublime. In critical theory, we should recall, the treatise of Longinus had owed its attraction in no small degree to its association with biblical sources. Its discovery had been hailed in part for the unique instance it provided of an ancient Greek author citing the Scriptures, his comment that the passage "Let there be light!" in the biblical account of creation constituted a true instance of the sublime. How deeply that Longinian reference impressed itself on the eighteenth-century imagination is evidenced by Haydn's oratorio *Creation* (composed in the aftermath of his visit to England). After a prolonged *pianissimo* passage representing the inert state of primeval chaos, the choral thundering of the final word in the phrase "Let there be Light!" was clearly intended to evoke for contemporary audiences sublime associations with that Longinian identification.

In the process of the dissemination of Longinus's ideas in England, the scriptural connection had continued to be emphasized. The annotated edition produced by William Smith in 1739, which did so much to popularize its ideas in the eighteenth century, enhanced that association in the footnotes by his repeated reference to the Bible for illustrations of the genre. Perhaps the most influential of Smith's comments was his quotation of a passage from the Book of Job, again depicting man fearful and humbled before a wrathful God rebuking him for carrying his reliance upon human reason to the level of presumptuousness:

> In thoughts from the visions of the night, when deep sleep falleth upon men, fear came on me, and trembling, which made all my bones to shake: Then a spirit passed before my face, the hair of my flesh stood up. It stood still, but I could not discern the form thereof: an image—before mine eyes—silence—and I heard a voice,—Shall mortal man be more just than God?[54]

The direction this passage gave for the Gothic novel is patent, with its dimly perceived and ghostly spirit flitting terrifyingly by. And its effect was significantly deepened when Burke took up the hint a few years later, quoting the same passage with admiration in his *Philosophical Enquiry into the Sublime and the Beautiful* as being

"more awful, more striking, more terrible than the liveliest description, than the clearest painting could possibly represent it." John Baillie's *Essay on the Sublime*, published posthumously in 1747, again pointed to the image of an angry God as constituting a perfect source of sublime terror and Lord Kames's *Elements of Criticism* confirmed in 1762 the earlier connection of it with Christian self-abasement by recording how the human mind, on confronting the infinite power of the Deity, "unable to support itself in an elevation so much above nature, immediately sinks down into humility and veneration."[55]

In the key passages in the development of the movement, that same sentiment is repeatedly echoed. Gray, in a widely quoted letter written in 1739, not only ridiculed the parterres of Versailles as being vastly inferior to the sublimities of the Grande Chartreuse, but saw that sublimity as, in its religious power, capable of overwhelming any theological hesitations on the part of the rationalist: "Not a precipice, not a torrent, not a cliff, but is pregnant with religion and poetry. There are certain scenes that would awe an atheist into belief without help of other arguments."[56] By mid-century these associations had become standard, with anonymous poems in the *Gentleman's Magazine* frequently expressing the sense of divine power and religious awe generated by such scenes, and their earlier function as the source of prophetic fire:

> Trembling, I ask, what mighty arm could raise
> Those spiring summits from their rooted base?
> Whose cloudless points as high in Aether glow,
> As sink the caverns of the deep below;
> What awe, what thoughts these pathless wilds impart?
> They whisper omnipresence to the heart! . . .
> I wonder not the bards of old inspir'd,
> Or prophets by celestial visions fir'd,
> To unfrequented scenes like these retir'd.[57]

The archetypal quality of the eighteenth-century sublime as proposed here, its origin as a transference of guilt when, as in landscape gardening, the designer subconsciously recognizes in his work a prideful usurpation of God's creative power, may be perceived as haunting the imagination of writers and artists throughout this period, well into the Romantic era. It may be perceived as constituting the substructure of one of the most powerful and durable works of Gothic fiction produced at that time. For the sin of Frankenstein in producing his monster was essentially the

same in that regard, the presumptuousness of the new scientist to arrogate to himself the creative function reserved for God, an act bringing upon him a dreadful retribution. Only gradually does he recognize the superhuman responsibilities he has thoughtlessly undertaken—"For the first time . . . I felt what the duties of a creator towards his creature were"—acknowledging that there was indeed justification in the monster's bitter recrimination of him as the "cursed, cursed creator" who so wantonly bestowed life.[58] Like the ancient mariner to whom he grimly compares himself, Frankenstein must expiate his sin in the lonely arctic wastes, the wild seas and unvisited regions of mountainous ice where man is impotent before the vengeful forces of nature.

(iii)

It is time, perhaps, to return to the follies and to enquire into the place of those structures within this larger scheme. The grotto was, of course, fashioned primarily on the Italian Renaissance version, a cool, cavernous retreat from the mediterranean sun designed to look as if it were under water, with ornamentation of shells and imitation seaweed to increase the effect. For those in England simply following a current fashion, the grotto was often no more than a pretentious outdoor parlour, as the contemporary satirist, Richard Graves, scathingly observed:

> A place—for holy meditation,
> For solitude, and contemplation;
> Yet what himself will rarely use,
> Unless to conn his weekly news;
> Or with some jovial friends, to sit in,
> To take his glass, and smoke, and spit in.[59]

But we should not overlook the opening lines of the passage, with their recognition that for those encouraging the introduction of the grotto into the English estate the purpose had indeed been more serious, to evoke a mood of philosophical and often religious meditation—a purpose, incidentally, which had not held true for the Renaissance version intended simply for pleasurable relaxation. Once again, we are confronted not with a simple imitation of an earlier model but with an adaptation calculated to suit different needs.

The contemplative aim of the grotto, to open "to the Mind a vast Field to entertain the Tongue or Pen of a Philosopher,"[60] has been validly connected with Hobbesian and Lockean theories of association, especially the belief in the stimulus to the mind provided by external objects;[61] but perhaps even more significant are the repeated allusions in the literature of this period, as well as in the design of the grottoes themselves, to the religious or semi-religious musings which its English form was intended to inspire. There was, moreover, the association of the grotto with the hermitage usually constructed nearby, of which there had been no equivalent in the Italian garden, suggesting an aspect of this fashionable movement deserving investigation. The very term *grotto* (philologically a corruption of the word *crypt*)[62] evoked for the Englishman, we should recall, certain sacred connotations beyond those of the Italian pleasure retreat—of the Grotto of the Nativity in Bethlehem and the Grotto at the Church of the Holy Sepulchre in Jerusalem. Although the New Testament accounts placed the birth of Jesus within a stable, the cave or grotto beneath the Church of the Nativity in Bethlehem had, from at least the second century, been revered as his true birthplace, an object of pilgrimage for the various Christian sects. Byzantine art normally depicted the Nativity as occurring within or before the entrance to a cave, an iconographic tradition adopted into western art until the early Renaissance, with the grotto setting frequently echoed in the cribs erected in the Christmas season throughout Europe within the formal *praesepe* tradition.

In the retreat which Pope constructed at Twickenham, there is an element which has received only cursory mention, the prominence accorded there to Christian emblems as though in proclamation of its purpose. Over the main entrance was affixed an incised stone representing the Five Wounds of Christ from the *arma Christi*, and over the river entrance a second stone representing the Crown of Thorns from the same heraldic source, both, it is believed, transferred from dismantled chapels.[63] Nor does their purpose emerge as merely whimsical in the light of the established recognition of such caverns and grottos as valuable stimulants to religious and moral reflection. John Evelyn had recorded in a letter to Sir Thomas Browne as early as 1659:

> We will endeavour to shew how the aire and genious of Gardens operat upon humane spirits towards virtue and sanctitie, I meane in a remote, preparatory and instrumentall working. How Caves, Grotts, Mounts, and irregular ornaments of Gardens, do contribute to contemplative and philosophicall Enthusiasme; how *Elysium, Antrum, Nemus, Paradysus, Hortus, Lucus, &c.,*

signifie all of them *rem sacram et divinam*; for these expedients do influence the soule and spirits of man, and prepare them for converse with good Angells. . .[64]

Within the framework of our present theme, the eighteenth-century grotto may be seen as a secular version of the religious retreat usually associated with Catholicism, that connection being preserved in this century by the repeated evocation of hermits and monks. How close the eighteenth-century grottoes, caverns, and groves remained to that tradition, despite their air of fashionable secularism, may be seen from the Valley of the Shadow of Death by Jonathan Tyers described above. There are, however, numerous instances of this association beyond those which have been mentioned here, suggesting from such more overt allusions the degree of subliminal transference present even when the parallel was camouflaged.

It might, for example, seem far-fetched to connect the grotto erected in 1733 on Sir John Chetwode's estate at Oakley with this religious contemplative tradition, were it not for the survival of an anonymous contemporary poem which leaves no room for doubt. The structure was intended, the writer informs us, to evoke the use of such grottoes by early Christians as holy refuges from oppression. In those ancient days, the poet reminds us, such structures had offered sanctuary for reflection and prayer not only for the committed anchorite but for the layman too, who (like his eighteenth-century counterpart) could experience there the pious contemplation epitomised by hermit and nun without the burden of undertaking vows of celibacy or of ascetic withdrawal from active life:

> This Cavern long was made a House of Prayer,
> When free'd from Persecution, Noise and Care,
> The thronging Penitents retir'd to pray;
> And so turn'd Nuns and Hermits twice a Day.[65]

In that context, the adoption of the Gothic mode for so many of the garden structures and, as at Oakley, often for the grotto itself, becomes not merely a nostalgic harking back to ancient building styles crumbling in ruins but an evocation far more pertinent to its subliminal religious purpose. Psychological dream transference involves almost invariably a process of mental disguise, a change of certain key elements as the mind avoids confronting the true source of its guilt or sense of failure. For the eighteenth-century Protestant, uncomfortably aware at some level of his being that his devotional spontaneity was being sacrificed on the altar of intellectualism, the translation of his dream world into a specifically Catholic setting

offered an ideal escape route. At one level he could, without blasphemy and with the confident condescension of an intellectual, indulge in the Gothic cult as a whimsical fashion of the day, while at the same time, under the guise of aesthetic pastiche, surreptitiously (and without compromising his conscious allegiances) find in his nostalgic identification with the medieval monk or hermit a surrogate for his own frustrated devotional impulses. Within the Gothic novel itself, with all its apparent contempt for the supposed corruption and hypocrisies of the Catholic religious orders, that vein of subdued nostalgia remains. *The Mysteries of Udolpho* records how, along the monastery wall, a glimpse of the outside world was permitted to the monk, now that he had renounced its pleasures, to console him with the certainty of having escaped its evils. As Emily walks pensively along, she considers "how much suffering she might have escaped had she become a votaress of the Order, and remained in this retirement from the time of her father's death."[66]

Barbara Jones has rightly noted the centrality of the hermit in a landscape tradition which has generally been seen as primarily classical in its Claudean aspirations. While there are no recorded instances of nymphs hired to swim in the ornamental lakes in order to lend authenticity to the supposed Arcadian scenes, nor of shepherds to play pipes there idyllically beside their flocks, yet for some reason (for which she is able to offer no explanation) the collective imagination was fired by thoughts of hermits and hermitages as essential components of the gardens.[67] That hermit cult, we may suspect, was something more than a decorative device, expressing, not always explicitly, an undercurrent of envy for a lost world. There is frequently in the century an overt contempt for a way of life discarded by the Protestant, as in the gardens at Stowe, which included in its inscriptions a set of droll verses on a hermit struggling to overcome his sexual desires by fashioning a female figure out of snow and (perhaps with echoes of Watteau's seductive statues) eventually assuaging his lusts by lying down with her, or in the withering scorn poured by the atheist Gibbon on Simeon Stylites, for what he termed with heavy irony the anchorite's "lofty" elevation upon a sixty-foot pole where, he continued, such voluntary martyrdom, instead of intensifying the self-flagellant's spirituality, "must have gradually destroyed the sensibility both of the mind and the body." But usually an ambivalence prevails, a personal dissociation tinged with nostalgia for the spiritual integrity which that way of life represented, a way of life no longer attainable for the writer. William Stukeley's comment on the hermitage he himself built in 1738 was that it resembled the dreariness of those habitations "where I suppose the mistaken zeal of the starved anchorite" prompted him to worship his saint or trinket. But

Stukeley desired nonetheless the presence of the hermitage within his garden. In accordance with the theory of the *tabula rasa*, whereby ideas are seen not as innate but as created by experience, Addison had advocated in *Spectator* 417 feeding the sight with a variety of objects which should by association awaken the imagination. The pseudo-hermitages were therefore often regarded as reminders from afar of the existence of such monastic cells, to promote a mood of contemplation in the viewer rather than for use as retreats from the world. Dummy figures of hermits were often placed within these settings to enhance the distant effect, and on one occasion the owner of such a hermitage, Charles Hamilton, advertised for an anchorite to live in it for payment, in order to provide a more convincing scene for himself and his visitors. His tenant in fact left after only three weeks—understandably, when one considers the harsh conditions listed in the advertisement, that for a period of seven years he was to wear a camel robe, never to cut his beard, hair, or nails, to exchange not a word even with servants, and at no time to stray beyond the limits of the grounds.[68] But for all the absurdity in this incident, the offering of financial remuneration to a supposed ascetic despising worldly wealth, Hamilton's very desire to have a genuine anchorite in close proximity suggests some residual respect, perhaps a vicarious longing for the life of holiness and spiritual dedication.

Thomas Parnell's poem *The Hermit*, itself an unimpressive versification of an ancient legend, contained what was to become the standard eighteenth-century description idealizing the eremite's life. He is seen as not only retired from daily activities but also, by his location in the heart of nature, isolated from the urbanism which had come to characterize contemporary intellectualism:

> The moss his bed, the cave his humble cell,
> His food the fruits, his drink the crystal well:
> Remote from man, with God he pass'd the days
> Prayer all his business, all his pleasure praise.

If in this passage the tone is uninvolved and dispassionate, in the same poet's *A Hymn of Contentment* the evocation takes on a markedly more personal note, more obviously genuine in its religious ambience, in the speaker's longing for withdrawal from the hubbub of life to a garden retreat desired for its sweetness, but most of all for its devotional potential. There, he believes, solitude might yet inspire him with the celestial visions afforded in the past to the biblical prophet, the scriptural figure who, merging with the ancient bard, was to become the composite eighteenth-century variant of the hermit:

Oh! by yonder mossy seat,
In my hours of sweet retreat,
Might I thus my soul employ,
With sense of gratitude and joy!
Rais'd as ancient prophets were,
In heavenly vision, praise and prayer;
Pleasing all men, hurting none,
Pleas'd and bless'd with God alone.[69]

Part of the inspiration for these hermitages and for the cult of melancholy associated with them was, of course, Milton's *Il Penseroso*, a poem which, as Shenstone remarked on inspecting the relevant volume of *Dodsley's Miscellany*, "has drove half our Poets crazy."[70] But Milton's wistful evocation of the "peaceful hermitage, / The hairy gown and mossy cell" as appurtenances conducive to his attaining to prophetic strain had been, like the pastoral setting of his *Lycidas*, a graceful poetic image, not to be taken literally. Milton was, we should suspect, the last person to advocate a withdrawal from the world of action, as unlikely to retire to a hermitage in real life as he was to put off his worsted coat and don the hairy mantle of the prophet. Moreover, the desire expressed in that passage was, even poetically, in no sense for identification with the Catholic hermit renouncing the world (anathema to the Puritan poet) but, as the hairy gown specified, a yearning for the tradition of the biblical prophet, whose passionate poetry should, from his lonely outpost, inspire and direct the moral course of mankind. The distinction is significant. For although the eighteenth-century fashion for melancholy contemplation may have been consciously evocative of the mood prevailing in that poem, its model had now become quite specifically the recluse or hermit of the Catholic faith. Within the new garden hermitage its occupant was once again conceived, in the tradition of the medieval monk, as contemplating the ephemerality of human existence, evidenced by the skull displayed over the doorway of these garden cells such as the design for a hermitage by William Wrighte in 1767 (*fig. 68*).[71] In the Gothic novel, where one sensitive critic has indeed perceived the horror to be a form of displaced religious experience, the Catholic associations are more prominent, with their monastic settings, dark catacombs, and crumbling abbeys,[72] but that Catholic identification applies no less to the garden grottoes and Gothic follies out of which the genre arose.

It was an identification persisting well into the romantic era. We may recall how even that staunchly Unitarian author of *The Ancient Mariner* ensured that his guilt-

68. WILLIAM WRIGHTE, design for a hermit's cell

ridden protagonist be granted Catholic confession and absolution at the hands of the hermit before beginning the second stage of his penitential task:

"O shrieve me, shrieve me, holy man!"
The Hermit crossed his brow.

The placing of the story within the ancient past necessarily assumed a Catholic setting, but there was no requirement for the ritualistic aspects of that creed to be incorporated into the process of spiritual renewal were they not germane to the poet's larger purpose.

The distinctly un-Protestant fascination with the paraphernalia of death implicit in the eighteenth-century Gothic was clearly no minor element in view of the vogue of graveyard poetry, charnel houses, and decaying corpses, not only in the more lurid scenes of the Gothic novel itself but in such more distinguished works of the century as Gray's *Elegy in a Country Churchyard*, with its melancholy musings in the

darkening cemetery where "heaves the turf in many a moldering heap." Here, too, Salvator Rosa's influence may be discerned in the development of this gloomier view of the human condition. His etchings included the well-known *Democritus in Meditation* (*fig. 69*), which has generally been taken by historians at face value as being essentially classical in theme, the portrait of a Greek philosopher; but we should not ignore the patent iconographic allusions to Christian concerns. The title of the etching, and of a similar painting executed a few years later on that subject, pointedly assumes the classical-Christian merger typical of post-Renaissance art, associating the overt pagan theme with the Christian contemplation of *media vita in morte sumus*. Democritus is depicted in a pose characteristic of that latter tradition in contemporary religious art, gazing thoughtfully at a human skull, with obelisks and sarcophagal urns introduced as classical counterparts.[73] And lest the point be missed, a scroll at the foot of the etching bears the legend appropriate to a *memento mori*: "Democritus the mocker of all things, confounded by the ending of all things."

For Protestant England of the eighteenth-century such scenes were, of course, never so intensely experienced as they had been during the baroque period on the continent, becoming for the builders of these pastiche hermitages more a flirtation with the Catholic idea of death, the cultivating of an aura of religious melancholy for its own sake. But that dilettantism should not be allowed to obscure its function as a substitute for an emotional dimension felt to be lacking in the contemporary scene. The amateurism in such pursuits, which helped detractors to dismiss them as mere "follies," becomes, in that light, more understandable. It reflects the psychological discomfort involved in all such attempts to sublimate a suppressed impulse without consciously acknowledging its existence.

Grave monuments, too, undergo a change reflecting these shifts in viewpoint. In place of the apotheoses of the baroque era representing the glorious acceptance of the soul ascending into heaven—as on the ceiling of the Banqueting Hall in Whitehall—the imagination now stops short at the moment of death within *this* world. Roubiliac's *Nightingale Tomb* of 1761 in Westminster Abbey marmoreally depicts a husband vainly endeavouring to fend off Death as it reaches out to rob him of his wife (*fig. 70*). Roubiliac, having been invited to England, may be presumed to have discussed the theme of the statuary with the relatives, but even on the continent where Catholicism had inaugurated and so long preserved the portrayal of heavenly visions beyond the grave, the focus was now becoming directed to the terrestrial sphere. The distraught widow of the Comte d'Harcourt instructed Pigalle in 1776 to create for her at his tomb in Notre Dame a sculptural representation of her

Democritus omnium derisor
in omnium fine defigitur

Salvator Rosa Inu. fecit

69. SALVATOR ROSA, *Democritus in Meditation*

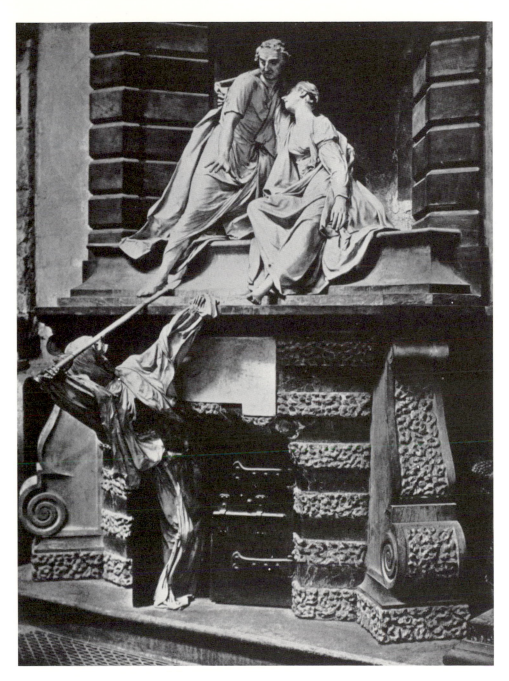

70. ROUBILIAC, *Nightingale Tomb*

71. PIGALLE, *Monument to Comte d'Harcourt*

eagerness to join her husband not in heaven but in the grave (*fig. 71*). In a chilling scene, so ghoulish to modern taste that it was for many years incorrectly interpreted as paralleling the *Nightingale Tomb* in theme, with the widow pleading for her husband's release from death, in fact, as we know from contemporary sources, it depicts the Angel of Death raising the cover of the tomb to reveal the emaciated corpse of her late husband, beside which she is about to be willingly interred.[74]

The religious melancholy exemplified in the graveyard movement is by no means unrelated to the mountain terrors associated with the sublime, the same terms being used interchangeably. The terror which cragged peaks and precipices inspired was seen in its day as analogous to the emotion evoked by temporal dilapidation, as in Arthur Young's description in 1768 of the uncultivated regions of the north: "This horrible wildness greatly strengthens the idea raised by falling walls, ruined columns, and imperfect arches: both are awful, and impress upon the mind a kind of religious melancholy."[75] Both elements, the wildness of nature and the passing of time exemplified by ancient ruins, betoken a concern, even when unspoken, with the fear of death. Transmuted from its traditional Christian context into an ostensibly aesthetic appreciation of overwhelming prospects, pseudo-hermitages, and imitation ruins, it retained even in that guise the duality implicit in its original religious form—a dread of annihilation mingled with a sense of potential salvation. Such was the twofold impulse unifying that mode from its earliest surrogate manifestations, as in the following passage from Dennis, shifting back and forth in its evaluation of the natural scene from a sense of its terrifying severity to a sense of its benign gentleness. The mountain's

> . . . craggy Clifts, which we half discern'd, thro' the misty gloom of the Clouds that surrounded them, sometimes gave us a horrid Prospect. And sometimes its face appear'd Smooth and Beautiful as the most even and fruitful Vallies. So different from themselves were the different parts of it: In the very same place Nature was seen Severe and Wanton. In the mean time we walk'd upon the very brink, in a litteral sense, of Destruction; one Stumble and both Life and Carcass had been at once destroy'd. The sense of all this produc'd different emotions in me, *viz.* a delightful Horrour, a terrible Joy, and at the same time, that I was infinitely pleas'd, I trembled.[76]

Within the broader setting, this duality, then, expressed itself, when polarized, in terms of the Beautiful and the Sublime, the landscaped gardens representing with hints of Eden the harmony of man's unity with God, while the grottoes and hermitages erected within them corresponded in their melancholic quality to the fascina-

tion with death inspired by the horrific scenes in the wilder areas of nature. At times that duality was more obviously separated, as in the garden envisaged by Aaron Hill in 1734, with a Temple of Happiness surrounded by a pastoral scene suggestive of Paradise to fulfil the Claudean prospect, and, in contrast, the Valley of the Shadow of Death designed by Jonathan Tyers.[77] In general, however, the eighteenth-century response to Nature was more intricately intertwined, those two themes forming aspects of a complex response, primarily religious in origin through its psychologically transmuted process of spiritual gratification, divine wrath, and achieved humility.

In concluding one should note, perhaps, that this sublimation of Christian experience during a predominantly secular age was not confined to interpretations of nature. In a different context, Ronald Paulson has wisely observed how Joseph Wright's depiction of industrial scenes conforms in many ways to the iconographic patterns of religious art.[78] His *Iron Forge* of 1772 (*fig. 72*) employs the glowing ingot as the source of illumination in much the same way as religious painters had traditionally achieved the supernatural effect of a Nativity scene, with the newborn Child, as in Guido Reni's *Adoration of the Shepherds* (*fig. 73*), shedding light on all around. What significance that evocation bore in Wright's work Paulson does not attempt to establish—perhaps it was a sense of the miraculous, discoverable even in the material and scientific sphere. But from another of his paintings we may suspect the existence of a disturbing ambivalence in the artist's treatment of such themes, a sad awareness of the mutual exclusiveness of the older beliefs and the new, not unrelated to the themes examined in this chapter. His *Experiment on a Bird in the Air-Pump* of 1768 (*fig. 74*), illustrating the inability of a bird to fly once the air has been extracted from the glass flask, depicted its helpless collapse within the vacuum created by the pump. What strikes the art historian most forcibly is the painter's reversion to the chiaroscuro techniques of Caravaggio to deepen the effect of mystery in what is supposedly a rationally conducted experiment. Yet one must acknowledge that such mysterious responsiveness to the emotional implications of the demonstration rather than its overt theme, the acquiring of empirically tested knowledge, would seem to undercut the purpose of the painting.

If, however, instead of resisting the implications of the chiaroscuro, we see them as integral to the painting, an allusion to the iconological principles of traditional art intended to be caught by the viewer, a more subtle theme emerges, a disturbed questioning of earlier assumptions evidenced by the ironic structuring of the work. The dove, as the symbol of the Holy Spirit, had for generations been placed by artists centrally above a religious scene to convey the providential presence of the

72. JOSEPH WRIGHT, *The Iron Forge*

73. GUIDO RENI, *Adoration of the Shepherds*

74. JOSEPH WRIGHT, *An Experiment on a Bird in the Air-Pump*

divine. Here that same dove, still centrally placed above, no longer presides reassuringly over all but lies inert within the laboratory flask, the victim, as it were, of the new science. The compassion of a young girl at the side, instinctively shielding her eyes from the sight of the dove's suffering and resisting her father's urging to look and learn, echoes the painting's commentary on the displacement of traditional faith by the rationalism of the laboratory, with the girl's compassion perhaps hinting at the tradition of the *Pietà*.[79]

Such secularizing of religious scenes pervades much of the art of this period, offering the palimpsestic effect of a new reading imposed upon the old, as in de Loutherbourg's powerful canvas *Coalbrookdale by Night* of 1801 (*fig. 75*), with its depiction (unfortunately toned down in monochrome reproduction) of the lurid brilliance of the factory furnaces, glowing like a vision of Hell from within the "dark, satanic mills" of industrialized England. It was a merger of old and new visions reflected in Carlyle's contemporary depiction of the manmade infernos of Birmingham, the brick and iron factories where

> . . . at night the whole region burns like a volcano spilling fire from a thousand tubes of brick. But oh the wretched one hundred and fifty thousand mortals that grind out their destiny there! . . . they were wheeling charred coals, breaking their ironstone, and tumbling and boring cannon with a hideous shrieking noise such as the earth could hardly parallel; and through the whole, half-naked demons pouring with sweat and besmeared with soot were hurrying to and fro . . .[80]

The religious impulse behind the eighteenth-century conceptions of the beautiful and the sublime were remarkably persistent, enduring well into the Romantic era itself as its poets withdrew from classical imitation to a revalidation of the prophetic model not only stylistically but thematically too, in their sense of the moral forces of nature working upon the human spirit. It was a phenomenon paralleled in painting. If for much of the century the religious conceptions of the sublime and beautiful initiated by Burnet, Dennis, and Addison were to find artistic expression often in a disguised secular form, towards the end of the century that initial impulse became more overt. John Martin's painting, *The Bard* of 1817 (*fig. 76*), conveys with dramatic power the immensity of the crags physically dwarfing and thereby spiritually elevating the prophetic figure, emotionally swept aloft by the scene; but even that was not sufficiently explicit for his purposes, and in search of the sublime he returned to the source. He won enormous success both in England and on the continent for a series of canvases devoted to scriptural scenes from Genesis to Reve-

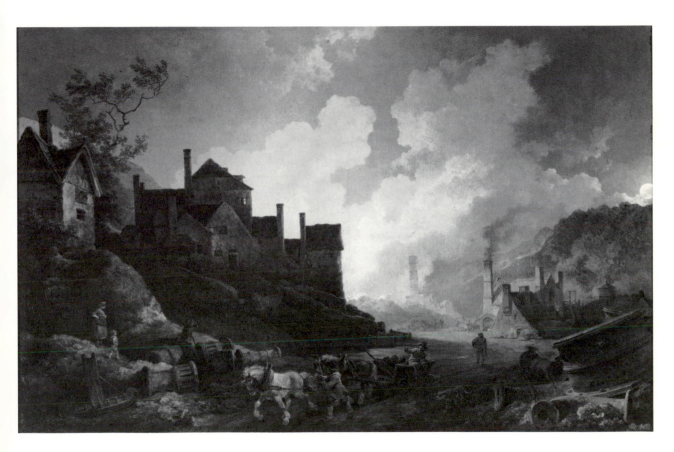

75. DE LOUTHERBOURG, *Coalbrookdale by Night*

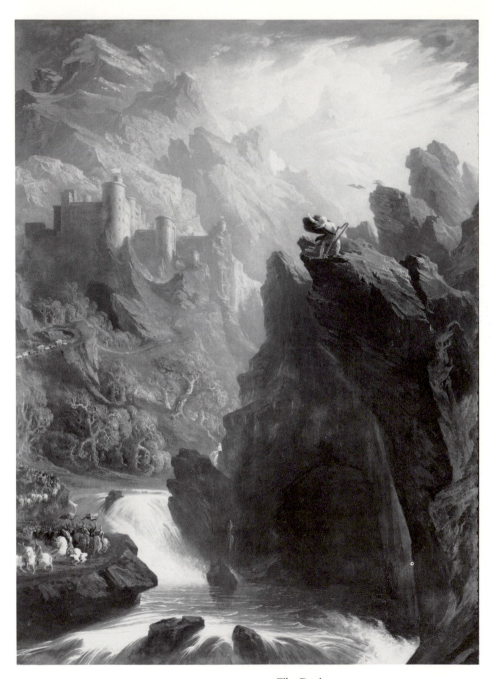

76. JOHN MARTIN, *The Bard*

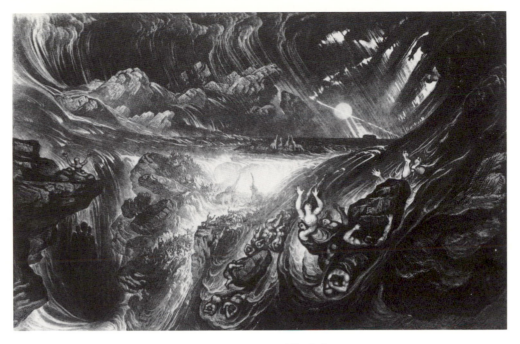

77. JOHN MARTIN, *The Deluge*

lation selected for their sublimity of conception and grandiose might—*Joshua Commanding the Sun to Stand Still, Belshazzar's Feast, The Destruction of Sodom*.[81] Among them was *The Great Day of His Wrath*, offering an apocalyptic vision of divine retribution, and his *Deluge* (*fig. 77*) which in effect completed the circle. They reaffirmed the religious apprehension of the sublime as it had been inaugurated by Poussin's *Deluge* and Burnet's awed account of the Flood.

There was, we may conclude, a more intimate connection than has been thought between those apparently diverse eighteenth-century phenomena, the sophisticated cultivation of landscaped gardens and the awed responsiveness to the sublime forces of nature. So far from being polarized modes independently indebted to the influence of Claude Lorrain on the one hand and to the discovery of Longinus's treatise on the other, they are to be seen (as indeed the eighteenth century instinctively saw them) as aesthetic concomitants, representing, in a period of rationalization within a country deprived of the confessional as an outlet for suppressed religious emotion, a sublimation or transference to the aesthetic sphere of those alternating emotions of intellectual self-confidence and spiritual self-abasement so central to the Christian experience.

6

BLAKE'S
INWARD PROPHECY

(i)

For those attracted to synchronic investigation of the kindred arts, there would appear to be an especial interest in approaching the work of Blake, a rare opportunity to explore the similarities and contrasts discernible in the poetry and painting of the same creative artist. Here, it would seem, we may examine under ideal conditions, undisturbed by differences in the personality of painter and poet which normally hamper such investigation, the variations in technique appropriate to the verbal and visual media in manifesting both his individual genius and his responsiveness to broader contemporary modes. Blake's status as an acknowledgedly major figure both for the art historian and for the literary critic—until recently, generally examined compartmentally within each discipline—divorces him from other writers who, like Pope or D. H. Lawrence, experimented in the sister art of painting but achieved distinction only in literary composition.

Yet a comparative study of Blake's work in search of insights into the general principles of such interdisciplinary investigation, stimulating as it may be, is complicated by two factors which it would be well to confront at the outset. As Northrop Frye, Jean Hagstrum, and W.J.T. Mitchell have so wisely reminded us, his work does not consist in the main of productions in the disparate media, of paintings intended for the delectation of the viewer and poems for perusal by the reader, each available for comparison of their stylistic or semiotic qualities as the diverse products of a single hand. Instead they are for the most part instances of a composite art, in which he functioned as a conscious integrator of the two media in works exploiting simultaneously the opportunities offered by both forms of expres-

sion.[1] His verse, distinctively inscribed in his own flowing hand and intended to be read in that form, appeared upon a page illuminating it visually, picturing or extrapolating its poetic metaphors (at times with contrasting effect), but above all interacting subtly with the text in a manner which inevitably detracts from the total effect if the poem is printed alone, as so frequently occurs. Moreover, in his later period his masterly illustrations to the *Inferno*, to *Paradise Lost*, and to the Book of Job were intended to be savoured not in isolation but in close conjunction with those literary works, as pictorial evocations of their verbal message. The resulting product is therefore an interfused art form, susceptible in only a very limited degree to comparative intermedia study.

The second factor complicating such investigation has received less attention in recent criticism—the need to recognize that while he excelled in both media, the degrees of excellence were not concomitant in their developmental progression.[2] Despite the enthusiasm and care with which the prophetic books have been critically expounded in recent years, few would deny preference as poetry to the haunting lyrics of his earlier years, the exquisitely fashioned poems published before 1795 which gradually gave way in his writings to the increasingly esoteric prophetic works, rich in symbolic allusiveness but relying less upon literary exploitation of their poetic form and at times even preferring prose. His engravings and watercolours, on the other hand, reveal a more traditional process of maturation, a process beginning with his less skilful productions, the sketchy, often disappointing illustrations to his *Songs of Innocence and Experience*, including his acknowledgedly unsatisfactory representation of the *Tyger*,[3] but blossoming into their fullest power in the consummate artistry of his final phase from 1807 onwards. To compare the best of Blake's work, therefore, is really to compare two chronologically disparate Blakes, the inspired poet of his youth and the masterly draftsman and experienced watercolourist of his maturer years.

With those reservations in mind, it may be well to begin by exploring a phenomenon which is free of such temporal discrepancy because of its simultaneous manifestation within the developing phases of Blake's art. It was a significant transformation which marked both his poetry and painting at a mid-point in his career. One of the few non-hybrid works he produced, intended neither as a commentary upon an original poem by his hand nor as an illustration for an accompanying text by others, was his magnificent watercolour *A Vision of the Last Judgment* from 1808, commissioned by the Countess of Egremont (*fig. 78*). It is an astonishing achieve-

ment both in conception and in execution. Indebted as it was to the famed altarpiece in the Sistine Chapel, it emerges despite that conscious emulation as a profoundly original work. It discards the brooding pessimism of Michelangelo's *Dies Irae*, the grim mood of that artist's final phase, in favour of a scene animated by radiance and glory. Where Michelangelo's fresco had been dominated by the stalwart figure of a stern, condemnatory Christ, inexorably assigning the sinners to their eternal doom, a Christ from whom even the Virgin turns her head away in sorrow as if helpless to intercede, Blake's version is a glowing image of salvation, a design energized by the brilliance of the divine throne whose incumbent, while indeed despatching the damned to their suffering below, draws upward towards the light in a sweeping, irresistible movement, husbands and wives, parents and children, reunited in joy to take their place at the right hand of God.[4] Although it has become fashionable in recent years to praise Blake particularly for his success in integrating picture and text, this rare instance from his canon of a work free from literary admixture, biblical in inspiration but not related to chapter or verse, may well indicate by its visionary splendour his true potential as an artist when liberated from the constrictions of producing, often under the pressure of financial need, composite material which he mistakenly believed to have a greater commercial appeal.

The burgeoning structure of *The Vision of the Last Judgment*, rising from hell through the stem-like centrality of the trumpeting angels to flower into the vision of Adam and Eve kneeling humbly before their merciful Judge, is evocative of the floral arabesque, its overall design recalling the intricate patterns ornamenting the panels of Rococo salons with, on either side of a vertical dividing line, mirrored forms subtly variegated, yet preserving the visual balance integral to that art. Yet Blake's version is at the same time markedly different, animated in a manner incompatible with those ornamental designs, deserting the stasis of Rococo art in favour of swirling, visionary movement, of figures soaring upward on one side and hurtling downward on the other. That restless equivalence in design emerges, in fact, as a dominant pattern in his painting from the 1800s onward, as in *Ezekiel's Vision* from 1803–5 (*fig. 79*), *Mercy and Truth Are Met Together*, *The Fall of Man*, and numerous others from the same period. In an earlier chapter, the arabesque, interpreted as expressing the ideal of equilibrium prevailing in Rococo art and architecture, was, it may be recalled, related there to Pope's contemporary version of the heroic couplet, both forms expressing a regard for the rational weighing of alternatives, with the caesura dividing his lines into two halves to create a sense of con-

78. BLAKE, *The Vision of the Last Judgment*

79. BLAKE, *Ezekiel's Vision*

trolled oscillation and with the end rhymes providing an extrapolation of that echo-
ing mode into the outer structure. It may be relevant, on the same principle, to
connect Blake's revitalized form of the arabesque to the innovative elements dis-
cernible in his own poetic forms at the time of this transformation in his visual
designs.

The lyrical grace of Blake's earlier verse, the poems of joy and sorrow in his
Poetical Sketches and his *Songs of Innocence and Experience*, drew their metrical forms,
as we know, primarily from the revived ballad tradition, the model associated with
the bardic poet. Praised early in the century by Addison in what was then con-
demned unhesitatingly as "the quirk of an otherwise impeccable critic," gradually
gaining respect through the publication of Percy's *Reliques of Ancient English Poetry*
in 1765 (which even there needed to be prefaced by the editor's apology for having
spent his leisure time on "a parcel of Old Ballads"), they were by the end of the
century becoming particularly attractive to a poet such as Blake searching for a
genre divergent in emotional timbre as well as structural patterning from the intel-
lectualized wit of Augustan verse.[5] Metrically, he declined to be tied to the stanzaic
form of the ballad, experimenting with trochaic and anapestic variations, yet retain-
ing the simplicity of diction, the brevity of line, and the aura of fresh, unmediated
emotion learnt from that earlier tradition:

> How sweet I roam'd from field to field,
> And tasted all the summer's pride,
> 'Till I the prince of love beheld,
> Who in the sunny beams did glide!

If the *Songs* were intended, as their subtitle proclaimed, to demonstrate "the Two
Contrary States of the Human Soul," the antitheses which they explored were far
removed from those predominating in the intricate interplay of the heroic couplet.
Here the contrasts were conveyed not within a single line, nor even within the same
poem, but in the larger counterpointing of one poem with another, such as "The
Chimney Sweeper," as it appeared in *The Songs of Innocence*, and its complementary
version in the *Songs of Experience*. Read in isolation, the individual poems contained
no hint, either in their metrical form or in their structural patterning, of the inter-
nally balanced design which had prevailed in Rococo verse. Yet at the height of his
poetic creativity Blake suddenly deserted that newly crafted verse form which he
had derived from the ballad in favour of a line split like Pope's by a centrally placed
caesura and also producing an effect of alternation for the two balanced halves:

I will lament over Milton/in the lamentations of the afflicted
My Garments shall be woven/of sighs & heart broken lamentations
The misery of unhappy Families/shall be drawn out into its border
Wrought with the needle/with dire sufferings poverty pain & woe
Along the rocky Island/& thence throughout the whole Earth . . .

<div align="right">(Milton 1:18:5–9)</div>

The auditory effect of oscillation is unmistakable even with the caesuras unmarked.

Those central pauses dominating the verse he began writing at this time in fact resemble closely the new technique apparent in his watercolours, as well as in *The Vision of Judgment*, the existence as it were of an invisible vertical line dividing into two halves so many of the paintings he produced in this period as to become characteristic of this phase in his artistic production.

The system of contrarieties in Blake's philosophy Robert Simmons has rightly distinguished from the *concordia discors* predominating earlier in the century, seeing in Blake's more vital form of it a "scathing satiric critique of the whole basis of eighteenth-century rationalism," an attack upon the fixed and finite world as conceived by the preceding age. The matching of the initial and final illustrations in *The Book of Urizen* and the thematic echoing within the text represent, he maintains, not a harmony attained by reconciliation but a demonstration of the evils attendant upon the fallen condition of man. But the point needs to be taken further; for here, too, the symmetry he discusses, like the complementary poems of Innocence and Experience, is not an inner equivalence such as the "arabesque" verse of an earlier generation displayed, but a thematic contrast between separate units.[6]

The specifically internal symmetry we are discussing here, which simultaneously entered both his poetry and painting, despite any surface resemblance it may suggest to the Augustan verse line or to the Rococo arabesque, derived, it may be argued, from an entirely different source, a source more germane to the new visionary quality of his writings and of the paintings associated with them. In that context, the purpose of the echoing halves may be seen as intended to create not the stasis of objective, judgmental equilibrium, but rather a pulsating pattern of affirmation, in which the second hemistych served as an incantational throb of fervour ratifying the sentiment expressed in the first, the oscillation being not cerebral but emotional. It was an innovation in fact deriving from new conceptions of biblical poetry which, once absorbed into his own verse, affected by association his visual representation of the prophetic ideas they conveyed.

<div align="center">261</div>

In the decade prior to Blake's composition of the prophetic books, the revolution occurring in the eighteenth-century analysis of Hebraic verse forms had provided a new model for poets. Milton, consciously drawing upon the scriptures for the archetypal content, the vision of history, and the divine authority of his major epic, had echoed at times their familiar imagery and phraseology; but stylistically they could provide him with no model for his poetic forms, for which he was compelled to turn instead to classical or Renaissance precedents. For despite tireless efforts on the part of scholars throughout the centuries, biblical verse had remained a metrical mystery, refusing to conform to any system comprehensible to the western world. The imagery and tautness of language, to be found in the Psalms, the Song of Songs, and the prophetic books of the Old Testament, were felt by any sensitive reader to be poetic in the highest degree even in translation, but the original proved unscannable by any standards of prosody known to western civilization. And the Hebrew people could be of no assistance. Since the practice of its composition had died out soon after the close of the biblical period, medieval Hebraists such as Yehuda Halevi had unashamedly borrowed their verse forms from their Arab neighbours, and there were therefore no contemporary practitioners to assist in solving the problem.

As I have argued elsewhere in connection with the poetry of the period (and not, as here, in relation to its painting), Robert Lowth's highly praised series of lectures on *The Sacred Poetry of the Hebrews*, delivered from 1753 onwards, produced an effect on the literary scene which eddied far beyond his subject matter. It is important to recall that he delivered that series not as a theologian but as the newly appointed Professor of Poetry at Oxford, a position which had normally evoked commentaries on literature at large. Instead, he enunciated for the first time his theory of the parallelist basis of ancient Hebraic verse, a theory which not only solved the problem of interpreting biblical poetic forms. It also offered to contemporary writers a new model for poetry whose sacred source, in an age of Neoclassicism, protected it from disqualification on grounds of its non-classical origin.[7] Free from the strict scansional rules of Latin quantitative verse or of English accentual metre, it relied instead, he demonstrated, upon a loose rhythmical pattern of hemistyches (possibly emerging from an ancient tradition of alternating choir and anti-choir), the latter half of each verse echoing by repetition, elaboration, or antithesis the sentiment of the first, with only an approximate, generalized equality in length or sound.[8] The result was a more flexibly structured verse form, the rhythmic undulation created, particularly in the prophetic books of scripture, by the impassioned declarative or denunciatory rhetoric of the seer instead of adherence to numerically

ordered patterns. In 1778, the publication of Lowth's English translation of the Book of Isaiah provided a practical explication of the theory he had adduced. Breaking away from established traditions of biblical translation, he provided neither a literal prose equivalent such as the King James Version had offered, nor a versified elaboration such as poets had so often supplied, extraneously imposing their individualistic poetic style upon the content of the scriptures to replace what seemed to be missing. Instead, his new version, keeping scrupulously close to the original, set out the text line by line as poetry in its own right, unadulterated by admixtures of accentual patterning or imported rhyme schemes, with the passionate rhythmic throb of its content, of the prophetic testimony, alone serving as the poetic vehicle:

> Let the desert cry aloud, and the cities thereof;
> The villages, and they that dwell in Kedar:
> Let the inhabitants of the rocky country utter a joyful sound;
> Let them shout aloud from the top of the mountains.
> <div align="right">(Isaiah 42:11)</div>

The implications of Lowth's theory were evident to his contemporaries even before the appearance of his translation, particularly the encouragement it offered for those writers desiring liberation from the constrictive Augustan rules of verse in favour of a freer, emotionally charged poetry sanctioned by so venerable a source. It found, for example, an immediate admirer in Christopher Smart who, praising Lowth's lectures with enthusiasm as "one of the finest productions of the century," soon adopted its principles for his own verse composition, his *Jubilate Agno* echoing not only the fervour of Psalmist and prophet in its rapturous paean to heaven but also the loosely parallelistic verse form which he had learned from Lowth:

> Let man and beast appear before him, and magnify his name together.
> Let Noah and his company approach the throne of Grace, and do homage to
> the Ark of their Salvation.
> Let Abraham present a Ram, and worship the God of his Redemption.
> Let Isaac, the Bridegroom, kneel with his Camels, and bless the hope of his
> pilgrimage . . .[9]

Similarly, Macpherson's *Ossian*, of whose genuineness Blake was convinced, fascinated readers with a rhythmical prose more poetic in its spontaneity than the formal verses appearing regularly in the *Gentleman's Magazine*, and it, too, derived its literary force from the undertow of parallelistic pulsation, now recognized on scriptural authority as an authentic form of verse patterning:

Their souls are kindled at the battles of old; at the actions of other times. Their eyes are flames of fire. They roll in search of the foes of the land. Their mighty hands are on their swords. Lightning pours from their sides of steel. They come like streams from the mountains; each rushes roaring from the hill.[10]

For Blake, the revealing of this new poetic model in the very writings of the prophets with whom he so intimately identified his own function as a poet provided a powerful incentive for a metamorphosis in his own verse forms; and the change observable in his writings is indeed a shift away from the ballad-inspired metres of his earlier *Songs* to the fluctuating throb of meaning, the hemistychal re-affirmation of passionate assertion which constitutes the dominant metre of such works as *The Four Zoas*, no longer making any pretence of conformity to established metrical patterns. There, fallen man

Beheld the Vision of God/& he arose up from the Rock
And Urizen arose up with him/walking thro the flames
To meet the Lord coming to Judgement/but the flames repelld them
Still to the Rock in vain they strove/to Enter the Consummation . . .[11]

Because of the Old Testament's severe prohibition against images, there existed in those ancient times no visual form of this contrapuntal effect, so fundamental to the literary imagination of the scriptures, which might have offered a model for the painter—apart, perhaps, from the twin cherubim placed above the holy ark, which became significantly a favoured and reiterated motif in Blake's later paintings (cf. *Satan Going Forth*, *fig. 91*).[12] In Blake's work, that literary process of ardent affirmation—recapturing the principle of the song of Moses *answered* by Miriam and her maidens, the markedly antiphonal form of numerous Psalms, and the rhythmic parallelism of the Bible's finest poetry—found, it would seem, its pictorial counterpart in the transformation discernible within his own paintings at the very same period as the literary echoing of emotionally proclaimed certitudes was being incorporated into his verse; and the dates are indicative. In 1804, he recalled in the preface to *Jerusalem* how, in his search for a metre allowing for greater freedom from scansional limitations, he had first considered employing blank verse as being at least unconstricted by rhyme: "But I soon found that in the mouth of a true Orator such monotony was not only awkward, but as much a bondage as rhyme itself. I therefore have produced a variety in every line, both of cadences & number of syllables . . . Poetry Fettr'd, Fetters the Human Race!"[13] The variety of cadences he finally

264

selected as the vehicle for his prophetic books, consciously echoing the writings of Isaiah and the scriptural prophets, was, as we have seen, the flexible, rhythmic undulation of parallelist form. In the paintings, too, which he produced during those years, that freer, passionate echoing becomes a dominant element of the design. It was, we may recall, the period of Blake's reinvigorated faith, his return to creativity "free from fetters" after his own dreadful experience of the slough of despond. As he remarked in a famous letter to Hayley dated 4 December 1804: "I have indeed fought thro a Hell of terrors & horrors (which none could know but myself) in a Divided Existence. Now no longer Divided nor at war with myself I shall travel on in the Strength of the Lord God."[14] In that new confidence, his *God Writing on the Tables of the Covenant* of 1805 (*fig. 80*), like *Ezekiel's Vision*, surges upwards in flaming symmetry, with the trumpeting angels on either side creating, as in his newly adopted verse form, not a precise, measurable equivalence but, by the unconstrained fervour of repetition, a dazzling display of celestial power before which in the foreground the prophet kneels in adoration.

It is in that context that the Petworth *Last Judgment* should be seen. Technically, it preserves the circular Sistine pattern of souls rising to take their place at the right hand of God while those to his left plummet down to Hell; but in contrast there is introduced here a central section, also symmetrically designed, whose vigorous upward movement counteracts any downward tendency, thereby producing an overall effect of redemption through divine Grace. Within that section and carrying the eye up towards the figures of Adam and Eve in penitence before the divine again two rows of trumpeting angels, seemingly infinite in number as they stretch into the distance, provide in their gesturing towards the throne a visual analogy for the antiphonally responsive angels of Isaiah's vision "calling one unto another" in veneration, Holy, holy, holy is the Lord of Hosts.

(ii)

No reader acquainted with Blake's writings will need to be reminded that his own religious affirmations rarely coincided with the paeans of the heavenly host as recorded in the scriptures. In place of a laudatory "Holy, holy, holy . . . ," he was more likely to denounce the Creator of the World for his cruel tyranny, summarizing the Christian Redemption in the irreverent terms: "First God Almighty comes

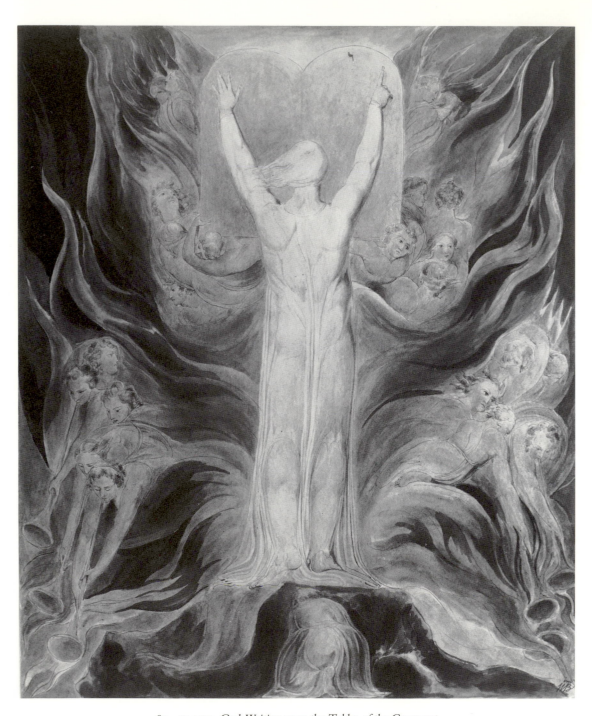

80. BLAKE, *God Writing upon the Tables of the Covenant*

with a Thump on the Head. Then Jesus Christ comes with a balm to heal it."[15] On the other hand, his reaction was less idiosyncratic in its time than might at first appear, forming part of a broader movement perceptible throughout Europe at the turn of the century. Even among those most sensitive to religious experience and firmest in their commitment to scriptural teachings, a desire was emerging for new cosmogonies, for a revitalization of Christian myths and moral values in a world resistant to the older forms of belief. Their desire for such doctrinal realignment often betrayed a paradoxical element, on the one hand a defiant reassertion of traditional faith in the face of rationalist attack, yet on the other an admission of the inadequacies which that opposition had exposed and a desire to rectify or at least modify them.

Within painting the dissatisfaction with tradition had been amply demonstrated, notably in the secularizing of Christian themes mentioned in an earlier chapter in connection with Joseph Wright of Derby, the transference of iconological patterns from their biblical or saintly settings to more contemporary political, social, and even scientific scenes. That tendency revealed a distancing of general cultural concerns from the confines of the church. As Robert Rosenblum has shown, the genre of hagiography was being similarly deflected, transferred from glorifying the martyrs of the church to honouring the martyrs of the French Revolution, as in David's acclaimed *Death of Marat* and the series of portraits he provided to memorialize the fallen leaders of the Revolution. Goya's *Executions of May 3rd* now provided a more harrowing and more immediate protest against man's ruthlessness to man than traditional depictions of *The Murder of the Innocents* by the soldiers of Herod; and the Pietà of earlier generations was now being relocated in military or imperial settings, as in the canvases of Copley and West depicting a Major Peirson or General Wolfe expiring on the battlefield in the arms of mourning comrades.[16]

Yet such transmuting of Christian symbolism eventually provoked a reaction, a small but notable countermovement among those resentful of such secularization. It arose from the initiative of a few influential painters during the last years of the century who were less concerned with revalidating the formal rituals of the church than with promoting spiritual renewal, with encouraging some form of rededication to the divine. Caspar David Friedrich's *Cross in the Mountains*, like his controversial Tetschen altarpiece,[17] by replacing the traditional scene at Calvary with that of a contemporary cross erected on a craggy mountain peak in order to comfort the lonely wayfarer, offered in effect a meditation not so much upon the Crucifixion itself as upon the divinity of nature suffused with religious mystery. Runge's un-

completed series *Times of the Day* aimed at reviving iconographically, with echoes of the infant Samuel, the innocence of childlike faith in God. And Samuel Palmer's paintings, such as *Coming from Evening Church*, created in their dreamy occultism an idyllic mood symbolic of universal Christian brotherhood. Their shared quality was an eschewing of the doctrinal, often sectarian motivation which had dominated religious art at least since the Counter-Reformation in favour of evocations of personal religious visions, often alien to scriptural convention.

Blake, more aggressive than others in his desertion of inherited Christian concepts and more vigorous in asserting the authenticity of his own interpretations, belonged nevertheless within that contemporary group of artists and writers desirous of creating new cosmogonies. One major aspect was his condemnation of God the Father, apprehended by him in strongly anti-Pharisaic terms as a stern exactor of law, demanding obedience to His precepts. In that regard, Blake revealed affinities not only to the revitalizers of religious faith but also, I believe, to a further contemporary reaction in the art and literature of his day.

As in so many eras, the changing vision of God constituted in effect a mirror image of contemporary social and cultural patterns, a projection onto the heavens of human familial modes which, by a circular process, themselves gained authenticity through the belief that they conformed to the celestial design. For society of the early eighteenth century, committed to universal rules and ordered processes of thought and behaviour and looking back to the classical period for the aesthetic and moral sanctions for its Stoic-Christian code, respect for parental authority was accorded a primacy rarely manifested in other periods, as the reiteration of that theme in contemporary art and literature confirms. As always, such thematic convergence betrays, by the frequency of its appearance, its centrality to the major concerns of the age. Renaissance theories of cosmic hierarchy had, of course, also proclaimed the authority of the father as head of the family, deserving the loyalty and obedience of all its members; but it was only at times of conflict—when Juliet or Hermia reject a proposed marriage, or Goneril behaves with mordant ingratitude to her parent—that the requirement of filial piety was invoked. In the eighteenth-century theatre, on the other hand, insistence upon filial obedience became a central and reiterated theme, a doctrine asserted at the slightest of opportunities, often without relevance to the developing plot, as being the very fountainhead of moral rectitude.

As the licentiousness of the Restoration comic stage, originally catering to an aristocracy newly returned from France, eventually provoked the protests of Sir

Richard Blackmore, Jeremy Collier, and others, and as Addison and Steele undertook to make fashionable for literature a bourgeois morality closer to the earlier Puritan tradition than to that of Rochester and Wycherley, the solemn duties of compliance to parental wishes began to occupy pride of place.[18] In the sentimental drama especially, it became an ordinance whose mildest transgression marked out the perpetrator as irremediably corrupt, while conversely hero and heroine display at all times (in speech if not always in action) a reverential regard for the smallest whim of their parents.[19] In Steele's *The Conscious Lovers*, the young hero Bevil, Jr., displays a rhetorical confidence in his own unwavering filial probity distinctly unpalatable, at least to a modern generation, in its complacent assurance of personal rectitude; yet it was clearly acceptable to his contemporaries as redounding to the speaker's credit. As his father enters, apologizing for disturbing his son, the latter assures him that "One to whom I am beholden for my birthday might have used less ceremony," and on being asked if he will follow his father's instructions in marrying replies: "Did I ever disobey any command of yours, sir? Nay, any inclination that I saw you bent upon?"[20]

It is a sentiment echoed too often upon the stage of that time to require any assemblage of quotations here. One need only cite an exasperated comment from Samuel Foote's *The Patron* of 1764. There Bever, glancing through a sentimental play, remarks with reference to the flood of such scenes being performed on the contemporary stage that the "coxcomb has prefaced every act with argument too in humble imitation, I warrant, of Mons. Diderot—'shewing the fatal effects of disobedience to parents'; with, I suppose, the diverting scene of a gibbet."[21]

It is in this period, too, that one may discern the introduction to comedy of an innovative figure, the legal guardian, usually a stepmother or aunt, functioning as obstacle to the desired marriage—Mrs. Hardcastle in *She Stoops to Conquer* or Mrs. Malaprop in *The Rivals*. The traditional comic situation defined by Northrop Frye, with young lovers circumventing the "wintry" authority of parents opposed to their union, was, it would seem, no longer morally acceptable; hence the introduction of a character serving only *in loco parentis*, a person to whom deference was not obligatory and whose outwitting should detract in no way from the moral impeccability of hero and heroine.[22]

The extent to which such filial reverence was observed outside the theatre, in daily life, may be evidenced by an event in Samuel Johnson's own experience. In his final years he recounted to a young clergyman how a minor incident of disobedience

in his youth, some childish refusal to accompany his father to Uttoxeter market which in other eras would have been almost instantly forgotten, preyed upon him throughout his years as a grievous act of impiety, the remembrance of which was ever painful to him. Towards the end of his life, as he records, he undertook a ceremonial act of penitence: "I desired to atone for this fault; I went to Uttoxeter in very bad weather, and stood for a considerable time bareheaded in the rain, on the spot where my father's stall used to stand. In contrition I stood, and I hope the penance was expiatory."[23]

In painting as well as theatre that unreserved respect for parental authority had received unusual prominence. In an illuminating study of transformations in late eighteenth-century art, attention has been drawn to the encouragement offered to painters in France to deflect their interest to history scenes in preference to portraiture (the scale of fees being adjusted accordingly) in order to help restore the grandeur of Louis XIV's court to a later period conscious that its own stature had been diminished.[24] As part of that impetus, artists were urged to produce representations of *exempla virtutis* from the past, such as Jacques-Louis David's *Oath of the Horatii* of 1784, or Louis Lagrenée's *Fabricius Luscinus Refusing the Gifts of Pyrrhus* (1777). What has not been noted, however, is the emergence, both as part of that movement in France and independently in England (suggesting that the theme was of broader scope), of didactic paintings exalting the principle of filial obedience so emphasized in the theatre. Recurrent in such canvases was a validation of the most drastic forms of parental severity on the assumption that the father, as the guardian of moral values and the upholder of law and justice, may not compromise them even in favour of the impulses of natural affection.

The concentration upon that theme in the closing decades of the century is remarkable. In 1761, Nathaniel Dance exhibited at the Society of Artists in London his painting *The Death of Virginia*, illustrating a scene derived from Livy—a father slaying his daughter to prevent her from being taken into dishonourable captivity by the decemvir Appius Claudius. The parental decision is fully approved in the painting as an *exemplum virtutis*. A few years later in 1770, Benjamin West chose as his theme for exhibition at the Royal Academy a less gruesome but didactically comparable subject borrowed from Plutarch, *Leonidas and Cleombrotus* (*fig. 81*), in which the Spartan king banishes his son-in-law, and thereby his daughter and grandchildren too, for an act of treason against the state. The slumped, despondent figure of Cleombrotus confirms the artist's endorsement of the king's decision in preferring an equitable dispensing of justice to promptings of personal affection and

270

81. BENJAMIN WEST, *Leonidas and Cleombrotus*

82. BERTHÉLEMY, *Manlius Torquatus Condemning His Son to Death*

the ties of blood. Artistic validation of the rights of stern fathers increases dramatically during the following years. Across the channel Jean-Simon Berthélemy's *Manlius Torquatus Condemning His Son to Death* (*fig. 82*) portrayed a father agonizingly preserving impartiality as he sentences his own son to death—this time not even for treason but, on the contrary, for an excess of patriotic ardour which led the young man to engage the enemy in violation of military orders. Sympathy is again evoked for the nobility of Torquatus's action as he is represented turning away his head in anguish, one hand clutching at his heart, the other extended in confirmation of the sentence. Probably the most famous of such scenes was David's *Lictors Returning to Brutus the Bodies of His Sons* from the Salon of 1789 (*fig. 83*), which created a sensation on its initial showing and became at once a theme particularly favoured by painters at this time because of the doubling of effect, the sacrifice involved in sentencing both his sons to death for their attempt to restore the Tarquins to power. The father's grief is here vicariously displayed through the group of his lamenting wife and daughters to the right, while he himself sits in shadow, unable to face the bodies borne in upon the stretchers, yet in unshaken belief that his duty has been performed and the law painfully yet impartially administered.

A parallel, and clearly related theme emerging at this time was that of the prodigal son. In literature that topic had seen its major flowering in the Christian-Terence movement of the sixteenth century when its function had been little more than an educational device—to supply a biblical setting and hence a moral sanction for the scenes of carousal and overthrowing of order popular in the plays of Terence and Plautus then being studied in the schools, but thereby concluding in a more didactically satisfying manner with the repentance and forgiveness of the son upon his return to the parental fold. Now, however, its revival was to serve an entirely different purpose, providing, as on the contemporary sentimental stage, solemn lessons on the danger of filial disobedience. Jean-Baptiste Greuze's much admired work *The Punished Son*, originally exhibited in 1765 as a drawing and transposed to canvas in 1778 (*fig. 84*), preached in visual form the new bourgeois morality, with its warning to errant offspring that repentance may come too late for the prodigal to receive his father's blessing and forgiveness.[25]

Reverence for progenitors and for the authority that accrued to them by virtue of their position was not only symptomatic of a desire for a rationalized social order but, as always in periods favouring parental respect, was indicative, too, of an assumption that advancement in years brought with it the experience and responsibility necessary for a true dispensation of justice. The obverse of that same belief was

83. DAVID, *Lictors Returning to Brutus the Bodies of His Sons*

84. GREUZE, *The Punished Son*

the premiss in the early eighteenth century that children were undeveloped adults, to be treated with indulgence for their understandable immaturity and recognized as not yet in possession of the reasoning powers or knowledge necessary for full membership in the community. While Locke's theory of the *tabula rasa* was to give rise in later decades to a new emphasis on the importance of childhood experience as the moulder and determinant of all later responses, the belief that the child was father to the man produced, in its original submission to the public, the very reverse effect, militating against any residual faith in Platonic *anamnesis* by denying that the child retained any memory of a supposed ideal world of wisdom from which it had been transposed. The principle that the infant's mind was an intellectual blank at birth, a clean slate upon which all information must be recorded *ab initio*, implied that the child's acquisition of knowledge and of the discriminatory faculty for ordering that knowledge was a gradual process taking many years before maturity of judgment was to be achieved. Hogarth's sensitive portrayal of the Graham children, Reynolds's *The Age of Innocence* (*fig. 85*), Madam Vigée LeBrun's self-portrait with her daughter, and Angelica Kauffmann's *Cornelia, Mother of the Gracchi* of about 1785 all typify in their naturalistic depiction of the innocence or shy insecurity of the young the contemporary awareness of their distance from adult confidence, self-reliance, and discrimination.

The reaction to this assumption of the superior wisdom of parents was not long in coming. Although Rousseau's influence upon the Romantic movement has been seen primarily as stimulating a return to nature, Paul Cantor has recently shown that an even more formative element was his insistence, notably in his *Second Discourse, Upon the Origin and Foundation of Inequality Among Men* (1755), on his conception of the universe as progressive. Rejecting the traditional belief in a perfect prelapsarian world created by divine *fiat*, he argued intuitively for what Darwin was later to support with scientifically based evidence, that there existed an evolutionary process whereby each generation was capable of development and advancement, and hence of improving upon the lessons taught by parents. If man had moved too far from his natural environment into an urban framework dominated by laws of property, it was within the power of human free will (no longer blemished by original sin) to modify those self-imposed rules and achieve by rectification its own desired compromise. Rousseau's faith in man's ability to progress towards newer and generally improved patterns of living implied a rejection of inherited forms of behaviour, placing a new premium upon youth as the justified rebel against tradi-

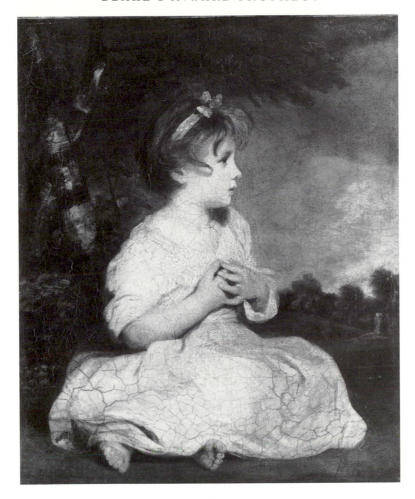

85. REYNOLDS, *The Age of Innocence*

tion, resisting patriarchal attempts to foist upon him established laws of morality or the restrictive conditions of a settled society. Within such a shift in philosophical sensibility, the ideal of the mature rationalist was replaced by an admiration for the inspired zest of infancy, as represented symbolically in Blake's *Nativity* or *Finding of Moses* (*fig. 86*), in both of which the infant leaps out from his cradle with an alertness and instinctual energy vividly contrasted with the wondering hesitation of the adults around him.[26]

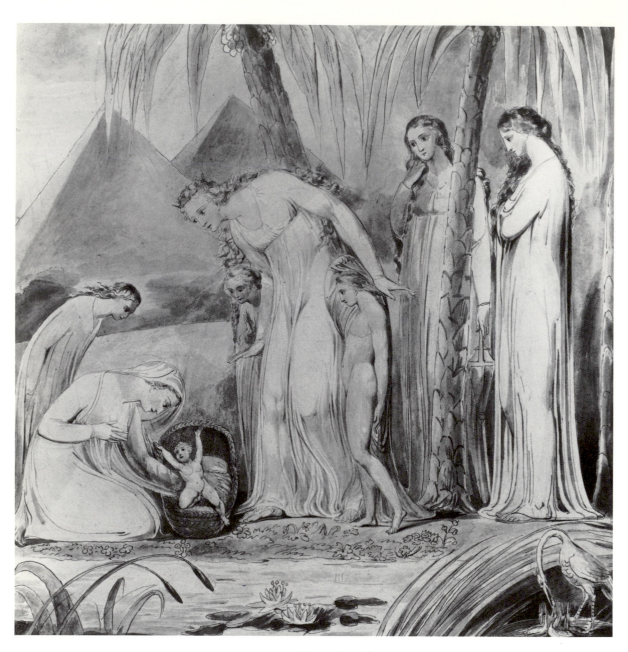

86. BLAKE, *The Finding of Moses*

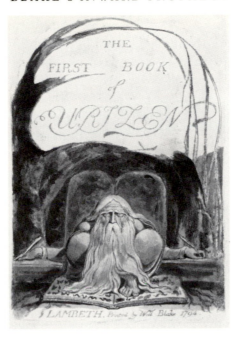

87. BLAKE., titlepage to
The First Book of Urizen

The political implications of Blake's condemnation of the Father of Heaven have been well documented in terms of the general tendency to overthrow established authority. But his theological rebellion, like that of Shelley, deserves to be backgrounded, too, by a more general reaction to the familial patterns of parental authority evidenced in the art and theatre of the eighteenth century. Blake's representation of God as the tyrant Urizen, inflexibly declaring:

Lo! I unfold my darkness: and on
This rock, place with strong hand the Book
Of eternal brass, written in my solitude.[27]

or, in his illustrations to that poem (*fig. 87*), blindly inscribing man's fate in a scene dominated by the tomb-like stones of the commandments, marked not only a dramatic reconstruction of biblical myth but also, by association, a revolutionary realignment of filial sympathies within the social and artistic traditions of his time.

279

The centrality of such rejection of patriarchal authority is confirmed by the most horrifying artistic example to appear, marking the culmination of the tendency to which Blake's Urizen belonged—Goya's depiction of *Saturn Devouring His Children* (*fig. 88*) from about 1819, with its gruesome scene of the god insanely consuming the dismembered, bleeding corpse of yet another offspring, gorging his appetite on the young he had begotten. While mythologically it was intended to represent Time consuming its Products, the nauseating realism of its presentation suggests the artist's selection of the theme as an outlet for a nightmarish fantasy of broader significance, a Promethean protest, shared with many Romantic contemporaries, against the ruthless tyranny of the father figure. Such rebellion formed, as has long been recognized, part of a broader social distaste for authoritarianism, a rejection of the imposition of ancient precept or established rule over the spontaneous, instinctual impulses of a new generation. But the choice of the parental relationship as the image for that spiritual insurrection derives from a more specific source, the prominence during the preceding generation, in both theatre and painting, of the themes of justified parental severity as examples of virtue and the demand for unhesitating filial obedience from both hero and heroine as the prerequisite for moral probity. The new image reflected a reversal of allegiance within the patterns of family life itself.

(iii)

Blake's rejection of divine tyranny was to prove relevant both for the prophetic stance which he adopted in his verse—his representation to the eighteenth century of the impassioned poet-seer deriving his authority from the scriptural tradition— and also for a modification in artistic perspective, to which his paintings were to give expression. In order to appreciate the transformation he effected in the pictorial medium, it may be necessary to examine first the literary implications of that biblical identification and the shift in sensibility which had occurred since Milton first introduced the merger of prophet and poet upon the English scene.

The majestic opening passage of *Paradise Lost*, with its declaration of the ambitious purpose proposed for the epic, had, in its literary format, been sufficiently within the conventions of the classical genre to create a sense of the familiar, an echoing of the traditional Homeric or Vergilian appeal to the muse for inspiration

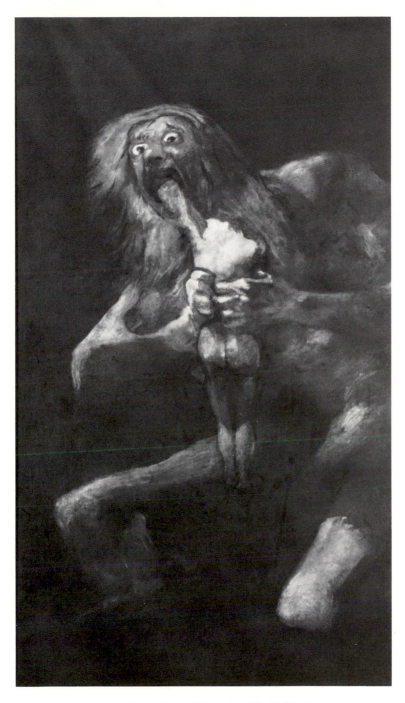

88. GOYA, *Saturn Devouring His Children*

and guidance. Milton's sensitive adaptation of that ancient convention to the religious theme of the poem—the muse appropriately transferred from the summit of Olympus to the secret top of Oreb or of Sinai, the fountain of Hippocrene replaced by Jerusalem's brook of Shiloah, and the poet's appeal redirected from Calliope to the Holy Spirit that sat brooding over creation—is indeed effected with such ease that the innovative quality of the invocation is scarcely felt. Yet the implications of that passage, the composite image of the poet as hierophant which emerged from it, possessed a significance extending far beyond the specific needs of the epic itself, challenging indeed a central element of contemporary critical thought. For it provided by example rather than by theoretical argumentation the most effective answer yet to those long-standing doubts over the status of poetry which Plato's condemnation of its fictions in the *Republic* had implanted, the view that the poet's work, by offering only a shadow of a shadow, constituted a reprehensible movement away from the ideal world rather than towards it.

Milton's evocation of the Hebraic tradition of poetry, the Old Testament's impassioned insistence on moral probity and its uncompromising interpretation of human affairs not in local terms but viewed *sub specie aeternitatis*, accomplished what Sidney's defensive allusion to King David as *vates* had failed to achieve.[28] To recall that the Psalms, too, had been written in verse was merely to suggest that poetry was not in principle an invalid vehicle of communication; but to revive for his own age, as Milton did, the image of the poet as robed in the mantle of prophetic inspiration, dedicated to the holiest of causes, and elected to convey through his visionary verse those eternal truths which less gifted men were unable to discern was to withdraw poetry from the category of fiction and elevate it to the dignity of a divinely authenticated pursuit.

> And chiefly Thou O Spirit, that dost prefer
> Before all Temples th' upright heart and pure,
> Instruct me, for Thou know'st; . . .

During the immediately subsequent period when religious poetry and claims to divine inspiration were out of favour, Elkanah Settle was to be reproved by Dryden for foolishly imagining that he "has a light within him, and writes by an inspiration; which (like that of the heathen prophets) a man must have no sense of his own when he receives."[29] But even in such moments of scorn one may perceive the new sensitivity which had been imparted, Dryden's careful insertion of the guard epithet

"heathen" to separate the condemned enthusiasts of his day from their biblical counterparts, who had by now been firmly identified with the noblest aims of poetry as such. When eventually impassioned verse-writing did return to favour, the lessons implanted by Milton could be more confidently evoked, but by then the process of validation had been interestingly reversed. Where Milton's bond with the ancient Hebrew prophet had been founded on the religious intention of his verse—the sanctity of his epic undertaking aimed at justifying the ways of God to men—the Romantic understood his bond with the prophet as emanating from the shared profession of poetry itself, now seeing that literary pursuit as endowing his themes, however secular they might be, with the gravity of prophetic utterance. It is not the prophetic call which directs Wordsworth to write poetry but, conversely, his dedication to poetry which endows him with a prophetic calling, bestowing upon him by that cultivation of metre the sacred mantle of the seer:

> poetic numbers came
> Spontaneously, and cloth'd in priestly robe
> My spirit, thus singled out, as it might seem,
> For holy services.[30]

Blake, as the prophet-poet *par excellence* linking the two, was in some ways more consciously identified with the tradition of the biblical seer even than Milton himself. In contrast to his mentor, perhaps because of the new literary model the parallelist Bible now afforded, he firmly dissociated himself from the classical-humanist tradition as being a pernicious influence—"Greece and Rome . . . so far from being parents of Arts & Sciences as they pretend: were destroyers of all Art."[31] Yet it is essential to distinguish what has been too long obscured, a signal discrepancy between the Blakean idea of the poet's function and the conception prevailing within the prophetic mode as it had originally functioned within the Old Testament setting—a discrepancy arising, indeed, from a fundamental contrast between the biblical apprehension of poetry itself and the classically derived counterpart, predominant in western literature, with which Milton had acknowledgedly merged it and which Blake had less obtrusively admitted into his verse.

Implicit in Milton's appeals for heavenly inspiration, and echoed in the passage from Wordsworth's *Prelude* cited above, is a sense of the poet's pride in the distinction of having been singled out for the noble task of transmitting to mankind the truths entrusted to him from a divine source.

What in me is dark
Illumine, what is low raise and support;
That to the highth of this great Argument
I may assert Eternal Providence . . .

Such inspiration is seen as a rare privilege granted only to those endowed with special qualities, and these invocations, pleas for divine aid in the loftiness of the task, assume on the part of the poet a longing to fulfil that undertaking and to prove worthy of the elevated function he is to perform. But the picture of the prophet which emerges from the Old Testament, upon whom the later poet draws for support, not only contains no hint of that desire for fame so central to the revitalizing of the poetic tradition in the western world, the election of the poet to ennobled status within society, but reveals on the contrary a profound reluctance to perform the task for which he has been selected. The message he is to deliver is pointedly characterized throughout the scriptures as the *massa* or "burden" of prophecy, a burden which the chosen communicator longs to cast off but is compelled to carry, however fiercely he resists.[32] Such reluctance is rooted in the very patterns of biblical prophecy. Moses, the first of the prophets and the archetype for subsequent visionaries—ironically, the very figure chosen as model in Milton's opening invocation, the shepherd "who first taught the chosen Seed, / In the Beginning"—displays so deep-rooted an unwillingness at the time of his call with so lengthy a series of pretexts for refusal as to exasperate the reader of the biblical account even before he angers his God. When his final subterfuge that he is slow of speech is scornfully rejected, his sullen response "Send, I pray Thee, through whom Thou wilt!"—a euphemism that God should choose as emissary anyone but him—verges on blasphemy in its stubborn refusal, finally kindling divine wrath and the insistence that he fulfil the mission whether he wishes or not.[33] Such reluctance is a far cry from the Miltonic prophet-bard entreating the heavenly muse for the cherished gift of inspiration.

That unwillingness permeates the scriptural record of prophetic preaching. Isaiah, appalled at his unsuitability to appear in the presence of God even in a vision, echoes Moses' claim of oral impediment: "Woe is me for I am undone; for I am a man of unclean lips" (Isaiah 6:5). Jeremiah submits under severe duress to the agony of the prophetic impulse, to the painful "burning within my bones" from which he is granted no relief (Jer. 20:9); and lest one suspect such disinclination to be a form of literary coyness, a ploy intended to strengthen credibility, an entire prophetic

book is devoted to a third-person narration of Jonah's desperate flight from the presence of God in order to avoid the mission which had been entrusted to him. Perhaps most significant of all in this contrast with their English imitators is the scriptural prophets' patent lack of interest in literary immortality, their desire for personal anonymity, for submerging their own identities in the larger purpose of the divine mandate. The refrain reiterated throughout their writings, "thus saith the Lord," was a means not only of emphasizing the source of their warnings but also of discarding all pretence to originality, poetic or otherwise, on the part of the preacher, reducing his function to that of an instrument, generally unwilling, through whom the divine rebuke or comfort was being conveyed. The nomenclature of the prophets as recorded in the Bible is too obviously pertinent to the message they are transmitting to constitute the true names they bore in real life: Isaiah ("the Lord will save"), Jeremiah ("the Lord will raise up"), Ezekiel ("God will strengthen"), Malachi ("My messenger"). There is, moreover, the tradition whereby later prophets (the so-called deutero-Isaiah, for example) would attribute the authorship of their own works to famous predecessors, submerging their own identities in the process in order to add authority to their words at the expense of any personal accreditation.[34] In a culture contemptuous of poetry except as a vehicle for moral truth,[35] fame was neither the spur nor even the infirmity of poetic minds, in contrast to the noble winning of the laurel wreath in the classical and humanist traditions.

It is a distinction, I believe, essential for an appreciation of Blake's contribution both as artist and poet, and of the metamorphosis in conception of the prophetic function perceptible on the English scene. Milton, while ostensibly retaining this sense of functioning as the transmitter of divine truths, nonetheless places himself proudly to the fore as the stylistic originator and interpreter of the message he transmits. It is for "*my* advent'rous Song" that he requests heavenly aid, himself daring things unattempted yet in prose or rhyme; and if he claims a little later that the poem is in fact dictated to him from above, by one

> who deigns
> Her nightly visitation unimplor'd,
> And dictates to me slumb'ring, or inspires
> Easy my unpremeditated Verse:
> Since first this Subject for Heroic Song
> Pleas'd me long choosing and beginning late . . .

he is careful to add that it was he the poet who chose after long deliberation the subject of the heroic song and, as he informs us elsewhere, selected the epic genre and metrical form which it was to adopt.[36]

The intensity of Blake's moral earnestness was unquestionable, as was his certitude that his visions were authoritative revelations of eternal truths. In that, he belonged genuinely to the biblical, prophetic mode. But his Gnostic affiliation and the duality implicit in his distinction between God as Elohim and as Urizen obviated any wholehearted, unreserved acceptance of divine impulses from heaven in the scriptural sense. He may in moments of trust declare: "I see the face of my Heavenly Father he lays his Hand upon my Head & gives a blessing to all my works," but in other moods that same Heavenly Father would be contemptuously rejected as a mere Nobodaddy. As Leopold Damrosch has suggested, it was the very tension between those contradictory views that helped produce the energy of Blake's visions;[37] and it is their effect upon his creativity as artist and poet that I should like to examine.

His visions, unlike those of Isaiah, Ezekiel, or their disciple Milton, were not an opening up of the heavenly scene for viewers privileged to see through him what had previously been hidden but, in reverse direction, a focussing into his own richly endowed interior world, his painting and poetry conjuring up in place of a glimpse of the celestial a projection of his own imaginative experiences. That inner world was furnished with the familiar events and environs of the Bible, but in recounting his visions and in commenting upon them he cherished throughout a right, never exerted by his scriptural forebears nor even by his closer predecessor Milton, to challenge and even subvert the most basic doctrines of the faith he was ostensibly promoting. Milton may have been startlingly unorthodox at times in his doctrinal principles or exegetical readings of texts, but never without authoritative precedent culled from his scholarly and often eclectic study of sources. Blake, however, was unhesitating in exerting his right to act as moral determinant even in the face of unequivocal scriptural decree. In that, he differed fundamentally from the biblical prophets from whom he ostensibly drew his own authority. Their desire for anonymity, for submerging their own personalities in the universal truths of the divine so central to the biblical conception of the prophetic mandate, is now replaced by the mortal seer's unhesitating confidence in himself as arbiter, with the authenticity of the vision deriving not from its heavenly origin but from the creativity, genius, and imaginative power of the poet himself.

286

The great baroque painters contemporary to Milton had, like him, remained, for all their interest in artistic fame, closer to the biblical tradition of prophecy in their attempt to open man's eyes to the celestial scenes above, to capture in human terms, as in Ezekiel's vision of the divine chariot, the awesome events of heaven, glimpsed, as it were, by the inspired artist in his mental journey aloft. Witness Andrea Pozzo's impressive ceiling fresco (see *fig. 29*) or Milton's prefatory verses to the seventh book of *Paradise Lost*:

> Up led by thee
> Into the Heav'n of Heav'ns I have presum'd,
> An Earthly Guest and drawn Empyreal Air,
> Thy temp'ring; with like safety guided down
> Return me to my Native element.
>
> <div align="center">(PL 7:12–16)</div>

Blake defines his own major purpose as being in a contrary direction. His aim is, he declares, the turning of man's sight *inwards*, into the human mind, to perceive the everlasting values of the inner self:

> I rest not from my great task!
> To open the Eternal Worlds, to open the immortal Eyes
> Of Man inwards into the Worlds of Thought: into Eternity . . .[38]

If the major shift at the beginning of the eighteenth century in both art and literature had been its deflection of focus from the celestial scene to the human and social, the new concern to which Blake gave perhaps the first clear expression was to the primacy of the human imagination, not in the sense that Addison had used the term as a source of aesthetic pleasure, but in the sense of creative visionary experience capable, in contrast both to the biblical prophet and to Milton, of defying the authority of the divine, of condemning the moral standards both of scriptural narrative and of ecclesiastical dogma by right of human genius. He, too, of course, insists at times that he is "under the direction of Messengers from Heaven, Daily & Nightly," but how subserviently he responds to those messengers is left open to conjecture; and the very term which he employs to describe his poetic inspiration takes on an ambivalence in his usage which allows for considerable flexibility in interpretation. "One Power alone," he states, "makes a Poet.—Imagination the Divine Vision"; but that latter term may well mean his personal vision of what is or

should be divine rather than, in the conventional sense, a vision originating with God. His identification with the ancient prophet, although he never acknowledged the distinction and continued to derive his poetic authority from that tradition, ended at this vital point of personal submission. As he unhesitatingly declared, his freedom to determine his own religious and artistic tenets took precedence over all other authority: "I know of no other Christianity and of no other Gospel than the liberty both of body & mind to exercise the Divine Arts of Imagination."[39]

The validity of the poet's claim to individual interpretive vision was extended to others too. Every man, he remarked, conceives the glorious scene of the Last Judgment differently, and his own sketch of that scene, he admitted, represented it only "as I saw it."[40] Both poet and reader, and in art both painter and viewer, were no longer mortals privileged in such visionary scenes to perceive the fixed and eternal truths of heaven but now were themselves creators, judges, and modulators of those truths. Isaiah had called upon heaven and earth to give ear, "for the Lord hath spoken," and proceeded to repeat in first-person terms the actual words of God as the prophet claimed to have heard them. It is, however, not to the words of God but to the words of the Bard that Blake calls for attention, a poet who has indeed hearkened at some time to the divine voice but who is free to transmit it as he chooses and whose own insights into the eternity of the human situation he proposes to proclaim:

> Hear the voice of the Bard!
> Who Present, Past, & Future sees
> Whose ears have heard,
> The Holy Word,
> That walk'd among the ancient trees.

Significantly, Blake dispenses with an invocation either to the Holy Spirit or to the Muse, relying instead, in the introductory poems both to the *Songs of Innocence* and to the *Songs of Experience*, upon his own self-generating inspiration to activate and direct his poetic composition.

The effect of that distinction is perceptible both in his writing and his painting. In looking back beyond the socially oriented, intellectual verse of the Augustans for a poetic model more congenial to his inspirational mode, he found, of course, his natural forebear in England's leading baroque poet, Milton, from whose work he gained encouragement particularly in relation to his prophetic writings. There were reservations to his admiration, and Joseph Wittreich has discussed at length the

doctrinal disparities between them, pointing to Blake's attempt "to redeem Milton's vision from the encumbering intrusions of orthodoxy."[41] But perhaps no less illuminating is the manifestation of this difference between them in the source of their visions.

For Milton, identifying himself with the cyclical view of biblical history, the Puritan "post-figurative" reading of the Old Testament in which he saw himself and his generation as reliving the archetypal stories of the scriptures, the scenes from the Bible as he recounted them were endowed with the palpability of historical actuality. As a baroque artist, moreover, he fostered that tactile quality, however enlarged the scene might be, so that it partook of the material massiveness and energy of the mechanistic universe—the cosmic vastness furnished not with twinkling stars but immense, rugged planets, the measurable distances to be wearily traversed even by the angels, the solidity of the ponderous doors through which Satan must force his way to begin his journey from Hell to earth described in haptic terms:

> three folds were Brass,
> Three Iron, three of Adamantine Rock,
> Impenetrable . . .

That aspect of his epic writing had no appeal for Blake. His own verse was to possess its own consummate power and energy, but it emerges as a dematerialized visionary power, never reified or expressed in corporeal form because it made no serious claim to recreate history nor to reproduce actualities as perceived by the seer. Where the vehicle of Milton's message is its physicality, divine might demonstrated *a minori* by the martial clash of two immense armoured hosts, Blake prefers allusively metaphorical terms abstracted from reality even when concerned with the most immediate dangers, corruptions, or falsity of values. His concern is with the "mind-forged manacles" of the human spirit, the blasting of the infant's tear, the invisible worm that flies in the night. Even in his prophetic books which, as Bronowski and Erdman have documented, are so often rooted in contemporary political affairs,[42] the topicality of the scene is similarly attenuated, elevated into allegorical forms, into myths transcending historical limitation to achieve an apocalyptic effect remote from the factual:

> The Wine-press on the Rhine groans loud, but all its central beams
> Act more terrific in the central Cities of the Nations

Where Human Thought is crushd beneath the iron hand of Power.
There Los puts all into the Press, the Opressor & the Opressed
Together, ripe for the Harvest & Vintage & ready for the Loom.[43]

If Milton's purpose had been, for all its vibrant poetic inventiveness, to retell in epic form the true story of man's Fall, Blake chooses avowedly to originate, to project through his poetry his own rich imaginative world, frequently in flagrant contradiction of the sources. Milton may recreate Adam or Samson in his own image, but the figures which emerge are so rooted in the biblical world, emerging from the weighty scholarship of Milton's exegetical reading, that they seem more authentic than their originals, enlargements of characters only sketchily drawn in the brief biblical verses devoted to them, while Blake's Los or Urizen are, despite their scriptural ambience, as patently the product of his inventiveness as the Hobbit characters of Tolkien.

That distinction is sufficiently apparent in a comparison of the poetry, but it needs to be applied to his painting too, a distinction most clearly discernible in his illustrations to *Paradise Lost*, which, although intended as a visual accompaniment to Milton's epic, reveal a stylistic disparity indicative of deep dissimilarities in outlook. In the epic, the scene of Satan jealously watching the endearments of Adam and Eve is located within a luxuriantly fertile setting representing in its tangible profusion the blessings generously bestowed upon mankind before the Fall. If the rural seat he describes is ultimately Miltonic, to serve, as we have seen, as the model for eight-eenth-century landscaping, it is in perfect conformity with the Bible's laconic description of Eden as planted with "every tree pleasant in appearance and good for food." His task is to elaborate, so that we are shown the garden in all its glory as comprising groves, grape-laden vines, rose-bushes, myrtles, and flowers of every hue "pour'd forth profuse," amidst which, entertained by friendly birds and beasts, our Grand Parents recline upon a downy bank consuming the savoury pulp of nectarine fruits and, with the rind, scooping their drink from the brimming stream (*PL* 4:235–335). In Blake's charming but fundamentally different version (*fig. 89*), the verdurous garden has disappeared, to be replaced by a symbolic floral throne, a cushion of stalkless flowers unknown in nature, with twin palm fronds forming an ornamental arabesque, while beyond them a sun and moon, simultaneously present in the sky, emblemize with similar artificiality the perpetuity of their joys had they refrained from disobedience. Together with that change, the physical palpability of Milton's epic is transposed to a dream world. Milton's Satan had eyed them from a

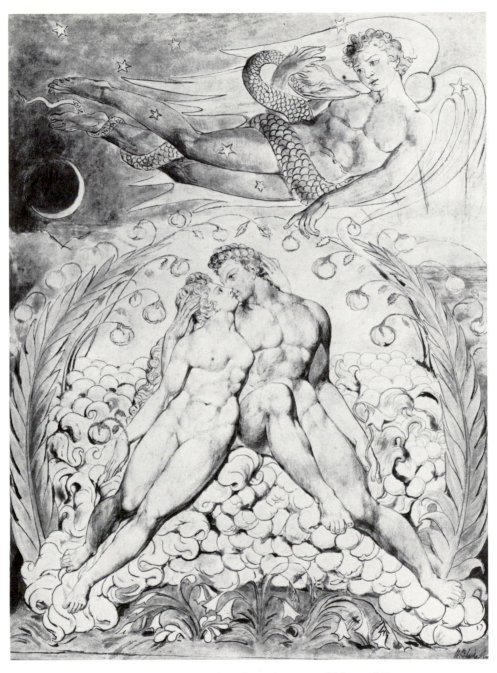

89. BLAKE, *Satan Watching the Endearments of Adam and Eve*

place of concealment within the garden, a fixed location within the actualized scene, seated like a cormorant upon a bough in order to deceive them. Here he is represented as floating above, a weightless figure with a serpent heraldically entwined about him, not only in a freely devised and personal re-creation of the scene but, in addition, removed from the realm of a historical event rooted in time into the eternity of a mythological tableau, a symbolic scene conjured up in the mind of a visionary for its figurative significance. I find it difficult to understand how Pamela Dunbar came to the conclusion that in this version of Milton's scene "Almost every detail . . . has been faithfully rendered or suggested" when the two are so strikingly different both in conception and in presentation. Particularly notable in relation to a poem so intensely aware of spatial and temporal perspective is the dream-like lack of depth in this watercolour. It portrays an embrace occurring *in vacuo*, within an eternity disconnected from the corporeality of earthly affairs, thereby typifying the contrast between the two artistic styles.[44]

That aspect of his art may cast some light upon what Anne Mellor has seen as a puzzling contradiction between Blake's philosophical creed and his artistic practice. His insistence on boldly demarcated outlines in his paintings and drawings, his conviction that the "great and golden rule of art, as well as of life, is this: That the more distinct, sharp, and wiry the bounding line, the more perfect the work of art," introduced, she argues, a "closed form" to his paintings, a constriction totally at variance with the liberty he so earnestly espoused particularly in his later phase. If, as Arnheim has remarked, the elementary form patterns in art "carry the core of meaning," Blake's emphasis upon the lineaments of his figures was, she argues, paradoxically more appropriate to Urizen's tyrannical imposition of rational limitation on man's potential divinity than to the free-flowing forms of his own art.[45]

Blake's preference for contour was, we may assume, derived in large part from his training as an engraver, where the subtleties of *sfumato* shading or the gradual merging of one colour into another needed to be reduced to more clearly defined incisions; and his vehement defence of that technique had something within it of offended professional pride. It was, of course, a tendency augmented by the contemporary "Hellenic" fashion in art, the interest in Greek vase decoration introduced into England towards the end of the century under the influence of Winckelmann, and adopted by Blake's friends Fuseli and Flaxman. The latter's sketches for designs to be incorporated into the delicate jade and blue vases produced by Josiah Wedgewood provide exquisite examples of the technique (cf. *fig. 104*). However, to

assume that Blake was too "artistically committed" to the contemporary convention of contouring to break away from it, even though it represented for him the constricting of Energy by Reason, or to argue that its aesthetic unsuitability to his developing beliefs constituted a profound problem producing a continual tension in his work seems strangely inappropriate for a writer and artist who has become recognized as the epitome of artistic and religious independence, unhesitatingly rejecting convention whenever it failed to conform to his moral or aesthetic standards. Even in his later years, he seems to have sensed no conflict between his creative powers and this supposed need for rational limitation, repeatedly claiming as the very axiom of his art the necessity for firm lines—"I defy any man to Cut Cleaner Strokes than I do." What may be questioned is whether the basic premiss of this supposed clash between technique and purpose, the equation of the wiry line bounding his figures with Reason, is itself valid. The crucial passage on which it is founded is his statement in *The Marriage of Heaven and Hell*: "Energy is the only life and is from the Body and Reason is the bound or outward circumference of Energy."[46] It is, one notes, not the body itself which he regrettably claims to be circumscribed by Reason—a reading which might indeed have paralleled his firm delineation of human figures—but the energy emanating *from* the body which is so constrained. That broader, metaphorical application would conform closely to what Mellor rightly records as the gradual movement in his paintings from tectonic to atectonic design, to his eventual rejection of the careful framing which had characterized his illustrations to the *Songs of Innocence* in favour of the more dynamic movement of his later work, such as his *Whirlwind of Lovers* from the illustrations to Dante, in which, in his resistance to such constraints, the figures seem to surge beyond the outer limits of the picture and thereby to portray energy bursting through the confines that reason attempts to impose.

The firm contouring of his figures, therefore, (once we discard the equation of it with his statement on rational constriction) so far from being problematic should be recognized as an intrinsic and positive constituent of his art in all stages of his career. For its effect was not to restrain but to release the figures from earthly bonds. In contrast to the tradition of *sfumato*, the delicate shading of objects in order to create a more intense visual realism, here the unmodulated areas enclosed by such delineation serve on the contrary to de-accentuate mass and volume, producing an effect of unreality, an effect increased by the thin watercolour wash he applied, as in Adam and Eve's pale thighs and upper torsos in *Satan Watching the Endearments* . . .

He obtained thereby for his painting the disembodied quality characteristic also of his visionary verse. Allegorical paintings of the Renaissance, we may recall, employing the mythology of the classical past, had been intentionally more corporeal in visual effect since the gods and goddesses representing War, Wisdom, or Love had been traditionally conceived in fleshly form, descending to seduce maidens on earth or involved in unseemly domestic squabbling on Olympus. The resulting art had left little basis for distinguishing deities from humans. Blake's figures, however, are imaginative creations, never to be confused with mortal bodies of flesh and blood. Their muscles are, as has been noted by others, quite inaccurate anatomically in their exaggerated, scale-like effect (*fig. 90*), and whether that inaccuracy arose from the artist's lack of physiological training or from a conscious rejection of realism (since volume and weight belonged in Blake's view to the despised Newtonian or empirical conception of the universe), the result is suggestive of spiritual energy rather than physical prowess.[47] His admiration of Michelangelo's art, which indeed espoused physical muscularity and might therefore seem unsuited to his needs, derived, we may assume, from two fortuitous factors, that the scenes on the Sistine Chapel to which Blake responded so sympathetically were frescoes, where the figures, by the nature of that technique, tend to be shallower and more firmly outlined than in oil; and also that Blake, who never travelled to the continent, would have seen them only in engraved copies, which again by their nature emphasized the firm delineation he preferred. What the wiry, bounding line offered Blake, therefore, was not Urizenic constriction but a valued distancing from reality, the transformation of the specific and tangible into an artefact of the symbolic and eternal.

While the larger design of his paintings becomes increasingly atectonic, there is, nonetheless, a "closed-in" element of a different kind, not a constriction of the energy emanating from the figures but a reduction in the range of the celestial panorama. The subjectivity of his paintings together with his antipathy to the empirically based theories of Galileo and Newton meant that for him, in contrast to Milton, the vastness of the heavens, even when viewed as a symbol of the infinity of the Creator, was of little interest. The heavens in his illustrations, as in the scene of Satan sent to try Job (*fig. 91*), function rather as a canopy for human experience, an area for the mental extrapolation of human thought or of human visionary perception, than as an awesome expanse belittling to human dignity. That characteristic diminution of celestial space within his paintings constituted in no sense a cramping of human activity but the very reverse, an expression of his faith in the limitless

90. BLAKE, *Los*

potentiality of the Human Form Divine, to which the entire cosmos becomes sub-servient, a corollary or annexe for the imaginative life of the individual. As he declared in an illuminating passage confirming this reading of the heavens as a canopy:

> The Sky is an immortal Tent built by the Sons of Los
> And every Space that a Man views around his dwelling-place,
> Standing on his own roof, or in his garden on a mount
> Of twenty-five cubits in height, such space is his Universe;
> And on its verge the Sun rises & sets . . .

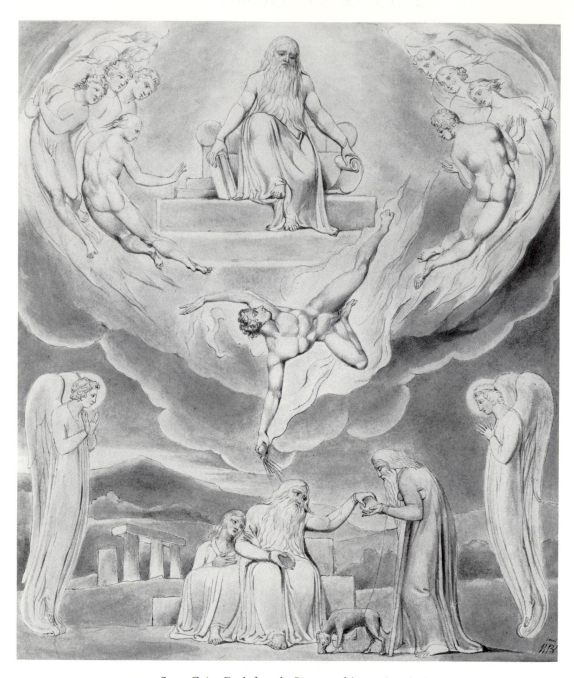

91. BLAKE, *Satan Going Forth from the Presence of the Lord, and Job's Charity*

He was fully conscious of the conflict between this avowedly anthropocentric conception of the universe and the spatial vastness of the cosmologists which the baroque had absorbed, as he records a few lines later:

> Such are the Spaces called Earth & such its dimension:
> As to that false appearance which appears to the reasoner,
> As of a Globe rolling thro Voidness, it is a delusion of Ulro
> The Microscope knows not of this nor the Telescope. They alter
> The ratio of the Spectators Organs but leave Objects untouchd
> For every Space larger than a red Globule of Mans blood
> Is visionary . . .[48]

(iv)

Whatever his reservations over Milton's beliefs—and Harold Bloom has sensitized us to the oedipal, love-hate relationship often existing between poetic disciple and master[49]—Blake admired him profoundly as a writer of true religious vision, the last of the great inspirational poets prior to the stultifying advent of rationalism, and therefore the model closest in time for the composition of his own verse. His response, however, to Milton's leading baroque counterpart within the pictorial arts, to Rubens who could have been expected to afford him the same inspiration for painting as Milton had for his verse, was strangely, even violently, negative. Rubens, also a deeply committed Christian devoting, like Milton, a considerable proportion of his work to cosmic scenes of religious splendour, to affirmations of divine grandeur and power, became, in contrast to Blake's poetic forebear, the object of his most scathing comments, treated like Reynolds as a "blockhead," as a personal anathema representing everything in art of which Blake most strongly disapproved.[50] Since he praised Giulio Romano as a man "of the Most Profound sense of Genius" and, as we know, deeply admired Michelangelo and Raphael together with other continental Catholic painters, his antipathy to Rubens clearly originated neither from chauvinistic nor from sectarian motives. Although he mentions at one point the "rattle traps of Mythology" which Rubens introduced into his paintings, that element, too, could not have been the true cause of his hostility, Milton being (as Samuel Johnson complained of *Lycidas*),[51] no less guilty on that count without having aroused Blake's ire. What, then, were the causes for Blake's

intense dislike of one who might otherwise have been thought peculiarly congenial to his own artistic purposes?

The more obvious reasons have been enumerated by Edward J. Rose. There was his anger, no doubt touched with suppressed envy, at Rubens's worldly success, described uncharitably by Blake as a despicable pandering to the rich, a readiness to be "Hired by the Satans for the depression of Art." He charged him (with a sidelong glance at Reynolds) with having established a factory where assistants churned out innumerable commissioned works for which the artist received both the credit and the payment—"All Rubens' Pictures are Painted by Journeymen"— and summarized the attack upon his motives with the acid comment that Christ had been a carpenter and not a "Brewer's Servant."[52] Yet his professional irritation could have been levelled at many other successful painters from the past, and, from his more specific comments, it is clear that their main source was aesthetic in nature, his sense that Rubens constituted an offence against his own artistic creed. For Rubens was not attacked in isolation, but included in fulminations against an amalgam of painters, the "Venetian & Flemish ooze" which, he believed, had corrupted the taste of the leading connoisseurs of his own day: "Till we get rid of Titian and Corregio, Rubens and Rembrandt, We shall never equal Rafael and Albert Durer, Michael Angelo, and Julio Romano."[53]

There is no sustained critical passage in Blake's work to explain the nature of his animosity, his animadversions on Rubens consisting of squibs fired off at odd points throughout his prose writings, notably in the *Descriptive Catalogue*, in his *Annotations on Sir Joshua Reynolds*, and in his *Public Address*; but from the frequency with which he refers to that aspect, the most likely cause would seem to be that Rubens represented to him in the past, as Reynolds did for his own time, the leading colourist oil painter of Renaissance and post-Renaissance art, condemned by him not because such painters did not understand drawing but because they did not understand colouring. Behind this attack there may lurk shadows of the earlier controversy in the French Academy between the Poussinists insisting on the priority of line and Rubenists defending the primacy of colour. For Blake, however, there would seem to have been an additional factor easy to overlook today.

For those of us who recall the period some thirty years ago when a newly developed process for cleaning Old Masters of their accumulated varnish was first applied to canvases by leading art galleries, the astonishing contrast such cleaning produced is never to be forgotten. A painting such as Titian's *Noli Me Tangere*, long familiar in its more sombre form, seemed suddenly to leap to life, with colours emerging as

fresh as if they had just been laid on. In Blake's day, long before that process had been introduced, the dull brown effect produced by layers of varnish added through the generations was not only regarded as the hallmark of great painting and unthinkingly assumed to be the manner in which they had been originally produced, but had become in itself a hallmark of greatness, an effect consciously reproduced by contemporary painters. The oft-quoted story of Constable holding a fiddle against the grass to distinguish true green from the brownish colour associated with Old Masters as well as their modern imitators reveals how ingrained that idea was in Blake's time, and it was to continue well beyond Constable's own period. The latter's friend and biographer, C. R. Leslie, records the fate of one of his canvases little more than a year after the painter's death—"Its silvery brightness was doomed to be clouded over by a coat of blacking, laid on by the hand of a picture dealer; yet that this was done by way of giving tone to the picture, I know from the best authority, the lips of the operator; who assured me that several noblemen considered it to be greatly improved by the process."[54] The paintings which Blake himself would have seen (Rubens's *Judgment of Paris*, for instance, was exhibited in London in 1792) were then of course in their uncleaned state, which would explain to some extent the disgust they invoked in a watercolourist delighting in the freshness of his hues: "To my eye Rubens's Colouring is most Contemptible. His Shadows are of a Filthy Brown somewhat of the Colour of Excrement. These are filld with tints and messes of yellow & red. His lights are all the Colours of the Rainbow laid on Indiscriminately & broken one into another. Altogether his Colouring is Contrary to The Colouring of Real Art and Science."[55]

The term "filthy brown" could scarcely be applied today to the rich and vivid colouring of Rubens's great canvases in their cleaned state, yet that was the main charge which Blake levelled against him, remarking in connection with the art which the "outrageous demon" Rubens popularized that oil "will not drink or absorb colour enough to stand the test of very little time and of the air. It deadens every colour it is mixed with, at its first mixture, and in a little time becomes a yellow mask over all that it touches."[56]

It may be, however, that beyond that colourist difference, important as it was for defending Blake's professional status as an engraver and watercolourer, there was a further subject of contention. Similar to the quality distinguishing his poetry from Milton's but felt by Blake more acutely in the visual form of presentation, was the contrast between the palpability so central to baroque art in its conjuring up of visionary scenes as if they are actually being witnessed in all their magnificence or

dynamism and the personalized inward vision of Blake, reproducing not so much an event in Christian history as a scene from within the artist's mind. Rubens's *Fall of the Damned* (*fig. 92*) comes clearly within the former category, impressing the viewer with the force of Michael's mission from God, the myriad rebels plunging headlong before him in physical, muscular torment from the distant heavens towards the murky depths of Hell below, as if it were now occurring in all its awesome power. Blake's version of essentially the same scene, *The Fall of Satan* at the end of days rather than at their beginning (*fig. 93*), is once again, like his illustrations to Milton's baroque epic, an invitation to witness not the original scene but an envisioned artefact, his own mental re-creation. The scene is framed above by twin cherubim symmetrically placed against a formally designed cloud with figures below, which, for all their evocation of Michelangelo's, are here enclosed within a leaf-shaped flame whose jagged nether lines provide a symbolic suggestion of movement such as would never have been employed in a volumetrically realistic baroque canvas. That difference alone had not deterred Blake from admiring the poetry of Milton, but coupled with his hatred of oil painting in the form in which he saw it, it was sufficient in Rubens to disqualify as a model one who in other respects might have offered Blake so much.

The man-centered element in Blake's visionary process, his location of its origins within his own mental cognizance rather than as a privilege bestowed from above, is discernible, then, in the pictorial representations no less than in the verse. In the traditional baroque apotheosis, with its comforting message of the divine recompense for Christian virtue, it was the graciousness or magnificence of heaven which served as the motive force as the saint or martyr rose passively aloft, either drawn into the vortex above by swirling celestial powers (cf. *fig. 29*) or raised more sedately by angels or cherubs (cf. *fig 22*). For Blake, it was the imaginative force of the mortal being himself which could alone forge the contraries into union and win him his place above. In *Jerusalem*, Albion must himself stretch his hand into infinitude to grasp the fourfold Bow of gold, silver, brass, and iron, and then fire from it the fourfold arrows to drive the Body of Death into eternal resurrection. In the vigorous illustration which concludes that poem, representing the consummating union with the Universal Father (*fig. 94*), the baroque apotheosis is accordingly reversed, with the source of energy emanating from below. A flaming upward surge of power originating from beneath Albion's feet thrusts him aloft, his arms outstretched and body curved from the force of this pressure towards a Father functioning no longer as the inaugurator of the dynamic ascent but as the recipient, a

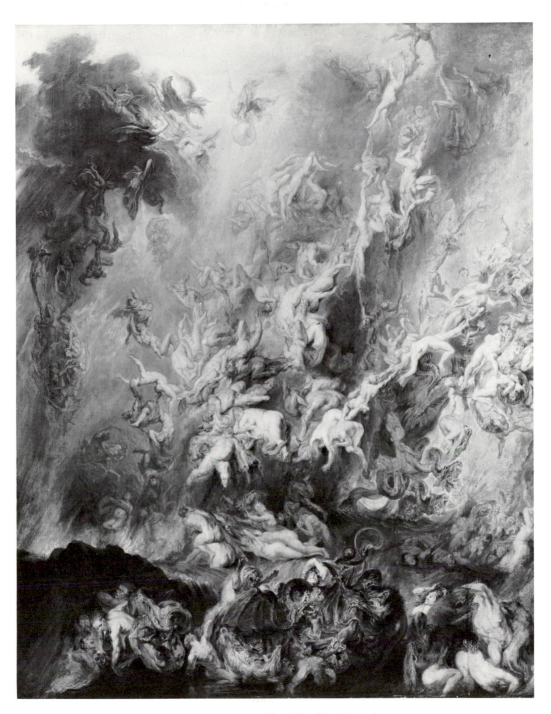

92. RUBENS, *The Fall of the Damned*

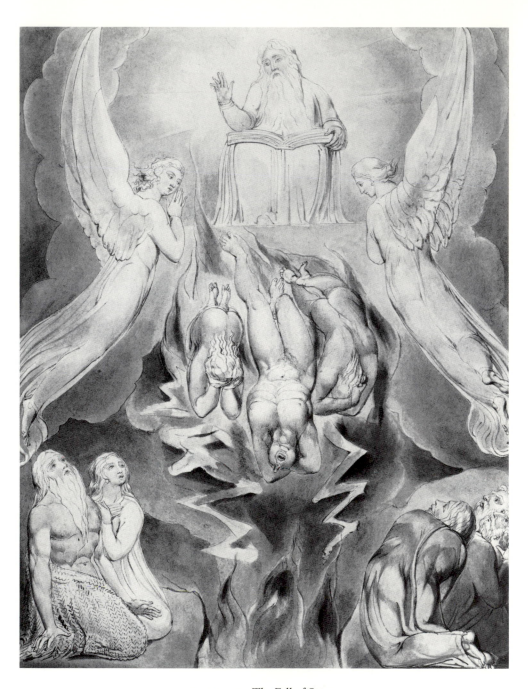

93. BLAKE, *The Fall of Satan*

94. BLAKE, *The Reunion of Albion*

patriarchal figure welcoming to his bosom one whose own indomitable determination has elevated him to eternal life.

One further style in art is relevant to Blake's painting. His indebtedness to Michelangelo and Raphael, particularly in his more confident Felpham phase, was, as Anthony Blunt has noted, primarily to the mannerist aspects or phases of their art.[57] That tendency once again may have been augmented by his acquaintance with their works not directly but through engravings; for, belonging to a later generation, the engravers by their own stronger mannerist affiliation instinctively accentuated the

tendency to distortion and disturbing imbalance characteristic of that mode. Suggestions have been made of the direct influence of specific engravings on Blake's art, Jean Hagstrum indicating a number of noteworthy parallels, especially to drawings by the late-sixteenth-century engraver Hendrick Goltzius; and there would indeed appear to be justification for acknowledging such influence. Although the reputation of mannerist art went into a general decline not long after its main period of creativity, Parmigianino was, in the eighteenth century, held in high regard, many of his drawings being included in the collections of Benjamin West and Joshua Reynolds; and an edition of seventy-four of his drawings was published by Conrad Metz in 1790.[58]

Such speculation may, however, prove misleading, not only because we have little knowledge of the engravings that Blake actually saw, but because similarities in artistic expression may arise not through imitation but quite independently, from a communion of philosophical outlook or motivation on the part of two artists. Blunt, for example, traces the winding staircase in Blake's painting of *Jacob's Dream* (*fig. 95*) to Salviati's fresco of *David and Nathan* in the Palazzo Sacchetti in Rome, which Blake may possibly have known through Scamozzi's engraving of it. But what may be more significant is the reason motivating both artists to choose that particular form. Staircases have, in fact, a peculiar importance in mannerist art. Salviati's version, whether indebted to it or not, closely resembles the stairway in Pontormo's earlier canvas *Joseph in Egypt*. The element which unites them all is the sense of precariousness they create, the distinctive lack of banister or balustrade, with ascending or descending figures stepping perilously near the edge, which lends to all those works a mannerist aura of disembodiment, of disregard for the exigencies of material existence, closely suited to the dream effect at which Blake aims in this painting.[59]

In conformity with what Spengler perceived as the predominantly pendular movement of culture, its repetitive series of action and reaction,[60] it was perhaps natural that Blake, resisting the rationalist tendencies of eighteenth-century art, should experience an affinity with mannerism, which had in its day similarly resisted the firm logicality, proportion, and optical fidelity of the Renaissance mode. In both responses, particularly in their religious manifestations, there is a conscious validation of the visionary over the factual; and there is no necessity to prove whether Blake had ever seen an engraving or copy of Tintoretto's *Last Supper* (*fig. 96*) to sense the artistic consanguinity of his incandescent portrayal of the Crucifixion (*fig. 97*). In each, the supernatural, miraculous element is endorsed, a weird light dematerializes the scene to authenticate its transcendental significance, before

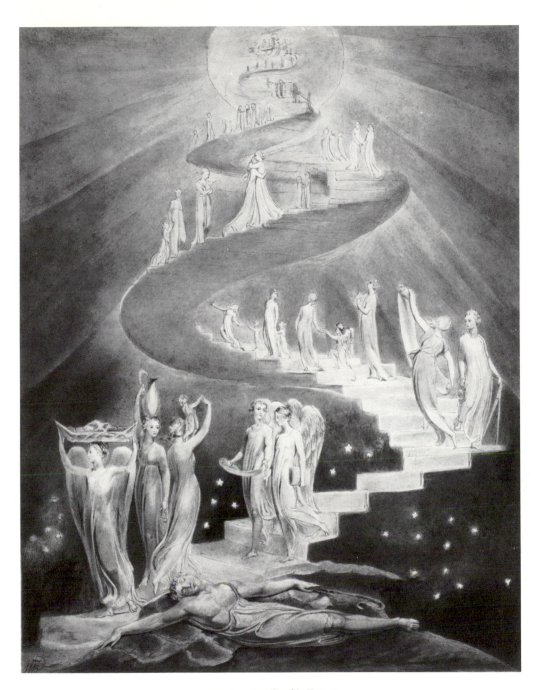

95. BLAKE, *Jacob's Dream*

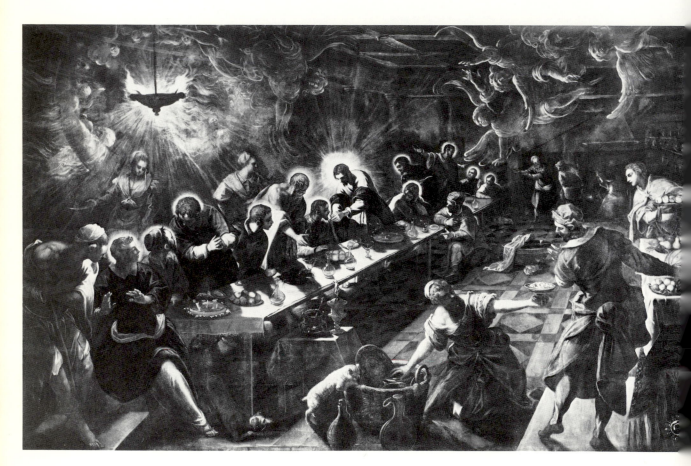

96. TINTORETTO, *The Last Supper*

97. BLAKE, *Soldiers Casting Lots for Christ's Garments*

which the laws of earthly experience shimmer away as irrelevant. Both modes culti-vate a startling, often paradoxical inversion of convention, adopting shock tactics which challenge traditional assumptions to awaken the viewer into new forms of thought, as in Blake's *Ancient of Days*, representing Creation not as the benevolent imposing of order upon chaos, but as the harsh imposition of constraint upon liberty.

Yet for all their similarities there are fundamental distinctions which must not be glossed over; for Blake's art was by no means an unreserved return either to the techniques or to the aims of mannerism. For the earlier mode, intellectually admit-ting the disturbing revelations of the cosmologists and yearning to reaffirm spiritual commitments despite them, the physical world had constituted a barrier to be forc-ibly overcome, the poet often grappling with the fascinations of logic in order to disqualify reason finally as being relevant only to this mundane setting and not to his spiritual needs; or in painting resorting to a Sprecher figure to seduce the reluctant viewer out of the security of his earthly setting into the phosphorescent world of emotionally charged meditation (cf. *fig. 19*). For Blake, in contrast, the real world possessed no such compelling authenticity requiring resistance, outward creation being, he contemptuously declared, "as the Dirt upon my feet No part of Me." Accordingly, his paintings convey an ease of access into the visionary world, a familiarity with the angels echoing his casual comment that "the Prophets Isaiah and Ezekiel dined with me." Others before him, not least George Herbert among the mannerist poets, had resembled him in regarding this world as a window through which to perceive the eternity beyond; but for them such perception involved an arduous process of decoding, the deciphering of anagrams placed by the divine in nature for the instruction of mankind, the resulting vision resembling at best our peering through a glass darkly. For Blake, reliant on a more personal sensibility, the transparency of objects in the physical world allowed for a remarkable ease of inter-course with the eternal reality imagined by him beyond the dross of the empirically evident—"I question not my Corporeal or Vegetative Eye any more than I would Question a Window Concerning a Sight. I look thro it & not with it." The inability of others to perceive the truths so manifest to him served only to reassure him of his privileged function as a seer:

> For double the vision my Eyes do see
> And a double vision is always with me
> With my inward Eye 'tis an old Man grey
> With my outward a Thistle across my way[61]

It is that comfortable assurance of this visionary power which frees him from the agonizing conflicts and tensions so characteristic of the art and literature of the religious mannerists, the urgent need of a Donne or El Greco to struggle towards the truth, wresting it from reality by means of convoluted paradox or labyrinthine casuistry, by the elongation or contraction of natural forms, in order to discern however faintly the incandescent, surrealistic verities beyond. That envisioned transcendental eternity was Blake's natural home, the inner experience of his own mind; and the familiarity and ease with which he consorted with its inhabitants remains a primary element distinguishing both his art and his poetry from his baroque and mannerist predecessors. "Imagination," he remarked, "is My World this world of Dross is beneath my Notice."[62]

7

THE "INCONVENIENCE"
OF JANE AUSTEN

THE NOVELS OF JANE AUSTEN HAVE LONG CONSTITUTED AN ANOM-
aly on the literary scene. They appear to defy the general principle that works of
originality and genius stand at the threshold of change, either themselves evolving
new modes of thought and expression or, at the very least, responding sensitively
to the harbingers of such cultural shifts. Their author has by general consent been
seen instead as looking back toward a past generation, ignoring, perhaps because of
her relatively circumscribed environment, the revolutionary ferment of ideas on the
larger European scene in favour of the more settled standards which had prevailed
in the Augustan tradition of the eighteenth century. Such chronological discrep-
ancy, if substantiated, poses a challenge to interdisciplinary studies, to the assump-
tion that an integral relationship exists between creative writing and the artistic or
cultural patterns contemporary to them. Indeed, as A. C. Bradley pointed out with
typically English understatement as long ago as 1929, the disparity also raises
doubts concerning the very concept of literary periodization:

> To the historian of literary epochs Jane Austen is, or should be, a little
> inconvenient. She was born a few years later than Wordsworth, Coleridge,
> and Scott. When she died, Byron was famous, and Shelley and Keats had
> already published. She belongs therefore to the period commonly entitled
> that of the Romantic Revival, or the Revival of the Imagination. And yet
> these titles do not suit her in the least . . . We might even say that she got
> nothing from the Romantic Revival except the opportunity of making fun of
> Mrs. Radcliffe. Essentially, it appears to me, her novels belong to the age of
> Johnson and Cowper.

Saintsbury, a few years beforehand, had identified her stylistically with an even earlier generation, commenting that her "demureness, minuteness of touch, avoidance of loud tones and glaring effects" were strongly reminiscent of Addison's essays; and as more modern criticism turned its attention to her works, that association with the Augustan era, whether in its initial or mid-century phase, has continued to prevail. Reuben Brower, in an influential essay appearing in 1951, noted how the rhythmical pattern of her prose sentences approaches the formal balance of the heroic couplet, while the tonal layers of her wit "can be matched only in the satire of Pope," and it has become a truism of scholarship to acknowledge her affinities to an era previous to her own.[1]

To attribute this anachronism to the comparative seclusion of Jane Austen's life, which supposedly insulated her from contemporary aesthetic change, is to contradict both a general principle of cultural history and our knowledge of her own personality. From the broader viewpoint, synchronic study rests on the hypothesis that shifts in cultural sensibility—the advent, for example, of analytical psychology in the twentieth century—permeate every aspect of an age, making it impossible for any intelligent person to be untouched by their assumptions, whether the individual chooses to accept or oppose them, and for such pervasive cultural osmosis limitations in social intercourse produce little effect. Emily Dickinson was far more of a recluse than Austen, shrinking from all contact with others and throughout her life rarely venturing from her home; yet her mind and art were, as a discriminating critic has defined them, "thoroughly contemporary," revealing her as being intellectually a woman of her time, responsive to cultural innuendo as well as to current poetic innovation.[2] Jane Austen's novels may contain no reference to that major European upheaval, the French Revolution, but with the husband of her beloved cousin guillotined in France by the Republicans in 1794, the widow returning to Jane Austen's circle to marry the latter's brother and thence meet with her frequently, she can be charged with ignorance neither of the Revolution's existence nor of its cruelties, and her decision to exclude any mention of it from her novels must be attributed to artistic choice and not to incognizance.

In more recent scholarship, some modification concerning her supposed insularity has been effected on the ideological and social level, notably in Marilyn Butler's perceptive study of the relationship of her novels to the contemporary war of ideas between the English Jacobins, as their opponents called them, and the more conservative forces cherishing the older dispensation. The radical ideas of writers such as

Godwin, Erasmus Darwin, and Maria Edgworth, advocating the liberalizing of political, social, and sexual mores in English society, had produced a groundswell aimed at countering the threat, and Butler, associating Austen with that conservative response, suggests with some caution that it is at least "open to question whether *Sense and Sensibility* and *Mansfield Park* can in fact ever be fully independent of their historical context."[3] The introduction into the latter novel of Kotzebue's *Lovers' Vows*—a play notorious at that time among the English anti-Jacobins for its supposed moral perversion—as the play chosen for amateur performance and condemned by Edmund as liable to corrupt the morals of the performers, acquires, in the setting of that conflict, a more topical significance than had been thought; and Warren Roberts has developed that discernment of her contemporaneity by exploring, through the facade of a settled England which her novels appear to present, her sensitivity to current changes on the English scene, including shifts in class consciousness, the growth of Evangelicalism, and re-assessments of the status of woman in society.[4] On the other hand, the evaluation of her stylistic affinities, both literary and aesthetic, has remained virtually unchanged, preserving the sense of temporal inconsistency articulated by Bradley.

If Jane Austen did not always choose to follow current literary fashions, there are, of course, numerous indications in her writings that she was familiar with them. In her first published novel, she includes a lively parody of the contemporary vogue of sentimentalism; in *Northanger Abbey*, a caricature of "Gothic" mystery, with Catherine's fearful discovery within a dark cabinet of an ancient manuscript, only to be identified in the light of morning as a discarded laundry list; and, more positively, there was her warm responsiveness to natural scenery, her pleasure in the "picturesque," inspired, as her brother Henry informs us, by her reading of William Gilpin's *Observations* and no doubt encouraged by its wider dissemination from the 1790s onward through the work of Richard Payne Knight, Uvedale Price, and Humphrey Repton. In that area, too, she reveals a sensitivity to immediately contemporary developments, dissociating herself from the cult it had recently become, from the mere emotional posing and technical jargon indulged in by the less discriminating acolytes of the movement. As Edward remarks to Marianne:

> . . . remember, I have no knowledge in the picturesque, and I shall offend you by my ignorance and want of taste if we come to particulars. I shall call hills steep, which ought to be bold; surfaces strange and uncouth, which

ought to be irregular and rugged; and distant objects out of sight, which ought only to be indistinct through the soft medium of a hazy atmosphere. You must be satisfied with such admiration as I can honestly give.[5]

She could indeed play the role of the provincial *ingénue* when it suited her, assuring the Prince Regent's librarian with something less than veracity that she boasted herself to be "the most unlearned and uninformed female who ever dared to be an authoress"; but she promptly belied that self-description by producing a burlesque of his inept suggestions, a burlesque based upon her own wide knowledge of current fiction, in her *Plan of a Novel*, a satirical sketch intended only for home consumption.[6]

In poetry, too, while she was reserved towards the fervent outpourings of Romantic verse, she was clearly familiar with its productions, gently deriding what she perceived as excesses, not least in her portrayal of Captain Wentworth in *Persuasion*. A soulful admirer of Scott and Byron, he shows himself "intimately acquainted with all the tenderest songs of the one poet, and all the impassioned descriptions of hopeless agony of the other." His enthusiasm, however, only elicits from his female companion the sobering and perceptive comment that she thought it was the misfortune of such poetry to be seldom safely enjoyed by those who enjoy it completely, her added warning no doubt reflecting the author's own view that "the strong feelings which alone could estimate it truly, were the very feelings which ought to taste it but sparingly."[7] On the other hand, even if the assumption of her cultural insularity proves to be unfounded, her unresponsiveness to current Romantic fervour and the scepticism with which she viewed the cults of ghostly ruins, Alpine crags, and exquisite sensibility would themselves support the charge of aesthetic conservatism—unless, as this chapter proposes to argue, an affinity can be discerned in her novels to an alternative artistic trend prevalent in her time, allowing her to be perceived as the literary exponent of an aesthetic mode more congenial to her quieter temperament than the *Sturm und Drang* of the Romantic poets, but no less a part of the immediately contemporary scene.

The most significant attempt to relate her novels to the aesthetic modes prevailing in the eighteenth century, an article reprinted as a standard ingredient of critical collections and frequently quoted in subsequent studies, has, for all the valuable insights it contains, served to intensify this impression of her aesthetic conservatism. On the basis of apparently minor scenes in *Pride and Prejudice* which he saw as symbolizing the major concerns of the novel, Samuel Kliger argued for the essen-

tially Augustan assumptions of the work as a whole. The performances on the piano by Mary and Elizabeth present, he suggests, an antithesis between "art" and "nature" which would have been immediately recognizable to the contemporary reader, an antithesis familiar from innumerable critical essays published during the century and employing terminology made current in formal discussions of aesthetics. Mary's playing, while technically superior, is, as the authorial voice informs us, pedantic, lacking the "easy and unaffected" charm of her sister's. Such partiality for Elizabeth's rendition conforms, we are told, to Pope's claim for poetry formulated early in the century and echoed throughout the subsequent decades that, however necessary the universal rules may be, they require in addition "a grace beyond the reach of art." The letter-writing scene at Netherfield represents once again, Kliger maintains, the novel's preference for nature over art. When Darcy deplores Bingley's "precipitance" in epistolary composition, extending his criticism, as the banter proceeds, to include the latter's social impetuosity too, Elizabeth's defence of such spontaneity is seen as adumbrating the central themes of the novel, her eventual modifying of Darcy's artificiality of manner in favour of a more "natural" relationship with people, closer to Elizabeth's own.[8]

To employ this very general contrast between art and nature as if it were a fixed principle of eighteenth-century aesthetic is in itself a dubious procedure. As the leading historian of ideas warned us long ago, the very word *nature* was in that period the most elusive and Protean of terms, the multiplicity of its meanings making it only too easy not only for the critic but for the writer, too, "to slip more or less insensibly from one connotation to another, and thus in the end to pass from one ethical or aesthetic standard to its very antithesis, while nominally professing the same principles."[9] In fact, the originality of Pope's thesis, and hence its main thrust, had not been to establish a contrast between nature and art but the very reverse, to proclaim their fundamental identity, a recognition that the constraints whereby nature is to be translated into art themselves form part of nature:

Nature, like *Liberty*, is but restrain'd
By the same Laws which first *herself* ordain'd.
. .
Learn hence for Ancient *Rules* a just Esteem;
To copy *Nature* is to copy *Them*.[10]

The grace beyond the reach of art upon which Kliger's argument rests, as it was formulated in the *Essay on Criticism* more than a century before the writing of this

novel, was included there not as a recommended principle of artistic creativity but as a guard phrase, a protective device. It was required by Pope to explain away awkward contradictions, those major exceptions to the rules which may "seem Faults" according to the system, yet are so obviously not. And at the same time, in a work didactically explicating the rules of poetic composition, it served as a means of reserving some distinction between the plodding observer of the proposed compositional principles and the true poet (including the author of those lines) who somehow rises above them. Pope might occasionally approve a certain "warmth of fancy" to help carry the writer beyond the mere mechanics of correctness, but as the prime advocate of that very *propriety* and formality in all things which Darcy represents so stiffly in the earlier part of the novel, Pope can scarcely be invoked as the inspiration for Elizabeth's dislike of that principle and her determination to amend it. Jane Austen's own estimation of Pope appears to have been distinctly cool. Elinor, the representative of the author's views in *Sense and Sensibility*, teases her sister, perhaps with a sly allusion to the very "propriety" we are discussing, that Marianne should be well satisfied with her morning's work, having ascertained her admirer's opinion in almost every matter of importance, including his enthusiasm for Cowper and Scott, and "his admiring Pope no more than is proper."[11]

The tendency of such interart studies of this period to elasticize chronology, stretching Pope's definitions of nature to fit the aesthetic modes dominant at the end of the century as if nothing significant had occurred in the interval, is to some extent attributable to a semantic inconsistency between the media, a trap for the unwary. It is the discrepancy between the term *Neoclassical* applied by literary historians to the Augustan period from Pope to Johnson, and the same term employed by art historians with reference to the later classical revival, predominantly Etruscan or Greek in inspiration, emerging during the final decades of the century. Kliger, for example, generously admits that the article from which he has "quoted practically verbatim," constituting for him the authoritative guide for the aesthetic principles governing that age, was R. S. Crane's entry on "Neoclassicism" contributed to J. T. Shipley's *Dictionary of World Literature*. The latter is indeed a brilliant article, justly recognized for its masterly survey of a complex subject; but it is noteworthy that, since Crane's theme is *literary* Neoclassicism, he focusses upon a period terminating in the 1760s, with only an occasional glance beyond. As Jane Austen, born in 1775 and writing at the turn of the century, lived in a world whose fashions, familiar to her from her repeated visits to such centres as London, Bath, and

Brighton, were being dictated by an essentially new artistic sensibility, still indebted to classical sources but deriving its inspiration from certain newly revealed aspects of ancient art, that later form of "neo-classicism" familiar to the art historian would seem to be more relevant for identifying the aesthetic assumptions governing her novels.

The dramatic uncovering of the buried cities of Herculaneum in 1738 and of Pompeii in 1748, with their wall-paintings and artefacts so amazingly preserved beneath the layers of volcanic lava (the freshness of the wall-paintings often fading soon after their exposure to the air) did not produce an immediate impact upon contemporary artists and designers. The delay was in part created by difficulty of access. King Charles III of Spain, at that time the ruler of Naples prior to his accession to the Spanish throne, jealously guarded his rights over the property, and his son Ferdinand continued the restrictions on his succeeding to the monarchy in 1759. Where permission to examine the treasures was occasionally granted, sketching them was forbidden until as late as the 1770s, even note taking only being permitted under the supervision of a guard. The lavishly produced volumes of the *Antichità di Ercolano esposte*, produced under royal direction, did little to increase the candidacy of the treasures as artistic models, since the books were not available for purchase, being bestowed as gifts on privileged recipients. It was only in 1773 that the plates were at last reproduced in London and made more widely accessible.[12]

One may suspect, however, that there was a further reason for the delayed response. There are undoubtedly instances in which a discovery may have an immediate impact upon artistic taste; but, as I argued in an earlier volume in connection with the eclecticism of the humanist revival, with its preference for Seneca over Aeschylus, of Plutarch over Livy, and of Ovid over Horace, complex changes in cultural modes more often direct creative writers and artists of a specific generation to exploit new models only when those are recognized, consciously or not, as supplying an existent need. The initial response to the Neapolitan artefacts during the 1740s and 1750s, when the stylistic authority of the Augustan period in Rome remained strong, was accordingly cautious, even supercilious, resembling the condescension towards the ballads prevailing in the early years of their eighteenth-century revival. Attention was directed to the shameless phallicism in certain Pompeian pieces, clearly representative, it was thought, of a decadent society. But as the desire for universal rules and formal restraints weakened and individual sensitivity began to be held in higher regard, this revelation of an unfamiliar aspect of ancient art, still

317

classical and therefore impeccable in lineage, offered an opportunity for introducing under its aegis a subtle modulation both in taste and in artistic expression.

England, at last able to compete with the continent in the plastic arts as well as in literature, was at the forefront of the innovative trend, Robert Adam providing some of the finest examples of the new decorative style. It should be noted in connection with Jane Austen's supposedly Augustan qualities and her imputed indebtedness to Johnson that Adam's style, too, was not a rejection of the classical tradition as William Kent had presented it architecturally in the earlier part of the century, but a variation upon it. Nevertheless, throughout his career, while he remained a respectful admirer of his mentor, he was at the same time transforming that tradition to suit a new generation. The changes he introduced were far-reaching, setting a new fashion in interior decoration from the 1760s through to the 1790s, by which time the Empire style was entering from France to consolidate the vogue in England, there to be known as Regency.

To return to its origins, the mode in domestic architecture and furnishings established by William Kent, under the patronage and frequently the close direction of Pope's friend Lord Burlington, constituted an artistic embodiment of the principles enunciated in the literature of the time. Holkham Hall, begun by Kent in 1734, marked a conscious rejection of the flamboyant baroque style (regarded by Burlington as an unfortunate aberration on the English scene) in favour of a return to the Palladian house, although now with an even stronger emphasis upon the ancient Roman source than the Renaissance architect had allowed. The entrance hall (*fig. 98*), with its noble columns and antique sculpture, combined a Palladian design indebted to Vitruvius with the apse of a Roman basilica, to produce, as had been intended, an effect of austere dignity rather than the warmth of a country home. That austerity was appropriate to the museum function which the building was in part to fulfill, as its owner Lord Leicester was to display there one of the finest collections of Roman antiquities to have been assembled in England;[13] but it suited, too, the authoritative classical tone that pervaded the art and literature of the time. A senatorial figure (unfortunately concealed by a pillar in our illustration, the only copyright picture at present available) confirmed in sculptural terms the dignity of the emulated Roman republic. Kent also excelled as a designer of interiors for houses built by others, the marble parlour at Houghton Hall (*fig. 99*) revealing characteristics similar to the entrance hall despite its more intimate purpose as a dining room, with columns inserted here as pilasters along the walls, a marble fire-

98. WILLIAM KENT, entrance hall, Holkham Hall

place crowned by a classical pediment, and furniture whose appearance of solidity and stability was enhanced by the richness of its tapestry, and the carved, gilded woodwork lending it weight and prestige.

Initially, Adam remained close to Kent's style, but by the 1770s he was creating his own version. The splendid music room at 20, Portman Square, London, designed and executed by him for the Countess of Home during the years 1775–77 (*fig. 100*), provides an impressive instance of the innovations he introduced.

99. WILLIAM KENT, marble parlour, Houghton Hall

While preserving Kent's apse and the proliferation of classical pilasters, he has transformed their effect, creating a delicacy and refinement unprecedented on the English scene. The apse is shallower, its gentle curve continued through pediment and doorway in a manner no longer suggestive of the authority of an ancient temple or basilica but of tasteful aesthetic sensitivity. The pilasters offer no support, even visual, for a projecting cornice but are slender decorative elements, artistic evocations of their past function. Above all, the classical urns and wreaths, as well as the figure motifs borrowed from Pompeii, have attained in themselves a finesse lacking in their ancient models and, in their patterning upon the wall, an exquisite subtlety of form reminiscent of a Mozart divertimento.[14] The "Etruscan Room," which he completed at Osterley Park during that period (*fig. 101*), reveals a similar refinement, the ornamental motifs borrowed from the Neapolitan excavations once again

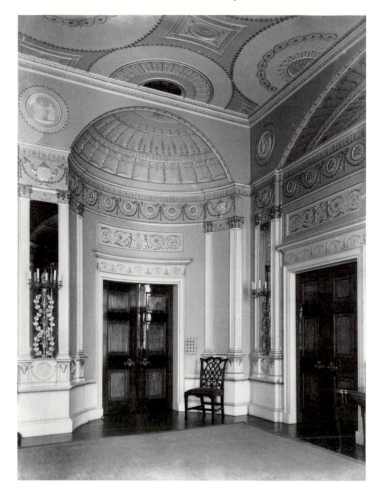

100. ROBERT ADAM, music room, 20 Portman Square, London

undergoing a process of attenuation during their importation to ensure their fragile elegance and pastel tonality. The overall impression the room creates, as in the work of his rival James Wyatt, is thus no longer of heavy classical authority, the rules by which art must function, but rather of aesthetic discrimination and personal taste.

That shift in fashion manifested itself in many aspects of contemporary art. Adam, who insisted upon designing every detail of his interiors including, it was said, even the keyholes for the bureaus, had supplied his designs to leading furniture

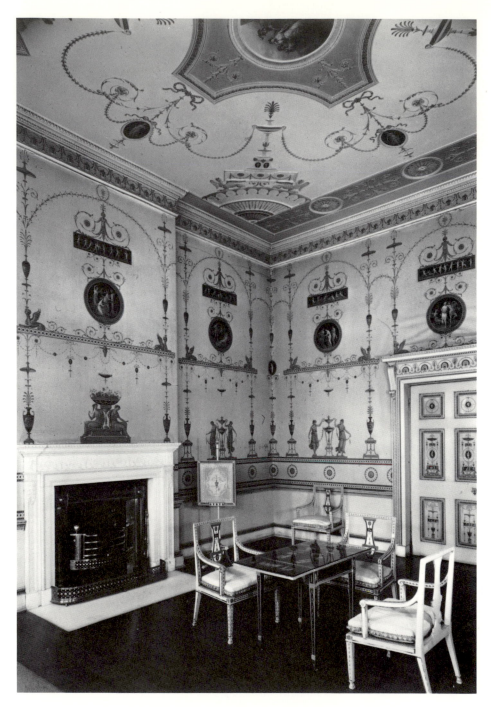

101. ROBERT ADAM, "Etruscan Room," Osterley Park

makers for execution, and through them his ideas were rapidly disseminated. One of those suppliers, Thomas Chippendale, began to incorporate the style as a major motif in his catalogue, and by the time of Hepplewhite's highly successful *Cabinet-Maker and Upholsterer's Guide* of 1788 and Thomas Sheraton's *Drawing-book* produced in 1791–94, the elegant chairs, gently curved sofas, and graceful side tables of the Adam style had effected a revolution in English furniture, becoming a synonym for refinement and delicacy of design. His innovations had prepared the way for the Greek revival in fashion, already implicit in the urns and tripods on the walls of his room in Portman Square and eventually to culminate in the famed Wedgwood vases. There, too, the original Greek urns (with the exception of the famed replica of the Portland vase) were not copied but adapted to the new aesthetic, the traditional black and red of Attic vases being replaced once again by pastel shades, with pure white figures exquisitely set against a jade or blue background (*fig. 102*). And that same sensitivity was extended to the designs, the often primitive or violent depictions of satyrs, battles, or bacchanalian orgies displayed on those ancient urns or on the marble frieze brought to England from the Parthenon by Lord Elgin being generally discarded in favour of more graceful mythological or literary scenes intended for the appreciation of the cognoscente, as in *The Apotheosis of Homer* designed by Flaxman for the same vase in 1778 and (perhaps more appropriate for book illustration here, since the vase needs to be turned to be fully appreciated) in the plaque which he produced the following year from the same design (*fig. 103*). Flaxman's drawings, too, such as his *Penelope's Dream* from his illustrations to Homer's Odyssey (*fig. 104*), admitted a rare fragility of line and transparency of form into English art, a style peculiarly suited to the refinements of contemporary taste.

The arabesque of the earlier Rococo salon, with its play on symmetrical forms displaying pastoral scenes, had been similarly softened by Adam, not only by the adoption of variegated hues in place of the standard gilt upon white but also by a more flimsy symmetricality, a play, as on the walls and ceiling of the Etruscan Room, on wispy wreaths and feather-like forms curling and interweaving in insubstantial lightness. In Mozart's *Cosi Fan Tutte*, exactly contemporary with this change, may be perceived that same light interplay of symmetrical patterning. Instead of those splendid solo arias such as *Il Meo Tesoro* or *Voi Che Sapete* which characterize his other operas, the dominant form here is of duets charmingly varied as in a protracted minuet between two interchanging sets of lovers. With the males, disguised as visiting orientals, making love not each to his *inamorata* but temporarily

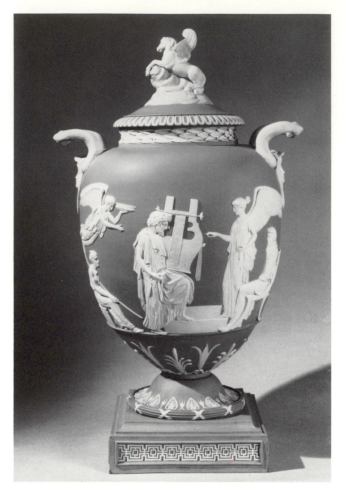

102. FLAXMAN, Wedgwood vase

exchanging partners as part of a wager, the duets delightfully succeed each other in that same pattern of flimsy interweaving, with Don Alfonso, the initiator of the wager, acting as the pivotal figure for this lighter arabesque, directing and rearranging the insubstantial alliances on either side.

This softer, more sensuous version of classicism was to inspire Thomas Jefferson on his visit to Europe in the 1780s to carry the style across the Atlantic, where he was to erect as the dominant structure of the University of Virginia campus his impressive Rotunda (*fig. 105*), unfortunately known until recently only in its badly reconstructed form after a devastating fire in the nineteenth century, but skilfully

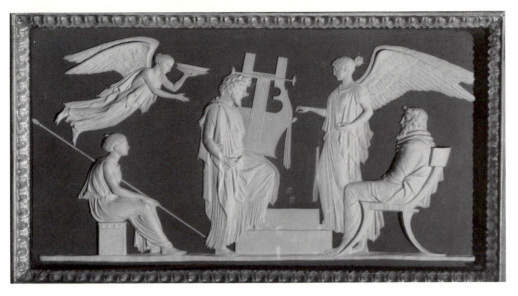

103. FLAXMAN, plaque prepared from Wedgewood vase design

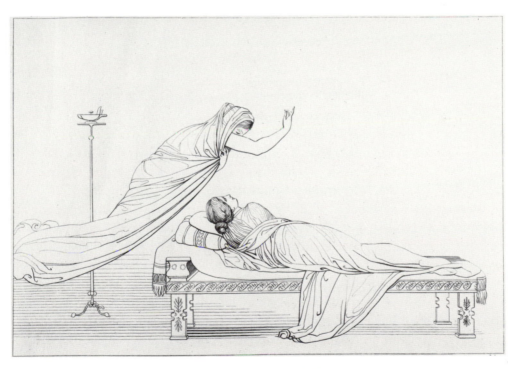

104. FLAXMAN, *Penelope's Dream*

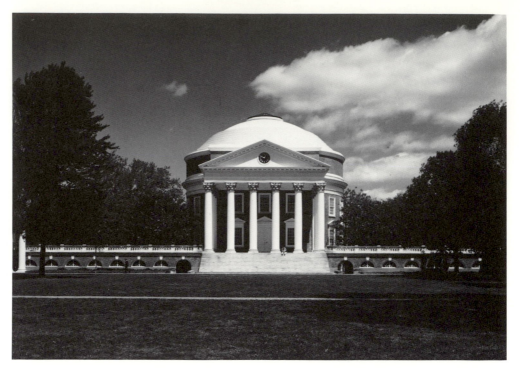

105. THOMAS JEFFERSON, The Rotunda, University of Virginia

restored in 1976 to its pristine purity. The building, as Jefferson designed it, resembled Adam's interiors in being consciously evocative of the Palladian model, yet subtly adapted to the new mode. In place of the grey stone of the original Villa Rotunda near Vicenza (cf. *fig. 41*), he introduced a chromatic tonality evocative of the Wedgwood vases, with white columns and pediments set against the delicately contrasting hue of roseate brickwork. And inside, beneath the domed assembly room inherited from the earlier villa (although here presented in gleaming white), he created a floor plan of extraordinary gracefulness (*fig. 106*), a division of the available circular space into three oval rooms, so that the vestibule formed by their walls produces a symphony of curves, original in conception and deeply pleasing in visual effect. In an era proclaiming the rights and freedoms of the individual, Jefferson's Rotunda was a demonstration of aesthetic independence, a modifying of authoritative classical propriety and decorum to express the personal predilections of a connoisseur.

326

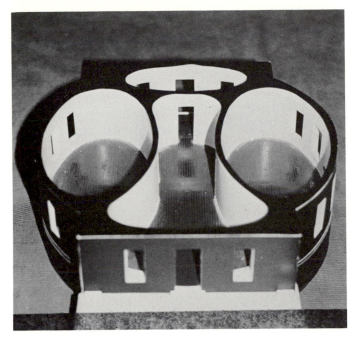

106. Model of the lower floor of the Rotunda

It was in fact a leading romantic, Sir Walter Scott, who was the first to identify the "exquisite touch" which distinguishes the novels of Jane Austen.[15] To associate her stylistically either with Addison and Pope or with that later bastion of Augustanism, Samuel Johnson, on the grounds of her classical formalism and supposedly traditional standards is to ignore what is, perhaps, the most rewarding aspect of her art—that very finesse, independence of judgment, and personal sensibility which she shared with the later or Greek version of Neoclassical art. The attractiveness of her own favourite heroine, Elizabeth Bennett—in her own words, "as delightful a creature as ever appeared in print"—her charm both for the reader and for Darcy himself, lies precisely there, in Elizabeth's spirited discrimination. While affirming the general framework of social and moral convention, she unhesitatingly challenges or modifies its claims whenever she perceives it encroaching upon the individual judiciousness and freedom of choice which she values so dearly. Such independence may at times lead her astray, but far better, Austen suggests, the errors resulting from personal evaluation than a dull subservience to universally imposed standards. Accordingly, where Pope's wit had been aimed at reaffirming established

order, as in the reassuring conclusion to his uniting of elephant and tortoise, hers functions best in resistance, when curbing its excessive demands. It is a quality eminently demonstrated in the scene where Elizabeth coolly opposes that most intimidating female representative of social authority, Lady Catherine de Bourgh. Calm beyond her years, respectful of rank, and cautious never to overstep the bounds of good breeding, she responds to the imperative bludgeoning of her interrogator with a lightness of tone and tactful turn of phrase that preserve her independence unsullied, winning the reader's unqualified admiration:

> "Miss Bennet, do you know who I am? I have not been accustomed to such language as this. I am almost the nearest relation he has in the world, and am entitled to know all his dearest concerns."
> "But you are not entitled to know *mine*." (p. 354)

In terms of a modern feminist reading, Elizabeth is indeed open to criticism, as Judith L. Newton has remarked, for her assumption that marriage is the ultimate haven for womanhood;[16] but within the context of that contemporary belief, it is her treasuring of personal choice in such matters which is distinctive, constituting the central theme of the novel—her refusal of what society would acclaim as a brilliant match in favour of that true meeting of minds and sensibilities in marriage which Elizabeth was eventually to achieve.

Elizabeth's sensitivity, her dedication to the singularity of the self in a society exacting unswerving obedience to fixed rules of behaviour, with its matrons ensuring that no digression from its standards should go unreprimanded, has a direct bearing upon Austen's stylistic as well as philosophical relationship to Samuel Johnson. The confident tone of Austen's authorial voice, with its mordant commentary on contemporary manners articulated as solemn axioms, is clearly indebted to the learned doctor in much the same way as Robert Adam remained throughout his career consciously evocative of the classical Kent. But the similarity extends also to her transformation of that heritage in the process of its adoption. Johnson's own statements are calculated to convey the full weight of considered opinion, to crush opposition by the firm assertion of an unquestionable verity:

> Mankind are universally corrupt, but corrupt in different degrees; as they are universally ignorant yet with greater or less irradiations of knowledge."[17]

Austen's celebrated opening to her novel typifies her innovative inversion of that tradition, her ability to preserve the outward form of proverbial pronouncement while subverting the message it conveys:

It is a truth universally acknowledged, that a single man in possession of a good fortune, must be in want of a wife.

The humour of that sentence cannot and has not been missed, but its broader social subversiveness has been sadly camouflaged by the continued application to her work of the umbrella term *irony*, with little attention to a substantial difference in intent between her own usage of that mode and that of her predecessors. Swift had, of course, revitalized in a manner peculiarly his own the strategy of solemn tongue-in-cheek pronouncements conveying a meaning opposite to that expressed; but the purpose of his irony had of course been to ridicule the eccentric and the idiosyncratic, to expose, as in *A Modest Proposal*, reprehensible deviations from universally approved humanitarian norms in order to reassert thereby the standards to which all thinking men should rightly conform. Jane Austen's irony functions in the reverse direction. The principle she enunciates in that opening sentence, as elsewhere in her novels, is the need for a perceptive minority, for individuals blessed with discernment to resist the weight of established opinion. The identifying of a wealthy bachelor as marital prey was indeed a truth universally acknowledged by female society, by the Mrs. Bennets, the Lady Lucases, the Lydias, and even perhaps the Jane Bennets, who represent in larger or smaller degree its concern with matrimony as the passkey to property and rank, to the world of carriages, gowns, and liveried servants. Only those rare exceptions endowed with discrimination—Elizabeth and, until her defection, Charlotte—possess the sensitivity to perceive the vulgarity of the marital market and to cherish a conception of matrimony as a joining of kindred spirits rather than a means of financial advancement; and with Charlotte surrendering to the fear of spinsterhood, Elizabeth is left to represent alone the standards of true refinement and good taste.[18] It is that elitist minority which the reader is invited to join.

The difference between Austen's exquisite touch and Johnson's impressive but somewhat ponderous assertions of established truths may be highlighted by Oliver Goldsmith's amusing exchange with him on the subject of fables. When Goldsmith was considering the composition of a literary piece in the style of Aesop, the fable of the fishes which see a bird flying above them, Goldsmith remarked on the necessity in such fables of making the animals convincing, the literary skill required in this instance to make them talk like little fishes. Boswell records Johnson shaking with laughter at the notion, upon which Goldsmith smartly retorted that if his learned friend were to make little fishes talk, "they would talk like WHALES."[19]

Austen may have admired her "dear Dr. Johnson," but she never wrote like a whale. Moreover, she was capable, we may suspect, of gently mocking his pomposities; for what, indeed, is Mary Bennet, who "piqued herself upon the solidity of her reflections," if not a parody of the very style of writing with which the author's critics have so long associated Jane Austen herself?[20] The mere mention of a word is sufficient to prompt Mary's pontifical pronouncements of accepted truths, her imparting, to the supposed Boswells about her, of the definitive and lexicographical observations at which she has arrived. Of pride, it is her Johnsonian conviction "that human nature is particularly prone to it, and that there are very few of us who do not cherish a feeling of self-complacency on the score of some quality or other, real or imaginary. Vanity and pride are different things, though the words are often used synonymously. A person may be proud without being vain. Pride relates more to our opinion of ourselves, vanity to what we would have others think of us" (p. 20). To which a young Lucas, puncturing the solemnity of the utterance, protests that if *he* were rich he would not care how proud he was but would keep a pack of foxhounds and drink a bottle of wine every day.

Johnsonian articulation of universal truths was itself, of course, a facet of the vogue of "sentiment" in the original meaning of that term—the solemn expression of moral opinion which had come to dominate not only *belles lettres* but also the drama of the early eighteenth century. It is not to that tradition that Jane Austen belongs, but rather to the opposition, the reaction emerging in the 1770s just at the time of Robert Adam's cultivation of a more individualistic style. Once again it was Johnson's close friend Goldsmith who, through the character of young Marlow in *She Stoops to Conquer* (1773), mocked the Augustan tendency towards weighty generalization—a young man tongue-tied by the distasteful need to speak in moral clichés in the polite society of his class, but able to relax as a rattling blade in the presence of any pretty barmaid or servant. The scene, as Kate Hardcastle teasingly informs him that she admires the grave conversation of a man of sentiment and he, with eyes desperately averted, confusedly replies, constitutes a powerful burlesque of that convention:

MARLOW: In this age of hypocrisy there are few who upon strict inquiry do
 not − a − a − a −
MISS HARDCASTLE: I understand you perfectly, sir.
MARLOW (aside): Egad! and that's more than I do myself.
MISS HARDCASTLE: You mean that in this hypocritical age there are few

that do not condemn in public what they practise in private, and think they pay every debt to virtue when they praise it.

MARLOW: True, madam; those who have most virtue in their mouths, have least of it in their bosoms. But I'm sure I tire you, madam . . .[21]

Within her novel, this element of pompous moralizing is obvious enough in the insufferable Collins, mouthing ethical platitudes as a screen for his self-advancement; but it is worthy of note that Darcy's conscious pride during the earlier scenes of the novel is expressed by a similar, if less exaggerated sententiousness. Almost every comment he utters emerges there as an authoritative Johnsonian "sentiment," defining the rules of social or moral behaviour for which he is, as it were, the final arbiter. Here it is Elizabeth who functions as the amused deflater of his imperiousness, querying his summary of the basic requirements to be expected from the truly accomplished woman, which include, she discovers, a thorough knowledge of music, singing, drawing, dancing, and the modern languages, and besides all this a certain something in her air and manner of walking, as well as in the tone of her voice:

> "All this she must possess," added Darcy, "and to all this she must yet add something more substantial, the improvement of her mind by extensive reading."
> "I am no longer surprised at your knowing *only* six accomplished women. I rather wonder now at your knowing *any*." (p. 39)

The relaxed form of her response is in itself a commentary on his arrogance, the formal impersonality of his own sweeping definition contrasting with the simple individualism of her reply, a reply tinged as always with the mirth of one capable at all times of laughing both at herself and at the foibles of others. It is to Darcy's great credit that he appreciates that quality in her even when the barbs are levelled at him. When accused by her of the very sin we have been discussing, an incorrigible desire to impress others by the profundity of his proverbial pronouncements, he has the perceptiveness to recognize that her inclusion of herself in the accusation is intended solely to soften the blow directed at him:

> "I have always seen a great similarity in the turns of our minds—We are each of an unsocial, taciturn disposition, unwilling to speak unless we expect to say something that will amaze the whole room and be handed down to posterity with all the éclat of a proverb."

"This is no very striking resemblance of your own character, I am sure," said he. "How near it may be to *mine*, I cannot pretend to say." (p. 91)

By the close of the novel, her playfulness has won through, her liveliness of mind and independence of spirit have modified the formalism of his address, while on her part she has learned that behind the forbidding propriety of his demeanour there lies a tastefulness and delicacy of discrimination suited to her own, those qualities first revealed to her on her visit to Pemberley.

The symbolic significance of the great houses in Austen's novels, especially for establishing the rank and status of their owners, has not passed unnoticed,[22] but their presence there takes on an added dimension in the context of this present interart investigation. In *Mansfield Park*, the young people visit Sotherton Court to confirm the complaint of its heir that it is an unsatisfactory house in urgent need of refurbishing. The house is, as the authorial voice specifically informs us, in the impressive, but by now outmoded style popular in the mid-century, with heavy furniture and fittings clearly reminiscent of Willam Kent's Holkham or Houghton Hall. The visitors are guided "through a number of rooms, all lofty, and many large, and amply furnished in the taste of fifty years back, with shining floors, solid mahogany, rich damask, marble, gilding and carving, each handsome in its way." Edmund agrees that both the house and the gardens sorely require improvement but privately deplores Rushworth's determination to hire the great Humphrey Repton, significantly preferring, were he the owner, to exercise his own individual taste.[23] In *Pride and Prejudice*, the three great houses similarly represent their owners' strengths and weaknesses of character. Netherfield, lacking, like Bingley, an ancestral tradition—rented, deserted, and re-inhabited at a moment's whim in accordance with its owner's impetuosity—is architecturally nondescript, with a library, inherited from his father, consisting of only a meagre collection. Lady Catherine de Bourgh's home, Rosings, is both formidable and ostentatious, Collins' proud enumeration of the vast number of windows and the cost of their glazing patently echoing her own boast. In contrast, Darcy's Pemberley reveals tastefulness and aesthetic sensitivity. The building itself, as an inherited family home, represents only the dignity of his aristocratic background, but it is to him that the choice of furniture is attributed, Elizabeth responding to it "with admiration of his taste." But her most generous praise is reserved for the delicacy of his personal touch, a taste evocative of the Adam style rather than the weightier classical form, as she visits Miss Darcy's charming sitting room, a recent gift from her brother, "fitted up with greater elegance and lightness than the apartments below."[24]

At that point my argument rests. But I am tempted to add a whimsical afternote which is admittedly less firmly based. In a rare reference to painting, Austen recorded with some amusement her visit to an exhibition in search of portraits which could represent her own fictional creations, Jane and Elizabeth Bennet (referred to in the passage by their married names). For Jane she was eminently successful— "Mrs. Bingley's is exactly herself, size, shaped face, features, & sweetness; there never was a greater likeness"—but she could find no portrait resembling Elizabeth: "I was very well pleased—particularly (pray tell Fanny) with a small portrait of Mrs. Bingley, excessively like her. I went in hopes of seeing one of her Sister, but there was no Mrs. Darcy;—perhaps however, I may find her in the Great Exhibition which we shall go to, if we have time;—I have no chance of her in the collection of Sir Joshua Reynolds' Paintings which is now shewing in Pall Mall, & which we are also to visit."[25] Her conviction that there would be nothing resembling Elizabeth in the retrospective Reynolds collection proved correct. He had been, after all, the painter *par excellence* of the Augustan grand style, elevating the particular to the universal. Where his friend Johnson had proclaimed that it was not the business of the poet to number the streaks of the tulip but to remark general properties and large appearances, Reynolds argued in his *Discourses* for nobleness and dignity in art, for portraiture representing comprehensive truths rather than pusillanimous fidelity to detail: "Alexander is said to have been of low stature: a Painter ought not so to represent him. Agesilaus was low, lame, and of a mean appearance: none of these defects ought to appear in a piece of which he is the hero."[26] The artist, he maintained, should exalt his subjects to lofty proportions. Accordingly, his famous painting of the actress Mrs. Siddons presents her enthroned as the Tragic Muse, and a family portrait of the three Montgomery daughters becomes translated by him into a mythological scene of *The Three Graces Adorning a Statue of Hymen* (*fig. 107*).

In his latter years, however, Reynolds, began to display a surprising responsiveness to the newer modes in art. His final discourse delivered in 1788, for example, offered a generous appraisal of the naturalism and vivacity in the paintings of his late rival Gainsborough, acknowledging that if the reputation of the English school should be preserved to posterity, Gainsborough would be recognized "among the very first of that rising name." At the time he was composing that lecture, he himself was commissioned to paint Lady Elizabeth Foster, adopting there a similar naturalism and absence of mythological formality, and it is the charming portrait resulting from that sitting (*fig. 108*) which would, I believe, have been welcomed by Jane Austen as a likeness of Elizabeth Bennet had she known it, and for reasons

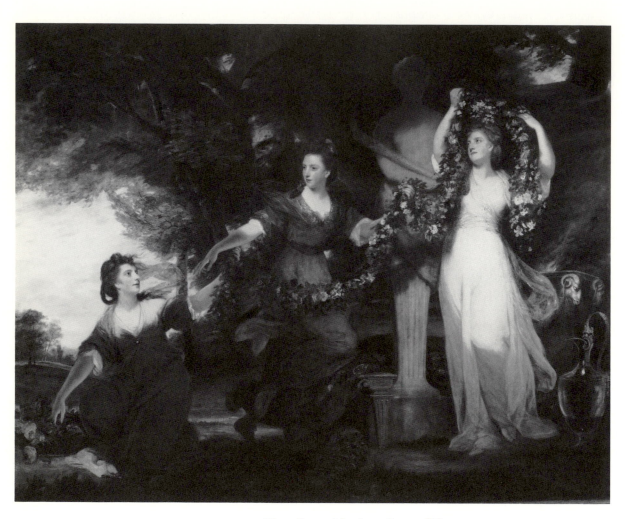

107. REYNOLDS, *Three Graces Adorning a Statue of Hymen*

108. REYNOLDS, *Lady Elizabeth Foster*

closely related to the theme of this present chapter. She may be assumed in fact never to have seen the portrait, as it was only once exhibited in 1788, thereafter remaining in the private collection at Chatsworth.

Abandoning any tendency to ennoble or exalt, Reynolds presents his sitter simply and directly, as a young woman of considerable grace and beauty, gazing at the artist with an expression of intelligent confidence as well as mild amusement. In real life, although more morally daring than Elizabeth, she partook of that same independence of judgment and spirited challenging of authority. Imprudently married (as Elizabeth almost was to Wickham) to a rather drunken member of the Irish parliament, she had had the courage to leave him, joining her devoted friend Giorgiana, the Duchess of Devonshire, to form, in defiance of convention, a famous *ménage à trois* together with the Duke.[27] Reynolds, aware of the anomalous household situation and no doubt aware also of her reputation for social recalcitrance and witty observation, has captured to perfection the strong vein of individualism in her personality, the self-reliance and humour which isolate her from the conventional Grand Manner of Augustan portraiture. If Elizabeth Bennet was less openly rebellious, especially in matters of matrimony, what distinguished her in the changing climate of that time from other heroines, as well as from the characters surrounding her in the novel, endowing her with her attractiveness and vitality, was her similar insistence on personal judgment and individual taste. And those are the qualities which I find so brilliantly captured in this fine portrait from Reynolds' later period.

Be that as it may, the thesis of this chapter relies upon other evidence. What emerges from a close reading of Jane Austen's work is that in both style and cultural outlook she may be seen as belonging more intrinsically to contemporary aesthetic modes than has previously been thought. Within the setting of Adam's graceful Neoclassical interiors, the delicacy of Hepplewhite furniture, and the aesthetic sensitivity of the Wedgwood vase, it is Austen's softening or modulation of the proprieties dominating the Augustan era that emerges as her most characteristic feature. And once that affinity to contemporary art has been perceived, its application to her own literary forms reveals her not as Popean or Johnsonian in her wit and observations but, on the contrary, as providing through Mary Bennett, the pompous Collins, and Darcy in his unregenerate phase, an amused parodying of the very Johnsonian sententiousness with which she has so long been associated. Romanticism was neither monolithic nor exclusive, embracing within its parameters the Regency style together with *Sturm und Drang*; and if Austen preferred the more delicate, less revolutionary form for her own writing, she belonged no less to the artistic mode of her time.

ROMANTICISM

8

LOWERING SKIES

(i)

The rejection towards the end of the eighteenth century of authoritarian, universal rules for art in favour of imaginative, individual creativity produced a stylistic and thematic heterogeneity in Romanticism which has at times placed in doubt the validity of any attempt to comprehend its varied forms within the parameters of a single movement. Poetry ranging in tonality from the sensuousness of the Keatsian ode to the cool cynicism of Byronic satire, from the contemplation of rural beauty in Wordsworth to the passionate rebelliousness of Shelley, together with the philosophical inconsistencies inherent within the mode led earlier in this century to the claim that the plurality of the term "romantic" had robbed it of meaning, that the word had ceased to perform the function of an effective verbal sign.[1] If that more extreme view has been challenged and the term formally reinstated, primarily under the aegis of René Wellek and Geoffrey Hartman—with the latter perceiving as an underlying coordinator the Romantics' desire to return to Unity of Being, "the interacting unity of self and life"—nevertheless warnings against postulating comprehensive definitions of the movement or even of delineating cohesive motifs within it continue to place us upon our guard.[2] Both Anne Mellor and Jerome McGann, in response to deconstructionist theory, have argued persuasively in recent years for the dialectical quality of Romantic thought, distinguishing between the conscious, formulated assertions of the poets and their sceptical or ironic recognition that the patternings of human experience they propounded were themselves ultimately fictive. The poet, engaging in the creative, fluctuating cycle of life as he now conceived it, eagerly constructed new myths which, as he sensed, bore within them the seeds of their own destruction; for as part of that very mutability theory, they, too, were destined to yield to new forms in a never-ending process that be-

339

came an analogue for life itself. As McGann wisely points out, critical recognition of this dialectical element in Romanticism parries the negative implications of deconstructionist theory by perceiving the "ironist stance" as an essential component of the philosophical scheme and the diversity as part of its programmatic ideology.[3]

In Romantic painting a similar diversity is discernible, partly attributable to the same cause, the new value that had been placed upon individualism, but partly also to a more pragmatic reason, an economic factor affecting the market for the artist's wares. The establishment of the Royal Academy in 1768, with the opportunity it offered for canvases to be exhibited for sale, had to some extent freed the painter from subservience to the dictates of conservative aristocratic patronage. The wider public to which the painter now had access, expanded by the upward mobility of an increasingly wealthy middle class, allowed him the possibility of initiating projects rather than merely fulfilling commissions, of exploring innovative themes and techniques in the trust that he would eventually find a sympathetic buyer among the numerous visitors to the annual exhibition. Even within the traditional system of patronage, the raised status of the artist, like that of the contemporary musician emerging from the liveried service pertaining in the days of Haydn and Mozart to the greater independence of Beethoven's era, emboldened him frequently to dictate the themes of his commissioned works and hence to indulge his personal leanings rather than conform to established norms.

One major aspect of his search for new forms was a weakening of the divisions between the various aesthetic disciplines. The recognition of poetry and painting as kindred arts, which had, under the auspices of Horace's dictum, been fully acknowledged throughout the earlier part of the century, was now expanded to include the discipline of music, its appeal enhanced (for a generation valuing the sensual) by its ability, unmediated by words, to play directly upon the emotions of the listener. Accordingly, it began to take precedence, even in the estimation of poets, as the acme of artistic forms. Schiller argued that all arts, including poetry, strive towards it, and at their best "become music and move us by the immediacy of their sensuous presence." In a formula imported into England by Madame de Staël and widely disseminated there, he described even architecture as being in its most successful forms a kind of "frozen music."[4] There had, of course, long been a precedent for such a view in Alberti's adoption of Pythagorean principles to equate the proportions of Renaissance architecture with the harmonic scales of music; but the principle there had been arrived at empirically, through the discernment of measurable mathematical ratios shared by the two media, rather than on the basis of simi-

larities in the emotional response they aroused. It was the latter which now provided the impetus for advocates of synaesthesia, the current theory that a sensation produced by one artistic medium could stimulate similar sensations in another. Schubert's *Lieder* cycles created a new genre by their exploration of emotional tonality in the setting of Romantic narrative; and the possibilities of such amalgamation were not missed by the poets. The sensuous quality of song supplied Shelley with his poetic image of lingering memory, the nostalgic reminiscence of "Music when soft voices die"; the Aeolian lyre, harmoniously responsive to the breath or spirit of nature, became the accepted symbol for poetic creativity; and it was to the oriental music supplied by a friend that Byron composed his exotic *Hebrew Melodies*. In the new dispensation, the long-established comparison of verse to painting was now only rarely invoked, displaced by the new analogy, with Hazlitt claiming for poetry the distinction of being "the music of language, answering to the music of the mind."[5]

Yet the relationship of poetry to the visual arts, if no longer a major principle of aesthetic theory, continued in practice to engage the imagination. In 1798, the Royal Academy bestowed formal recognition on that correlation when it granted permission to exhibiting members to append poetic quotations to the titles of their canvases.[6] The motive behind that change was a desire to validate the growing tendency among artists to find inspiration for their paintings in scenes culled from literature, but it encouraged also a more intimate relationship between the two modes. Painters, Turner prominent among them, often took over both functions, composing their own poetic lines to accompany their canvases, verses intended on the one hand as commentary upon the depicted scene but even more as an emotive stimulus, augmenting the visual response by verbal resonances and associations as a means of evoking in the viewer a sympathetic mood.

This dislodgement of mimesis as the acknowledged purpose of art in favour of a cultivation of the sensual and the expressive, coupled with the primacy now accorded to the subjective function of the imagination, intensified the cherishing of individualism which was to become the hallmark of the genre. Constable, rejecting the criterion of the universally approved in favour of what was distinctively his, voiced a view shared with his peers in proclaiming his desire for uniqueness: "Whatever may be thought of my art, it is my own; and I would rather possess a freehold, though but a cottage, than live in a palace belonging to another."[7] It was, paradoxically, that shared penchant for the difference implicit in uniqueness that united the Romantics in their very diversity.

Their insistence on individuality cannot conceal, however, certain collective or coordinating elements of Romanticism transcending the pursuit of uncomformity, among these their sense of spaciousness, the denial by both painter and poet of the settled boundaries that had lent comfort to the Augustan conception of man as part of an ordered, hierarchically static cosmos with preordained limitations for human knowledge and achievement. The new creative impulse demanded a wider range, breaking through such constrictions in yearning for the distant and the exotic, reaching across aeons in time, searching back in memory, and traversing continents in journeys either real or imaginary.

Yet a distinction needs to be made in identifying that Romantic concept. The baroque, too, had been fascinated by infinity and spaciousness, imaginatively soaring aloft in order to gaze with awe at the vast and illimitable. The focus there had been upon the cosmic, upon the immense forces of heaven, displayed in order to excite in man an adoration of the divine. If that vision had proved unpalatable to Augustan taste, Romanticism, on the familiar "grandfather" principle in history whereby a rebellious generation redressing the innovations of its forebears experiences a kinship with the very mode which their "parents" had rejected, reinstated the vast and boundless as fit objects of contemplation. But the sense of infinity was no longer cosmic, as it had been for an era struggling to absorb the revolutionary discoveries of Copernicus and Galileo. Instead vastness became terrestrially located, expressed in an admiration of deserts, mountains, and oceans situated upon earth rather than of the orbiting planets or solar systems above.[8] For Wordsworth, the heavens had become remote from his concerns, in a sense irrelevant. In the account of his childhood borrowing of the skiff, it is to the mountainous peaks that he turns his fearful gaze as the source of moral authority, dismissing the celestial as too distant for his concerns:

> I fixed my view
> Upon the summit of a craggy ridge,
> The horizon's utmost boundary; for above
> Was nothing but the stars and the grey sky.[9]

Such major shifts in philosophical or religious outlook frequently find their artistic expression in apparently minor symbols. In recent years considerable attention has been paid to the emergence of cloud imagery in Romanticism, to Wordsworth's kinship with it as a symbol of his lonely wandering, to Shelley's identification with its self-regenerating powers, and, in the visual arts, to the new prominence it occupied in Constable's paintings. Kurt Badt, quoting lines from Shelley's poem as the

epigraph for his investigation, was the first to examine in detail Constable's intense interest in variable cloud formations and the remarkable sketches that he produced in the years 1821–22 under the influence of the findings of the English chemist, Luke Howard. The latter's treatise of 1803, in which the process of cloud generation was first analysed and their varied formations distinguished, had in its day provided Goethe with what he excitedly termed the "missing thread" for his own nature poetry; but it was only after the publication of Howard's larger study, *The Climate of London*, in 1818–20 that Constable came into contact with the theory, devoting much of his own work in the following two years to a meticulous examination of cloud structures and to experimentation with the methods of incorporating them pictorially into his canvases. Badt, followed by most subsequent historians, has attributed this Romantic interest in clouds primarily to the symbol they provided of impermanence and inconstancy in nature, an inconstancy which the poet perceived as reflecting his own nature, his unstable, shifting moods, and the sense of his own subjection to change. The cloud image was a representation from within nature of the poet's innovative desire to capture in his verse, as did the artist upon his canvas, the mercurial quality or capriciousness of life—a symbol, as for Shelley, of their own evanescence and mutability:

> We are as clouds that veil the midnight moon;
>> How restlessly they speed, and gleam, and quiver,
>> Streaking the darkness radiantly!—yet soon
>> Night closes round, and they are lost for ever . . .[10]

For Turner, too, the painter's task was no longer to record unalterable, universal truths but to be "roused by every change of nature in every moment, that allows no languor even in her effects which she places before him, and demands most peremptorily every moment his admiration and investigation, to store his mind with every change of time and place."[11] As Morse Peckham argued cogently some years ago, Romanticism represents in its basic tenets a shift from the conception of the universe in the earlier part of the century as a fixed or stable mechanism to a comprehension of it as essentially organic, a world of imperfection and emergence in which the creative force of the artist both participates in and contributes to those processes of change.[12]

This theory of Romantic mutability is essentially true, but there is a chronological discrepancy in its application to the cloud image. By the time of Constable's sketches of cumulus and nimbus formations in the 1820s, that aspect of impermanence had undoubtedly become their prime attraction. In that period, their meteor-

ological inconstancy fascinated Shelley no less than it did Constable, as the poet recorded in a letter to Mr. and Mrs. Gisborne in July 1818, no doubt perceiving in the climatic variability of that region a projection of his own volatile temperament: "I take great delight in watching the changes of atmosphere here, and the growth of the thundershowers with which the noon is often overshadowed, and which break and fade away toward evening into flocks of delicate clouds." The introduction of naturalistic clouds into painting had, however, occurred many decades before that interest in impermanence had developed, and it arose, we may suspect, for entirely different reasons. Under the clear Italian skies of the Arcadian world depicted by Claude Lorrain and his imitators, where shepherds sang to their loves through eternal summers, clouds had rarely appeared and if at all, consisted of unobtrusive wisps. The seventeenth-century Dutch painters, including Ruisdael and Cuyp, had, in their naturalistic landscapes, given them greater visual substance; but, as was noted earlier, their realism had failed to win admiration in England, where for many years their art was dismissed as a mere literalistic or pedantic copying of nature in a manner lacking Claudean grandeur. But one keen admirer of Dutch painting did emerge, and it is with Gainsborough that clouds first gain body and depth in England as credible natural phenomena pregnant with rain and thunder. The landscape canvases of country scenes he produced were, of course, painted primarily for the artist's own pleasure. They could never provide him with a source of livelihood but did offer him a satisfaction he was unable to find in the formal portraits of his professional career. With a wistful yearning for the rustic, he proclaimed in a well-known comment: "I'm sick of Portraits and . . . hate . . . being confined *in Harness* to follow the track, whilst others ride in the waggon, under cover, stretching their Legs in the straw at Ease, and gazing at Green Trees & Blue skies."[13] Since Gainsborough's artistic delight in the open countryside in a non-Claudean and non-pastoral sense has long been recognized as marking a turning point in the development towards a Romantic view of nature, his innovative cloud patterns should perhaps be regarded as of more than local significance.

One of his earliest experiments in that genre, his scene of Cornard Wood from 1748, often known as *Gainsborough's Forest* (*fig. 109*), established his practice for later ventures, namely his discarding of the traditional justification for landscape art by means of supposedly mythological associations or by loosely related biblical titles intended to ennoble them through historical allusion. Instead, such scenes are presented with directness and simplicity, as rural activities deserving contemplation for their own sake. So much is obvious; but the means employed to achieve that

109. GAINSBOROUGH, *Cornard Wood*

110. GAINSBOROUGH, *The Cottage Door*

effect are perhaps less apparent. Genuine rural painting in that period demanded a conscious countermanding of viewer expectation, the traditional seeking for celestial implications in the scene, such as the hint in Claude's paintings of golden horizons glowing in the far distance beyond the human figures and redolent with Edenic promise. Gainsborough's innovation in this specific canvas, his earliest painting in the genre, was the insertion of a thick bank of clouds which blocks off the sky above the trees, resisting by its positioning as well as by its own naturalness any tendency on the viewer's part to look beyond the rural scene towards the heavens. This enclosing or isolating of the human and the natural from the empyrium serves furthermore, by reflecting back potential interest to the scene itself, to validate terrestrial nature as a self-sufficient entity, the wood and its inhabitants no longer functioning as in a Claude landscape merely as the starting point for a visual journey beyond but as worthy of contemplation in their own right. The baroque artist, regarding the heavens as the infinite, dynamic abode of God, reflecting the divine splendour of the Creator, had expressed that sensibility by optically breaking through the vault or dome of the church to display the celestial glory beyond (cf. *fig. 29*). But the Romantic reversed that process, imagining the skies as an architectural solidity enclosing or encapsulating the natural scene. In Shelley's poetry the heavens have become an opaque canopy overarching the realm of human habitation, "the dome of a vast sepulchre" seen from within, and obstructing loftier vision. Even for poets more theologically conservative than Shelley, the conception of God as immanent in the natural scenes upon earth had made the traditional association of the divine with the distant heavens both antiquated and inapposite.

This specific painting, as Gainsborough acknowledged in later years, had been only a jejune experiment in the genre, but it introduced the technique that he was to employ with such striking effect in his later canvases where, as in his *Carthorses Drinking* of 1760, the lowering clouds again disqualify ethereal associations, deflecting the eye down to the sharply sloping cart and thence to the watering of the horses in the foreground, which now forms the focal point of the scene. The paintings of Salvator Rosa (cf. *figs. 66 and 67*) had also darkened the scene, with beetling rocks jutting over the human figures; but there, as contemporaries realized, the effect was of the insignificance of mortals, a threatening sublime contrasting with the open, lighter landscape of a Claude. In Gainsborough's paintings the atmosphere is far from menacing, with *The Cottage Door* of 1780 (*fig. 110*) employing clouds and overhanging trees to enfold the peasant family within the bosom of nature, creating a sense of human intimacy and warmth within the country setting.

In this study of perspective, less in terms of mimetic reproduction of three-dimensional effect than as expressive of man's philosophical relationship to the world beyond as he conceived it in each generation, Gainsborough's new pictorial frame of reference was as integral to Romanticism as the superior vantage point of Canaletto and Guardi had been for the earlier part of the century. If the latter represented a dissatisfaction with baroque scenes of divine splendour dramatically viewed from below and a preference for a panoramic view of the urban affairs of men and women as social beings, the Romantic was to create a viewpoint more appropriate to his own changed needs. No longer a dispassionate spectator gazing curiously upon the scene from above (where no blocking off of the celestial had been required), by positioning himself upon earth, level with his subject, he reveals in both painting and poetry his sympathy with a shared human condition. Gainsborough views the rustics as though from a nearby path concealed from their view, as a passing traveller unseen yet participating in the scene; Keats stands within the darkling forest, brooding amid the incense hanging upon the bough; Wordsworth wanders through the forest experiencing a kinship with Leech Gatherer or Reaper, while Byron and Turner regard with awe the immense power of the sea not from afar but standing upon the deck of a ship, themselves tossed in the towering waves or sped swiftly over its surface, sharing in the ocean's beauty and power:

> Once more upon the waters! yet once more!
> And the waves bound beneath me as a steed
> That knows his rider. Welcome, to their roar!
> Swift be their guidance, wheresoe'er it lead![14]

James Heffernan has written eloquently of the "re-creation" of landscape in Romantic poetry and painting, arguing that while it was claimed to be an unmediated vision it in fact required, as all art requires, a process of reshaping and reconstructing, to be modulated by the memories and associations of the creative artist himself. Constable's claim in a letter to John Dunthorne in 1802 that he would attempt a "pure and unaffected representation" of scenery, closely paralleled as a cultural phenomenon of the time Wordsworth's manifesto in the Preface to the *Lyrical Ballads* that he would adopt for his own descriptions "the language normally used by men"; but Heffernan argues that both, while consciously adhering to the ideal of artistic fidelity to the natural scene, in fact departed from it, and he points out how Constable's *Dedham Vale* (*fig. 111*), so often cited as a true nature painting, is in fact an artefact, a conscious reworking by him of Claude Lorrain's *Hagar and the Angel* (cf. *fig. 52*) owned by his friend Sir George Beaumont.[15]

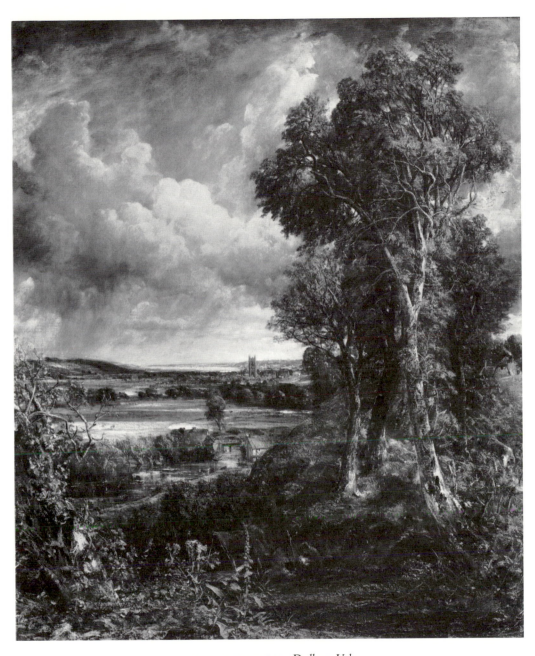

III. CONSTABLE, *Dedham Vale*

Even more impressive than his indebtedness to the earlier painting is, however, the method whereby the metamorphosis from classical pastoral to nature painting was effected by Constable, a process increasingly apparent in the various versions he produced, which makes the fact of its having been modelled upon the Claude canvas now seem little more than academic. In his transformation of the vista from eternal, Arcadian idyll into an English country scene, the introduction of the low clouds scudding over the countryside is clearly paramount, not only in its suggestion of the evanescence of the moment but also in its delimiting of the spatial implications, replacing the golden infinity of mythic promise in Claude's depiction by a sense of the physical closeness of the natural world and the ensconcing of the local scene in the intimacy of individual experience.

As the church in this painting demonstrates, the religio-mythological connotations of traditional landscape scenes had not been entirely expunged, nor was the presence of Dedham Church there dictated by the topography. It appears repeatedly in his Suffolk canvases, being frequently transposed from its actual location in order to be employed as a compositional device; but his choice of a church for that purpose was too closely bound up with the exigencies of Romantic art to be fortuitous. M. H. Abrams has revealed in his brilliant study *Natural Supernaturalism* the substratum of Christian thought upon which Romanticism rests, the recurring images of creation, fall, and redemption, its millennial hope of a rebirth for mankind, and its apocalyptic visions of the soul's recovery from self-division to unity expressed in terms of sacred marital embrace.[16] That Romantic element, too, is to be distinguished from a phenomenon discussed in an earlier chapter. The displacement of religious faith into the secular aesthetic of the sublime and the beautiful had resulted, it was argued there, from the constraints imposed by a rationalist society upon religious devotionalism, the value placed upon intellectual self-discipline producing among the potentially devout an unconscious psychological transference of their frustrated religious emotions into an aesthetic, ostensibly secular, experience. By the end of the century, however, the restraints upon emotional expression had been lifted. The rise of evangelicalism had long removed any bar to religious fervour, the hymns of the Methodists, and gradually of the Church of England too, once again encouraging devout prayer and spiritual self-abasement even in a communal setting—Augustus Toplady, a bitter opponent of the Wesleys, expressing in his Anglican hymns the same desperation and emotional dependency as the evangelists:

Nothing in my hand I bring,
 Simply to Thy Cross I cling,

Naked come to thee for dress;
Helpless look to Thee for grace.[17]

In the absence of external pressures, the assimilation of theological ideas into Romantic thought cannot, therefore, be seen as a sublimation of repression. It constituted rather a fusion of two impulses. On the one hand, there was the tendency as in all eras of change (compare the construction of the first Elizabethan playhouses in the form of an inn) to rely, especially during the initial transitional period, upon inherited models or familiar thought patterns as receptacles for the innovative mode. Yet on the other hand, and by no means to be underestimated, there was the archetypal authority which evocations of the Bible and the Christian tradition at large could lend to the most revolutionary and radical of views, producing the anomaly of Shelley, an avowed agnostic, employing in so much of his poetry the prophetic fervour and terminology of religious experience.

Moreover, the sense of guilt that had motivated much of the awe associated with the sublime during its earlier phase no longer functioned in the same way. For if the landscaper restoring Eden had experienced a sense of sin in usurping divine prerogative, the Romantic validation of individualism had reversed the implications. The poet now eagerly appropriated to himself the act of creativity as a fully justified ideal. In the works of both Constable and Wordsworth there emerges a vatic quality, endowing the most natural of scenes with a sense of mystic force, the archetypal sanctity of a holy experience—"Stop here, or gently pass." Yet as the title of Abrams's work implies, it is a supernaturalism no longer celestial in conception but immanent, a mystic source of inspiration residing within the leafy forests or glades of man's earthly habitation. The refocussing, as in Gainsborough's painting, upon the human scene enclosed within nature rather than upon the distant or celestial motivates Constable's advice to his fellow painters, advice not merely technical: "Get your foreground right and the rest will follow." In 1856, commenting upon the metamorphosis which had occurred at that time in landscape painting and had continued into his own generation, Ruskin, who was so much closer to that period than we are, was to single out for especial attention what he termed the extraordinary *cloudiness* that had entered such depictions, a replacement of the perfect light and clear heavens of the Claude Lorrain tradition by sombre, rain-charged skies. While not actually attributing that shift in representation to the mental closing off of the divine heavens as has been suggested here, Ruskin does see the presence of weather elements in such canvases as symbolising in some sense a secularization of nature. The change, he argues, denotes both for the initiators and for his own gener-

351

ation of painters a "total absence of faith in the presence of any deity therein. Whereas the mediaeval never painted a cloud, but with the purpose of placing an angel in it; and a Greek never entered a wood without expecting to meet a god in it; *we* should think the appearance of an angel in the cloud wholly unnatural, and should be seriously surprised by meeting a god anywhere."[18]

The cumular blocking off of the celestial has wider implications. If it has become customary in recent years to note the religious aura of Wordsworth's poetry and his frequent naming of God as the source of that mystic force, it is, on the other hand, not difficult to perceive how tenuous that attribution was, the name itself often being interchangeable with the vaguer term Nature, also conceived as the source of moral teaching and inspiration. Wordsworth frequently introduced alterations into his later version of the *Prelude* in order to counter current charges of unorthodoxy and even heresy, especially in regard to his pantheistic tendencies. The phrase

God and Nature's single sovereignty (9:237)

appears, for example, in altered form in the 1850 version as

Presences of God's mysterious power
Made manifest in Nature's sovereignty.

and he would often, even in the original version, prevaricate over the identity of the force to which he attributed his inspiration:

The sense of God, or whatso'er is dim
Or vast in its own being, above all,
One function of such mind had Nature there
Exhibited by putting forth, and that
With circumstance most awful and sublime . . .[19]

As Peter Thorslev has recently noted, four out of the six leading Romantic poets—Wordsworth, Byron, Shelley, and Keats—repudiated Christian doctrine either privately or publicly in their early years and found it necessary to create alternate destinies through which to find their places in the social or natural worlds.[20] And even when they did employ traditional patterns of belief, the divine impulse was no longer a personal revelation, a meeting of the soul with its Creator, but had been transformed into an objective entity discernible to the perceptive. As the Venerable Sage explains in a crucial passage in *The Excursion*, that moral force is not a

divinely transmitted message tailored for a specific viewer but resides impersonally within the properties of each object:

> An *active* Principle:—howe'er removed
> From sense and observation, it subsists
> In all things, in all natures; in the stars
> Of azure heaven, the unenduring clouds,
> In flower and tree, in every pebbly stone
> That paves the brooks, the stationary rocks,
> The moving waters, and the invisible air.
> Whate'er exists hath properties that spread
> Beyond itself, communicating good. . .[21]

Here, too, despite the return to pre-Augustan concerns with divine impulses and moral inspiration, the focus is exclusively upon the terrestrial scene, the stars as viewed from upon earth, the clouds, plants, brooks, and rocks of man's earthly habitation which are no longer, as in the poetry of Herbert and emblematic literature, merely the bearers of didactic messages left there encoded by God for Christian edification, but have become themselves the holy source of spiritual and moral inspiration.

(ii)

This secularizing of the divine and its transference to the natural scene in both the painting and poetry of Romanticism was manifestly indebted in large degree to the spread of Deism, initiated in England by Shaftesbury and growing in influence throughout the subsequent years as it weaned its adherents away from traditional Christian dogma towards a more generalized belief in benevolent immanence. That secularization was not, however, an isolated phenomenon, and in this study of correlations between the arts, it may be valuable to return to our earlier discussion of the "follies" and the suggestion that they may have been more significant in the development of ideas than has usually been thought. If the Gothic hermitages and grottoes expressed, for all the apparent drollery of their paraphernalia, a nostalgic yearning in the potentially religious for the integrity of faith predominant in a past era, the popular vogue of chinoiserie may represent the contrary movement, a de-

sire among those of a different disposition to be released from the pressures of a Christian society. That the eighteenth-century admiration of the Chinese contributed to a change in aesthetic standards and a broadening of the parameters of taste has long been recognized, but it has been seen primarily as offering a release from Augustan prescriptions, as the main outlet for anti-classical tendencies. But it implied also, I believe, a questioning of Christian tenets as it arose concurrently with Deism, reflecting and strengthening the universalizing aspects of that creed and fortifying the atheistic tendencies of the *philosophes*.

On the principle of eclecticism assumed throughout this work, the assumption that each generation chooses as its models only those elements from history or from the world about it that suit its particular needs at the time, it is illuminating to note the time lag, that it was only in the eighteenth century that the much earlier contacts with Cathay manifested themselves as cultural changes upon the western scene. Although European missionaries began their activities there in the sixteenth century and by as early as 1585 a report based on their accounts had already been published in Rome by Juan Gonsalez de Mendoza, an Augustine friar of Toledo, praising the Chinese for those very achievements that were later to excite admiration, it was to take nearly a hundred years before any significant response was evoked. His laudatory descriptions of that country, to be echoed throughout the eighteenth century, focussed upon the exemplary order of its society, the beauty of its houses and gardens, its responsible provision of homes for the sick and needy which left its streets free of beggars, and the scrupulous fairness of its judicial system—all aspects, we may note, so deplorably lacking at that very time on the European scene. Elizabethan London was notorious for its teeming prostitutes, cut-throats, and tricksters, the dross thrown up by an impoverished working class in a society whose judicial system, as Fielding was to complain, remained grossly maladministered for at least two centuries. Yet what proved fascinating for Europeans in the initial stages was neither the aesthetic appeal of their buildings nor the improvements the Chinese model could offer in social planning. Architecturally, despite the laudatory remarks by Juan Gonsalez, the general response to the buildings of China was negative. One Jesuit father, Louis Le Comte, voiced the consensus when he commented in 1690 that Chinese architecture was "very unpleasing to foreigners, and must needs offend anyone that has the least notion of true architecture."[22] What appealed instead during the rise of Deism was the proof China offered that a well-ordered community could be established on the basis of a humanitarian morality innocent of the hegemony of a Christian church.

Ironically, it was the Society of Jesus itself, the Loyolan Catholic order established to revive and strengthen Christian faith in Europe especially among the intellectuals, which was responsible for providing its opponents, the Deists, with this valuable example of an infidel society admirable for its moral probity. The Jesuit missionaries sent to China in the late sixteenth and early seventeenth century, such as the learned orientalist Matteo Ricci, had discovered, in contrast to other, often barbaric countries they had attempted to convert, that in this instance they were dealing with a highly sophisticated and rational society, whose thinkers, to their chagrin, dismissed as mere superstition the faith in the supernatural so fundamental to Christian belief. To overcome their contempt, Ricci set a pattern for subsequent missionaries to that country by adopting the dress and customs of the Chinese and immersing himself in their literature and philosophy in order to gain their respect as a scholar, regarding that conciliatory action as a first step to winning their souls— the latter, a more difficult task than had been envisaged. The Society of Jesus, as part of that campaign to establish their credentials with the Chinese, as well as, no doubt, out of a genuine regard for the civilized community they had encountered, began publishing in the latter part of the seventeenth century commendatory accounts of that distant civilization, as well as a translation of the teachings of Confucius.

The effect of what has long been regarded as a primarily aesthetic influence on contemporary religious controversy became at once apparent, as the savants of Europe seized upon those very Jesuit documents as evidence that there was indeed a possibility for human society to be established on moral principles, with a rational dispensing of justice, humanitarian care for the disabled, and a contented populace free from unrest; and all this without resorting to the tyranny of a church or priesthood speaking in the name of a supernal godship. The discovery of so impressive an alternative to traditional ethics and the success of its practical application confirmed in such laudatory terms by visitors to that country seemed to undermine the Christian claim to an exclusivity of truth. In 1697, Leibniz, after immersing himself in the principles of Confucian philosophy, wryly concluded in his *Novissima Sinica*: "I almost think it necessary that Chinese missionaries should be sent to us to teach us the aim and practice of natural theology, as we send missionaries to them to instruct them in revealed theology." As Adolf Reichwein, one of the earliest and most reliable of the historians of this east-west relationship has confirmed, these discussions on the "natural morality" of the Chinese proved largely instrumental in forcing the theological faculty of the University of Paris in the direction of Deism.[23] And that more specific instance has wider implications.

The notorious incident of Christian Wolff's persecution for having advocated the study of Chinese thought was in itself religious in motivation. An academic oration he delivered in 1721 at the University of Halle entitled *De Sinarum Philosophia Practica*, in which he argued, mildly enough, that the doctrines of Confucius not only did not conflict with Christian morality but were in accord with *natural* morality, touched upon a sensitive nerve. It produced an immediate furor as theologians, accusing him of being both "a Heathen and an Atheist," successfully petitioned the King of Prussia to banish him from the country on pain of death, with only forty-eight hours granted for his departure. The fear of contamination implicit in the swiftness of the expulsion suggests that the threat was sorely felt, admiration of Chinese culture being seen as intrinsically inimical to Christian faith.

The aspect of Chinese civilization most frequently praised in this period was, significantly, its "enlightenment," the orderliness of its way of life resulting from calm, rational processes of thought rather than inherited dogmas; and it was above all the contemplative aspect of Chinese life that appealed to the western intellectual at this time. In the charming decorative panels by Watteau, pastoral scenes from the classics now frequently alternated with glimpses of an idealized Chinese world, depicting the polite formality of an oriental court or the relaxed, reflective life of its citizens. And it was for its leading philosopher that the earliest recorded chinoiserie garden building in England was named, the House of Confucius, designed by Joseph Goupy and erected at Kew in 1745.

The European vogue of chinoiserie was, as we know, largely a fiction, the country being too distant and inaccessible for verification of the impressions transmitted by travellers, and European chauvinism ensured that this oriental interest was often tinged with ridicule; but the form the European fiction adopted and the uses to which it was put reveal the more serious need it was answering.[24] Goldsmith was aware that his Chinese citizen of the world would probably fail to recognize as modelled upon his own country the weird pastiche structures bearing the epithet "Chinese" in the gardens he visited, yet Goldsmith himself, however he might scoff at the absurdities of the mode, employed it with great success as a measure for satirizing the supposed civilization of eighteenth-century Europe, one prominent element being its religious practices. His sober Chinese visitor is amazed to discover that, while his own country selected for high office men of superior sanctity and learning, in England they were usually inducted into the church merely to please a senator or to provide for a younger branch of a noble family, their function being

to "preside over temples they never visit; and while they receive all the money, are contented with letting others do all the good."[25]

By the 1760s, the political facets became more pronounced as the neomon-archists of France found in the long-lasting benevolent dynasty of the Chinese a valuable counter-model to set against the democracy of ancient Athens, so often cited by the republicans. But within the political debate too, where the theory of *laissez-faire* as well as the principle of open civil service examinations derived their authority from the admired Chinese system,[26] their religious freedom from clerical-ism remained a main attraction for the savants, with Voltaire declaring in his *Dieu et les Hommes* of 1769: "Worship God and practice justice—this is the sole religion of the Chinese *literati* . . . O Thomas Aquinas, Scotus Bonaventure, Francis, Dom-inic, Luther, Calvin, canons of Westminster, have you anything better? For four thousand years, this religion, so simple and so noble, has endured in absolute integrity."[27]

The vogue of chinoiserie was not, of course, restricted to the continent, Sir William Temple's popularizing of the Chinese term *sharawaggi* (whatever the origin of that mysterious word may have been) having proved a turning point in introduc-ing the system of "irregular" landscape gardening into England, destined to be famed throughout the continent as *le jardin Anglo-Chinois*. Nor is it fortuitous that within those gardens it was the sacred Chinese pagoda or Buddhist temple that caught the imagination, so that, as James Cawthorne commented in 1756 in his poem *Of Taste*;

> On every hill a spire-crown'd temple swells,
> Hung round with serpents and a fringe of bells.

In the centre of Kew Gardens, Sir William Chambers erected in 1763 the great pagoda which still stands there, although it has long since been denuded of the eighty coruscating dragons, overlaid with glass of variegated hues, which had orig-inally ornamented the projecting eaves on each storey (*fig. 112*). The prominence throughout such pastiche buildings of the sacred Chinese dragon or serpent, a bene-ficent force in oriental mythology regarded as dispensing blessings, was a patent and no doubt provocative inversion of traditional Christian associations of that creature with Satan, highlighting the pagan implications of the new vogue. In 1755, one writer expressed his alarm lest "the Chinese taste, which has already taken posses-sion of our gardens, our buildings, and our furniture, will also find its way into our

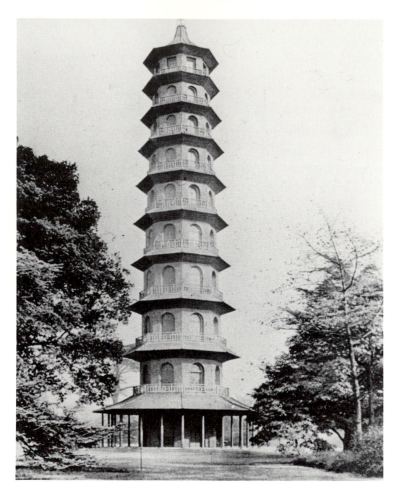

112. WILLIAM CHAMBERS, The Pagoda, Kew Gardens

churches," and imagines how they would appear "embellished with dragons, bells, pagods, and mandarins."[28] In the gardens themselves there were, of course, together with the Chinese pagodas, numerous Doric temples, whose presence might suggest that the Chinese sanctuaries were mere variations; but for the eighteenth-century visitor the cultural associations were markedly different. However heathen the earlier worship within the Doric temples may have been, the classical world had long had its pagan associations neutralized by the tradition, reaching back to such Renaissance Neoplatonists as Pico della Mirandola, whereby the gods of Olympus

had been absorbed into the Christian pantheon as personifications of Virtues and Vices or as shadowy prefigurers of events in Christian history. As a result of that sanctioned merger, their presence in Claudean landscapes had suggested no religious conflict with the biblical scene supposedly represented, the same holding true for the gardens modelled upon those canvases. But no such process had occurred for the Chinese, whose imitated temples or houses for philosophical contemplation retained to the full their foreign and pagan flavour, associated with the pleasurable self-indulgence of a civilized world far removed from Christian society. Hence, no doubt, the Prince Regent's acceptance of Repton's suggestion that the Royal Pavilion at Brighton intended for the entertainment of his mistresses and friends should be redesigned in the Chinese style, with the initial plans drawn up by William Porden (*fig. 113*). Eventually, when the work was carried out, transferred to Nash instead of Repton, it managed to combine a mainly Chinese interior with an exotic Indian and Moorish exterior (*fig. 114*). Predictably, Queen Victoria on her accession to the throne regarded it as quite unsuitable as a summer residence for herself— "a strange, odd, Chinese-looking thing both inside and out"—disapprovingly removing most of the furniture and fittings into storage.[29]

As a concomitant to this Chinese fashion (although little evidenced on the continent since it arose in large part from England's imperial interests) was the Indian country house, as at Sezincote in Gloucestershire where Sir Charles Cockerell designed a home for a retired nabob in the style of a Moghul palace. The influence in this instance, one should note, was two-directional, no doubt because of the close inter-communication between the two countries, the facade of the famed eighteenth-century Palace of the Four Winds in Jaipur having obvious affinities with eighteenth-century European Rococo design and a room in the Amber Palace on the outskirts of that city containing decoration strongly reminiscent of Wedgwood artistry. But in England the exotic flavour of Indian architecture and design served to fortify the pagan tendencies, the Indian influence towards the end of the century often blending with the Chinese. That hybrid orientalism was to characterize the Royal Pavilion as it was, after numerous changes in design, eventually constructed, both national models suggesting a relaxation of Christian restraint in favour of a pleasurably pagan and sensuous languor. The association of such indolent self-indulgence with heathen models found, of course, its poetic echo in Coleridge's opium-induced vision of Cathay where, beside a palace devoted to pleasure, there runs a meandering holy river reminiscent of, yet contrasting with, the more restrictive "compassing" or bounding rivers of the biblical Eden:

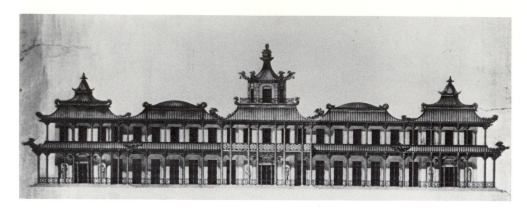

113. WILLIAM PORDEN, design for the Royal Pavilion, Brighton

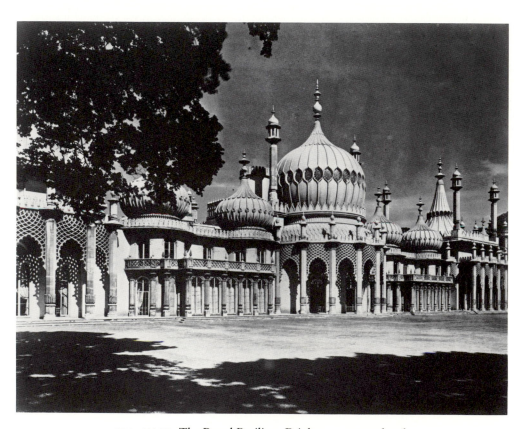

114. NASH, The Royal Pavilion, Brighton, as completed

In Xanadu did Kubla Kahn
A stately pleasure-dome decree;
Where Alph, the sacred river ran
Through caverns measureless to man
 Down to a sunless sea.

It was generally the religious buildings of the remote culture that served as the main models for the Indian derivatives too, the prototype for the exterior of Brighton Pavilion being one of the most sacred buildings of India, the Great Mosque or Jami Masjid of Delhi. Similarly, in the original designs for the Pavilion, Repton had included the construction of a royal aviary in the form of a Hindu temple. And a further pagan model was provided by the uncovering of the Sphinx in Cairo by archeologists accompanying Napoleon's invading troops, reinforced by their accounts of the magnificence of the royal tombs. A country in which death and afterlife were the central themes of artistic expression, yet conceived in a manner totally alien to the Christian conception, added a new dimension to the oriental interest, deepening the vein of allusiveness in the art of the time both to paganism and to the symbols sacred to heathen faiths. It introduced into the furniture and interior decoration of the continental Empire style and soon to England, too, numerous motifs whimsically borrowed from those funerary rites. Thomas Hope imported such decorative forms of animal and other deities from those tombs into the "Egyptian"

115. THOMAS HOPE, chair and settee in the Egyptian style

furniture designed for his own London house in Duchess Street (*fig. 115*); and in the commentary accompanying engravings of those pieces reproduced in his immensely influential *Household Furniture and Interior Decoration* of 1807, he emphasized their cultural source. He remarked that the crouching figures supporting the chair's armrests were copied from an Egyptian idol, that the back panel depicted the winged goddess Isis, and that the vases above were imitations in design of canopic vases preserved from the tombs, such annotation deepening the vein of allusiveness in the art of the time to paganism and to the sacred symbols associated with heathen faiths.[30]

The cultural pluralism introduced by the oriental movement of the eighteenth century has rightly been associated with the rich vein of exoticism in Romantic verse and the encouragement it gave for expressions of emotional intensity such as the sensuous self-surrender in Shelley's *Indian Serenade*:

> O lift me from the grass!
> I die, I faint, I fail!
> Let thy love in kisses rain
> On my lips and eyelids pale . . .

But that indulgence in emotional self-gratification implied a release, we should recall, not only from the self-discipline of reason but also from the restraints of Christian propriety. The transfer of allegiance from traditional theology to a more generalized belief in "natural" morality owed much to Deism, but it was to no small extent through the eighteenth-century cult of chinoiserie, offering a civilized, pagan counter-model to the theocracy dominating western society for so long, that Deism was able to spread its influence, thereby opening the way for freer modes of belief.

<div align="center">(iii)</div>

We may now return to the broader secularization of the natural scene, of which the oriental pagodas placed within the landscaped gardens formed one facet. In the rural paintings of Gainsborough, with their transposing of focus from the heavens traditionally conceived as the divine abode to a more intimate natural scene isolated from the cosmos, may be perceived, in its more developed form, an enhanced empathy

<div align="center">362</div>

with the lot of those dwelling within the humble cottages and engaged in seasonal agricultural tasks; but he, like most innovators, found it difficult to break completely with the past, retaining at first some elements of the tradition he was deserting. His *Rustic Courtship* of 1756 (*fig. 116*), while it reveals a non-Claudean interest in the more humble elements of the country scene with its gnarled tree stump, lowly cottage, and solitary windmill replacing the Arcadian splendours and classical ruins of that earlier tradition, remains condescending in its attitude to the poor, amused at applying the lofty term "courtship" to the awkward overtures of a bucolic lover towards a simpering milkmaid. Rousseau's ennobling of the humble peasant involved indeed a more radical change in outlook than is sometimes imagined, rescinding that humorous contempt for the amours of the illiterate yokel which had persisted uninterrupted from the flirtation of the mud-covered Hodge in *Gammer Gurton's Needle*. John Barrell has argued with considerable acuity that the more sympathetic treatment of the poor in the poetry and painting of the late eighteenth century was dictated less by compassion for their struggle against adversity (since their conditions had not significantly worsened during those latter decades) than by the growing realization that they posed, by their increasing unrest, a potential threat to settled society. The repeated depiction of them as contentedly labouring in the fields formed part therefore of an attempt by their employers (the class which constituted the purchasers of these paintings) to encourage the idea of the nobility of agricultural labour and the need for contentment with one's lot. Yet Barrell himself acknowledges that this Marxist reading, valid as it may be in part, leaves much unexplained, the theory often being contradicted by what he is compelled to call an ambiguity in the paintings; but what does emerge from his study as entirely convincing is the movement it displays away from the model offered by Vergilian pastoral towards that provided by the Georgics, that is, from Arcadian idyll towards a more realistic embedding of such scenes in the local landscape and conditions of contemporary England.[31] Hence the rougher garments of the labourers, and the replacement of the traditional shepherdess at ease beneath the Italian sky by an English milkmaid either engaged in her mundane tasks or at the very least accompanied by the implements of her office.

Although first appearing as a serious theme in the mid-century, such agricultural realism is to be seen as an outgrowth of the well-publicized dispute between Pope and Ambrose Philips over the very nature of pastoral, Pope arguing for the idyllic tradition of classical literature against Philips's preference for a depiction truer to

116. GAINSBOROUGH, *Rustic Courtship*

contemporary life. John Gay had produced in 1714, as a satiric commentary on the discussion, his enormously popular comic pastoral *The Shepherd's Week*, in the Proeme of which he proclaimed with tongue in cheek: "Thou wilt not find my shepherdesses idly piping on oaten reeds, but milking the kine, tying up the sheaves, or if the hogs are astray, driving them to their styes." But as sentiment towards the poorer classes deepened, his burlesque suffered the ironic fate of being taken seriously, readers either, like John Aikin, puzzling whether Gay's work had been written "in jest or earnest" or enjoying it quite unaware of the comic intent.[32] Pope himself, while upholding the classical convention of pastoral as a conscious artefact with shepherds competing in a stylized setting for a literary prize, could in real life respond at times with sympathy to the sufferings of local rustics; but the rejoinder he elicited on one occasion from his friend Lady Mary Wortley Montagu reveals how deeply rooted the traditional scorn for the labouring class still remained. When two peasants engaged to be married were, on taking cover beneath a haystack during a thunderstorm, killed by lightning on a nearby estate, Pope, moved by the event, composed a verse epitaph of which he sent a copy to Lady Mary, inviting her to compose her own version. But for her, such dignifying of the incident constituted merely a lapse in good taste, the peasantry being in her estimation a subject for humour, not for elegy. The poetic version she supplied was therefore anything but a tribute, approximating in its patronizing amusement to the mood of Gainsborough's canvas, and concluding, after a witty minimizing of the event, with a sly rebuke to her friend for his inappropriate choice of subject:

Who knows if 'twas not kindly done?
For had they seen the next Year's sun,
A Beaten Wife and Cuckold Swain
Had jointly curs'd the marriage chain.
Now they are happy in their Doom
For P. has wrote upon their Tomb.[33]

Eventually Gainsborough did break away from that tradition of condescension, and such canvases as his *Carthorses Drinking* or his charming *Market Cart* of 1786 (*fig. 117*) reveal a genuine feeling for the harmonious cycle of rural activity and the warm family relationships of the peasants. It was a feeling of intimacy to be inherited and repeatedly echoed in the paintings both of George Morland and of Constable. As ideas are gradually modified in the process of their transmission from generation to generation, it is rare for an exact moment of metamorphosis to be recorded

117. GAINSBOROUGH, *The Market Cart*

for the historian; but within this desertion of the universal, the classical, and the supposedly more noble in favour of the local and the familiar, that very moment of transition has been interestingly captured. What was to become the paradigm for the growing sympathy with the country labourer, Gray's *Elegy in a Country Churchyard*, contains in its manuscript form the lines:

> Some mute inglorious Tully here may lie,
> Some Caesar guiltless of his country's blood.[34]

Disturbed, it would seem, at his own instinctive recourse to the conventional distancing which had formed part of his upbringing as a poet, on second thoughts he struck through the names of Cicero and Caesar, replacing them with those of their more recent English counterparts Milton and Cromwell, thereby aligning himself with the new tendency to find the inspiration for art in the experience not of some authoritative culture from the past but in that of one's own nation or individual experience. It was a tendency exemplified in Benjamin West's painting of *The Death of General Wolfe* from 1771, which was acknowledged both by the artist and by his contemporaries as an innovation which "broke through the ancient shackles and modernised the art" by clothing the heroic figures in contemporary dress.[35]

Constable is of course the landscape artist who marks most fully the transition exemplified by Gray's manuscript correction. Deeply as he admired the classical landscapes of Lorrain, his own preference was for the familiar scenes of his beloved Suffolk, those redolent with childhood memories such as Willy Loft's cottage, Flatford Mill owned by his father, and the country views within walking distance of his home. Moreover, while they were to be enlivened by the inclusion of some narrative episode—a boy drinking from a stream or the crossing of a brook—they were to be peopled not by invented figures or mythological characters culled from heroic incidents in the past but by real persons who chanced to appear on the scene while the painter was engaged in his task. As his early mentor J. T. Smith instructed him, such casual intruders, if patiently waited for by the artist, "will in all probability accord better with the scene and the time of day than will any invention of your own."[36] The advice may sound trifling, but its centrality to the Romantic configuration becomes apparent when one recalls the almost obsessive concern with which Wordsworth recounts at the head of his poems the specific incident from real life or the chance meeting with odd characters in his own experience which had inspired such poems as *The Old Cumberland Beggar* or his account of the Leech-Gatherer in *Resolution and Independence*. At the head of the latter poem he carefully

records: "Written at Town-end, Grasmere. This old Man I met a few hundred yards from my cottage; and the account of him is taken from his own mouth . . . The image of the hare I then observed on the ridge of the Fell." While the poem was to represent his own imaginative response to the incident, the incident itself must, as he implies, be anchored in actuality for the resultant poem to be valid. So in Constable's major series of canal and river paintings completed between 1819 and 1825, he selected as the focal point for each an episode with narrative associations, such as the closing of the lock gates, or a tow horse leaping over the cattle barrier (the latter a standard procedure on the towpath of the River Stour, which would in all likelihood have entered the area of his canvas while he was painting the scene).

The connection between that aspect of Constable's canvases and Wordsworth's desire to choose as the subject for his poetry incidents and situations drawn from common life is intimately related to the more natural "colouring" adopted for their respective works. The impact created upon the Barbizon school by the exhibition of three of Constable's paintings at the Louvre in 1824, among them *The Haywain* (*fig. 118*), derived principally from what was at once perceived as the dewy freshness or sparkle of his canvases, the flecks of white which had been condemned by English critics as "snow." If Constable had been inspired early in his career by Claude Lorrain, it may be argued that his true contribution was not, as some have maintained, in his absorption of that classical style into his own art but in his subsequent liberation from it. Hence the fierceness of his opposition to the establishment of the National Gallery when the idea of it was first mooted, seeing in the encouragement it would give young artists to imitate famous paintings from the past a stultification of originality which would provide, he believed, the deathblow to English art: "Should there be a National Gallery (which is talked of) there will be an end of art in poor old England, and she will become, in all that relates to painting, as much a nonentity as every other country that has one. The reason is plain; the manufacturers of pictures are then made the criterions of perfection, instead of nature."[37]

His plea for "light—dews—breezes—bloom—and freshness" and for the language of the heart as the only true vehicle for painting, formed part of his larger objection, reminiscent of Blake's hostility to the Rubenists, to the contemporary attempt to imitate the dark hues associated with the Old Masters, and the tendency to forget that the venerable gloom of their paintings was not part of their intent but the result of the numerous layers of varnish laid over the originals during subsequent generations. Whether the story of his holding a Cremona fiddle against the grass to demonstrate the natural colour of verdure is authentic we cannot know

118. CONSTABLE, *The Haywain*

with certainty, but the same sentiment was certainly expressed in the comment he made to Beaumont when the latter began to praise a Gaspar Poussin landscape in his possession: " 'But suppose, Sir George,' replied Constable, 'Gaspar could rise from the grave, do you think he would know his own picture in its present state? or if he did, should we not find it difficult to persuade him that somebody had not smeared tar or cast grease over its surface, and then wiped it imperfectly off?' "[38] In subject matter *The Haywain* avoids the heroic or ennobling, capturing with exquisite delicacy the tranquillity of an everyday country scene, and the bond of companionship between carter, horses, and dog; but it does so in large part by the fidelity to the colours of the scene, the variegated hues of green and brown as trees and field are touched at points by the sun gleaming through gaps in the cloud.

The correspondence between that artistic strategy and Wordsworth's attack upon poetic diction is indeed close; for Wordsworth's objection was not directed against poetic diction in the modern sense of the term—the use of such antiquated forms as *thou hast* or *where'er*, since he himself unembarrassedly used those forms in his own poetry. As his examples and comments demonstrate, it was levelled much more specifically at the contemporary technique of poetic composition deriving from the *Gradus ad Parnassum* prevalent throughout the century, and discussed in an earlier chapter. That "mechanical device of style," as he termed it in the preface to the *Lyrical Ballads*, in contrast to the "flesh and blood" of naturalistic poetry which he elected to compose, had introduced personifications of abstract ideas as well as set patterns of words imagined to be more appropriate for poetry. Fields, in such verse, he points out, are not permitted to produce corn but instead must "all their *wonted tribute* bear." That preference for circumlocutory diction validated by ancient usage, for "phrases and figures of speech which from father to son have long been regarded as the common inheritance of the Poets," he condemned as inhibiting natural description, echoing thereby Constable's dislike for the darkening of Old Masters and his refusal to overlay his own natural scenes with a similar browning effect. The eighteenth-century poet, as Wordsworth realized, had endeavoured to ennoble his art by imitating not the sparkling originality of a Vergil or Juvenal but the received forms learned at second hand in the classroom, the well-worn phrases culled from those ancient poets and too often dulled in their eighteenth-century usage by the varnish of generations.[39]

The sense of immediacy and intimacy conveyed by these new forms of rural poetry and painting manifested an essentially human concern, their narrative episodes drawn, as Wordsworth proclaimed, from scenes of common life. The forma-

tions of low cloud introduced into English art by Gainsborough and Constable contributed to that interest in daily human experience not only as symbols of the transitory and changeable. They functioned, too, as components of a new aesthetic, in which the divine had been imaginatively detached from its Christian framework, in part through the secularizing effects of orientalism, transposed to a terrestrial setting and diffused through the natural scene, leaving the distant celestial regions, the traditional abode of the deity and conventional object of spiritual yearning, no longer paramount for poet or artist.

9

THE CONTEMPLATIVE MODE

A CURIOUS ANOMALY OF ROMANTICISM, ACCEPTABLE IN ITS ILLOGI-cality because of the avowedly anti-rationalist stance of its proponents, is the self-reflexive or circular nature of its poetic inspiration. The poet, while attributing the source of his moral or emotional edification to impulses received from the harmony of Nature or from the spirit of the Supreme Being immanent within it, at the same time lays proprietary claim to such creative stimulus as originating ultimately from within his own imaginative faculties. Within awful and sublime scenes there is, Wordsworth informs us, a transcendent force that men cannot choose but feel when Nature displays it; but that force, we are then told, is itself a mirror image of the inner light possessed by men of distinction:

> The power, which all
> Acknowledge when thus moved, which Nature thus
> To bodily sense exhibits, is the express
> Resemblance of that glorious faculty
> That higher minds bear with them as their own.

The "kindred mutations" such higher minds send abroad may echo or, he adds cautiously, may be compared to echoes of celestial harmony, but in the form in which they manifest themselves they are a product of the human spirit; and where he had begun in this germinal passage by praising the majestic intellect of the divine, feeding upon infinity and brooding over the dark abyss, as the pure source from which man derives his quickening impulses, he concludes climactically with an apostrophe to the ideal poet who has nurtured the independence of his own moral judgments:

> Oh! who is he that hath his whole life long
> Preserved, enlarged, this freedom in himself?
> For this alone is genuine liberty.

As Wendy Steiner has recently reminded us, this self-reflexive element is to be found in many areas of art. Sometimes interest in the sources of creative power may be overtly acknowledged—as in Escher's wry presentation of two hands, each drawing the other, a depiction wittily undercutting the fictive persuasiveness at which so much art aims. At other times, a blurring of the distinction between fact and fantasy becomes, whether consciously employed or not, a positive ingredient for furthering such persuasiveness. Coleridge's poetic theory belongs in the latter category, his ambiguity in identifying the source of poetic inventiveness producing a circular effect whereby the esemplastic imagination, while inspired by the divine *fiat*, nevertheless functions independently, appropriating in its own inventiveness qualities associated with the celestial. It is on the one hand "a repetition in the finite mind of the eternal act of creation in the infinite I AM," while at the same time is seen by him as a human force dissipating, unifying, and recreating by means of its own essential vitality.[1]

It was in this period, as Thomas Weiskel has noted, that the word "vast" became transposed in its attachments. While still applied literally to the physical objects gazed upon, the oceans, deserts, and mountains recurrent in Romantic poetry, the epithet is now increasingly reassigned as a metaphor for the imaginative capabilities of the viewer himself who, absorbing, as it were, the infinitude of the natural scene, expands his own creative faculties to share their limitlessness, or even to transcend them by means of the inexhaustible variety at the disposal of the human mind.[2] Behind that usage lay Kant's theory of the sublime, whereby a person overwhelmed by an object of extreme magnitude defeating human powers of comprehension and thereby producing an initial frustration, substitutes for that sense of impotence an escape route into a pleasurable sense of boundlessness. That pleasurable sense, transmogrified by poet and artist into an image of his own dynamic potential, eventually usurps, or at the very least complements, the natural forces that had inspired it. The adoption of that process in the writings of Shelley is especially notable in view of his rejection of the divine in any traditional Christian sense. Ostensibly he may have subscribed to atheism, yet, as Angela Leighton has perceived, in formulating his theory of poetic inspiration he instinctively resorted to the vocabulary of religious ecstasy and the terminology of the eighteenth-century religious sublime as a means, by transferal, of enlarging the idea of human originality. Intellectually impressed by the epistemology of Locke and Hume and their empirical conception of the human mind as essentially passive, responding to the stimuli of received impressions, he yet could find there no stronghold for his own faith in the creative role of the poet; and it was from the tension resulting from those contrary beliefs that the energy and

urgency of his *Defence of Poetry* arose. While vigorously rejecting Peacock's attack upon contemporary poets, the condemnation of their social irresponsibility in imposing a world of "fairies and hob-goblins" onto the reality perceived by common sense, Shelley was in effect attempting to still his own mental reservations; and, in the process of his argument, was led eventually to concede that poetry "is indeed something divine" and the poets themselves, "the hierophants of an unapprehended inspiration."[3] As so often in this period of weakening faith or of vague Deistic attributions, his discomfort in acknowledging the presence of the divine was frequently mollified by his resorting in poetry to the use of personification, a recognition, as in the opening lines of his *Hymn to Intellectual Beauty*, not of God but of the "awful shadow of some unseen Power" visiting and consecrating human thought. And for him too, that insubstantial activating force of inspiration—"dearer for its mystery"—was gradually absorbed and directionally reversed until it became his own creative impulse, replacing and in a sense outstripping the original external form.

His *Ode to the West Wind* provides a vivid demonstration of that process in action. The speaker commences his paean to the forces of nature in reverential humility, struggling to make his tiny voice heard through the awesome rushing of the wild breath of autumn's being, each stanza concluding with the desperate plea "hear, oh hear!" Like some tiny creature dwarfed by the sublimity and vastness of Nature, meekly he begs to be lifted in his sore need, if only as a leaf or cloud, participating, however passively, in its immense power until suddenly from within that apparent self-abasement, there emerges the first hint of a proud awareness of essential identity, not only in shared suffering but in character too:

> A heavy weight of hours has chained and bowed
> One too like thee: tameless, and swift, and proud.

From here the process of his growth in stature proceeds apace, culminating only a few lines later in an extraordinary reversal of roles, the vast wind now commanded to be absorbed into the speaker's own being:

> Be thou, Spirit fierce,
> My spirit! Be thou me, impetuous one!

Its function now is subordinate, serving to disseminate the poet's revitalizing thoughts over the universe and, by the incantation of *his* poetry, to awaken mankind to innovative ideas:

Drive my dead thoughts over the universe
Like withered leaves to quicken a new birth!
And, by the incantation of this verse,

Scatter, as from an unextinguished hearth
Ashes and sparks, my words among mankind![4]

In this connection, Paul de Man pointed out some years ago how the Romantic poet, depressed by his own sense of mutability, devises strategies to acquire or temporarily to borrow the immortality of nature.[5] But having preempted that quality, one should add, the poet arrogates to himself together with the sense of eternity, its numinous powers of generation and productivity which at times are seen as excelling in their human context those of the natural forces themselves. The process results, then, in a circular movement, with the Romantic ostensibly drawing strength from nature yet eventually sanctifying as the ultimate source his own imaginative energies.

M. H. Abrams's perception of the mode as constituting in large part a secularization of religious experience has revealed how many of its literary configurations and thought processes were in fact transpositions of the archetypal patterns of scriptural tradition into contemporary equivalents, an adaptation of concepts revered through past ages into vehicles for their own aesthetic innovations. The poets' identification with the prophetic tradition and their messianic yearning for an Apocalypse had, perhaps, been self-evident, if not understood in the more detailed form he provides; but other aspects of that secularization of religious forms had not been previously recognized—how far, for example, their sympathy with the poor of this earth, the peasants and waggoners, the starving, the criminal, and the social outcast, reveals in the biblical overtones of language and imagery an extrapolation of the Christian religion of humility, of dignifying the meek and the lowly who will inherit the kingdom of heaven.[6] That insight may assist us in responding more sensitively to the biblical reverberations of such poetry. The description in *Michael* of the shepherd's family as a proverb for endless industry in the vale clearly conforms in social or in Rousseauesque terms to such cottage paintings as George Morland's *Morning: Higglers Preparing for Market*; but the mention of the "mess of pottage" set out on the supper board or the "covenant" of unhewn stones which the shepherd erects for his son Luke to remind him in the city of his moral duties introduces an added dimension, a set of inherited moral traditions drawing their strength from scriptural associations:

> hither turn thy thoughts,
> And God will strengthen thee: amid all fear
> And all temptation, Luke, I pray that thou
> May'st bear in mind the life thy Fathers lived,
> Who, being innocent, did for that cause
> Bestir them in good deeds.[7]

The primary message of the poem is by no means biblical, a contrast, with markedly contemporary relevance, between the corrupting influence of the city and the purity of natural, country life; but the framework for its presentation invokes the moral imperatives and ethical values of the scriptural tradition.

With that principle in mind, I should like here to re-examine an aspect of Romantic indebtedness, shared by both poetry and painting, which has received only cursory examination in the past—the transposition into contemporary terms of the religious meditative tradition and its connection with that circular conception of poetic inspiration discussed above. The significance of the spiritual exercises for western literature at large was first recognized only a few decades ago, when Louis L. Martz focussed attention upon its intimate relationship to the metaphysical poetry of the seventeenth century. The subsequent identification by Norman Grabo and Barbara Lewalski of a parallel Protestant meditative tradition, not merely imitating the continental forms re-instituted by Ignatius Loyola but developing versions of it appropriate to a creed less supportive of martyrology, provided a firm historical basis for tracing its influence upon English literature of that period.[8] But the possibility of its presence in later generations has never been seriously examined, on the assumption that the eighteenth-century Enlightenment, with its trust in daylight and reason, left little encouragement for withdrawal into a darkened room in order to conjure up in the mind scenes of saintly bliss or agony as incentives to renewal of personal faith. If, however, as is now apparent from Abrams's work, traditional patterns of Christian belief which had been discouraged or intellectually suppressed during that period were frequently revived within the Romantic era in a secular form, providing familiar frameworks for new emotional experiences, the persistence of the meditative tradition as an archetypal model for that later era should no longer appear improbable.

After the enormous success on the continent achieved by Loyola's *Spiritual Exercises*, his prescriptions for temporary retreat from worldly affairs in order to meditate on holy scenes, the Protestant cultivation of such exercises in England was soon

to follow. In a work which was to prove seminal in England, *The Arte of Meditation* (1606), Joseph Hall, pointedly ignoring the contemporary Catholic versions which had clearly prompted his interest, blandly claimed that he had learned of the tradition from the writings of a medieval monk, conveniently anonymous—"I would his humility had not made him niggardly of his name." Urging his fellow Protestants to adopt that ancient Christian method of religious self-improvement, he emphasized the need for regular withdrawal from the daily business of the world: "Solitariness of place is fittest for meditation. Retire thyself from others if thou wouldest talk profitably with thyself." And although he still recommended the envisioning of scenes of Christ and other saints which figured so prominently in the Catholic versions, he suggested (with some significance for the later Romantic variant) that scenes from the workings of nature could also be the subject of contemplation.[9] His lead was soon followed by others. Robert Dingley's *The Spiritual Taste described; and a glimpse of Christ discovered* from 1649 offers striking evidence of the centrality of the meditative practice in the religious life of that time, and the image it uses towards the close of the passage suggests how easily the process could be transferred in later years to a Romantic setting:

> What shall I say, for meditation is the very life of our life . . . It is the food of our soules, the fuell of our zeale, the spur of our devotion; The soule that can meditate on God, is never lesse alone, than when alone; for his fellowship is then with the Father and his son Jesus Christ. It delights to walke in these groves, and fold the armes in these shadie bowers of solitary but divine meditation, where it heares the Nightingale of good conscience warble melodiously.[10]

Upon the continent, the visual emphasis within that tradition, as we examined in an earlier volume, had left a deep impression upon painting of the late sixteenth and seventeenth centuries. A frequent concomitant of those scenes—depicting the electrifying moment in which a meditator witnesses in his mind's eye the bliss or torment of a martyrdom, of an ascension, or of some sacred portent—was the *repoussoir* or Sprecher figure, who represented in a sense a projection of the artist himself, acting as an intermediary between the viewer and the envisioned scene (cf. *figs. 19 and 23*). As part of the Counter-Reformation's desire to arouse religious fervour among the people, and its employment of the arts to stimulate ecstatic or agonized empathy with the saints of Christian history, the Sprecher was depicted at the moment of his own emotional involvement, in the Tintoretto painting writhing

in tormented passion as he pulls aside the curtain to reveal the miraculous event or, as in the El Greco canvas, gesturing in stunned homage towards it. As an intermediary, the Sprecher appears most often in such paintings in a posture otherwise extremely rare in the history of art. He is usually depicted from behind, his face often not revealed to us. The purpose of that widely adopted posture was clearly to encourage viewer involvement; chorically the Sprecher invites us to step forward, to merge into him imaginatively as it were, and thereby to take his place as the witness of the vision, drawn into the meditative re-enactment itself.

In the paintings of that most representatively Romantic of European painters, Caspar David Friedrich, the adoption of that pose is so recurrent as to become a hallmark of his style. The viewing of a scene from behind the depicted persona (the *Rückenfigur*) typifies such canvases as his *Moonrise over the Sea*, *The Sailing Boat*, *Sisters Gazing over the Harbour*, and numerous others. The eponymic figure in his *Traveller Gazing over the Mists* (*fig. 119*) from 1818 stands, characteristically, with his back towards us, brooding over the magnificence of the mist-covered mountain peaks and, in the tradition of that earlier mode, by his positioning making it well-nigh impossible to resist the pull towards viewer identification and a vicarious sharing of his mood of rapt cogitation. His *Man and Woman Watching the Moon* from 1819 (*fig. 120*)—a prototype for Durand's *Kindred Spirits* soon to reflect that concern across the seas—similarly initiates us into the spiritual communion of two sensitive souls awed by the solemnity of the natural scene.

The filaments connecting this new type of art with the meditative tradition reveal that this link is not merely in the technicalities of presentation. Friedrich, a devout Lutheran whose mystical faith in divine immanence permeates his work, adopted principles for his own painting clearly evocative of the Loyolan *Spiritual Exercises*. In that treatise as in those of his followers, the meditator had been enjoined to darken the room in which he conjured up his visions in order to concentrate upon the imaginary scene being revitalized in his mind. El Greco, we learn from a contemporary, kept the shutters of his studio closed even at midday in order that he might see more clearly with his inner eye. And Friedrich, too, as his friend Carl Gustav Carus recorded (the comment corroborated by an extant self-portrait showing the artist at work in his studio), customarily painted with the lower half of the window shuttered at eye-level to prevent any outside view from interfering with his spiritual vision. His aim, Friedrich maintained, was to reproduce the scene mentally conjured up in the darkness, not setting brush to canvas until the image of his proposed work "stood life-like before his soul." The advice he proffered to

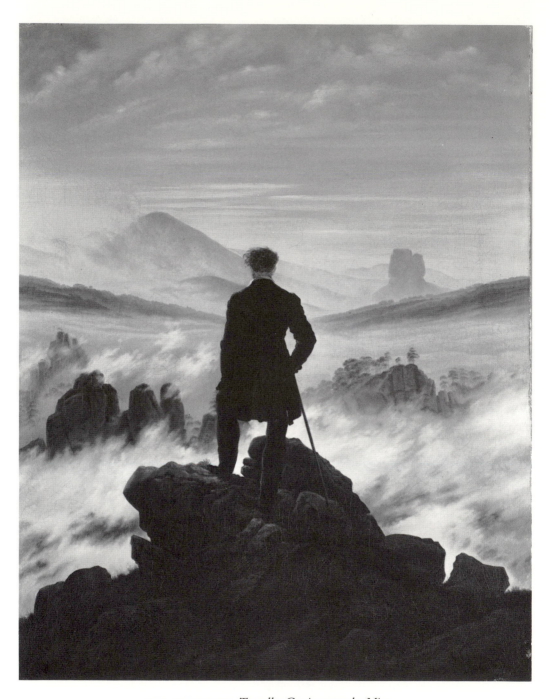

119. FRIEDRICH, *Traveller Gazing over the Mists*

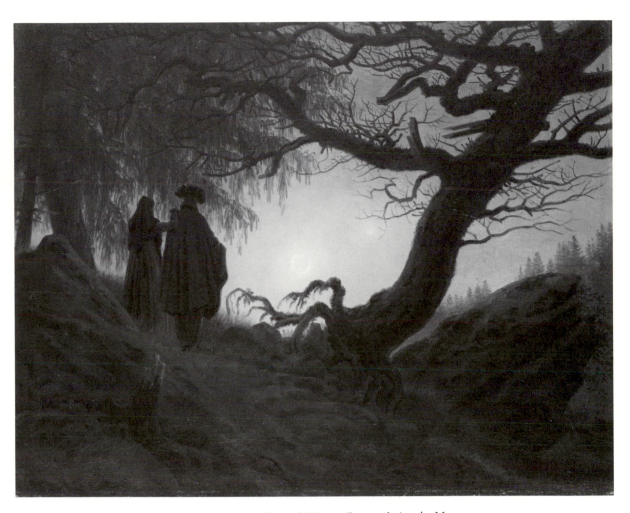

120. FRIEDRICH, *Man and Woman Contemplating the Moon*

aspiring artists confirms the degree to which his own practice was patterned upon the meditative tradition, the very wording echoing the instructions of the religious manual: "Close your eye, so that your picture will first appear before your mind's eye. Then bring to the light of day what you first saw in the inner darkness."[11]

Yet if this innovative style derives from the Christian exercises, its transposition to an aesthetic context introduced notable changes. In the paintings of the religious mannerists cited above, there can be no question concerning the primacy of interest. It is the miraculous scene of Christian martyrdom or bliss which functions as the focal area of the painting, with the Sprecher as only a minor adjunct, directing attention towards it and at the same time helping to draw the viewer away from the tactile reality in which he stands into the metaphysical vision beyond. In Friedrich's works the order of precedence is significantly reversed. Just as, in the circular process discussed above, the Romantic poet tended to dislodge the divine creative force and himself become the dominant figure, so here it is less the scene eliciting the mood that takes prominence, a scene often only dimly visible beyond the figure, than the emotional experience of the Sprecher himself, the Romantic persona projected into the canvas, soliciting our respect for the sensitivity and profundity of contemplation which the natural scene has inspired in *him*. That poetic dislodgement of the divine is eloquently conveyed in Friedrich's *Traveller Gazing over the Mists*, where the Sprecher figure is located not among the mountain crags but above them, in a pose evocative of the Supreme Creator gazing down upon his work and pronouncing that it is good. It is now the artist's or poet's own torment or ecstasy which is to be the primary focus and, as in the meditation, vicariously experienced by viewer or reader. Moreover, the momentous event depicted frequently obtains its interest solely from the impact it had had upon the artistic imagination. A scene in nature which most men would have passed by without remarking becomes holy not in itself, but because of its significance in the poet's spiritual progression, for having awakened in him thoughts that do lie too deep for tears. And having once achieved that status, it partakes of the second major function of the religious meditative tradition. It is recorded in order repeatedly to be conjured up afresh in later days, both on the poet's inward eye and by extension on the reader's too, as a means of recovering the earlier inspirational mood:

> For oft, when on my couch I lie
> In vacant or in pensive mood,
> They flash upon that inward eye
> Which is the bliss of solitude . . .

In portraiture of this period, the contemplative mood resulting from such withdrawal from reality was now to become the pose professionally associated with artist or poet. In the earlier tradition, as in the series of paintings provided for the members of the Kit-Kat Club or in the later vogue instituted by Reynolds and Gainsborough, the purpose, in conformity with the wishes of the sitter, had been essentially to dignify by an indication of professional calling. One recalls the painting of Garrick flourishing a quill or Reynolds's somewhat pretentious portrait of himself in doctoral robes standing before a statue of Michelangelo. But the new generation of writers and artists preferred to be recorded for posterity in contemplation, brooding with soulfulness and sensitivity over matters of great moment. The pose now thought appropriate is the "pensive mood" or, as Wordsworth describes it elsewhere, the disposition of a "meditative, oft a suffering man." Haydon depicts him sunk in profound thought, Severn's miniature of Keats displays the poet ruminating chin on hand, and in Friedrich's self-portrait of 1810 he seems with solemn gaze to be contemplating some mysterious world beyond the viewer.[12]

Keats's *Ode to a Nightingale* is characteristic of that aspect in its recording of an essentially meditational withdrawal from the haptic world of actuality, with flowers at his feet and white hawthorn and eglantine about him, into the realm of the far more valid imagined or envisioned experience, with the final stanzas marking a reluctant return to reality. The speaker in his poem muses in solitude and in darkness, wearied by the world, and longing like his meditative forebears for redemptive death or for the ecstatic vision associated with the act of dying:

> Darkling I listen; and for many a time
> I have been half in love with easeful Death,
> Call'd him soft names in many a mused rhyme,
> To take into the air my quiet breath;
> Now more than ever seems it rich to die,
> To cease upon the midnight with no pain,
> While thou art pouring forth thy soul abroad
> In such an ecstasy!

The religious meditator, on his reluctant return from the visionary world to his mundane surroundings, had been instructed to ask himself what immediate meaning the imagined scene of martyrdom bore for him and, while it was still vividly before him in his mind's eye, how far he was fulfilling its teachings in his own life. Here, too, the closing stanzas of such poems, tolling the speaker back to his sole self, frequently focus upon the implications of the journey into the waking dream,

the lessons to be learnt from that ecstasy for one now "forlorn" in the world of reality.

In Coleridge's *Rime of the Ancient Mariner* there is that same structured movement from reality into the imagined world and back, with the dream-like vision conforming even more closely in theme to those of the earlier practice. For the inner narrative, the Mariner's reminiscence of his purgational experience, is a symbolic re-enactment of the "agony" of the Crucifixion itself, re-visualized from the viewpoint of Christ's murderer, with the intensity of his dreadful guilt experienced by the meditator as if at first hand. In this, too, it relied on earlier models. The spiritual exercises had been intended above all as didactic programmes, encouraging an emotional re-living of a Christian conversion or martyrdom as a means of strengthening the meditator's faith; and one figure with whom the meditator was to associate himself as a warning against backsliding was Christ's murderer. As John Donne had argued in the most vividly realized of his meditative poems, "Spit in my face you Jews . . . ," beginning with an imaginative identification with the figure of Christ on the road to Calvary but at once transferring reluctantly to the Judas figure as being more appropriate to the speaker's self, his own grave impiety in moments of weakened faith was cause for greater anguish even than the sin of the original murderers. As he saw it,

> They kill'd once an inglorious man, but I
> Crucifie him daily, being now glorified.

It is that same theme of the later Christian failing to heed the lesson of selfless love and thereby re-crucifying Christ which forms the motif of the Mariner's own tortured narration:

> "God save thee, ancient Mariner!
> From the fiends, that plague thee thus!—
> Why look'st thou so?"—With my crossbow
> I shot the ALBATROSS.

The function of the Sprecher figure in this scene is clearly discharged by the Wedding Guest, serving once again as a means of seducing an initially resistant viewer into personal participation in the emotionally charged scene. Hypnotically compelled like the Guest to share the agony of religious guilt and conversion, and emerging deeply shaken by the metaphysical experience "like one that hath been stunned, / And is of sense forlorn," the reader, too, is prompted to awaken from his brooding upon the implications of that vision a sadder but a wiser man.

Coleridge was, of course, well-versed in seventeenth-century religious thought, as Roberta Brinkley's collection of his numerous writings on that subject has confirmed. Moreover, his own conception of the poetic imagination was based in part upon theological precepts, a parallel process of withdrawal from the physical into the contemplative. Mystic philosophy, with which he allied himself as a poet, arises initially, he remarks, from a setting aside of the intrusive images of sense. Room is then left for the contemplation of ideas or spiritual truths that present themselves "like the Stars, in the silent Night of the Senses . . . To these solemn Sabbaths of Contemplation we must add the work-days of Meditation" whereby history and the facts of nature are transmuted into symbolic forms.[13]

The indebtedness of Romanticism to the meditative tradition is no less apparent in its emphasis upon recall, not only in the sense mentioned above, the employment of the momentous scene as a storehouse for future refreshening of spiritual experience, but in the broader sense of its retrospective orientation, its nostalgic attaching to the past of a greater significance than can be achieved in the tawdry and wearisome present. Recurrent in the structural as well as thematic patterns of Romantic poetry is the desire to regenerate some past moment of personal joy, grief, or fancy which, like the holy scene of the Loyolan tradition, may lead the meditator to reassess his place in the universe and the responsibilities that have devolved upon him. The sanctity of the relived scenes from that earlier tradition is preserved in this later form, the hushed sense of a holiness not to be infringed:

> Behold her, single in the field,
> Yon solitary Highland Lass!
> Reaping and singing by herself;
> Stop here or gently pass!

Before examining more closely the secularized re-embodiment in Romantic poetry of that religious tradition, we should note the way in which a corresponding system of recall became equally prominent in Constable's artistic practice. The custom of executing preparatory sketches had of course long been established before his arrival, but for previous artists its purpose had been experimental, an opportunity for testing out figural poses, for solving possible compositional problems, or for planning special effects. In Constable's usage there was an essentially new motivation, a conviction that the scene to be depicted must first be experienced with intense emotional immediacy as (to use Wordsworth's terminology) a series of impulses felt in the blood and along the heart, and only later to be recollected, recaptured, and reproduced during the longer process of completing the final work. He

developed, therefore, the technique of sketching in the open air with such concentration that he seemed entranced or hypnotized as he responded to the freshness of the dew upon the grass or a gleam of sunlight upon a cornfield, taking the sketch back to the studio as an *aide-mémoire* for the final, more soberly worked version which should formalize the work while still retaining or recapturing the original fervency of response.[14] It has been rightly noted that this innovative process was a close counterpart to the new literary ideal of poetry as "emotion recollected in tranquillity";[15] but the emphasis has been placed upon the requirement of emotion rather than the practice of recall. Within the context of the present study, it is the principle of making the artistic work a conscious recollection of past experience that is most striking, the immediacy of response being deliberately displaced into the past with the act of creativity reserved for the process of evocation rather than direct transcription. Ironically, with the hindsight afforded by Impressionist painting which it later influenced, Constable's brilliant sketch for *The Haywain* in the Victoria and Albert Museum is today often preferred to the completed canvas; but in its day, we should note, it was not the sketch but the formal completed version that so delighted French artists such as Gericault and Delacroix on its exhibition in Paris. Delacroix, for all his admiration of the freshness of colour and immediacy in that painting and while admitting the vitality of improvised sketches, did not, as George Mras has pointed out, himself advocate, as did the later Impressionists, the exhibition of such sketches as final works.[16] Like Constable himself, he used the intensity and vividness of his preliminary sketches as the basis for *recapturing* rather than formally recording the artist's response to a scene, that process of emotional recollection constituting in both the poetry and the painting of the Romantic era a prescription for artistic creativity.

The tradition of returning imaginatively to spiritually momentous scenes from one's own past was being revived and similarly re-adapted in an entirely different contemporary context on the English scene. Within the Evangelical movement, too, as part of the new focus upon subjective experience, the martyr or saint who had previously served as the source of inspiration, occupying centre stage in the vision, began to be displaced by the narrator's projection of himself into that role. A scene particularly favoured for meditative self-renewal in the seventeenth century had been the Conversion of Paul on the way to Damascus, the scene in which—in a manner so inviting to the practiser of spiritual exercises—the scoffing Saul is blinded by the dazzling light of revelation, and the previous validity of the visible world replaced by the authenticity of the divine. In the splendid version by Caravaggio (*fig. 121*), the central figure performs the dual function of Sprecher and

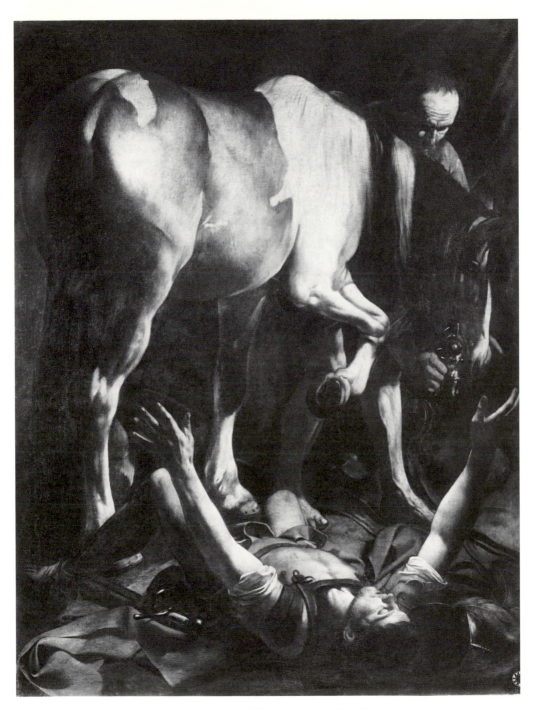

121. CARAVAGGIO, *The Conversion of St. Paul*

saint. Viewed once again from the rear, he is seen flung backwards by the force of the vision almost into the arms of the spectator, forcibly inviting the empathic "conversion" of the viewer himself as the latter is compelled mentally to invert his stance and regard the scene from that prostrate position below. In Evangelical, particularly Methodist confessions of the eighteenth century, the Christian convert is encouraged to recount the moment of his own miraculous salvation by grace, the wondrous event of his own inner transfiguration being repeatedly revisualized both for his own spiritual strengthening and for the edification of others. It is a recurrent pattern within the confessional biographies of the day as well as in the oral re-enactments fervently related to those who had yet to experience such revelation. Thus a sailor, previously impervious to spiritual concerns, is described in a tract printed in 1812 as relating how, during a shipwreck, "trembling with horror upon the verge both of the watery and the fiery gulph . . . the ghosts of his past sins stalked before him in ghastly forms," and he saw the divine light. A prototype for such confessional narrations was the conversion of the future Methodist leader George Whitefield, an incident often recounted by him and frequently quoted by others. His reminiscence included, as so often in these accounts, a nostalgic fondness for the location, the place, now sacred to him, in which he first discovered the possibility of a vital union with God; and he records how he loved to revisit "the spot where Jesus Christ first revealed himself to me and gave me new birth."[17]

For Wordsworth too, the recalling of such regenerative moments in his own spiritual development is often prompted, as at Tintern Abbey, by his return to the locality associated with them. The "spots of time," his vividly re-envisioned evocations of the moments of inspiration, insight, or bliss which marked the stages in his own moral progression, are to be seen within that same cultural configuration. The "rapturous moment" recorded in book nine of the *Excursion*, an experience which, he informs us, was to remain thereafter indelibly fixed in his mind, follows the structural patterning of the religious meditation. The poet's self appears within the re-envisioned scene in two forms. He is present in person as the minor Sprecher figure of the older tradition, an involved witness rather than the primary experiencer of the bliss; but he has also projected himself into the scene as the Priest, the central figure of poetic "sainthood" awed by the divine splendour of a sunset, the magnificence of which elevates his soul and purges it of earthly tarnish in that miraculous, revelatory experience. In the earlier tradition too, the Sprecher, as an extrapolation of the meditator, had frequently appeared more than once in a painting. In El Greco's *Burial of Count Orgaz* he is both the Franciscan friar mourning at the left

388

and also his counterpart on the right, the priest raising his eyes heavenward to the scene above, a scene invisible to others where the Count's soul kneels in penance before the divine throne. In Wordsworth's poem, the Priest and his awed companions, the latter representing both poet and reader in that recalled scene, gaze "in silence hushed" until, with eyes still intent upon the refulgent spectacle, in ecstasy or "holy transport" the Priest expresses to the Eternal Spirit his gratitude for the spiritual purgation the scene has afforded:

> accept the thanks
> Which we, thy humble Creatures, here convened,
> Presume to offer; we, who—from the breast
> Of the frail earth, permitted to behold
> The faint reflections only of thy face—
> Are yet exalted, and in soul adore!
> Such as they are who in thy presence stand
> Unsullied, incorruptible, and drink
> Imperishable majesty streamed forth
> From thy empyreal throne, the elect of earth
> Shall be—divested at the appointed hour
> Of all dishonour, cleansed from mortal stain.[18]

Such acts of recall are, of course, more than mere indulgence in nostalgia. The process of savouring the remembered scene, of reliving it imaginatively offers, as here, vicarious purgation for both meditator and reader, a strengthening of faith amid the distractions and debilitations of daily life. Wordsworth's customary choice of a priest or hermit as his meditational *Doppelgänger* was no isolated phenomenon. Friedrich, who also saw himself as the votary of art withdrawn from the hurly-burly of daily life, would often don a monk's garb for his lone walks along the shore, and depicted himself in that role in his *Monk on the Sea-shore* from 1809.[19] The identification of both painter and poet with the religious votary reflected the dual aspects of their heritage, the religious ambience from which the revived meditative process was derived and the withdrawal from human society regarded as so necessary for its implementation.

The Romantic fascination with childhood experience forms part of this cultural indebtedness, but also reflects, as do the more general affinities, a complex shift in sensibility. In an earlier chapter it was noted that Locke's principle of the *tabula rasa*, the theory that the mind of a newborn infant was an intellectual blank at birth, a

clean slate upon which all information must be recorded *ab initio*, had, on its original submission to the public, not been interpreted in a manner likely to arouse reverence for the newborn. In an age of intellectualism, the assumption that the infant's mind was merely an empty receptacle at birth implied that for a child attainment of knowledge was a gradual process taking many years before maturity of judgment was to be achieved and with it the discriminatory faculty for ordering that knowledge. Hence the contemporary depictions in eighteenth-century painting of the young as shy and sweetly inexperienced (cf. *fig. 85*), remote from the confidence and self-assurance to be acquired only later in life.

That condescending attitude was to undergo a process of bifurcation in the later decades of the century. On the one hand, a new harshness made its appearance, a Calvinist sternness which has often been associated with the moral oppressiveness of Victoria's reign but which in fact existed well before her accession to the throne. Theologically, the dogma that the child was born into the world bearing the burden of original sin and requiring severe discipline in order to eradicate its evil potential was not new; but the rigour with which it was reinforced in Evangelical circles and was fortified by revived Calvinist tendencies produced chilling results. Hannah More, for example, insisted in her *Strictures on the Modern System of Female Education* in 1799 that children were of "a corrupt nature and evil dispositions" in need of the sternest discipline; and the extent to which that view was enforced may be demonstrated by the standard instructions given to Sunday school teachers at Caistor in Lincolnshire at about the same time, that they were, in handling their charges, to: "tame the ferocity of their unsubdued passions—to repress the excessive rudeness of their manners—to chasten the disgusting and demoralizing obscenity of their language—to subdue the stubborn rebellion of their wills."[20]

On the other hand, there arose in tandem, as in the poetry of Blake and Wordsworth, a linking of the infant not to evils brought with it from the other world but (with echoes of Platonic *anamnesis*) to a residual knowledge of the divine. Here, too, there was a shadowy allusiveness to the Fall, at least in the corollary that man, as he grows away from perfection and is corrupted by the world, is seen as having lost the spontaneity of instinctual perceptiveness.[21] But with regard to the infant itself, the response was entirely positive, a reverence for the freshness, spontaneity, and vitality of the child, still in contact with the heavenly vision. In this belief that it came from the celestial "trailing clouds of glory" can be perceived a further link with the meditative tradition and the prescription it offered for the spiritual renewal of the individual. Within that earlier mode such images of child-

hood purity had lain ready to hand for both poet and painter in the innocence of the *putti* (with their link to the divine cherubs of the Bible) and of the infant Jesus—wise despite their years in their belonging to the celestial world, their portrayal so central a part of religious meditative exercises, as in such paintings as Murillo's vision of the *Immaculate Conception* (cf. *fig. 22*). Such indebtedness served as the substratum for Philip Otto Runge's *Morning* of 1803 (*fig. 122*) with its babes symbolically forming part of the natural flora and imbuing the scene with joy, as well as his *Child in the Meadow* of 1809 (*fig. 123*), with the infant lying naked upon the earth and gazing towards the heavens in confidence and love, its arms outstretched as though to receive the warm effulgence from its recent abode.

Constable would appear to lie outside the tradition in that respect. He was fond of children, yet displayed little interest in depicting them as individuals, although frequently introducing them as small figures within his landscapes.[22] Nevertheless, in a different way he may be seen as participating in that contemporary revalidation of infancy, interpreting, like Wordsworth, his own infancy as a primary source of his inspiration. The freshness of vision that typified his canvases derived, as he fully acknowledged, from his habit of looking back to the artistic perceptiveness of his own earliest years. He attributed the source of his paintings to pictorial images recalled from his childhood, the impressions of his father's mills at Flatford and Dedham as well as of other local scenes from around the River Stour as he had mentally conceived them during his earliest years, long before he had learnt to draw. "I had often thought of pictures of them before I had ever touched a pencil," he remarked, and the great series of "six-footer" canvases which eventually won him his reputation were, he maintained, recollections of those unsullied responses. Wordsworth's claim that the child is father to the man seems to have held an especial appeal for him—they are the only lines of that poet which we know Constable to have copied out for his own use; and he repeatedly acknowledged in his own development both the formative influence of his childhood experience and his need to recall those early emotional responses which had left him loving "every stile and stump, every lane in the village, so deep rooted are early impressions."[23]

Whatever their conscious purpose may have been in acknowledging this source, it is clear that there is for both artist and poet a degree of oversimplification in this attribution. Constable may have drawn to some extent upon his infant picturing of the Suffolk scenes, but his process of maturation as an artist, evidenced by his later discovery of Claude as a model and his increasing mastery of painting techniques, including the reproduction of cloud formations, reveals that he could not, as he

122. RUNGE, *Morning*, from the *Times of Day*

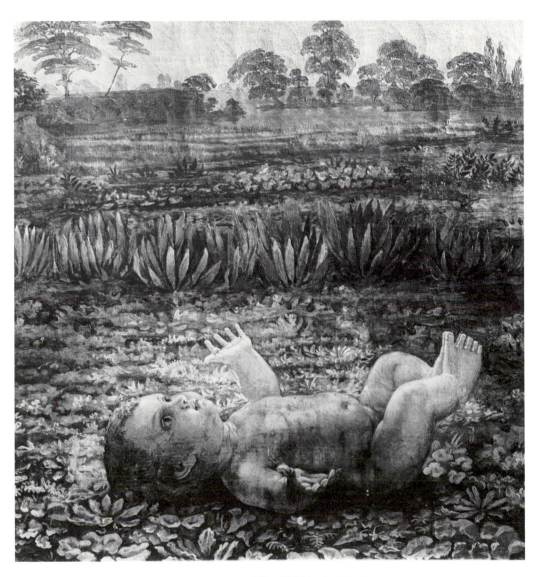

123. RUNGE, *The Child in the Meadow*

maintained, have merely been recording those early impressions. The same holds true for Wordsworth, whose major composition *The Prelude* belies his parallel claim; for, whatever superior insights that poem may accord to childhood perception, it is avowedly an account of the *growth* of a poet's mind, an examination, in fact, of "how far Nature and Education had qualified him for such an employment." One suspects that behind such repeated claims of childhood inspiration there must lie some deeper psychological impulse.

For the late-eighteenth-century Calvinist, perhaps most vividly represented in the Wesleyan movement, the revived doctrine of original sin formed an integral part of their emphasis upon the Day of Judgment, namely the punishments awaiting the sinner or the rewards to be proffered to the faithful in the world to come. The hymns of the Methodist movement were saturated with warnings of hell-fire or, conversely, with comforting pictures of the virtuous being welcomed into the bosom of Abraham. Since the appearance of the works of Max Weber and R. H. Tawney, we have become acutely aware of the social implications of such focussing upon the afterlife, the tendency of Evangelical leaders to inculcate in the minds of their lower-class members an industrious work discipline as well as a meek submission to the dictates of their employers, thereby strengthening the hand of the manufacturers in their exploitation of the poor. One of Isaac Watts's hymns or *Moral Songs* contains a stanza particularly unsavoury to modern ears:

> What though I be low and mean
> I'll engage the rich to love me,
> While I'm modest, neat and clean,
> And submit when they reprove me.[24]

The reward for such humility in this vale of tears was, they were assured, stored up for them in the world to come.

There was, however, a class discrepancy in this renewal of faith. Among the intellectuals, even those of religious commitment, the afterlife had ceased to be of major concern, the new source of inspiration being, even for such devout artists as Friedrich, the divine immanence in Nature, the ability to respond here on earth to the mystery of creation and of the Supreme Being present within it. Hence, as we have seen, the symbolic function of the clouds introduced into painting, representing the comparative irrelevance of the cosmic and celestial for the new dispensation. The revived interest in the doctrine of *anamnesis* may be seen as part of that intellectual movement; for by turning away from external, aetherial sources of inspiration

in favour of the subjective inner self, Romanticism produced a reversal of the tradi-
tional Christian yearning for the afterlife, a desire for contact with the divine no
longer as a future consummation awaiting the soul beyond the grave but as an
experience to be found instead within one's own being, to be sensed not at the end
of life but retrospectively at infancy, dimly perceived by evoking the period of one's
own life closest to that entrance into mortality, the period which retained a residual
memory of celestial bliss. In place of the tormented striving for eternity beyond
death, the moment when the subtle knot joining body to soul was to be untied, such
as had animated the mannerist poet and painter in their meditative visions and in
which the human skull so often served as the symbol,[25] their Romantic counterpart
celebrated immortality in a reverse direction, experiencing his intimations of it in
memories of a childhood only recently removed from the celestial realm, a period
still bathed in visionary gleam, when

> meadow, grove, and stream,
> The earth, and every common sight,
> To me did seem
> Apparelled in celestial light,
> The glory and the freshness of a dream.

The spiritual sustenance was derived, then, from his own revelatory experience of
ecstastic union in the past rather than from the agonies or bliss accorded to the saints
of Christian history. But the overall pattern of meditative practice was preserved as
he sought comfort from a nostalgic re-visioning of those scenes at times of aliena-
tion or despair within the weariness of this world and imaginatively re-created those
scenes in poetry, as did Friedrich in painting, in order that they should serve not
only as encouragement for himself but as moral inspiration for others.

All art, as Ernst Gombrich has so wisely shown, is only in a limited sense mimetic.
Suspension of disbelief, whether willing or unwilling, is never complete. The artis-
tic work, however persuasive, remains ultimately a metaphor, with both reader and
viewer retaining at all times a knowledge, however subdued, that the work is con-
trived. In that sense, metaphor extends beyond the locally illustrative to embrace
the artistic or literary work as a whole, becoming, as Murray Krieger expresses it,
co-extensive with its own body.[26] The response to the artefact is thus seen as more

complex, consisting of an affirmation of the proffered illusion at one level with a simultaneous and parallel acknowledgment, never fully surrendered, that it is indeed counterfeit.

It is in that context that the Romantic recourse to the meditative tradition should be considered; for by the poet's adoption of an established religious process, immediately recognizable to a contemporary reader if less apparent to his twentieth-century counterpart, that recourse provided an associative corroboration of the truths that were being fictively enunciated. For the seventeenth-century Christian meditator, the visions of martyrdom or of solemn moments from Christian history conjured up in the darkened room had been far from illusory or "metaphorical" in the sense that Krieger suggests but, on the contrary, interpreted as glimpses of eternal verities more real than anything within his own transitory life. They resembled those momentous scenes from the life of Christ performed in the medieval mystery cycles, where ultimate authenticity passed from reality to the stage, the latter becoming a holy area partaking of eternity with the mortal actor trembling at his own temerity in daring to play the role of the divine.[27] The very purpose of the spiritual exercises in their original form had been similarly to encourage the worshipper to withdraw from the flimsiness of the mundane and temporal in order to participate imaginatively in the transcendentally true and eternal.

For the Romantic poet in an age of industrialism and mercantile expansion, such conviction of the final efficacy of the inner experience could no longer be assumed. In the task of elevating the poet's function into a sacred calling, Wordsworth instinctively drew upon the meditative tradition as a means of lending his own verse a vicarious authenticity. His re-envisioning of past events in his own intellectual progression as a poet, the moments of inspiration which had provided insight into the divine impulses in creation, bestowed, by that association, a sanctity upon them which to some extent countered the fictive quality of their poetic presentation, endowing them with an aura of transcendent truth. The effect is that of a palimpsest. The new poetic text, superimposed upon the religious meditative tradition in a manner which left the patterning of that older text still discernible to contemporary readers, transferred the sacerdotal quality to the secular experience. In the mystical paintings of Friedrich, in Constable's evocations of childhood scenes, in Coleridge's imaginative re-enactment of the Crucifixion through the eyes of Christ's murderer, in Wordsworth's recalling of the enchanting period of his own infancy when his soul was more magically responsive to visions of divine immanence in nature, and in Keats's movement within the darkness from reality into the richer world of the

imagination, there is a nostalgic mood of recollection that should not be isolated from the patterns of thought which had for past generations been cultivated in solitary, contemplative mood by the very priests, hermits, and religious devotees with which the poets and artists now felt a renewed identity. The purpose of that visionary recall may have become secularized, but it still drew its inspiration, as Wordsworth declared of his own poetry, from "meditations holy and sublime."[28]

In more general terms, a perception of the shared cultural patterns of the time—the complex of received ideas challenged by the resistance of a new generation, to which, with all due differences in personal proclivity, both poet and artist necessarily respond in the act of creativity—allows, with some degree of authenticity, for critical judgments transcending the traditional division of the arts into their separate media. The stoic self-restraint connecting the rhymed form of Dryden's heroic plays with the "frozen" poses of Poussin's figures, the lively invitation to reader response innovated by Hogarth and Fielding, the delicate modulation of classical principles in the productions of Jane Austen and Robert Adam, these emerge as the shared aesthetic modes of contemporaries, sometimes aware of each other's work but more frequently providing, through their art, independent interpretations of the intellectual configuration of their time, and thereby justifying critical comparisons which may illumine the work of each.

NOTES

INTRODUCTION

[1] V. A. Kolve, *Chaucer and the Imagery of Narrative* (Stanford, 1984), Roland M. Frye, *Milton's Imagery and the Visual Arts* (Princeton, 1978), and Ronald Paulson, *Book and Painting: Shakespeare, Milton, and the Bible: literary texts and the emergence of English painting* (Knoxville, 1980).

[2] Ferdinand de Saussure, *Cours de linguistique génerale* (Paris, 1967), and Claude Lévi Strauss, *Le Cru et le cuit* (Paris, 1964).

[3] Julia Kristeva, *Semiotiké: récherches pour une sémanalyse* (Paris, 1969), p. 146, developed by Harold Bloom in *A Map of Misreading* (New York, 1975); and Mary Ann Caws, *The Eye in the Text: essays on perception, mannerist to modern* (Princeton, 1981). The reference is to E. H. Gombrich, *Art and Illusion: a study in the psychology of pictorial representation* (Princeton, 1960), and Rudolf Arnheim, *Art and Visual Perception: a psychology of the creative eye* (Berkeley, 1966).

[4] Alastair Fowler, "Periodization and Interart Analogies," *New Literary History* 3 (1972): 488, and René Wellek, "The Parallelism between Literature and the Arts," in *English Institute Annual 1941* (New York, 1942), p. 35.

[5] Wylie Sypher, *Four Stages of Renaissance Style: transformations in art and literature 1400–1700* (New York, 1955), p. 115. Fowler quotes the passage in a slightly abbreviated form, omitting a subordinate clause. As that may be thought unfair to Sypher, I have here quoted it in full. Cf. also Mario Praz, *Mnemosyne: the parallel between literature and the visual arts* (Oxford, 1970), as well as Frederick H. Artz, *From the Renaissance to Romanticism: trends in style in art, literature, and music 1300–1800* (Chicago, 1962).

[6] D. W. Robertson, Jr., *A Preface to Chaucer: studies in medieval perspective* (Princeton, 1962).

[7] Michel Foucault, *The Archeology of Knowledge*, trans. A. M. Sheridan Smith (New York, 1972), and Hayden White, *Metahistory: the historical imagination in nineteenth century Europe* (Baltimore, 1973).

[8] Stephen Greenblatt, *Shakespearean Negotiations: the circulation of social energy in Renaissance England* (Berkeley, 1988), p. 86

[9] On the literary implications, see Earl Miner, "That Literature is a Kind of Knowledge," *Critical Inquiry* 2 (1976):501, and W.J.T. Mitchell, "Spatial Form in Literature: towards a general theory," *Critical Inquiry* 6 (1980):539 (which quotes Wayne Booth's comment without recording the source). There is an account of the history of spatial concepts and their psychological implications in Max Jammer, *Concepts of Space* (New York, 1960), pp. 3–4, and of spatial metaphor in Rudolf Arnheim's essay "Space as an Image of Time" in K. Kroeber and W. Walding, eds., *Images of Romanticism* (New Haven, 1978), pp. 1–12.

CHAPTER I

[1] Heinrich Wölfflin, *Renaissance and Baroque*, originally published in 1888, trans. Kathrin Simon (Ithaca, 1967), p. 67. There is a helpful account of the changing and often conflicting critical views of the baroque in W. Stechow, "Definitions of the Baroque in the Visual Arts," *Journal of Aesthetics and Art Criticism* 5 (1946):109, followed by his later article, "The Baroque: a critical summary," in the same periodical, 14 (1955):171. Among the most valuable studies from the viewpoint of the art historian are Victor L. Tapié, *The Age of Grandeur: baroque art and architecture* (New York, 1966), Rudolf Wittkower's monumental study *Art and Architecture in Italy, 1600–1750* (Harmondsworth, 1973), and J. R. Martin, *Baroque* (London, 1977). Carl J. Friedrich, *The Age of the Baroque, 1610–1660* (New York, 1965), broadens the range to include political aspects of the period. Studies of the literary form include Wylie Sypher, *Four Stages of Renaissance Style: transformations in art and literature 1400–1700* (New York, 1955), Roy Daniells, *Milton, Mannerism, and Baroque* (Toronto, 1963), Frank J. Warnke, *Versions of Baroque* (New Haven, 1972), and Peter N. Skrine, *The Baroque: literature and culture in seventeenth century Europe* (London, 1978).

[2] My study of *Milton and the Baroque* (London, 1980) restricted its attention to *Paradise Lost*, but the opening chapter examined the broader implications of the baroque mode. Its motivation is seen there as arising from the church's need to resist the mechanistic and hence anti-religious implications of contemporary cosmological theory. Instead of denying the validity of the physical, as mannerism did, it harnessed the enlarged conception of the universe, the view of it as representing a dynamic interplay of immense forces, in order to assert the greater glory of its Supreme Creator.

[3] Northrop Frye, *Spiritus Mundi: essays on literature, myth, and society* (Bloomington, 1976), pp. 218–21. John M. Steadman, *Milton and the Paradoxes of Renaissance Heroism* (Baton Rouge, 1987), p. 225, similarly notes how the "heroic prankster of the Book of Judges" needed to be transformed to suit Milton's purposes. Joseph Wittreich's *Interpreting "Samson Agonistes"* (Princeton, 1986) takes issue with Frye's statement, arguing that the less-suitable aspects of the biblical Samson are not suppressed by Milton but merely relocated. Yet that relocation is in itself a transmuting of the figure, and the result is a radically different personality.

For typological readings of Samson as a Christ figure, see *The Epistle to the Hebrews* 11:32–34, and Augustine's *Sermo de Samsone*. The culmination of that tradition in the seventeenth century is to be found in Thomas Hayne's *General View of the Holy Scriptures* (London, 1640), which offered a diagrammatic tabulation of such parallels. Milton, however, is concerned here with the Old Testament figure of flesh and blood, and not any shadowy prefiguration, as many have noted, among them Fredson Bowers in his "*Samson Agonistes*: Justice and Reconciliation," appearing in Robert B. White, Jr., ed., *The Dress of Words: essays in honor of Richmond P. Bond* (Lawrence, 1978), and R. A. Shoaf, *Milton, Poet of Duality: a study of semiosis in the poetry and prose* (New Haven, 1985), p. 187. For twentieth-century studies of the christological reading, see E. M. Clark, "Milton's Conception of Samson," *Texas University Studies in English* 8 (1928):88, the full-length treatment of the subject in F. M. Krouse, *Milton's Samson and the Christian Tradition*

(Princeton, 1949), and, in its most forthright form, T.S.K. Scott-Craig, "Miltonic Tragedy and Christian Vision," in N. A. Scott, ed., *The Tragic Vision and the Christian Faith* (New York, 1957), which argues that the play should really be entitled *Christus Agonistes*. There is a valuable discussion in William G. Madsen, *From Shadowy Types to Truth* (New Haven, 1968).

4 The changes that Milton introduced into the story, such as the transformation of Dalila from mistress (". . . and he loved a woman in the valley of Sorek") to wife were, as usual, based on his eclectic reading of earlier exegetical works, from which there emerges a figure ultimately of Milton's creating. The rabbinic commentator Kimchi, for example, widely read and admired by Christian scholars, attempted to clear both Samson and Rahab of moral blemish by arguing, on the basis of a linguistic affinity, that the word *harlot* in those two stories (in Gaza, Samson "lay with a harlot till midnight") referred simply to female innkeepers engaged in honest tasks, even though the meaning of the term *zonah* is unambiguously pejorative elsewhere in the Bible. For details, see Kimchi's commentary on the relevant biblical verses.

5 The point has often been made, for example by Ann Gossman, "Samson, Job, and 'The Exercise of Saints,' " *English Studies* 45 (1964):212, and Mary Ann Radzinowicz, *Towards "Samson Agonistes": the growth of Milton's mind* (Princeton, 1978), pp. 251–265.

6 It is not always clear which of them is a tempter and which a comforter. D. C. Allen in his *Harmonious Vision: studies in Milton's poetry* (Baltimore, 1954), p.86, argues that Manoa, with all his good intentions, is really tempting his son to love his father on earth instead of his Father in heaven, to settle down in comfort with him rather than to struggle towards his own redemption. All quotations from Milton's works throughout this book

are from *John Milton: complete poems and major prose*, ed. Merritt Y. Hughes, (New York, 1957).

7 E.M.W. Tillyard, *The Miltonic Setting* (London, 1938), pp. 85–86. In any case, Milton had little respect for stoic apathy, commenting that "sensibility to pain and even lamentations, are not inconsistent with true patience, as may be seen in Job and the other saints, when under the pressure of affliction," *Christian Doctrine* 1:10.

8 A.S.P. Woodhouse, pointing to the play's biblical rather than Hellenic insistence on willed action, states that Samson "never wavers from the conviction of his own responsibility." That I find hard to reconcile with the reiterated questioning of God's justice and the passionate search for an elusive patience. See Woodhouse's "Tragic Effect in *Samson Agonistes*," *University of Toronto Quarterly* 28 (1958):205. Arnold Stein, on the other hand, in his *Heroic Knowledge* (Hamden, 1965), p. 149, perceives that Samson possesses an Old Testament familiarity with God which allows him to make his challenge; and Miriam Muskin, "Wisdom by Adversity: Davidic traits in Milton's Samson," *Milton Studies* 14 (1980):233, relates the latter's mode of repentance more specifically to the Old Testament pattern established by King David.

9 On the autobiographical reading of the play, the best discussion is still J. H. Hanford, "*Samson Agonistes* and Milton in Old Age," *Studies in Shakespeare, Milton, and Donne*, by various hands (New York, 1925), pp. 165–89.

10 *Second Defence of the People of England* in Hughes, *John Milton*, p. 825. It was written to refute the anonymous *Regii Sanguinis Clamor ad Coelum adversus Parricidas Anglicanos* (1652), of which Alexander More was known to have been the editor and presumed to be the author, the true attribution to Pierre du Mou-

lin only being discovered later. There is a sensitive discussion of the more general theme of blindness and insight in the play in Anthony Low, *The Blaze of Noon: a reading of "Samson Agonistes"* (New York, 1974), pp. 90–117.

[11] Christopher Pye, "The Sovereign, the Theater, and the Kingdome of Darknesse: Hobbes and the spectacle of power," in Stephen Greenblatt, ed., *Representing the English Renaissance* (Berkeley, 1988), pp. 279–301, explores Hobbes's attitude to regal power; but, in contrast to the view expressed here, he assumes it to be essentially identical with that of the Elizabethan era (as outlined in Greenblatt's discussion of that phase in *Glyph* 8 [1981]:57), that is, as a corroboration rather than a departure.

[12] Hobbes, *Leviathan*, ed. C. B. Macpherson (London, 1968), p. 223.

[13] Giambologna (Giovanni Bologna) was acknowledgedly mannerist in his early work, including his famous *Mercury* of 1564 which challenged the fixed frontal viewing traditional for sculpture; but in his later years, he adopted the more vigorous style of the baroque.

[14] The scene of Samson tearing apart the lion's jaws had a lengthy history in art, but to perceive the new element of muscular conflict introduced by Rubens one need only compare such earlier versions as that on the stone capital in the church of S. André le Bas in Vienne from 1152, the fourteenth-century drawing in the Queen Mary Psalter, or the figurine just visible behind the Canon in Jan Van Eyck's *Virgin with Canon Van der Paele*.

[15] The linking of Samson and Hercules was a stock feature of hermeneutic literature because of their physical similarities, as well as more detailed parallels in their lives. They were both ruined by women, both slew lions, and both died voluntarily. Milton employs the term "Herculean Samson" in *Paradise Lost* 9:1060. Carole S. Kessner discusses the mingling of classical myth and Old Testa-

ment tradition in "Milton's Hebraic Herculean Hero," *Milton Studies* 4 (1974):243, while Eugene M. Waith, *The Herculean Hero: in Marlowe, Chapman, Shakespeare, and Dryden* (New York, 1962), strangely bypasses Milton's treatment of the theme.

[16] Krouse, *Milton's Samson*, p. 109.

[17] The connection of the hair's regrowth with the principle of *peripeteia* is discussed in Sanford Budick, *Poetry of Civilization: mythopoeic displacement in the verse of Milton, Dryden, Pope, and Johnson* (New Haven, 1974), pp. 52–56.

[18] Cf. Roland M. Frye, "The Teachings of Classical Puritanism on Conjugal Love," *Studies in the Renaissance* 2 (1955):148. Milton attributed the Fall in part to the "excessive uxoriousness" of Adam. See also Edward LeComte, *Milton and Sex* (New York, 1978), p. 114.

[19] Samuel Johnson, *The Rambler* 139 and 140 (1751).

[20] The connection of Harapha with the comic *miles gloriosus* was first noted by Daniel C. Boughner, "Milton's Harapha and Renaissance Comedy," *Journal of English Literary History* 11 (1944):297.

[21] Some have perceived in *Lycidas* a mannerist quality of indirection, as in Roy Daniells, *Milton, Mannerism, and Baroque*, especially pp. 41–42; but the matter is open to dispute. I have preferred not to enter into that aspect here as it is only tangentially relevant to the point under discussion.

[22] Kenneth Muir, *John Milton* (London, 1955), p. 167, and Barbara K. Lewalski, *Milton's Brief Epic: the genre, meaning, and art of "Paradise Regained"* (London, 1966), pp. 332–34.

[23] A. H. Gilbert's view was presented in the *Philological Quarterly* 28 (1949):98, and W. R. Parker's in the same volume of the periodical on p. 145, as well as in his article "The Date of *Samson Agonistes* Again," published posthumously in J. A. Wittreich, ed.,

Calm of Mind (Cleveland, 1971), p. 163. See also A.S.P. Woodhouse, "*Samson Agonistes* and Milton's Experience," *Transactions of the Royal Society of Canada*, third series, 43 (1949):157, and John Shawcross, "The Chronology of Milton's Poems," *Publications of the Modern Language Association of America* 76 (1961):345. Dating based on a metrical assessment of Milton's work was offered by Ants Oras, *Blank Verse and Chronology in Milton*

(Gainseville, 1966), with an interesting reply in the second of W. R. Parker's articles listed above. The contemporary debate was usefully summarized in Ernest Sirluck, "Some Recent Changes in the Chronology of Milton's Poems," *Journal of English and Germanic Philology* 60 (1961):749, and subsequent discussion appears in Mary Ann Radzinowicz, *Towards "Samson Agonistes,"* pp. 387-407.

CHAPTER 2

[1] Details of eighteenth-century performances are recorded in G. Nettleton and A. Case, eds., *British Dramatists from Dryden to Sheridan* (Boston, 1969), p. 114.

[2] Dryden's formula for heroic drama was presented most succinctly in his "Essay of Heroic Plays," to be found in *Essays of John Dryden*, ed. W. P. Ker (Oxford, 1961) 1:150. For the source of the psychological theory of the passions, see René Descartes, *Traité des Passions* (1649), appearing in an English version in *The Philosophical Works of Descartes*, trans. and ed. Elizabeth S. Haldane and G.R.T. Ross (Cambridge, 1912) 1:352-54. There are helpful examinations of Otway's play in A. M. Taylor, *Next to Shakespeare* (Durham, N.C., 1950), pp. 39-72, and in David R. Hauser, "Otway Preserved: theme and form in *Venice Preserved*," *Studies in Philology* 55 (1958):481. The former draws particular attention to the political interest of the play, presented at the time of the ferment surrounding the Popish Plot, but its continued popularity among later generations of theatregoers through the eighteenth century confirms that its topicality was by no means the primary cause of its success.

[3] *Tamburlaine I* 1.2.174-77, in *Complete Works*, ed. Fredson Bowers (Cambridge,

1973) 1:90. The previous quotations from *Venice Preserv'd* and *The Rehearsal* may be found most conveniently in Nettleton and Case, eds., *British Dramatists*, pp. 132 and 65 respectively.

[4] Sir Robert Howard first attacked the use of rhyme in drama in the preface to his *Foure New Plays* (1665), Dryden genially echoing his arguments through the person of Crites in his "Essay of Dramatick Poesie." Early in 1668, Howard returned to the attack in the preface to his tragedy *The Great Favourite: or the Duke of Lerma*, to which strictures Dryden now replied less amiably with the publication of his *Defence of Dramatick Poesie*, in which, although he attempted to answer other charges connected with plot and dramatic structure, he gave priority to defending his use of rhyme. Thomas Shadwell had added his voice to the attack on Dryden in the prologue to his play *The Sullen Lovers* (1668), an attack with which Dryden's satirical portrait of him in "Macflecknoe" would appear to be only slimly connected, as they maintained cordial relations until shortly before the appearance of the poem. There is an account of the dispute in Cecil V. Deane, *Dramatic Theory and the Rhymed Heroic Play* (Oxford, 1931), pp. 161-83. On the political back-

ground to the literary controversy, see George McFadden, *Dryden, The Public Writer 1660–1685* (Princeton, 1978), pp. 59–87, who concludes that whatever additional factors there may have been behind the quarrel with Howard, the latter's condemnation of Dryden for employing rhyme in the theatre was certainly the most cogent.

[5] Statistics for the publication of rhymed heroic plays in this period are from Allardyce Nicoll, *A History of English Drama, 1660–1900* (Cambridge, 1952) 1:100, their implications being examined by Eric Rothstein, *Restoration Tragedy: form and the process of change* (Madison, 1967), especially pp. 24–47, and Robert D. Hume's excellent study, *The Development of English Drama in the Late Seventeenth Century* (Oxford, 1976), pp. 270–71. Bruce King, *Dryden's Major Plays* (Edinburgh, 1966), argued, relying partly on D. W. Jefferson's article cited below, that Dryden was being ironic in his advocacy of the heroic ideal and suggested, with evidence drawn from the dramatist's own writings and those of contemporaries, that they recognized the "wit" in his heroic portrayals and appreciated that the latter were not to be taken seriously. The main counterargument is the appearance of Villiers's devastating *Rehearsal*, which could never have achieved such success as a dramatic burlesque if Dryden's plays had not been seen by his generation as serious in their intent. Significantly, Bruce King's study makes no mention of *The Rehearsal* throughout the work.

[6] Preface to *The Conquest of Granada* in *The Works of John Dryden*, ed. Edward N. Hooker et al. (Berkeley, 1956–) 11:8. Subsequent quotations are from that as yet incomplete edition whenever the work cited has already appeared there.

[7] T. S. Eliot, *John Dryden* (New York, 1932), p. 37. The second quotation, from an essay written in 1921, appears in his *Selected Essays, 1917–1932* (London, 1949), p. 310.

The contemporary censure of Milton as the source of the artificiality of eighteenth-century verse was argued most forcefully in R. D. Havens, *The Influence of Milton on English Poetry* (Cambridge, Mass., 1922).

[8] Allardyce Nicoll, *History of English Drama*, 1:100–102.

[9] Arthur C. Kirsch, *Dryden's Heroic Drama* (Princeton, 1965), pp. 22–33. Dryden, it is true, declared in the preface to *Aureng-Zebe* that he felt like a Sisyphus endlessly labouring at the drama when he would prefer to be writing a heroic poem; but an author's coy admission of reluctance or lack of talent for the work he is about to introduce to the public is, by its very placement in the preface to the work, a patent device for forestalling adverse criticism and should surely not be taken at face value. D. W. Jefferson, "The Significance of Dryden's Heroic Plays," *Proceedings of the Leeds Philosophical and Literary Society* 5 (1940):125, also stressed the verbal preoccupation in the plays. Dryden's most extended justification of dramatic rhyme, on the authority of contemporary continental plays, appears, of course, in his "Essay of Dramatic Poesie."

[10] For details of these acquisitions and of the artistic taste of Charles II, see the illuminating account by J. H. Plumb and H. Wheldon, *Royal Heritage: the treasures of the British Crown* (London, 1977), particularly pp. 126–38, and also, Margaret Whinney and Oliver Millar, *English Art, 1625–1714* (Oxford, 1957), pp. 7–14.

[11] *The Diary of John Evelyn*, 1 March 1644, in the edition by Austin Dobson (London, 1908), p. 35, which is characteristic of innumerable other entries. The comment, for example, on 27 December 1684 (p. 362) provides a useful indication of the kind of paintings hanging at that time in an English nobleman's house, including a Titian, several Van Dycks, and a Bassano.

[12] The "china" reference is, of course, to

Act IV, scene 3, of Wycherley's *The Country Wife.*

[13] Rensselaer W. Lee, *"Ut Pictura Poesis": the humanistic theory of painting* (New York, 1967), provides details of the development of this relationship from the Renaissance onward.

[14] Mark Van Doren, *John Dryden: a study of his poetry* (New York, 1946), p. 52, records some twenty references in Dryden's writings to the affinity of poetry to painting, including lines 59–60 and 94–96 in "Heroick Stanzas to Cromwell," written in 1658, very early in his career and long before his association with Dufresnoy's work. The latter's poem was extraordinarily popular in England during the eighteenth century, being greatly admired by Pope, re-translated by Defoe and others, and annotated by Sir Joshua Reynolds, as Jean Hagstrum records in his valuable *The Sister Arts: the tradition of literary pictorialism and English poetry from Dryden to Gray* (Chicago, 1958), pp. 169–75, which also surveys the growing interest in painting among writers during this period. Although it is less relevant to my present theme, Hagstrum also offers an interesting interdisciplinary discussion of "Dryden's Grotesque: an aspect of the baroque in his art and criticism," which appears in Earl Miner, ed., *John Dryden: writers and their background* (Athens, Ohio, 1972), pp. 90–119. William K. Wimsatt in "Samuel Johnson and Dryden's *Du Fresnoy*," *Studies in Philology* 48 (1951):26, points out that the art definitions which Samuel Johnson provided for his own *Dictionary* were derived largely from Dufresnoy's poem. P. O. Kristeller, "The Modern System of the Arts," *Journal of the History of Ideas* 12 (1951):496, traces to this period the more inclusive conception of the Fine Arts as embracing painting, architecture, literature, and music, a conception encouraging such comparative studies as Dufresnoy's. James S. Malek, *The Arts Compared: an aspect of eighteenth-century British aesthetics* (Detroit, 1974), studies attempts to relate painting and poetry in critical works from Dryden's translation onwards, while Lawrence Lipking, *The Ordering of the Arts in Eighteenth Century England* (Princeton, 1970), examines the histories of art, music, and literature in that period in their independent rather than interart interests.

[15] Louis I. Bredvold, *The Intellectual Milieu of John Dryden: studies in some aspects of seventeenth-century thought* (Ann Arbor, 1959), originally published in 1934. For further examinations of Dryden's philosophical stand, see Mildred E. Hartsock, "Dryden's Plays: a study in ideas," in R. Shafer, ed., *Seventeenth-Century Studies*, second series (Princeton, 1937); John A. Winterbottom, "The Place of Hobbesian Ideas in Dryden's Tragedies," *Journal of English and Germanic Philology* 57 (1958):665 and 61 (1962):868; Thomas H. Fujimura, "The Appeal of Dryden's Heroic Plays," *Publications of the Modern Language Association of America* 75 (1960):37; and, commenting in part on Fujimura, Anne T. Barbeau, *The Intellectual Design of John Dryden's Heroic Plays* (New Haven, 1970), especially pp. 25–39.

[16] See, for example, his preface to *Sylvae*—"accordingly I laid by my natural diffidence and scepticism for a while"—in *Essays* 1:260. Dryden seems to have altered his views during the less happy period when, on the fall of James II, he was deprived of the laureateship and his pension, commenting bitterly in the dedication to his *Don Sebastian* (1689) that "the ruggedness of a stoic is only a silly affectation of being a god." Cf. Eugene M. Waith, "Dryden and the Tradition of Serious Drama," in Miner, *John Dryden*, p. 85.

[17] Bredvold, *Intellectual Milieu*, pp. 13–14, and Phillip Harth, *Contexts of Dryden's Thought* (Chicago, 1968), especially pp. 3–15.

[18] Quoted in Anthony Blunt, *Nicholas Poussin: the A. W. Mellon lectures on the fine arts, 1958* (New York, 1967) 1:227.

[19] In my *Renaissance Perspectives in Literature and the Visual Arts* (Princeton, 1987), chapter 7.

[20] Blunt, *Nicholas Poussin* 1:129.

[21] The passage, in the wording of Dryden's translation, is most easily accessible in Elizabeth G. Holt, ed., *A Documentary History of Art* (New York, 1958) 2:167. The original poem was published in the year of the poet's death in 1668 but was composed over a period of some twenty years prior to that date. For a very general association of the poet and painter, see Dean Tolle Mace, "*Ut Pictura Poesis*: Dryden, Poussin, and the parallel of poetry and painting in the seventeenth century," in John Dixon Hunt, ed., *Encounters: essays on literature and the visual arts* (London, 1971), p. 58f.

[22] Walter Friedlaender, *Nicholas Poussin: a new approach* (New York, 1964), p. 127. Although the innovative approach claimed by its subtitle is unjustified, this study offers a useful overview of the artist's work.

[23] Stanley E. Fish, *Surprised by Sin: the reader in "Paradise Lost"* (Berkeley, 1967), especially the opening chapter.

[24] *Heads of an Answer to Rymer*, in *Works* 17:186.

[25] Earl Wasserman, "The Pleasures of Tragedy," *Journal of English Literary History* 14 (1947):283. H. James Jensen, *The Muse's Concord: literature, music, and the visual arts in the baroque age* (Bloomington, 1976), pp. 6–15, discusses the influence in England of F. N. Coeffeteau's *Table of Human Passions with their Causes and Effects* (1615), translated from the French in the year of its publication. It distinguished between the vegetable element in the soul controlling basic bodily needs, the concupiscible element housing the passions, and the rational element providing discrimination and control, and was thus closely allied to the new theories. Jensen's book offers some helpful comments on inter-art relationships in this era but is marred by his refusal, stated explicitly in the preface, to distinguish what he terms the Baroque from any of the neighbouring modes such as Renaissance, Mannerist, and Rococo, or even to acknowledge any internal divisions, as between the High Baroque of *Paradise Lost* and the Late Baroque to which Dryden belongs. The result is, inevitably, a disturbing blurring of definition.

[26] *The Conquest of Granada I* 3.1.508–11, in *Works* 11:61. My comments here are restricted to the English heroic couplet. Dryden of course justified his rhyme on the basis of the precedent offered by Corneille, and Roger Boyle defended his own use of it on the grounds that "his majesty Relish'd rather the French Fassion of Playes then the English," in *The Works of Roger Boyle*, ed. W. S. Clark (Cambridge, Mass., 1937) 1:23. Moreover, Racine, just when the English dramatists were finally deserting rhyme, began employing it in his plays with impressive effect. But as Kenneth Muir—himself a respected translator of Racine—has noted, there is a fundamental difference between English and French versification, and the effect of employing rhymed couplets in the English tongue inevitably creates the impression that we are hearing "a well-trained elecutionist declaiming a set speech." See his *Jean Racine: five plays translated into English verse* (New York, 1960), p. vi, and the similar view of John Cairncross, also translating into unrhymed verse, in his *Pierre Corneille* (Harmondsworth, 1975), p. 10.

[27] *Tyrannick Love* 4:1:374–76, in *Works* 10:159.

[28] *Essay on Dramatick Poesie*, in *Works* 17:69.

[29] *Conquest of Granada I* 1:1, in *Works* 11:31.

[30] *Essays* 1:8, and the prologue to *Aureng-Zebe*, 8–9. Dufresnoy's *De arte graphica* was composed during his long residence in Italy from 1633 to 1656 but, as was noted above, it was not published until Roger de Piles's posthumous edition of it in 1668.

[31] George Saintsbury, *Dryden* (London, 1881), p. 57. There is a detailed account of the

petering out of rhymed tragedy in Hume's *Development of English Drama*, pp. 310–18.

[32] Hagstrum, *Sister Arts*, pp. 190–97.

[33] Emile Mâle, *L'Art religieux après le Concile de Trente* (Paris, 1932), especially pp. 109–201. For other important discussions, see Mario Praz, *The Flaming Heart* (Gloucester, Mass., 1966), pp. 204–63, and Robert T. Petersson, *The Art of Ecstasy: Saint Teresa, Bernini, and Crashaw* (London, 1970), both of which connect Crashaw with this art movement without making the distinction suggested here.

[34] Cf. Louis L. Martz, *The Poetry of Meditation* (New Haven, 1962), especially pp. 25–56 and 331–38, and Barbara K. Lewalski, *Protestant Poetics and the Seventeenth-Century Religious Lyric* (Princeton, 1979), notably the opening chapter.

[35] While Bernini's sculptural group as a whole belongs to the High Baroque in its monumentality, its richness of decoration, and its conscious theatricality with sculpted spectators realistically seated in boxes alongside, the framed inner scene, based by Bernini upon a close reading of St. Teresa's account of her ecstasy in the *Vida*, is clearly mannerist in its visionary dematerialization of reality as she floats there ethereally upon a cloud.

[36] John Donne, *Holy Sonnet 9*, 9–12, in *Divine Poems*, ed. Helen Gardner (Oxford, 1978), p. 8.

[37] Cf. Donne's *Holy Sonnet 11*, in *Divine Poems*, p. 9, which dramatically merges the personality of the speaker-meditator into the figure of Christ at Calvary.

[38] The final stanza of Richard Crashaw, "*Vexilla Regis*: the hymn of the Holy Cross," in *Poetical Works*, ed. L. C. Martin (Oxford, 1968), p. 279, with the spelling modernized.

[39] *Conquest of Granada I* 3.1.336–39, in *Works* 11:56.

[40] Quoted in Rudolf Wittkower, *Art and Architecture in Italy, 1600–1750* (Harmondsworth, 1973), p. 275.

[41] George Herbert, "Marie Magdalene," pp. 7–12, in C. A. Patrides, ed., *The English Poems* (London, 1974), p. 179.

[42] Ignatius Loyola, *The Spiritual Exercises*, trans. A. Mottola (New York, 1964), p. 56.

[43] Richard Crashaw, "In Memory of the Vertuous and Learned Lady Madre de Teresa," 121–29, in *Poetical Works*, p. 34. Yvor Winters, *Forms of Discovery: critical and historical essays on the forms of the short poem in English* (Chicago, 1967), p. 92, has not been alone in criticizing the poem for its fairy-tale quality of childish pietism, but Louis L. Martz, *The Wit of Love* (Notre Dame, 1969), p. 135, and, more recently R. V. Young, *Richard Crashaw and the Spanish Golden Age* (New Haven, 1982), pp. 69f., have replied by arguing for the existence of a certain mild humour in the poet's treatment of her immaturity. Even if that is so, there is certainly no humour in his account of her actual martyrdom, where the saint's welcoming of her delicious agonies would appear retrospectively to ratify the account of her earlier "childish" longings.

[44] Cf. De Hooch, *A Dutch Courtyard*, and Jan Steen, *Skittle Players*, both from the National Gallery, London, and Adriaen Brouwer, *Smokers at an Inn*, from the Prado. Breughel's earlier paintings of peasant scenes were, of course, laden with symbolic overtones related to folkloristic proverbs and moral adages.

The bifurcation of art at this time is appropriately reflected in the works of Murillo. The popularizing purpose of the church during that period was twofold, to inspire the masses with a wondering sense of divine glory, yet also to create a personal identity with and affection for the Holy Family. As a result, his Immaculate Conceptions constitute the acme of pietistic fervour, of elevated scenes of heavenly ascension, while other paintings, such as his *Holy Family with a Bird* from the Prado, with the infant Jesus playing naturalistically with two of his pets in an en-

tirely relaxed, contemporary setting, parallel the interest in domestic realism.

[45] The column and draperies for such portraits had been introduced to England by Van Dyck, but Lely uses them here with a panache missing from the earlier versions.

[46] The lines, by Abel Evans, are incorrectly attributed to Pope in B. Sprague Allen, *Tides in English Taste 1619–1800* (New York, 1969), 1:104. For the correct attribution, see *The Spirit of the Age: eight centuries of British architecture* by Alec Clifton-Taylor et al. (London, 1975), p. 97. Pope did attack Blenheim for its poor inner planning—"it is the most inhospitable thing imaginable . . . no room for strangers, and no reception for any person of superior quality to themselves"—in a letter, probably sent to Martha Blount in 1717. See his *Correspondence*, ed. G. Sherburn (Oxford, 1956) 1:431–32.

[47] That the distinction is not intrinsic to the genres of tragedy and comedy is amply illustrated by the unrealistic dream-worlds of Illyria and Arden on the Elizabethan stage. Moreover, where on that earlier stage, comic scenes formed integral parts of the tragedies, attempts to write tragicomedy in the Restoration were notoriously ineffective, producing at most scenes alternating between the idealism and the realism of the disparate genres. The relationship of comedy to the society of the day was examined in Kathleen M. Lynch, *The Social Mode of Restoration Comedy* (New York, 1926), as well as in many subsequent studies.

[48] Mildred Hartsock and Thomas Fujimura in the articles noted above.

[49] The old view that these theatres attracted a coterie audience has been disproved. It is now recognized that the middle class composed a large proportion of the spectators, as Pepys noted at the time. See, for example, E. L. Avery, "The Restoration Audience," *Philological Quarterly* 45 (1966):54; Peter Holland, *The Ornament of Action: text and performance in Restoration comedy* (Cambridge, 1979), especially chapter 1; as well as Hume's *Development of English Drama*, pp. 24–28, which provides a useful summary of the controversy and of the evidence which has been adduced.

[50] For a general study of the subject, which draws to a close as our period begins, see Marvin T. Herrick, *Tragicomedy: its origin and development in Italy, France, and England* (Urbana, 1962).

[51] The quotations are from Dryden's prefaces to *The Mock Astrologer* and *Troilus and Cressida*, in *Essays* 1:143 and 210 respectively. The avowed and the real purposes of Restoration comedy are discussed in Joseph Wood Krutch, *Comedy and Conscience after the Restoration* (1924; New York, 1961), pp. 40–47.

[52] Paul E. Parnell, "The Sentimental Mask," *Publications of the Modern Language Association of America* 78 (1963):529.

[53] In *Works* 10:179, 163, and 183. Details of the play's connection with the Huysmans painting are discussed on p. 382 of that edition.

CHAPTER 3

[1] Arthur O. Lovejoy, *The Great Chain of Being: a study of the history of an idea* (1936; New York, 1960). Lovejoy does mention (p. 202) that the *imitatio dei* and ascent to God had disappeared from the Augustan version, but that element is not treated by him as a change of importance in his discussion of the pessimistic and optimistic implications of the theory.

[2] Lovejoy, *Great Chain*, pp. 183–84.

[3] Martin C. Battestin, *The Providence of Wit: aspects of form in Augustan literature and the arts* (Oxford, 1974). He is resisting there the views expressed in Rudolf Wittkower, *Architectural Principles in the Age of Humanism* (London, 1949); John Hollander, *The Untuning of the Sky* (Princeton, 1961); and Gretchen L. Finney, *Musical Backgrounds for English Literature 1580–1650* (New Brunswick, 1962).

[4] John Reynolds, *Death's Vision* (London, 1709), p. 34. The idea of *concordia discors* goes back at least to Pythagoras and Heraclitus, and the phrase itself would seem to have been coined by Pliny. See Leo Spitzer, "Classical and Christian Ideas of World Harmony," in *Traditio* 2 (1944):409–64. Jean H. Hagstrum, "Johnson and the *Concordia Discors* of Human Relationships," in J. J. Burke, Jr., and D. Kay, eds., *The Unknown Samuel Johnson* (Madison, 1983), p. 39, explores an interesting aspect of its later usage.

[5] Isaac Newton, *Opticks*, fourth edition, (London, 1730) 2:1:14.

[6] M. Ficino, *Opera Omnia* (Basle, 1576), p. 805.

[7] Pope, *Essay on Man* 2:23–30, from *Poems*, ed. John Butt (New Haven, 1963), which is the more accessible one-volume edition of the Twickenham text used for all subsequent quotations.

[8] S. Johnson, *A Review of a Free Enquiry into the Nature and Origin of Evil* (1757), in Donald Greene, ed., *Samuel Johnson* (Oxford, 1984), pp. 525–26, and Voltaire, *Dictionnaire philosophique* (1764).

[9] Pope, *Essay on Man* 1:123–30.

[10] A discussion of the symbolism in this painting appears later in this chapter.

[11] An early example of such separation in England can be found on the ceiling to the Sheldonian Theatre, Oxford, painted by Robert Streeter in 1668–69, which preserves the dazzling light in the centre and the sense of distant heights, but has the choric figures grouped below about a thick cloud. There is an illustration in Edward Croft-Murray, *Decorative Painting in England, 1537–1837* (London, 1962) 1:122. Pope's dislike of Verrio's "sprawling" saints is recorded in his *Epistle to Burlington*, 145–48 and, more mildly, in *Windsor Forest*, 307–8.

[12] Dryden, *Annus Mirabilis*, in *Works* 1:62. G. B. Tiepolo was born in 1696, only eight years after Pope, and is thus a close contemporary. The new tendency to represent earthly scenes in these ceiling or high-placed paintings and frescoes in place of views of the heavens was a return to the pre-baroque tradition represented by the ceiling of the Sistine Chapel, with its depiction of such events as the Flood bearing no relation to its location above the viewer. The artistic identification of the upper portions of the church or hall with the heavens formed, as I argued in my Milton book, part of the baroque response to the expanded view of the cosmos.

[13] Pope, *Essay on Man* 1:11–12. Bolingbroke viciously attacked metaphysicians who presume to enter into the councils of the Supreme Being and "to account for the whole divine economy as confidently as they would for any of their own paltry affairs," *The Works of Lord Bolingbroke* (Philadelphia, 1841; reprinted 1969) 3:209. Pope's relationship with Bolingbroke has been interestingly examined in Brean S. Hammond, *Pope and Bolingbroke: a study of friendship and influence* (Columbia, Mo., 1984).

[14] Pope, *Essay on Man* 1:17–22.

[15] See, for example, the entry on "Counterpoint" by Klaus-Jürgen Sachs and Carl Dahlhaus in the 1980 edition of *The New Grove Dictionary of Music and Musicians*, vol. 4. The application of the terms "vertical" and "horizontal" to counterpoint is there deplored as an oversimplification (p. 843), but its widespread usage suggests in itself a recognition of the new directional emphasis. The twin churches constructed by Rainaldi—S. Maria di Monte Santo and S. Maria de' Miracoli—are not perfectly identical, as the sites on which they were built were dif-

ferently shaped; but Rainaldi used his architectural ingenuity to the full in order to overcome that discrepancy, providing an oval dome for the narrower-sited former church and a circular dome for the latter in order to produce an optical effect of identity when they are viewed from the piazza. The central doorway in the south front of Longleat, as illustrated in the text, is not the original (it was altered in later years), but the change did not affect the point being made here, the symmetrical design of the building.

[16] Erwin Panofsky, *Meaning in the Visual Arts* (New York, 1955), p. 31, which sees "image" or "icon" in broad terms as representing current conceptions of space, of framing, or of non-representational *schemata*. For subsequent references see his *Gothic Architecture and Scholasticism* (New York, 1957); Georges Poulet, *Metamorphoses of the Circle*, trans. C. Dawson and E. Coleman (Baltimore, 1966); and W.J.T. Mitchell, "Metamorphoses of the Vortex," in R. Wendorf, ed., *Artistic Images: the sister arts from Hogarth to Tennyson* (Minneapolis, 1983), p. 125.

[17] *Essay on Man* 2:60. George Boas, "In Search of the Age of Reason," in Earl Wasserman, ed., *Aspects of the Eighteenth Century* (Baltimore, 1965), pp. 1–19, argued in the anti-Zeitgeist mood prevailing at that time that there are too many non-rationalist elements present to allow the period to be known by the sobriquet Reason. But a close reading of the article and of the instances he brings reveals, as does Donald Greene's work (discussed later in this chapter), that he is attacking the application of that term to the entire eighteenth century. The predominance of a faith in reason during its earlier years is, I believe, undeniable.

[18] Locke, *Two Treatises of Government* 2:6, in *Works* (London, 1963) 5:341.

[19] Locke, *An Essay Concerning Human Understanding* 2:11:2, in *Works* 1:145. The relationship of Pope's criticism to Locke's theory

is examined in David B. Morris, *Alexander Pope: the genius of sense* (Cambridge, Mass., 1984), pp. 59f. Douglas L. Patey, *Probability and Literary Form: philosophical theory and literary practice in the Augustan age* (Cambridge, 1984), pp. 126–133, discusses the changing meaning of the term "probability" for the eighteenth century, from the earlier sense of what is authoritatively approved to the later meaning of what is to be estimated on the basis of likelihood, itself a form of judgment.

[20] Newton, *Opticks* 3:1:31; Alexander Malcolm, *A Treatise on Musick, Speculative, Practical, and Historical* (Edinburgh, 1721), p. 452; Batty Langley in the introduction to *Ancient Masonry, both in Theory and Practice* (London, 1736), p. 7; and Edward Manwaring, *Stichology* (London, 1737), p. 20. I have deliberately culled these quotations from Battestin's discussion of symmetry (*Providence of Wit*, pp. 22–34) to indicate how the change in usage has so often passed unnoticed by critics, the term being regarded merely as a synonym for proportion.

[21] Wylie Sypher, *Rococo to Cubism in Art and Literature* (New York, 1960), especially pp. 5–10.

[22] Although Geoffrey Tillotson had earlier offered a defence of Pope's writing and Virginia Woolf a sympathetic biography, the turning point in criticism may be seen in Cleanth Brooks's chapter on Pope in *The Well-Wrought Urn; studies in the structure of poetry* (New York, 1947), and Maynard Mack's essay, "Wit and Poetry and Pope: some observations on his imagery," published in J. L. Clifford and L. A. Landa, eds., *Pope and his Contemporaries* (Oxford, 1949). They were followed by Earl Wasserman's essay in *The Subtler Language: critical readings of neoclassical and romantic poems* (Baltimore, 1959); Reuben A. Brower, *Alexander Pope: the poetry of allusion* (Oxford, 1959); and a host of subsequent critical works praising the subtleties of Pope's verse writing.

[23] J. I. Sewall, *A History of Western Art* (New York, 1961), for example, which has been widely used as a text for students, opens its section on the Rococo with the unqualified statement that "the eighteenth-century was not a century of great art" (p. 796), the word "great" there exemplifying the elision of the two meanings I discuss.

[24] Fiske Kimball, *The Creation of the Rococo* (New York, 1964), pp. 9–10, a valuable study, although unfortunately restricted to an examination of room interiors.

[25] In a comment to his friend Joseph Spence in the latter's *Observations, Anecdotes, and Characters of Books and Men*, ed. James M. Osborn (Oxford, 1966) 1:168. The comment is generally believed to refer to his *Dunciad*, of which he had just been speaking, but the point is equally applicable if he was alluding to *The Rape of the Lock*, where in line 5 he wryly admits the slightness of his subject matter.

[26] Thomas Sprat, *A History of the Royal Society*, ed. Jackson I. Cope and H. W. Jones (St. Louis, Mo., 1958), pp. 152–53.

[27] Peter Browne, *The Procedure, Extent, and Limits of Human Understanding* (London, 1728), pp. 473–74.

[28] Michael Levey, "The Real Theme of Watteau's *Embarkation for Cythera*," in *The Burlington Magazine* 103 (May, 1961):180. Jean H. Hagstrum, while recognizing the persuasiveness of that view, takes a contrary position in his *Sex and Sensibility: ideal and erotic love from Milton to Mozart* (Chicago, 1980), pp. 301–2 and 335. The three versions of the painting are *L'île de Cythère* in Frankfurt, *L'Embarquement à l'île de Cythère* in Berlin, and *Pèlerinage à l'île de Cythère* in the Louvre, although these titles underwent a number of changes. In their present form their wording is probably, as Levey mentions, that supplied by J. de Jullienne for his collection of Watteau's engravings, *Figures de différents Caractères, de Paysages et d'Etudes*.

(Paris, 1726–28). Details of the engraving by Desplace appear, together with a reproduction, in Marianne Roland-Michel, *Watteau: an artist of the eighteenth century*, trans. R. Wrigley (London, 1984), p. 203.

[29] The argument is presented in Jacques Derrida, *Positions* (Paris, 1972), pp. 39–40, while his examination of Saussure was presented earlier in his *De la grammatologie* (Paris, 1967). The implications for literary criticism, which Derrida deals with only obliquely, have been developed by many subsequent critics, notably in Geoffrey Hartman, *Saving the Text* (Baltimore, 1981), and (although it was written much earlier but made its impact on western criticism comparatively recently) Bakhtin's stimulating "Discourse in the Novel," available in *The Dialogic Imagination: four essays by M. M. Bakhtin*, ed. Michael Holquist (Austin, 1981). For a lively deconstructionist reading of Pope's verse, see G. Douglas Atkins, *Quests of Difference: reading Pope's poems* (Lexington, 1986).

[30] The origin of the *fêtes galantes* genre is examined in Thomas E. Crow, *Painters and Public Life in Eighteenth Century Paris* (New Haven, 1985), pp. 45–74. Quotations here are from *The Rape of the Lock* 2:56–62 and 3:143–4. The distinction between the *putti* of flesh and stone is less apparent on a monochrome reproduction. For further instances of Watteau's introduction of seductive statues into otherwise decorous paintings, compare his *Les Divertissements Champêtres* and *Les Champs Elysées*, both in the Wallace Collection.

[31] Kenneth Clark, *The Nude: a study in ideal form* (New York, 1956), p. 148. A.-P. de Mirimonde, "Statues et Emblèmes dans l'Oeuvre d'Antoine Watteau," in *La Revue du Louvre et des Musées de France* 12 (1962):11, suggests that there were precedents to Watteau's use of statues to express the sentiments of the humans in his paintings, notably in works by Netscher and Metsu, but the tech-

nique is used more effectively and consistently by Watteau. See also Calvin Seerveld, "Telltale Statues in Watteau's Painting," *Eighteenth-Century Studies* 14 (1980):151, and Thomas Crow, "Codes of Silence: historical interpretation and the art of Watteau," *Representations* 12 (1985):2.

[32] The *double entendre* is, of course, the cry, "Oh hadst thou, Cruel! been content to seize / Hairs less in sight, or any Hairs but these!" (4:175–6), discussed in Cleanth Brooks's "The Case of Miss Arabella Fermor," in *The Well-Wrought Urn*, p. 93, as well as in J. S. Cunningham, *Pope: "The Rape of the Lock"* (London, 1961), p. 41, Ralph Cohen, "Transformation in *The Rape of the Lock*," in *Eighteenth-Century Studies* 2 (1969):205, and David Fairer, *Pope's Imagination* (Manchester, 1984), especially chapter 1. Margaret Anne Doody, in her lively study, *The Daring Muse: Augustan poetry reconsidered* (Cambridge, 1985), p. 54, suggests that the "Freudian" slip betrays the artificiality of Belinda's speech, displaying the gap between style and content. Brooks's assumption that Pope's treatment of Belinda is delicate and tactful has, of course, become a focus of post-structural criticism since Paul de Man singled it out for comment. For a summary of present discussion, see Christopher Norris, "Pope among the Formalists: textual politics and *The Rape of the Lock*," in Richard Machin and Christopher Norris, eds., *Post-structuralist Readings of English Poetry* (Cambridge, 1987), pp. 134–61. The quotation is from Pope's letter to Henry Cromwell, 12 November 1711, in *Correspondence*, ed. George Sherburn (Oxford, 1956) 1:135.

[33] J. I. Sewall, *History of Western Art*, p. 802.

[34] The innovative nature of the *L'Escarpolette* theme is noted by Calvin Seerveld in his article quoted above. Earlier in the century, in 1714, John Gay has a clownish peasant recall the scene of the fair Blouzelinda

viewed in a swing: "With the rude wind her rumpled garment rose, / And show'd her taper leg and scarlet hose." It appears in his burlesque, *The Shepherd's Week: in Six Pastorals*, ed. H.F.B. Brett-Smith (Oxford, 1924), p. 19. Helmut A. Hatzfeld places considerable emphasis on the titillating aspects of art and writing in this period in his *The Rococo: eroticism, wit, and elegance in European literature* (New York, 1972). There is a very generalized and theoretical discussion of the ritualizing of love in the Rococo in Herbert Dieckmann, "Reflections on the Use of Rococo as a Period Concept," in P. Demetz et al., eds., *The Discipline of Criticism: essays in literary theory, interpretation, and history* (New Haven, 1968), p. 149.

[35] Dustin H. Griffin, *Alexander Pope: the poet in the poems* (Princeton, 1978), especially pp. 162–63. The dualities in the poem are helpfully examined in Wallace Jackson, *Vision and Revision in Alexander Pope* (Detroit, 1983), pp. 68f.

[36] Thomas R. Edwards, "Visible Poetry: Pope and Modern Criticism," in Reuben A. Brower, ed., *Twentieth-Century Literature in Retrospect* (Cambridge, Mass., 1971), p. 299.

[37] Douglas H. White, *Pope and the Context of Controversy: the manipulation of ideas in "An Essay on Man"* (Chicago, 1970), and Brower, *Alexander Pope*, p. 237. Martin Price, *To the Palace of Wisdom: studies in order and energy from Dryden to Blake* (New York, 1964), p. 146, suggests that Pope chose the pastoral tradition at this time because he could not cope with the complexities of the larger world, a theory which would support the reading of his *Essay on Man* as a poem of philosophical uncertainty. And on Pope's more general inner conflict expressed within the verse, see Leopold Damrosch, *The Imaginative World of Alexander Pope* (Berkeley, 1987).

[38] Denham's *Cooper's Hill*, 189–92. These lines were added in 1655, as Earl Wasserman

notes in *The Subtler Language*, p. 69. The discussion of the prosodic element is mainly on pp. 82–86 of his work. George Williamson's earlier study, "The Pattern of Neo-classical Wit," *Modern Philology* 33 (1935):55, saw the antithetical form of the couplet as reflecting a desire for the mean. The earlier history of the verse form is examined in Ruth Wallerstein's "The Development of the Rhetoric and Metre of the Heroic Couplet, Especially in 1625–45," *Publications of the Modern Language Association* 50 (1935):166.

[39] That aspect of seventeenth-century thought was discussed in chapter 8 of my *Renaissance Perspectives*.

[40] Spence, *Observations* 1:131. For a brief discussion of the pivotal element in Pope's verse as an example of his desire for "correctness," see Geoffrey Tillotson, *On the Poetry of Pope* (Oxford, 1938), pp. 124–30. See also Jacob H. Adler, developing Tillotson's point, in "Balance in Pope's *Essays*," *English Studies* 43 (1962):457, and, more generally, his later book, *The Reach of Art: a study in the prosody of Pope* (Gainesville, 1964).

[41] Thomas R. Edwards, Jr., *This Dark Estate: a reading of Pope* (Berkeley, 1963), especially the opening chapter. His discussion of the quotation from *Windsor Forest* in relation to its theme, not structure, is on p. 6.

[42] Dryden, *Absalom and Achitophel*, 1–4, in *Works* 2:5.

[43] Spence, *Observations* 1:24.

[44] Keats, *Sleep and Poetry*, 186–87, in *Poetical Works*, ed. H. W. Garrod (Oxford, 1973), p. 46. In a letter to William Walsh in 1706, Pope acknowledged the need to vary the placing of the caesura, since otherwise "it will be apt to weary the Ear with one continu'd Tone." In the same letter he objected that Dryden was too free with the use of triple rhyme, a technique which he himself used very rarely. See *Correspondence* 1:23–24.

[45] *Rape of the Lock* 2:7–8. Cf. W. Wimsatt, Jr., "Rhetoric and Poems: Alexander Pope," and "One Relation of Rhyme to Reason," both reproduced in his *The Verbal Icon: studies in the meaning of poetry* (New York, 1960), pp. 153–85.

[46] A comparable stairway to be found at Chatsworth House, reconstructed in 1709, is in fact a much later alteration by Wyattville, as is noted, for example, in Kerry Downes, *English Baroque Architecture* (London, 1966), pp. 61–63. Pope's acquaintanceship with artists and art connoisseurs of his time, his enthusiastic experiments with painting, his building of the villa at Twickenham, and his contributions to gardening are exhaustively documented in Morris R. Brownell's fine study, *Alexander Pope and the Arts of Georgian England* (Oxford, 1978). Pope's view of architecture is seen in the tradition of a literary genre in G. R. Hibbard, "The Country House Poem of the Seventeenth Century," in *Journal of the Warburg and Courtauld Institutes* 19 (1956):159, which, as an addendum, devotes its latter section to Pope.

[47] On reservations concerning the application of the term *Augustan* to this period, cf. Howard D. Weinbrot, *Augustus Caesar in "Augustan" England: the decline of a classical norm* (Princeton, 1978), preceded by J. W. Johnson, "The Meaning of 'Augustan,' " in the *Journal of the History of Ideas* 19 (1958):507, and Ian Watt, "Two Historical Aspects of the Augustan Tradition," in R. F. Brissenden, ed., *Studies in the Eighteenth Century* (Toronto, 1968), pp. 67–79. Weinbrot's confirmation of the modelling of Pope's verse on Horace and Juvenal appears in his *Alexander Pope: the traditions of formal verse satire* (Princeton, 1982).

Donald Greene's strictures concerning the term *Neoclassical* and his denial of any especial emphasis upon rationalism in this period appear in his *Age of Exuberance: backgrounds to eighteenth-century literature* (New York, 1970), especially pp. 160–61, and in his article, "The Study of Eighteenth-Century

Literature: past, present, and future," in Phillip Harth, ed., *New Approaches to Eighteenth-Century Literature* (New York, 1974), pp. 25–27. The quotation is from Pope's *Essay on Criticism*, 124–27, the subsequent lines explaining how Vergil derived his poetic principles from Homer. A view similar to Greene's and denying the rational control attributed to the era appears in Steven Shankman's book provocatively entitled *Pope's "Iliad": Homer in the Age of Passion* (Princeton, 1983).

[48] Jean Hagstrum, *The Sister Arts*, pp. 210–42. For Ben Jonson's indebtedness to Ripa, see Allan H. Gilbert, *The Symbolic Persons in the Masques of Ben Jonson* (Durham, 1948), as well as Stephen Orgel's major study, *The Jonsonian Masque* (Cambridge, Mass., 1965). The quotation is from Pope's *Epistle to Mr. Jervas*, 35–38.

[49] Hagstrum, *Sister Arts*, p. 145.

[50] Ronald Paulson, *Emblem and Expression: meaning in English art of the eighteenth century* (Cambridge, Mass., 1975), p. 21.

[51] Cf. Jean Seznec, *The Survival of the Pagan Gods: the mythological tradition and its place in Renaissance humanism and art*, trans. Barbara Sessions (Princeton, 1972).

[52] George Herbert, *Love III*, 11–18, in *Works*, ed. F. E. Hutchinson (Oxford, 1941).

[53] Claude Lévi-Strauss, *The Savage Mind* (London, 1962), pp. 217–44, and Roland Barthes, *Mythologies*, trans. A. Lavars (New York, 1972), pp. 109–59.

[54] This de-allegorizing of myth was at once seen to have implications for Christianity itself. It was eagerly applied by Protestants to the "superstitious" practices of Catholicism, as in Conyers Middleton's *A Letter from Rome, shewing an exact conformity between Popery and Paganism* (1729), and by extension helped to create the rationalist view of Christianity adopted by such English Deists as Shaftesbury. Frank E. Manuel, *The Eighteenth Century Confronts the Gods* (Cambridge, Mass., 1959), and Paul J. Korshin, *Typologies*

in England, 1650–1820 (Princeton, 1982), especially chapter 6, provide valuable studies of these changes, including a discussion of Pierre Bayle and Bernard Fontenelle. The eighteenth-century attitude to myth as being largely ornamental in function was examined in Rachel Trickett, "The Augustan Pantheon: mythology, and personification in eighteenth-century poetry," *Essays and Studies*, new series, 6 (1953):71.

[55] Andrew Marvell, *The Garden*, 57–64, in *Poems and Letters*, ed. H. M. Margoliouth (Oxford, 1963) 1:49.

[56] Cf. Belinda's cry in *Rape of the Lock* (3:46) parodying the divine *fiat* for the creation of light: "Let Spades be Trumps! she said, and Trumps they were."

[57] *Epitaph. Intended for Sir Isaac Newton, in Westminster Abbey*.

[58] Thomas Gray, *Elegy Written in a Country Churchyard*, 29–32. The relationship of these lines to sepulchral statuary was first pointed out in Cleanth Brooks's essay "Gray's Storied Urn," from his *Well-Wrought Urn*, pp. 105–23.

[59] James Beattie, *Essay on Poetry and Musick* (Edinburgh, 1776), p. 553. Also J. M. Creed and J.S.B. Smith, *Religious Thought in the Eighteenth Century* (Cambridge, 1934), pp. xi–xii.

[60] Details of its construction appear in Kerry Downes, *Hawksmoor* (Cambridge, Mass., 1980), pp.184–87.

[61] Pope's *Essay on Gardens*, in *Prose Works*, ed. Norman Ault (Oxford, 1936), p. 145.

[62] Barbara K. Lewalski, "Innocence and Experience in Milton's Eden," in T. Kranidas, ed., *New Essays on "Paradise Lost"* (Berkeley, 1969), p. 86.

[63] Pope, *Ode on Solitude*, 5–8. In his *Essay on Man* 3:27–47, he argues for moderation in this view of Nature as subservient to man's needs, reminding the reader that the fur that warms a monarch, once warmed a bear. But as that instance, and that of the pampered goose in the following couplet suggest, it is

man who has the final enjoyment.

[64] The Oxford dictionary records as the earliest reference in English the translation by J. James of *Le Bond's Gardening* in 1712. It describes such devices as being openings "to the very Level of the Walks, with a large and deep Ditch at the Foot, which surprizes . . . and makes one cry, *Ah! Ah!* from whence it takes its name." The more accepted usage was the reverse spelling *ha-ha*.

[65] *Rape of the Lock* 1:135–36, compared with George Herbert's *Aaron*, 11–12.

[66] *Rape of the Lock* 2:107–8.

[67] Ralph Cohen, "Pope's Meanings and the Strategies of Interrelation," in Maximillian E. Novack, ed., *English Literature in the Age of Disguise* (Berkeley, 1977), 101–30.

[68] Garrick, *Lethe*, in *Dramatic Works* (London, 1798) 1:16.

[69] Cf. Lawrence Stone, *The Family, Sex, and Marriage in England, 1500–1800* (New York, 1979), pp. 169–72, and Mark Girouard's excellent study, *Life in the English Country House: a social and architectural history* (Harmondsworth, 1980), especially pp. 143f.

[70] Shaftesbury, "Advice to an Author," in *Characteristics. . .* ed. J. M. Robertson (Gloucester, Mass., 1963), pp. 221f.

[71] Fiske Kimball, *The Creation of the Rococo*, p. 23, stresses that the introduction of mirrors to interiors was a phenomenon of the sixteen-sixties, prior to the appearance of the Rococo, with plate glass being developed in the years 1688–91 to cope with the heavy

demand. While that is true, their use in the manner described here was exclusive to the Rococo.

[72] *Rape of the Lock* 3:11–12.

[73] Examples of such gilt colouring in the *Rape of the Lock* alone may be found in 1:34 and 55; 2:38, 60, 69; 4:45; and 5:71. Pope's diatribe against excessive use of that technique in art appears in his *Essay on Criticism*, 293–96.

[74] *Essay on Criticism*, 315–19.

[75] Raymond D. Havens, *The Influence of Milton on English Poetry* (Cambridge, Mass., 1922).

[76] Gray's sonnet "In vain to me the smiling mornings shine," 2–3.

[77] I am grateful to the Rare Books department at the University of Illinois in Urbana for a microfilm of this edition of the *Gradus*.

[78] C. Hoole, *A New Discovery of the Old Art of Teaching Schoole* (London, 1660), pp. 156–58.

[79] Geoffrey Tillotson, "Eighteenth Century Poetic Diction," in *Essays and Studies by Members of the English Association* 25 (1939), p. 79. Pope's condemnation in his *Peri Bathous* of such circumlocutions as "The wooden guardian of our privacy" for *door* was, like his attack on Timon's villa, a protest against unseemly exaggeration of that technique, not an invalidation of the *Gradus* principle itself.

[80] *Peri Bathous: the Art of Sinking in Poetry*, ed. Edna L. Steeves (New York, 1952),

CHAPTER 4

[1] Ian Watt, *The Rise of the Novel* (Berkeley, 1957), preceded by Alan McKillop, *The Early Masters of English Fiction* (Lawrence, Kans., 1956). The Weber-Tawney view of the Protestant impact on capitalism, upon which Watt relies, has been frequently challenged, e.g., by H. R. Trevor-Roper, "Religion, the Reformation, and Social Change," *Historical Studies* 4 (1963):18, but Maximillian E. Novak, *Realism, Myth, and History in Defoe's Fiction* (Lincoln, Nebr., 1983), places Watt's valuable contribution and the controversy

among social historians in balanced perspective. Michael McKeon, *The Origins of the English Novel* (Baltimore, 1987), has laid new emphasis on questions of truth and virtue rather than sociological changes but accepts in principle much of Watt's thesis. For Defoe's indebtedness to Protestant spiritual biography, see J. Paul Hunter, *The Reluctant Pilgrim: Defoe's emblematic method and quest for form in "Robinson Crusoe"* (Baltimore, 1966), especially pp. 76–147, and Leopold Damrosch, Jr., *God's Plot and Man's Stories: studies in the fictional imagination from Milton to Fielding* (Chicago, 1985), pp. 187–212.

[2] Diana Spearman, *The Novel and Society* (New York, 1966), p. 51.

[3] Marjorie Nicolson's essays on "The Microscope and English Imagination" and on "Milton and the Telescope," both originally published in 1935, were republished in her *Science and Imagination* (Ithaca, 1956), pp. 155–234 and 80–109 respectively. On the satirical aspects, see David Renaker, "Swift's Laputians as a Caricature of the Cartesians," *Publications of the Modern Language Association* 94 (1979):936, and on the distortions created by gazing through such glasses, David Oakleaf, "*Trompe l'Oeil*: Gulliver and the distortions of the observing eye," *University of Toronto Quarterly* 53 (1983):166.

[4] Swift, *Gulliver's Travels* II:v, in Herbert Davis, ed. (Oxford, 1959), p. 119.

[5] Des Fontaines's analogy was first noted by W. A. Eddy in his *Gulliver's Travels: a critical study* (Princeton, 1923), p. 146. Marjorie Nicolson refers to the passage in *Science and Imagination*, p. 197, but without perceiving its relevance to her own theory, relegating it to a footnote concerning the nature of the Pocket Perspective Glass which Gulliver always carried. For the general interest in this theme, cf. Henry Baker's poem of 1733 entitled *The Universe: a poem intended to restrain the pride of man*, which employed the telescopic and microscopic views as counterarguments to Pope's *Essay on Man*. Details are recorded in William Powell Jones, *The Rhetoric of Science: a study of scientific ideas and imagery in eighteenth-century English poetry* (Berkeley, 1966), pp. 126–27.

[6] Cf. Milton, *Paradise Lost* 3:590 and 560–67, and on the new view of the Milky Way, 5:579.

[7] Carole Fabricant, *Swift's Landscape* (Baltimore, 1982), notably in her opening chapter, and in chapter 4 on the subversion of the country house ideal.

[8] The subject of this painting was much later identified in the National Gallery Catalogue as an *Annunciation*, but in recent years the original title has returned to favour. The setting is equally inappropriate for an Annunciation, which occurred, according to Luke 1:26, not in the open countryside but within the township of Nazareth.

[9] From a letter by Charles de Brosses to de Neuilly, 24 November 1739, quoted in W. G. Constable, *Canaletto: Giovanni Antonio Canal* (Oxford, 1976) 1:22–23. The style generally associated with Canaletto in fact appeared very early in the century. Cf. the painting of *The Bucintoro Departing from the Bacino di San Marco* from 1710 by Luca Carlevarijs, who greatly influenced Canaletto. It is now in the collection of the J. Paul Getty Museum in California.

[10] The opening of Juvenal's *Satire X* on which the poem is based, although similar in theme, is a factual statement with no hint of this superior panoramic observation specific to Johnson's time:

> Omnibus in terris, quae sunt a Gadibus usque
> Auroram et Gangen, pauci dinoscere possunt
> vera bona . . .

[11] Details of such illustrations are recorded in Robert Halsband, "Eighteenth-Century Illustrations of *Gulliver's Travels*," in Her-

mann J. Real and Heinz J. Vienken, eds., *Proceedings of the First Münster Symposium on Jonathan Swift* (München, 1985), p. 83. The quotations are from I:iv and I:v, in ed. cit., pp. 46 and 51.

[12] W. B. Carnochan, *Lemuel Gulliver's Mirror for Man* (Berkeley, 1968), pp. 135–36.

[13] *The Tale of a Tub*, ed. A. C. Guthkelch and D. Nichol Smith (Oxford, 1958), p. 51. I have modernised the spelling of *Satyr* to prevent misunderstanding.

[14] *The Correspondence of Jonathan Swift*, ed. Harold Williams (Oxford, 1963–65) 2:430. The travel books appear in the list he compiled at Moor Park in 1697–98 and in the sale catalogue at the time of his death. Investigations into the sources of the *Travels* are surveyed in Milton Voigt, *Swift and the Twentieth Century* (Detroit, 1964), pp. 65–76, and Percy G. Adams, *Travel Literature and the Evolution of the Novel* (Lexington, 1983), pp. 142–44.

[15] On Swift's indebtedness to More and Erasmus, see Robert C. Elliott, *The Shape of Utopias: studies in a literary genre* (Chicago, 1970), pp. 52–67, and Jenny Mezciems, "Swift's Praise of Gulliver: some renaissance background to the *Travels*," in Claude Rawson, ed., *The Character of Swift's Satire: a revised focus* (Newark, 1983), pp. 245–281. The Goldsmith reference is, of course, to his *Letters from a Citizen of the World* (1760–61), based upon Montesquieu's *Lettres Persanes* of 1721.

[16] I:vi, in ed. cit., p. 59.

[17] II:iii, in ed. cit. p. 107.

[18] Edward W. Rosenheim, Jr., *Swift and the Satirist's Art* (1963; Chicago, 1982), p. 156, and Denis Donoghue, *Jonathan Swift: a critical introduction* (Cambridge, 1969), p. 19. The latter contains a helpful chapter on perspective in *Gulliver's Travels*, although from a viewpoint quite different from that adopted here.

[19] *The History of Tom Jones* I:xi, ed. Fredson Bowers (Middletown, Conn., 1975) 1:66–67. Cf. *The Dialogic Imagination: four essays by M. M. Bakhtin*, ed. Michael Holquist (Austin, 1981), especially pp. 301–8. The exuberant digressiveness within this carefully structured novel has been compared to the curling arabesques of the Rococo within their clearly demarked panels. See Roger Robinson's interesting essay, "Henry Fielding and the English Rococo," in R. F. Brissenden, ed., *Studies in the Eighteenth Century II* (Toronto, 1973), pp. 93–111. Frederick W. Hilles, "Art and Artifice in *Tom Jones*," in Maynard Mack and Ian Gregor, eds., *Imagined Worlds: essays on some English novels and novelists in Honour of John Butt* (London, 1968), pp. 91–110, discusses the relationship of the novel's structure to the symmetrical form of the Palladian house and, specifically, of Prior Park, the stately home built by John Wood for Fielding's patron Ralph Allen.

[20] II:1, IV:8, and IX:1 in ed. cit., 1:76, 177, and 492. The comic-epic remark appears in the preface to *Joseph Andrews*, ed. Martin Battestin (Middletown, 1967), p. 4. There is a discussion of the genre source in E.M.W. Tillyard, *The Epic Strain in the English Novel* (London, 1958), pp. 51–58.

[21] Cf. David Blewett, *Defoe's Art of Fiction* (Toronto, 1979), pp. 28–54. The theme of imprisonment in that century is discussed in W. B. Carnochan, *Confinement and Flight: an essay on English literature of the eighteenth century* (Berkeley, 1977), and John Bender, *Imagining the Penitentiary: fiction and the architecture of the mind in eighteenth-century England* (Chicago, 1987). The latter, written in the wake of Michel Foucault's work, provides a fascinating exploration of the interaction between the arts in the course of exploring the changing attitudes to imprisonment in that century. Hunter's *Reluctant Pilgrim*, with its reading of Robinson's travels as a journey of spiritual maturation, is not exclusive in its claim, acknowledging the level of realistic

narrative and social isolation in addition to the emblematic.

22 Robert E. Moore, *Hogarth's Literary Relationships* (Minneapolis, 1948), has been followed more recently by P. J. de Voogd, *Henry Fielding and William Hogarth: the correspondences of the arts* (Amsterdam, 1981).

23 The allusions to Hogarth in Fielding's work are conveniently listed by the editor in the footnote to *Tom Jones*, ed. cit., p. 66, and discussed in Ronald Paulson, *Hogarth: his life, art, and times* (New Haven, 1971) 1:468–71. Frederick Antal, *Hogarth and his Place in European Art* (London, 1962), offers a more general study of his contribution. The fact that Hogarth requested a picture of Fielding on which he could base the portrait he undertook after the latter's death has cast some doubt on the assumption that there existed a personal friendship, but there can be no question of their admiration for each other's work.

24 Cf. Ronald Paulson, *Rowlandson: a new interpretation* (New York, 1972), p. 13.

25 Letter of July 10 in *Humphry Clinker* (Oxford, 1925) 1:266. Hazlitt's comment appears in his *Lectures on the English Comic Writers* (London, 1819), p. 278. Cf. also Jean Hagstrum, "Verbal and Visual Caricature in the Age of Dryden, Swift, and Pope," in H. T. Swedenberg, Jr., ed., *England in the Restoration and Early Eighteenth Century: essays on culture and society* (Berkeley, 1972), pp. 173–95.

26 Wayne C. Booth, *The Rhetoric of Fiction* (Chicago, 1961), especially pp. 215f., whose principles were developed in John Preston, *The Created Self: the reader's role in eighteenth-century fiction* (London, 1970). Cf. also Norman H. Holland, "Unity, Identity, Text, Self," *Publications of the Modern Language Association of America* 90 (1975):813.

27 Northrop Frye, *Fearful Symmetry: a study of William Blake* (Princeton, 1967), p. 427.

28 E. D. Hirsch, Jr., *Validity in Interpretation* (New Haven, 1967), remains the most persuasive defence of the text as determining force, although it presents its case in philosophical terms rather than through close analysis of literary works.

29 Wolfgang Iser, *The Implied Reader: patterns of communication in prose fiction from Bunyan to Beckett* (Baltimore, 1974), especially pp. 29–56.

30 A copy of the pamphlet, printed in London in 1748, is preserved in the Bodleian Library.

31 Mother Needham was later pelted to death by an angry mob when pilloried for her activities. Colonel Charteris had already been charged and condemned to death for the rape of Sarah Solleto, "a poor Country Wench, friendless and pennyless," who had, on her arrival in London, been approached by Mother Needham and offered a position in his household. As so often in this period, Charteris, as a man of means and a gentleman, was granted the King's pardon. His trial, held a few months before Hogarth began work on the series, was still fresh in the minds of Londoners when it appeared, as the story of Charteris's seductions had been related in numerous contemporary pamphlets, e.g., the anonymous biography, *The Life of Col. Don Francisco*, containing a portrait of the accused at the time of his trial. Details are recorded in Paulson's *Hogarth* 1:244–48.

32 The pamphlet, trading on the popularity of John Gay, gave only the surname of the supposed author on the cover, entitled *Mr. Gay's Harlot's Progress*, but inside, the title read more explicitly *Morality in Vice: an Heroi-Comical Poem. In Six Cantos. By Mr. Joseph Gay. Founded Upon Mr. Hogarth's Six Prints of A Harlot's Progress . . . London: Printed in the Year MDCCXXXIII.* For details, see R. E. Moore, *Hogarth's Literary Relationships*, pp. 40–43.

33 Rosemary Freeman, *English Emblem*

Books (London, 1948), and Mario Praz, *Studies in Seventeenth-Century Imagery* (Rome, 1964).

[34] Stanley Fish has argued in *The Living Temple: George Herbert and catechizing* (Berkeley, 1978) that in Herbert's poems, many of which do use emblems (although in a far more sophisticated manner than Quarles), there is to be discerned a reliance upon the catechistic tradition, whereby the reader is posed a series of questions intended to elicit responses leading eventually to the discovery of some religious truth. But even on the few occasions when that system is invoked and the reader is induced to imagine that the discovery is his own, the process has, of course, been carefully staged, with the reader as disciple led step by step towards the prepared, reassuring conclusion of the poem.

[35] That detail is noted in Paulson, *Hogarth* 1:254.

[36] Iser, *The Implied Reader*, p. 36, and Michael Fried, *Absorption and Theatricality: painting and beholder in the age of Diderot* (Berkeley, 1980) especially pp. 66f. The technique of "reading" Hogarth's clues reached its culmination in John Ireland's *Hogarth Illustrated*, 2 vols. (London, 1791). It was a process paralleled on the continent, notably in Georg Christoph Lichtenberg's *Ausführliche Erklärung der Hogarthischen Kupferstiche*, produced intermittently from 1784 onwards and issued in collected form in 1799. For a close analysis of the principles governing the latter study, see Frederick Burwick, "The Hermeneutics of Lichtenberg's Interpretation of Hogarth," *Lessing Yearbook 19* (1987):167.

[37] XI:ix, in ed. cit., 2:614. In his illuminating study, *Fielding and the Nature of the Novel* (Cambridge, Mass., 1968), p. 35, Robert Alter noted, in connection with the sexual innuendoes in *Tom Jones*, Fielding's requirement that the reader exert a "prehensile activity of the mind" to catch such references before they slide by. Fielding's encouragement to the reader to make his own conjectures is discussed in terms of an educational process in Leo Braudy, *Narrative Form in History and Fiction* (Princeton, 1970), pp. 152–55.

[38] Both quoted in R. S. Crane's essay, "The Concept of Plot and the Plot of *Tom Jones*," in R. S. Crane, ed., *Critics and Criticism: ancient and modern* (Chicago, 1952), p. 616.

[39] Cf. A. E. Murch, *The Development of the Detective Novel* (London, 1958), pp. 27f. On the divergent American form, see the excellent essay by George Grella, "The Hard-Boiled Detective Novel," reprinted in Robin W. Winks, ed., *Detective Fiction: a collection of critical essays* (Woodstock, 1988), pp. 103f. I am grateful to my colleague Sharon Baris for drawing my attention to it. Ellen R. Belton, "Mystery without Murder: the detective plots of Jane Austen," *Nineteenth Century Literature* 43 (1988):42, has argued that there are hints of detective techniques in Austen's novels, but makes no claim for any earlier novelist.

[40] Dickens, *Bleak House* (Oxford, 1982), pp. 88 and 250. The connection between the realism of the early novel and the tradition of popular crime-reporting has been examined in Maximillian E. Novak, *Realism, Myth, and History*, pp. 121–45, where he points out how such crime-reporting began to desert the merely lurid in favour of what one contributor claimed in 1720 to be no longer "fictions, form'd only to amuse and please, of which our English Gentry seem so fond, but such as are supported by uncontested Truth." In art, Hogarth's series on the moral corruption of harlot and rake derive much of their sharp verisimilitude from that public interest in contemporary vice, as does, of course, Fielding's *Jonathan Wild*. But they may both be connected to the crime-reporting tradition in another sense, as is suggested here. On the Gothic origins of detective fiction, see William P. Day, *In the Circles of Fear and Desire:*

a *study of Gothic fantasy* (Chicago, 1985), pp. 50–59, which provides bibliographical sources for the Gothic attribution.

[41] References are to XVIII:ii and, for both latter quotations, XI:ii, in ed. cit., 2:916, 573,

and 576 respectively. There are further instances of addresses to the supposedly sagacious reader in 1:411 and 441.

[42] I:v, V:v, IX:vii, and III:vii, in ed. cit., 1:45–46, 230, 519, and 139.

CHAPTER 5

[1] *The Journal of Garden History*, 1981– , founded and edited by John Dixon Hunt, who has himself contributed significantly to research on that subject. Bibliographical references for the authors cited here appear in subsequent notes.

[2] Joseph Burke, *English Art 1714–1800* (Oxford, 1976), pp. 43–44, argues that there was some initial movement towards such gardens in France prior to the English interest, notably in the designs of the dramatist Charles Dufresny de la Rivière who submitted to Louis XIV two plans for gardens at Versailles. The plans were, Burke admits, rejected. Whatever faint stirrings may be perceived on the continent, it is acknowledged that England was at the forefront of development and implementation of the new landscape art. This is not to deny the importance of the Italian version as a model, a subject examined in John Dixon Hunt's recent study *Garden and Grove: the Italian renaissance garden in the English imagination, 1600–1750* (London, 1986). But in the eighteenth-century revival of that interest, it is, I believe, the adaptation of the model to contemporary English taste that reveals the nature of the attraction.

[3] J. Thomson, *The Castle of Indolence* 1:38, in *Complete Poetical Works*, ed. J. L. Robertson (Oxford, 1951), p. 265.

[4] Elizabeth W. Manwaring, *Italian Landscape in Eighteenth Century England: a study chiefly of the influence of Claude Lorrain and Sal-*

vator Rosa on English taste, 1700–1800 (New York, 1925), pp. 43–44.

[5] Barbara Jones, *Follies and Grottoes* (London, 1953), p. 57, republished in 1974 in an expanded version.

[6] David Jacques, *Georgian Gardens: the reign of nature* (London, 1983), p. 17. On Tyers's professional activities, see James G. Southworth, *Vauxhall Gardens: a chapter in the social history of England* (New York, 1941), pp. 32f.

[7] Details of the re-assessments by Phillip Harth and Donald Greene appear in note 47 to chapter 3 above.

[8] John Donne, "Sermon Preached at Whitehall, February 11, 1626/7," in *Sermons* ed. George R. Potter and Evelyn M. Simpson (Berkeley, 1953–62), 7:361–62.

[9] Fielding frequently praises Barrow's teachings in the course of his novels, most notably when Captain Booth, confined in the bailiff's house for gambling debts, reads Dr. Barrow's sermons in proof of the Christian religion—"If ever an Angel might be thought to guide the Pen of a Writer, surely the Pen of that great and good Man had such an Assistant"—and as a result repents of his misdeeds. See *Amelia*, ed. Martin C. Battestin (Oxford, 1983), p. 511, and on the importance of Barrow's work for Fielding's moral and religious beliefs, Battestin's essay in *The Journal of English Literary History* 41 (1974): 613.

[10] Isaac Barrow, *Works* (New York, 1845) 2:180.

11 John Tillotson, *Sermons on Several Subjects and Occasions* (London, 1743) 1:43–44 and 3:105; and see Horton Davies, *Worship and Theology in England* (Princeton, 1975) 2:183, for a discussion of his rationalism. Even William Law, who is generally regarded as an opponent of rationalism, wrote in similar vein in his treatise, *A Serious Call to a Devout and Holy Life*, first issued in 1728: "It is therefore an immutable law of God, that all rational beings should act *reasonably* in *all* their actions; not at this *time*, or in that *place*, or upon this *occasion*, or in the use of some particular thing, but at *all* times, in *all* places, on *all* occasions, and in the use of *all* things"— quoted from the London edition of 1806, p. 70.

12 Michel Foucault, *Madness and Civilization: a history of insanity in the age of reason*, trans. Richard Howard (New York, 1965), pp. 244 and 256. His comment was made in connection with the establishment of Samuel Tukes's Retreat for the Insane in York during the latter part of the eighteenth century. See also Roy Porter's valuable study, *Mind Forg'd Manacles: a history of madness in England from the Restoration to the Regency* (London, 1987), especially pp. 62–81.

13 Thomas Parnell, *The Ecstasy*, in *Poetical Works*, ed. George A. Atiken (London, 1894), p. 212. Cf. also his *Piety: or the Vision*, pp. 110–114, which again presents the celestial scene in terms of a dream out of which the speaker eventually awakes into reality.

14 Samuel Johnson, *The Life of Waller*. A similar sentiment had been expressed earlier in Shaftesbury's "Advice to an Author" included in his *Characteristics of Men, Manners, Opinions, Times etc.*, ed. John M. Robertson (New York, 1900) 1:229. Since human wit can never aspire to what was divinely dictated, he argued, " 'twould be in vain for any poet or ingenious author to form his characters after the models of our sacred penmen." The prose devotions, which Johnson had composed over many years and for many different occasions, were collected with his permission during his final illness by the Rev. George Strahan and published in 1785 under the title *Prayers and Devotions*. The quotation is from the entry for Easter, 1761. Boswell records how agitated Johnson became when fear of death was mentioned, adding picturesquely: "His mind resembled the vast amphitheatre, the Colisseum at Rome. In the centre stood his judgement which, like a mighty gladiator, combated those apprehensions that, like the wild beasts of the *Arena*, were all around in cells, ready to be let out upon him. After a conflict, he drives them back into their dens; but not killing them, they were still assailing him"—*Life of Johnson* (Oxford, 1946) 1:404.

15 Charles Wesley's hymn *Jesu, Lover of my Soul*, 9–12.

16 Lawrence Stone, *The Family, Sex, and Marriage in England* (New York, 1979), pp. 154–55, and *Nicholas Ferrar: Two Lives*, ed. J.E.B. Mayor (Cambridge, 1855), p. 279.

17 J. G. Spurzheim, *Observations on . . . Insanity* (London, 1817), p. 154.

18 Carole Fabricant, "Aesthetics and Politics of Landscape" in Ralph Cohen, ed., *Studies in Eighteenth Century British Art and Aesthetics* (Berkeley, 1985), pp. 49–81, her reference being to *Spectator* 412.

19 John Barrell, *The Idea of Landscape and the Sense of Place, 1730–1840: an approach to the poetry of John Clare* (Cambridge, 1972), pp. 64–97.

20 *Spectator* 412 and 413.

21 Charles Cotton, *The Wonders of the Peake* (London, 1681); Addison, *Spectator* 477; and *Elizabeth Montagu, the Queen of the Bluestockings: her correspondence from 1720–1761*, ed. Emily J. Climenson (London, 1906) 2:189. Vicesimus Knox similarly remarked of Hagley that "the word Paradise itself is synonymous with garden"; see "On the Pleasures of a Garden" included in his *Essays Moral and*

Literary (London, 1778–79). Christopher Hussey, in his book *The Picturesque: studies in a point of view* (London, 1927), p. 25, comments that Paradise becomes synonymous with "prospect" in this period, and the opening chapter of Max F. Schulz, *Paradise Preserved: recreations of Eden in eighteenth and nineteenth century England* (Cambridge, 1985), offers a number of further instances of what is by now an acknowledged identification. Dustin Griffin, *Regaining Paradise: Milton and the Eighteenth Century* (Cambridge, 1986), has recently examined attempts to restore the Edenic world within the literature of that period. The earlier traditions, including the belief in an Eden beyond the seas, are recorded in George Boas's discussion of "Earthly Paradises" in *Essays on Primitivism and Related Ideas in the Middle Ages* (Baltimore, 1948), pp. 158f., and Jeffry B. Spencer, *Heroic Nature: ideal landscape in English poetry from Marvell to Thomson* (Evanston, 1973). From a reading of John Prest, *The Garden of Eden: the botanic garden and the re-creation of Paradise* (New Haven, 1981), which traces the changing attitudes to the garden in terms of prevailing ideas of Paradise, it becomes apparent how the attempt to re-create it on earth was a phenomenon specific to the seventeenth and eighteenth centuries.

[22] Stephen Switzer, *Ichnographia Rustica: or the nobleman, gentleman, and gardener's recreation* (London, 1718) 1:98–99.

[23] Luke 23:43.

[24] Marvell's *Garden*, 52–56, and Milton's *Paradise Lost*, 12:458–65 and 634–36.

[25] *Life and Letters of Edward Young*, ed. H. C. Shelley (Boston, 1914), p. 282; Horace Walpole, *Essay on Gardening*, appended to the fourth edition of his *Anecdotes of Painting* (London, 1771).

[26] Jay Appleton, *The Experience of Landscape* (London, 1975), and Daniel Bellamy, *Ethic Amusements*, the 1768 edition including an engraving of a Claude painting added by his son. For English artists influenced by Claude Lorrain, see Deborah Howard, "Some Eighteenth Century Followers of Claude," *Burlington Magazine* (December, 1969):726. Jonathan Richardson is reputed to have owned over eighty Claude drawings.

[27] Samuel H. Monk, *The Sublime: a study of critical theories in eighteenth-century England* (New York, 1935), pp. 31–32.

[28] Martin Shee, *Elements of Art: a poem in six cantos* (London, 1809), quoted by Monk, p. 3.

[29] Donne, *Holy Sonnet 14*.

[30] Marjorie H. Nicolson, *Mountain Gloom and Mountain Glory: the development of the aesthetics of the infinite* (1959; New York, 1963), pp. 213–14. Quotations are from Thomas Burnet, *The Sacred Theory of the Earth* (London, 1726) 1:188–89 and 155, which was originally published in Latin in 1681 as *Telluris Theoria Sacra*, the first English version appearing in 1684. The apostrophe to the mountains, "That do with your hook-shoulder'd height / The Earth deform," is from Marvell's *Upon the Hill and Grove at Billborrow*, in *Poems and Letters*, ed. H. M. Margoliouth (Oxford, 1927) 1:56.

[31] *Mountain Gloom*, p. 221. Similarly, she remarks in a footnote (p. 29) that the sublime is religious in origin, but her comment is not pursued further.

[32] Ernest Tuveson, "Space, Deity, and the 'Natural Sublime,' " *Modern Language Quarterly* 12 (1951):20. David B. Morris, *The Religious Sublime: Christian poetry and critical tradition in 18th century England* (Lexington, 1972), provides a valuable survey of the religious sublime in literary tradition but relates its genesis neither to rationalist suppression of spontaneous emotion nor to the concurrent conception of the Beautiful. Cf. also his article on "Gothic Sublimity" in *New Literary History* 16 (1985):299, an issue devoted to the theme of the sublime and the beautiful. The persistence of Burnet's influence on the Ro-

mantics may be seen in the lengthy note and quotation from the *Telluris Theoria Sacra* appended by Wordsworth to his *Excursion*, where he acknowledges the pleasure with which he had read it. See his *Poetical Works*, ed. E. de Selincourt (Oxford, 1950), p. 727.

[33] Samuel Johnson, *A Journey to the Western Islands*, in *Works*, ed. Arthur Murphy (London, 1806) 8:251.

[34] George Herbert, *The Flower*, 29–32 and 43–49, in *Works*, ed. F. E. Hutchinson (Oxford, 1959), pp. 166–67.

[35] *Paradise Lost* 9:600, 738, and 1001–2.

[36] From Locke's introduction to *An Essay Concerning Human Understanding* (1690).

[37] On the general history of the term "sublimation" and its relationship to the term "sublime," see Jan Cohn and Thomas H. Miles, "The Sublime in Alchemy, Aesthetics and Psychoanalysis," *Modern Philology* 74 (1977):289, and James B. Twitchell, *Romantic Horizons: aspects of the sublime in English poetry and painting, 1770–1850* (Columbia, Mo., 1983), pp. 4–7. Neil Hertz, *The End of the Line* (New York, 1985), p. 6, describes the sublime as a transfer of power, or a simulation of such transfer, from threatening forces to the poetic activity itself.

[38] Cf. Steele's essay *Spectator* 146 in praise of "that admirable Writer, the Author of the Theory of the Earth," and Addison's poem to Burnet, prefixed to the work in both its Latin and English versions from the 1719 edition onwards.

[39] *Sacred Theory* 1:89, 131–34, and 188–89.

[40] Morton D. Paley, *The Apocalyptic Sublime* (New Haven, 1986), while, as I have noted, accepting the traditional Longinian attribution, provides some valuable information supportive of the theory proposed here. Apart from noting the frequency with which the Deluge was painted (pp. 8–9), he draws attention to the extraordinary fascination among English artists for the theme *Death on a Pale Horse* from the Book of Revelation with its allegorical depiction of terrifying divine vengeance. John Hamilton Mortimer's version of 1775 produced numerous progeny, among them paintings by de Loutherbourg, Blake, Turner, Martin, Colman, and Danby.

[41] William Cowper, *The Castaway*, 61–66, in *Poetical Works*, ed. H. S. Milford (Oxford, 1967), p. 432.

[42] Jean Hagstrum rightly draws attention in his *Sister Arts*, p. 251, to this diversified interest in the seasons—a subject surprisingly ignored in Alan D. McKillop's *The Background of Thomson's "Seasons"* (Minneapolis, 1942)—but, by including the fifteenth-century Books of Hours, Hagstrum extends it far back beyond our period. I would suggest that the illuminations in the Books of Hours are quite different in purpose and in presentation. They appeared, in that book of meditation for laymen, in the Calendar traditionally prefacing it which marked with red letters the days in the year sacred to specific saints. Each month (not season) would, as in the Limbourg brothers' *Les Très Riches Heures du Duc de Berry*, be headed with an illustration relevant to that month either agriculturally or ceremonially. But there was no particular awareness of an ordered cycle, divided into four formal seasons, such as emerges so prominently in this later period.

[43] S. Freud, *The Future of an Illusion* (New York, 1953) especially chapter 4, and J. G. Frazer, *The Golden Bough: a study in magic and religion* (New York, 1960), pp. 448f.

[44] James Thomson, *A Hymn on the Seasons*, 16–20, ed. cit., pp. 245–46. Ralph Cohen, *The Unfolding of "The Seasons"* (Baltimore, 1970), p. 2, rightly emphasizes Thomson's awareness of man's inability, when he sows in the spring, to ensure that he will reap in the autumn, of man's pleasure in calm weather, and of his impotence before the storm.

[45] W. Sauerländer, "Die Jahreszeiten," *Munchner Jahrbuch der bildenden Kunst*, third se-

ries, 7 (1956):169. See also Anthony Blunt, *Nicholas Poussin* (New York, 1967) 1:332–34.

⁴⁶ As Brown quarrelled with Lord Lyttelton in 1760, the letter must have been written shortly before then. The quotation is from Dodsley's *Miscellany* (London, 1775) 1:51. One must read the eighteenth-century references to Poussin with care, as his brother-in-law, Gaspard Dughet, who was often associated with these three main inspirers of natural views, adopted the family name and was often known later as Gaspard Poussin.

⁴⁷ Manwaring, *Italian Landscape*, p. 229.

⁴⁸ For the manner in which pre-existent notions were read into Salvator Rosa's life and work, see John Sunderland, "The Legend and Influence of Salvator Rosa in England in the Eighteenth Century," *Burlington Magazine* 115 (1973):785.

⁴⁹ *Aedes Walpolianae: or a Description of the Collection of Pictures at Houghton-Hall in Norfolk* (London, 1752), p. xi. Cf. also Reynolds, *Discourses on Art* (London, 1969), p. 65, where he accuses the Dutch landscape artists of literalism in their fidelity to the actual scene as opposed to the more imaginative interpretations by the Italian painters.

⁵⁰ The letter, written four days after the crossing on 25 October 1688, is reprinted in his *Critical Works*, ed. E. N. Hooker (Baltimore, 1939–43) 2:380–82.

⁵¹ The satire appears in the comedy by Gay and Pope, *Three Hours After Marriage* (London, 1717), p. 21. Monk's *Sublime*, pp. 47–54, and Morris, *The Religious Sublime*, pp. 47–78, examine Dennis's critical works in this connection. The quotation on Longinus is from *Critical Works* 1:361.

⁵² Dennis, *The Grounds of Criticism in Poetry*, ed. cit., 1:356 and 362.

⁵³ Shaftesbury, *Characteristics* 1:39 and 2:123–25.

⁵⁴ Job 4:13–17 and William Smith, *Dionysius Longinus on the Sublime: translated from the Greek with notes and observations* (London,

1800), p. 116. The Job passage is quoted here with the dramatic punctuation of Smith's citation.

⁵⁵ Edmund Burke, *A Philosophical Enquiry into the Origin of our Ideas of the Sublime and Beautiful* (London, 1798), pp. 108–9; John Baillie, *An Essay on the Sublime* (London, 1747), in the Augustan Reprint Society edition (Los Angeles, 1953), p. 32; and Lord Kames (Henry Home), *Elements of Criticism* (Edinburgh, 1763) 1:314–15. On Kames, see W. J. Hipple, Jr., *The Beautiful, the Sublime, and the Picturesque in Eighteenth-century British Aesthetic Theory* (Carbondale, 1957), p. 112, and Edward Malins, *English Landscaping and Literature 1660–1840* (New York, 1966), pp. 91–93.

⁵⁶ Thomas Gray in a letter to Richard West dated 16 November 1739, in *Correspondence*, ed. P. Toynbee and L. Whibley (Oxford, 1935) 1:128.

⁵⁷ An anonymous poem published in the *Gentleman's Magazine* 13 (1743):608. Martin Price, "The Sublime Poem: pictures and powers," *Yale Review* 58 (1968):194, examines the experience of transcendence in such poems.

⁵⁸ Mary Wallstonecroft Shelley, *Frankenstein* (London, 1961), pp. 103 and 143. For evocations of *The Ancient Mariner*, see pp. 10 and 53.

⁵⁹ Richard Graves, *Euphrosyne* (London, 1776), p. 262.

⁶⁰ Robert Morris, "Lectures on Architecture" delivered in 1734.

⁶¹ Cf. J. Dixon Hunt, *The Figure in the Landscape: poetry, painting, and gardening during the eighteenth century* (Baltimore, 1976), pp. 46–47, and Frances Ferguson, "Legislating the Sublime," in Ralph Cohen, ed., *Studies in Eighteenth-Century British Art*, 128–147.

⁶² The entry for *grotto* in the Oxford English Dictionary attributes the origin of the word to a corruption in popular Latin of *crupta* to *grupta*. For an example of that earlier

grotto tradition incorporated into western medieval art, cf. the twelfth-century Nativity scene in the Palatine Chapel at Palermo, where the birth is presented as occurring before the entrance to a cave—the iconographic equivalent in that period of its having taken place within the cave. In relation to this grotto association too, it should be stressed that the theory proposed here is not intended to minimize the conscious indebtedness of these builders to the Italian model; but the religious elements within the eighteenth-century versions were, I would suggest, more profound than has been realized and hence reveal a more local and contemporary motivation than mere pastiche.

[63] Details, including an illustration of the Crown of Thorns, appear in Maynard Mack, *The Garden and the City: retirement and politics in the later poetry of Pope 1731–43* (Toronto, 1969), pp. 63–64. He plays down the devotional significance of these emblems, but admits that it is difficult to assess Pope's religious intent. There is a detailed account of Pope's gardening interests in Peter Martin's recent study, *Pursuing Innocent Pleasures: the gardening world of Alexander Pope* (Hamden, 1985).

[64] A letter from John Evelyn to Sir Thomas Browne, dated 28 January 1659/60, in *The Works of Sir Thomas Browne*, ed. Geoffrey Keynes (Chicago, 1964) 4:275.

[65] "Oakley. To Sir John Chetwode, Baronet," in *Poems on Several Occasions. Published by Subscription* (Manchester, 1733), p. 109. On the connection of grottoes with caverns, see Robert A. Aubin, "Grottoes, Geology, and the Gothic Revival" *Studies in Philology* 31 (1934):408.

[66] Ann Radcliffe, *The Mysteries of Udolpho* (London, 1949) 2:312.

[67] Barbara Jones, *Follies and Grottoes*, p. 57.

[68] For William Stukeley, see John Dixon Hunt, *The Figure in the Landscape*, pp. 2–3, which includes a drawing of the hermitage itself; for Charles Hamilton, ibid., p. 8; for the comic verses at Stowe, Ronald Paulson, *Emblem and Expression: meaning in English art of the eighteenth century* (Cambridge, Mass., 1975), p. 23; and for Simeon Stylites, Edward Gibbon, *The Decline and Fall of the Roman Empire* (London, 1820) 6:265–6.

[69] Thomas Parnell, *Poetical Works*, pp. 100 and 98–99. William Hayley, for example, liked to be known to his friends as the Hermit of Eartham, a predilection which Blake indulged in a poem appearing in Geoffrey Keynes's edition of the *Complete Writings* (London, 1966), p. 800. Northrop Frye, *The Secular Scripture: a study of the structure of romance* (Cambridge, Mass., 1976), although it deals primarily with mythic transfer, offers some support for the central concern of this chapter in its recognition of the close underlying relationship between the religious and secular forms of literature, often interchanged without the author's conscious intent. Thomas Weiskel, *The Romantic Sublime: studies in the structure and psychology of transcendence* (Baltimore, 1976), p. 14, who follows Monk in regarding the sublime as primarily Longinian in source, suggests that religious emotions were removed from the Deity and associated with natural phenomena and concludes that the sublime was by now largely divorced from its source. Geoffrey G. Harpham, *On the Grotesque: strategies of contradiction in art and literature* (Princeton, 1982), suggests in post-structural terms that throughout European history the contrast to the sublime has been the grotesque, rather than, as the eighteenth century believed, the beautiful.

[70] Quoted in J. Butt's volume in the Oxford History of English Literature, *The Mid-Eighteenth Century*, ed. and completed by Geoffrey Carnall (Oxford, 1979), p. 65.

[71] For the persistence of the skull within the hermitages, see Barbara Jones, *Follies and Grottoes*, 1974 edition, p. 186, a passage not

appearing in the earlier edition; and on the general theme of graveyard and other mournful poetry, Eleanor M. Sickels, *The Gloomy Egoist: moods and themes of melancholy from Gray to Keats* (New York, 1932).

[72] Joel Porte's essay, "In the Hands of God: religious terror in Gothic fiction," in G. R. Thompson, ed., *The Gothic Imagination: essays in dark romanticism* (Seattle, 1974), p. 42. M. H. Abrams's stimulating study, *Natural Supernaturalism: tradition and revolution in romantic literature* (New York, 1971), examines the secularizing of religious faith only in relation to the period of romanticism itself; but on the assumption that that manifestation marked the culmination of earlier tendencies, it would seem to corroborate suggestions offered here concerning the origins of the sublime. The Edenic element in Gothicism is discussed by William Patrick Day, *In the Circles of Fear and Desire: a study of Gothic fantasy* (Chicago, 1985), especially pp. 6–8, while the Gothic elements within the poetry of the time are examined in Patricia M. Spacks, *The Insistence of Horror: aspects of the supernatural in eighteenth-century poetry* (Cambridge, Mass., 1962).

[73] For the reading of this etching in classical terms, see Richard W. Wallace, *The Etchings of Salvator Rosa* (Princeton, 1979), pp. 60–62. Portraits of the monk or saint contemplating a skull are frequent in the years when this etching was executed, typified by Zurbarán's *St. Francis in Meditation* of 1639, in the National Gallery, London, or Georges de la Tour's *Mary Magdalen with Candle*, also from the 1630s, recently purchased by the Louvre.

[74] The Pigalle tomb scene has often been misread in the modern era as representing the widow's plea to Death that he forego his task and restore her departed husband; but the desire of the Comtesse for a *réunion conjugale* within the tomb and her instructions that the sentiment be immortalized in marble were widely known and applauded at the time, by Diderot among others. The incident is discussed in Louis Réau, *J.-B. Pigalle* (Paris, 1950), pp. 99f., and Jean Seznec, *Essais sur Diderot et l'Antiquité* (Oxford, 1957), p. 38.

CHAPTER 6

[1] Northrop Frye, who first drew attention to this element in his "Poetry and Design in William Blake," *Journal of Aesthetics and Art Criticism* 10 (1951):35, was followed by Jean Hagstrum, *William Blake: poet and painter* (Chicago, 1964), and W.J.T. Mitchell, *Blake's Composite Art: a study of the illuminated poetry* (Princeton, 1978).

[2] Anthony Blunt, *The Art of William Blake* (New York, 1959), pp. 1–2, points out with justice that, had Blake died at the age of thirty, his fame as a poet would have been secure, but as a painter he would have been remembered, if at all, only as a very minor and rather incompetent illustrator of literary texts.

[3] On the inefficacy of his *Tyger* illustration, frequently noted by critics, see, for example, Harold Bloom, *The Visionary Company: a reading of English romantic poetry* (New York, 1963), p. 33, which describes it as "a shabby, pawn-shop sort of stuffed tiger, more an overgrown house-cat." David V. Erdman, *The Illuminated Blake* (New York, 1974), p. 84, similarly notes that in the various versions its expression ranges from supercilious to gentle, never conveying the intimidating power of the poetic vision.

[4] In his own analysis of the work, contained in a letter to Ozias Humphry, who had been instrumental in obtaining the commission, Blake claimed that no figure in it had been copied directly from Michelangelo's fresco. The general indebtedness is, however, sufficiently apparent, as his own denial suggests. The letter is reprinted in Martin Butlin's splendid work, *The Paintings and Drawings of William Blake* (New Haven, 1981) 1:467–68, and in *The Complete Poetry and Prose of William Blake*, ed. David V. Erdman (Berkeley, 1982), pp. 552–54, the latter being the text used for all subsequent quotations. There are, of course, other extant versions by Blake on this specific theme, but my discussion here is restricted to the most finished and the most effective of them, the version at Petworth House. Albert S. Roe, "A Drawing of the Last Judgement," *Huntington Library Quarterly* 21 (1957):37, discusses the Rosenwald copy and provides details of the other extant versions. Blake probably knew of the Sistine Chapel altarpiece through the engraving of it by Bonasone which was in the collection of George Cumberland, as W.J.T. Mitchell notes in his *Blake's Visions of the Last Judgement* issued for the MLA Blake Seminar of 1975.

[5] In his preface to *Reliques of Ancient English Poetry*, Percy felt it necessary to offer a defence, expressing the hope that the names of the many men of learning he had quoted would "serve as an amulet, to guard him from every unfavourable censure for having bestowed any attention on a parcel of Old Ballads." On the reception accorded to Addison's advocacy of "Chevy Chace" in *Spectator*, numbers 70 and 489, see R. P. McCutcheon, "Another Burlesque of Addison's Ballad Criticism," *Studies in Philology* 23 (1926):451, and more generally, S. B. Hustvedt, *Ballad Criticism . . . During the Eighteenth Century* (New York, 1916), pp. 65–78. Alicia Ostriker, *Vision and Verse in William Blake* (Madison, 1965), pp. 27–30, discusses Blake's indebtedness to the ballad tradition.

[6] Robert E. Simmons, "*Urizen*: the symmetry of fear," in David V. Erdman and John E. Grant, eds., *Blake's Visionary Forms Dramatic* (Princeton, 1970), pp. 146–73.

[7] The indebtedness of Blake's prophetic verse forms to Lowth's parallelist theory of Hebrew poetry was suggested in my *Prophet and Poet: the Bible and the growth of Romanticism* (London, 1965), pp. 159–70, and discussed further in Morton Paley's *Continuing City: William Blake's "Jerusalem"* (Oxford, 1983), pp. 44–5. There is an interesting examination of Blake's more general indebtedness to Lowth, although only briefly touching upon the verse form, in Leslie Tannenbaum, *Biblical Tradition in Blake's Early Prophecies: the great code of art* (Princeton, 1982).

[8] Robert Lowth's lectures, *De Sacra Poesi Hebraeorum . . .* , published in their original Latin in 1753, appeared in a translation by G. Gregory entitled *The Sacred Poetry of the Hebrews* (London, 1787). James Kugel, *The Idea of Biblical Poetry: parallelism and its history*, pp. 96f., discusses Lowth's forerunners. For a linguistic examination, see Adele Berlin, *The Dynamics of Biblical Parallelism* (Bloomington, 1985).

[9] In 1756, three years before composing his *Jubilate Agno*, Smart reviewed Lowth's lectures in the January and February issues of his *Universal Register*. See W. F. Stead, *Rejoice in the Lamb* (London, 1939), p. 297. The quotation is from Smart's *Jubilate Agno*, 3–6, in *Poetical Works*, ed. Karina Williamson (Oxford, 1980) 1:1.

[10] "Fingal," in *The Poems of Ossian: translated by James Macpherson*, ed. William Sharp (Edinburgh, 1926), p. 36, now generally believed to be an eighteenth-century pastiche. Blake rejects the charge that they are spurious in his *Annotations to Wordworth's Poems*, adding: "I own myself an admirer of Ossian

equally with any other Poet whatever Rowley & Chatterton also."

[11] *The Four Zoas: night the ninth* 124:1–4, ed. cit., p. 393. I have marked the caesuras here, as in the previous quotation, to highlight the rhythmical effect.

[12] For the motif of twin cherubim derived from those described in Exodus 25:18, cf. Blake's *Christ Girding Himself with Strength*, *Christ in the Sepulchre*, or *Night of Peace*, among numerous others.

[13] Ed. cit., p. 145–46.

[14] Ed. cit., p. 758, the punctuation modernized. The quotation is from Isaiah 6:3.

[15] *A Vision of the Last Judgment*, ed. cit., p. 565.

[16] Examined in the two opening chapters of Robert Rosenblum's illuminating study *Modern Painting and the Northern Romantic Tradition: Friedrich to Rothko* (New York, 1975).

[17] The altarpiece was publicly attacked by the collector Ramdohr for the profanity of the artist in "sneaking landscape painting into the church." The incident is discussed in Linda Siegel, *Caspar David Friedrich and the Age of German Romanticism* (Boston, 1978). p. 55.

[18] Jeremy Collier, *A Short View of the Immorality and Profaneness of the English Stage* (London, 1698), had been preceded by the diatribe against the laxity of morals there in Sir Richard Blackmore's preface to his epic *Prince Arthur* of 1695.

[19] Paul E. Parnell, "The Sentimental Mask," *Publications of the Modern Language Association of America* 78 (1963):529, discusses the unconscious hypocrisy implicit in such portrayal.

[20] R. Steele, *The Conscious Lovers* (1723), ed. Shirley S. Kenny (Lincoln, Nebraska, 1968), p. 24. Cf. Indiana's emphasis upon that aspect of the hero's virtues at the conclusion of Steele's play: "Oh, had I spirits left to tell you of his actions! how strongly filial duty has

suppressed his love, and how concealment still has doubled all his obligations."

[21] *The Dramatic Works of Samuel Foote* (London, 1797) 1:385.

[22] See Northrop Frye, *Anatomy of Criticism: four essays* (Princeton, 1971), pp. 164–65. Tony Lumpkin's unbridled disrespect towards his mother is, of course, allowable in a clownish figure hopelessly unconformable to the laws of ordinary society.

[23] Boswell, *The Life of Samuel Johnson* (Oxford, 1946) 2:612.

[24] Robert Rosenblum, *Transformations in Late Eighteenth Century Art* (Princeton, 1967), pp. 50–106, where he also records other versions of the Brutus scene. The alteration of the official scale of fees in France and the establishment of the Ecole Royale to train young artists in history painting is documented in Jean Loquin, *La Peinture d'histoire en France de 1747 à 1785* (Paris, 1912), pp. 1–40. Wordsworth's poem *Michael* is, of course, a further exploration of the theme, but with the significant difference that its message has been changed from a warning against filial disobedience to the sentiment that there is "a comfort in the strength of love," a sympathy with the sorrowing yet continued faith of the father in the biblical covenant, symbolized by the heap of stones.

[25] Cf. Gnaphaeus's *Acolastus*, translated into English by John Palsgrave and published in London in 1540, and, the most famous collection of such plays, Schonaeus's *Terentius Christianus*, published in Cologne in 1592 and in London later the same year. Details of the latter's wide use in the schools appear in Foster Watson, *The English Grammar Schools to 1660* (Cambridge, 1908), pp. 322f.

[26] Paul A. Cantor, *Creature and Creator: myth-making and English romanticism* (Cambridge, 1985), especially pp. 4–23. In assessing the extent of Rousseau's influence, Cantor attributes Blake's generally negative comments upon him as arising from the

poet's incorrect bracketing of Rousseau with the *philosophes*, and Cantor offers convincing evidence of the indebtedness of the Romantics to these aspects of Rousseau's philosophy. Jean Hagstrum, "Blake and British Art: the gifts of grace and terror," in Karl Kroeber and William Walding, eds., *Images of Romanticism* (New Haven, 1978), p. 61, notes that Blake may have been influenced by Thomas Stothard's depictions of children. There is an interesting linguistic examination of Blake's depiction of babes, and the primary words he places in their mouths, in Robert N. Essick, *William Blake and the Language of Adam* (Oxford, 1989), pp. 109–11.

[27] *The Book of Urizen* 2:31–33, ed. cit., p. 72. John Sutherland "Blake and Urizen," in Erdman and Grant, *Blake's Visionary Forms Dramatic*, pp. 244f., attributes Blake's repressive father figures to the poet's relationship to his own father; but that explanation divorces the phenomenon from the notable parallels to it in contemporary art and literature.

[28] "And may I not presume a little further, to show the reasonableness of this word *vates*, and say that the holy David's Psalms are a divine poem? If I do, I shall not do it without the testimony of great learned men, both ancient and modern. But even the name of Psalms will speak for me, which, being interpreted, is nothing but songs; then that it is fully written in metre, as all learned hebricians agree, although the rules be not yet fully found . . ." Sir Philip Sidney, *A Defence of Poetry*, ed. J. Van Dorsten (Oxford, 1966), p. 22. William Kerrigan, *The Prophetic Milton* (Charlottesville, N.C., 1974) traces in its opening chapters the poet's relationship to the developing ideas of prophecy in post-biblical periods rather than to the original form.

[29] John Dryden, *Works*, ed. W. Scott and G. Saintsbury (London, 1882–93) 15:407.

[30] Wordsworth, *The Prelude* (1805 version) 1:60–63, ed. E. de Selincourt (Oxford, 1969), p. 2.

[31] *On Virgil*, ed. cit., p. 267. See also his attack on the classics in the Preface to his *Milton*, ed. cit., p. 94.

[32] The term *massa* in Hebrew may also be connected with the word for "elevation," in the same way as the English translation carries the secondary meaning of a refrain; but in both languages the primary meaning is clear. The reason for the reluctance of the prophets to undertake their mission is never specified, but an enigmatic comment in the thirteenth-century midrashic collection *Yalkut Shimeoni*, based upon much older sources, offers an illuminating insight in its comparison of three concepts of justice within the scriptures: "Prophecy was asked, what shall be done to the sinner? It replied, he shall die. The Pentateuch was asked, what shall be done to the sinner? It replied, he shall bring a guilt-offering and be acquitted. God himself was asked, what shall be done to the sinner? He replied, let him repent and he shall be acquitted." The prophet, it suggests, instinctively demands as a mortal the full and visible execution of justice as a prerequisite for repentance, thereby retrospectively justifying his own sombre warnings. He offers comfort only when the punishment has been fully meted out: "Comfort ye, comfort ye my people . . . for she hath received of the Lord's hand double for all her sins" (Isaiah 40:1–2). Jonah, fleeing because he foresees that his prophesying to the people of Nineveh will bring about their repentance, must be taught through the incident of the gourd the superior principle of divine forgiveness: "Then said the Lord, thou hadst pity on the gourd, for which thou didst not labour nor madst it grow . . . And should not I spare Nineveh that great city wherein are more than six-score thousand persons" (Jonah 4:10–11). See *Yalkut Shimeoni* (Vilna, 1898), vol. 2, comment 702 on Psalms, appearing in an earlier, slightly

shortened form in the Jerusalem Talmud, Tractate *Makkot*, chapter ii, ruling 6.

[33] Exodus 2–3.

[34] The idea of a deutero-Isaiah is not modern. Ibn Ezra suggested in his twelfth-century commentary the possibility that chapters 40 onward were written by another hand. For late-biblical works being attributed by their authors to earlier visionaries whose status might lend authority to their writings, cf. the anonymous Book of Enoch from the Apocrypha, purporting to contain revelations granted to Enoch and Noah.

[35] Cf. Ezekiel 33:32, on the emptiness of poetry when enjoyed for its beauty rather than its moral truths: "Thou art to them as the lovesong of one that hath a pleasant voice and plays well on an instrument; for they hear thy words but they fulfil them not."

[36] *Paradise Lost* 9:21–26, and on the choice of verse form, Milton's prefatory paragraph to the work as a whole. Blake also claimed at times to write "from immediate Dictation, twelve or sometimes twenty or thirty lines at a time without Premeditation & even against my Will" (Letter to Thomas Butts, 25 April 1803, ed. cit., p. 729), but he seems to have been referring to the control of his poetic mind over his conscious thinking process rather than to divine dictation.

[37] Leopold Damrosch, Jr., *Symbol and Truth in Blake's Myth* (Princeton, 1980), especially pp. 255–301.

[38] *Jerusalem* 1:5:17–19, ed. cit., p. 147.

[39] Letter to Thomas Butts, 10 January 1803, ed. cit., p. 724; *Annotations to Wordsworth*, ed. cit., p. 665; and *Jerusalem*, plate 77, ed. cit., p. 231. The Addison reference is, of course, to *Spectator* 411–21. On this distinction between biblical prophecy and Blake's conception of his poetic function, see Morris Eaves's helpful discussion in his *William Blake's Theory of Art* (Princeton, 1982), especially p. 189.

[40] *A Vision of the Last Judgment*, ed. cit., p. 555, and the "Introduction" to *Songs of Experience*, 1–5, ed. cit., p. 18. The biblical reference is to Isaiah 1:2.

[41] Joseph A. Wittreich, Jr., *Angel of Apocalypse: Blake's idea of Milton* (Madison, 1975), p. xviii, in which he argues that Milton was in his own way no less unorthodox than Blake. There is an earlier discussion of Blake's unorthodoxies in Thomas J. J. Altizer, *The New Apocalypse: the radical Christian vision of William Blake* (Michigan, 1967).

[42] J. Bronowski, *William Blake: a man without a mask* (London, 1943) and David V. Erdman *Blake: prophet against empire* (Princeton, 1954).

[43] *Milton* 1:25:3–7, ed. cit., p. 121.

[44] Pamela Dunbar, *William Blake's Illustrations to the Poetry of Milton* (Oxford, 1980), p. 56.

[45] Anne K. Mellor, *Blake's Human Form Divine* (Berkeley, 1974), p. xvii, which summarizes the themes sensitively developed throughout the book. She wisely notes the symmetry dominating the later paintings but here, too, sees the phenomenon in negative terms as arising from "his obsession with severely limited forms and patterns" (p. 197). Quotations are from Rudolf Arnheim, *Art and Visual Perception* (Berkeley, 1954), p. 64, Blake's *A Descriptive Catalogue*, ed. cit., p. 550, and his *Public Address*, ed. cit., p. 582.

[46] Ed. cit., p. 34. For Blake's relationship with Fuseli, see Carol L. Hall, *Blake and Fuseli: a study in the transmission of ideas* (New York, 1985).

[47] Kathleen Raine, *William Blake* (London, 1970), p. 111. Her theory, expounded in her earlier *Blake and Tradition* (Princeton, 1968), that Blake was fundamentally a Neoplatonist, was justifiably criticized by Jean Hagstrum and others for having overstated the case; but it is certainly true that Blake attributed greater validity to the "ideal" world as

he conceived it than to that of the senses. Blunt comments in his *Art of William Blake*, p. 94, that Blake's figures reveal a poor knowledge of anatomy, although the effect they convey of energy rather than muscular force may have been part of the artistic intent.

[48] *Milton* 1:29:4–8 and 14–20, ed. cit., p. 127. I have omitted the idiosyncratic full-stops inserted in the middle of sentences.

[49] Harold Bloom, *Anxiety of Influence: a theory of poetry* (New York, 1973).

[50] *Public Address*, ed. cit., p. 580. Rubens is reputed never to have missed attending early morning mass despite his enormously busy schedule.

[51] Cf. Johnson's discussion of *Lycidas* in his *Lives of the Poets*.

[52] Edward J. Rose, " 'A Most Outrageous Demon': Blake's Case Against Rubens," *Bucknell Review* 17 (1969):35.

[53] *Public Address*, ed. cit., pp. 574f.

[54] The story of the fiddle has been challenged as apocryphal, but his early biographer, C. R. Leslie, in his *Memoirs of the Life of John Constable* (Ithaca, N.Y., 1980, originally 1843), p. 114, does record the incident of Constable rejecting Sir George Beaumont's advice to adopt the colour of a Cremona fiddle as the dominant tone of his landscapes.

[55] *Annotations to the Works of Sir Joshua Reynolds*, in ed. cit., p. 655. The exhibition of the Rubens painting is recorded in Martin Butlin, *Paintings and Drawings of William Blake* 1:487.

[56] *Descriptive Catalogue*, ed. cit., p. 530. See also p. 547 for further objection to the "hellish brownness" of the style instituted by Rubens.

[57] Blunt, *Art of William Blake*, pp. 72f.

[58] Although Blunt mentions this indebtedness to mannerist engravers in the above book, he had dealt with it more thoroughly in his earlier article, "Blake's Pictorial Imagination," *Journal of the Warburg and Courtauld Institute* 6 (1943):190. See also Jean Hagstrum, *William Blake*, pp. 45–47, as well as Robert Rosenblum, *Transformations*, p. 8, footnote 20, which comments that the extent of Parmigianino's influence in the latter part of the eighteenth century deserves to be more fully investigated.

[59] Buontalenti's altar stairs in S. Stefano, Florence (discussed and illustrated in my *Soul of Wit: a study of John Donne* (Oxford, 1974), pp. 85–86), offer a further instance of mannerist suggestion of physical insecurity in this world as a means of encouraging faith in the eternity beyond.

[60] Cf. Oswald Spengler, *The Decline of the West*, trans. C. F. Atkinson (London, 1932).

[61] Lines 27–30 from verses included in a letter to Butts, 22 November 1802, ed. cit., p. 721. The other references are to ed. cit., p. 566.

[62] *Public Address*, ed. cit., p. 580.

CHAPTER 7

[1] A. C. Bradley, *A Miscellany* (London, 1929), p. 32; George Saintsbury's introduction to *Pride and Prejudice* (London, 1894), p. xiii; Reuben A. Brower, *The Fields of Light: an experiment in critical reading* (New York, 1951), pp. 164f.; and Frank W. Bradbrook, *Jane Austen and her Predecessors* (Cambridge, 1966). The latter, while supporting and extending the Augustan attribution, admits (p. 6) the presence of a certain compla-

cency and pomposity in Addison's writing which Austen did not share.

[2] Hyatt H. Waggoner, *American Poets* (Boston, 1968), pp. 182–83.

[3] Marilyn Butler, *Jane Austen and the War of Ideas* (Oxford, 1975), p. 4. Avrom Fleishman, *A Reading of Mansfield Park: an essay in critical synthesis* (Minneapolis, 1967), was an earlier application to her work of socio-economic principles of investigation.

[4] Warren Roberts, *Jane Austen and the French Revolution* (New York, 1979), is less specific than its title suggests, examining historical, sociological, and ecclesiastical changes on the English scene only loosely connected with that political upheaval. More recently Tony Tanner's otherwise sensitive study, *Jane Austen* (Cambridge, Mass., 1986), continues the tradition of linking her to a past generation, seeing her way of thinking (p. 25) as closely approximating to the ideas expressed in Locke's *Some Thoughts Concerning Education* (1693). He recognizes some degree of contemporary responsiveness in the very last of her novels but remarks that in *Pride and Prejudice*, although she reveals some knowledge of contemporary military movements and the naval mutinies of 1797, "the overall impression given by the book is of a small section of society locked in an almost—*almost*—timeless ahistorical present" (p. 104). The difficulties involved in "placing" Austen in her historical setting are discussed by Alistair M. Duckworth, "Jane Austen and the Conflict of Interpretation," in Janet Todd, ed., *Jane Austen: new perspectives* (New York, 1983), pp. 39f.

[5] *Sense and Sensibility*, p. 81. Quotations throughout this chapter are from the revised five-volume series, *The Novels of Jane Austen*, ed. R. W. Chapman (Oxford, 1967). I have not thought it necessary to preserve her occasionally strange spelling. Her early and unchanging fondness for William Gilpin's work

is recorded in Henry Austen's *Biographical Notice*.

[6] Letter to Rev. James Stanier Clarke, 11 December 1815, in R. W. Chapman, ed., *Jane Austen's Letters* (London, 1969), p. 443. On her burlesque of his suggestions, see Mary Lascelles, *Jane Austen and Her Art* (London, 1954), pp. 36–37.

[7] *Persuasion*, ed. cit., p. 101.

[8] Samuel Kliger, "Jane Austen's *Pride and Prejudice* in the Eighteenth Century Mode," *University of Toronto Quarterly* 16 (1947):357, reprinted in *Twentieth Century Interpretations* of the novel as well as in the collection of essays appended to the Norton Critical edition. It continues to be regarded as the definitive statement on the novel's aesthetic affinities. Marilyn Butler, for example, although she questions some of his literary conclusions, praises his art/nature distinction as providing a "powerful and systematic" interpretation of the work (pp. 197–98).

[9] A. O. Lovejoy, " 'Nature' as Aesthetic Norm," in his *Essays in the History of Ideas*, p. 69.

[10] *Essay on Criticism*, 90–91, 139–40, and 169f.

[11] *Sense and Sensibility*, ed. cit., p. 40.

[12] Cf. Mario Praz, *On Neoclassicism* (London, 1969), especially pp. 71–72, an eccentric but sometimes useful study. A more comprehensive survey is provided by Hugh Honour's *Neo-classicism* (Harmondsworth, 1968). See also David Irwin, *English Neoclassical Art: studies in inspiration and taste* (London, 1966), and on the Greek revival in this period, John Buxton, *The Grecian Taste: literature in the age of neo-classicism 1740–1820* (London, 1978).

[13] John Summerson, *Architecture in Britain, 1530–1830* (London, 1953), p. 204.

[14] Robert K. Wallace, *Jane Austen and Mozart: classical equilibrium in fiction and music* (Athens, Ga., 1983), provides a sensitive examination of this relationship.

[15] Scott, who had, to Jane Austen's delight, praised *Emma* in an anonymous report for the *Quarterly Review* in 1816, modestly recorded in his personal journal that her "very finely written novel" *Pride and Prejudice* revealed an exquisiteness of touch denied to him. See *The Journal of Sir Walter Scott*, ed. W.E.K. Anderson (Oxford, 1972), p. 114.

[16] Judith Lowder Newton, *Power and Subversion: social strategies in British fiction, 1778–1860* (Athens, Ga., 1981), pp. 55–85, while acknowledging the wit and intelligence with which Elizabeth is endowed, argues that, within the economic limitations placed upon women in that period, the conclusion of the novel, her marriage to Darcy, marks a "decline" or resignation on her part. Austen's reference to Elizabeth Bennet appears in her letter to Cassandra dated 29 January 1813, in *Letters*, p. 287.

[17] *Adventurer* 137. For a recent discussion of Johnson's masterful tone, cf. Frederic Bogel, "Johnson and the Role of Authority," in Felicity Nussbaum and Laura Brown, eds., *The New Eighteenth Century: theory, politics, English literature* (New York, 1987), pp. 189–209.

[18] Jane Nardin, *Those Elegant Decorums: the concept of propriety in Jane Austen's novels* (Albany, 1973), p. 51, notes that Charlotte had already displayed some degree of impropriety in deliberately staying to overhear the conversation between Mrs. Bennet and Mr. Collins (p. 114). Elizabeth's disappointment at her friend's desertion of their supposedly shared principles regarding matrimony has thus been prepared for in the reader's mind. Nardin's close study of decorum in the novels would seem to corroborate the thesis proposed here, that Augustan authority was being gently modified and individualized in the arts of the later neoclassical period. The "propriety" towards which the novel leads, ratified as Elizabeth and Darcy achieve spiritual communion, is, she suggests, a "principled respect for the rules of decorum, combined with an intelligent realization that merely to obey the rules in their strictest sense does not constitute the whole of good breeding."

[19] Boswell's *Life of Johnson* (Oxford, 1946) 1:497.

[20] I am not alone in this impression. Frank Bradbrook (p. 17), remarking that Mary frequently strikes a Johnsonian note, suggests, although somewhat hesitantly, that Austen's mentor may have been the source of a certain amount of satirical amusement as well as admiration.

[21] *Collected Works of Oliver Goldsmith*, ed. Arthur Friedman (Oxford, 1966) 5:147.

[22] Cf. Charles J. McCann, "Setting and Character in *Pride and Prejudice*," *Nineteenth-Century Fiction* 19 (1964):65; Martin Price, "The Picturesque Moment," in F. W. Hillas and Harold Bloom, *From Sensibility to Romanticism: essays presented to Frederick A. Pottle* (Oxford, 1965), p. 259; and especially Alistair Duckworth, *The Improvement of the Estate: a study of Jane Austen's novels* (Baltimore, 1971), which perceptively examines Austen's reservations concerning Repton, as well as the centrality within the novels of estate symbolism offering "grounds" for human action and the establishing of social position.

[23] *Mansfield Park*, ed. cit., pp. 84 and 56.

[24] *Pride and Prejudice*, ed. cit., pp. 161 and 250.

[25] Letter to Cassandra dated 24 May 1813, in *Letters*, pp. 310 and 312.

[26] Reynolds, *Discourses on Art* (London, 1969), pp. 57 and 68, with the reference to Gainsborough appearing on p. 218, and Johnson's *Rasselas*, chapter 10. Here, too, Goldsmith good-humouredly parodied current trends, when in chapter 16 of his *Vicar of Wakefield* the members of the vicar's family choose such varied mythological poses to dignify their portraits that the combined can-

vas is eventually discovered to be too large to be moved from the room in which it is has been painted. Gainsborough also scoffed at the custom, condemning "the ridiculous use of fancied Dresses in Portraits." See his letter to the Earl of Dartmouth dated 8 April 1771 in his *Letters*, ed. Mary Woodall (London, 1963), p. 49.

[27] Information on this portrait can be found in Gervase Jackson-Stops, ed., *The Treasure Houses of Britain: five hundred years of private patronage and art collecting* (New Haven, 1985), p. 534, while details of the household arrangements at Chatsworth are recorded, somewhat acerbically, in Arthur Calder-Marshall, *The Two Duchesses* (London, 1978). John Halperin, in his recent biography, *The Life of Jane Austen* (Baltimore, 1984), refers twice (pp. 66 and 150) to the possibility that she may have paid a visit to Chatsworth and may have modelled her description of Pemberley on that estate, but he provides no supporting evidence for the conjecture.

CHAPTER 8

[1] Arthur O. Lovejoy's essay, "On the Discrimination of Romanticisms," first published in 1924 and reprinted in his *Essays in the History of Ideas* (Baltimore, 1948), pp. 228–53.

[2] René Wellek, "The Concept of Romanticism in Literary History," *Comparative Literature* 1 (1949):1, reprinted in his *Concepts of Criticism* (New Haven, 1963), pp. 128–98, and Geoffrey H. Hartman, "Romanticism and Anti-self-consciousness," first published in 1962 and reprinted in his *Beyond Formalism: literary essays 1958–70* (New Haven, 1970).

[3] Anne K. Mellor, *English Romantic Irony* (Cambridge, Mass., 1980), and Jerome J. McGann, *The Romantic Ideology: a critical investigation* (Chicago, 1983).

[4] Friedrich Schiller, *On the Aesthetic Education of Man*, ed. and trans. E. M. Wilkinson and L. A. Willoughby (Oxford, 1967), p. 155. On the status of musicians in Mozart's day, cf. his sardonic comment on the eating arrangements awaiting him at the palace of Archbishop Colloredo in Vienna: "The two valets sit at the head of the table, and I have the honour to be placed above the cooks."

Otto Jahn, *The Life of Mozart* (London, 1891) 2:171.

[5] Cf. Thomas L. Ashton, *Byron's Hebrew Melodies* (London, 1972), and Hazlitt, *Complete Works*, ed. P. P. Howe (New York, 1967) 5:12. The disappearance of the painting analogy in this period is noted in M. H. Abrams, *The Mirror and the Lamp* (New York, 1953), pp. 50–51.

[6] Andrew Wilton, *J.M.W. Turner: his art and life* (New York, 1979), p. 15.

[7] C. R. Leslie, *Memoirs of the Life of John Constable* (London, 1949), p. 298. The best source for quality reproductions of his major works and details concerning them is Graham Reynolds, *The Later Paintings and Drawings of John Constable*, 2 vols. (New Haven, 1984).

[8] As Northrop Frye wisely notes: "If a Romantic poet . . . wishes to write of God, he has more difficulty in finding a place to put him in than Dante or even Milton had, and on the whole he prefers to do without a place, or finds 'within' metaphors more reassuring than 'up there' metaphors." His essay, "The Drunken Boat: the revolutionary element in Romanticism," appears in the collection he

edited, *Romanticism Reconsidered: selected papers from the English Institute* (New York, 1963), p. 8.

[9] *Prelude* 1:369–72. Quotations are from *Poetical Works*, ed. Ernest de Selincourt (Oxford, 1950), except where otherwise stated.

[10] *Mutability*, 1–4.

[11] Kurt Badt, *John Constable's Clouds*, trans. S. Godman (London, 1950), especially pp. 18f. It was Andrew Shirley in his preface to the 1937 edition of Leslie's *Memoirs* who first argued for the connection with Howard. For subsequent historians accepting the interpretation that the clouds signified the transitory in nature, cf. Graham Reynolds, *Constable: the natural painter* (New York, 1969), p. 19, and Karl Kroeber's stimulating study, *Romantic Landscape Vision: Constable and Wordsworth* (Madison, 1975), p. 19. It should be noted that Constable's own use of clouds in the manner I have outlined here long preceded his intensive study of them in the 1820s, the clouds in his *Flatford Lock and Mill* of 1812, for example, although less realistically sketched, functioning in precisely that way as enclosures of the terrestrial. He had, in fact, been influenced much earlier by Alexander Cozens's treatise, *A New Method of Assisting the Invention in Drawing Original Compositions of Landscape*, published in 1785, which drew attention to the beauty of changing cloud formations. The quotation is from Turner's lecture notes in the British Museum manuscript, Add. Mss. 46151 CC, transcribed in Andrew Wilton, *Turner*, p. 170. Arden Reed, *Romantic Weather* (Hanover, 1983), examines the prominence of meteorological interest in Coleridge and others, but makes almost no reference to painting.

[12] Morse Peckham, "A Theory of Romanticism" (1951), reprinted in *The Triumph of Romanticism: collected essays* (Columbia, 1970). The Romantic's sense of *essentia*, of his fleeting existence within a constantly changing universe, is further discussed in Thomas McFarland, *Romanticism and the Forms of Ruin: Wordsworth, Coleridge, and modalitites of fragmentation* (Princeton, 1981), especially pp. 276f.

[13] From a letter to William Jackson dated 4 June 1768, in *The Letters of Thomas Gainsborough*, ed. Mary Woodall (London, 1963), p. 115. His own later reference to the immaturity of the Cornard Wood painting is from a letter to Henry Bate dated 11 March 1788 in *Letters*, p. 35. See also John Hayes, *Gainsborough: paintings and drawings* (London, 1975), p. 33. The general disdain for Dutch painting persisted in England well into the Romantic period, Hazlitt remarking: "It would be needless to prove that the generality of the Dutch painters copied from actual objects. They have become almost a bye-word for carrying this principle into its abuse," *Complete Works*, ed. P. P. Howe (London, 1933) 18:123.

[14] Byron, *Childe Harold* 3:2, in *Complete Poetical Works*, ed. Jerome J. McGann (Oxford, 1980) 2:77.

[15] James A. W. Heffernan, *The Re-creation of Landscape: a study of Wordsworth, Coleridge, Constable, and Turner* (Hanover, 1984), especially pp. 22–25. A comparison of Constable's 1802 version of the Dedham landscape from the National Gallery, London, with that of 1828 reproduced here (the version Constable preferred above all others) is particularly revealing, as the earlier canvas, lacking the dark cloud formations, remains closer to Claude in its effect than to the Romantic view of nature.

[16] M. H. Abrams, *Natural Supernaturalism: tradition and revolution in romantic literature* (New York, 1971). Also relevant is Northrop Frye's *A Study of English Romanticism* (New York, 1968), pp. 3–24, which noted the projecting of traditional religious ideas onto the external world.

[17] After an early association with Methodism, Toplady took orders in the Church of England and became a sworn opponent of the Wesleys. The quotation is from his well-known hymn, *Rock of Ages*, 13–16.

[18] John Ruskin, *Modern Painters* 3:16, in *Works* (New York, 1886) 2:251.

[19] *The Prelude* (1805 version) 13:72–76, ed. E. de Selincourt (Oxford, 1969). John Jones, *The Egotistical Sublime: a history of Wordsworth's imagination* (London, 1954), pp. 155–57, illustrates how frequently Wordsworth introduced alterations into his later version of the *Prelude* in order to counter charges of unorthodoxy and even heresy, and G. B. Tennyson's essay, "The Sacramental Imagination," in U. C. Knoepflmacher and G. B. Tennyson, eds., *Nature and the Victorian Imagination* (Berkeley, 1977), p. 370, discusses how his *Ecclesiastical Sonnets*, contemporary in composition with Keble's *Christian Year* (1827), parallel its movement towards traditional Christian values.

[20] Peter L. Thorslev, Jr., *Romantic Contraries: freedom versus destiny* (New Haven, 1984), p. 17.

[21] *Excursion* 9:3–11.

[22] For some of the details in this section, I am indebted to an excellent study which remains the authoritative work in the field, G. F. Hudson, *Europe and China: a survey of their relations from earliest times to 1800* (London, 1931). A more recent work is William J. Appleton, *A Cycle of Cathay: the Chinese vogue in England during the seventeenth and eighteenth centuries* (New York, 1951), and, on the influence of Moslem art, Joka Sweetman, *The Oriental Obsession: Islamic inspiration in British and American art and architecture 1500–1920* (Cambridge, 1988). A. O. Lovejoy's classic article on "The Chinese Origin of a Romanticism," reprinted in his *Essays in the History of Ideas*, focusses, of course, upon the "irregularities" fostered by the new fashion in literature, not the liberation from Christian authority.

[23] Adolf Reichwein, *China and Europe: intellectual and artistic contacts in the eighteenth-century* (New York, 1925), p. 85.

[24] Hugh Honour, *Chinoiserie: the vision of Cathay* (New York, 1962), correctly stresses the fictional aspect of most supposedly Chinese forms introduced into the art and architecture of this period.

[25] Letters 14 and 41 in Goldsmith's *The Citizen of the World* (London, 1934), pp. 37 and 113–15.

[26] The French theorist François Quesnay argued in his *Le despotisme de la Chine* (1767) for the principle of free trade on the basis of the example set by China and recommended there that its system of public examination for civil service appointments be adopted by the west. See Hudson *Europe and China*, pp. 322–26.

[27] There were attacks on the "rose-coloured reports" that had been transmitted by the missionaries, and a certain amount of scoffing at the fashion itself. Cf. Reichwein, *China and Europe*, p. 96.

[28] *The Connoisseur* (1755).

[29] Cf. Peter Furtado et al., *Castles and Houses in Britain* (New York, 1986), p. 62.

[30] Patrick Conner, *Oriental Architecture in the West* (London, 1979), provides an account of the brief period in which Indian architecture served as a model.

[31] John Barrell, *The Dark Side of the Landscape: the rural poor in English painting 1730–1840* (Cambridge, 1980). The weakness of this otherwise stimulating book is its tendency to read Marxist ideas into the works without sufficient evidence. Thus he interprets Gainsborough's innocuous *Harvest Waggon* of 1767 as representing the labourers' journey to the annual feast provided by their employer, in which they will be "bribed by beer and frumenty" to accept the gruel-

ling economic conditions for the following year too. The point may be valid historically, but there is not a shred of evidence that that is the theme of the painting.

[32] John Aikin quoted in Barrell, *The Darker Side*, p. 55.

[33] *The Complete Letters of Lady Mary Wortley Montagu*, ed. Robert Halsband (Oxford, 1965) 1:446. The persistence of such condescension towards the rustic is indicated by Constable's early mentor J. T. Smith who stated in 1797 that he would be content if his etchings of rural and cottage scenery would be considered "as no more than a *low-comedy* landscape." See the note added by Andrew Shirley to his edition of C. R. Leslie's *Memoirs of the Life of Constable* (London, 1937), p. 7.

[34] *Complete Poems of Thomas Gray*, ed. H. W. Starr and J. R. Hendrickson (Oxford, 1966), p. 39, the textual variants noted at the foot of the page.

[35] West's own words, quoted by the American poet Joel Barlow and recorded in Yvon Bizardel, *American Painters in Paris* (New York, 1960), p. 77.

[36] Cf. Graham Reynolds, *Constable*, p. 22. There is a general survey of the relationship between Constable and Wordsworth in Russell Noyes, *Wordsworth and the Art of Landscape* (Bloomington, 1968). The fluctuations in Constable's reputation are documented in Ian Fleming-Williams and Leslie Parris, *The Discovery of Constable* (London, 1984).

[37] Letter to Fisher dated 6 December 1822, in Leslie, *Memoirs*, p. 115.

[38] Leslie, *Memoirs*, p. 132.

[39] As he elaborated in the 1802 Appendix to his Preface to the *Lyrical Ballads*, reprinted in *Poetical Works*, ed. Ernest de Selincourt (Oxford, 1950), p. 741: "In succeeding times, Poets, and Men ambitious of the fame of Poets, perceiving the influence of such language, and desirous of producing the same effect without being animated by the same passion, set themselves to a mechanical adoption of these figures of speech . . . A language was thus insensibly produced, differing materially from the real language of men in *any situation*." For the view that he was attacking a more general elevation of language, what the author calls the "social and civil idiom" of Pope's school, cf. Alec King's chapter on poetic diction in his *Wordsworth and the Artist's Vision: an essay in interpretation* (London, 1966), especially p. 125.

CHAPTER 9

[1] Wendy Steiner, *Pictures of Romance: form against context in painting and literature* (Chicago, 1988). The quotations are from *Prelude* 14:86–90 and 130–32, and from Coleridge's *Biographia Literaria* in *Collected Works*, ed. Kathleen Coburn (Princeton, 1983) 7:1:304. The developmental changes in the conception of the poetic imagination in this period and their relationship to contemporary philosophical innovations are sensitively examined in James Engell, *The Creative Imagination: enlightenment to romanticism* (Cambridge, Mass., 1981).

[2] Thomas Weiskel, *The Romantic Sublime: studies in the structure and psychology of transcendence* (Baltimore, 1976), pp. 15f., and 39f. There is a helpful discussion of the Kantian elements in Wordsworth's poetry in Steven

Knapp, *Personification and the Sublime: Milton to Coleridge* (Cambridge, Mass., 1985), especially pp. 106f.

[3] Angela Leighton, *Shelley and the Sublime: an interpretation of the major poems* (Cambridge, 1984), especially pp. 26f. Quotations are from Shelley, *Complete Works*, ed. R. Ingpen and W. E. Peck (New York, 1965) 7:135 and 140.

[4] *Ode to the West Wind* 60–67, in ed. cit. 2:296–97.

[5] Paul de Man, "The Rhetoric of Temporality," in C. S. Singleton, ed., *Interpretation: theory and practice* (Baltimore, 1969), pp. 174f. For an account of the differing attitudes to the subjectivity of Romanticism in modern critical writing, see especially Frank Lentricchia, *After the New Criticism* (Chicago, 1980), pp. 292f.

[6] Abrams, *Natural Supernaturalism: tradition and revolution in romantic literature* (New York, 1971), p. 397.

[7] *Michael*, 407–12.

[8] Louis L. Martz, *The Poetry of Meditation* (New Haven, 1954), and, on the Protestant versions, Norman S. Grabo, "The Art of Puritan Meditation," *Seventeenth Century News* 26 (1968):7, and Barbara K. Lewalski, *Donne's "Anniversaries" and the Poetry of Praise: the creation of a symbolic mode* (Princeton, 1973), especially pp. 74f. Martz briefly mentioned Wordsworth as belonging within the genre of the religious meditation (p. 324) together with a list of later poets including Tennyson, Hopkins, and Emily Dickinson, but did not develop the point. A few years later M. H. Abrams, in defining the sustained Romantic lyric as an essentially new genre, appended to his discussion a hesitant speculation on its possible affinity to the meditative poem, notably in its focus upon spiritual crisis. See his "Structure and Style in the Creative Romantic Lyric," published in Frederick W. Hilles and Harold Bloom, eds., *From Sensibility to Romanticism: essays presented to Fred-erick A. Pottle* (New York, 1965), pp. 527f. Albert O. Wlecke, *Wordsworth and the Sublime* (Berkeley, 1973), pp. 20–21, pursues the connection in a direction quite different from my own, using it as a means of exploring the Romantic conception of the sublime.

[9] Joseph Hall, *Works*, ed. Philip Wynter (Oxford, 1858) 6:47 and 55.

[10] Robert Dingley, *The Spiritual Taste described; and a glimpse of Christ discovered* (London, 1649), pp. 43–44, and George P. Landow, *Victorian Types, Victorian Shadows: biblical typology in Victorian literature, art, and thought* (Boston, 1980), especially p. 27.

[11] Included in Friedrich's unpublished *Observations on a Collection of Paintings . . .* (1830), from which excerpts were published by his friend Carl Gustav Carus in 1841. The passage is quoted in Lorenz Eitner, *Neoclassicism and Romanticism 1750–1850: sources and documents in the history of art* (Englewood Cliffs, N.J., 1970) 2:53.

[12] All three portraits of the poets are in the National Portrait Gallery, London, and the self-portrait by Friedrich, in the Staatliche Museen, Berlin.

[13] *Coleridge on the Seventeenth Century*, ed. Roberta F. Brinkley (London, 1955), pp. 692–93. The verse quotation is from John Donne, *Holy Sonnet 7 (XI)*, 6–7, in *Divine Poems*, ed. Helen Gardner (Oxford, 1978), p. 9.

[14] On Constable's trance-like state when painting in the open air, evidenced by the well-known story of the field mouse that crept into his pocket unnoticed, cf. Graham Reynolds, *Constable: the natural painter* (New York, 1969), p. 90.

[15] For this parallel, see Kurt Badt, *John Constable's Clouds*, trans. S. Godman (London, 1950), pp. 83–84, and Ronald Paulson, *Literary Landscape: Turner and Constable* (New Haven, 1982), p. 119.

[16] George P. Mras, *Eugene Delacroix's Theory of Art* (Princeton, 1966), pp. 72–98.

438

[17] From a tract by Joshua Marsden, *Sketches of the Early Life of a Sailor* (Hull, n.d.), probably written in 1812. George Whitefield's reminiscence is quoted in W. H. Daniels, *A History of Methodism in Great Britain and America* (New York, 1879), p. 99: "O, what a ray of divine light did then break upon my soul! I know the place: it may, perhaps, be superstitious, but whenever I go to Oxford I cannot help running to the spot where Jesus Christ first revealed himself to me and gave me new birth."

[18] *Excursion* 9: 622–33. Robert Langbaum, *The Mysteries of Identity* (New York, 1977), p. 41, notes how memory becomes for Wordsworth the instrument of an associative or transforming power. Christopher Salvesen's valuable study, *The Landscape of Memory: a study of Wordsworth's poetry* (London, 1978), examines the link between Wordsworth's nostalgic reminiscing and the tradition of the picturesque.

[19] Cf. Linda Siegel, *Caspar David Friedrich and the Age of German Romanticism*, p. 37.

[20] Hannah More, *Strictures on the Modern System of Female Education* (London, 1799), p. 44; the instruction to Sunday schools cited in R. C. Russell, *History of Elementary Schools and Adult Education in Nettleton and Caistor* (Caistor, 1960), p. 7. For the tradition out of which such attitudes developed, cf. John Wesley's notorious sermon *On the Education of Children*: "To humour children is, as far as in us lies, to make their disease incurable. A wise parent, on the other hand, should begin to break their will, the first moment it appears . . . never on any account, give a child any thing that it cries for . . . teach your children, as soon as possibly you can, that they are fallen spirits . . . Show them that, in pride, passion, and revenge, they are now like the Devil"—*Works* (New York, 1826) 6:126f.

[21] M. H. Abrams, *Natural Supernaturalism*, pp. 380–84. For the recognition that Shelley's *Hymn to Intellectual Beauty* was influenced by these same ideas, as contained in Wordsworth's *Ode on Intimations of Mortality*, see Harold Bloom, *The Visionary Company: a reading of English romantic poetry* (Ithaca, 1971), p. 291, and Judith Chernaik *The Lyrics of Shelley* (Cleveland, 1972), p. 33. In Plato's *Phaedo*, the newborn child is seen as entirely cut off from its previous existence, but the very idea that it could "recollect" truths from that earlier world opened the way for the view that it came bearing with it some residual knowledge.

[22] A rare exception is his *Master James Heys*, now in the Oscar Reinhart collection in Winterthur. All Constable's six-footer canvases include figures of children. C. R. Leslie, *Memoirs of the Life of John Constable* (London, 1949), p. 301, notes the pleasure he derived from children: "I have seen him admire a fine tree with an ecstasy of delight like that with which he would catch up a beautiful child in his arms."

[23] In 1829, Constable is recorded as having copied out for his own keeping the poem *My heart leaps up*, with its concluding lines:

> The Child is father of the Man;
> And I could wish my days to be
> Bound each to each by natural piety.

For the quotations which follow, see Reynolds, *Constable*, pp. 19, 27, and 90.

[24] Isaac Watts, *Moral Songs* 6:21–24, in *Horae Lyricae and Divine Songs* (Boston, 1854), p. 343. Cf. Max Weber's important essay, *The Protestant Ethic and the Spirit of Capitalism*, trans. T. Parsons (New York, 1958), originally published in 1904, and R. H. Tawney's *Protestantism and the Rise of Capitalism: a historical study* (New York, 1926).

[25] Cf., among many others, the paintings of St. Francis by El Greco and Zurbarán, and that of the Magdalene by Georges de la Tour, in each of which the skull is prominent as a source of meditational exercise.

[26] Murray Krieger, *Poetic Presence and Illusion: essays in critical history and theory* (Baltimore, 1979), pp. 193f., an approach echoed and extended in the introductory section to Paul de Man's "Pascal's Allegory of Persuasion," published in Stephen J. Greenblatt, ed., *Allegory and Representation: selected papers from the English Institute* (Baltimore, 1981), which enquires why allegory, so markedly sequential and narrative in form, is yet at the furthest remove from historiography, achieving its effect of transcendent truth by so referentially indirect a mode. On the poet's acknowledgment that his art is counterfeit, cf. Michael Ragussis, *The Subterfuge of Art: language and the romantic tradition* (Baltimore, 1978).

[27] This reversal of dramatic authenticity is discussed in my earlier volume, *Renaissance Perspectives . . .* , pp. 207–16.

[28] *Prelude* 7:445.

INDEX

A

Abelard, Peter, 89

Abrams, M. H., 350–51, 376f., 426n72, 434n5, 435n16, 439n21

Adam, Robert, 318f.

Adams, Percy G., 417n14

Addison, 201–3, 209, 227, 229–31, 238, 250, 260, 269, 287, 312, 327, 427n5

Adler, Jacob H., 413n40

Aeolian lyre, 341

Aikin, John, 365, 437n31

Alberti, 14, 102, 106, 340

Aler, Paul, 146

Allen, B. Sprague, 408n46

Allen, D. C., 401n5

Alter, Robert, 419n37

Altizer, Thomas J. J., 430n41

Amber Palace, Jaipur, 359

Andrews, Lancelot, 197

Antal, Frederick, 418n23

Appleton, Jay, 206–7, 422n26

Appleton, William J., 436n22

Aquinas, 103

arabesques, 105, 115, 257f., 290f., 323–24, 417n19

Aristotle, 55

Arnheim, Rudolf, 4, 174, 292, 399n3, 430n45

Artz, Frederick H., 399n5

Arundel, Earl of, 45

Ascham, Roger, 146

Ashton, Thomas L., 434n5

Atkins, G. Douglas, 411n29

Aubin, Robert A., 424n65

"Augustan" as literary term, 124–25, 317f., 413n47

Augustine, 400n3

Austen, Henry, 432n5

Austen, Jane, 311–36, 419n39

Avery, E. L., 408n49

B

Bach, J. S., 103

Badt, Kurt, 342–43, 435n11, 438n15

Baillie, John, 233

Baker, Henry, 416n5

Bakhtin, M. M., 111, 168, 411n29

ballad revival, 260, 427n5

Barbeau, Anne T., 405n15

Barberini Palace, 76

Barbizon school, 368

Barlow, Joel, 437n35

Barnardiston, Nathaniel, 201

baroque art, 13–18, 165, 287, 289, 342, 347, 400n2

Barrell John, 202, 363, 421n19, 436n31

Barrow, Isaac, 197–98, 227, 420n9

Barthes, Roland, 127, 414n53

Bartolo di Fredi, 6

Battestin, Martin, 90–92, 409n3, 420n9

Baxter, Richard, 151

Bayle, Pierre, 128

Beattie, James, 183

Beaumont, George, 156, 348, 370, 431n54

Beethoven, 340

Bellamy, Daniel, 207, 422n26

Bellori, 68

Belton, Ellen R., 419n39

Bender, John, 417n21

Berlin, Adele, 427n8

Bernini, 25, 37, 38, 60, 68, 407n35

Berthélemy, 273

biblical poetry, 283f., 429n28

Bizardel, Yvon, 437n35

Blackmore, Sir Richard, 428n18

Blake, 255–309, 368, 390, 423n40, 425n69, 427n4

Blenheim Palace, 76, 408n46

Blewett, David, 417n21

Bloom, Harold, 4, 297, 399n3, 426n3, 431n49, 439n21

Blunt, Anthony, 49, 303–4, 405n18, 406n20, 424n45, 426n2, 431n47, n57, and n58

Boas, George, 410n17, 422n21

Boffrand, 220

Bogel, Fredric, 433n17

Boileau, 209

Bologna, Giovanni, 25, 36, 402n13

Booth, Wayne C., 9, 173–75, 399n9, 418n26

Borromini, 17

Boswell, James, 329–30, 421n14

Botticelli, 29, 127

Boughner, Daniel C., 402n20

Boulle, 143

Bowers, Fredson, 400n3

Boyle, Roger, 406n26

Bradbrook, Frank W., 431n1, 433n20

Bradley, A. C., 311, 431n1

Brahe, Tycho, 14

Braudy, Leo, 419n37

Bredvold, Louis, 47, 405n15 and n17

Breughel, 407n44

Bridgeman, Charles, 194

Brighton Pavilion, 359

Brinkley, Roberta, 385

Bronowski, J., 289, 430n42

Brooks, Cleanth, 410n22, 412n32, 414n58

Brouwer, Adriaen, 407n44

Brower, Reuben, 116, 312, 410n22, 412n37, 431n1

Brown, Capability, 126, 194

Brown, Laura, 433n17

Browne, Peter, 108, 411n27

Browne, Sir Thomas, 55, 235, 425n64

Brownell, Morris R., 413n46

Brunelleschi, 13

Bruno, Giordano, 14, 89, 211

Budick, Sanford, 402n17

Buontalenti, 431n59

Burke, Edmund, 209, 232–33

Burke, Joseph, 420n2

Burlington, Lord, 122–23, 318

Burnet, Thomas, 210–19, 232, 250, 253, 422n30 and n32

Burwick, Frederick, 419n36

Butler, Marilyn, 312–13, 432n3 and n8

Butlin, Martin, 427n4, 431n55

Butt, J., 425n70

Buxton, John, 432n12

Byron, 311, 314, 339, 341, 348,

C

Cairncross, John, 406n26

Calder-Marshall, Arthur, 434n27

Calvinism, 393–94

Canaletto, 156–60, 348, 416n9

Cantor, Paul, 276–77, 428n25

Caravaggio, 222, 246, 386–88

Carlevarijs, Luca, 416n9

Carlyle, Thomas, 250

Carnochan, W. B., 164, 417n12 and n21

Carracci, Annibale, 59–60, 125

Carus, Carl G., 379, 438n11

Case, A., 403n1

Castle Howard, 76

Caws, Mary Ann, 4, 399n3

Cawthorne, James, 357

ceiling frescoes, 94f., 165, 287, 409n11 and n12

Cellini, 25

Chambers, Sir William, 357

Charles I, 45, 76

Charles II, 45, 128–29, 404n10

Charles III of Spain, 317

Charron, Pierre, 48

Chatsworth House, 413n46, 434n27

Chaucer, 6–7

Chernaik, Judith, 439n21

cherubim, 264, 428n12

Chetwode, Sir John, 236

child imagery, 273–77, 389–94, 439n20–23

chinoiserie, 353f., 436n22

Chippendale furniture, 323

Chiswick House, 122–24

Christian–Terence plays, 273, 428n25

Christie, Agatha, 185–86

church architecture, 13–18, 130–32

Cicero, 84

Cimabue, 68

Clark, E. M., 400n3

Clark, Kenneth, 112–13, 411n31

classical gods, 127–28, 294

Claude glass, 194–96

Clifton-Taylor, Alec, 408n46

cloud imagery, 342f., 391–94, 435n11

Cockerell, Sir Charles, 359

Coeffeteau, F. N., 406n25

Cohen, Ralph, 139, 412n32, 415n67, 423n44

Cohn, Jan, 423n37

Coleridge, Hartley, 222

Coleridge, S. T., 239–40, 311, 359–61, 374, 384–85

Collier, Jeremy, 269, 428n18

Collins, Wilkie, 184–85

Colman, 423n30

concordia discors, 91, 117, 139, 261, 409n4

Confucius, 355–56

Congreve, 41

Constable, 219, 299, 341f., 367–71, 385–86, 431n54, 438n14, 439n22 and n23

Constable, W. G., 416n9

Copernicus, 89, 342

Copley, 267

Corneille, 406n26

Correggio, 125, 298

Cortona, Pietro da, 14, 37

Cotton, Charles, 203, 421n21

Council of Trent, 60

Cowley, Abraham, 139

Cowper, William, 200, 219, 311, 316

Cozens, Alexander, 435n11

Crane, R. S., 316, 419n38

Crashaw, Richard, 74

Creed, J. M., 414n59

Croft-Murray, Edward, 409n11

Crow, Thomas E., 411n30, 412n31

Cudworth, Ralph, 48

Cunningham, J. S., 412n32

Cupid figures, 111–15

Cuyp, 195, 344

D

Dahlhaus, Carl, 409n15

Damrosch, Leopold, Jr., 117, 286, 412n37, 416n1, 430n37

Danby, 423n40

Dance, Nathaniel, 270

Daniells, Roy, 400n1, 402n21

Daniels, W. H., 439n17

Darwin, Erasmus, 313

Davenant, William, 43, 80

David, J.-L., 267, 270, 273

Davies, Horton, 421n11

Day, William P., 419n40, 426n72

de Brosses, Charles, 416n9

De Hooch, 75, 407n44

de Joullienne, J., 148, 411n28

de la Rivière, C. D., 420n2

de la Tour, Georges, 426n73, 439n25

de Loutherbourg, 219, 250, 423n40

de Man, Paul, 376, 412n32, 438n5, 440n26

de Mendoza, J. G., 354

de Saussure, Ferdinand, 4, 110, 399n2
de Staël, A.-L.-G., 340
de Voogd, P. J. 418n22
Deane, Cecil V., 403n4
Defoe, Daniel, 151, 170, 405n54
deism, 127, 353–62, 414n54
Delacroix, 386
Delaunay, Nicolas, 115
Demetz, P., 412n34
Denham, John, 117–19
Dennis, John, 226–27, 245, 250, 424n50 and n51
Derham, William, 147
Derrida, Jacques, 110, 174, 411n29
Des Brosses, S., 156
Des Fontaines, 153–54, 416n5
Descartes, 42, 54, 403n2
Desplace, 110
detective stories, 184–86, 189, 419n39 and n40
Devis, Arthur, 136
Dickens, 185–86
Dickinson, Emily, 312
Diderot, 426n74
Dieckmann, Herbert, 412n34
Dingley, Robert, 378, 438n10
Dodsley's Miscellany, 221, 239, 424n48
Donatello, 24–25
Donne, John, 63, 72, 139, 197, 209–10, 309, 384, 420n8, 438n13
Donoghue, Denis, 167, 417n18
Doody, Margaret Anne, 412n32
Downes, Kerry, 413n44, 414n60
Dryden, 37, 41–86, 101, 120, 124, 128–29, 282
Du Bartas, 145
du Moulin, Pierre, 23, 401n10
Duccio, 68
Duckworth, Alistair M., 432n4, 433n22
Dufresnoy, Alphonse, 46–47, 54, 58, 405n14, 406n30
Dughet, Gaspar, *see* Poussin, Gaspar

Dunbar, Pamela, 292, 430n44
Duquesnoy, Francesco, 63, 68
Durand, 379
Dürer, 298
Dutch painting, 195, 223–24, 344, 424n49, 435n13

E

Eaves, Morris, 430n39
Eddy, W. A., 416n5
Edgworth, Maria, 313
Edwards, Thomas R., 116, 119, 412n36, 413n41
Egyptian style, 361–62
Eitner, Lorenz, 438n11
El Greco, 5–6, 60, 72, 309, 379, 388–89, 439n25
Eliot, T. S., 43–44, 404n7
Elizabeth, Queen, 24, 75–76
Elliott, Robert C., 164, 417n15
emblem poetry, 126–27, 180–81, 419n34
Empire style, 318f.
Engell, James, 437n1
Erdman, David V., 289, 426n3, 427n4, 430n42
Escher, 374
Essick, Robert N., 429n26
Etherege, 41, 80
Etruscan design, 320–23
evangelicalism, 350–51, 386–87, 394, 439n17
Evans, Abel, 408n46
Evelyn, John, 45, 235–36

F

Fabricant, Carole, 155, 201–2, 416n7, 421n18
Fairer, David, 412n32
female saints, 68
Ferguson, Francis, 424n61
Ferrar, Nicholas, 201

Ferrata, Ercole, 63

fêtes galantes, 108f., 129, 411n30

Ficino, 92

Fielding, 91, 168–89, 198–99, 354, 418n23, 419n37, 420n9

filial piety, 268f., 428n20

Finney, Gretchen, 90, 409n3

Fish, Stanley E., 54, 406n23, 419n34

Flaxman, 292, 323

Fleishman, Avrom, 432n3

Fleming-Williams, Ian, 437n36

follies, 196–97, 234f., 353

Fontenelle, Bernard, 128

Foote, Samuel 269

Ford, John, 6

Foster, Lady Elizabeth, 335–36, 434n4

Foucault, Michel, 8, 199, 399n7, 417n21, 421n12

Fowler, Alastair, 5, 399n4 and n5

Fragonard, 115–16

Frazer, J. G., 423n43

Fréart, Paul de, 49

Freeman, Rosemary, 181, 418n33

Freud, Sigmund, 220, 423n43

Friedlaender, Walter, 54, 406n22

Friedrich, Carl J., 400n1,

Friedrich, Caspar David, 36, 267–68, 379–82

Frye, Northrop, 18, 174, 255, 269, 400n3, 418n27, 426n1, 425n69, 428n22, 434n8, 435n16

Frye, Roland M., 3, 399n1, 402n18

Fujimura, Thomas H., 405n15, 408n48

Furtado, Peter, 436n29

Fuseli, 219, 292

G

Gainsborough, 193, 333, 344f., 383, 434n26, 436n31

Galileo, 14, 89, 153, 294, 342

Gammer Gurton's Needle, 363

Garrick, David, 136, 140, 383

Gaulli, 17, 94, 165

Gay, John, 91, 226, 365, 412n34, 418n32, 424n51

George I, 132

Géricault, 386

Gheeraerts, Marcus, 24, 75–76

Gibbon, Edward, 237, 425n68

Gibbons, Grinling, 135–36

Gibbs, James, 130–31

Gilbert, A. H., 38, 402n23, 414n48

Gillray, 172, 189

Gilpin, William, 313, 432n5

Giorgiana, Duchess of Devonshire, 336, 434n27

Girouard, Mark, 415n69

Glanvill, Joseph, 48

Gnaphaeus, 428n25

Gnosticism, 286

Godwin, William, 313

Goethe, 343

Goldsmith, Oliver, 91, 165, 269, 329–31, 356–57, 428n22, 433n26

Goltzius, Hendrick, 304

Gombrich, Ernst, 4, 174, 395, 399n3

Gossman, Ann, 401n5

Gothic revival, 184–85, 237, 313, 419n40, 422n32, 426n72

Goupy, Joseph, 356

Goya, 267, 280

Grabo, Norman, 377, 438n8

Gradus ad Parnassum, 146–50, 370, 415n77 and n79

grand tour, 45–46, 181

Graves, Richard, 234, 424n59

Gray, Thomas, 45–46, 129–30, 146, 233, 240–41, 367, 424n56

Great Chain of Being, 89f.

Great Mosque, Delhi, 361

Greek revival, 292–93, 323f., 327

Greenblatt, Stephen, 8, 24, 399n8, 402n11, 440n26

Greene, Donald, 124, 410n17, 413n47, 420n7
Grella, George, 419n39
Greuze, 273
Griffin, Dustin, 116, 412n35, 422n21
grottoes, 234f., 424n62, 425n65 and n69
Guardi, 160–67, 348

H

Hagstrum, Jean, 59–60, 125, 255, 304, 405n14, 407n32, 409n4, 411n28, 414n48 and n49, 418n25, 423n42, 426n1, 429n26, 430n47, 431n58
ha-ha, 136, 140, 415n64
Haldane, Elizabeth S., 403n3
Halevi, Yehuda, 262
Hall, Carol L., 430n46
Hall, Joseph, 378
Halperin, John, 434n27
Halsband, Robert, 416n11
Hamilton, Charles, 238, 425n68
Hammond, Brean S., 409n13
Hanford, J. H., 401n9
Hardwick Hall, 141
Harpham, Geoffrey G., 425n69
Harth, Phillip, 48, 420n7
Hartman, Geoffrey, 339, 411n29, 434n1
Hartsock, Mildred E., 80, 405n15, 408n48
Hatzfeld, Helmut A., 412n34
Hauser, David R., 403n2
Havens, Raymond D., 145, 404n7, 415n75
Hawkesworth, John, 160
Hawksmoor, Nicholas, 132, 180
Haydn, 220, 232, 340
Hayes, John, 435n13
Hayley, William, 425n69
Hayne, Thomas, 400n3
Hazlitt, 171, 195, 219, 341, 434n5, 435n13
Heffernan, James, 348, 435n15
Hepplewhite furniture, 323, 336

Heraclitus, 409n4
Herbert, George, 72, 117–18, 126–27, 139, 213, 217, 220, 308, 353, 419n34
hermits, 237–40, 389
heroic couplet, 56–59, 120–22, 406n26, 413n38–45
Herrick, Marvin T., 408n50
Hertz, Neil, 423n37
Hibbard, G. R., 413n46
Hill, Aaron, 246
Hill, John, 203
Hilles, Frederick W., 417n19
Hipple, W. J., Jr., 193, 424n55
Hirsch, E. D., Jr., 174, 418n28
Hobbema, 195
Hobbes, 24, 80, 235, 402n11 and n12
Hogarth, 170–89, 193, 276, 418n23, 419n36 and n40
Holkham Hall, 318, 332
Holland, Norman H., 418n26
Holland, Peter, 408n49
Hollander, John, 90, 409n3
Holt, Elizabeth G., 406n21
Home, Countess of, 319
Homer, 132, 151, 280, 323
Honour, Hugh, 432n12, 436n24
Hooke, Robert, 152
Hooker, Edward N., 404n6
Hoole, C., 147, 415n78
Hope, Thomas, 361–62
Horace, 46, 124, 151, 227, 317, 340
Houghton Hall, 318, 332, 424n49
Howard, Deborah, 422n26
Howard, Luke, 343
Howard, Sir Robert, 43, 82, 403n4
Hudson, G. F., 436n22
Hughes, Merritt Y., 401n6
Hume, David, 374
Hume, Robert D., 404n5, 407n31 408n49
Hunt, John Dixon, 406n21, 420n1 and n2, 424n61, 425n68

Hunter, Paul J., 151, 416n1, 417n21
Hussey, Christopher, 193, 422n21
Hustvedt, S. B., 427n5
Huysmans, 83, 408n53

I

Ibsen, 36
iconology, 103, 180–81, 246, 425n62
imprisonment, theme of, 417n21
Indian influence, 359
Ireland, John, 419n36
Irwin, David, 432n12
Iser, Wolfgang, 175, 177, 182, 415n80,
 419n36, 418n29

J

Jackson, Wallace, 412n35
Jackson-Stops, Gervase, 434n23
Jacques, David, 420n6
Jahn, Otto, 434n4
James I, 101
James II, 76, 405n16
Jammer, Max, 399n9
Jefferson, D. W., 404n5 and n9
Jefferson, Thomas, 324–26
Jensen, H. J., 406n25
Jenyns, Soames, 92
Jesuit order, 355f.
John of the Cross, 60
Johnson, J. W., 124, 413n47
Johnson, Samuel, 34–35, 92, 124, 139, 159,
 200, 212–13, 269–70, 297, 311–18,
 402n19, 405n14, 421n14, 431n51, 433n26
Jones, Barbara, 195–96, 237, 420n5, 425n67
 and n71
Jones, Inigo, 102, 125
Jones, John, 436n19
Jones, William Powell, 416n5
Jonson, Ben, 125, 414n48

Jukes, Vincent, 151
Jung, Carl, 127
Juvenal, 124, 151, 370, 416n10

K

Kames, Lord (Henry Home), 233, 424n55
Kant, Immanuel, 374, 437n2
Kauffmann, Angelica, 276
Keats, 121, 311, 339, 348, 383
Kent, William, 194, 318–19
Kerrigan, William, 429n28
Kessner, Carole S., 402n15
Killigrew, Thomas, 80
Kimball, Fiske, 107, 411n24, 415n71
Kimchi, 401n4
King, Alec, 437n39
King, Bruce, 404n5
Kirsch, Arthur, 44, 57, 404n9
Kit-Kat Club, 383
Kliger, Samuel 314–16, 432n8
Knapp, Steven, 437n2
Kneller, 171
Knight, Richard P., 194, 313
Knox, Vicesimus, 421n21
Kolve, V. A., 3, 399n1
Korshin, Paul J., 414n54
Kotzebue, 313
Krieger, Murray, 395–96, 440n26
Kristeller, P. O., 405n14
Kristeva, Julia, 4, 399n3
Kroeber, Karl, 399n9, 429n26, 435n11
Krouse, F. M., 30, 400n3, 402n16
Krutch, Joseph W., 408n51
Kugel, James, 427n8

L

Lancret, 38
Landow, George P., 438n10
Langbaum, Robert, 439n18

Langley, Batty, 106, 410n20
Lascelles, Mary, 432n6
Law, William, 421n11
Lawrence, D. H., 255
Le Comte, Louis, 354
Le Nôtre, 193
LeBrun, Charles, 49
LeBrun, Vigée, 276
LeComte, Edward, 402n18
Lee, Rensselaer W., 405n13
Leibniz, 92, 355
Leicester, Lord, 318
Leighton, Angela, 374, 438n3
Lely, 76, 171
Lentricchia, Frank, 438n5
Leonardo da Vinci, 68, 170
Leoni, Giacomo, 122
Leslie, C. R., 299, 431n54, 434n7, 439n22
Lessing, 171
Levey, Michael, 110, 411n28
Lévi-Strauss, Claude, 4, 127, 399n2, 414n53
Lewalski, Barbara K., 37, 133, 377, 407n34, 414n62, 438n8
Lichtenberg, G. C., 419n36
light imagery, 75
Limbourg brothers, 6, 423n42
Lipking, Lawrence, 405n14
Livy, 270, 317
Locke, 90, 105–6, 215, 235, 276, 374, 389–90, 432n4
Lombard, Peter, 89
Longinus, 209, 219, 226, 232, 253, 423n40, 424n51
Longleat House, 102–5, 410n15
Loquin, Jean, 428n24
Lorrain, Claude, 155–56, 195, 204–21, 253, 344f., 391, 416n8, 422n26
Lotto, Lorenzo, 45
Louis XIV, 24, 76, 140–41, 270
Lovejoy, Arthur O., 89f., 315, 408n1 and n2, 432n9, 434n1, 436n22

Low, Anthony, 402n10
Lowth, Robert, 262–63, 427n7–9
Loyola, Ignatius, 9, 60, 72, 94, 377, 385
Lynch, Kathleen M., 408n47
Lyttelton, Lord, 221, 424n46

M

Mace, D. T., 406n21
Mack, Maynard, 107, 410n22, 425n63
Macpherson, James, 263–64, 427n10
Madonna paintings, 68–72, 75–76
Madsen, William G., 401n3
Malcolm, Alexander, 106, 410n20
Mâle, Emil, 60, 407n33
Malek, James S., 405n14
Malins, Edward, 193, 424n55
mannerism, 60–61, 66–72, 75, 303f., 400n2, 402n13 and n21, 407n35, 431n58 and n59
Manuel, Frank E., 414n54
Manwaring, Edward, 106, 410n20
Manwaring, Elizabeth, 193, 195, 420n4, 424n47
Marlow, William, 156
Marlowe, Christopher, 42, 55–56,
Marsden Joshua, 439n17
Martin, J. R., 400n1
Martin, John, 219, 250–51, 423n40
Martin, Peter, 425n63
martyrology, 68–76, 267
Martz, Louis L., 74, 377, 407n34, 407n43, 438n8
Marvell, Andrew, 128, 204, 422n30
Mary Magdalene, 72
Masson, David, 38
McCann, Charles J., 433n22
McCutcheon, R. P., 427n5
McFadden, George, 404n4
McFarland, Thomas, 435n12
McGann, Jerome, 339–40, 434n2

McKeon, Michael, 151, 416n1

McKillop, Alan, 415n1, 423n42

meditative tradition, 60–72, 377f.

melancholia, 199f., 421n12, 426n71

Mellor, Anne K., 292–93, 339, 430n45, 434n2

Metsu, 411n31

Metz, Conrad, 304

Mezciems, Jenny, 417n15

Michelangelo, 5–6, 25, 36, 217, 257, 294, 297–98, 303, 427n4

Middleton, Conyers, 414n54

Miles, Thomas H., 423n37

Millar, Oliver, 404n10

Milton, 13–39, 44, 54, 107, 129, 132–34, 145, 153–55, 203–4, 212, 214, 222–23, 239, 262, 280f., 367

Miner, Earl, 9, 399n9, 405n14

Mitchell, W.J.T., 9, 103, 255, 399n9, 410n16, 426n1, 427n4

Molinari, Antonio, 84

Monk, S. H., 209–10, 226, 422n27, 424n51, 425n69

Montagu, Elizabeth, 203

Montagu, Lady Mary W., 365

Montaigne, 47

Montesquieu, 417n15

Moore, Robert E., 171, 418n22

More, Alexander, 401n10

More, Hannah, 390, 439n20

More, Sir Thomas, 164–65

Morland, George, 365, 376

Morris, David B., 211, 226, 410n18, 422n32, 424n51

Morris, Robert, 424n60

Mortimer, John H., 423n40

Mozart, 320, 323–24, 340, 432n14, 434n4

Mras, George P., 386, 438n16

Muir, Kenneth, 37, 402n22, 406n26

Müller, Johann S., 160

Murch, A. E., 419n39

Murillo, 68, 72–74, 391, 407n44,

music and painting, 340f.

Muskin, Miriam, 401n8

mystery cycles, 396

mythology, 124–29, 294, 414n51–54, 433n26

N

Nardin, Jane, 433n18

narrative process, 168

Nash, 359

National Gallery, establishment of, 368

Neoclassicism, 124–25, 316–17

Neoplatonism, 9, 13–14, 24, 48, 75–76, 89–90, 103, 122, 127–28, 358–59, 430n47

Neri, Philip, 60

Nettleton, G., 403n1

New Historicism, 8, 24

Newton, 90–91, 106, 129, 197, 294

Newton, Judith L., 433n16

Nicholas of Cusa, 89, 211

Nicoll, Allardyce, 44, 404n5 and n8

Nicolson, Marjorie, 152–54, 210–11, 217, 416n3 and n5, 422n30 and n31

Norris, Christopher, 412n32

Novak, Maximillian E., 415n1, 419n40

Noyes, Russell, 437n36

Nussbaum, Felicity, 433n17

O

Oakleaf, David, 416n3

Oras, Ants, 403n23

Orgel, Stephen, 125, 414n48

orientalism, 353–62

Ossian, 263–64, 427n10

Osterley Park, 320–21

Ostriker, Alice, 427n5

Otway, 41–42

Ovid, 317

P

Pacheco, Francesco, 68
Palace of the Four Winds, Jaipur, 359
Palatine Chapel, Palermo, 425n62
Paley, Morton D., 219, 423n40, 427n7
Palladian style, 102–3, 122, 318–19, 417n19
Palmer, Samuel, 268
Pannini, 160
Panofsky, Erwin, 103, 410n16
parallelism, 262f.
Parker, W. R., 38, 403n23
Parmigianino, 304, 431n58
Parnell, Paul, 83, 408n52, 428n19
Parnell, Thomas, 199–200, 238–39, 421n13
Parris, Leslie, 437n36
Parthenon frieze, 323
Patey, Douglas L., 410n19
patronage, 340
Paulson, Ronald, 3, 126, 171, 246, 399n1,
 414n50, 418n23 and n24, 419n35, 425n68,
 438n15
Peckham, Morse, 343, 435n12
Percy, Thomas, 260, 427n5
periodization, 7–9
personification, 125–26
perspective, 9–10, 417n18
Petersson, Robert T., 407n33
Philips, Ambrose, 180, 363–64
Picasso, 36
Pico della Mirandola, 126, 180, 358–59
picturesque, 313
Pigalle, 241–45, 426n74
Plato, 92, 129, 276, 282, 390, 439n21
Plumb, J. H., 404n10
Plutarch, 270, 317
Poe, E. A., 184–85
poetic diction, 145–50, 370, 415n79, 437n39
poetic fame, 284f.
Pontormo, 304
poor, attitude towards, 363–70
Pope, Alexander, 36, 38, 90–150, 194–96,

215, 226, 235, 255–60, 312–16, 363–65,
 405n14, 408n46, 413n44, 424n51, 425n63
Porden, William, 359
Porte, Joel, 426n72
Porter, Roy, 421n12
portraiture, 383
Poulet, Georges, 410n16
Poussin, Gaspar, 370, 424n46
Poussin, Nicolas, 47f., 195, 217f., 253
Poussinists, 298
Pozzo, Andrea, 17–18, 94–97, 165, 204, 287
Praz, Mario, 5, 181, 399n5, 407n33, 419n33,
 432n12
Prest, John, 422n21
Preston, John 418n26
Prévost, l'Abbé, 152
Price, Martin, 412n37, 424n57, 433n22
Price, Uvedale, 194, 313
Prior Park, 417n19
prophetic reluctance, 284f., 429n32
Pye, Christopher, 402n11
Pyrrhonism, 47–48
Pythagoras, 340–41, 409n4

Q

Quarles, Francis, 181, 419n34
Quesnay, F., 436n26
Quintilian, 84

R

Racine, 406n26
Radcliffe, Ann, 237, 311, 425n66
Radzinowicz, Mary Ann, 38, 401n5, 403n23
Ragussis, Michael, 440n26
Rainaldi, Carlo, 103, 409n15
Raine, Kathleen, 430n47
Raphael, 68, 75, 105, 125, 297–98, 393
rationalism, 49f.
reader response, 54, 147–48, 164, 172–75,
 418n26–29

Réau, Louis, 426n74
Reed, Arden, 435n11
Regency style, 318f.
Reichwein, Adolf, 355, 436n23
Rembrandt, 298
Renaker, David, 416n3
Reni, Guido, 68, 125, 209, 246
Repton, Humphrey, 313, 332, 359, 361,
 433n22
Restoration comedy, 80, 268–69
Reynolds, Graham, 434n7, 435n11 437n36,
 438n14
Reynolds, John, 91, 409n4
Reynolds, Sir Joshua, 193, 276, 297–98, 304,
 333–34, 383, 405n14, 424n49, 433n26
Ribera, 222
Ricci, Matteo, 355
Ricci, Sebastian, 97
Richardson, Jonathan, 422n26
Richardson, Samuel, 83, 152, 170
Richmond, Duke of, 159–60
Rigaud, Hyacinthe, 76
Riley, John, 80–82
Ripa, Cesare, 125–26, 180–81, 414n48
Roberts, Warren, 313, 432n4
Robertson, D. W., Jr., 6, 399n6
Robinson, Roger, 417n19
Rochester, Earl of, 269
Rococo art, 107f.
Rococo salon, 140–45
Roland-Michel, Marianne, 411n28
Romano, Giulio, 297–98
Rosa, Salvator, 156, 195, 221–25, 241, 347,
 424n48
Rose, Albert S., 427n4
Rose, Edward J., 298, 431n52
Rosenblum, Robert, 267, 428n16 and n24,
 431n58
Rosenheim, Edward W., Jr., 167, 417n18
Ross, G.R.T., 403n2
Roston, Murray, 400n2, 406n19, 413n39,
 427n7, 440n27

Rothstein, Eric, 404n5
Roubiliac, 241–42
Rousseau, J. J., 276–77, 363, 376, 428n25
Rowlandson, 172, 189
Royal Academy, 340–41
Royal Hospital, Greenwich, 101f.
royal portraiture, 24, 75–76
Rubenists, 298, 368
Rubens, 25–26, 38, 101, 107–8, 165, 297f.,
 402n14, 431n50
Ruisdael, 223, 344
Runge, 267–68, 391
Ruskin, John, 351–52, 436n18
Russell, R. C., 439n20
Rymer, Thomas, 74–75

S

Sachs, Klaus-Jürgen, 409n15
Saintsbury, George, 58, 312, 406n31, 431n1
Salisbury Cathedral, 130
Salviati, 304
Sauerländer, W., 221, 423n45
Scamozzi, 304
Schiller, Friedrich, 340, 434n4
Schubert, 341
Schulz, Max F., 422n21
Scott, Nathan A., 401n3
Scott, Samuel, 156
Scott, Sir Walter, 311, 314, 316, 327,
 433n15
Scott-Craig, T.S.K., 401n3
seasonal cycle, 219–21, 423n42 and n44
Seerveld, Calvin, 412n31 and n34
Selvesen, Christopher, 439n18
Senate House, Cambridge, 132
Seneca, 317
sentimental drama, 55, 83, 269f., 313
sepulchral statuary, 125, 129–30, 241–45,
 414n58
Settle, Elkanah, 282
Sewall, J. I., 411n23, 412n33

Sezincote House, 359
Seznec, Jean, 414n51, 426n74
Shadwell, Thomas, 43, 82, 403n3
Shaftesbury, Lord, 142, 227–29, 353, 414n54, 421n14
Shakespeare, 5–6, 43, 59, 66, 84, 119, 126, 170, 184, 195
Shankman, Steven, 414n47
sharawaggi, 357
Shawcross, John, 403n23
Shee, Martin, 209, 422n28
Shelley, Mary W., 233–34, 424n58
Shelley, P. B., 103, 219, 230–31, 279, 311, 339–47, 351, 362, 374–76, 439n21
Shenstone, 194, 239
Sheraton furniture, 323
Sheridan, 269
Shipley, J. T., 316
Shirley, Andrew, 435n11, 436n33
Shoaf, R. A., 400n3
Sickels, Eleanor M., 426n71
Sidney, Sir Philip, 282, 429n28
Siegel, Linda, 428n17, 439n19
Simeon Stylites, 237, 425n68
Simmons, Robert E., 261, 427n6
Sirluck, Ernest, 403n23
Skrine, Peter N., 400n1
Smart, Christopher, 200, 263, 427n9
Smith, J.S.B., 414n59
Smith, J. T., 367, 437n33
Smith, William, 232, 424n54
Smollett, 171–72
Southworth, James G., 420n6
Spacks, Patricia M., 426n72
Spearman, Diana, 152, 416n2
Spence, Joseph, 411n25
Spencer, Jeffry B., 422n21
Spengler, Oswald, 304, 431n60
Spenser, 24, 36–37
Spitzer, Leo, 409n4
Sprat, Thomas, 108, 411n26
Sprecher figure, 66, 74, 378f., 407n37

Spurzheim, J. G., 201, 421n17
St. George's, Bloomsbury, 132, 180
St. Martin-in-the-Fields, 130–31
Stead, W. J., 427n9
Steadman, John M., 400n3
Stechow, W., 400n1
Steele, 184, 269, 423n38
Steen, Jan, 407n44
Stein, Arnold, 401n8
Steiner, Wendy, 374, 437n1
Sterne, Lawrence, 91, 175
Streeter, Robert, 409n11
stoicism, 48f., 401n7, 405n16
Stone, Lawrence, 141, 201, 415n69, 421n16
Stothard, Thomas, 429n26
Stourhead, 126, 208
Stowe gardens, 203, 208, 237, 425n68
Stukeley, William, 237–38, 425n68
Summerson, John, 432n13
Sunderland, John, 424n48, 429n27
Sweetman, Joka, 436n22
Swift, Jonathan, 152–68, 215
Switzer, Stephen, 203, 422n22
synaesthesia, 341
synchronic studies, 3–8, 311–12
Sypher, Wylie, 5, 106–8, 399n5, 400n1, 410n21

T

Tannenbaum, Leslie, 427n7
Tanner, Tony, 432n4
Tapié, Victor L., 400n1
Tate, Nahum, 37, 75, 82
Tawney, R. H., 394, 415n1
Taylor, A. M., 403n2
Temple, Sir William, 357
Tennyson, G. B., 436n19
Teresa of Avila, 60, 74
thematic convergence, 217
Thompson, G. R., 426n72

Thomson, James, 220, 420n3, 423n42 and n44
Thornhill, James, 94–101, 127
Thorslev, Peter L., 352, 436n20
Tiepolo, G. B., 97, 409n12
Tillotson, Geoffrey, 145–47, 410n22, 413n40, 415n79
Tillotson, John, 197–98, 227
Tillyard, E.M.W., 20, 401n7, 417n20
Tinker, C. B., 171
Tintoretto, 304–5, 378
Titian, 45, 50, 125, 298
Toplady, Augustus, 350–51, 436n17
travel literature, 164–65, 417n14
Trevor-Roper, H. R., 415n1
Trickett, Rachel, 414n54
Tukes, Samuel, 421n12
Turner, 103, 219, 341, 348, 423n30
Tuveson, Ernest, 211
Twitchell, James B., 423n37
Tyers, Jonathan, 196–97, 236, 246, 420n6
typology, 400n3, 438n10

V

Van Doren, Mark, 405n14
Van Dyck, 76, 171, 408n45
Van Eyck, Jan, 402n14
van Leeuwenhoek, Antony, 152
Vanbrugh, 76f.
Vauxhall Gardens, 196–97
veduta painting, 156f.
Vergil, 124, 132, 145, 151, 280, 363, 370
Vermeer, 75, 158–59
Verrio, Antonio, 45, 409n11
Verrocchio, 25
Versailles, Palace of, 24, 75, 143, 183, 233, 420n2
Victoria, Queen, 359–61, 390
Villa Rotunda, 122–23, 326
Villiers, George, 41
Vitruvius, 318

Vivaldi, 219
Voigt, Milton, 417n14
Voltaire, 92, 357

W

Waggoner, Hyatt H., 432n2
Waith, Eugene M., 402n15, 405n16
Walding, William, 399n9, 429n26
Wallace, Richard W., 426n73
Wallace, Robert K., 432n14
Wallerstein, Ruth, 413n38
Walpole, Horace, 196, 204, 219
Walpole, Sir Robert, 177
Warnke, Frank J., 400n1
Warton, Joseph, 126
Wasserman, Earl, 55, 117, 406n25, 410n22, 412n38
Watson, Foster, 428n25
Watt, Ian, 124, 151, 413n47, 415n1
Watteau, 107–15, 129, 148–50, 165, 237, 411n28 and n30
Watts, Isaac, 200, 394, 439n24
Webb, John, 102
Weber, Max, 394, 415n1
Wedgewood, Josiah, 292, 323f., 359
Weinbrot, Howard D., 124, 413n47
Weiskel, Thomas, 374, 425n69, 437n2
Wellek, René, 5, 339, 399n4, 434n1
Wendorf, R., 410n16
Wesley, Charles, 200, 421n15
Wesley, John, 350, 435n17, 439n21
West, Benjamin, 267, 270, 304, 367, 437n35
Wheldon, H., 404n10
Whichcote, Benjamin, 48
Whinney, Margaret, 404n10
White, Douglas H., 116, 412n37
White, Hayden, 8, 399n7
White, Robert B., 400n3
Whitefield, George, 388, 439n17
Williamson, George, 413n38
Wilson, Richard, 207

Wilton, Andrew, 434n6, 435n11

Wimsatt, William K., 405n14, 413n45

Winckelmann, 292

Winterbottom, John A., 405n15

Winters, Yvor, 74, 407n43

Wittkower, Rudolf, 90, 400n1, 407n40,
409n3

Wittreich, Joseph A., Jr., 288–89, 400n3,
402n23, 430n41

Wlecke, Albert O., 438n8

Wolff, Christian, 356

Wölfflin, Heinrich, 14, 400n1

Woodhouse, A.S.P., 38, 401n8, 403n23

Woolf, Virginia, 410n22

Wordsworth, 146, 283, 311, 339, 342, 367–
74, 383, 422n32, 428n24, 436n19,
439n21

Wren, Christopher, 102

Wright, Joseph, 223, 246, 267

Wrighte, William, 239

Wyatt, James, 321

Wyattville, 413n46

Wycherley, 41, 269, 405n12

Y

Young, Arthur, 245

Young, Edward, 204

Young, R. V., 74, 407n43

Z

Zoffany, 136, 165

Zurbarán, 426n73, 439n25